INIGO JONES

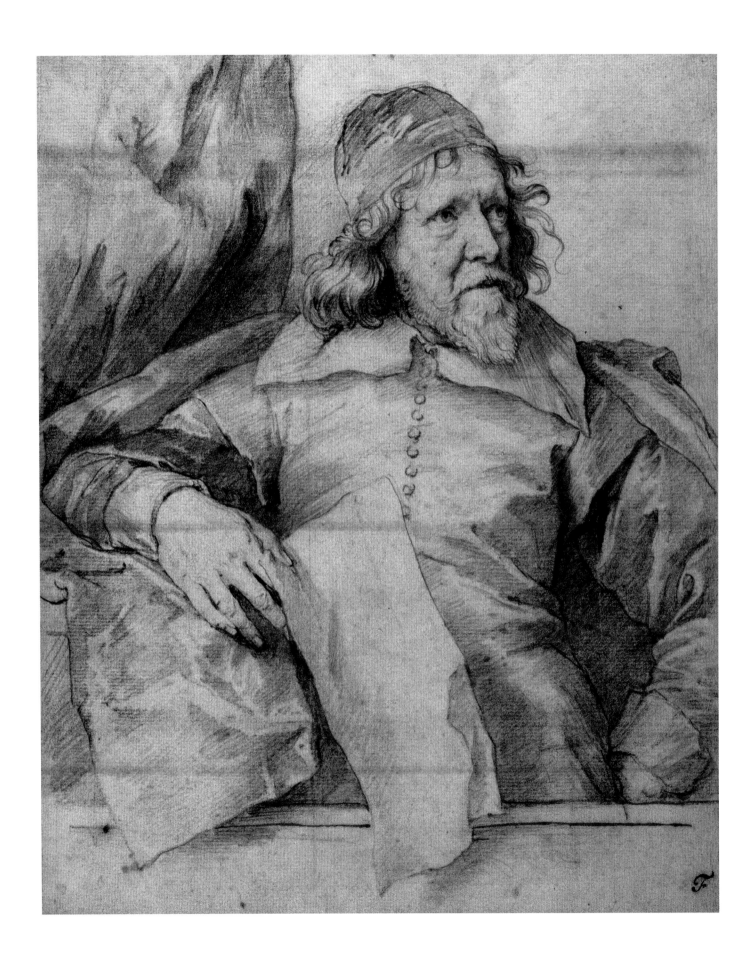

VAUGHAN HART

INIGO JONES
THE ARCHITECT OF KINGS

PUBLISHED FOR

THE PAUL MELLON CENTRE FOR STUDIES IN BRITISH ART

BY

YALE UNIVERSITY PRESS

NEW HAVEN AND LONDON

Designed by Gillian Malpass

Printed in China

Library of Congress Cataloging-in-Publication Data

Hart, Vaughan, 1960-
Inigo Jones : the column and the crown / Vaughan Hart.
p. cm.
Includes bibliographical references and index.
ISBN 978-0-300-14149-8 (cl : alk. paper)
1. Jones, Inigo, 1573-1652–Criticism and interpretation.
2. Classicism in architecture–Great Britain.
3. Architecture and state–Great Britain.
I. Title.
NA997.J7H38 2011
720.92--dc22

2011009909

A catalogue record for this book is available from
The British Library

Front endpapers The column and the crown in the Jones-Webb design for Whitehall Palace,
as engraved by Henry Flitcroft for William Kent's *The Designs of Inigo Jones* (1727)

Back endpapers The lion and the unicorn, together with the Corinthian capital,
in the Jones-Webb design for Whitehall Palace,
as engraved by Henry Flitcroft for William Kent's *The Designs of Inigo Jones* (1727)

Frontispiece Anthony Van Dyck, *Inigo Jones*, sketch, *c.*1640. Devonshire Collection, Chatsworth

Page vi Anthony Van Dyck, *Inigo Jones* (detail), *c.*1635–6, oil on canvas.
State Hermitage Museum, St Petersburg

To Charlotte and Christopher

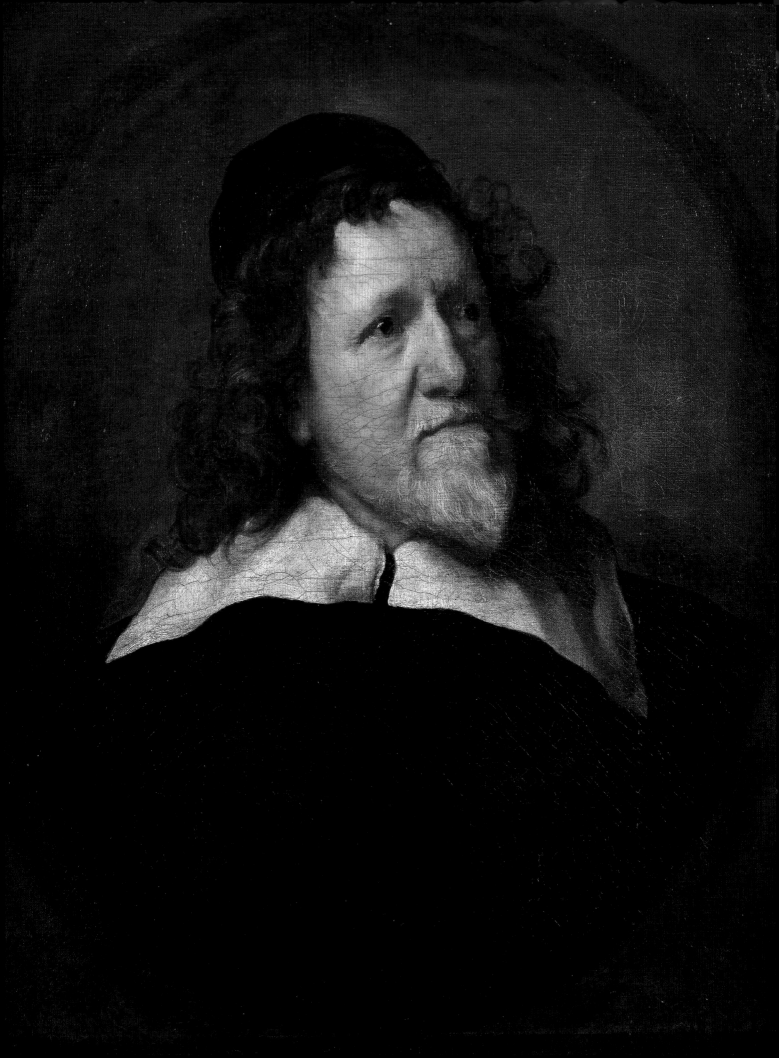

CONTENTS

ACKNOWLEDGEMENTS

I should like to thank the following for their advice and support at various stages in the preparation of this book over many years: Professor Joseph Rykwert, Professor David Watkin, Professor Michael Hunter, Professor Edward Chaney, Professor Robert Tavernor, Professor George Hersey, Professor Caroline van Eck, Professor Elizabeth Cropper, Professor Peter Hicks, Dr Simon Thurley, Dr Peter Clarkson, Dr Ian Campbell, Dr Stephen Johnson, Mary Courtman-Davies, Marion Harney, Hannah South, Delia Gaze, David Baldwin (Sergeant of the Vestry at St James's Palace, London) and Gillian Malpass, of Yale University Press. My colleague Mark Wilson Jones commented on a draft of the book, and Dr Gordon Higgott assisted with a number of references. John Newman, formerly of the Courtauld Institute of Art, University of London, assisted with transcribing Jones's annotations. Dr Michael Lewis helped during my study of Inigo Jones's copy of Serlio in the collection of the Canadian Centre for Architecture in Montreal. Peter Day at Chatsworth House and Dr Colin Shrimpton at Alnwick Castle assisted with my visits to their archives. Librarians at the following should be thanked: The Sir John Soane's Museum, RIBA Library Drawings Collection in London, Worcester College and The Queen's College in Oxford, Magdalene College in Cambridge, the British Library in London, Bath University Library, Guildhall Library, Lambeth Palace Library, St Paul's Cathedral Library, Cambridge University Library and the National Archives at Kew. Dr Joanne Parker, Librarian of the Rare Books Department at Worcester College, Oxford, should also be thanked. Important aspects of the research and writing of this book were carried out in 2009 whilst Ailsa Mellon Bruce Visiting Senior Fellow in the Centre for Advanced Study in the Visual Arts (CASVA) in the National Gallery of Art, Washington, DC, and thanks are due to the librarians and all the staff in the Centre who patiently dealt with my requests.

Joseph Robson and Professor Alan Day of the Centre for Advanced Studies in Architecture (CASA) at Bath University collaborated on the computer models that reconstruct Jones's Covent Garden, original Banqueting House façade, unrealised design for St Paul's Cathedral, and perspective masque stage (discussed in Appendix 2), whilst Dr Richard Tucker was a co-author of articles that form the basis of chapters Six and Seven.[1] Professor Paul Richens assisted with some of the images. Bath University provided financial assistance for travel associated with this work, and the British Academy awarded me a research grant to study in Montreal at the Canadian Centre for Architecture. Finally, I should like to thank my wife, Charlotte, for her encouragement, patience and support.

Vaughan Hart
University of Bath, 2010

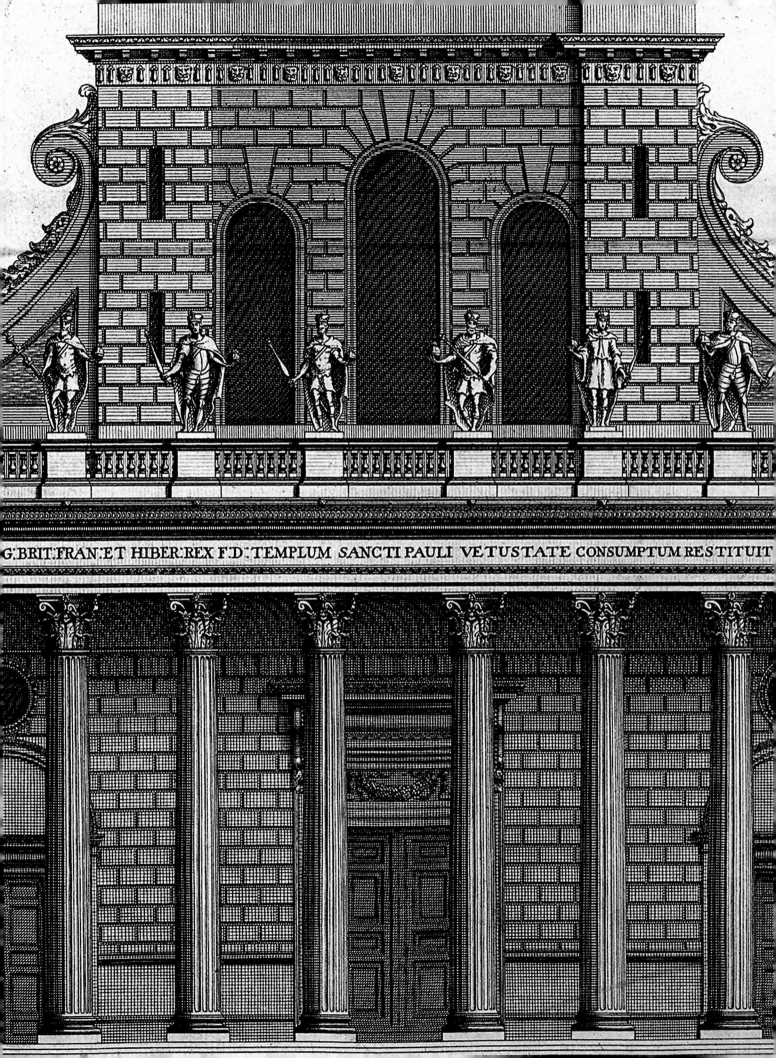

G. BRIT. FRAN. ET HIBER. REX F D. TEMPLUM *SANCTI PAULI VETUSTATE CONSUMPTUM RESTITUIT*

PREFACE

In July 1650 the Puritans tore down the statues of the two Stuart kings, James I and Charles I, that crowned the portico on the west front of St Paul's Cathedral in London (Fig. 1). According to one contemporary report, the new republican authorities went on to allow the portico's Corinthian columns, which had been erected only a few years earlier by Inigo Jones (1573–1652), to be 'shamefully hewed and defaced'.[1] Clearly, his architecture, or certain forms of it, did not enjoy immunity from the Puritan animosity directed at royalist and religious iconography during the Civil War and its aftermath. This conflict had brought to a head the underlying religious tensions and related aesthetic sensitivities that Jones had had to respect throughout his career popularising the antique (or *all'antica*) style of building.

The first half of the seventeenth century had seen a fundamental change in the accepted style of English court buildings. Construction practices moved away from the mixture of Gothic elements and rich antique decoration that had frequently been favoured by Elizabethan courtiers towards the exclusive and more restrained use of the ornament and forms of antiquity. In 1624 the Stuart ambassador to Venice and architectural theorist Henry Wotton (1568–1639) noted the 'naturall imbecility of the sharpe *Angle*', and advised that any such arches 'ought to bee exiled from judicious eyes, and left to their first inventors, the *Gothes* or *Lumbards*, amongst other *Reliques* of that barbarous *Age*'.[2] He advocated the use of the five antique columns, also called 'Orders', and styled Tuscan, Doric, Ionic, Corinthian and Composite. Jones was by then leading the way in introducing this fashion for building *all'antica*, following Renaissance practices common in Europe. He is famously styled the 'Vitruvius Britannicus', since his buildings were the first ever in England to follow coherently the principles of the Roman architectural writer Vitruvius (*c*.80/70–*c*.15BCE).[3] They

were designed using the antique rules of proportion, symmetry and decorum that determine the choice and arrangement of the five columns. Earlier English architect-masons had used classical columns in isolated but coherent-enough ways, as on the gate to Gonville and Caius College in Cambridge (1573–4; Fig. 2) and on

2 Gate of Honour at Gonville and Caius College, Cambridge, 1573–4

3 Kirby Hall in Northamptonshire, 1570–75

that to the Old Schools in Oxford (1613–24; see Fig. 132). And Elizabethan façades were sometimes framed by arcades composed of pilasters with flamboyant hybrid capitals and other embellishments. Notable in this regard are Longford Castle in Wiltshire (1591) and Kirby Hall in Northamptonshire (1570–75; Figs 3 and 4). But the Orders had not been used to compose an entire building façade in quite the way that Jones was to achieve so majestically at the Banqueting House, built next to the old Holbein Gate in Whitehall between 1619 and 1623 (Fig. 5; see Fig. 7). The Banqueting House was the first building in England to rival the work of the Italian masters in reflecting in such an articulate manner the Vitruvian concept that a symmetrical façade could be ordered by the column and its measured relationship to an entablature. The status of the column was raised from its being a mere aspect of a rich and varied palette of Elizabethan ornament to its being used to dictate the whole architectural composition. Jones's approach was to be firmly based on the antique theory and practice of architecture, assisted by contemporary decorative conventions in native arts, such as geometry, and crafts, such as heraldry.

But as the attack on St Paul's suggests, the introduction of the Orders was by no means straightforward. They carried the obvious risk of being seen as foreign, pagan or worst of all popish, at least by Puritans, and as such they needed to be reconciled to English sensitivities and national identity. This assimilation was that much more important when the columns were used by Jones in the service of the crown, rather than for private citizens as had been the case for the most part in Elizabethan architecture. His 'antique' style therefore necessarily acquired a political purpose, for it expressed the Stuart court's pretension to have restored a glorious ancient Britain. This antiquity was cultivated in order to give apparent legitimacy to James I's accession to the English throne. Moreover, much like the architectural treatise-writers of his day, Jones also attempted to overcome the alien aspects of ancient and modern classical architecture through what amounted to a nationalistic interpretation of the *all'antica* style, sensitive to time and place. Where Elizabethan patrons and masons had often chosen the Orders for flamboyant decorative effect and apparently at random, Jones's use can be seen to possess much greater discipline. He understood fully that the selection of ornament, prin-

4 Detail of pilaster at Kirby Hall, 1570–75

(held at Chatsworth House, Derbyshire) in now-famous notes made on his return to England the following year. Here he observed that whilst decorative fancies could be entertained internally, externally English buildings should bear the public countenance of a 'wise man' and, in continuing the gender-based analogy, be 'masculine and unaffected',

> In all invencions of C[a]ppresious ornamentes, on[e] must first designe yᵉ Ground, or yᵉ thing plaine, as yt is for youse. and on that, varry yt. addorne yt. Compose yt wᵗʰ deccorum according to the youse, and yᵉ order yt is of . . . and to saie trew all thes composed ornamentes, the wᶜʰ procced out of yᵉ aboundance of dessignes, and wear brought in by Michill Angell and his followers. in my oppignion do not well in sollid Architecture and yᵉ facciati of houses but in gardens loggis, stucco or ornamentes

5 The Holbein Gate in Whitehall (destroyed), watercolour by anonymous artist, 1725; the gate stood next to Jones's Banqueting House. The Guildhall Library, Corporation of London

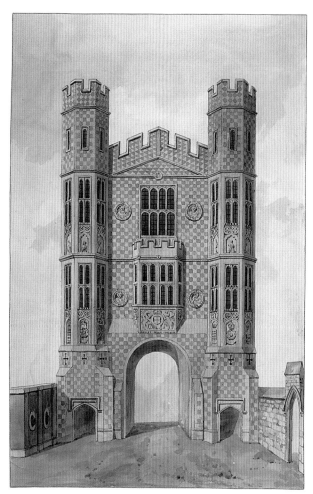

cipally concerning which style of column to use where, had not been an arbitrary affair in antiquity but had followed decorous rules related to the ethics and decorum of display. He collected treatises on these and other classical subjects, which he constantly annotated (these works form part of what survives of his library held at Worcester College in Oxford). Jones was guided by ancient principles of decorum when balancing the need to display the royal status of his patrons and their projects, and their natural inclination towards decorative opulence and luxury (at least internally), with the preference of many Puritans for propriety and temperance in external ornament. Although highly decorative façades were sometimes patronised by private citizens or institutions, such as the Inns of Court and Oxbridge colleges, Jones imposed limits on his use of the *all' antica* style. His choice of ornament was influenced by what type of building was to be decorated, from 'humble' stable to 'rich' palace, necessarily tempered, however, by the political and religious climate current during a particular project.

Jones's negative reaction to the Mannerist excesses of the Counter-Reformation in Rome as witnessed by him in 1614 was recorded in his 'Roman Sketchbook'

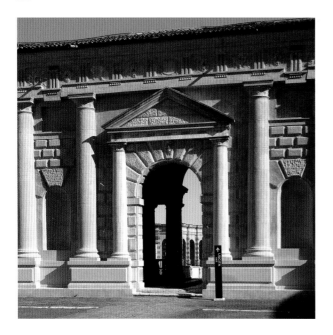

6 Giulio Romano, Palazzo Tè, Mantua

for. & yt inwardly hath his ~~mynd~~ [*sic*] Immaginacy set free, and sumtimes liccenciously flying out, as nature hirsealf dooth often tymes Stravagantly . . . So in architecture y^e outward ornamentes oft to be sollid, proporsionable according to the rulles. masculine and unaffected.[4]

On this visit to Italy Jones studied closely the work of one such 'follower' of Michelangelo, Giulio Romano (Fig. 8). The masculine characteristics of Romano's Palazzo Tè in Mantua must have appealed to him, given that he carefully studied its rusticated columns, but less attractive were its capricious dropped triglyphs (Fig. 6).[5] In reflecting Protestant sentiment, the 'masculine and unaffected' was a rule that Jones stuck to in most, if not quite all, of his court buildings. His well-known 'unaffected' works include the Queen's House at Greenwich, the Queen's Chapel at St James's Palace and St Paul's at Covent Garden (see Figs 41, 47, 221).

The question arises, however, as to why, only four years after making this statement, Jones began erecting what can only be described as a 'feminine and affected' façade at the Banqueting House in Whitehall (Fig. 7)? The reasons for his occasional use on court buildings of the feminine Ionic and Corinthian Orders, as well as the more capricious Composite, will be seen to have

of chimnies peeces & in the inner partes of houses thes composisiones ar[e] of neccesety to be yoused: for as outwar[d]ly every wyse ma[n] carrieth a graviti in Publicke Places, whear ther is nothing els looked

7 Inigo Jones, Banqueting House, Whitehall, 1619–23

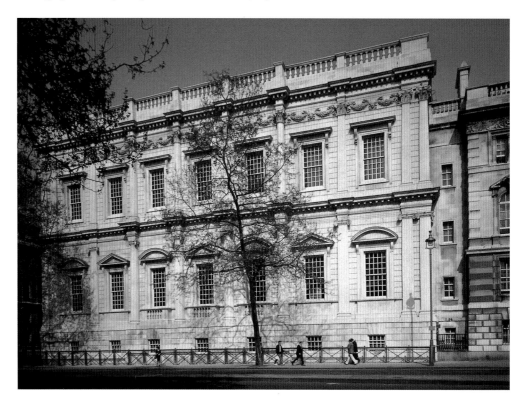

I DISEGNI che seguono sono di vna fabrica in Vicenza del Conte Ottauio de' Thieni, fù
del Conte Marc'Antonio:il qual le diede principio. E' questa casa situata nel mezo della Città, vici-
no alla piazza, e però mi è parso nella parte ch'è verso detta Piazza disponerui alcune botteghe:
percioche deue l'Architetto auertire anco all'vtile del fabricatore, potendosi fare commodamente,
doue resta sito grande a sufficienza. Ciascuna bottega ha sopra di se vn mezato per vso de' botte-
ghieri; e sopra vi sono le stanze per il padrone. Questa casa è in Isola, cioè circondata da quattro stra
de. La entrata principale, ò vogliam dire porta maestra ha vna loggia dauanti, & è sopra la strada
più frequente della città. Di sopra vi sarà la Sala maggiore: laquale vscirà in fuori al paro della Log
gia. Due altre entrate vi sono ne' fianchi, lequali hanno le colonne nel mezo, che vi sono poste non
tanto per ornamento, quanto per rendere il luogo di sopra sicuro, e proportionare la larghezza all'
altezza. Da queste entrate si entra nel cortile circondato intorno da loggie di pilastri nel primo or-
dine rustichi, e nel secondo di ordine Composito. Ne gli angoli vi sono le stanze ottangule, che rie-
scono bene, sì per la forma loro, come per diuersi vsi, a' quali elle si possono accommodare. Le stan
ze di questa fabrica c'hora sono finite; sono state ornate di bellissimi stucchi da Messer Alessandro
Vittoria, & Messer Bartolomeo Ridolfi; e di pitture da Messer Anselmo Canera, & Messer Bernardi-
no India Veronesi, non secondi ad alcuno de' nostri tempi. Le Cantine, e luoghi simili sono sotto ter
ra: perche questa fabrica è nella più alta parte della Città, oue non è pericolo, che l'acqua dia im-
paccio.

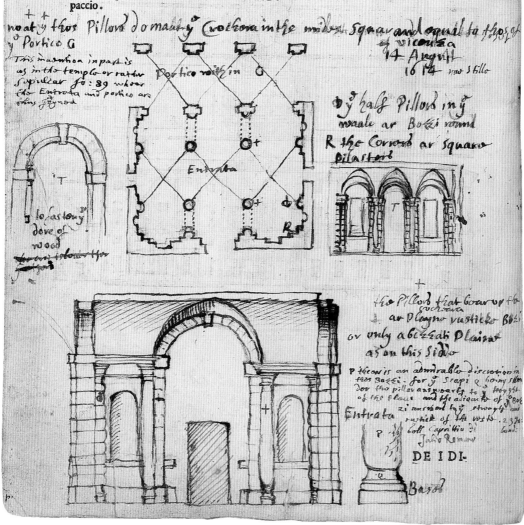

8 Inigo Jones, annotations recording his visit to the Palazzo Thiene, Vicenza, and his study of the work of
Giulio Romano, made in his copy of Andrea Palladio's *I quattro libri dell'architettura* (1601 edition), Book Two,
p. 12. Worcester College, Oxford

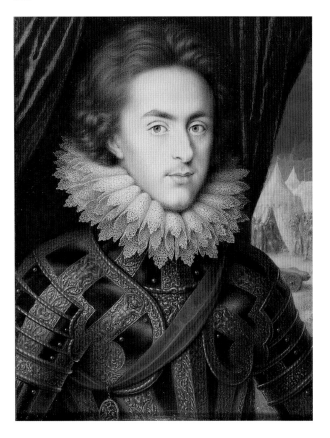

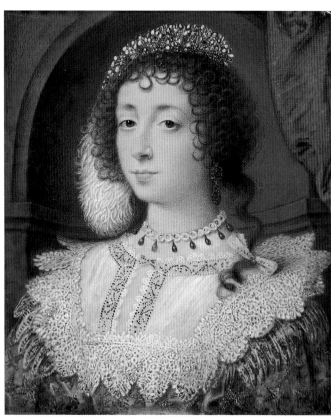

9 Isaac Oliver, *Henry, Prince of Wales*, *c*.1610–12. Royal Collection

10 John Hoskins, *Queen Henrietta Maria*, *c*.1648. Royal Collection

related, at least, in part, to circumstance. Of particular influence were the contrasting religious affiliations, or more accurately the evolving attitudes to Catholicism, of the Church and the courts in which Jones served. These attitudes ranged from the Protestant militancy of James's eldest son, Prince Henry, and, officially at least, the milder Protestantism of James himself, to the Catholic toleration of Charles I and open Catholic allegiance of his queen, Henrietta Maria (Figs 9–10). James's queen, Anne of Denmark, was also a Catholic, although she was secretive about it (Fig. 11). Anne had been converted by a Jesuit, Robert Abercromby, sometime around 1600 whilst in Scotland, and she had caused embarrassment three years later at James's coronation by refusing to take Anglican Communion. The taste of both queens for the visual arts, which reflected their religious preference, played a fundamental role in Jones's development. Anne devoted herself to court entertainments, spending extravagantly on productions like Ben Jonson's *Masque of Blackness* (1605) with its designs by Jones, in which she herself took part (Fig. 12). One of Jones's most important early architectural commissions, the Queen's House, was started in 1616

for her and was later finished for Henrietta Maria. Henrietta Maria's patronage of Jones allowed him to develop a Catholic court style, albeit in the 'private' realms of the court masques and interiors such as those of the Queen's House and two Catholic chapels. As the daughter of Henry IV of France, she imported the French fashion for lace and finery captured in the portraits of her by Van Dyck and which these interiors reflected (see Fig. 145). Although practising a moderate and unshowy form of Counter-Reformation Catholicism, Henrietta Maria was far more overt a Catholic than Anne had been. Whilst for Anne the practice of her Catholic faith was personal and secretive, for Henrietta Maria it was a communal act involving public display.[6] Under Charles the Anglican Church too moved increasingly away from the Calvinism of James I towards the High Church doctrines of the last Stuart archbishop of Canterbury, William Laud. This denominational dichotomy will be seen played out, perhaps unsurprisingly, in Jones's remarkable resurfacing of Gothic St Paul's Cathedral, which involved the addition of the western portico and other *all'antica* ornament more for symbolic than for practical purposes.

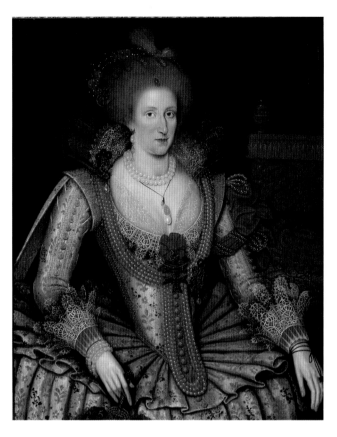

11 Marcus Gheeraerts the Younger, *Anne of Denmark*, 1614. Royal Collection

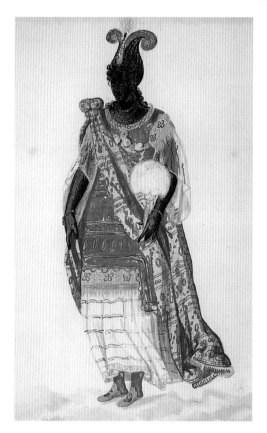

12 Inigo Jones, costume design for *The Masque of Blackness* (1605). Devonshire Collection, Chatsworth

Given that both Protestant monarchs were married to Catholic queens, religious tensions in the Stuart court were inevitable, and Jones's own official position as Surveyor of the King's Works (from 1615) consequently relied on political, religious and indeed artistic flexibility. His aim was to produce a 'native classicism' based on an understanding of architecture as a social and political art form perfectly capable of reflecting the shifting moral and religious convictions not just of his royal patrons but also of Stuart culture as a whole. In representing the court's authority, Jones's architecture was seen by its royal patrons as lending stability in volatile times: the Stuart era had opened with the Gunpowder Plot and was to close with the beheading of an archbishop and a king (Fig. 13; see Figs 259a and b). It is now commonplace to consider Jones's masques as expressions of the court's political and religious attitude prevalent at the time of their performance, and this is especially the case with the later, more 'decorative' masques produced for Henrietta Maria.[7] And so his ability as the Royal Surveyor to give more public expression to the same nuances through his court architecture and its ornament should not be surprising.[8] As

Jonson's well-known prefatory argument to the 1606 masque *Hymenaei* observed, Jones's pencil had been taught to 'present occasions'.[9]

★ ★ ★

Jones's ideas were thus shaped by a negative reaction to certain types of modern Italian architecture. His debt to the more classically correct work of the Vicentine master Andrea Palladio has been one of the most discussed themes in English architectural history, but this is not the subject of this book.[10] Concentration on Italy as the all too obvious source for Jones's work has left it divorced from its national context. For this reason the book sets out to describe how Jones attempted to reconcile the Orders to English tastes and sensibilities via his sensitivity to native themes and conventions. These influences include the Stuart cultivation of 'British' mythology, established craft techniques, legal concepts and the idealisation of the body of the king. Along with recognising the nationalistic intentions behind Jones's court architecture, this study attempts to show the variety of ways in which his buildings were understood

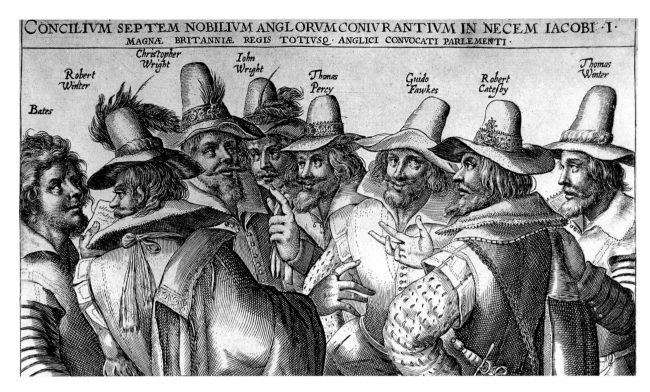

13 Crispijn van de Passe the Elder, *The Gunpowder Plot Conspirators*, engraving, c.1605. National Portrait Gallery, London

by his contemporaries. Evidence for this can be found in the activities of his close friends, men such as Edmund Bolton, Henry Peacham and George Chapman, as well as in those of the contemporary groups with whom he either collaborated or later clashed. The former included the City Livery Companies, Knights of the Garter, and Protestant preachers, poets and mythographers employed by the court and Church; and the latter were the Parliamentary authorities that targeted particular buildings during and after the Civil War. Some sources for the occasionally conflicting interpretations of his work were intended as private to the court, as with masques and paintings. Others were public events, like the Protestant sermons that helped prompt and popularise the programme behind Jones's refacing of St Paul's Cathedral, for example, and which reflected contrasting Low and High Church aesthetic preferences. It is these preferences that will be seen to have found expression in Jones's work through his selective application of ornament.

The book offers new interpretations of Jones's surviving, destroyed and unrealised court buildings, frequently in relationship to his parallel designs for the court masque.[11] Following the Introduction outlining his early career and influences, and all his major works

for the crown, the opening chapters examine the various ways in which the Orders were first explained and used before and during Jones's lifetime. The aim is to demonstrate how his understanding of them would have been conditioned by their early use in royal events. In this regard the masques are examined in Chapter One and processions in Chapter Two, and royal images such as heraldry in Chapter Three and the idealisation of the king's legal body in paintings and poetry in Chapter Four. These chapters explore the concept of the columns as 'bearers of meaning', and what they may have signified to Jones in his unique role as Royal Surveyor. Chapter Five shows how English puritanical sensitivities to certain forms of Continental decoration, and to the Orders in particular, were overcome by the early English *all'antica* architectural theorists John Dee, John Shute, Richard Haydocke and Henry Wotton. It forms a necessary preparation for the examination of Jones's Church and court buildings in the light of his own interpretation of ornamental propriety. Each of these later chapters takes as an example one of these buildings – or group of buildings – in order to demonstrate Jones's use of theory in practice. The book is therefore not intended as a general study of his work. Nor is its focus on functional matters, but rather on the

much more symbolic and eloquent matter of decoration. It examines Jones's conception and application of the antique column as the principal and most consistent element in his vocabulary of architectural forms.

In recent years there has been a revival of interest in Jones's life and works. A number of publications on the architect are currently in print, the first being John Summerson's brief introduction to Jones, which appeared in 1966 and which was republished with minor corrections in 2000. A biography of Jones was published in 2003 by Michael Leapman entitled *The Troubled Life of Inigo Jones* (with a paperback in 2004), whilst Edward Chaney edited Jones's 'Roman Sketchbook' in twin volumes published in 2006. Most recently, two studies with similar titles have focused on the influence of European classicism on Jones, namely Christy Anderson's *Inigo Jones and the Classical Tradition* and Giles Worsley's *Inigo Jones and the European Classicist Tradition*, both published in 2007.

Whilst Jones may have been avant-garde at home, it has been commonly assumed that he was backward in his apparent architectural preference for the plain and simple, when seen in the context of the Europe of his day. After all, his later work coincided with that of Bernini and Borromini. Worsley sets out to overturn this view of Jones's work as anachronistic. This re-evaluation involves detailed study of contemporary classical buildings by French architects such as François Mansart and Jean Androuet du Cerceau, Dutch architects such as Jacob van Campen and Pieter Post, German architects such as Joseph Heintz and Elias Holl, and, most famously, the Italians Vincenzo Scamozzi and Alessandro Tesauro. When seen in the context of this contemporary taste for antique fidelity, even simplicity, Jones emerges with restored European credentials. Following Summerson, Worsley argues for the attribution to Jones of the pavilions at Stoke Park in Northamptonshire, of importance given the fact that only four buildings survive for which Jones's authorship is undisputed. These are the Banqueting House at Whitehall, the Queen's House at Greenwich, the Queen's Chapel at St James's Palace and St Paul's at Covent Garden (see Figs 7, 41, 47, 221).[12] They are all that remain of a prolific architectural career, ranging from the extensive buildings at Newmarket and the hunting lodges at Bagshot Park and Hyde Park to the giant portico to St Paul's Cathedral, works now lost.

The second myth that Worsley sets out to debunk is the idea, established by Colen Campbell and Lord Burlington in the eighteenth century and propagated by Rudolf Wittkower in the twentieth, that Jones was

first and foremost a Palladian. This implied that his main inspiration and the meaning behind his work came from the work of Palladio (Fig. 14). Worsley takes the

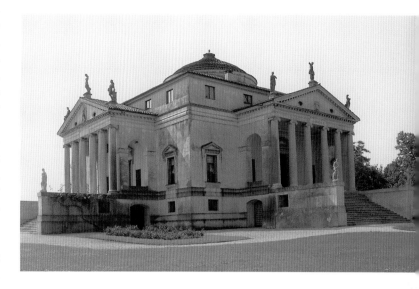

14 Andrea Palladio, Villa Rotonda, near Vicenza, c.1569

case of Stoke Park, with its apparently unorthodox play of solid and void, and points out that its attribution to Jones has been questioned principally on the grounds that it failed to fit the Palladian canon (Fig. 15). He observes that this kind of 'confusion has led to such constructs as Sir John Summerson's "Artisan Mannerism" – essentially a rag-bag of everything classical in the early Stuart period other than Jones's grander buildings', which are seen as Palladian.[13]

Whereas the eponymous 'classical tradition' is manifest for Worsley in contemporary European buildings, for Anderson it is evident in the books that Jones collected and studied in his library. Unlike Worsley, Anderson deals in some detail with this library, outlining for the first time the full range of Jones's scholarship and his literary interaction with the past masters in the art of building. Anderson's links between Jones's books and buildings are limited in being focused on his choice of antique architectural models, and she goes on to conclude that such associations are 'tenuous'.[14] In contrast, it will be argued here that Jones's theory of design that informed these choices and the architecture that resulted was directly influenced by his close study of the books in his library, not just on architecture but, as significantly, on natural philosophy and ethics.

Placed together with John Peacock's *The Stage Designs of Inigo Jones: The European Context* (published

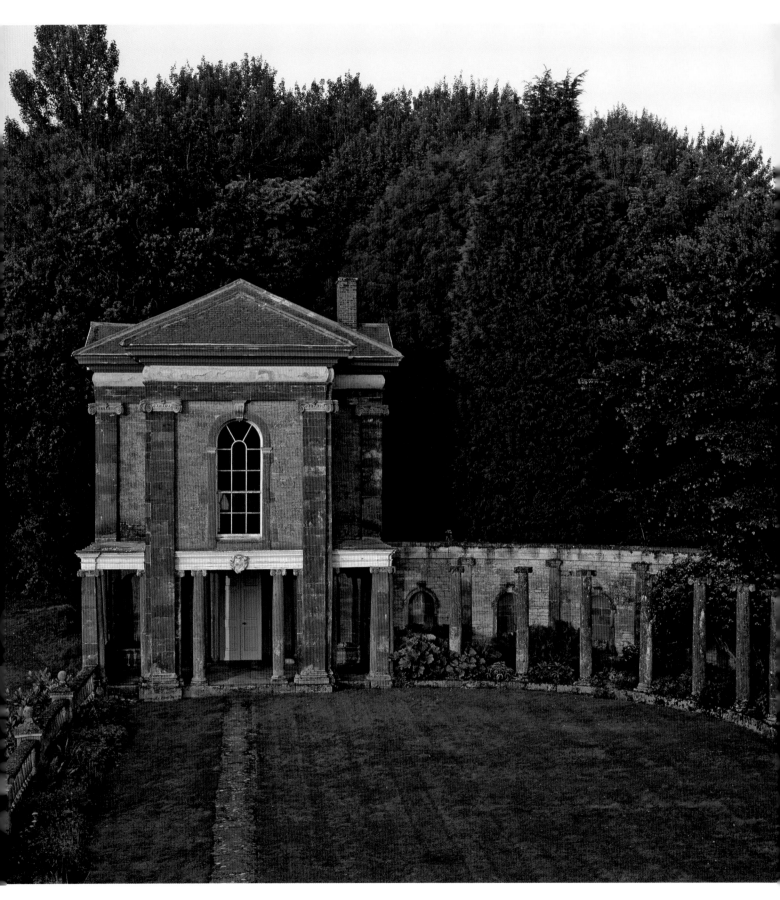

15 The west pavilion at Stoke Park, Northamptonshire, *c.*1629. Country Life Picture Library

in 1995), these recent books allow one to start to get a fuller picture of Jones's European classical influences and his attempt to imbue his architecture with a meaning compatible with the aspirations of his educated compatriots. Of course, the more local influence on Jones was that of Stuart court symbolism and its particular adaptation of British mythology. Although previous authors including Francis Yates, Roy Strong, Per Palme and myself (in a book entitled *Art and Magic in the Court of the Stuarts* published in 1994) have discussed this court symbolism at some length, it has yet to be integrated with the all-important Protestant debates on the appropriateness of the display of pagan and Catholic architectural forms. A more complete picture of Jones as an architect can emerge only after understanding the full nationalist and necessarily insular religious sensitivities that marked the particular conditions that characterised English court patronage before the Civil War. These religious sensitivities and their influence on Jones's style have largely been ignored by previous commentators, save passing observations such as that by Leapman that Jones's

> St Paul's Church in Covent Garden is aggressively plain because seventeenth-century Protestants and Puritans were deeply suspicious of the gaudy display of the Catholic Church that the nation had abandoned a hundred years earlier. Designing the lovely Queen's Chapel in St James's, initially meant for a Catholic princess, Inigo had to be careful that the splendour of the interior was not reflected in its external appearance, for fear that it would inflame passers-by.[15]

Jones's stylistic sensitivities, coupled with his interest in British antiquity, will be seen in the forthcoming pages as the real context for his popular title as the 'Vitruvius Britannicus'.

16 John Webb and Inigo Jones, design for the elevations of the King's Court and the Queen's Court, Whitehall Palace, London, c.1638. Whinney P11, Devonshire Collection, Chatsworth

THE ENGLISH VITRUVIUS:
WHO WAS INIGO JONES?

'PASSING INTO FOREIGN PARTS':
THE EARLY LIFE AND TRAVELS OF
INIGO JONES

When Inigo Jones stood with Charles I in the royal park at Greenwich and viewed a half-completed Queen's House some time in 1632, an event captured by the painters Adriaen van Stalbemt and Jan van Belcamp, he surely cannot have failed to reflect on his rise from humble origins to his position as Surveyor of the King's Works and the most powerful court artist in the land (Fig. 18). He was born to a clothworker in Smithfield in London, and was baptised on 19 July 1573 (Fig. 19).[1] Not much is known about his early life. According to George Vertue, Christopher Wren had information that Jones had served as an apprentice to a joiner in St Paul's churchyard.[2] At some point he became the painter to the Manners family, for in June 1603 he was paid £10 as a 'picture maker' to Roger Manners, 5th Earl of Rutland (1576–1612).[3] Jones's pupil John Webb noted that the architect was 'particularly taken notice of for his skill in the practice of landscape painting'.[4] His early years are shadowy, and his travels uncertain. It is possible that he accompanied Roger's brother Francis Manners, Lord Roos (1578–1632), on a tour of Europe in 1598, and he may well have made his first visit to Italy in 1601: there is a worn inscription placing him in Venice on that date written on a flyleaf of his now-famous 1601 edition of Palladio's *I quattro libri dell'architettura* (held at Worcester College in Oxford; Fig. 17).[5]

In Jones's only publication, a book on Stonehenge produced posthumously by Webb in 1655 from 'some few indigested notes', Jones (or Webb writing for him) echoed Palladio's opening lines when reporting at the outset:

17 Annotations by Inigo Jones, including '1601 doi docato Ven' (bottom right) to the flyleaf of his copy of Andrea Palladio's *I quattro libri dell'architettura* (1601 edition). Worcester College, Oxford

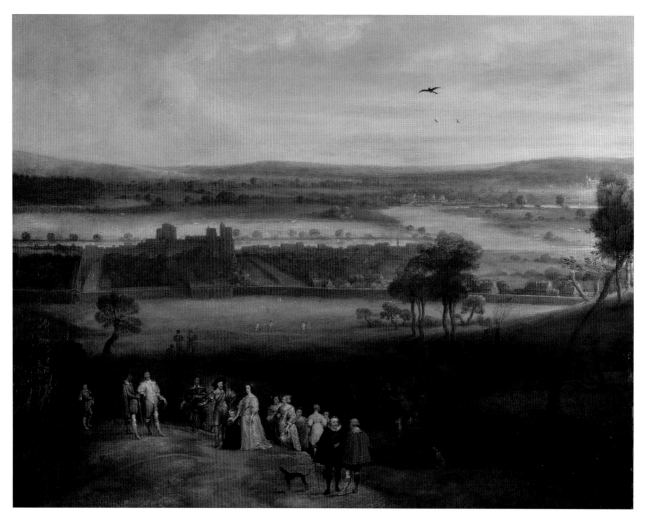

18 Adriaen van Stalbemt and Jan van Belcamp, *A View of Greenwich*, *c.*1632, showing Charles I and Henrietta Maria with the unfin-
ished Queen's House. The figure on the extreme left, with skullcap and cane, is commonly identified as Jones. Royal Collection

Being naturally inclined in my younger years to
study the *Arts of Design*, I passed into forrain parts to
converse with the great Masters thereof in *Italy*,
where I applied myself to search out the ruines of
those ancient *Buildings*, which in despight of *Time*
itself, and violence of *Barbarians* are yet remaining.
Having satisfied myself in these, and returning to my
native *Countrey*, I applied my minde more particu-
larly to the study of *Architecture*.[6]

From June to October 1603, around the time of his
thirtieth birthday, Jones was in Denmark with Roger
Manners. Here he is reported by Webb to have entered
the service of King Christian IV, upon whom the Order
of the Garter was being conferred. Garter celebrations,
and more general ideals of British Protestant chivalry,
became important themes in Jones's later work. By 1605

he was back in England and collaborating with Ben
Jonson on staging masques for, amongst others, Christ-
ian's sister and the wife of James I, Anne of Denmark.
Clearly by this time Jones had acquired a reputation
from his study abroad. In his gift to Jones of Giovanni
Francesco Bordini's *De Rebus Praeclare Gestis a Sixto V*
(1588), Edmund Bolton famously recorded in Latin:

30 December 1606. As an earnest and a token of a
friendship which is to endure forever with Inigo
Jones, I, Edmund Bolton give this little book. To his
own Inigo Jones through whom the hope is that
sculpture, modelling, architecture, picture, theatrical
representation, and all that is praiseworthy in the
elegant arts of the ancients, may some day insinuate
themselves across the Alps into our England.
MERCURY SON OF JOVE.[7]

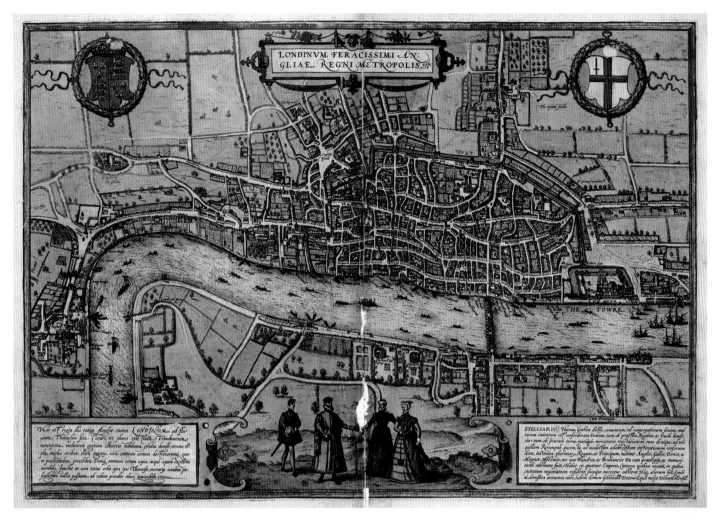

19 London in 1570, showing Smithfield (north-west of St Paul's Cathedral), from George Braun and Franz Hogenberg's *Civitates Orbis Terrarum* (1572)

In the late summer of 1605 Jones had been employed on the scenery and devices necessary for three 'theatrical representations' to be performed before the king on 28 August in the hall of Christ Church in Oxford. By contemporary report, 'They hired one Mr Jones, a great traveller, who undertook to further them much, and furnish them with rare Devices, but performed little to what was expected.'[8]

Despite what would appear to be a poor start, Jones was to be heavily involved throughout his life in the design and production of these court spectacles. He worked alongside court poets to inform not only the masques' setting but also their content. For the next thirty-five years he produced more than fifty masques and similar entertainments inspired by the Medici court tradition; indeed, more than 450 of his drawings for scenery and costumes survive, as opposed to fewer than

100 of his architectural drawings (Figs 20–23). One of the first of his buildings, the Banqueting House in Whitehall, was constructed between 1619 and 1623 as a setting for the staging of masques. In adapting the proscenium type of theatre as the temporary masque stage, Jones and his assistant Webb followed in the footsteps of the Renaissance architectural theorist Sebastiano Serlio; in 1545 Serlio had illustrated this kind of theatre layout in his architectural treatise, in the second book or 'chapter' on perspective (see Figs 275–8). Masques required the full application of the Renaissance arts of perspective and proportion (for scenery), as well as emblematics and arms (for costumes), and mechanics and optics (for staging effects). Jones's perspective scenery was either fixed, as Serlio's had been, or rotated, whilst on occasion it slid in grooves in order to work apparently magical transformations under the

20 (*above*) Inigo Jones, the garden of a princely villa, the final scene of the masque *Coelum Britannicum* (1634). Devonshire Collection, Chatsworth

21 (*right*) Inigo Jones, the 'House of Fame' for *The Masque of Queens* (1609). Devonshire Collection, Chatsworth

command of the king. As a measure of how important these productions were to the Stuarts, both Prince Henry and Henrietta Maria were active performers on the stage, and both Stuart monarchs also appeared in masques. When not on stage himself the king was always seated in the best optical position directly in line with the vanishing point of the backdrop, whilst most of the spectators sat sideways on to the stage.[9]

The medium of masque represented Jones's 'theatre of ideas'. He used it to introduce to the court audience the still-novel *all'antica* architectural principles of harmony and proportion long before he was able to

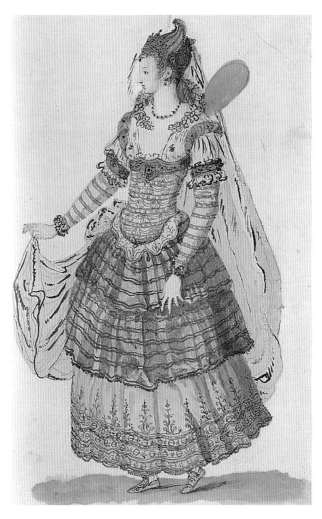

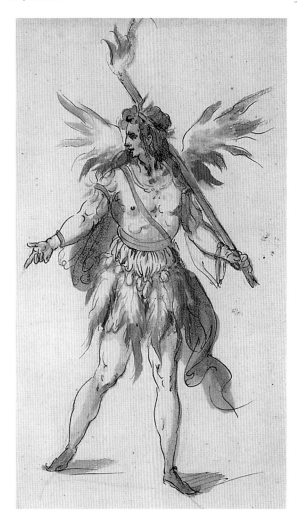

22 Inigo Jones, costume design for a torch-bearing fiery spirit for Thomas Campion's *The Lords Masque* (1612–13). Devonshire Collection, Chatsworth

23 Inigo Jones, costume design for a winged masquer, possibly for *Hymenaei* (1606). Devonshire Collection, Chatsworth

express the same ideas more publicly in stone. His early masque backdrops depicting ancient porticoes and statues helped give legitimacy to the new Stuart monarchy and its future use of the Orders (see Fig. 21). Jones went on to develop his understanding of the *all'antica* architectural language in these performances, which often allowed him a freedom of expression in terms of capricious decoration that he was not afforded in more public works. Links between Jones's stage and built work were made explicit on the occasions when his actual buildings formed the backdrop, as when he used the façade of the Banqueting House as the setting in the opening scene in Jonson's masque *Time Vindicated to Himself and to His Honours* (1623; Fig. 24). This was one of the first masques to be staged in the hall, and its scenery captures perfectly the new building's revolutionary character in contrast with its chaotic sur-

roundings. Jones and Jonson were destined to quarrel over the supremacy of the architect's spectacle over the writer's poetry. Jonson believed that poetry dictated the masque's meaning, or fable and theme, whilst costume and scenery represented mere outward show. Jones on the other hand held quite the opposite view. Jonson's famous satire of Jones as a joiner who 'will joyne with no man' in *A Tale of a Tub* (1633), and as 'Coronell Vitruvius' or 'Colonel Iniquo Vitruvius' in *Love's Welcome at Bolsover* (1634), reflected something of Jones's single-minded, even egotistical, personality.[10]

Jones may have travelled to Italy in 1605, but if this is so he was back home by the following year.[11] For soon after this date he produced a number of *all'antica* architectural designs for Robert Cecil, 1st Earl of Salisbury, which could have been inspired by this trip. Around 1608 the Surveyor of the King's Works, Simon

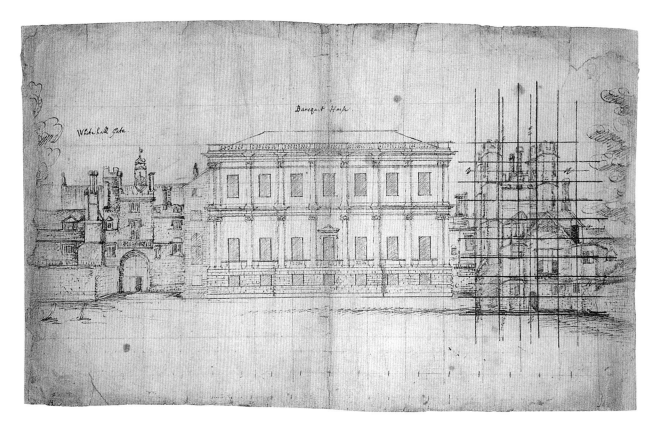

24 Inigo Jones, Banqueting House and Holbein Gate, scene for Jonson's masque *Time Vindicated to Himself and to His Honours* (1623). Devonshire Collection, Chatsworth

25 (*below*) Inigo Jones, design for the elevation of the New Exchange in the Strand, London, 1608. Worcester College, Oxford

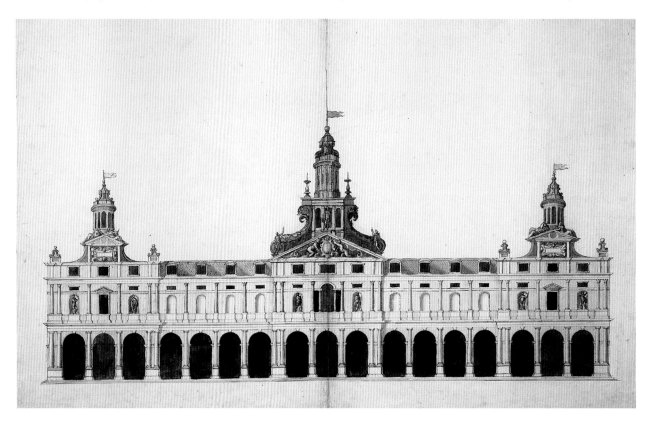

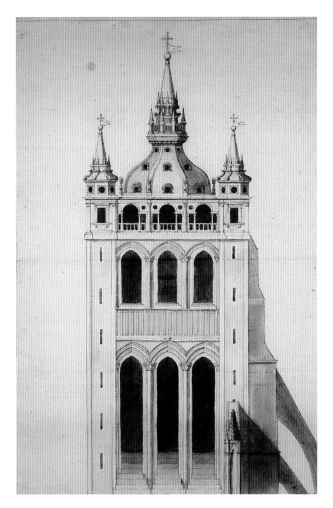

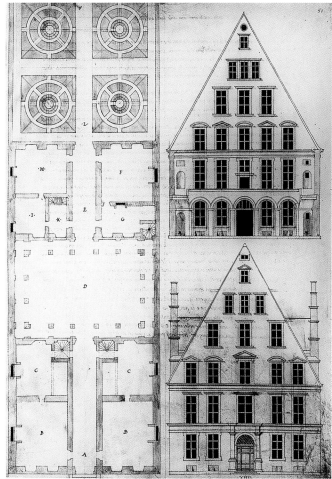

26 Inigo Jones, design for a new termination to the tower of St Paul's Cathedral in London, *c*. 1608. Worcester College, Oxford

27 Sebastiano Serlio, model *all'antica* design for the 'Rich Citizens or Merchant's House in the Parisian Style', from the unpublished Book Six, *D'Architettura*, MS, *c*.1547–54, fol. 51r. Staatsbibliothek, Munich

Basil (d. 1615), involved Jones in two important projects in London. These were Salisbury's New Exchange in the Strand and a replacement for the destroyed cap to the tower of old St Paul's Cathedral (a project under the auspices of a commission upon which Salisbury sat; Figs 25–6).[12] Although neither of Jones's designs was built, they are stylistically similar in blending *all'antica* and medieval motifs. In this marriage of the unfamiliar and foreign with the familiar and native, Jones introduced the *all'antica* style to his countrymen in a way that was calculated to maximise the acceptability of the architectural Orders; in this he followed the example of Serlio and Philibert de l'Orme in France (Figs 27–8). Rather than lacking sophistication, as is so often claimed, these early designs represent a subtle response to national circumstances and prejudices that would equally resonate in Jones's approach to ornament in his later, apparently more coherent *all'antica* designs.[13] The

variation in ornament evident in the development of Jones's work, from one building to the next, can be seen to follow fluctuations in the attitude towards decoration within the court, and the type of building being decorated, rather than fundamental changes in his own approach and tastes.

Better recorded is Jones's tour of France in 1609 with Salisbury's eldest son, Lord Cranborne, during which he visited Paris, Bordeaux, Toulouse, Provence and the Loire Valley. He returned to England via Paris after making detailed studies of the Roman antiquities of Provence with reference to his copy of Palladio's *I quattro libri*.[14] During this time he saw the Temple of Diana and the Pont du Gard at Nîmes, the Roman theatre at Orange and antique sarcophagi at Arles, as well as De l'Orme's Château de Chambord with its powerful mixture of French medieval roofscape and *all'antica* decoration (Figs 29–30). Chambord's famous

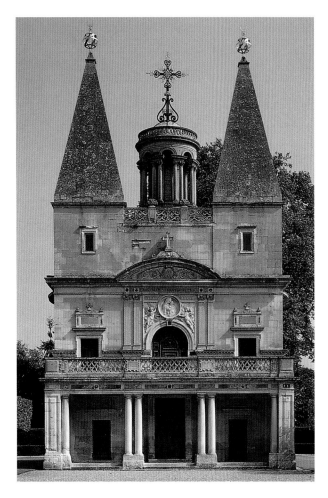

28 Philibert de l'Orme, Chapelle Royale at the Château d'Anet, France, *c.*1552

29 (*below*) Philibert de l'Orme, Château de Chambord, from Jacques Androuet du Cerceau's *Les plus excellents bastiments de France* (1576–9)

central staircase certainly impressed him, as he recorded in his copy of Palladio.[15] Jones could well have studied other works by De l'Orme, whose *Le Premier Tome de l'architecture* published in Paris in 1567 he owned and annotated. In his designs of Oberon's Palace for the masque *Oberon, the Fairy Prince* (1611), Jones copied the stag and baying hounds used by De l'Orme in his Doric gateway at Anet of around 1552; Jones did this in order to signify the hunting prowess of the young Prince Henry (the heir to the throne, for whom the masque was designed; Figs 31–2). This gate had celebrated Diane de Poitiers in her role as her namesake, Diana, the 'goddess' of the hunt.[16] Here, as elsewhere, De l'Orme mixed *all'antica* and medieval motifs in much the same way that Jones was to do, as a means to blend traditions and adapt foreign styles to native circumstances. But whilst in De l'Orme's case these circumstances were the Catholic France of Diane de Poitiers, in Jones's they were the fiercely Protestant Arthurian court of Prince Henry.

Under Salisbury's influence, in January 1611 Jones had been appointed Surveyor of Works to Henry.[17] Jones's earliest known architectural design, for a monument to Lady Cotton in St Chad's church at Norton-in-Hales in Shropshire of around 1610, may have been connected with this appointment (see Figs 111, 114); Rowland Cotton (who was responsible for commissioning Jones) was probably attached to the prince's court since Henry is referred to as Cotton's 'master'.[18] Rather than realise any of his own designs for the prince, however, Jones became the coordinator of Henry's plan for his garden at Richmond in Surrey, designed in part by Salomon de Caus (1576–1626) and the Italian sculptor Constantino de' Servi (1554–1622). Work was halted by the premature death of the prince in November 1612, at the age of eighteen. None the

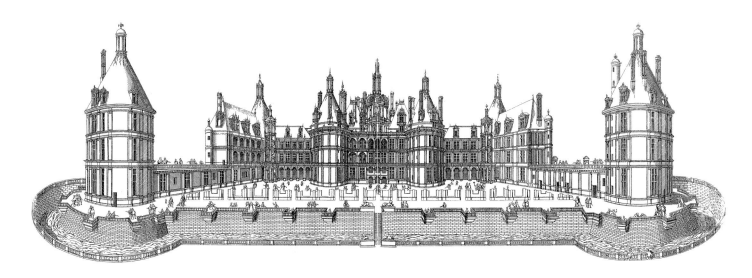

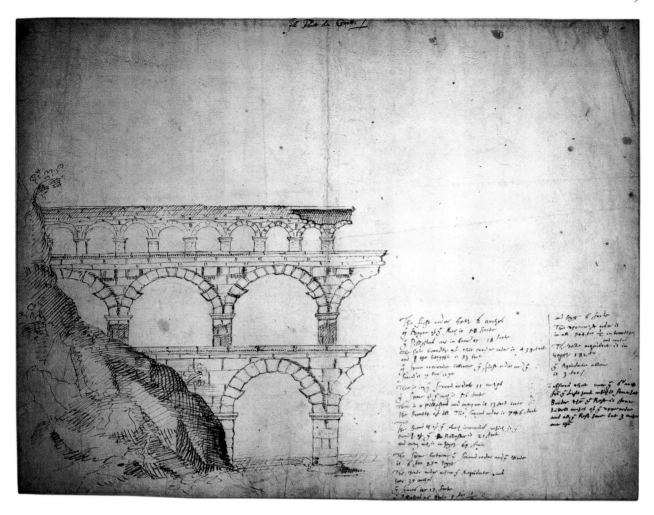

30 Inigo Jones, study of the Pont du Gard, near Nîmes, France, c.1609, based on a woodcut from Jean Poldo d'Albenas's *Discours historical de l'antique et illustre cité de Nismes* (1560). RIBA Library Drawings Collection, London

less, Jones was establishing his reputation in court circles, as a number of contemporary publications bear witness. Thomas Coryate's account of his travels entitled *Crudities* appeared in 1611 with fifty-nine commendatory verses edited by Jonson and including one by Jones. To celebrate the book's publication, Coryate held a 'philosophical feast' at the Mitre tavern in Fleet Street in London on 11 September of that year with a group of friends including John Donne, Lionel Cranfield and Jones. In a dog-Latin verse read out at the time to commemorate this event, the architect was described as 'Nec indoctus nec profanes / Ignatius architectus' (Neither unlearned nor uninitiated / Inigo the architect).[19] Then in February 1613 George Chapman, in *The Memorable Maske of the two honorable houses, or Innes of Court: the Middle Temple, and Lyncolns Inne*, went out of his way to refer to Jones with pride as 'our kingdom's most artfull and ingenious architect'.[20]

The masque was performed with stage sets by Jones, and celebrated the marriage of Princess Elizabeth, the daughter of James I, to Fredrick V, the Elector Palatine. In April Jones travelled to Heidelberg as part of the royal party that escorted the couple to the Rhineland led by Thomas Howard, 2nd Earl of Arundel (1585–1646), and a close supporter of the late Prince Henry (Fig. 33).[21]

Jones and Arundel then journeyed south, crossing the Alps into Italy in June and embarking at some discomfort on what amounted to a Grand Tour that was to last for just over a year.[22] Progressing via Milan, Parma and Padua in July, Jones's trip involved two weeks of intensive sightseeing in Venice in early September 1613, where he made notes on Palladio's unfinished convent of the Carità. He was in Vicenza by 23 September, visiting the Teatro Olimpico, Palazzo Thiene and the Villa Rotonda (see Fig. 14). By

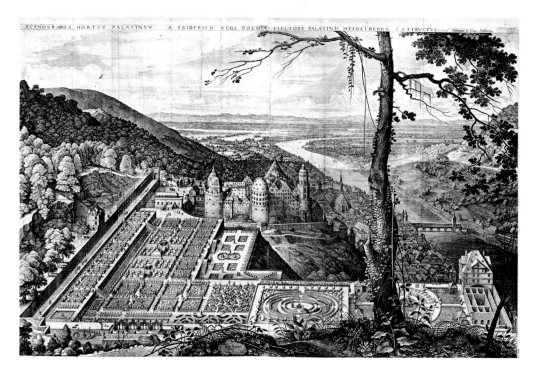

33 (*above*) Salomon de Caus, Heidelberg Castle from *Hortus Palatinus a Friderico Rege Boemiae Electore Palatino Heidelbergae extructus* (1620)

31 (*facing page top*) Philibert de l'Orme, entrance pavilion, Château d'Anet, France, *c.*1552

32 (*facing page bottom*) Inigo Jones, interior of Oberon's Palace from *Oberon, the Fairy Prince* (1611). Devonshire Collection, Chatsworth

2 January 1614 Jones was in Rome, travelling in March to Naples at the southernmost point in his journey (where he paid particular attention to the so-called Temple of Castor and Pollux) and returning to Rome by the end of May.[23] As a tourist in Rome he was evidently much assisted by his 1609 edition of Palladio's pocket guide *Antichità di Roma*, given that he partly translated it in his so-called Roman Sketchbook.[24] Whilst there, he witnessed the dramatic demolition of columns from the Temple of Peace and that of Nerva Trajan to make Pope Paul v's triumphal Corinthian column standing in front of Santa Maria Maggiore.[25] In his copy of Palladio's *I quattro libri* he recorded the concern amongst contemporaries that due to such demolition, 'all the good of the Ancientes will bee utterly ruined ear longe questo Papa e poeta'.[26] Nevertheless, the fundamental link between the column and the crown could not have been made clearer. This message was reinforced by the ancient free-standing commemorative columns, with their statues of the saints added a few years earlier by Sixtus v, which Jones would have seen (see Fig. 108). Fully aware of the value of the ancient remains, he studied them closely. Such wonders as the Pantheon and the Temple of Fortuna Virilis provided him with a rich source for quotation and models in his subsequent buildings. His portico for St Paul's Cathedral, as but one example, would be directly based on the 'Temple of the Sun and Moon' (the Temple of Venus and Rome; see Fig. 110) and, in terms of magnitude, the Pantheon (Fig. 34).[27] As for Rome's modern buildings, Bramante's *all'antica* Tempietto at San Pietro in Montorio met with approval (Fig. 35). But more capricious ornamental works by what Jones termed 'Michill Angell and his followers' led him to articulate (again in his 'Roman Sketchbook') the need for a decorative distinction between the inside and outside of buildings, which is crucial to our understanding of his work. These 'Sketchbook' notes show how fundamental Jones's Roman experiences were to the development of his attitudes to ornament, and these attitudes will form a major subject of this book.

In early June the party travelled east and then north, with Jones visiting the temples at Tivoli and Trevi and then buildings in Florence before moving back, probably now alone, to the Veneto. Whilst in Venice in August he met, or possibly met again, the elderly Vincenzo Scamozzi, and Jones made a critical study of his

35 (*right*) Bramante's Tempietto at San Pietro in Montorio,
Rome, from Serlio's Book Three, *D'Architettura* (1540), fol. XLIII

34 (*below*) The Pantheon, Rome, from Sebastiano Serlio's Book
Three, *D'Architettura* (1540), fol. VIII

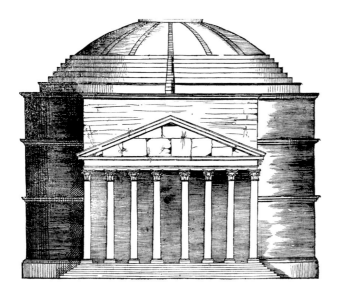

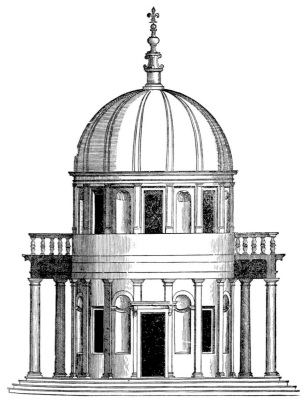

Palazzo Trissino. Scamozzi had been the pupil of Palla-
dio, and it would be tempting to present this meeting
as establishing a living link between Italian and English
Palladianism. But evidently there was no meeting of
minds between the old pupil and the English visitor.
Jones recorded some disparaging remarks in his Palla-
dio, calling Scamozzi 'purblind' and noting with regard
to the shortening of columns on upper storeys: 'in this
as in most thinges else Scamotzio erres'; Jones strongly
disapproved of Scamozzi's criticisms of his former
master, adding: 'all which sheaues y^e ignoraunce and
malise of Scamotzio against Paladio'.[28]

Jones travelled with a number of books, chief
amongst which was this copy of Palladio. He annotated
it on site and when back in London with observations
concerning the monuments he witnessed, their orna-
ment and any discrepancies between the woodcuts and
the buildings themselves. For example, in Book Four,
against a long list of ancient temples, he notes: 'The 2
of January 1614 new stille I being in Roome Compared
thes desines following with the Ruines Them Sealves:
Inigo Jones'.[29] His notes focus on the use of ornament,
demonstrating its enduring importance to him (Fig.
36). Jones had made notes in this book from as early as
1608, when he was working on his very first designs
(for the New Exchange and St Paul's Cathedral), and

in order to continue this study of Italian Palladianism
he would acquire Scamozzi's *L'idea dell'architettura uni-
versale* in 1617, two years after its publication.[30]

Arundel and Jones met up again in Genoa and in
November 1614, travelling via Turin and Paris, they
returned to England (it is presumed together), Arundel
with a large number of sculptures, paintings, miniatures,
drawings, and books on art and architecture.[31] The earl
was renowned as a collector of art, and owned draw-
ings by Leonardo, Parmigianino and Holbein. This col-
lection included original drawings by Palladio and
Scamozzi; a number of these, on the subject of private
and public buildings, Arundel gave to Jones (and which
are now held at the Victoria and Albert Museum in
London and at Chatsworth House). Arundel was an
equally active patron of artists such as Rubens and Van
Dyck, and he also gave Jones two important commis-
sions. These were the remodelling of his house at
Greenwich (designed in 1615, but destroyed by fire soon
after, in January 1617) and a new gallery for the earl's
growing collection of antique sculpture at Arundel
House in the Strand (this gallery, too, was designed
around 1615, and destroyed in 1678; some of the sculp-
tures are now in the Ashmolean Museum in Oxford).[32]
The gallery was matched by another for paintings, also
designed by Jones. The earl turned to Jones to redesign

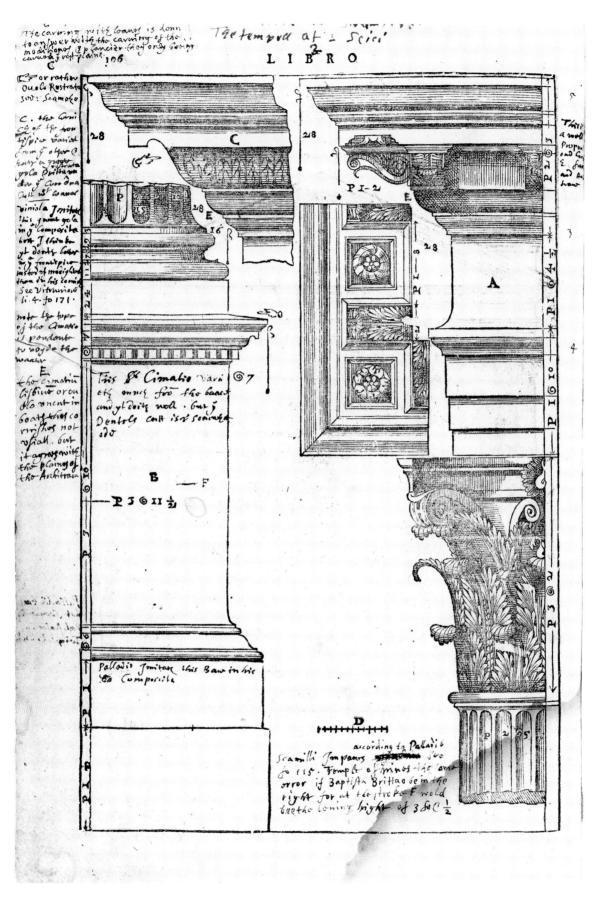

36 Annotations by Inigo Jones to his copy of Andrea Palladio's *I quattro libri dell'architettura* (1601 edition), Book Four, p. 106. Worcester College, Oxford

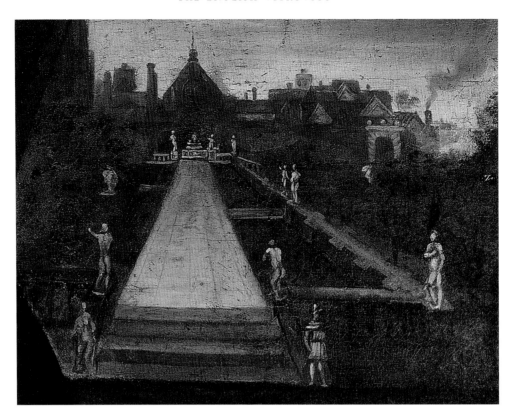

37 The East Garden of Arundel House with the antique sculpture collection and a gateway by Inigo Jones, detail of Daniel Mytens (attributed), *Thomas Howard, Earl of Arundel, c.1627.* Private collection

the gardens at Arundel House, in order to amaze the visitor with further examples of his sculpture collection. This gave Jones the chance to lay out a 'garden of antiquities' in London on the model of the Cortile del Belvedere in Rome (Fig. 37). In these early works he was at last able to put theory into practice.

'TURNING TO ARCHITECTURE':
SURVEYOR OF THE KING'S WORKS

Following the death of Simon Basil, Jones became Surveyor of the King's Works in October 1615, aged forty-two. He had been promised the appointment two-and-a-half years previously, on 27 April 1613, and his recent Italian trip was no doubt intended as preparation for the role. Jones's past experiences and new position at court placed him in an unrivalled position, one that was never seriously challenged throughout the reigns of James I (1603–25) and Charles I (1625–49). The well-established Office of Works' style, as promoted by Basil, had comprised a mix of late Elizabethan neo-Gothic with a Netherlandish Mannerist overlay. With his experiences in Italy fresh in his mind, Jones was to

take a radically different direction. He advanced a much purer expression of the *all'antica* style using, or sometimes omitting, the Orders. Jones marshalled the principles of Renaissance architecture in the service of the crown, albeit adapting these principles to suit English tastes and sensibilities. All his royal buildings, from his masquing hall in Whitehall (1619–23), intended to celebrate the 'King's Peace', to his triumphal arch at Temple Bar (1636–8), intended to stamp authority on the City of London, should be read in their form and iconography as a public expression of court policy and self-image.

One of Jones's early projects as Surveyor was the Queen's House at Greenwich, originally commissioned as a royal lodge for Anne of Denmark. His surviving drawings record the intention for a two-storey villa surmounted by a pediment, but at the time of Anne's death in 1619, when work stopped, the rusticated ground storey was all that had been constructed (see Figs 18, 195). Two preliminary designs by Jones have traditionally been associated with Anne's lodge. The first is a plan of a rectangular villa, with a circular stair adjacent to a vaulted square hall marked externally by six pilasters (the hall of 40 feet, like the future Queen's

38 (*above*) Inigo Jones, design for the ground plan of a villa, *c*.1616, possibly for the Queen's House at Greenwich. RIBA Library Drawings Collection, London

39 (*right*) John Webb, a rectangular villa on a sheet of sketch designs possibly copied from Jones's lost originals (see Fig. 40)

House, Fig. 38).[33] This was possibly intended as one of a pair of buildings either side of the main road that the Queen's House eventually straddled. The simple rectangular plan is similar to one that appears on a sheet of sketch designs – all in the hand of Webb – copied (it has been assumed) from Jones's lost originals (Fig. 40).[34] On this sheet, amongst houses of varying degrees of grandeur, there is a plan for an H-shaped building across a highway (Fig. 39). This 'H' plan has been identified as a second preliminary design for the early lodge because, with its columnar bay and balcony, it fits two elevations by Jones for the Queen's House that have been dated to 1616.[35] The first is for the south, the second for the east or west (or probably both; see Figs 195–6).[36] The declared accounts for expenditure between 8 October 1616, when work was about to commence, and 30 April 1618 record that he had received payments for two designs, £10 for 'making the first module [or design] of the newe building at Grenewich' and £16 for 'making and p[er]fecting the second module of the same buildinges at Grenewich in the forme the same was to be builded and finished by the late Quene Ma[jesties] commaundement'.[37] On 21 June 1617 John Chamberlain told Sir Dudley Carlton that the queen 'is building somewhat out of Greenwich w^ch must be finished this Sommer yt is saide to be some curious devise of Inigo Jones, and will cost above £4000^li'.[38] Jones's

H-shaped plan of two buildings united by a covered bridge across the highway, allowing Anne to pass between the palace gardens on the north side and the relatively exclusive royal park on the south, was certainly unusual.[39] Along with solving the practicalities of straddling the road, it may have reflected the Elizabethan practice of emblematic planning in which the 'H' had some significance in terms of novelty or royal symbolism consistent with Carlton's term 'devise' (perhaps rather fancifully hinting at the medieval title 'Highness', or some other conceit?).[40] In the picture by Van Stalbemt and Van Belcamp of around 1632, the incomplete house is shown straddling the park wall and therefore the adjacent highway (see Figs 18, 197). Even though a bridge over this road was almost certainly unbuilt by the time work stopped in 1619, this and other pictures would seem to confirm that it was always intended for the Queen's House to be in the form of an 'H'.[41]

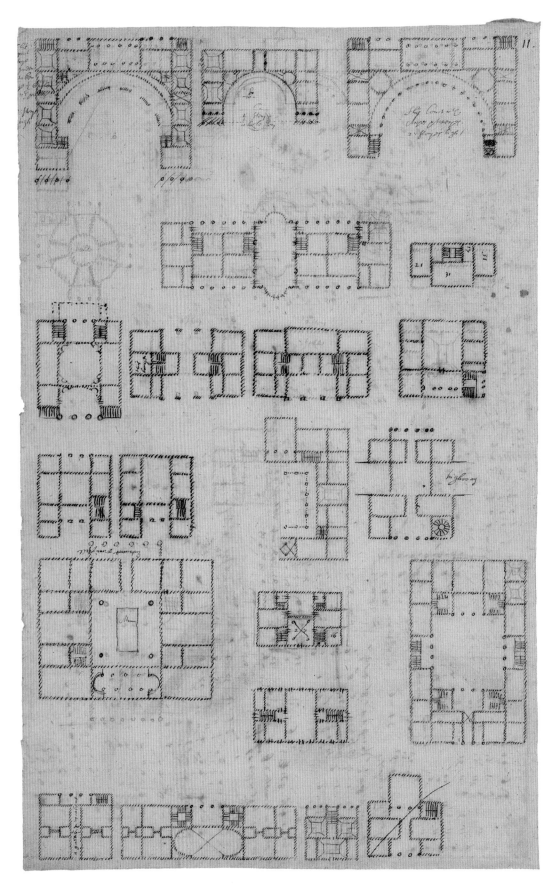

40 John Webb, a sheet of sketch designs possibly copied from Jones's lost originals. RIBA Library Drawings
Collection, London

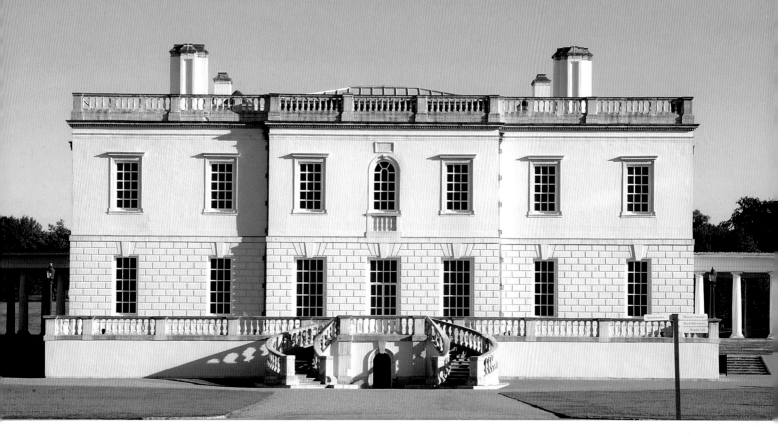

41 Inigo Jones, the north façade of the Queen's House at Greenwich, 1632–8. The first classical villa in England, the Queen's House was a radical departure from the gabled Elizabethan house

Work resumed shortly after this picture, and the house, minus its planned pediment, was finally finished in 1638 (Fig. 41; see Figs 198–9). The cube hall was modelled on the ancient Roman house illustrated by Palladio, and much studied by Jones (see Fig. 148).[42] Superficially, at least, the Queen's House has affinities with Florentine villas such as Giuliano da Sangallo's Medici villa at Poggio a Caiano of about 1485, although simplified through the removal of the portico (Fig. 42).[43] Jones's early designs in his role as Surveyor demonstrate his skill in adapting Continental architectural models to suit English tastes. His design for the

42 Giuliano da Sangallo, Poggio a Caiano, near Florence, c.1485–92

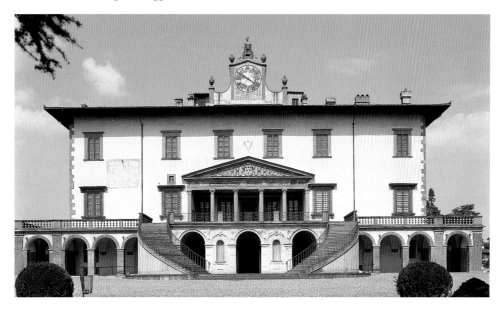

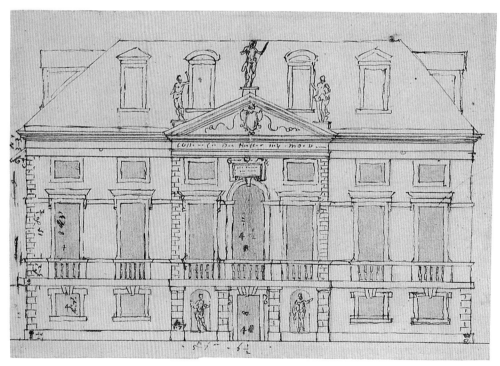

43 (*top*) Inigo Jones, design for the Prince's Lodging at Newmarket, 1618–19. RIBA Library Drawings Collection, London

44 (*above*) Inigo Jones, alternative (or later) design for the Prince's Lodging at Newmarket, 1618–19. RIBA Library Drawings Collection, London

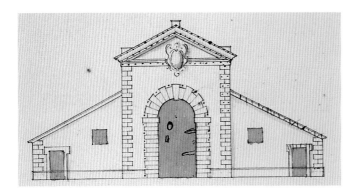

Catafalque of James I in Westminster Abbey of 1625 was a much more sober version of Domenico Fontana's for Pope Sixtus V of 1591 (see Figs 129–30).[44] Jones removed Fontana's fussy embellishments and added James's royal heraldry. Jones's designs often incorporated heraldry along with pediments and porticoes as signs of the building's royal association. The design for the Star Chamber in the royal palace at Westminster of 1617, for example, has a central section that is emphasised by an attached portico in the form of an ancient temple front (this design was unexecuted; see Fig. 150). Jones noted in his Palladio that pedimented porticoes were 'y^e greatest ornament a house cann haave'.[45]

Jones's project of 1618–19 for the Prince's Lodging at Newmarket also has a central section surmounted by a pediment with heraldry, although it is unknown if this feature was retained in the finished building (demolished fewer than forty years after construction; Figs 43–4). One of Jones's early tasks as Surveyor was to add to Simon Basil's small group of buildings at Newmarket, to accommodate Prince Charles during the hunting and racing seasons. Jones built this lodging and, according to the Office of Works' Accounts, between 1616 and 1617 had built a 'new stable for the greate horses, a new dog house with lodgings over it, a new brewhouse & riding house and a store house'.[46] It is not known what these ancillary buildings looked like, but it might be surmised that they resembled Jones's elevations for stables of around 1610 and the early 1620s, with their rustic blocks, and his brewhouse or buttery of around 1648, with its Tuscan portico, which were once identified as Newmarket works (Figs 45a and b; a stable of c.1610 is now identified with Hatfield, see Fig. 123).[47] The only reliable surviving record of the ancillary designs at Newmarket is from a sheet of sketches for small houses drawn by Webb. On this a two-storey cottage was inscribed 'Office of ye Works at Newmarkett', and, as Harris notes, was almost definitely the Clerk of Works' house described in a Parliamentary

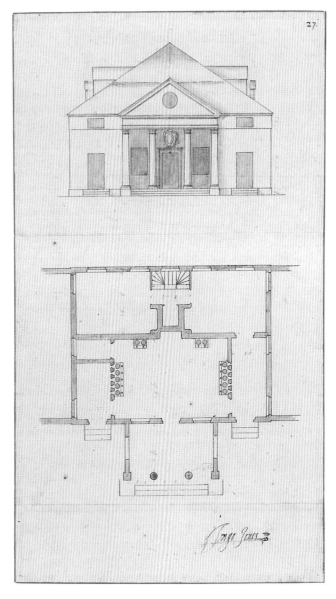

45a and b (*above and left*) Inigo Jones, a. elevations for a stable of the early 1620s; and b. with John Webb, brewhouse or buttery of c.1648, with its Tuscan portico, possibly for Cobham Hall. Worcester College, Oxford; RIBA Library Drawings Collection, London

survey of 1649 (Fig. 46).[48] This astylar design (that is, one without columns) was perfectly matched to its artisan function. The most significant Newmarket building was the Prince's Lodging, and two elevations by Jones have survived, pasted on one sheet, both of 1618–19 and both with their regal pediments (see Figs 43–4).[49]

In the case of the early schemes for the Banqueting House in Whitehall, they too had a pediment, which was, however, dispensed with in the building as constructed (the pediment complete with royal heraldry;

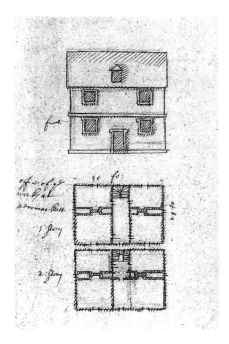

46 John Webb, a two-storey cottage inscribed 'Office of ye Works at Newmarkett'. Worcester College, Oxford

Banqueting House possibly represented the first stage of a new palace at Whitehall. The grandiose and somewhat unrealistic plans for this are recorded in a series of remarkable drawings in Webb's hand of around 1637–8 (these plans were probably drawn with Jones's assistance; Figs 16, 49–53).[52] In dreaming of this new palace Charles I had obvious aspirations to rival the Spanish Escorial (the palatial residence built by Philip II, the most powerful Catholic king) and the French Louvre, as also structures of more ancient fame, such as the Temple of Solomon built at God's command (Fig. 54; see Fig. 73). Poignantly, during Charles's imprisonment in Carisbrook Castle, his groom, Sir Thomas Herbert, reported that the king was studying reconstructions of Solomon's Temple.[53] Whitehall Palace was Jones's most ambitious 'new-build' project, in which he finally got to use a richness of ornament befitting a king and on a grand scale, but it was destined to remain on paper.

At the Queen's Chapel in St James's Palace of 1623–5 Jones combined an astylar façade and a pediment (Fig. 47). As Leapman indicates, this plainness in external

see Figs 242–3). The Banqueting House stands today as Jones's most important surviving work, with its double-cube hall for the staging of court masques. It was erected from 1619 to 1623 following a fire that had destroyed the earlier masquing hall which had stood on the site. This had been designed in 1606, possibly by Sir David Cunningham as the King's Master of Works in both Scotland and, albeit briefly, England, rather than by the more obvious English candidate Simon Basil.[50] It is also possible that Jones was consulted, given his growing influence at court as a masque designer. The plan was recorded by Robert Smythson in 1609, with bay window projections on both sides in the Jacobean manner and an interior measuring 120 by 53 feet (Fig. 48). Posts supported a gallery, which divided the walls into two storeys, Doric below and Ionic above; Jones followed this gallery model, although he upgraded the internal decoration to Ionic and Corinthian and cantilevered his gallery on large brackets, thereby removing the obstruction of the posts. As ever with Jones, functional imperatives were combined with decorative niceties. He also regularised the internal dimensions to the more Platonically perfect 55 feet by 110, and also gave the hall a height of 55 feet to produce the double cube. Given the lean-to nature of the gallery's access stair, the exact function and future role of this gallery are uncertain.[51] It is likely that it was intended to connect to a larger complex, in that the completed

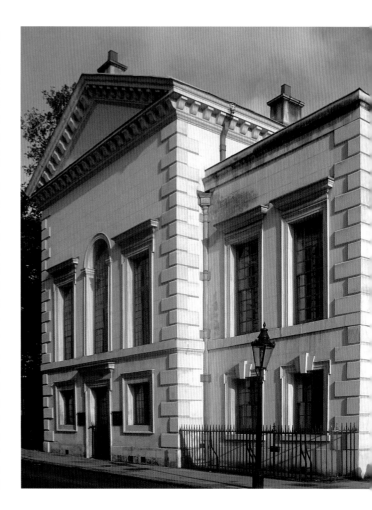

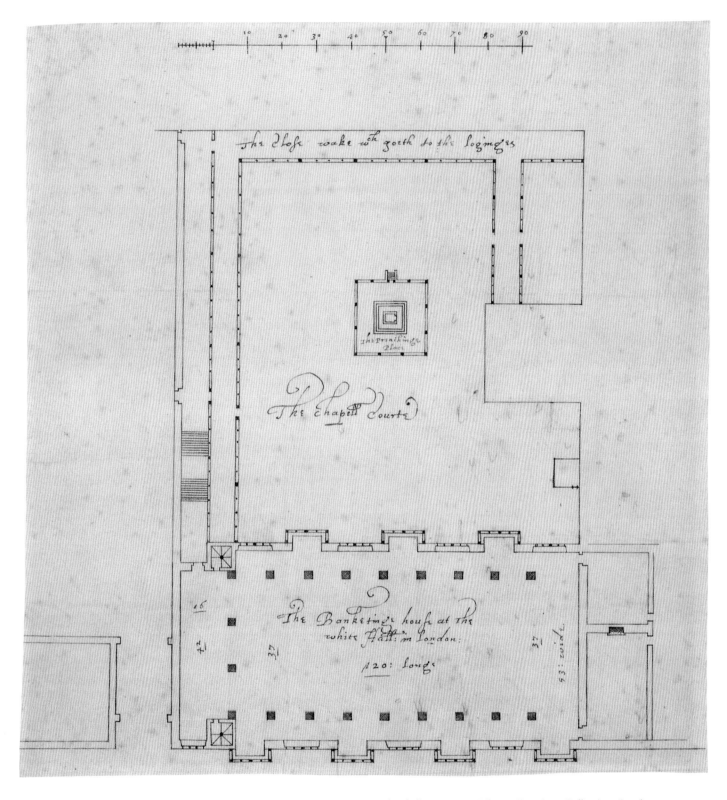

The close roake wth goeth to the loginges

The preachinge place

The Chapell Courte

16

47

37

The Banketinge house at the white Hall: in London:
120: longs

37

63: wide

48 Robert Smythson, survey drawing of the (second) Banqueting House, Whitehall, 1609. RIBA Library Drawings Collection, London

47 (*facing page bottom*) Inigo Jones, west elevation of the Queen's Chapel at St James's Palace, London, 1623–5

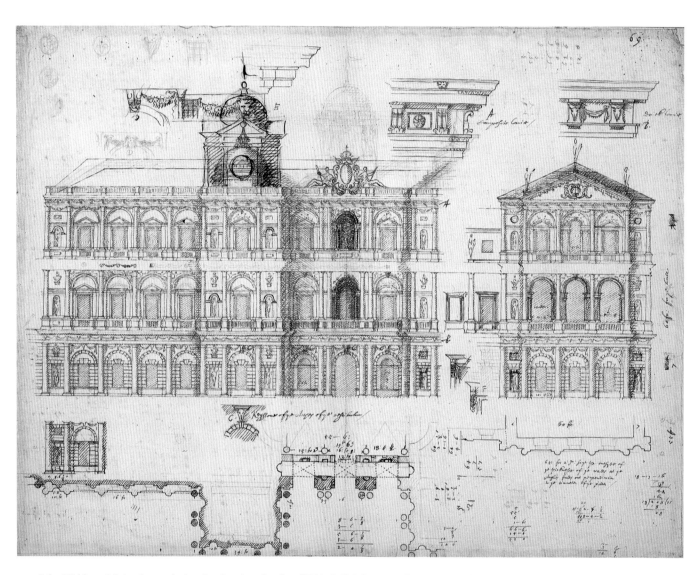

49 John Webb and Inigo Jones, design for the river façade of Whitehall Palace, London, c.1638. Whinney P9, Devonshire Collection, Chatsworth

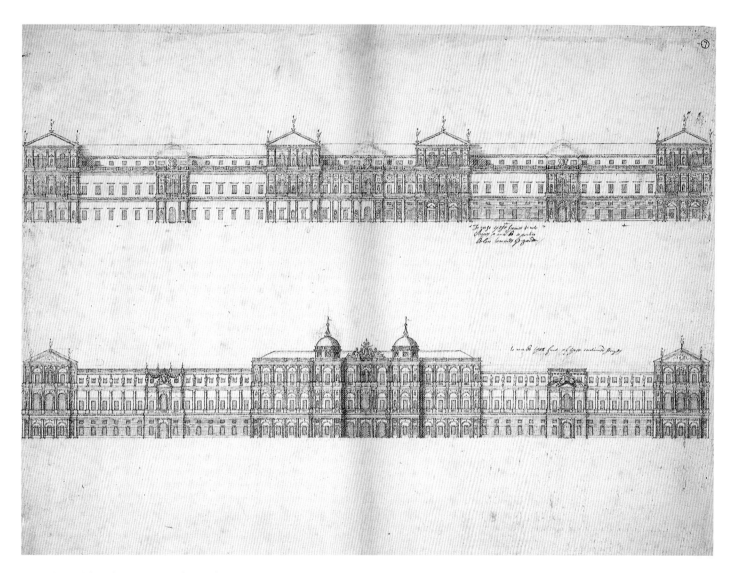

50 John Webb and Inigo Jones, design for the river and park fronts of Whitehall Palace, London, c.1638. Whinney P8, Worcester College, Oxford

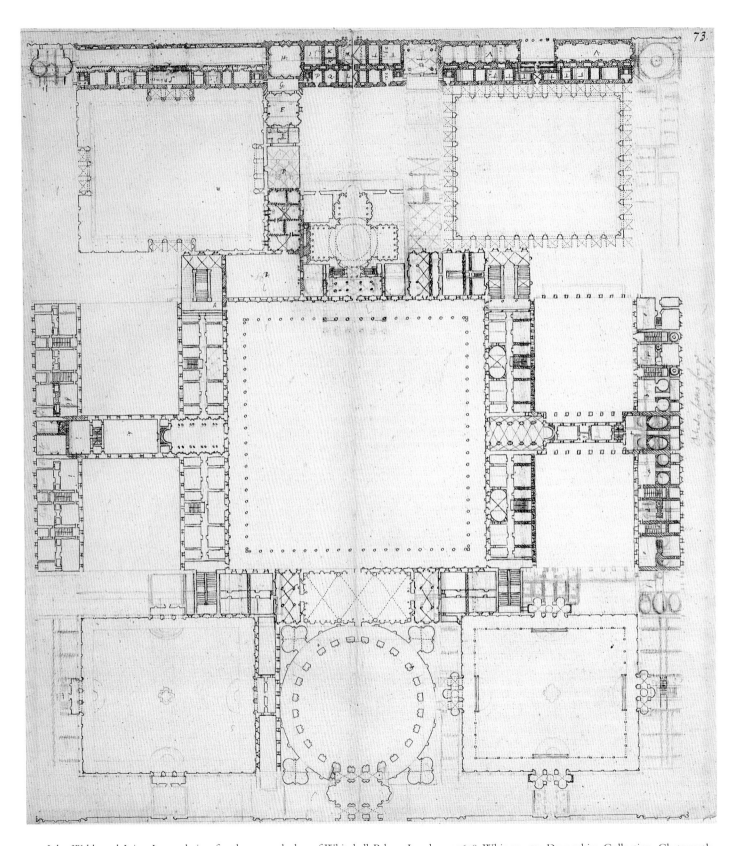

51 John Webb and Inigo Jones, design for the ground plan of Whitehall Palace, London, c.1638. Whinney P4, Devonshire Collection, Chatsworth

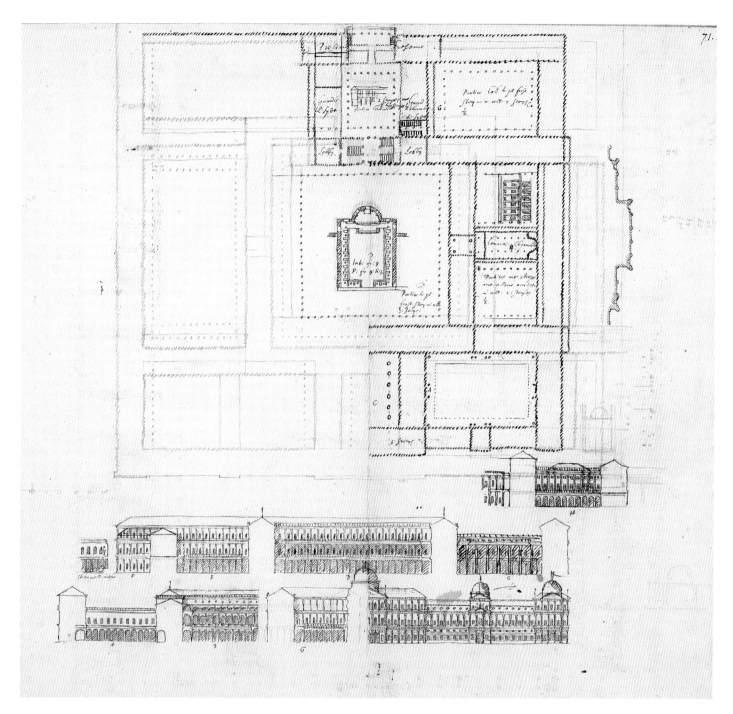

52 John Webb and Inigo Jones, design for Whitehall Palace, London, c.1638. Whinney PI, Devonshire Collection, Chatsworth

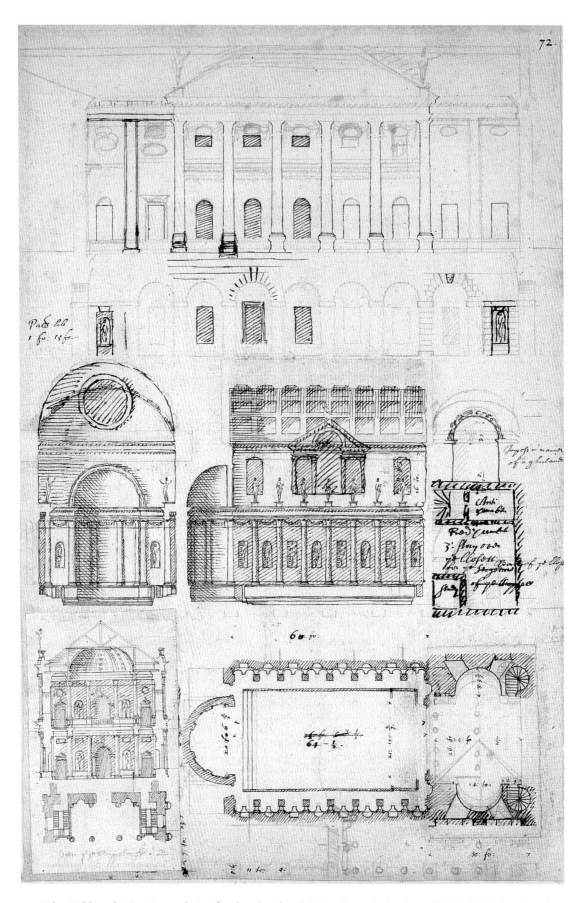

53 John Webb and Inigo Jones, design for the chapel and Privy Council chamber of Whitehall Palace, London, c.1638. Whinney P12, Devonshire Collection, Chatsworth

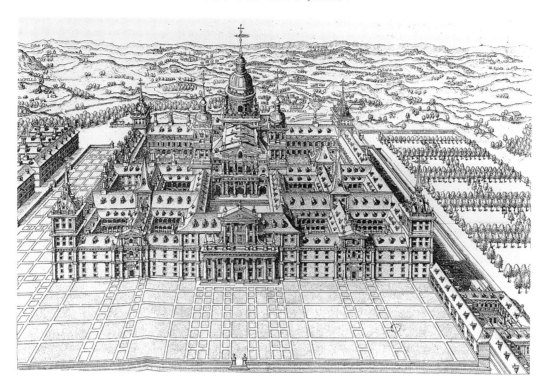

54 The Escorial, Madrid (from 1562), based on the seventh print of Juan de Herrera's *Estampas* (1589)

decoration may well have had much to do with the desire to avoid any overt celebration of the fact that the chapel's denomination was Roman Catholic. Ever since the preliminary negotiations for the proposed marriage between Charles, Prince of Wales, and a Spanish princess (the so-called Spanish Match) Spain had demanded a public Catholic church in London for the Infanta, which, somewhat predictably, James had refused. The marriage articles had been sent to England in 1615, and in 1617 James relented and allowed the construction of a chapel within St James's Palace.[54] Although private in name, this was to have a public entrance admitting the queen's Catholic servants. On 16 May 1623 the cornerstone for the chapel was laid at a ceremony at which the Spanish ambassador officiated. It was completed in 1626 for Charles's actual bride, the French princess Henrietta Maria, and her Capuchin friars. The outer walls are markedly austere, and are rendered and lined out to resemble masonry with only the quoins and dressings constructed of Portland stone. Any ornamental superfluity might easily have drawn the attention of native Protestant observers to the new architectural style's long-established use on Catholic chapels abroad. The only ornamental embellishment is at the chapel's private east end, which has a 'Serliana' window (see Figs 209–10). Like the pediment, this form was also used by

Jones to signify royalty, following its use on such as the model palaces illustrated in Book Six of Serlio's architectural treatise (see Fig. 186).[55]

Between 1630 and 1635 Jones designed another Catholic chapel, again for the Capuchin friars, this time at Somerset House (it was demolished in 1775; see Figs 216, 218–20).[56] Jones had produced a design for the chapel seven years earlier when, during the negotiations with Spain, the project was proposed as the companion to the chapel at St James's Palace. Unfortunately, this earlier design has been lost. James had granted Somerset House to Charles in 1619 following Anne's death, and Charles in turn presented it to his queen on St Valentine's Day in 1626. The ensuing building activity at the palace concluded around 1638, and found Jones continually employed on the work.[57] As well as the chapel, he remodelled or created two richly decorated cabinets and a gallery with a pergola. In the garden a new river landing stage and stair were constructed (1628–31), along with two fountains (1636–7).

In 1631 Jones laid out the first piazza in London, at Covent Garden (Fig. 55; see Figs 89–95). On this occasion he worked not for the crown but for Francis Russell, 4th Earl of Bedford. The piazza was bordered by arcaded housing designed by Jones, but working, or so it is thought, with the French architect Isaac de

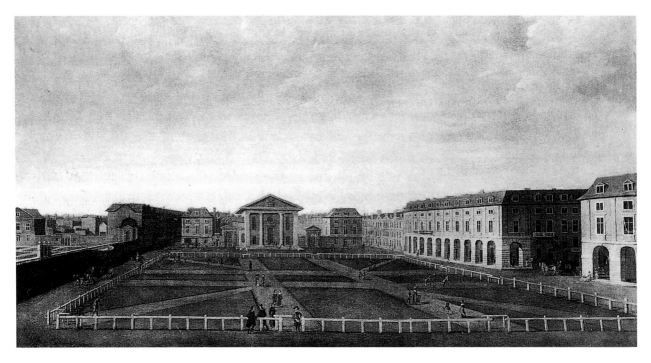

55 Unknown French painter, *Covent Garden*, c.1640. Private collection

Caus. It was also bordered, on the western flank, by the first church to be built in London since the Reformation, St Paul's (see Fig. 221).[58] The church was constructed in 1631–3 in the form of an ancient temple complete with a plain Tuscan portico. As will be seen later in this book, there is strong evidence to support Leapman's assertion, quoted above, that this restrained use of ornament was seen by Puritans, and by Bedford himself, as appropriate for Protestant church architecture. With this church placed at the focus of the long

vista, Covent Garden owed much to Renaissance ideal cities such as that painted by Piero della Francesca around 1470 or that built at Livorno (also called Leghorn, with whose cathedral Jones has been incorrectly associated; Fig. 56).[59]

Jones's most important work outside the Office of Works, however, was probably that at Wilton House in Wiltshire for Philip Herbert, 4th Earl of Pembroke (Fig. 57). Along with the earls of Bedford and Arundel, Pembroke was a great supporter of Jones and of leading

56 Computer reconstruction of the ideal city ('Urbino panel') attributed to Piero della Francesca, c.1470. Alberti Group (Joseph Rykwert, Robert Tavernor with Jason Cornish), 1995

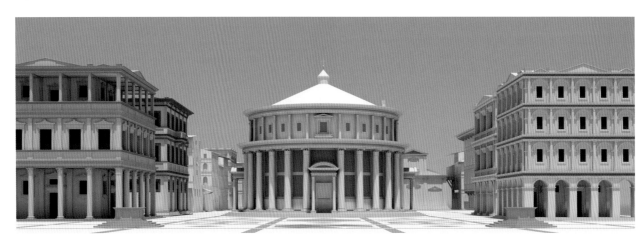

artists such as Anthony Van Dyck. As recognition for this patronage, Shakespeare's first folio of 1623 was dedicated to Pembroke and his elder brother, William; it described them as nothing less than 'the Most Noble and incomparable pair of brethren'. When Pope Urban VIII sent Charles I a large shipment of paintings, Pembroke was one of a select group, including Henrietta Maria and Jones, invited to join the king in opening the cases.[60] On the death of James I, Pembroke had become Lord Chamberlain, a post that he held until 1641 and which included responsibility for the Office of Works under Jones's direction. As a tangible expression of Pembroke's interest in architecture, the famous south front and range of his seat at Wilton was rebuilt for him between 1636 and 1640 by Isaac de Caus, most likely working under Jones's aegis much as at Covent Garden (Fig. 58).[61] De Caus designed also the extensive gardens at Wilton, where he put into

THE RIGHT HONOVRABLE. SIR PHILLIP HERBERT Knight. Earle, of Pembroke & Montgomery. Baron Herbert of Cardiffe & Sherland, Lord Parr & Rosse of Kendall. Lord Fytz-hugh. Marmyon & Saint-Qvyntin. Lord Lieutenant of Wylter. Hampshire & the Ile of Wight. Glamorgan, Monmouth, Brecknock, Carnarvon & Merioneth. Chancellor of the Vniversity of Oxford, Knight of the most noble order of the Garter & one of his Mai:ties most hono:ble privy Councell.

57 Wenceslaus Hollar, *Philip Herbert, 4th Earl of Pembroke*, 1642

58 (*below*) Isaac de Caus, great design for Wilton House and garden, *c*.1631. Worcester College, Oxford

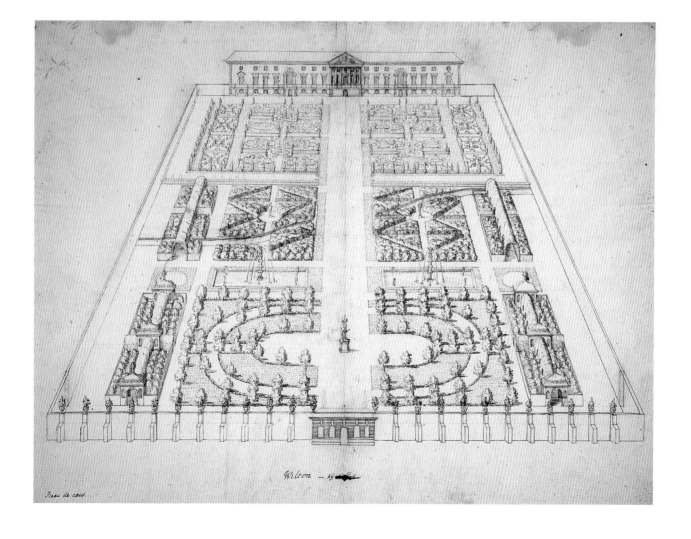

practice mechanical ideas that were illustrated in his treatise *Nouvelle invention de lever l'eau* published in London in 1644. Meanwhile, the house was made fit for a king, with a state apartment for Charles and Henrietta Maria and a 'Double Cube' room that served as a reception chamber in the centre of the first floor. Wilton was a royal favourite, and Pembroke entertained Charles when hunting and on progress.

The main source for Jones's involvement at Wilton is John Aubrey's slightly inaccurate report that:

> King Charles the first did love Wilton above all places, and came thither every summer. It was he that did put Philip first [*sic*] Earle of Pembroke upon making this magnificent garden and grotto, and to new build that side of the house that fronts the garden, with two stately pavilions at each end, all *al Italiano*. His Majesty intended to have had it all designed by his own architect, Mr. Inigo Jones, who being at that time, about 1633, engaged in his Majesties buildings at Greenwich, could not attend to it; but he recommended it to an ingeniouse architect, Monsieur Solomon de Caus [*sic*], a Gascoigne, who performed it very well; but not without the advice and approbation of Mr. Jones: for which his Lordship settled a pension on him of, I think, a hundred pounds per annum for his life, and lodgings in the house.

It is very likely that Jones was again involved at Wilton a decade later, from 1648 to 1651, this time assisting Webb in the rebuilding of the south front after a fire (see Fig. 265). Aubrey goes on to observe that:

> The south side of this stately house, that was built by Monsieur de Caus, was burnt ann. 1647 or 1648, by airing of the roomes. In anno 1648 Philip (the first) re-edifyed it, by the advice of Inigo Jones; but he, being then very old, could not be there in person, but left it to Mr. Webb, who married his niece.[62]

At the time of the first phase of work in the later 1630s Jones was fully occupied as Royal Surveyor, finishing the Queen's House and his work at Somerset House. Following Aubrey's report it is thought that Pembroke, as a royal favourite, was consequently given access to his services as a consultant only. By the time of the second phase at Wilton Jones was about seventy-five years old. Nevertheless, that he was involved in this later work, if not the earlier, is confirmed by drawings by Webb for doors and ceilings dating from 1649 that are annotated by his elderly master.[63]

Jones was also busy during the second half of the 1630s with his work at St Paul's Cathedral. Acting once

again outside the Office of Works, here between 1633 and 1642 he undertook the largest building project of his career in refacing the nave and transept walls and repairing the choir. The cathedral was damaged beyond repair in the Fire of London in 1666, and the most complete visual record of Jones's work is to be found in William Dugdale's *The History of St Paul's Cathedral in London* of 1658 (with an enlarged edition of 1716). Dugdale published a plan, a view of the original south elevation complete with spire and views of the restored north, south and west elevations, all of which were engraved by Wenceslaus Hollar (see Figs 245–7). Perhaps if work had not been interrupted by the Civil War, and money had been raised, the inside might also have been encased by Jones, but there is no actual evidence of this intention. Further, Summerson argues from the building accounts that, unlike the Romanesque transepts and nave, the Gothic choir was 'highly valued and there was no thought of modernisation'.[64] Given the extent and detailed nature of the external repair work to the choir evident from these accounts, it does indeed seem unlikely that a future encasing was planned.[65] The repair of Gothic details on the choir would have been familiar work to the native masons employed by Jones, quite unlike the carving of antique ornament for the new surfaces on the nave.[66] Only three of what must have been a substantial collection of Jones's cathedral drawings survive.[67] One is a design for the north and south nave doors (dated 1637), another a north transept elevation (undated but presumably post-1633), and the third records what is an unexecuted design for the west front, without the portico or any overt reference to the royal benefactor (see Figs 244, 253, 270).[68] This west-front drawing has no scale or date, leading commentators to date it through Jones's apparent stylistic development tied to the various restoration campaigns, that is of 1608, 1620 and 1630–31.[69]

Jones added the huge portico to the cathedral's west front, which was funded directly by Charles I.[70] It was composed of sixteen columns and two pilasters, all of the Corinthian Order, whilst two further Corinthian pilasters flanked the central door. Webb reported that Jones set these columns out with what he understood to be the Roman method of optical correction.[71] Behind them were three great marble doorways, whilst the columns rested on a platform some 2 feet 3 inches in height built of black Irish marble.[72] The only scale drawings of Jones's west front as executed are a sketch elevation by one Daniel King, undated but probably taken from Hollar, and a much-reproduced engraving by Henry Flitcroft from William Kent's *The Designs of Inigo Jones* (1727; see Fig. 252).[73] This purports to show

59 Thomas Wycke, sketch of the south transept of St Paul's after the Great Fire (1666). The Guildhall Library, Corporation of London

the built west front to scale, sixty years after the cathedral had disappeared, and as such may be a copy of a lost drawing in the hand of Jones or Webb, since their drawings generally formed the basis of Flitcroft's engravings.[74] Flitcroft's columns are each topped with a statue, ten in all, and in this respect his drawing is imaginary since only two statues, one of James and the other of Charles, were actually put in place.[75] In fact, there is no evidence that other statues were planned. This portico rivalled Michelangelo's projected (but unbuilt) one for St Peter's as the largest free-standing Corinthian portico in the Western world since antiquity.[76] The encasing of the old building transcended any functional necessities to become a crucial expression of Stuart court iconography, and of state mythology.

Despite the ideals of perfect proportion and ordered harmony implicit in *all'antica* architecture, no applied surface can be totally independent from the older structure that it conceals. The blend of medieval and *all'an-*

tica ornament at St Paul's was more of a forced marriage than it had been in the case of the mixed style of Jones's earliest works, including his cathedral tower of 1608, in that here the medieval structure dictated the outer profile and overall proportions of the work. He accepted this fact, for his obelisks aligned with the existing bays of the lower and upper nave walls whilst what were proto-Tuscan pilasters served to frame these Gothic bays. Even when designing the portico Jones did not have total freedom from the proportions of the existing building, 'Mr. Jones's being constrain'd', according to Webb, 'to observe the Breadth of the old Work'.[77] Following the fire of 1666, sketches by Thomas Wycke show Jones's work in ruins and reveal the subtlety of his integration of new with old (Fig. 59).[78] That Jones's west front literally masked the cathedral's Gothic section is shown in these sketches, where the imprint of what is most likely the old pointed central window beneath the rebuilt gable can be seen on the reverse of

the new façade. This integration is also true of Jones's details, for the three windows on his new front fit exactly within, and yet disguise, the pointed window of the old façade.[79] After the Fire Samuel Pepys observed: 'It is pretty here, to see how the last church was but a case brought over the old church; for you may see the very old pillars standing whole within the wall of this.'[80] Jones thus skilfully overlaid the new upon the old, reflecting what he had aimed to do in the mixed style of his earliest designs. If Wren's record of the youthful Jones having worked as a joiner in the cathedral yard is correct, he thereby effectively ended his career where it began.

'STUDYING THE ARTS OF DESIGN': JONES'S LIBRARY

Jones's commitment to his art, so evident in his copious annotations, is perhaps most perfectly expressed by his motto taken from Petrarch: 'Altro diletto che imparar non trovo' (I find no other delight but to learn).[81] Jones made a clear distinction between architectural 'theory' and 'practice', the first emanating from the mind and the second from application on the ground (Fig. 60). In the absence of a master, Jones learned most from his travels and also from reading the books in his library. Through his underlining and annotations Jones can be seen studying passages on matters ranging from philosophical theory to mundane building practice. He is seen translating these ideas, in both a literary and an architectural sense, from Italian into English and from ancient into modern. In helping to understand the range of his interests and to follow closely his studies it is fortunate to have preserved a section – possibly nearly all – of this library.[82] Approximately fifty books survive, almost all of which are held at Worcester College in Oxford (forty-six volumes). The exceptions are a Vitruvius edited by Daniele Barbaro, held at Chatsworth House; a Lomazzo in the National Art Library in London; a Serlio at Queen's College in Oxford; and a further Serlio at the Canadian Centre for Architecture in Montreal (Fig. 61). A eulogy to Henry, Prince of Wales by George Chapman is attributed to Jones's ownership, although this is now disputed.[83] It is impossible to say what proportion of Jones's library these volumes represent. But certainly it would have formed an extensive and valuable collection that was larger than what has survived. For example, Jones also owned a copy of Antonio Labacco's *Antiquità di Roma* because he makes reference to it on a number of occasions in his Palladio concerning the Temple of Mars.[84]

Equally, he refers in his 'Barbaro' Vitruvius to Bernardino Baldi's *Vite dei mathematici* (1587–96) and elsewhere to Albrect Dürer's *Della simmetria dei corpi humani* (1591), both works now lost.[85] Wren reports in his second 'tract' on architecture that:

> I have seen among the Collections of *Inigo Jones*, a Pocket-book of *Pyrrho Ligorio's* . . . wherein he seemed to have made it his Business, out of the antique Fragments, to have drawn the many different Capitals, Mouldings of Cornices, & Ornaments of Freezes, etc. purposely to judge of the great Liberties of the ancient Architects, most of which had their Education in *Greece*.[86]

Jones makes passing reference in his Palladio to this copy of Ligorio, but it too is now lost.[87] Alongside his own books, Jones had easy access to other private libraries, including the impressive collection of Sir Robert Cotton.[88]

Of the surviving books, forty-eight are in Italian, two in French and one in English. Jones evidently read these books carefully, although his preference for modern Italian translations of ancient texts on history, philosophy and, of course, architecture, rather than Latin originals, indicates limitations to his scholarship. Twenty-eight books bear Jones's annotations that take many forms: translation of important passages (which constitute the vast majority), underlinings, references to other treatises in the collection, redrawing of illustrations, and commentary based on travels and discussions with other architects.[89] These were sometimes accompanied by a pointing hand pictogram drawn in the margin (☞), indicating text of a particular interest. The diversity and range of Jones's annotations, and especially his later ones, demonstrate that his studies extended far beyond the immediate subject of architecture. They are vital clues as to his design theory and principles in the absence of a fully formed treatise on architecture (that is, other than his and Webb's book on Stonehenge). Three topics in particular caught his early imagination: the practicalities of building and materials; Vitruvius on the principles of *all'antica* architecture including, as will be seen in this book, those of decorum; and Palladio's interpretation of the proportions and ornaments of the Five Orders. Later he turned to the temples in Palladio's Book Four, and Serlio's description of ancient monuments in his Book Three (Fig. 62).

The books containing Jones's annotations can be divided into three main categories. The body of volumes on art and architecture is the largest, and includes the treatises of Vitruvius (Barbaro of 1567 and also Rusconi of 1590), Serlio (1559–62 and also 1600),

60a and b Inigo Jones, allegorical figures of 'Theory' and 'Practice', details from the proscenium arch to the masque *Albion's Triumph* (1632). Devonshire Collection, Chatsworth

L'altezza de gli archi è palmi xliiij. l'altezza della basa disotto segnata E, è pal-
mo uno, & un terzo la fascia D, che ne gli angoli fa cornice è di altrettanta altez-
za. Et il giudicio di questo Architettore molto mi piacque, ch'ei nol facesse aggetto
di cornice nelle parti inferiori, acciò non impedisse i negocianti. L'altezza dell'al-
tre cornici non furono misurate, ma ben tolsi la sua forma con diligenza, le quali
dimostrerò nella seguente carta.

61a and b (*above and facing page*) Annotations by Inigo Jones to his copy of Serlio's Book Three (1600 edition, published by Francesco de' Franceschi), fols 98r and 105r. Collection Centre Canadien d'Architecture/Canadian Centre for Architecture, Montreal

62 Sebastiano Serlio, frontispiece to Book Three, *D'Architettura* (1540). The inscription reads: 'How Great Rome was, the Ruins themselves Reveal'

Alberti (1565), De l'Orme (1567), Cataneo (1567), Vasari (1568 and 1588), Lomazzo (1584), Palladio (1601), Vignola (1607), Scamozzi (1615) and Viola Zanini (1629).[90] These texts are supported by practical works on mechanics by Ubaldo (1581) and geometry by Euclid (1575) and Scala (1603), whilst Jones's extensive scribbling in his Vegetius (1551), Lorini (1609) and Busca (1619) indicates his close interest in the art of war.[91] He also owned works on antique warfare by Dio Cassius (1548), Appian of Alexandria (1551), Cretensis and Phrygius (1570) and Patricii (1583).[92] The second group of Jones's books comprises works by antiquaries, historians and geographers, both ancient and modern: these include Herodotus (1539), Sarayna (1540), Fulvio (1543), Florus (1546), Curtius Rufus (1559), Ptolemy (1561), Polybius (1558, with his description of the Roman military camp), Strabo (1562–5, acquired from Scamozzi),

Gamucci (1569), Guicciardini (1580), Leandro Alberti (1588), Bordini (1588), Cartari (1592), Summonte (1601–2), Cherubini, bound with Palladio's guide to ancient Rome (1609), and Caesar (1618).[93] As might be expected, Jones also studied Pliny the Younger's villas, as described in the Roman's epistles, in comparison with the villas of the ancients in Palladio and Scamozzi.[94] Finally, Jones owned an important collection of philosophical texts, comprising Xenophon (1521 and 1547), Aristotle (1551), Plato (1554), Plutarch (1567, 1607 and 1614) and Piccolomini (1575).[95] All these books on moral philosophy received his analytical attention. Of the works on art and architecture, three-quarters bear notes in Jones's hand. The most famous and scrutinised of these annotations are, of course, those to his Palladio, followed by those in his volume of Vasari's *Le vite de' più eccellenti pittori, scultori, e architettori*. A note records that he had the Vasari with him in Venice in 1614. Hardly surprisingly, he paid particular attention to the lives of architects, and notably Fra Giocondo and Antonio da Sangallo the Younger.

Jones's cross-referencing suggests that he was working towards a consistent theory of design rooted in antique philosophy. Thus Palladio was cross-referenced with Vitruvius, Serlio, Ligorio, Labacco, De l'Orme, Vignola, Scamozzi, Viola Zanini, Pliny, Herodotus and Scamozzi; Alberti with Palladio, Vitruvius and Aristotle; and Aristotle with Plato. True to his motto, Jones's studies were evidently made throughout his working life. As but one example, against the Corinthian capital in his Palladio (which it was noted he annotated from 1608) he observed: 'Viola Zanini followes Palladio directly', in reference to his copy of Viola Zanini's treatise of 1629.[96] Whilst it is difficult to establish the precise purpose behind Jones's study of individual passages, there is clear evidence of an attempt to trace themes underlying the antique principles that governed the use of the Orders in different contexts. Prompted in particular by Scamozzi, he consequently sought to understand architectural decorum outlined by Vitruvius and to identify the ethical and rhetorical origins of these principles.

'THE ORATOR AND THE ARCHITECT': JONES AND THE ART OF RHETORIC

To assist their comprehension of the rules of *all'antica* design, Renaissance architects had followed the example of Leon Battista Alberti in turning to the ancient rhetorical art of oratory as codified by Cicero and other antique philosophers. Jones had himself acknowledged connections between the two arts when

noting in his copy of Plutarch's *Opuscoli morali* that the 'foundatio[n] of all arte and siences ar 3 that is folosofi orratori and mathematikte'.[97] Palladio's patron, Daniele Barbaro, had famously compared the architect to the orator in the commentary to the opening chapter of the Third Book of his 1567 Italian translation of Vitruvius. In the course of discussing the choice of suitable ornament, Barbaro explained that the orator persuades through the combination of simplicity of style and splendour of content.[98] This comparison interested Jones, for in his copy of Barbaro's translation he annotated in the margin: 'an excellent Comparison of Barbaro between the orator and the architect'.[99] Connections between oratory and the Orders were highlighted through the double row of wooden columns, with pictures of ancient orators and poets, erected by Wotton in the Lower School of Eton College; and through the frontispiece to Walter Raleigh's *The History of the World* (1614), with its four Corinthian columns bearing emblems taken from Cicero's *De oratore* (Fig. 63).[100] Jones read the *De oratore* to assist in his study of Vitruvius, noting in the First Book of Vitruvius: 'for so much as belonged to Architecture of every science as I expressed above for this see Cissero li.3 fo.254 as I have noted in my notebook of Architecture'.[101] Cicero's three types of oratory (one 'full' and 'round', another 'fine' and 'strong', and a third partaking of both with an 'intermediate quality') had provided, according to John Onians, 'a close model for Vitruvius's classification of Doric and Corinthian as extremes of [decorative] "severity" and "softness", with Ionic embodying *mediocritas* in between'.[102] It will be seen that on occasions Jones was himself to mix and combine apparent stylistic opposites, in an equivalent act of well-balanced persuasion aimed at seducing the onlooker. The Banqueting House façade is a prominent example (see Fig. 7).

Why did Jones admire Barbaro's analogy between the architect and the orator? Both figures had much in common. Just as the classical orator carefully selected images and modes of speech that 'fitted', or characterised, their argument, so the classical architect was supposed to follow the principles of architectural decorum in choosing ornament (and principally the Five Orders) that fitted and signified their building's purpose and character. In this analogy, the various Orders might be seen as similar to the chosen modes of speech and images of the rhetorician. This view of the column types is compatible with the understanding in Jones's time of them as forms of heraldry and emblematics, used by him in masques. The analogy between architecture and oratory is underlined by the

63 The emblematic frontispiece to Walter Raleigh's *The History of the World* (1614)

need for ornamentation, which both arts have in common. In this way the architect-orator moved an audience through a work's style, its embellishment and, on suitable occasions, its splendour. It follows that the architect's use of grotesques, or what Jones called 'capricious ornaments', can be understood as similar to special types of figures of speech advocated by Quintilian and Cicero to facilitate the orator when emphasising a point through surprise, in departing from the conventional or the expected.[103] This conception of rhetoric, reliant on modes of speech as a form of ornament, had been explained in England in the context of

64 The emblematic frontispiece to Henry Peacham's *The Garden of Eloquence* (1593 edition)

a metaphorical garden by Henry Peacham. His *The Garden of Eloquence, Conteining the Most Excellent Ornaments, Exornations, Lightes, flowers, and formes of speech, commonly called the Figures of Rhetorike. By which the Singular Partes of mans mind, are most aptly expressed, and the sundrie affections of his heart most effectuallie uttered* first appeared in London in 1577 and was republished in 1593 (Fig. 64). As the title suggests, Peacham was concerned with the orator's most appropriate, or 'apt', use of 'ornamental' embellishments and different forms of speech in order to persuade. His ornaments were the persuasive devices of irony, dissimulation and wit.[104] Jones may well have seen this book, given that he was a friend of Peacham's son, also called Henry (*c*.1576–*c*.1643). The younger Henry is well known for publishing the related work *Minerva Britanna (or a Garden of Heroical Devices)* in London in 1612, dedicated to Jones's first patron, Prince Henry.[105]

Through the use of images and styles of speech, one of the principal aims of the orator was thus to persuade. It will be seen that through matching ornament to the purpose or denomination of the building and the status of the patron, necessarily tempered by the prevailing (and fluctuating) puritanical tastes at a given time, Jones's wider aim was similarly to persuade. In his case, the English viewer was to be persuaded of the moral propriety and appropriateness of the new *all'antica* style. For like Peacham and De l'Orme, Jones also sought to produce an 'architecture of eloquence' containing 'the most excellent ornaments', which would 'utter the affections of his heart' (Fig. 65). To stretch the point further, the Banqueting House façade with its swags of fruit and flowers might perhaps be viewed as just such a 'garden of eloquence'. Much as the courtier understood Jones's masque backdrops through the recognition of his scenic sources, frequently assisted by the text, so the observer was intended to *read* the ornament and forms of his buildings assisted by the growing awareness of antique sources and the vocabulary of the classical language in which Jones as an architect-orator chose to 'speak'. This vocabulary was formed around the antique Orders, and so it is natural that his understanding and use of ornament should form the subject of this book.

65 Philibert de l'Orme, the eloquent architect and his student in a garden, from *Le Premier Tome de l'architecture* (1567)

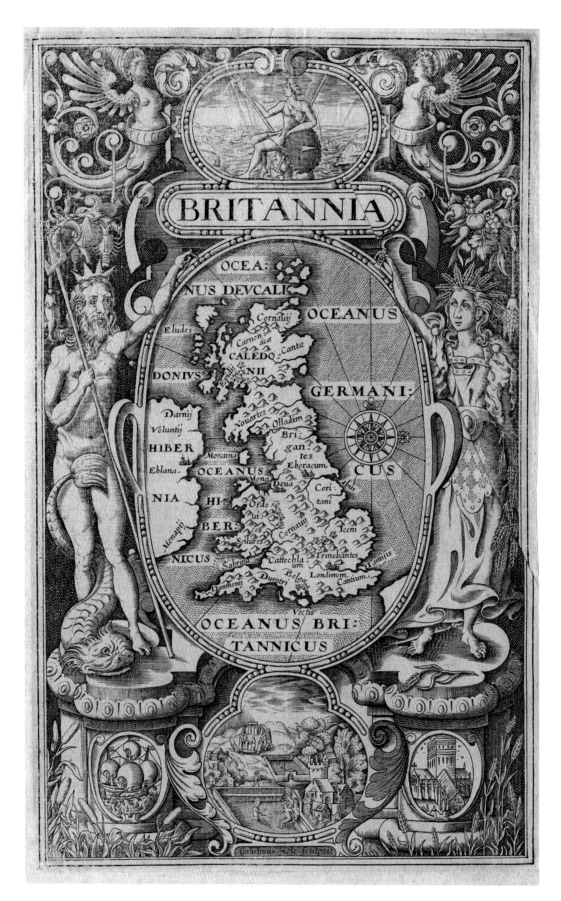

66 The emblematic frontispiece to William Camden's *Britannia* (1607 edition)

ALBION AND JERUSALEM: PROTESTANT ANCIENT BRITAIN AND JONES'S TUSCAN STONEHENGE

James I came to the English throne in 1603, having been king of Scotland since 1567. In order to give national legitimacy to his rule, and the concept of a united 'Great Britain' that it had brought about, he followed the well-established method adopted by newly installed European monarchs and identified himself with legendary figures. This pantheon included the British Trojan prince Brute (or Brutus), the Old Testament kings David and Solomon, the Roman emperor Augustus, the Christian emperor Constantine and the chivalrous king Arthur. All these heroes became bound up in a glorious story of national origins that drew on the Protestant mythology of the earlier Reformers. This mythology held that the Church of England had 'restored' an ancient British Church founded by the Apostles and which was consequently free of Catholic corruption. Not surprisingly, Stuart court sermons and propaganda presented London as at the centre of this national 'restoration'. And as the restored capital of 'Great Britain', London became projected as a worthy successor to the fabled cities of Troy, Rome and Jerusalem. In short, it was this British mythology to which Jones sought to give expression through his projects for new all'antica palaces, basilicas and churches.

This chapter will therefore show that the ancient columns came to be understood as expressing this British Protestant antiquity when they were used in the service of the crown by Jones as its Surveyor. Although apparently pagan in origin, the architectural Orders had become Christianised in recent times through the cultivation of their legendary associations with Solomon and Christ. This obviously assisted in legitimising the use of the Orders, and nowhere more so than when the columns were used by Jones to ornament London's principal Protestant church, St Paul's Cathedral. As will be seen, this was 'restored' by Jones with its magnificent Corinthian portico to rival that at the ancient temple of Jerusalem and the modern one proposed at the Vatican. But it was the simplest of the Orders, the Tuscan, that was identified most in court propaganda and art with Britain's antiquity. As will also be seen, Jones made this association himself when investigating the original purpose and appearance of Stonehenge. His all'antica architecture can be understood to have been underwritten, as it were, by his imaginary reconstruction of this enigmatic ancient monument and the vision of a once-glorious classical past that it came to embody.

'PORTICOES AND SEATS FOR KNIGHTS': JONES'S DORIC PORTICO TO ST GEORGE

The principal legends of British national origins were gathered together by a cleric called Geoffrey of Monmouth and presented in the *Historia Regum Britanniae* of around 1130. According to this account, the British race became heirs to a lost antiquity of a Trojan and later Arthurian 'Albion'. Much like Virgil's Roman ancestry, Geoffrey's British kings descended from Brute, the grandson of Aeneas of Troy and founder of Rome. Following a prophecy from Diana, Brute had conquered Britain and founded London as Troy Novant.[1] Geoffrey has Caesar comment: 'Those Britons come

67 Inigo Jones, scene design with the newly refaced St Paul's Cathedral as the focus, from the masque *Britannia Triumphans* (1638). Devonshire Collection, Chatsworth

from the same race as we do, for we Romans, too, are descended from Trojan stock', adding, however, that: 'they have become very degenerate when compared with us'.[2] Geoffrey's Albion reached full glory when, centuries after Brute, King Arthur reunified the country and went on to conquer most of northern Europe, forming an ancient British empire in rivalry with that of Rome. After the death of Arthur the country was overrun by the Saxons, but not before the last of the British rulers, Cadwallader, had received from an angel the prophetic message that Britons would one day recover their heritage.[3] The Stuart court viewed all its actions, including the patronage of Jones's *all'antica* architecture, as the fulfilment of this prophecy. Although not the first British monarch to cultivate Geoffrey's history, James saw his act of union as the most important historical parallel.[4] In order to give this claim credibility, elaborate genealogies were drawn up to document James's and later Charles's Trojan and Arthurian ancestry. Thomas Heywood's *TROIA BRITANICA; or, Great Britaines Troy* (1609), for example, took the form of a chronicle, 'from the first

man, unto us, this second time created *Britons*, with a faithfull register . . . of memorable thinges done in *Troy* and this Island'.[5] Heywood would go on to produce the parallel *Life of MERLIN . . . His Prophesies, and Predictions Interpreted . . . Being a Chronographicall History of all the Kings . . . from BRUTE to the Reign of our Royall Soveraigne King CHARLES* (1641). In line with the court, the Livery Companies of the City of London not surprisingly also celebrated the legend of Brute's Troy Novant. Trojan origins formed a frequent theme within the Lord Mayors' progresses, as with Thomas Dekker's *Troia-Nova Triumphans LONDON TRIUMPHING* (1612), in which the twelve Companies were commanded to 'guard this new Troy'.[6] Court art, too, consistently celebrated these Trojan and Arthurian themes. For example, James I was flanked by a figure presumed to be Brute in the famous panels painted by Peter Paul Rubens on the ceiling of Jones's Banqueting House (see Figs 229–31).[7] The return of Merlin was promised in the masque *Britannia Triumphans* (1638), set against a backdrop designed by Jones to focus on his newly refaced St Paul's Cathedral (Fig. 67).[8] Jones's act of

68 Inigo Jones, Stonehenge as a Tuscan temple, woodcut from Jones's *STONE-HENG . . . RESTORED* (1655)

resurfacing the Protestant cathedral with a new *all'antica* ornamental skin, work on which had started in 1633, was seen by members of the court not as mere repair but rather as reflecting this concept of reviving or *restoring* a heroic national antiquity. In 1620 Bishop John King had urged the Chapter of St Paul's to 'undergo this worke of *restauration*'.[9] The inscription on Jones's Corinthian portico included the medieval notion, stemming from Geoffrey, that the British kings were heirs to France, and it praised Charles I specifically because he 'restituit' the cathedral.[10] Equally, Jones saw his study of Stonehenge as a 'restoration', achieved as much through his definitive attribution of the ancient monument to the Romans as by his imaginary reconstruction of its original form as a Tuscan temple (Fig. 68). This concept was emphasised in the study's published title: *The MOST NOTABLE ANTIQUITY OF GREAT BRITAIN, Vulgarly called STONE-HENG, ON SALISBURY PLAIN, RESTORED, By Inigo JONES, Esq, Architect General to the King* (1655).

Geoffrey's legend of a British antiquity, linked as it was to the Golden Ages of Troy and Rome, underpinned Jones's introduction of what would otherwise have been a foreign and new style of architecture. The legend gave special legitimacy to contemporary claims for London as the New Troy and second Rome, to which he sought to give physical expression. The Stuart intention to restore this antiquity through architecture was proclaimed early on within one court production in particular: Ben Jonson's masque *Prince Henry's Barriers* was performed on 6 January 1610 with stage sets by Jones, and focused on the future Stuart monarch, the fiercely Protestant Prince Henry.[11] Henry was making his first official court appearance, aged just fifteen.[12] He was introduced on stage by none other than Merlin, and was cast as Meliadus, a figure drawn from Arthurian

romance (Fig. 69). At the same time James I was hailed as a second King Arthur, having restored the ancient unity of Britain achieved by his legendary predecessor. Protestant knights were clothed in antique costume, and

69 Inigo Jones, characterisation of Merlin from the masque *Prince Henry's Barriers* (1610). Devonshire Collection, Chatsworth

70 Inigo Jones, 'The Fallen House of British Chivalry', design for the masque *Prince Henry's Barriers* (1610). Devonshire Collection, Chatsworth

71 Inigo Jones, 'St George's Portico' from *Prince Henry's Barriers* (1610). Devonshire Collection, Chatsworth

the chivalrous world of Henry's barriers was visualised by Jones as rising from the antique ruins of an ancient Britain.[13] His efforts were as yet concentrated on the scenic design for these masque productions, and they articulated the themes his later architecture would embody in more permanent form as well as the hope for renewal that it represented. Jones's opening stage set depicted antique ruins entitled 'The Fallen House of British Chivalry' (Fig. 70). It was complemented by a prophecy of the prince's future Protestant chivalrous architecture delivered by 'The Lady of the Lake':

> Now, when the island hath regained her fame
> Entire and perfect in the ancient name, . . .
> How brighter far than when our Arthur lived,
> Are all the glories of this place revived!
> What riches do I see; what beauties here! . . .
> What ornaments of counsel as of court! . . .
> Only the House of Chivalry (howe'er
> The inner part and store be full, yet here
> In that which gentry should sustain) decayed,
> Or rather ruined seems; her buildings laid
> Flat with the earth, that were the pride
> of time, . . .
> When in a day of honour fire was smit
> To have put out Vulcan's and have lasted yet.[14]

This reference to Vulcan alluded to the legendary destruction of Troy. Vulcan had burnt Troy, but in vain, for it had been rebuilt first at Rome and then at Troy Novant, or London – only to be subsequently re-established, or so it is implied, by James.[15] The intention of this scene was to convey the idea that antique architecture had become ruined because Protestant chivalry was no longer practised. In the next set, 'St George's Portico', this chivalry was restored and along with it a heroic *all'antica* architecture, which Jones represented in the form of a proto-Doric portico or gate (Fig. 71).[16]

King Arthur expected of Henry 'that by the might / And magic of his arm he may restore / These ruined seats of virtue, and build more'.[17] In thus associating the young prince, and the Protestant mythology of his court, with the *all'antica* character of the setting, these early performances provided a 'manifesto' for Jones's expected architectural work for the prince as his surveyor. Jonson's description of Albion's 'House of Chivalry', with its Arthurian 'porticoes', 'obelisks', 'triumphal arches' and 'columns', introduced the nationalistic context in which Jones's future architecture was to be understood by his royal patrons. This was particularly so for his early patrons, Henry and James, given their Protestant proclivities. The restoration of an architecture composed of these antique elements, on some occasions

overlaid by Jones onto existing medieval buildings in a literal act of restoration (as at St Paul's Cathedral), was clearly seen to have the power to renew national chivalrous virtues:

> O, when this edifice stood great and high, . . .
> When to the structure went more noble names
> Than the Ephesian temple lost in flames;
> When every stone was laid by virtuous hands;
> And standing so (O that it yet not stands!), . . .
> There porticoes were built, and seats for knights
> That watched for all adventures, days and nights,
> The niches filled with statues to invite
> Young valours forth, by their old forms to fight,
> With arcs triumphal for their actions done,
> Outstriding the Colossus of the sun,
> And trophies, reared of spoiled enemies,
> Whose tops pierced through the clouds and
> hit the skies.[18]

There can be no doubt that the antique columns used nine years later on Jones's Banqueting House façade were validated, in the eyes of the court at least, by the ancient Britain of Geoffrey's legend. Merlin's reappearance in front of a restored St Paul's in *Britannia Triumphans* of 1638 signalled just this fact.

The cultivation of antique 'Albion', with its intensely Protestant ideal of Arthurian chivalry personified by St George, had an inevitable counterpart in the mythology of the English Church. It nurtured a corresponding ideal of Protestant Britain as the chosen 'New Jerusalem' now restored and defended by the king. This parallel view also helped legitimise Jones's general use of antique forms, and found a particular expression in his cathedral refacing, given its status as the principal Protestant church of the land. And in reflecting this official Solomonic mythology, Jones's Orders naturally became 'ornaments of counsel as of court', to use the language of the masque.

'ORNAMENTS OF COUNSEL AS OF COURT': JONES'S SOLOMONIC CORINTHIAN PORTICO TO ST PAUL'S CATHEDRAL

The broad body of opinion that constituted the Church of England under the Stuarts – that is, Puritans and Calvinists on the one hand, and the High Church Arminians and Laudians on the other – had stemmed from the flimsy unity of the Elizabethan settlement. This formed the foundation of the English Church inherited by James I.[19] Like Jones's architectural style

and James's very succession, a question of legitimacy had also surrounded the Protestant Church. Given this insecurity, there was by necessity a further aspect to Stuart mythology, namely an ancient Church prefiguring and thereby justifying the Church of England.[20] This also needs to be considered in some detail in order to understand its role in legitimising Jones's use of the Orders to represent a Protestant monarch.

For Puritans, and Calvinists in particular, the primitive Church had been directly established in Britain by the Apostles, and it prophesied the Protestant Church formed under the Elizabethan settlement. As legend had it, Joseph of Arimathea lay buried at Glastonbury, having preached long before the arrival of the popish monk Augustine, and Arthur's Albion thereafter became the burial land of the Holy Grail. According to the Protestant cleric John Gordon, preaching to the king:

> For we read in *Theodoretus, Metaphrastes*, and *Nicephorus*, that S. *Paul*, S. *Peter, Joseph of Arimathaea*, and *Simon Zelotes* did preach the Evangell of Christ in Brittannie, that is, the new covenant between God and man: at which time this said Iland of great Britannie did beare the same name of Gods covenant as it doth now.[21]

Moreover, through hearing St Paul's sermons it was the people of Britain that 'before all nations first publikely receaved the Faith of Christ'.[22] The three 'great Windowes newly glazed, in rich colours, with the story of Saint *Paul*', which John Stow recorded at St Paul's and which James inspected after a sermon in 1620 urging restoration of the cathedral, may well have depicted this British visit.[23] But in any case a restored St Paul's using Jones's *all'antica* ornament was seen by many clerics as a celebration of British 'primitive' Christianity founded by none other than the cathedral's patron saint. Bishop Richard Corbet, whilst speaking of the restoration plans, exclaimed: 'one word in St. Paules beehalfe . . . hee hath raysed our inward Temples, let us help to requit him in his outward'.[24] This 'pure' Church, compromised only on the arrival of Augustine, animated everything written in defence of the English Church in the sixteenth and seventeenth centuries. Such is the case with John Foxe's *Actes and Monuments* (1563), for example, and Matthew Parker's *De Antiquitate Britannicae Ecclesiae* (1572).

From James I's Calvinist point of view, church history naturally centred on the monarch; he was proclaimed as the saviour of his people through the cultivation of the tripartite role of Jewish king, pagan emperor and Christian prince.[25] This imperial view of Church history was outlined in sermons preached to James at the commencement of his rule by Protestant apologists such as Gordon.[26] In January 1604 Gordon was presented at the Hampton Court conference as 'Deane of Sarum' and in the same year preached to James *ENOTIKON; OR, A SERMON OF THE Union of Great Brittannie, in antiquite of language, name, religion and Kingdome*. In this, the act of royal union under Stuart rule became a fulfilment of a prophecy 'mystically' contained in the name 'Brit-an-iah', which was a word of Hebrew origin signifying the land of God's Covenant.[27] It follows that James was seen to repeat Solomon's restoration and unification of the primitive faith, with the Temple its physical symbol. After its building 'was established the kingdome of God in earth, which was joyned with the united estate of the temporall and worldly kingdome'.[28] Here in 1604 is the animating ambition behind Jones's later restoration of St Paul's. For it was none other than James 'by whom', according to Gordon, 'God hath builded his Temple in the *Spirituall Jerusalem*'.[29] The Protestant dream was to unify Church and State in line with the great Old Testament kings, David and Solomon, and indeed the virtuous pagan emperor Augustus and the even more admirable Christian one, Constantine.[30] Hence in a sermon preached before James in June 1621 William Laud, then Dean of Gloucester, emphasised that Church and State 'were commended to the Jewes, and both are to us; And both under one name, *Jerusalem* . . . Therefore when you sit downe to consult, you must not forget the Church; And when we kneele downe to pray, we must not forget the State: both are but one *Jerusalem*.'[31] James's translations of the Psalms of David were intended to assist his own claimed descent, as the 'British Solomon', from the House of David. As will be seen in a moment, Jones's Orders had a similar ancestral claim and as such came naturally enough to express this pretension.

According to Stuart mythology, reliant again on Geoffrey of Monmouth, primitive Christianity was first fully installed in Britain under the ancient British king Lucius in the second century. In this way Lucius took his place in line with Brute and Arthur in James I's official ancestry.[32] Lucius's ancient Church justified the position of the British Church in subservience to the wishes of the crown. This view of the episcopate was reinforced by Geoffrey's report of the birth of Constantine in Britain, the son of a British princess, in the first century.[33] For Constantine had supposedly spread his Christian empire from none other than Britain, first to Rome and then to the Orient. Thus, Gordon reports, 'by all these victories this Britaine King became Emperour, King, and Monarche of the whole world'.[34]

Since Constantine represented the archetype of the British Christian prince, James necessarily became, 'our newe *Constantinus*'.[35] The royal propagandist George Marcelline echoed these sentiments when hoping in 1610 that 'under the name and family of *Steuart*, all Christendome shall flourish in an absolute Monarchy' so 'it may be said of you' that '*you are a Caesar*'.[36] James's identity as the natural inheritor to Roman imperial authority served only to reinforce his role as Protestant head of a reunited Holy Roman Empire in rivalry to the pope and the Church of Rome.[37] It also helped justify his patronage of the architecture of imperial Rome as described by Augustus's architect, Vitruvius.

In this way Gordon's Protestant history contained four distinct periods of the true faith – under the imperial rule of Solomon, Constantine, Lucius and ultimately James. Naturally enough, each one of these periods found its origin in Britain.[38] This historical narrative directly informed Jones's work. Most obviously, it was given pictorial expression on Rubens's Banqueting House ceiling, which can be seen as a form of Stuart 'self-portrait' (see Figs 229–31). James is pictured pointing to an infant, in the presence of figures identified as Brute, Lucius and Constantine. As such, he is not only presented in the guise of Solomon (from the story in 1 Kings 3.16–28), but, as Roy Strong notes, 'also here in his role as the nursing father of the newly reunited British Church'.[39] Jones's triumphal arch design at Temple Bar (1636–8), in being based on the Arch of Constantine in Rome, thereby emphasised the Stuart monarch's role as the 'British Constantine' (see Figs 99–102). The use of this ancient arch as a model had added relevance since according to James Howell, writing in 1657, much of Stuart London lay over an ancient city built by Constantine, 'which took up in compasse, above three miles, so that it inclosed the Model of the City almost four-square'.[40]

As the principal church restoration project proposed by the Stuart monarchs, St Paul's Cathedral was the natural setting, as it were, for the expression of this Protestant view of antiquity. Gordon had urged in 1604 that James 'should finish the full delivery and restorating of Israel, and of the Churches of your realmes'.[41] Jones's restoration sought, in particular, to give physical expression to the Reformers' spiritual ambition to establish the New Jerusalem. For in his preliminary design of the west façade, the angels with their palms above the door are a direct quotation from the biblical description of the Temple in Jerusalem (Fig. 72; see Fig. 244). According to Ezekiel (41.17–18), 'above the door' of Solomon's Temple were to be found 'cherubim and palm trees'. Inside were further cherubim and palms,

together with carved lions (1 Kings 7.36). Jones placed the head of a winged cherub over each of the nave windows of the cathedral, and lion's heads in the frieze (see Figs 1, 252, 254).[42] He was, of course, well aware of the biblical origins of this iconography. For in 're-storing' and Christianising Stonehenge, he argued that 'the *Temple* at *Hierusalem*' was 'adorned with the figures of Cherubims, that thereby the Nations of the Earth might know it was the habitation of the living God'.[43]

The Orders used on the cathedral also shared this link with Solmon's Temple. The identification of James I with Solomon, Augustus and Constantine quite obviously bolstered his legitimacy and the Protestant-inspired claim to rule by Divine Right; equally, it gave a further national sanction to the antique Orders that these wise rulers were thought to have used. Ostensibly Graeco-Roman, the Orders came not only to embody the national merits of Albion (where, it will be remembered, 'porticoes were built, and seats for

72 Juan Bautista Villalpando, illustration of Solomon's 'Holy of Holies', with cherubim and palms, from *In Ezechielem Explanationes* (1604)

VNIVERSI TEMPLI HIEROSOLYMITANI ORTHOGRAPHIA QVAE OSTENDIT ORIENTALEM FACIEM MVRI ATRII EXTERIORIS ET PARTEM MVRI PORTICVS GENTIVM QVAE DEINDE DICTA EST S ALOMONIS

73 Juan Bautista Villalpando, reconstruction of the Temple of Solomon from *In Ezechielem Explanationes* (1604)

knights'), but more general biblical virtue as well. This virtue was particularly true of the Corinthian Order, which it will also be recalled Jones used for his majestic portico added to the west end of the cathedral. The Order had well-established Solomonic associations, following its use in the much-studied reconstruction of Ezekiel's description of the Temple published by the Jesuit Juan Bautista Villalpando in 1604 (Fig. 73).[44] Somewhat later, John Evelyn, in his *Parallel of the Ancient Architecture with the Modern . . . upon the Five Orders* (1664), was to comment on the Corinthian:

> You see what *Vitruvius* reports: But *Villalpandus* who will needs give this *Capitel* a more illustrious and antient Original, pretends that the *Corinthians* took it first from the Temple of *Solomon*, of which *God* himself had been the *Architect . . .* The *Design* which we shall hereafter describe with the whole *Entablature* of the Order, drawn precisely according to the Measures which *Villalpandus* has Collected, and which I expressly followed.[45]

So it was that here again Jones's cathedral iconography reflected a Solomonic theme. He must have seen Villalpando's reconstruction, since it was mentioned twice in the sermon entitled *Great Britains SALOMON* delivered by Bishop John Williams at the funeral of James I in 1625.[46] A copy of the Jesuit-inspired commentary belonged to the old royal library and bears James I's arms on its binding, and it was this commentary that Charles I studied when imprisoned in Carisbrook Castle.[47]

Villalpando had provided the earliest literal and pictorial source for this 'Christianised' view of the Orders, in helping to legitimise their otherwise pagan origins. They were further Christianised through links with the emperor Augustus, whose rule was apparently blessed by being chosen as the moment for Christ's birth. As Gordon relates, the 'beginning of the foundation of Christs kingdome was in the age of a generall peace established by *Augustus*'.[48] Given that Vitruvius had dedicated his treatise to this emperor, the architectural Orders he described also became Christianised by association. Writing in 1570, John Dee pointed out that Vitruvius 'did write ten bookes' on architecture that were dedicated 'to the Emperour *Augustus* (in whose daies our Heavenly Archemaster, was borne)'.[49] Such links with Solomon and Christ, as with Augustus and Constantine, helped the Orders to become accepted as appropriate ecclesiastical ornament amongst those like Bishop Williams who were educated and well connected in court and Church. Moreover, in the absence of any established and explicitly Protestant mode of building, Jones's 'antique manner' became transformed, through links with this Christian and British antiquity, into the architecture of the Church of England. This was despite the fact that it was ostensibly taken from Catholic Italy. Accordingly, it was hoped by many Protestants that St Paul's, and by implication all new churches, would express the origins of the English Church free of Roman impurity whilst equal to Roman splendour.[50]

Not surprisingly therefore, the wider ambition of refounding London as a Protestant second Rome animated public justifications for Jones's work at St Paul's Cathedral. These took the form of sermons urging restoration. In that delivered in 1620 by Bishop King announcing James I's plans for the cathedral, the image of St Paul's refaced *all'antica* was presented as equal to '*Rome Caput Mundi*; Rome the head of the World'. Directly addressing James, who was present for the occasion, the bishop continued by articulating something like a coherent vision for London restored on classical terms. Focusing on public buildings that, for the most part, had been or were soon to be the subject of *all'antica* schemes by Jones, he observed:

Your Citty hath beene anciently stiled *Augusta* . . . Not to weary mine eyes wandering and roving after private, but to fixe upon publicke alone . . . your Royall Exchange for Merchants, your Halls for Companies, your gates for defence, your markets for victuall, your aquaeducts for water, your granaries for provision, your Hospitalls for the poore, your Bridewells for the idle, your Chamber for orphans, and your Churches for holy Assemblies; I cannot denie them to be magnificent workes, and your Citty to deserve the name of an Augustious and majesticall Citty.

Bishop King went on to declare concerning the cathedral: 'finally, this unto you, as *S. Peters in the Vatican* at Rome'.[51] Given that St Peter's in Rome was supposedly founded by Constantine, James's aspiration to reface the Protestant St Paul's in direct rivalry with the great Catholic basilica represented a further celebration

of his role as the 'new Constantine'. Jones's portico in particular was eventually conceived in this context, as the largest north of the Alps. It was a worthy rival to those on Rome's two great temples, the ancient portico fronting the Pantheon and the modern one proposed for St Peter's.[52] Such rivalry was compatible with the Stuart view of history that placed British Christianity older than the Church of Rome. Ephraim Pagitt's *CHRISTIANOGRAPHY* of 1640, for example, claimed: 'By which computation of times I gather, that the *Faith* was preached in *Brittain* some years before there was a Church founded in *Rome* by *Saint Peter*.'[53] St Peter's had influenced Jones's work at St Paul's early on in his career. His design for the cathedral tower of 1608 was based closely on one for the basilica in Rome by Antonio da Sangallo the Younger, and Jones visited the Vatican whilst in Rome (Figs 74–5).[54]

Equally unsurprisingly, the parallel ambition of refounding Stuart London as the prophesied New

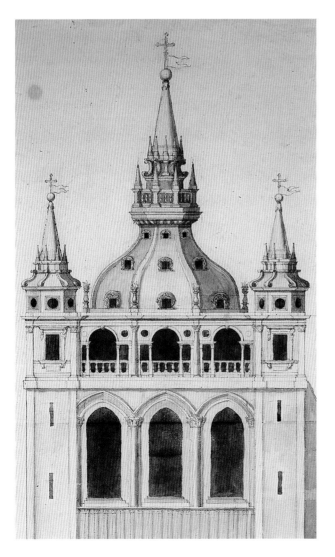

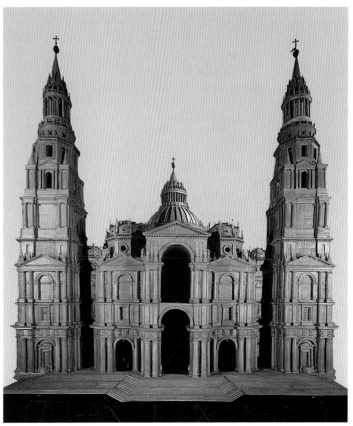

74 (*left*) Inigo Jones, detail of design for a new termination to the tower of St Paul's Cathedral in London, 1608 (detail of Fig. 26)

75 (*below*) Antonio da Sangallo the Younger, wooden model of the project for St Peter's (made by Antonio Labacco), 1539–46. The pinnacles and spire were a source for Jones's design for St Paul's Cathedral

Jerusalem, to which Jones's work would give such literal expression, also pervaded practically all public sermons in favour of cathedral restoration. In evoking the image of the 'glorious Temple of *Salomon*', Bishop King continued: 'This Church is your Sion indeed, others are but *Synagogues*, this your *Jerusalem the mother to them all*.'[55] After this sermon, Psalm 102 (13–14) was read:

> Thou shalt arise, and have Mercie
> upon Zion: for the time to favour her,
> yea the set time is come.
> For thy servants take pleasure in
> Her stones: and favour the dust therof

When writing his history of the cathedral in 1658, William Dugdale reported that these lines were 'pertinent to the business in hand'.[56] The idea of the British Solomon re-edifying the temple in his New Jerusalem was a constant theme of John Donne's sermons at St Paul's around 1620.[57] And Bishop Corbet, in calling at Norwich for contributions towards the restoration in 1634, pleaded: 'Now your turne comes, to speake, or god in you by yr hand, for soe he uses to speake many times, by ye hand of Moses & Aaron, & ye hand of Esay & Ezekiell, & by ye hands of you his minor Prophets now.'[58] Both Stuart kings were thus hailed as great builders in the Solomonic mould. Bishop Williams's sermon delivered at James I's funeral in 1625 claimed that 'Salomon beautified very much his Capitall Citie with Buildings, and Water-workes, I Kings 9.15. So did King James'; this point was underlined by the fact that James was 'the most constant Patron, of Churches'.[59] Later, Charles I was praised in similar terms. A sermon of 1640 at St Paul's eulogised that he was 'a *Glorious builder*', and added: 'Nor will I carry you farre off for instance. As the disciples to Christ concerning the Temple of *Jerusalem*, so let me say to you . . . See the Materialls for the re-edifying of this Mother Church.'[60]

Later still, after the destructions of the Civil War, Dugdale introduced his record of Jones's work on the cathedral with a description of the crafts that had been involved in the building of the 'glorious work' of Solomon's Temple. He also emphasised that London had once served as the seat of the archbishop's see before its removal by Augustine to Canterbury. He implied that the Stuart restoration of St Paul's was thereby a restoration, in spirit, of the metropolitan seat of the ancient British Church.[61] But these boasts were now out of step with events, given that the Corinthian portico had recently suffered at the hands of the Puritan authorities. Whatever the original Arthurian and Solomonic justifications made in court masques and sermons, as well as in biblical commentaries owned

by the king, Jones's cathedral decoration must have appeared decidedly Roman and, worst still, Roman Catholic to many ordinary Stuart citizens. This would have been especially so to Puritans nurturing Calvinist hostilities to Italian art and decoration.

'THE FIRST FACE OF ANTIQUITY': JONES'S TUSCAN ORDER AT STONEHENGE

In this way both Stuart kings presented themselves as having restored the spiritual and physical virtues of a lost British antiquity. This national story consisted of Trojan and later Roman invaders who were seen as ancestors of civilised, pre-popish Britons initiated in primitive Christianity by sermons from St Paul; this antiquity in turn became linked to the Golden Age of King Arthur and thence (despite their Catholic allegiance) to the later Crusaders. With the hazy antiquity of Troy as support, a past equality with and independence from Rome bolstered equivalent Protestant imperial claims for the present, and validated the otherwise new Stuart court and its patronage of Jones's apparently foreign architectural style. This mythology could be temporarily fractured, as in the prelude to the masque known as the 'anti-masque', for example, to serve as a warning against disunity; Geoffrey's ancient British king Lear had been used by Shakespeare in much the same way. The physical restoration of this antiquity was to be celebrated through Jones's use of the architectural Orders, most fittingly on the Protestant cathedral of St Paul. But in his attempt to legitimise the concept of the new *all'antica* architecture as having revived ancient architectural practices in Britain, Jones and his royal patrons lacked physical evidence in the form of actual ruins. This evidence was found at the ancient though enigmatic monument called Stonehenge.

Jones opened his study of Stonehenge, published posthumously by John Webb in 1655, with a list of the monument's mysterious qualities:

> Among the ancient Monuments whereof, found here, I deemed none more worthy the serching after, than this of *Stone-Heng*; not only in regard of the *Founders* thereof, the *Time* when built, the *Work* it self, but also for the Rarity of its *Invention*, being different in *Form* from all I had seen before.[62]

Jones pointed out that Sir Philip Sidney had described Stonehenge as one of the seven 'Wonders of England', and by 1620 the monument had become an object of

much contemporary curiosity.[63] John Aubrey reported that the Duke of Buckingham had ordered a pit to be dug at Stonehenge in that year, in the manner of the somewhat crude archaeology organised by members of the court on sites at Corinth and the like.[64] The Lord Chancellor, Francis Bacon, recorded his own interest in Stonehenge in *Novum Organum*, published the same year: 'Passing therefore so often by those monuments of ancient time, I could not but make somewhat a deeper inspection into them than one of the vulgar. Methought the venerableness of them did riquire a stop and respect.'[65] During 1620 the king himself was so intrigued by Stonehenge whilst staying nearby at Wilton House, as Jones's introduction informs us, that he asked the Royal Surveyor to investigate. Stonehenge evidently became part of the discussion of the arts at Wilton, prompted by William Herbert, 3rd Earl of Pembroke. The Royal Surveyor received 'his Majesties commands to produce out of mine own practice in *Architecture*, and experience in *Antiquities* abroad, what possibly I could discover concerning this of *Stone-Heng*'. Implied in this request is the notion that Stonehenge was 'architecture', and antique architecture at that. In this way Jones was prompted by court patronage into assuming the role of antiquarian. As Webb is careful to tell the reader in his dedication to Philip, 4th Earl of Pembroke, Jones was even acknowledged as such by none other than John Selden, the leading antiquarian of the day.[66]

Jones's title made clear that in the course of his study Stonehenge was to be 'restored', and by this he meant restored to its rightful place as a work of the Romans. The idea of a lost Roman Britain had held obvious romantic appeal to Elizabethan poets, conferring as it did a second overlay of antique culture to complement the Trojan. In Edmund Spenser's *Ruines of Time* (1591) a mournful woman represents the Genius of a lost Roman London, a city built in the image of Rome:

> I was that citie, which the garland wore
> Of *Britaines* pride, delivered unto me
> By *Romane* Victors, which it wonne of yore;
> Though nought at all but ruines now I bee . . .
> High towers, faire temples, goodly theaters,
> Strong walls, rich porches, princelie pallaces,
> Large streetes, brave houses, sacred sepulchers,
> Sure gates, sweete gardens, stately galleries,
> Wrought with faire pillours, and fine imageries,
> All those (O pitie) now are turnd to dust.[67]

Even what Spenser terms the 'elder sister' of Roman London, Troy Novant, was apparently no match for its splendour. His lost Roman palaces clearly added extra

legitimacy to Jones's own 'faire pillours' used in the cause of restoring Stuart London. The virtues of Roman occupation were also spelt out in the works of William Camden and John Stow.[68] The emblematic frontispiece to Camden's *Britannia* (1607 edition), for example, represented an idyllic ancient Britain, complete with Roman baths and 'Stonehenge-like' ruins under a bright sun (Fig. 66). Further, this vision is pictured alongside a cathedral curiously similar to old St Paul's (see Figs 84, 137, 248). Jones quoted Camden on the subject of Roman Britain when noting: '*It was the Brightnesse of that most glorious Empire, which chased away all savage Barbarism from the Britains minds, like as from other Nations, whom it had subdued.*'[69] Ephraim Pagitt went so far as to regard the Roman Empire in Britain as semi-Christian, for: 'I read also of *Pomponia Grecina* a Christian, wife of *Aulus Plantius*, the first Lieutenant of *Brittaine*: yea, some of the *Roman* Deputies here were converted, even in the day spring of Christianity, as *Trebellius Pertina* . . . more publickly to maintain the Gospel.'[70] Jones reflected these views in turning Stonehenge into an emblem of the artistic and political virtues of Roman imperialism; for it was built in 'such a flourishing Age, as when *Architecture* in rare perfection, and such *People* lookt upon, as by continuall successe, attaining unto the sole power over *Arts*, as well as *Empires*, commanded all'.[71] Accordingly, imperial ambition and the perfection of architecture went hand in hand for Jones, mirroring Stuart imperialism and its claims to have renewed the antique Golden Age.

Fundamental to Jones's argument for having 'restored' Stonehenge to the Romans was the necessary transformation of the crumbling monoliths into classical columns. In line with the simple style of worship practised by primitive Christianity as portrayed by the Protestant apologists, he chose the Tuscan Order; this, as the most plain of the Five Orders, stood as a reflection or emblem of ancient Britain's simple character, since 'the *Romans* for so notable a structure as *Stone-Heng*, made choice of the *Tuscane*, rather than any other Order . . . as best agreeing with the rude, plain, simple nature of those they intended to instruct, and use for which erected'.[72] Jones emphasises the didactic power of the columns and their ability to instil social decorum, themes that will be explored later in this book with regard to his own work. He goes on to illustrate these 'Tuscan' columns, minus their capitals, which had, or so he claims, been eroded by weather and vandals (see Fig. 68).

Jones's attempt to relate the Tuscan Order, and by implication the Orders in general, to national origins here at Stonehenge echoed the Italian architectural the-

orists. The Tuscan owed its invention not to the Greeks but to the Romans, and in the Renaissance it had even been traced back, with an etymological leap via 'Etruscan', to the 'Trojan'.[73] Serlio and Palladio both pointed out its status as the first Roman Order, and this did not escape Jones's notice, since in his Palladio he translates 'Toskani first Reseved Architecture'.[74] Jones was not alone amongst Stuart commentators too in identifying the Tuscan with national origins, since the Order had enjoyed a special place in Stuart court mythology. The frontispiece to Michael Drayton's *Poly-Olbion* (1613) represented Trojan Brute and Caesar surmounting Tuscan columns; and in Rubens's ceiling panels at Whitehall a circular temple composed of Tuscan or simplified Doric columns forms the setting for James I pictured in his role as the 'nursing father' of the newly reunited British Church (Fig. 76; see Fig.

76 The emblematic frontispiece to Michael Drayton's *Poly-Olbion; or, A Chorographicall Description of Tracts, Rivers, Mountaines, Forests, and other parts of this renowned Isle of Great Britaine* (1613)

230).[75] It is perhaps significant in this regard that in *Prince Henry's Barriers* Henry was introduced to the court as the imperial Protestant heir not within decorative Corinthian palaces but rather within proto-Doric porticoes and rusticated monuments set in untamed nature.[76]

On the subject of Stonehenge, Horace Walpole correctly observed: 'it is remarkable that whoever has treated of that monument, has bestowed it on whatever class of antiquity he was peculiarly fond of'.[77] Geoffrey of Monmouth, for example, had presented it as a product of Merlin's magic and as a memorial to Celtic nobility. Jones reviewed many of these previous explanations of Stonehenge's origins, and in so doing revealed much as to his own views of British history. His Stonehenge came to embody its Roman, or rather Romano-British, Tuscan virtues by a reasoned process.[78] He began by rejecting the popular theory of the pre-Roman Druids as having built Stonehenge, arguing:

> *Stone-Heng* could not be builded by them, in regard, I find no mention, they were at any Time either studious in *Architecture . . . Academies* of *Design* were unknown unto them: publique Lectures in the *Mathematiques* not read amongst them: nothing of their *Painting*, not one Word of their *Sculpture* is to be found, or scarse of any Science (*Philosophy* and *Astronomy* excepted) proper to informe the judgement of an *Architect*.[79]

Uninitiated as they were in the Vitruvian subjects, the Druids as Jones sees them could not possibly have built Stonehenge. Here his attitude was ambiguous, however, for according to him the Druids were also held in 'great esteeme' in ancient times as 'the Bishops and Clergy of that Age'.[80] Thus it was that these native Britons, understood as a fierce race at first resistant to Roman force, were a people of rich potential for the overlay of Roman virtue (no doubt as Jones viewed the native circumstances of his own time). As unpretentious clergy, the Druids,

> esteeming it, questionlesse, the highest secret of their mystery, rather to command in caves and cottages, than live like Kings, in Palaces, and stately houses. They were too wise, knew too well, 'twas their humility, integrity, retired manner of life, and pretended sanctity possess the people with an awfully reverend esteem of them.[81]

Jones's evident admiration for this primitive race and clergy may even have prompted him to use a monument built by them as a basis for one of his own buildings. William Stukeley in *Stonehenge, a Temple restored to*

the *British Druids* (1740) claimed that Jones's Barber Surgeons' anatomy theatre of 1636–7 was based on the (now lost) ancient oval Druid monument of Eglwys Glominog at Llanycil in Merionethshire.[82]

The sequence of events in Jones's British history was subject to the general development of mankind outlined by Vitruvius, namely a progression from primitive, noble savages to citizens capable of ordered reason. This development was replicated in the Roman author's treatise by an architectural progression from timber buildings to those of stone. Hence Jones's early Britons lived in the primitive huts of the Vitruvian narrative, 'their idolatrous places being naturally adorned, only with wild, and over-grown shades, designed and brought to perfection by Dame Nature her self, she being Architect generall to all their Deities'.[83] This was Jones's 'first Age of the world'; it was a later, civilised 'middle Age' of Britain under Roman occupation that built the antique stone architecture of which the only remains were Stonehenge.[84] Not surprisingly, the Romans made the Britons 'skilfull in erecting sumptuous *Palaces*, stately *Portico's*, and publick places', after which, 'our *Britans*, in ancient time possessed, together with the *Roman* civility, all good *Arts*'.[85]

Following his rejection of the Druids and arguments in favour of a Roman pedigree for Stonehenge, Jones expressed a faith in the accuracy of the British chronicles of Bede, William of Malmesbury and Roger of Hoveden. Since none made reference to Stonehenge, Jones found nothing to contradict in these, 'the most ancient and authentick *British* Historians'.[86] He pointed out that the only chronicler to mention Stonehenge was Geoffrey of Monmouth – whose claim for Merlin as architect of the stones he rejected. Jones also discounted the further tradition that Stonehenge was a monument to Britons massacred in battle, as repeated by the 'modern Historians' John Speed and John Stow.[87] He did not dispute the existence of such a monument, for with reference to the medieval antiquary John Leland he reported that a tomb had been discovered at Ambresbury (Amesbury) monastery in Wiltshire with the inscription 'R.G. A.C. 600',

> Concerning which . . . why might it not be the Sepulchre of Queen *Guinever*, wife of King *Arthur*; especially the Letters R.G. as much to say, *Regina Guinevera*, declaring her title and name; and the date *An. Chr.* 600 (if truly copied) agreeing (possibly well enough) with the time of her death? Besides, *Leyland* affirms, severall Writers make mention, she took *upon her a Nuns* veil at Ambresbury, *died, and was buried there* . . . he will by no means allow . . . her body

to be . . . buried by her husband King *Arthur* at *Glastenbury*.[88]

Jones goes on to report that Arthur received his 'death's wound' in Cornwall, and this story represents one of the few asides in his argument (Fig. 77).[89] As such, it confirms not only the vitality of the Arthurian legends as far as he was concerned, but also that he saw the West Country area around Stonehenge as their Christianised domain. Further, if this area represented the 'spiritual home' of Jones's work, as his Roman arguments for Stonehenge surely imply, it is perhaps significant that, as Aubrey reports, Jones 'bought the Mannour of Butley [*sic*] neer Glastonbury (once belonging to it . . .)'.[90] If this is to be believed (and Webb certainly acquired the estate at Butleigh), Jones moved to within close proximity of where Joseph of Arimathea had established his centre of devotion. Incidentally, on a visit to this house, 'in a large Parlour' Aubrey discovered Jones's now-lost studies of British history in the form of drafts of 'stately Castles'.

Jones went on to dismiss the account of Stonehenge related by Polydore Vergil, who in his history of England commissioned by Henry VIII had attributed the monument to Ambrosius, King of the Britons. As far as Jones was concerned, this was 'grounded (as I conceive) upon no great likelihood'.[91] Instead, he accepted Geoffrey's account of Ambrosius buried, once again, at the monastery of Ambresbury; the town had itself been named after the king according to Jones. This monastery was presented as a general resting place for British nobility, for Jones reported, here too with reference to Camden, that here 'certain ancient King's, by report of the British Story, lay interred'. Ironically, he even criticised the method of attribution that he had himself adopted; for, 'historians in succeeding Ages, finding so notable an *Antiquity* as *Stone-Heng* . . . and not apprehending for what use it was first built, suppos'd no other thing worthy *A. Ambrosius*, or those *Britans*, than such an extraordinary Structure'.[92] The final theory to be rejected by Jones was that Stonehenge was the tomb of Boadicea (Boudicca), a story found in what the architect described as an 'anonymous' translation of *Nero Cæsar; or, Monarchy Depraved* (1624), but was in fact by his friend Edmund Bolton.[93] Not surprisingly, Jones dismissed this claim for Stonehenge with some vigour, for it had been Boadicea who was understood to have 'pulled down and demolished' Roman 'royall *Ensigns, Trophies, Statues, Temples*'.[94] Here he placed ensigns at the head of a list of antique structures, a common-enough association at this time explored in Chapter Three. Jones even compared Stonehenge with the famous

N de br fe Artu Rex Assu londe ex

77 Nicolaes de Bruyn, *King Arthur*, c.1586–1635. British Museum, London

remains of ancient Rome that he had witnessed on his travels, namely Diocletian's Baths, the Theatre of Marcellus, Vespasian's Temple of Peace, 'and other prodigious works of the *Romans*'.[95] The British monument was presented as on a par with those remains of antiquity upon which Renaissance architects generally considered their work to be based. And in essence Italian ruins were seen by him as a mirror to lost British ones.

Finally, following his arguments for Roman authorship, Jones specified Stonehenge's original purpose. This was in serving as a temple dedicated to a god named Coelus. But Coelus was a peculiar choice of deity, a largely Renaissance invention barely making it into the classical pantheon. As Stephen Orgel points out, there was no Roman cult of Coelus and no antique temple was ever dedicated to him.[96] For in fact he was not a god at all, but merely a personification of the heavens. The importance of Coelus lay in his mythological position at the head of a theological hierarchy. The Renaissance mythographer Natalis Comes, one of Jones's sources, presented Coelus at the top, synonymous with God the Father as the heavenly spirit and great cosmic force. Orgel notes: 'if we look closely, it becomes apparent that the myth is in fact a translation of the Christian scheme into classical terms'. Jones too attributed Coelus with Christian achievements, in being responsible for converting men '*from wild and savage*' creatures, '*to the conversation of civill life*'.[97] As such Jones was, according to Orgel, 'directly Christianizing' Stonehenge. He adds: 'we may go even further and say that he is Protestantizing it. Catholic churches are dedicated to particular figures in a large hagiology; it is reformed churches that are dedicated to God the Father.'[98] Thus, instead of specifying a Roman god who was unambiguously pagan, Jones deliberately went out of his way in choosing Coelus to associate Tuscan Stonehenge with as much Christian virtue as possible, and Protestant virtue at that.

In so doing Jones confirms the central importance of the British monument, in its role as a Tuscan emblem for the long-lost 'Albion and Jerusalem', to the meaning of his own work. Stonehenge came to enjoy something of a unique status for him as the only remaining physical evidence of the national antiquity celebrated by official mythology and, by extension, his own *all'antica* architecture. This possibility was no doubt why none other than the king had become interested in the monument in the first place. It is hardly surprising, therefore, that Jones was to conclude that the battered stones represented nothing less than 'a shew (as it were) of that first face of *Antiquity*'.[99]

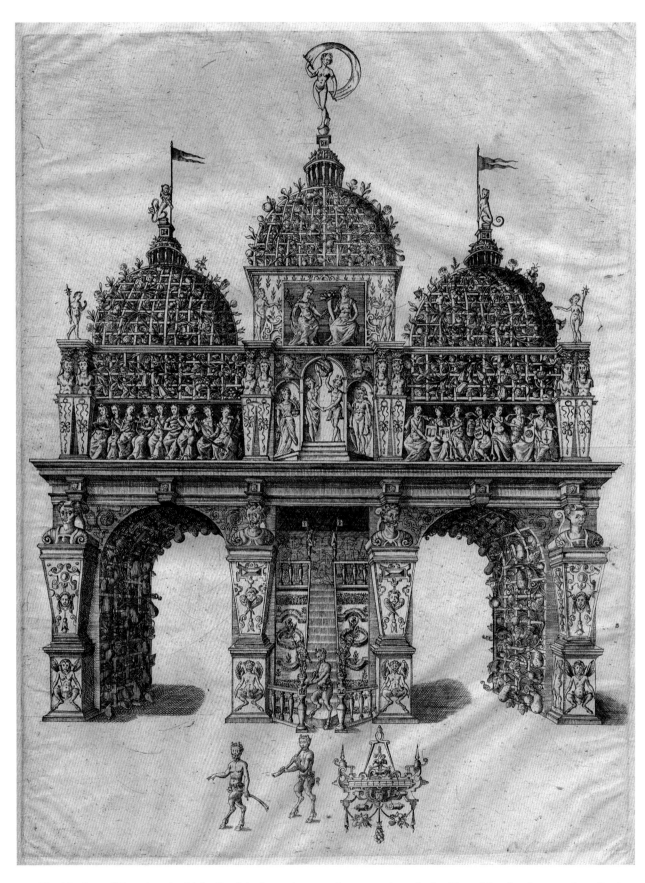

78 The 'Garden of Plenty' at the Little Conduit, James I's coronation entry through the City of London in 1604, from Stephen
Harrison's *Arches of Triumph* (1604). Magdalene College, Cambridge

CHAPTER 2

MAGNIFICENT INVENTIONS: JONES'S ARCHITECTURAL ORDERS AS EMBLEMS OF ROYAL TRIUMPH

The use of the antique column in pageants and processions was central to the public identity of the Stuart monarchy right from the start of their rule, long before Jones's first buildings. The columns had been introduced to the citizens of the City of London alongside James I via a series of triumphal arches built in 1604 to celebrate, somewhat belatedly, his coronation in 1603 (Figs 78, 80, 81).[1] In this royal procession through the City, the novel *all'antica* columns were bound up in the popular message of an equally new era of royal harmony and triumph ushered in by Stuart rule. This event drew on the Renaissance tradition of the Triumph, or 'entry', which united heraldry, costume, music and, perhaps most importantly, the *all'antica* arch (Fig. 79).[2]

These temporary arches framed the route of the king, and were architectural emblems encapsulating the virtues of the ruler in order to charm the citizens with the show of monarchy. In proclaiming a new Golden Age, they projected royal powers as being at the centre of the cosmos and reflected the civic order that, prior to Jones's buildings, only the king's personal authority could assure. It was these very virtues of order and harmony, introduced in a temporary way here, that Jones's columns would go on to embody in more permanent form. That Jones understood this interrelationship between the Triumph and his architecture is intimated by Webb's claim in 1660 that he was 'brought up by his Unckle Mr. Inigo Jones upon his late

79 Denys van Alsloot, *The Ommeganck in Brussels on 31 May 1615: The Triumph of Archduchess Isabella* (1615) (detail). British Museum, London

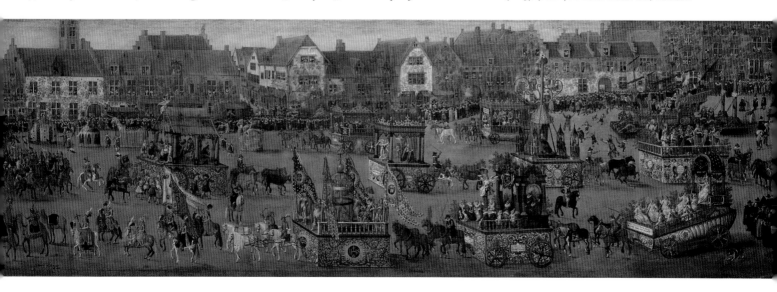

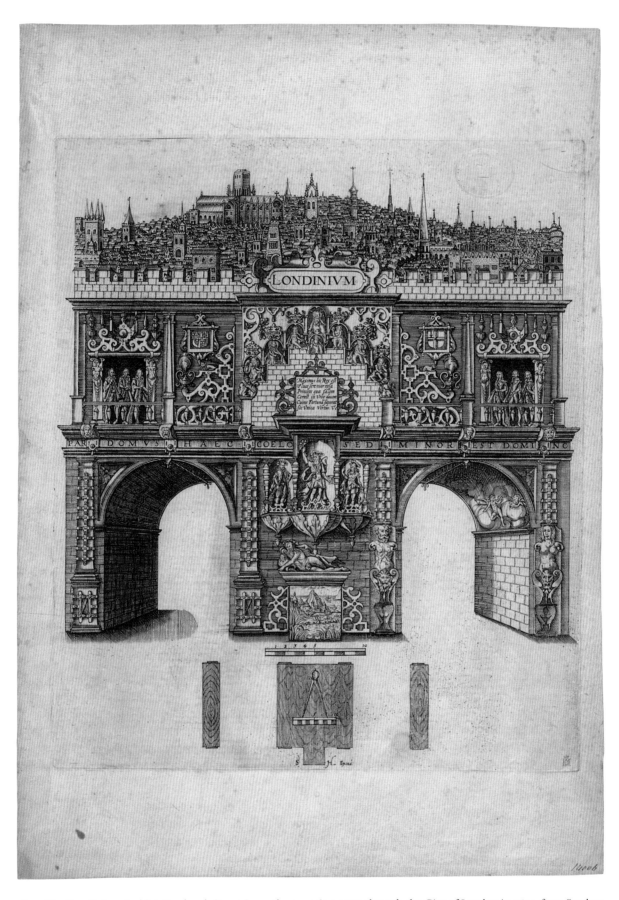

80 The 'Londinium Arch' at Fenchurch Street, James I's coronation entry through the City of London in 1604, from Stephen Harrison's *Arches of Triumph* (1604). Magdalene College, Cambridge

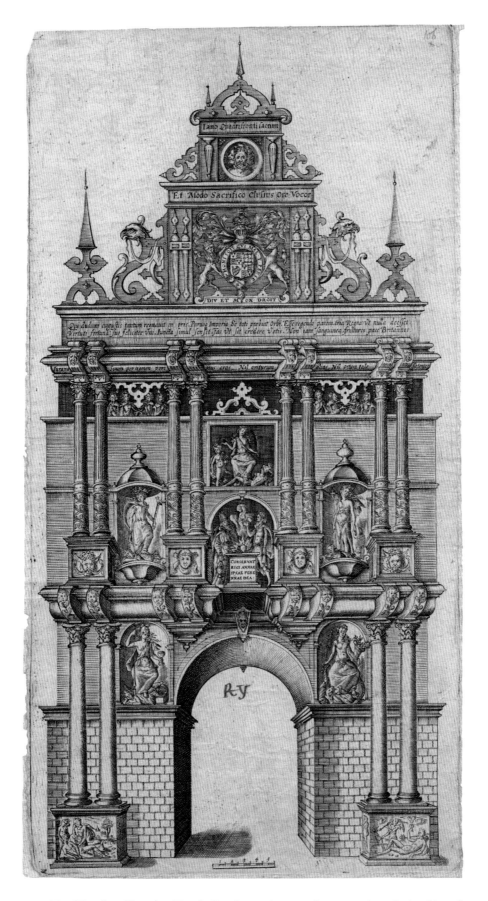

81 The 'Temple of Janus' at Temple Bar, James I's coronation entry through the City of
London in 1604, with the lion and the unicorn, from Stephen Harrison's *Arches of Triumph*
(1604). Magdalene College, Cambridge

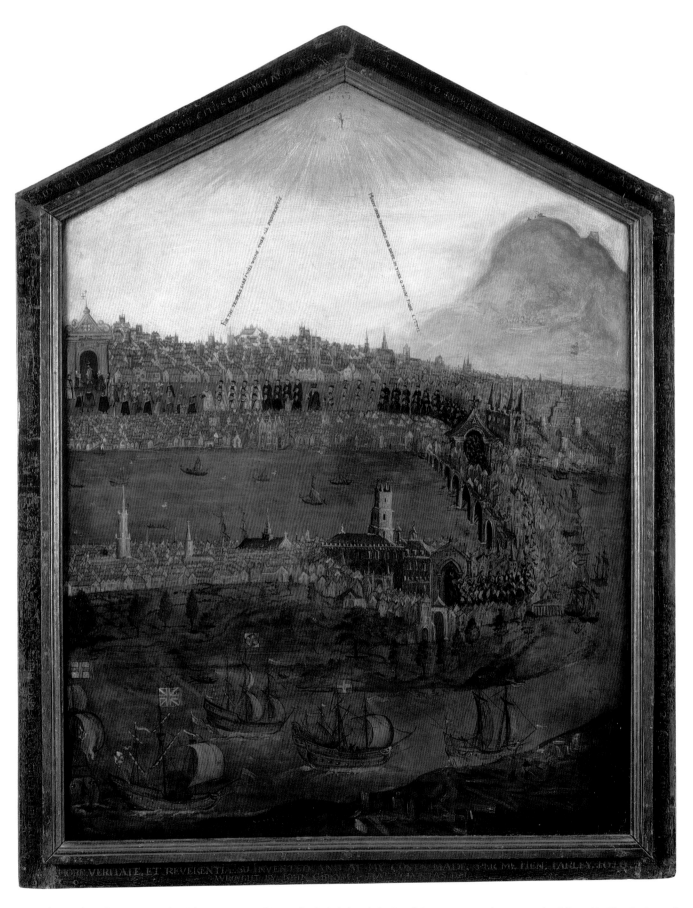

82 John Gipkyn for Henry Farley, *The Restoration of St Paul's Cathedral and the Royal Progress*, c.1616 (outer panel of diptych). The Society of Antiquaries, London

Maiestyes command on the study of Architecture, as well that wch relates to building as for masques, Tryumphs and the like'.[3]

James I took part in a further important procession, this time on 26 March 1620 when, according to John Stow, 'being Midlent Sunday, the King in great state came from White-hall to *Paules* Church'.[4] The route from St Paul's to Westminster was especially significant because the monarch travelled from the Tower via the cathedral and Temple Bar at the end of Fleet Street to Westminster for his (or her) coronation, as James had done on his procession in 1604. In addition, the Lord

many of his buildings formed (or would have, if they had been built) a permanent backdrop to this traditional royal way. As such, they inevitably recalled the initial association of the Orders with the Triumph made during James's coronation celebrations.[6] The design of architecture that lined such routes was often influenced by them. As but one example, the background buildings in the 'King's Procession' drawings of Henri III progressing in 1583 through Paris from the Louvre to the church of the Grands Augustins (the chapel of the Order of the Holy Spirit, which he had founded) related to the emblematic characters in the procession.[7]

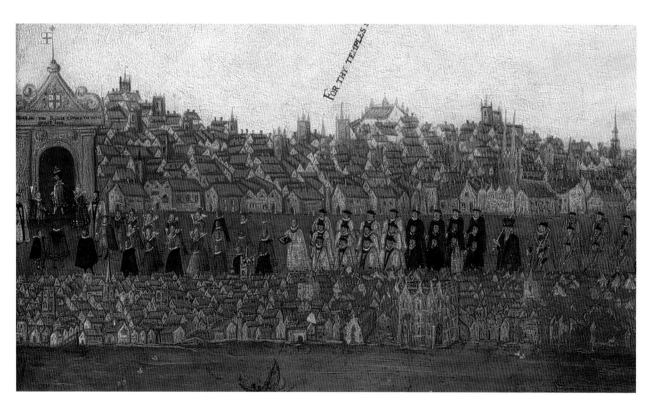

83 Detail of a progress (see Fig. 82)

Mayor went from the Guildhall via Temple Bar to Westminster for his swearing in.[5] The cathedral and Paul's Cross formed the regular objects of civic processions, on the feast-days of All Saints, Pentecost and Christmas. The purpose of James's procession to the cathedral in 1620 was to announce his intention to reface the building and celebrate its future role at the heart of royal ceremonial. It follows that other past and future projects by Jones on this route along the Strand, some of which were, like St Paul's, limited to the design of new *all'antica* fronts, may well have also owed something in their conception to processions and Triumphs. It cannot have escaped the Royal Surveyor's notice that

Pictures of these royal events in Stuart London are rare, although an imaginary royal procession was painted by John Gipkyn probably around 1616 for an ordinary Stuart citizen, a legal clerk called Henry Farley. Farley made a series of appeals for the cathedral's repair between 1616 and 1622 directly addressed to James I. One consisted of two panels, or a diptych, the outer leaf of the first panel of which portrayed a procession to the precinct of St Paul's, led by the king, to hear a sermon at Paul's Cross, represented on the inner side of the panel (Figs 82–4).[8] It is possible that Gipkyn recorded the actual procession of 1620, although Queen Anne is pictured (in the upper floor of the sermon

84 John Gipkyn for
Henry Farley, *Paul's Cross*
(first inner panel of
diptych), pictured as the ·
object of the procession,
*c.*1616. The Society of
Antiquaries, London

house), and she died in 1619, and Farley's procession is
from Southwark. Farley thereby underlined the signifi-
cance of such processions to the planned refacing
(indeed, if 1616 is the painting's correct date, why else
would he record a procession that had not yet taken
place?). His appeal served to emphasise a crucial inten-
tion behind the restoration, and one clearly understood
by the populace at large, namely a programme to
glorify the goal of these royal progresses and thereby
consolidate what was, by tradition, a decorated route. It
is this intention as well as its implications for Jones's
buildings on the route that will be examined shortly.

'A MIXED CHARACTER':
ROYAL PROCESSIONS AND
JONES'S ARCHITECTURAL ORDERS

James I's coronation entry into the City of London in
1604 followed the medieval tradition of the entry
enacted by Henry VI in 1431, Edward VI in 1547, Mary
I in 1533 and Elizabeth I in 1559 (Fig. 85).[9] Coming as
he did from Scotland, James had more need than most
of his predecessors for such proclamations of authority.
Seven temporary arches were built within the City that
formed a continuous narrative on the subject of Stuart
virtue, and one further structure (a rainbow between
obelisks) was erected in the Strand (see Figs 78, 80, 81).

The route went from the Tower to the first arch at Fenchurch, progressed via the Exchange and Soper Lane End (south of Cheapside), stopped at St Paul's school to view the cathedral, moved on to the Conduit in Fleet Street and the gateway to the Strand at Temple Bar. James then progressed along the Strand, passing further spectacles, to Whitehall. This event was directed by the City Livery Companies, which sponsored the arches. The poet and playwright Michael Drayton was commissioned to write *A pæan triumphal; composed for the Societie of the Goldsmiths of London, congratulating his Highnes' magnificent entring the Citie. To the Majestie of the King* (1604). And the dramatists Ben Jonson, Thomas Dekker and Thomas Middleton wrote the entertainments and speeches for various points on the route.

As the first coherent public display of the antique columns in London, these seven arches brought together heraldry and the Orders, which had thus far for the most part been seen together only in Elizabethan royal iconography (see Fig. 112). Jonson outlined the meaning behind the arches, or 'devices' as he calls them, and echoed the connection in Neoplatonic philosophy between the picture-language of hieroglyphics, emblems and *imprese*:

The nature and propertie of these Devices being, to present alwaies some one entire bodie, or figure, consisting of distinct members, and each of those expressing it self, in the owne active sphaere, yet all, with that generall harmonie so connexed, and disposed, as no one little part can be missing to the illustration of the whole: where also is to be noted, that the *Symboles* used, are not, neither ought to be, simply *Hieroglyphickes, Emblemes,* or *Impreses,* but a mixed character, partaking somewhat of all, and peculiarly a[da]pted to these more magnificent Inventions.[10]

Jonson echoed Leon Battista Alberti's definition of 'beauty' concerning *all'antica* architecture, which argued for 'that reasoned harmony of all the parts within a body, so that nothing may be added, taken away, or altered, but for the worse'.[11] Each arch was composed in a harmonious way with what were quite diverse and decorative versions of the Orders. As such, the columns formed part of the emblematics of the spectacle, and played their part in expressing the national harmony that was expected from James in uniting the equally 'mixed character' of the country at large.[12]

85 Edward VI's procession along Cheapside on 19 February 1547, the day before his coronation, with the cathedral to the right of centre. Detail from a lithograph of *c*.1790 of a contemporary (*c*.1550) wall painting at Cowdray House, Sussex, destroyed by fire in 1793. British Museum, London

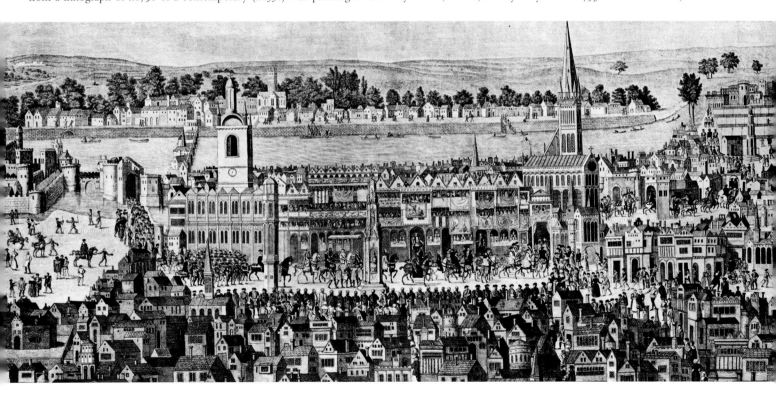

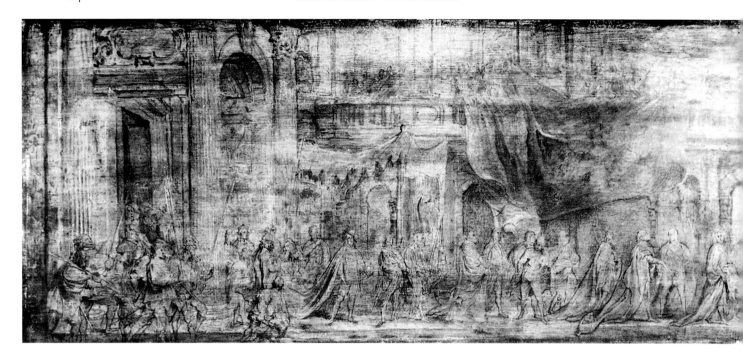

86 Anthony Van Dyck, *Charles I and the Knights of the Garter in Procession*, c.1638. Rutland Collection, Belvoir Castle

The first arch, at Fenchurch, was called 'Londinium' and celebrated the ancient Roman name for the city (see Fig. 80). It was capped by a model of London accompanied by emblematic figures including personifications of 'Divine Wisdom', 'Vigilance' and 'Loving Affection'. Dekker confirmed the prominent role played by the columns in the composition of each arch, reporting that on either side of the Fenchurch arch there 'stood a great French Terme, of stone, advanced upon wodden Pedestalls; two half Pilasters of Rustick, standing over their heads'. The second gate, called 'The Italian's Pageant' and sponsored by Italian merchants, included the arms of Great Britain and celebrated the theme of peace with palm and references to Virgil, as well as being 'garnished with foure great columnes'. Dekker was careful to emphasise that the reverse of the arch had, together with a picture of Apollo, an 'equall number of *Columnes*, Pedestals, Pilasters, Lim'd peeces, and Carved Statues'.[13] The theme of royal harmony that these columns embodied was given particular emphasis by music performed on the route; this was understood as incantatory, conjuring up natural forces that were expected to guide the British king in his rule. At the arch at Soper Lane End according to Dekker, together with music from a gallery, birdsong filled the air and two choristers from St Paul's sang in 'sweete and ravishing voices' declaring that 'Troynovant is now a sommer arbour'.[14] Before arriving at St Paul's school,

James stopped to 'behold the cathedral temple of Saint Paul upon whose lower battlements an anthem was sung by the Choristers of the church to the music of loud instruments'.[15] This procession thus embraced two important sites for Jones's later projects, since after St Paul's it went on to the final arch at Temple Bar, which prefigured Jones's own arch proposal of 1636–8. Here the temporary arch was conceived as a 'Temple of Janus' (the two-faced god of gates), complete with statues of Peace and Wealth, and which identified James's rule with the Golden Age of Saturn (see Fig. 81).

As if to herald Jones's future work for the crown, Dekker celebrated the power of the king's presence, as witnessed on such occasions, in terms of architectural transformations. He noted that: 'For such Vertue is begotten in Princes, that their verie presence hath power to turne a Village to a Citie, and to make a Citie appeare great as a Kingdome.' This mood of royal transformation was also reflected by the arches, in expressing the general theme of ancient virtues revived. They represented a triumphal overlay upon the relative disorder of medieval London, and a temporary harmonic ordering that Jones's subsequent *all'antica* architecture would seek to consolidate. And it is in the context of this familiar national display of power and monarchy, rather than that of Palladio's unfamiliar buildings in Italy, that Jones's architecture would surely most likely have been understood by those ordinary

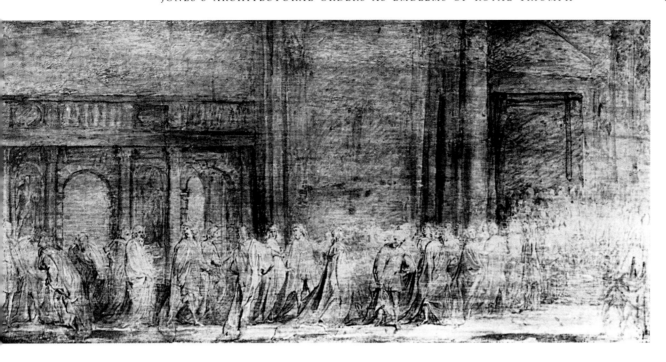

Stuart citizens who had witnessed the celebrations in London in 1604.

The contemporary identification of Jones's Strand projects with the Triumph would have been assisted by a further ornamental aspect of it, namely the tradition of decorating major buildings on the route. These were ornamented with heraldry and antique symbols to incorporate them into the festivities. Much like Jones's use of emblematic costumes in the court masque, various themes of monarchy and its institutions were displayed during a procession through heraldry and uniforms. In particular, the emblems of the City Companies traditionally played an important role in decorating the route of royal processions through the City to St Paul's. According to Stow's *Annales; or, A Generall Chronicle of England*, during James's procession to the cathedral in 1620, 'the streets being rayled on both sides, and the severall Companies of London in their severall places, in their Liveries and Banners, gave their attendance all the way to *Paules*'.[16] There were 'tapestry-hangings all the while hanging out of the windows', and the choir 'was adorn'd with his own Hangings'.[17] On such occasions it was the responsibility of the Lord Mayor to see that members of each Company lining the royal route were properly dressed, in the colours of their craft and arranged in order. Writing to the Stationers in 1620 he instructed:

> You take special care that all persons of the Livery of your said Company may be in readiness against

that time, with their Livery Hoods, attired in their best apparell, to wait and attend his Majestie's coming . . . the foreraile to be covered with a fair blew cloth . . . Your Standards and Streamers to be sett up, as shall best beseeme the place.[18]

The west front of St Paul's Cathedral, soon to be refaced by Jones, was commonly used as a backdrop for chivalric displays of City armour. The hereditary banner-bearer of London marched to the west door where the banner of the City, an image of St Paul, was presented to the Lord Mayor.[19] In this ritual, 'there needs no greater demonstration of the Cities ancient honor', according to Jones's friend Edmund Bolton, than the fact that 'The figure of St. *Paul* (titularie patron of *London*) advanced it selfe in the Standard'.[20] Jones's new cathedral portico was seen as a means of providing a fitting triumphalist setting for these celebrations.

Given that these processions foreshadowed Jones's work, in its capacity to make permanent what had been temporary manifestations of royal power, it is perhaps not surprising to find the Orders depicted as the backdrop to processions involving the monarch and the Order of the Garter. A sketch for proposed tapestries by Van Dyck of around 1638 pictured Charles I in such a procession, leading the Garter on the feast of St George's Day held at either Windsor or Whitehall (Fig. 86).[21] Garter ceremonies of a processional nature in which the Stuart kings participated were developed into quasi-ecclesiastical rituals, comparable in splendour

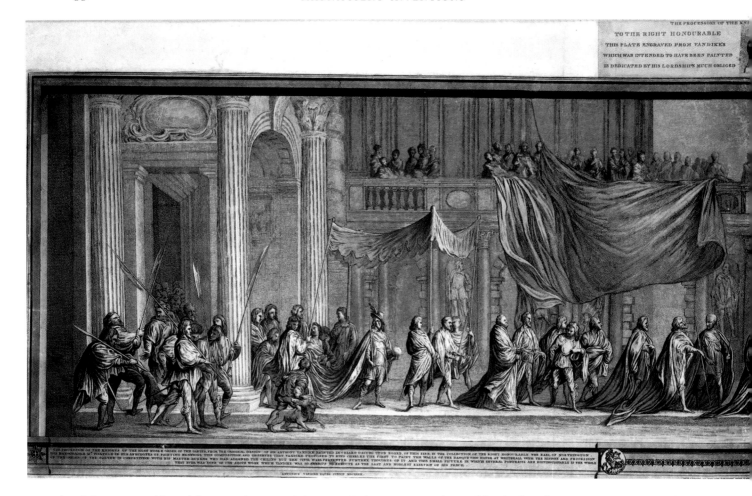

87 Edward Cooper II, etching of the procession, 1782. Inigo Jones is shown amongst the royal band of gentlemen pensioners carrying battleaxes, on the left of the engraving. British Museum, London

to the Roman 'Ecclesia triumphans'. Elias Ashmole would define such Garter processions in relationship to the royal 'entry':

> We think it not amiss in speaking of *Processions* to divide them into *Military*, *Civil*, and *Ecclesiastical*: Under the *Military* may best be comprehended *Triumphs*, and the *Transuection* of the *Roman Knights*; under the *Civil*, the pompous *Entries* or *Cavalcades* of *Princes*, in to or through any great *City*; and the *Ecclesiastical* are those generally so called, wherein the *Church* proceeds upon a solemn account of *Supplication* or *Thanksgiving*: To all which, in the last place, shall follow the order of the *Grand Procession* of this most Noble [Garter] *Order*; which in reference to the Degrees of the Persons appearing therein, is composed of a mixture of such as are to be seen in each of the three former.[22]

The king is pictured by Van Dyck under a canopy of gold and set against an *all'antica* backdrop, matching the imperial Roman theme of the procession. This image no doubt reflected Charles's dream of building an imperial palace at Whitehall, given that the intended location for the tapestries, of which Van Dyck's sketch was merely the first stage, was Jones's Whitehall Banqueting House. A later etching of the sketch, made in 1782, includes Jones in the procession (Fig. 87). Of course, Van Dyck may be recording an actual Garter procession within the Banqueting House, thus providing a perfect illustration of how Jones's architecture was bound up in the conception of these chivalrous events.

'SACRED POMP AND PROCESSION':
FROM PALACE TO TEMPLE IN
STUART LONDON

Many of Jones's projected or realised buildings in London, which spanned his entire working life, lined the main route to the City along the Strand (Fig. 88).[23]

It has been seen that the Strand was also the traditional route of royal processions to and from the City, such as James I's in 1604 and 1620. When starting at Whitehall Palace (with its Banqueting House), the route progressed past projected or executed work by Jones at the New Exchange, Covent Garden piazza and church, Somerset House, Temple Bar, and concluded at St Paul's Cathedral.[24] As a permanent reminder of the monarch, Jones's *all'antica* façades on this route from palace to temple clearly had a special significance. They would have been viewed by his contemporaries, somewhat inevitably, as consolidating what was by its very nature a transient manifestation of royal power and order in the city. This is regardless of any actual intention to implement such a unified vision for the city over many years, of which there is not, of course, any certainty in the absence of a city plan in Jones's hand. It follows that one interpretation of Jones's Orders used on these façades, as understood by the Stuart citizenry and by the Royal Surveyor himself, would have been as emblems of royal triumph. As such, the columns became a powerful form of royal and civic heraldry, a

link discussed in the following chapter. This interpretation would obviously have been consistent with the function of the Orders on the arches of 1604 along part of the same route. Moreover, much like these arches, each building on the route can be seen to have expressed various virtues of Stuart rule. With such a route in place the requirement for the king to make what were often uncomfortable public appearances in London would have been eased. This development was mirrored by the increasing isolation of Charles I's court in its absolutist phase and its reliance on the closed art form of masque for the presentation of the royal image. Charles had famously refused to stage a coronation entry in February 1626, for example.

The royal progress entered the City of Westminster from Whitehall. If Charles had had his wish, the entrance would have been through triumphal arches in a new palace façade of which, as the Introduction discussed, Jones's Banqueting House formed a part (see Fig. 51). Here Rubens's painted ceiling, with its associations between the Orders and Solomon as well as the ancient British Church and crown, came to visualise the

88 Reconstruction of Inigo Jones's façades along the triumphal route, from palace (right) to temple (left): Whitehall Palace (as planned, part built), New Exchange façade (as planned), Covent Garden (as built, connecting road possibly planned), Somerset House façade (as planned), arch at Temple Bar (as planned), old St Paul's Cathedral (as built)

monarchy's harmonious virtues embodied by the actual columns on Jones's façades planned or realised on the route to St Paul's.

From Whitehall Palace the monarch progressed along the Strand. The view of the new Covent Garden piazza and church, the design of which was begun by Jones in 1631 sponsored by the Earl of Bedford, was blocked from here, but a view similar to that enjoyed today via Southampton Street may well have been intended (Figs 90–93). For in Wenceslaus Hollar's engraving of this area published in 1658, only a thin strip of buildings along with the garden wall of Bedford House separated the Strand from Covent Garden (Fig. 89). The houses that formed the sides of the piazza were restricted to the east and north sides, with the new church occupying the western flank. The southern boundary running down to the Strand was left open in original plans

recording perimeter building plot dimensions now held at Alnwick Castle.[25] If a view and access to the piazza from the Strand were indeed intended, this would help explain the piazza's obvious incompleteness (even though the earl owned the land on the fourth, Strand side, in forming the site of the garden to Bedford House); Colen Campbell felt the need to 'correct' matters in 1717 by illustrating the square with houses on all sides (Figs 94, 95).[26] By applying the optical rules of perspective, the celebration of vistas to distant piazzas such as here had been a norm of the Renaissance Triumph. Urban spaces were frequently decorated, like the settings in a masque, to correspond to the point of view of the prince as he moved through the city.[27] The Covent Garden development had a number of important symbolic and regal associations for Charles 1, who was actively involved in its design from the time of his

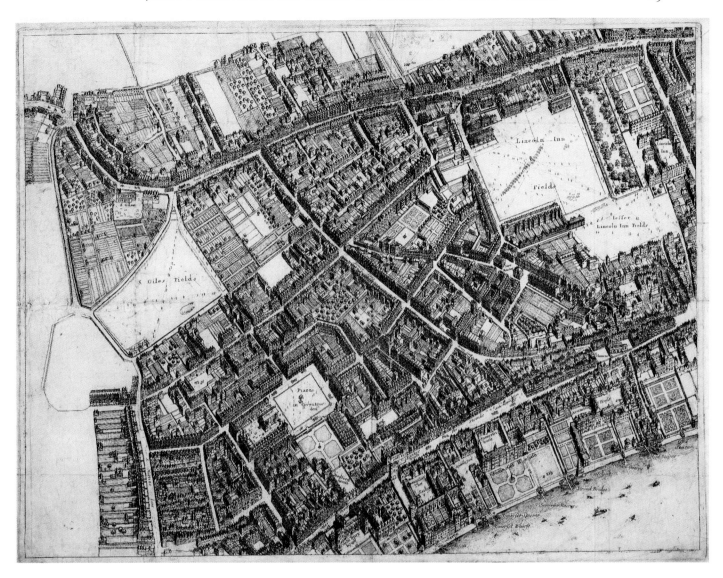

89 Wenceslaus Hollar, aerial view including Covent Garden, the Strand and Lincoln's Inn Fields, London, 1658. British Library, London

initial approval for it. Although sponsored by Bedford, it would have been seen by the king as a successful example of the ordering effect intended for the whole city through royal building proclamations (see Fig. 151). These had been issued by his father in 1615 and 1619 and had alluded to the civic achievements of Augustus.[28] Charles's identification with the development is underlined by the fact that a bronze statue of him had been promised by Bedford for the piazza's centre.[29] Whilst a link with the busy Strand would have had commercial advantages for Covent Garden, and this would no doubt have provided its principal justification, it also had the advantage of connecting the new development to the Strand's symbolic role as a royal processional route.

In progressing along the Strand the monarch would have passed the New Exchange, forum of commerce in the City of Westminster, followed by Somerset House, the official residence of the queen from 1617 (when it had been renamed Denmark House). At different times during the Stuart era both buildings were the subject of schemes involving grandiose Strand façades, which were never built (although Jones's New Exchange design may well have been adapted by the former Surveyor, Simon Basil, for the completed building).[30] Jones's New Exchange elevation (of 1608; see Fig. 25) was a solo effort at the start of his career, but no less sophisticated for that. It was to be formed around five equal squares, and involved the persuasive medley of *all'antica* and medieval motifs discussed in the Intro-

90–93 Computer reconstructions of Inigo Jones's Covent Garden Piazza

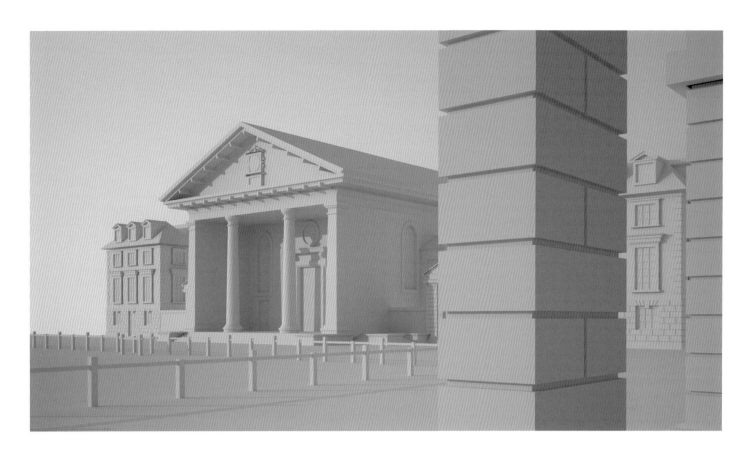
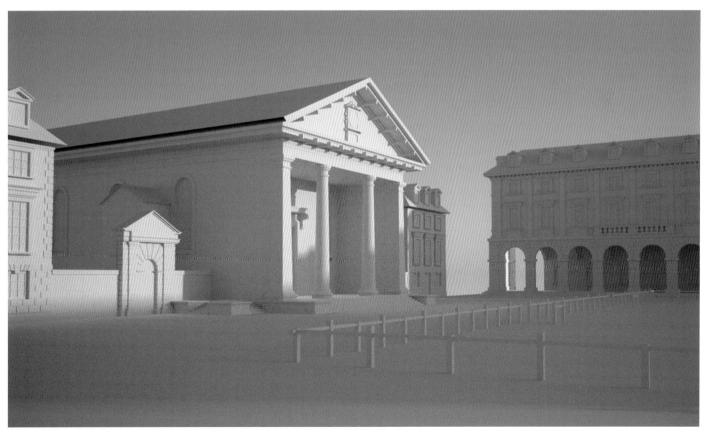

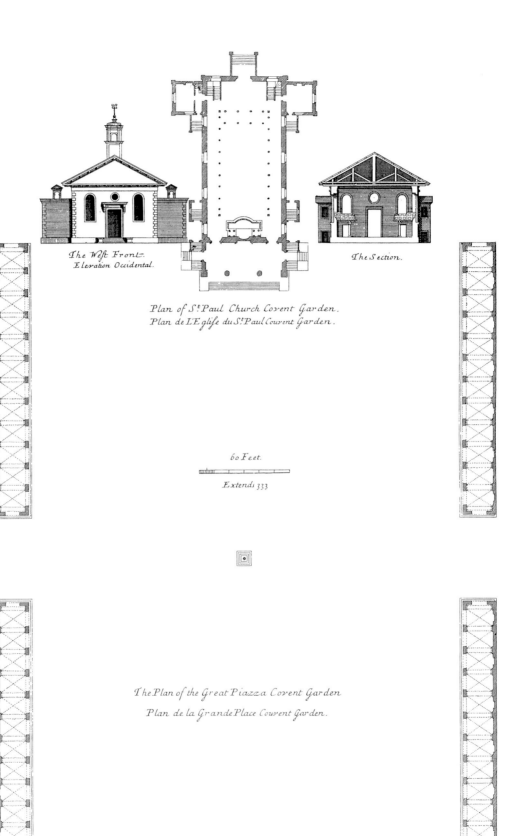

The West Front.
Elevation Occidental.

The Section.

Plan of St Paul Church Covent Garden.
Plan de L'Eglise du St Paul Couvent Garden.

60 Feet.

Extends 333

The Plan of the Great Piazza Covent Garden

Plan de la Grande Place Couvent Garden.

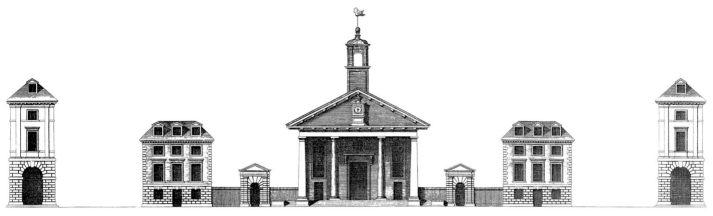

The East prospect of S.t Paul Church Covent Garden to the Great Square.
Elevation Oriental de L'Eglise du S.t Paul Couvent Garden du coté de la grande Place.

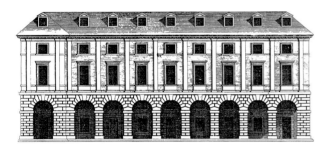 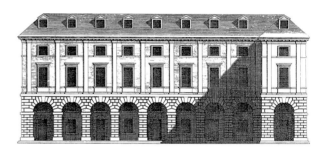

a Scale of 100 Feet

The West prospect of Covent Garden. Invented by Inigo Iones 1640.
Elevation Occidental de la Grande Place de Couvent Garden.

This Plate is most humbly Inscrib'd to her Grace the Duchess of Bedford &c.

94 and 95 (*facing page and above*) Colen Campbell, 'Covent Garden Piazza', from Campbell's *Vitruvius Britannicus*, vol. 2 (1717)

duction. Much later, in 1638, Jones worked in partnership with Webb to design a monumental front on an unprecedented scale for Somerset House. There are two versions in Webb's hand, both dated, which appropriately enough give full regal expression to the Orders; for example, the first design has a Tuscan base with an Ionic middle storey and a Corinthian attic (Figs 96–7). The project illustrates the importance attached to the palace's Strand frontage as a symbolic element celebrating Stuart, or more particularly the queen's, virtues (given that the refacing served no major practical purpose, much like at St Paul's Cathedral). Amongst other things the project had the effect of emphasising the role of the palace façade as a backdrop to the royal route. Indeed, mere stylistic change through building in the new fashion could not have been the motive; for a

refacing had already taken place in the early 1550s involving a symmetrical design and an applied frontispiece with pediments and columns arranged to resemble a triumphal arch (drawn by John Thorpe in 1610/11; Fig. 98). Through their new ordered façades that incorporated heraldry and *all'antica* statues, Jones's designs along the Strand thus celebrated, in classical terms, the value of commerce and monarchy. The New Exchange hailed the growing role of trade in Westminster, whilst Somerset House celebrated the institution of the queen's household (and, more specifically, that of Queen Henrietta Maria) recently installed here by the Stuart court.[31]

Jones's final Strand scheme was an explicit celebration of the royal entry, in the form of a triumphal arch. If built, this arch would have marked the boundary

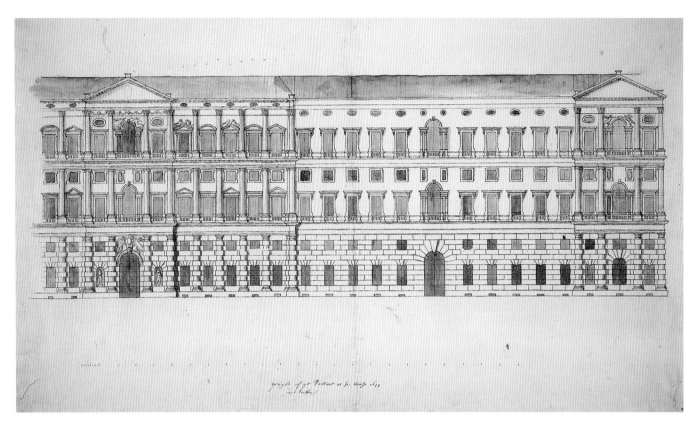

96 John Webb, after Inigo Jones, first design for the Strand elevation of Somerset House, London, 1638. Worcester College, Oxford

97 (*below*) John Webb, after Inigo Jones, second design for the Strand elevation of Somerset House, London, 1638. Worcester College, Oxford

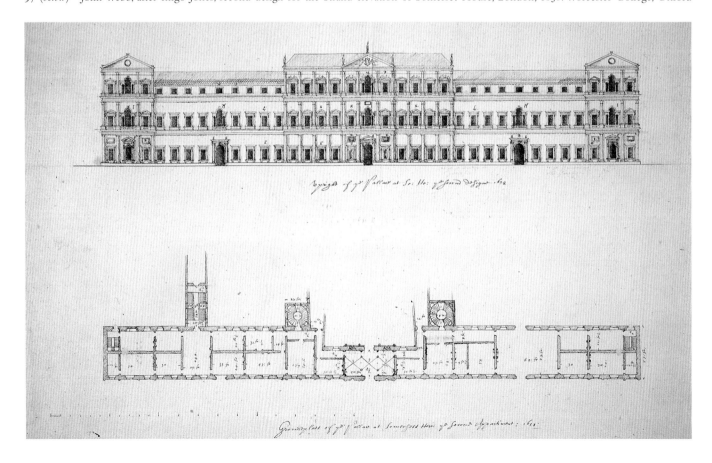

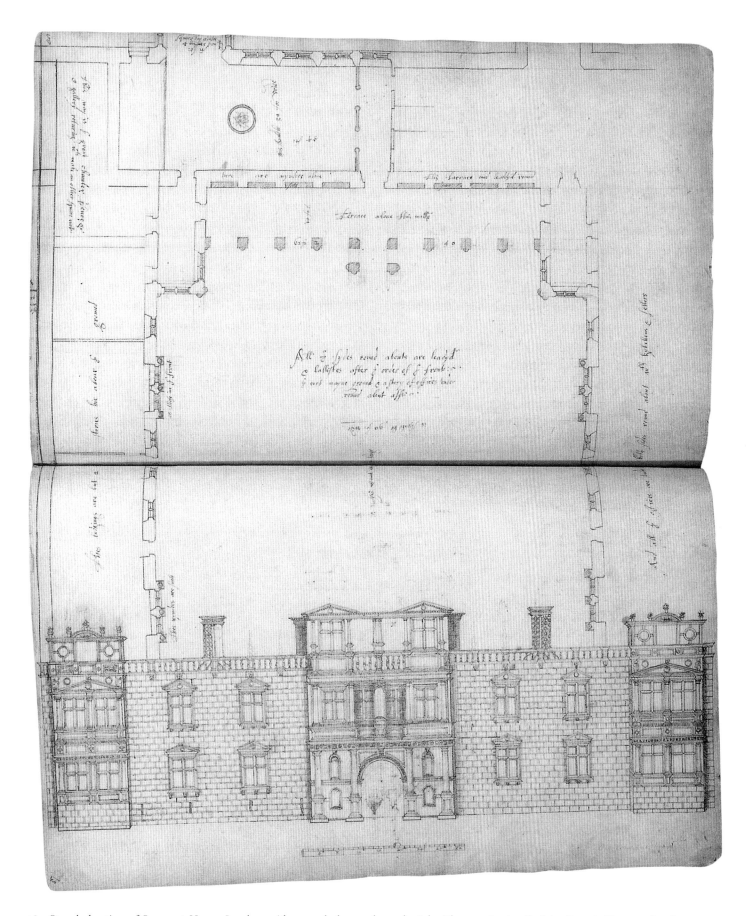

98 Strand elevation of Somerset House, London, with ground plan, as drawn by John Thorpe, 1610/11. Sir John Soane's Museum, London

99 Inigo Jones, design for an arch at Temple Bar, 1636: the Order may be Composite, following the Arch of Constantine, but the
detail shows Corinthian. RIBA Library Drawings Collection, London

between the capital's two cities – the City of London
and the City of Westminster. A wall had been built in
medieval times to enclose the City of London, and
Jones's proposed arch replaced one of the old
gateways, known as Temple Bar, at the end of the

Strand.[32] It will be remembered that this is where the
final arch had stood in 1604. Two designs for a tri-
umphal arch were prepared for the City authorities in
the years 1636–8, one in Jones's hand and the other in
Webb's (Figs 99–101). Both were based on the arch of

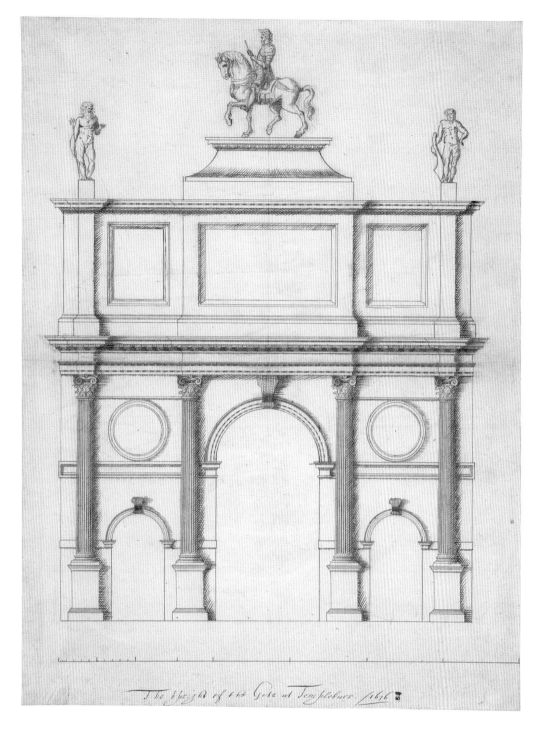

100 John Webb, design for an arch at Temple Bar, 1638. RIBA Library Drawings Collection, London

the Roman emperor Constantine, and Jones's careful study of this arch is recorded in his two editions of Serlio (Fig. 102).[33] And it was seen earlier that in presenting London as a second Rome and New Jerusalem, the Stuart kings naturally enough identified themselves with Constantine on account of his supposed British birth and his role as the first emperor to embrace Christianity. Jones's arch, if constructed, would therefore have been justified by, and celebrated, this British antiquity. An equestrian statue of Charles I surmounted

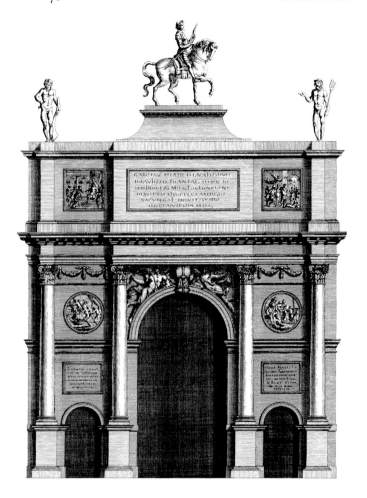

Webb's arch, flanked by a statue of Neptune on the left and Ceres on the right (as gods of sea and land). Equestrian statues were a norm of imperial symbolism, but here the king is clad in armour as a chivalrous knight mirroring the costume of the ancient Britons in masque. Unlike the arches of 1604, which were used sequentially, Jones's arch replicated the original Roman use of an arch as a symbolic gateway, by passage through which the emperor signalled his sovereignty over the city. Charles would have seen this depicted in Andrea Mantegna's nine-panel composition *The Triumphs of Caesar*, for which he had paid the huge sum of £10,500 in 1629 (Fig. 103). And the king's identification with the triumphal arch form, as an emblem of power, was alluded to in one of Van Dyck's famous equestrian portraits of Charles (Fig. 104).

In this sense the Temple Bar arch would, if built, have formed part of the royal route whilst serving a symbolic purpose in helping to reinforce the authority of the monarch over the City. For through the statue of Neptune on Webb's scheme and the relief panels bearing emblems of shipping on Jones's, the arch in its two versions not only celebrated the imperial signifi-

101 (*left*) The Temple Bar arch as engraved by Henry Flitcroft for William Kent's *The Designs of Inigo Jones* (1727)

102 (*below*) The Arch of Constantine, Rome

103 Andrea Mantegna, *The Triumphs of Caesar*, panel IX: Julius Caesar on his triumphal chariot in front of an arch, *c*.1484–92. Royal Collection

cance of Britain's sea power but also carried a specific political message (Fig. 105). At that time Charles was engaged in a conflict with the City Companies over contributions towards the cost of the navy performing its role protecting commerce. The payment of ship money represented one of the main themes of William Davenant's masque *Britannia Triumphans* of the same year as the second arch design, 1638.[34] Both schemes can be understood in this context, for in passing through the arch on a Triumph or procession, Charles I, as an absolute monarch, would signify his victory over the City on this issue. By the time of the following court masque, Davenant's *Luminalia* (later in 1638), Charles's victory had been assured and this was celebrated by the Neoplatonic imagery of light subjecting darkness. Jones's arch at Temple Bar also asserted the Stuart monarchy's triumph, but in the more durable

medium of stone, and in this message the regal Corinthian columns fully participated. The arch demonstrates the emblematic nature of Jones's built work, as also its consolidation of temporary decorations. For not surprisingly, perhaps, its Corinthian columns and roundels celebrating 'joyfulness' and 'good humour' (personified by figures clutching cornucopia) recalled the Golden Age imagery and the Order of the final coronation arch standing in the same position in 1604 (see Fig. 81).[35]

Then as now, the two cities that this gate straddled formed related but distinct financial and ecclesiastical centres. Both had Exchanges, the 'Old' in the City of London and the 'New' on this route in Westminster, and both had centres of worship. Stow's *Survey* of 1598 mentioned them in the same breath: '*the Cathedrall Church of S.* Paule *in* London, *and the Colledge of S.* Peter

at Westminster'.[36] By report a wooden structure had
stood in Saxon times on the site of St Paul's and, as the
first Saxon church in the capital, it pre-dated the abbey,
which was a later Benedictine foundation.[37] A degree
of rivalry had always existed between the eastern and
western temples.[38] The Stuart attentions paid on St

Paul's expressed the wish to restore the cathedral's
eminence over that of the abbey, the Gothic expanse
of which was left untouched. The cathedral became the
focus, over and above the abbey, for the celebration in
classical terms of the king's central Protestant role as
Defender of the Faith. In Westminster the task of glori-

105 (*above*) Inigo Jones, relief panels bearing emblems of shipping on Jones's arch design at Temple Bar, 1636. RIBA Library Drawings Collection, London

104 (*facing page*) Anthony Van Dyck, The column and the crown: *Charles I with M. de St Antoine*, pictured with Garter insignia (1633). Royal Collection

fying Stuart rule was given to Jones's Banqueting House. Moreover, with William Laud having served as Bishop of London, it was natural that the metropolitan cathedral should form the centre of his vision for the Church when he became Archbishop of Canterbury. In any case, St Paul's had the advantage over the abbey as far as any proposed building work was concerned in being sited on an established civic as well as royal processional route and attracting finance from the rich City Companies who worshipped there. Nevertheless, the resurfaced cathedral further reinforced the king's authority over both the City of London and its principal church when seen as the object of the progress.

During the royal procession to St Paul's on 26 May 1620 the officers of the City, all on horseback, met James I at Temple Bar. The Lord Mayor presented him with a purse of gold and by contemporary report, 'Robert Heath, Recorder, congratulates his entrance into the City'.[39] On this occasion Temple Bar and the cathedral were physically linked along Fleet Street by 'the foreraile . . . covered with a fair blew cloth'.[40] Stow's *Chronicle* added that,

> being Midlent Sunday, the King in great state came from White-hall to *Paules* Church, accompanied with Prince *Charles,* many of the chiefe nobility, and seven or eight Bishops, and at Temple barre, the Lord Maior, Aldermen, and Recorder, received him, and presented him with a purse of gold, and from thence attended him to *Paules* . . . at the great West dore of *Paules* . . . [James] kneeled, and having ended his Orisons, he was received by the Deane and Chapter of that Church, being all in rich Capes, the Canopy was supported by the Arch Deacons of the Diocesse.[41]

By the end of Charles I's reign the dean was able to receive the monarch, had he wished to visit the newly refaced cathedral, beneath one of the most magnificent porticoes in the world. It was pointed out that the fact that a royal procession was the chosen 'medium' for James I's announcement of restoration plans in 1620 highlights the importance of these events to the planned refacing. As the final object of the monarch's triumphal journey through the city and the most important focus of Stuart attempts to proclaim publicly a new Golden Age, Jones's refaced cathedral represented the ultimate achievement of Stuart rule presented on the route. This was the restoration of the 'true' ancient British theology and unity, here expressed in stone. Elsewhere, his backdrop in *Britannia Triumphans* (1638) also focused on a 'restored' St Paul's, and was interpreted in the masque as an emblem 'which might be taken for

all of great Britain' (see Fig. 67).[42] As such, it was seen by Jones and his royal patrons as a potent symbol of the authority of rule by Divine Right.

The area in front of the cathedral's west end, to which Jones's new portico formed a dramatic backdrop, was conceived as a setting for the enactment of court rituals and public 'theatre', such as the Triumph. The portico fronted one of the main ceremonial spaces in London, the extension of which numbered amongst Jones's first acts when building work began in 1633. William Dugdale reports that 'the Houses adjoyning to, and neer the Church, being compounded for, and pulled down'.[43] This controversial clearance was motivated as much by the practical need to open up the processional space as by the wish to dignify the cathedral.[44] The large central door in the cathedral's west front, which in Jones's built design was framed by fluted Ionic pilasters and an entablature with brackets, was opened on the occasion of royal or civic processions. Stow reported that on the feast-day of St Paul,

> the Dean and Chapter being apparelled in Coapes and Vestments, with Garlands of Roses on their heads, they sent the body of the Bucke to baking, and had the head fixed on a Pole, borne before the Crosse in their Procession, untill they issued out of the West doore; where the Keeper that brought it, blowed the death of the Bucke.[45]

Fittingly, this central door has an ox head in place of a keystone in Jones's preliminary west front design (see Fig. 244). As part of the work to enhance the ceremonial space, the streets radiating from the cathedral to the west down Ludgate Hill and to the east down Cheapside and Lombard Street were cleared in an effort to extend the building's visibility in the Stuart capital, in the way illustrated in *Britannia Triumphans*.[46]

As well as using the Orders, whose triumphal associations were established in the City through the memory of the arches of 1604, Jones's cathedral refacing incorporated iconography traditionally linked with the Triumph. The palm leaves on this preliminary design for the west face, when presented at the conclusion of the Triumph, recalled those laid before Christ on his entry into Jerusalem. In Mantegna's *The Triumphs of Caesar* the emperor is pictured progressing with palm leaves in his hand, as Charles and Jones would have seen (see Fig. 103). In Jones's recasting of the nave he removed the crenellations and topped the quasi-Tuscan pilasters with what Roger Pratt described as 'vast Pineaples'.[47] These are recorded in the building accounts and in Christopher Wren's drawings (Fig. 106).[48] As a very rare fruit in England at this time, the

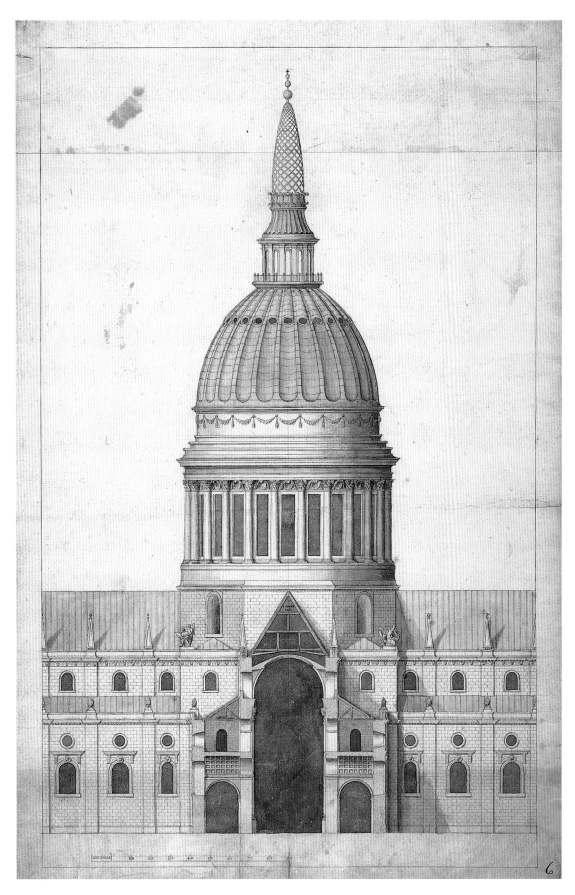

106 Christopher Wren, elevation and section of old St Paul's before the Great Fire, showing proposed new dome and Jones's pine-cones and obelisks, looking east, May–August 1666. All Souls II.6, Oxford

pineapple would seem a strange choice. It was synony-
mous with what would now be called a 'pine-cone',
and this is the more likely interpretation.[49] The pine-
cone was part of the imperial imagery of the Christ-
ian Triumph at two of its most important sites. The
processional approach to St Peter's (a kind of *Via Tri-
umphalis*) contained a font of ablution in the shape of
a pine-cone, which Jones must have viewed during his
stay in Rome in 1614.[50] And a pine-cone was to be
found in the courtyard of the Triconchos of the Great
Palace at Constantinople, where the emperor enacted
the part of Christ in the Triumphal Entry on Palm
Sunday.[51] These allusions at the cathedral to the
Triumph would have been assisted by the lion's heads
that the building accounts record as being carved in
1636, and which Jones's surviving drawing for a transept
façade and Henry Flitcroft's engraving of the completed
west front confirm were placed in the upper nave frieze
(see Figs 1, 252, 270).[52] Vitruvius had discussed the use
of lion's heads as gargoyles on ancient Ionic temples
(v.xv), but at St Paul's, at least on the front, they served
no equivalent practical function. The lion had symbol-
ised Roman power, together with Solomonic and sub-
sequent British heraldic virtues, and was commonly
depicted either pulling or decorating the chariots used
in the Triumph (having been identified with Her-
cules).[53]

<p style="text-align:center">★ ★ ★</p>

Hence, through a series of new, ordered façades that
fronted a traditional royal route and which in some
cases were applied to existing buildings, the Stuarts
intended to signify the imposition of their rule on
established medieval institutions. This work celebrated
the king with the Banqueting House at Whitehall
Palace, the encouragement of commerce by the court
with the New Exchange and Covent Garden, the
queen with Somerset House, the City and its Compa-
nies with Temple Bar, and finally the Church with old
St Paul's. Through employing the device of the column,
with its harmonic proportions and ordered relation-
ships, these new façades would have permanently
embodied the virtues of harmony and 'solar' enlight-
enment personified by the monarch.

<p style="text-align:center">★ ★ ★</p>

'SHINE LIKE THE CHARIOT OF THE SUN': THE LORD MAYOR'S PROCESSION AND JONES'S ST PAUL'S CATHEDRAL

There is no doubt that Jones was fascinated by the
Roman Triumph, closely studying Onuphrius Pan-
vinus's depictions of it in *De Ludis Circensibus* (1581) for
his masque designs.[54] He had recreated one early in his
career. Chapman's *The Memorable Maske* of 1613
included 'two Carrs Triumphall' in which 'advanc't, the
choice Musitions of our Kingdome' and 'in the under-
part of their Coronets, shin'd sunnes of golde plate,
sprinkled with pearle'. These golden suns expressed an
important theme of the Triumph, for here the sacred
nature of kingship found particular expression through
the monarch's identification with the sun and the star's
triumphant journey across the heavens.[55] James I had
made reference in *Basilikon Doron* (1599) to the concept
of the god-king spreading the light of his virtues
amongst the people via his physical presence:

> Remember then, that this glistering worldly glory of
> Kings, is given them by God, to teach them to
> preasse so to glister and shine before their people, in
> all workes of sanctification and righteousness, that
> their persons as bright lamps of godliness and virtue,
> may, going in and out before their people, give light
> to all their steps.[56]

It follows that much later, during Charles I's absence
in Scotland in 1641, the City of London was pictured
by the civic authorities as in darkness, with 'a contin-
uall and heavy night' and 'our joys . . . eclipsed'. Only
on the return of the solar king were the streets re-
illuminated with 'the warme sunne of his illustrious
countenance', whilst a banquet was prepared by the
City Companies to celebrate the ending of their
mourning, 'put off at the sight of his beams'.[57]

The Stuart monarch's identification with the sun
in Triumphs and processions was naturally replicated
in those centred on the 'king' of the City of London,
the Lord Mayor, who since medieval times had been
chosen in turn from amongst the ranks of the twelve
main Companies. Dekker in *Troia-Nova Triumphans
LONDON TRIUMPHING*, the Lord Mayor's pageant
of 1612, observed,

> TRYUMPHS are the most choice and daintiest fruit that
> spring from peace and abundance; Love begets them;
> and much cost brings them forth . . . For the chaires
> of magistrates ought to be adorned, and to shine like
> the chariot which carries the sunne; and beams (if it
> were possible) must be thought to be shot from the

one as from the other: as well to dazzle and amaze the common eye, as to make it learne that there is some excellent, and extraordinary arme from heaven thrust downe to exalt a superior man, that thereby the gazer may be drawne to more obedience and admiration.[58]

The annual Lord Mayor's pageant commonly set off from St Paul's and progressed along Cheapside towards the Guildhall and a dinner, returning for evening prayers at the cathedral. This event came to represent a celebration of the twelve Companies as a model of cosmic order, with the Lord Mayor cast as the sun and the participation of what Bolton termed the 'twelve principall Monopolies (the Zodiacke of the citie, in whose Eclipticke line their Lord Maior must ever runne his yeares course)'.[59] As but one example, the procession for Edward Barkham, the Lord Mayor in 1621, was designed by Thomas Middleton and entitled *Sunne in Aries*. It celebrated solar civic virtue expressed through two building restorations, one planned for the cathedral and one recently achieved at the more modest New Standard (a small ancient tower in Cheapside capped with a dome and a statue of Fame blowing a trumpet):[60]

> *his Lordship being gracefully conducted toward the New Standard, one in a cloudy ruinous habit leaning upon the turret, at a trumpet's sounding, suddenly starts and wakes, and in amazement throwes off his unseemely garments.*

> What noise is this wakes me from ruine's
> wombe?
> Hah! Blesse me, Time, howe brave am
> I become! . . .
> Vertue's faire aedifice rais'd up like mee.
> Why, here's the Citie's goodness, showen
> in either,
> To raise two worthy buildings both together . . .
> Nay, note the Citie's bountie in both, still
> When they restore a ruine, 'tis their will
> To be so noble in their cost and care,
> All blemish is forgot when they repaire;
> For what has beene re-edified a late
> But lifts its head up in more glorious state;
> 'Tis grown a principle, ruine's built agen,
> Come better'd both in monuments and men.[61]

In this way the Lord Mayor's procession served as a means each year to publicise the past and future achievements of the City Companies, which obviously included new building work. Perhaps unsurprisingly, the restoration of the cathedral was presented here as

bound up with the revival of a supposed ancient civic freedom, and as a virtuous product of the twelve Companies' celestial rule over the City expressed by the progress's title. As such, these processions recorded a manifesto, as it were, for virtues that the Companies expected to be celebrated by Jones's refacing. The progress of 1620, entitled *The Tryumph of Peace*, which commemorated the inauguration of Sir Francis Jones, presented a programme for the coming year dictated by 'Peace': 'Within this Citty . . . for one whole yeare / Thy mandats are obay'd, then have a care / To see me safely kept'.[62] As Chapter Eight will discuss in more detail, the theme of 'peace' influenced the cathedral sermons of that year calling for restoration, as too the 1620 restoration committee on which Francis Jones served, and eventually informed the work itself.

The sermon at Paul's Cross used by James to announce publicly his restoration plans for St Paul's in 1620 was delivered following the procession to the cathedral led by the king. Apparently, James had progressed, 'from his Court to this Cross . . . with a kinde of sacred pompe and procession'.[63] The text was suggested by James himself, it being reported by the preacher, Bishop John King, that 'he laid my foundation for me, and set me my patterne (as God did Moyses in the Mount) to worke by'. This sermon is therefore of particular importance in understanding the themes of Jones's subsequent restoration. One such was the 'solar' Triumph, whose significance was implied by Bishop King when asking:

> When ever did your *Sunne,* since his first arising amongst you, stand still in your Gibeon? The person (I meane) of your King, vouchsafe to be a part of your auditorie in this place, (with that glorious *starre* that followeth the *Sunne,* and the whole *host* of our earthly firmament about him; with so many thousands of soules besides, *seeking the face of their Ruler,* as I say not but in a triumph or show where they come to gaze, or along the streets in traine and succession, there have beene more, but in a garland and ring of an auditorie couch't together, never have more beene seene) til this day?[64]

The Triumph was once again understood as a public show of a court hierarchy reflecting the heavens, with the journey of the king coinciding with that of the sun in illuminating a newly restored St Paul's. For just as Solomon's Temple had been 'the strongest and stateliest pile of building that ever the eyes of the Sunne looked upon', so in succession St Paul's was to be restored befitting 'the body of the King, the morning & mid-day influence of that *glorious Sun*'.[65]

'TAKEN OUT OF DARKNESS':
JONES'S CATHEDRAL AND THE
TEMPLE TO APOLLO

Various characteristics of the cathedral's west front can be seen to have celebrated its role as the object of the monarch's solar progress. According to the drawings by Hollar and Wren, Jones placed obelisks above the pine-cones that ran along the sides of the nave and transepts (see Figs 106, 245–7).[66] Each obelisk supported an orb at its apex. Obelisks had long associations with the sun, given their resemblance to solar rays. They had been used as such to 'illuminate' ancient Rome following the example of Heliopolis in Egypt.[67] In more modern times Sixtus v had sought the permanent translation of Rome into a radiant city animated by the light of God, a new Heliopolis, through the erection of obelisks at important sites in 1586. Symbols of ancient Rome, including the obelisk, were relocated to proclaim con-tinuity between ancient and modern Rome, as well as between the bishops of Rome and the Roman emperors (Fig. 107). It has been pointed out that rather than proposing wholesale demolition in London, the Stuarts adopted a similar approach in building new structures at significant sites and by refacing, with *all' antica* façades, medieval buildings belonging to the city's institutions – albeit their approach was to focus on a specific route and was executed on a piecemeal basis. This overlay was equivalent in action to the resurfac-ing of medieval St Paul's, and made manifest their policy to transform the medieval city into the 'second Rome' and 'New Jerusalem'. Jones would have known of Sixtus v's use of obelisks similarly to transform Rome into a radiant city through his visit there in 1614, as well as through studying books on the subject by Domenico Fontana and Giovanni Francesco Bordini (with its diagrammatic engraving of this very scheme; Fig. 108).[68]

107a and b Domenico Fontana, two views of moving the Vatican obelisk, from *Della trasportatione dell'obelisco vaticano et della fabriche di nostro signore Papa Sisto V* (1590)

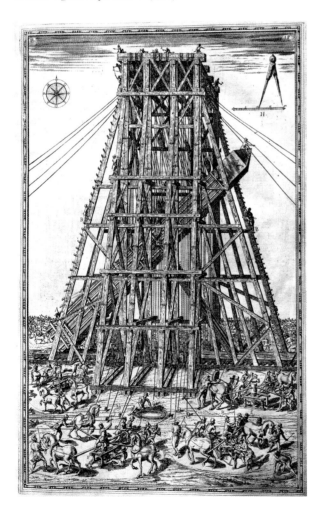
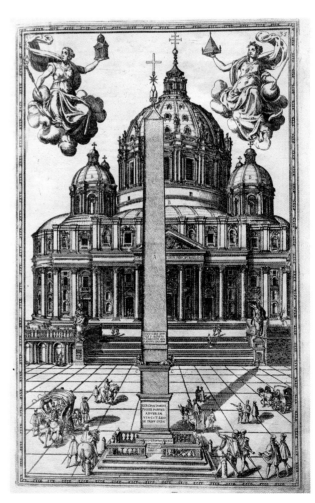

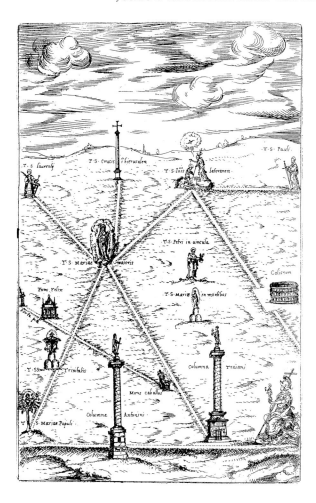

108 Diagramatic plan of Domenico Fontana's reordering of Rome for Sixtus V, from Giovanni Francesco Bordini's *De Rebus Praeclare Gestis a Sixto V Pont. Max* (1588)

But there were other precedents closer to home for Jones's use of the obelisk at St Paul's to signify the king's 'solar' Triumph, since British royal iconography frequently linked obelisks and solar illumination. Perhaps the most prominent example was the emblematic frontispiece to James I's *Workes* of 1616, where the decoration of the obelisk with four crowns makes it a particularly British symbol (see Fig. 115).[69] During James's entry in 1604 he had passed an emblem of the sun and moon set between two obelisks, which were seen to herald the king as the 'new Augustus'.[70] Once again, the iconography subsequently used by Jones at the cathedral thus made permanent the symbolism earlier employed in this Triumph (which had itself been linked to the cathedral by passing it). It might even have been hoped that Jones's columns and his obelisks set against the sky at St Paul's possessed similar powers to those featured in *Prince Henry's Barriers*. Here Jonson

had claimed for these ornaments the potential to confer nothing less than celestial virtues on the British court, with: 'Those obelisks and columns broke, and down / That struck the stars, and raised the British crown / To be a constellation . . . / Outstriding the Colossus of the sun'.[71] Such magical imagery recalled, albeit indirectly, the sun and moon mounted on two Doric columns in the frontispiece to John Dee's Neoplatonic work entitled *Monas hieroglyphica* (1564).

The use of solar iconography had an obvious theological dimension too. The cathedral dean from 1621 was the poet John Donne, one of Jones's friends.[72] The sun was a common-enough theme of his religious poetry, 'The Sunne Rising' (*c*.1603) being perhaps the most notable example.[73] Through his sermons, St Paul's became the setting for Donne's identification of Christ with the sun, an image informed by Copernican astronomy.[74] It might be assumed that any cathedral scheme advanced by Jones that intended to evoke the power of divine mysteries and the light of God through its iconography would have found sympathy with Donne in his role as guardian of the fabric.[75] Jones's preliminary west façade design, of uncertain date, reflected this very theme at its apex in the giant candelbra and an actual solar icon. This was the glorification of Christ's name, *Jesus Hominum Salvator*, in the form of an IHS sunburst (see Fig. 244).[76] In line with court art, later Laudian iconography also often featured the sun as an emblem of the Reformed religion.[77]

The most striking public manifestation of the Laudian policy promoting the 'beauty of holiness' was Jones's cathedral portico, composed of sixteen columns of the Corinthian Order. This portico was based on the front of the Roman temple of the Sun and Moon as illustrated by Palladio in a woodcut much studied by Jones (Book IV, chapter 10; Fig. 110); indeed, he visited the temple whilst in Rome.[78] Both porticoes are capped by a simple balustrade and statues rather than a pediment, and both have ten Corinthian columns to the fore; the ancient temple even has the same central window trio found at St Paul's.[79] The ancient portico clearly provided a wholly appropriate model for the modern one in its role receiving the 'solar monarch' on the occasion of the Triumph, as urged by Bishop King in 1620. The portico also reaffirmed initially James I's and then Charles I's general identification with the sun in court art and sermons, alongside the corresponding presentation of Henrietta Maria as the moon.[80] Gerard van Honthorst's painting of Charles and his queen as Apollo and Diana of 1628 is an obvious example, intended for display in Jones's Banqueting House (Fig. 109).[81]

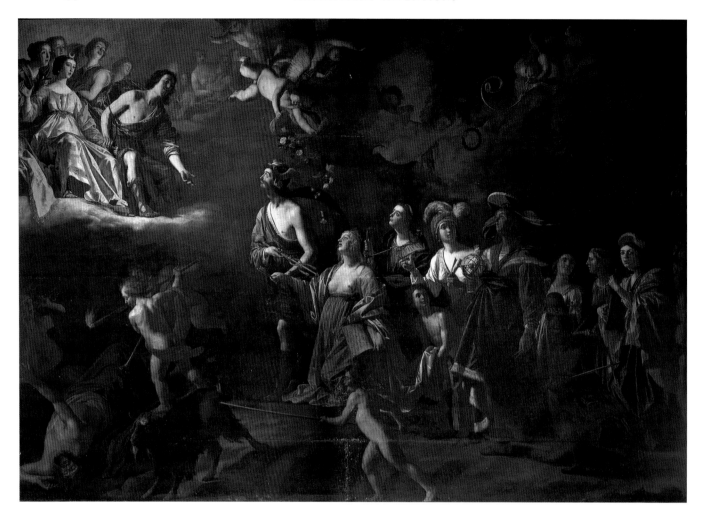

109 Gerard van Honthorst, *Charles I and Henrietta Maria as Apollo and Diana* (1628). Royal Collection

Jones's use of this ancient temple as a model for the portico at St Paul's Cathedral, and its identification with the royal couple who funded the portico, would have been reinforced by Geoffrey of Monmouth's report, much cultivated by the Stuarts, of an ancient Romano-British temple to Apollo in London; there was even a related legend of one to Diana as having stood on the actual site of St Paul's.[82] Drayton speculated in *Poly-Olbion* (1613) on the etymology of the name London:

> I could imagine, it might be cald at first *Lhan Dien.i. the Temple* of Diana, as *Lhan-Dewi* . . . and so afterward by strangers turned into *Londinium,* and the like. For, that *Diana* and her brother *Apollo* (under name of *Belin*) were two great Deities among the *Britons,* where is read next before, *Caesars* testimony of the *Gaules*; and that she had her Temple there where *Paules* is, relation in *Camden* discloses to you.[83]

Jones was himself to claim that a Roman temple was

buried under the cathedral, based on ox heads that he had dug up on the site (and it was noted that, curiously enough, an ox head was placed over the central door in his preliminary west front design).[84] Diana's legendary temple also featured in Bishop Richard Corbet's sermon of 1634 praising the cathedral's restoration:

> It was once dedicated to Diana, (at least some Part of it); but the Idolatry lasted not long, and see a Mystery in the Change: St Pauls confuting twice that idol, there in person – where the crye was, '*Great is Diana of the Ephesians!*' and here, by Proxy, Paul installed while againe Diana is thrust out. It did magnify the Creation, that it was taken out of Darkness. Light is not the clearer for that, but it is the stranger and more wonderfull.[85]

Corbet presented the site of the cathedral as once having undergone a masque-like transformation from

pagan 'darkness' to Christian 'light', a process about to be repeated, or so he implies, by the Stuart resurfacing.

The court poetry of Edmund Waller often described the monarchy bathed in heavenly light, since 'the light which now informs our age / Breaks from the court'.[86] In Waller's verse concerning the restoration, Jones's *all'antica* façades for the cathedral, and the west front in particular, were presented as bathed in the light of the solar progress:

> The Sun which riseth to salute the quire
> Already finish'd, setting shall admire
> How private bounty could so far extend,
> The King built all, but Charles the
> western end.[87]

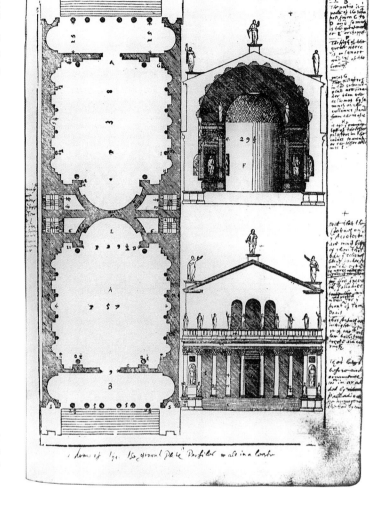

110 Palladio's temple to the Sun and Moon (Book IV, chapter 10, p. 37), from Jones's annotated copy of *I quattro libri dell' architettura* (1601 edition; Worcester College, Oxford), a source for Jones's west portico to St Paul's Cathedral (see Fig. 252)

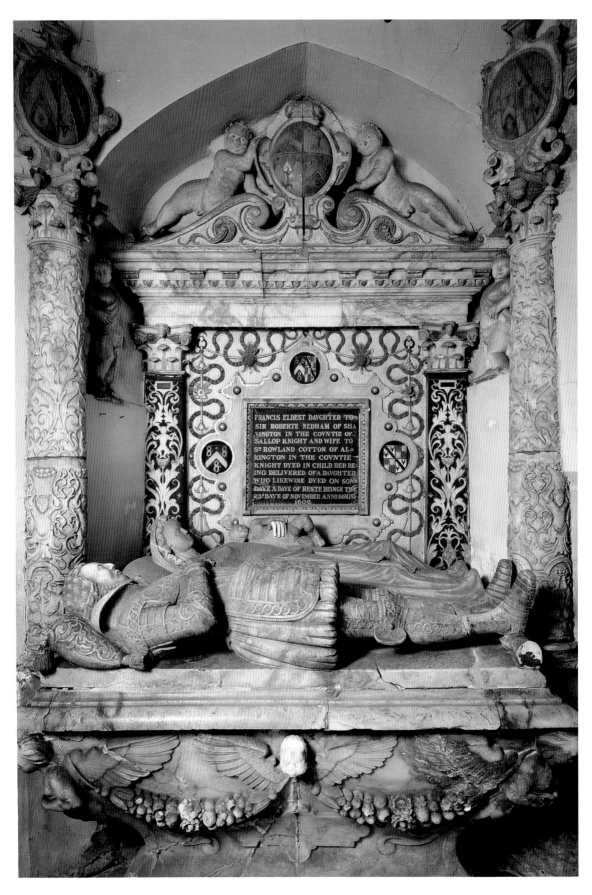

111 Inigo Jones, the Cotton Monument in St Chad's church, Norton-in-Hales, Shropshire, completed after 1634

A PIECE OF GOOD HERALDRY: JONES AND THE ORDERS OF CHIVALRY AND ARCHITECTURE

During the sixteenth century the buildings designed for members of the English court became increasingly embellished with *all'antica* ornament, a development that culminated with the flamboyant Elizabethan 'prodigy' houses (see Figs 3–4). This process might be compared with the ornamentation of armour, another highly functional court artefact first decorated during the Renaissance by the Holy Roman Emperor Maximilian I (1459–1519). Both were emblazoned with heraldry and antique emblems to express the status of the owner, as well as his, or occasionally her, relationship with their dynasty and its mythology.[1] In Scotland during this period the post of Master of Works was linked with heraldry, and James I would have remembered this when appointing Jones as Surveyor of the English Works in 1615.[2] Not surprisingly, therefore, arms and antique architecture were presented as perfectly compatible in the early Stuart court, for according to Jonson's *Prince Henry's Barriers* of 1610, 'arms and arts sustain each other's right'.[3] Indeed, it has been seen that as part of this marriage, Jones's newly 'rediscovered' Orders of architecture, and the masculine ones in particular, were used in early masques to express the established orders of Protestant chivalry centred on the king. And, of course, these chivalric orders were traditionally also represented by the native arts and crafts of armour, pageantry and, most importantly, heraldry.

These kinds of associations in the masque resulted, at least in part, from the desire to explain and integrate Jones's new architectural style using familiar craft, geometrical and even legal terminology. Such references helped overcome the somewhat inevitable English sensitivities to foreign artistic styles. This chapter will examine the influence on Jones of the links that were being made by his contemporaries between the design of the Orders and the better-understood art of heraldry. As with the Triumph, the early use of the columns in royal images and heraldic events can be seen to have paved the way for Jones's use of the Orders for the crown. The chapter will also consider his buildings in the context of the mythology and heraldic ceremonial of the Protestant Garter knights and the Companies of the City of London with which he collaborated. For Jones's understanding of the Orders was necessarily conditioned as much by institutions such as these, and by native arts and crafts, as by Continental architectural practices and antique principles.

'ARCHITECTURAL HERALDRY': JONES'S ORDERS AND THE THEORY AND PRACTICE OF HERALDRY

Connections between Jones's architecture and heraldry are inevitably implied by the dual meaning of the word 'house', both dynastic and architectural, and as notably expressed by Jonson's title 'The Fallen House of British Chivalry'.[4] Architectural elements have always featured prominently in heraldic grammar, including the terms 'arched', 'castle', 'portcullis' and, of course, the antique 'column'. The column has been particularly important to heraldic design.[5] For example, the heraldic definition of 'pillar' states: 'In addition to appearing, of necessity, to support an arch (q.v.), the pillar, also termed "col-

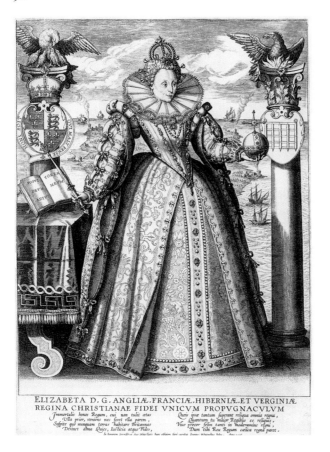

112 Engraving of Elizabeth I by Crispin de Passe (Senior), 1596, presenting a combined image of heraldic and architectural Order. Published by Jan Woudneel in London. British Museum, London

113 Mark of the printer John Daye in John Foxe's *Actes and Monuments* (1570 edition)

umn", appears alone as a charge: the order – Doric, Ionic or Corinthian – may be stated. The pillar generally acts as a support for some other charge, even a prosaic object representing a trade or a craft.[6] Jones employed two columns in this way, to support shields, in his tomb design for Lady Cotton (Figs 111, 114). They make reference to the pillars, Jachin and Boaz, that stood in the porch of the Temple of Solomon (1 Kings 7.15–22), whilst the addition of heraldry suggests a very British interpretation of these ancient pillars.[7] In this design Jones replicated the manner in which the column had first been represented in England during the sixteenth century, in royal emblems and engravings. This representation was some time before the more coherent and public use of the column on the triumphal arches of 1604 or its even more fluent use on Jones's Banqueting House façade of 1619–23.[8]

Elizabethan royal symbolism often employed the free-standing column as a heraldic sign. The famous engraving by Crispin de Passe (Senior) of 1596 pictured Elizabeth I flanked by two Corinthian columns, following the example of the heraldry of the emperor Charles V in which the device of twin columns signified the northern imperial ideal (Fig. 112). More specifically, the Elizabethan columns are made to carry royal arms that transform them into 'Pillars of State'. In the printer's mark of John Daye, reproduced in the 1570 edition of John Foxe's *Actes and Monuments*, the entire imperial image is heraldic (Fig. 113). Standing in for Elizabeth are the royal arms, whilst the Corinthian columns are set on plinths bearing shields. In the frontispiece to the *Workes* of James I, published in 1616, Corinthian columns once again carry British royal insignia – Tudor roses, thistles and so on – much as if the column itself was the heraldic shield (Fig. 115). Here royal arms surmount the architectural composition and combine to give the impression of an ancient royal lineage. As an important aspect of Elizabethan and Stuart imperial symbolism, this early use of *all'antica* columns as heraldry and its implications for the understanding of Jones's work has largely gone unnoted.[9]

The imperial heraldry represented in these Tudor engravings was also used as a symbol for the Church of England at the time of its reform, given that the monarch had taken the place of the pope as its head. Royal arms enjoyed a status as the first Protestant iconography, having replaced images of the saints in churches during the Reformation.[10] In this way the antique column, as an integral element of such heraldry, became part of Protestant symbolism. The most prominent example of the use of free-standing columns in Stuart England (as opposed to their use as pilasters) was

Here lyeth one yt
h'eauen sent to earth
To see no doubt her peer
yer soule, conioyned
wth mortall mass, she
findes a dearth
wirtue so spent, that she
at first resigned
Her mortall virtues, and
at first aspired
wth Immortalitye —
Borne wth desyre, burninge
abreade her preised,
she finds eternitye —

114 Inigo Jones, design for the Cotton Monument in St Chad's church, Norton-in-Hales, Shropshire, c.1610. RIBA Library
Drawings Collection, London

115 'Heraldic' columns in the emblematic frontispiece to James I's *Workes* (1616)

Jones's Corinthian portico at St Paul's Cathedral. As a celebration of Protestant monarchy, the portico was surmounted by statues of the House of Stuart, James I and Charles I, in their role as 'Defenders' of the Protestant faith. It was also formed from the Order that had most associations with Elizabethan royal heraldry, and can be seen as a logical extension of the Protestant iconography inaugurated by royal arms.

In a similar manner to this use of the column in royal arms, Elizabethan frontispieces often represented

it within a heraldic composition. In these emblems a coherent architectural structure was composed by the Orders long before Jones's use of them in this way. In the shielded frontispiece of Gerard Legh's *The Accedens of Armory* (1562), a broken Corinthian column forms an isolated 'charge'; an obelisk draped in arms is pictured by Legh at the end (Fig. 116). Arms appear pinned to the Corinthian columns in the frontispiece to the 1631 edition of John Stow's *Chronicle*, as also in the first edition of John Guillim's *A Display of Heraldrie*, published in 1610 (Figs 117–18). An opening poem explains that the 'Display of Heraldrie', or 'edifice' as Guillim

116 (*top left*) A broken Corinthian column forming an isolated 'charge' in the shield in the centre of the emblematic frontispiece to Gerard Legh's *The Accedens of Armory* (1562)

117 (*top right*) Arms 'pinned' to Corinthian columns, in the emblematic frontispiece to John Stow's *Annales; or, A Generall Chronicle of England* (1631 edition)

118 (*right*) Arms between Corinthian columns forming an 'heraldic' triumphal arch, surmounted by the royal arms, in the emblematic frontispiece to John Guillim's *A Display of Heraldrie* (1610 edition)

119 and 120 Fireplace at Bolsover Castle, Derbyshire; window at Broughton Castle, Oxfordshire

terms the work, is represented by this frontispiece, in which:

> The noble *Pindere* doth compare somewhere,
> Writing with Building, and instructs us there,
> That every great and goodly *Edifice*,
> Doth aske to have a comely *Frontispiece*.
> Where (*Guillim*) better can the curious looke,
> T'have this observ'd, than in they present
> *Booke*? . . .

> First, *England*, being thy *Scene* thou doest present,
> In a Triumphall *Arch* her *Regiment* . . .
> And Head of every Priviledge, the KING
> Is set above: From whom those *Six* beside,
> Betweene the *Pillars* by their *Coats* descri'd.[11]

Guillim's frontispiece – not only opening the book but also here imagined by him fronting a building – mirrored the link between royal heraldry and the Orders that Jones was himself soon to make for the crown. On the following page William Sagar, Garter King of Arms, continued the architectural metaphor, for never was a 'Groundworke *truer laid, / to raise a* Fabricke *to your lasting name*'. In this way the Orders and heraldry were first pictured as joint elements of the antique revival, or Renaissance, providing a context for Jones and Jonson's *Prince Henry's Barriers* of the same year.

Guillim's architectural metaphor fronting a book on the 'display' of heraldry would have been familiar enough, since Elizabethan and Stuart buildings com-

monly expressed a distinctly heraldic character. This was through the display of shields on walls or within glass, and through trophies of arms set within niches where columns provided a supporting frame. Heraldry was central to the design of Elizabethan stained-glass windows, for example, and by 1540 or thereabouts Gothic designs had largely given place to *all'antica* forms for shields and accessories (that is, long before Jones's use of such forms).[12] Any number of sixteenth-century buildings, tombs and arches illustrate this relationship between columns and arms. This is particularly apparent on elements such as fireplaces (at Bolsover Castle, Derbyshire), windows (at Broughton Castle, Oxfordshire) and doorways (at Blickling Hall, Norfolk; Figs 119–21). Gateways and pediments were also ideal for the display of heraldry. Palladio had awarded the prime location on his façades, the centre of the pediment, to the heraldic shield, and arms and ensigns were equally important in Jones's *all'antica* vocabulary.[13] For example, they feature in his design for the pediment of an entrance bay to an unidentified house and in pediments in early court schemes for the Queen's House and the Banqueting House (Fig. 122; see Figs 195, 242–3).[14] Jones also used arms on his proposed façade for the Star Chamber, on his design for the arch at Temple Bar, and on many villas (see Figs 99, 150).[15] This use of the pediment for heraldry and shields was a notable feature of Jones's designs throughout his working life, from his earliest schemes – for the New Exchange of 1608 and a stable of around 1610 – to his last designs – with Webb for Whitehall Palace of around 1638 (Fig. 123).[16] The Whitehall scheme, as published by William Kent in 1727, also included metopes decorated in triumphalist manner with trophies of arms and crowns inspired by emblem books (Figs 124–5; here following such examples as the chapel of the château at Villers-Cotterêts built by François I between 1532 and 1540, where the columns carry the royal heraldry of the salamander and the crown).[17] Later, Webb was to be even more inventive, in adapting capitals to express the heraldic characteristics of the patron. His designs for those in the King Charles Building at Greenwich featured the lion and the unicorn, emphasising the link between the column and the crown (Figs 126–7); whilst those for the Library of the Royal College of Physicians included the torch of life and the Aesculapian serpent.[18]

Arms were equally prominent in Jones's gateway designs, most notably those for New Hall in Essex and Hatton House at Ely Place in London; as too in the dome of his catafalque for James I of 1625, with its shields, banners and decorative finials all supported by Doric columns (Figs 128–9).[19] The heraldic nature of

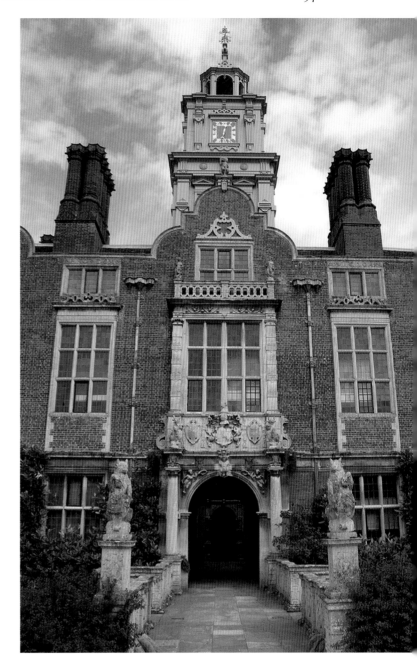

121 Doorway at Blickling Hall, Norfolk

this design reflected such earlier catafalques as that for Edward Stanley, 3rd Earl of Derby (d. 1572), although Jones classicised this particular precedent by adding the all-important antique columns.[20] In so doing he followed in the footsteps of countless provincial designers, since it was to the traditionally heraldic architectural structures such as tombs, frontispieces and gateways that the Elizabethan use of the Orders had, for the most part, been initially restricted.

But Jones also followed the theoretical links made by architectural and heraldic writers of his day. In line with

122 Inigo Jones, elevation for the entrance bay to an unidentified house, 1616. RIBA Library Drawings Collection, London

123 Inigo Jones, design for a stable (possibly at Hatfield House, Hertfordshire), c.1610. RIBA Library Drawings Collection, London

124 Trophies of arms in Doric metopes, part of the Jones-Webb design for Whitehall Palace as engraved by Henry Flitcroft for William Kent's *The Designs of Inigo Jones* (1727)

125 The column and the crown, part of the Jones-Webb design for Whitehall Palace as engraved by Henry Flitcroft for William Kent's *The Designs of Inigo Jones* (1727)

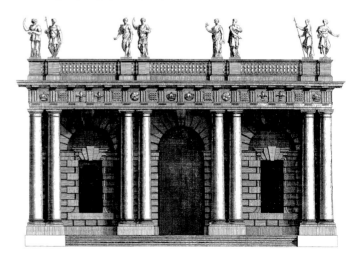

the fact that heraldry and the Orders were often displayed together in the early Stuart court, their design was governed by common 'Rules and Axioms', as Guillim termed heraldic composition.[21] For example, in *The Elements of Armories* (1610) Jones's friend Edmund Bolton described heraldic design as the art of arranging an emblem (explained here without the more usual accompanying text), and emblems were equally linked to the art of architectural composition.[22] The emblematic frontispiece frequently had an architectural framework, as has been seen, and the occult art of artificial memory united emblems with real architecture.[23] Vitruvian architecture was fundamental to Jones's masque designs that involved the use of hieroglyphs or emblems for costumes and backdrops. This was no doubt one reason why Jonson eventually branded Jones's work 'Court hieroglyphics'.[24] It is reasonable to suppose that Jones thought of emblematic set design and more permanent architecture in a similar way, given that he designed both. There can be no more dramatic demonstration of the compatibility of Jones's emblematic backdrops and his architecture than the fact that

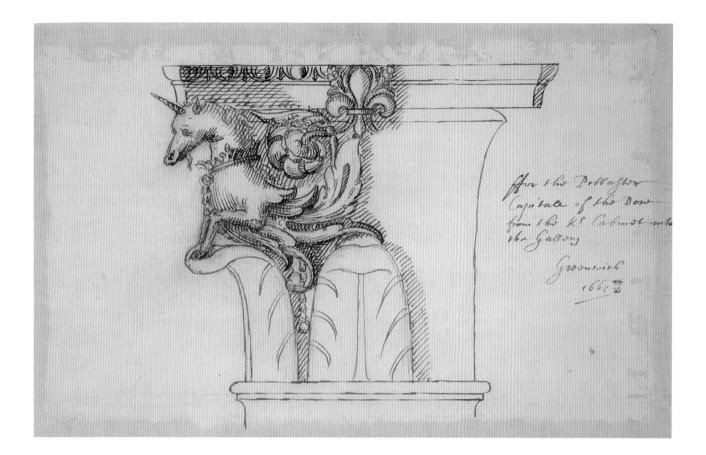

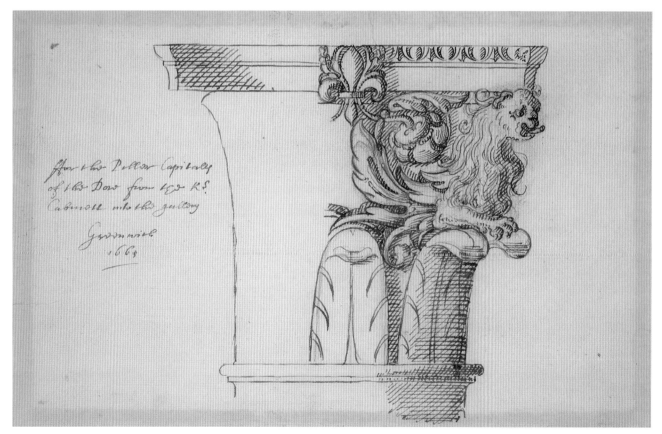

126 and 127 John Webb, designs for capitals for the King Charles Building at Greenwich featuring the unicorn and the lion, 1665. RIBA Library Drawings Collection, London

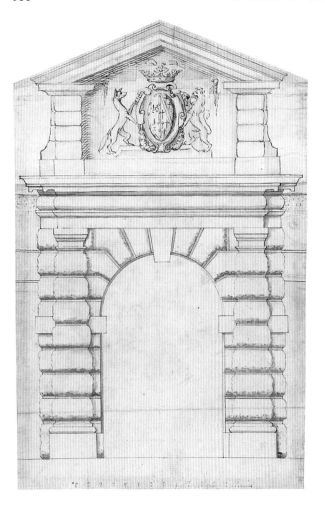

128 Inigo Jones, elevation for a Tuscan carriage gate, Hatton House, Ely Place, London, c.1622. RIBA Library Drawings Collection, London

129 Inigo Jones, catafalque for James I built at Westminster Abbey, 1625. Worcester College, Oxford

notable examples of the latter were used by him in the former, as, for example, with St Paul's used in *Britannia Triumphans* (1638; see Fig. 67). A design parallel between heraldry and Jones's architectural Orders becomes apparent: both might be seen as a form of Renaissance emblematics.

Further design parallels existed. It was a common-place in Renaissance architectural theory to regard the design of the Orders as a geometric art. One of the first English expressions of this idea was in John Shute's *The First and Chief Groundes of Architecture* (1563), as his illustrations of the Orders made clear (see Figs 153, 159–62). Heraldry too was commonly presented as a branch of geometry. Not only were heraldic characters arranged geometrically, but also geometric figures became heraldic 'charges' – circles, triangles and the Shield, or Star, of David, for example. Bolton opened his book with the fact that in heraldic design, 'all Arts

conjon'd in this do appear / By structure of a choice Phylosophie / GEOMETRIE gives lines in ordred place, Numbers ARTHMETICK'.[25] He emphasised the similarity between architecture and heraldry in terms of their relationship to geometry when observing on merchant's marks: 'Neither are . . . [they] of so diverse forme from Armes, or Armories in their perfection, as an excellent peice of Architecture from the first elements of Geom-etry, out of which not withstanding it rose.'[26] Given his close friendship with Jones at this time, it is reasonable to suppose that both men talked about this link. With antique architectural canons in mind, one of the most explicit design parallels between the two arts was con-tained in Guillim's ambition '*to give unto this erst unshapely and disproportionable profession of* Heraldry, *a true* Symmetria *and proportionable correspondence of each part to other*'.[27] Here the relatively unfamiliar rules and termi-nology of Vitruvian design have been applied to the

130 Domenico Fontana, catafalque for Sixtus v, 1591, from *Della trasportatione dell'obelisco vaticano et della fabriche di nostro signore Papa Sisto V* (1604 edition)

much more familiar medieval art of heraldry. Qualities of symmetry, harmony and proportion thus represented fundamental similarities between the Orders and well-designed heraldry.

Additional evidence of design links between the two, and of Jones's understanding of these, can be found by consulting the albeit scarce literary sources on architecture dating from this time. The English treatises and literature on architecture – by Shute before the Stuarts, and Jonson and Wotton during James I's reign – all have heraldic themes. For example, connections between the Orders of architecture and chivalry would account for the particular interpretation of Vitruvius's 'masculine' Tuscan and Doric Orders by Shute in 1563 (see Figs 159–60). Both were personified as armed antique warriors, the Doric with plinths bearing representations of shields and other trophies of arms. In Sebastiano Serlio's treatise of 1537–75, the English edition of which

appeared in 1611 dedicated to Prince Henry, Book Four concluded by describing and illustrating examples of heraldry (Fig. 131). Shields were bound up with what were described in the English edition as the 'Rules for Masonry, or Building *with Stone or Bricke, made after the five maners* or orders of Building, viz. Thuscana, Dorica, Ionica, Corinthia and Composita'. In this book dedicated to Jones's then patron, the 'new' Orders were linked to the 'old' English arts of masonry and heraldry. It has been seen that Jonson's works provide equally valuable evidence as to the understanding of the Orders during the period when Jones was active. It was also pointed out that the first coherent use of the columns in London was on James I's coronation arches of 1604, and in explaining these Jonson emphasised the connection between hieroglyphics, emblems and imprese or shields, since 'the *Symboles* used, are not, neither ought to be, simply *Hieroglyphickes, Emblemes,* or *Impreses,* but a mixed character, partaking somewhat of all,

131 Shield designs terminating Book Four of Sebastiano Serlio's *D'Architettura,* translated as *The first (-fift) Book of Architecture, made by Sebastian Serly, entreating of Geometrie. Translated out of Italian into Dutch, and out of Dutch into English* (1611)

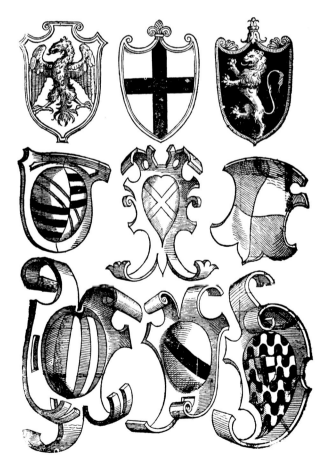

and peculiarly a[da]pted to these more magnificent Inventions'.[28] He would seem to confirm that the design of the architectural Orders on 'these Devices' was bound up with that of emblems and imprese, with the Orders 'partaking somewhat of all'.

The only English treatise on the Orders published during Jones's lifetime was Wotton's *The Elements of Architecture* (1624). In this he outlined the 'masculine Aspect' of the Doric Order:

> His ranke or degree, is the lowest by all *Congruity*, as being more massie then the other three, and consequently abler to support . . . To descerne him, will bee a peece rather of good *Heraldry*, than of *Architecture*: For he is best knowne by his place, when he is in company, and by the peculiar ornament of his *Frize* . . . when he is alone.[29]

Wotton's significant phrase 'rather of good *Heraldry*, than of *Architecture*' suggests a greater familiarity with the rules of the former, and indicates their dominance over or absorption of the similar, but newly perceived, rules defining the latter. In other words, he introduces the antique column as part of the established design art of heraldry, whose 'charge' is certainly 'best knowne by his place, when he is in company'. Wotton thus makes explicit the links between heraldry and the architectural Orders that Jones's work suggests. Given that the masculine Orders in particular had been visualised by him as emblems of chivalry, in masque scenes such as the proto-Doric St George's Portico and Oberon's Palace, these links would have seemed natural enough to a contemporary courtly reader of Wotton (see Figs 71, 225). And when seen in this light, entire façades such as Jones's early Banqueting House schemes might easily have been conceived as heraldic in nature, not just the pediments with their royal arms.

Wotton understood the columns as possessing a 'rank', with the Corinthian, 'his degree, one Stage above the *Ionique*, and alwaies the highest of the simple *Orders*'. This ranking quite clearly reflected that used by the orders of chivalry and knighthood, as traditionally expressed by their costumes and heraldry. In the case of the columns, their ranking was articulated through their decorative character, from 'poor' to 'rich'. So, with the Doric it was its frieze, complete with triglyphs and metopes, that aided its identification with heraldry. Wotton observed on the Composite Order that: 'to Know him will be easie by the verie mixture of his *Ornaments,* and *Clothing*'.[30] It follows that when stripped of this clothing, or heraldic 'charge', Wotton's column stood as a 'body' or basic element much like a blank shield or heraldic 'field'. The column might even be

compared to the body of a knight awaiting his coat of arms. The seventh rule of Guillim's *Display of Heraldrie* dictated: 'In the *Blazoning* of any Coate, you must evermore observe this speciall rule. First, to beginne with the Field, and then proceed to the blazon of the Charge, if any be.'[31] Jones had emphasised this process in his 'Roman Sketchbook' when discussing the design of capricious ornament. According to him, 'on[e] must first designe ye Ground, or ye thing plaine, as yt is for youse. and on that, varry yt. addorne yt'.[32] In a similar way, the costumes for masques were invariably drawn by him directly from the emblem books and were added to the 'body' of the actors to display their 'character'. Given their heraldic characteristics, the Orders here again became compatible with emblematic design through an elemental process in which the surface was built up. Perhaps this is also how Jones saw the process of ornamenting or 'dressing' his buildings.

With Wotton's Orders collectively displaying a court hierarchy, he built a 'House of Chivalry' with one column surmounting the other in correspondence with its rank. On the Ionic he observed: 'in degree as in substantialnesse, next above the *Dorique*, sustayning the third, and adorning the second Storey'.[33] The Tuscan might be included in this structure as a kind of rusticated plinth, as on Jones's Banqueting House façade, beneath the other more noble Orders that he 'labours' to support; in the case of the Banqueting House the second storey is indeed Ionic, further suggesting these comparisons. This hierarchical arrangement of the Five Orders had been applied as a frontispiece to the medieval tower of the Old Schools in Oxford between 1613 and 1624, more or less contemporary with the Banqueting House (Fig. 132). James I is seated between columns in the Corinthian storey, just below the royal arms, thereby reflecting the heraldic imagery of Elizabeth. Moreover, given that Jones saw the Tuscan at Stonehenge as emblematic of ancient rustic simplicity, it follows from these heraldic and chivalrous hierarchies that his Corinthian at St Paul's might well have been seen as perfectly appropriate for Solomonic royalty. After all, Villalpando had made this association clear enough in 1604.

Jones most likely read Wotton's book on or before its publication, and saw the description of the heraldic Doric Order. Annotations in his copy of Palladio record a familiarity with Wotton's collection of drawings by the Italian, depicting the Orders and ancient buildings.[34] Wotton's unique work enjoyed widespread circulation amongst Jones's peers, and John Chamberlain reported it 'reasonably commended'.[35] The first copy was presented to the king, and the second to Prince Charles.

Wotton gave one to George Abbot, archbishop during the commission of 1620 considering the restoration of St Paul's.[36] Since this copy is preserved in the library of Lambeth Palace, the subsequent archbishop, William Laud, may well have also read it in connection with Jones's actual work at the cathedral. Some years after publication, in 1636, Wotton also sent a copy to William Juxon, the Bishop of London; by then the restoration work was well under way.[37] Evidence that the *Elements* found court favour is provided by the fact that it played a part in gaining for Wotton the Provostship of Eton, written as it was for this purpose.[38] By report it was down to the Duke of Buckingham 'to name the man' for Eton, and Buckingham, one of the 1620 cathedral commissioners, would therefore almost certainly have also read Wotton's explanations.[39]

Of course, Wotton's remarks are of special significance given that their publication coincided with Jones's earliest built work for the court. The book provides important evidence of how at least some members of the court and Church might have understood aspects of this work, even if the emerging High Church faction would have disagreed with Wotton's puritanical reservations about the more decorative Orders, examined shortly. Moreover, for any of these contemporary readers, Jones's architecture would have offered one of the few coherent examples of the unfamiliar ornamental language that Wotton described. Perhaps more significantly, apart from the somewhat esoteric writings of Shute and Jonson, Wotton's *Elements* advanced the only English explanation for Jones's buildings and the Orders from which they were composed. The guiding theme of Wotton's book was the attempt to adapt Italian country villas to the British climate.[40] As an aspect of this he set out to make an otherwise Italian style of architecture appealing to English tastes, and the presentation of the Orders as akin to heraldry (by tradition badges of national identity) is a peculiarly anglicised notion. In so doing he echoed Jones's earlier celebration of Arthurian chivalry in scenes of antique columns and Doric porticoes.

Indeed, Jonson's terminology in these masques when describing Jones's *all'antica* architecture in general, and the Orders in particular, was decidedly heraldic. In the *Haddington Masque* of 1608, the fourth production upon which he and Jones collaborated, there 'were erected two *pilasters*, chardg'd with spoiles & *trophees*, of love'.[41] In the *Barriers*, too, this terminology is apparent in the description of the 'House of Chivalry': although this had 'shields and swords / Cobwebbed, and rusty', apparently:

132 The column and the crown: the gate of the Old Schools in Oxford, resurfaced between 1613 and 1624, which leads to Thomas Bodley's library

More truth of *architecture* there was blaz'd
Than liv'd in all the ignorant *Gothes* have raz'd.
There porticos were built, and seats for knights
That watched for all adventures, days
 and nights.[42]

Following the rusty antique shields, Jonson's line 'More truth of *architecture* there was blaz'd' certainly has a strikingly heraldic ring to it. A blazon was a coat of arms, as Guillim's seventh rule indicates, and blazonry was the

traditional art of decoration within heraldry.[43] In this way 'true' British architecture – not the misshapen type of the 'ignorant *Gothes*', as Jonson was keen to explain, but a harmonious one composed with Jones's Orders – was once again explained with reference to heraldry.

Thus it was that the relatively unfamiliar Vitruvian rules governing the design of the Orders were explained in early seventeenth-century Britain with reference to the well-established medieval art of heraldic design. This was appropriate since heraldry was a prominent component of Elizabethan architecture and was considered to be the only art to have survived from antiquity in unbroken craft practices. It is natural, therefore, that shields and columns were combined by Jones in the masque to express the ancient ancestry claimed by the Stuart monarchs. As will now be seen, this joint display was made even more compelling by the fact that both forms of decoration were themselves understood to have the same biblical and antique origins.

'THE HIEROGLYPHICS OF NOBILITY': THE COMMON ANCESTRY OF JONES'S ORDERS AND HERALDRY

Along with the 'revived' use of the architectural Orders by Jones, the parallel revitalisation of heraldry was understood by the Stuarts as a further sign of the court's claims to be the rightful inheritors of the many virtues of biblical and classical antiquity. Bolton made explicit the notion that heraldry had been a component of antique architecture when noting that 'Armes are in sort the onely remayning customary evidences, or testimonies of Noblesse, now that neyther Statues, Archs, Obelisks, Tropheas, Spires nor other publike magnificent erections are in use.'[44] Of course, it was to his friend, Inigo Jones, that Bolton looked in wishing for the revived use of these ancient forms. With the design of heraldry representing an unbroken link with this lost world, it is maybe not surprising that in the *Barriers* a shield became the ultimate symbol of the once-glorious 'obelisks and columns broke, and down'. For as the future Prince of Wales, Henry received his inheritance of Protestant chivalry from Arthur encapsulated symbolically in a shield, 'wherein is wrought / The truth that he must follow'.[45] A surviving drawing by Jones for an unidentified masque shows a knight dressed in antique costume and holding this kind of impresa shield, here again illustrating their antiquity (Fig. 133).

Claims made for the antiquity of heraldry reflected works such as Heywood's *TROIA BRITANICA* (1609),

where not only James's ancestry but also that of ensigns were traced back to Troy. The Trojan king,

> calling now to mind the Bird that soared
> About his rich Pavillion, he ordained
> Her picture should be drawne and quaintly skored,
> Upon a Crimson Ensigne richly stained . . .
> Till then, they bore no flags, no Scutchions drew,
> *Ioves* Eagle was the first, in field that flew.[46]

Perhaps not unexpectedly, Trojan arms became a common feature of Stuart books on heraldry and emblems, as in *Minerva Britanna (or a Garden of Heroical Devices)* (1612) published by another of Jones's friends, Henry Peacham.[47] Further evidence for considering heraldry an ancient art was to be found in biblical history. The frontispiece of the Geneva Bible, as published in 1600 and in editions thereafter, was decorated

133 Inigo Jones, a knight with impresa shield, dressed *all'antica*. Undated, masque unknown. Devonshire Collection, Chatsworth

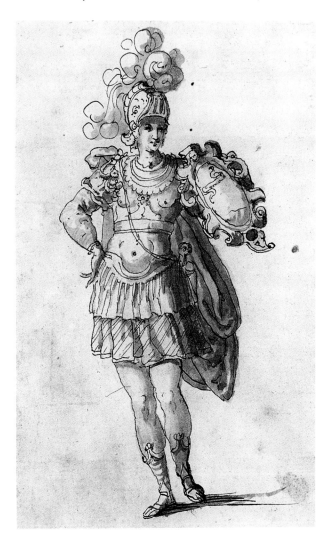

134 The emblematic frontispiece of the Geneva Bible (1611 edition)

with the heraldic shields of the twelve tribes of Israel (Fig. 134). These standards had been pitched 'about the Tabernacle' according to Numbers 2.2. This authority was quoted by William Dugdale when justifying the use of monuments and ensigns in the wake of the iconoclasm of the Civil War: 'So that by this you may see' that ensigns 'be no new inventions of men, so they are also things allowable by the word of God. Neither do *Obsequies or monuments* ensuing worthy acts want the authority of Scriptures.'[48] The Tabernacle of Moses prefigured the Temple of Solomon, and with increasing regularity in the seventeenth century the Temple had,

as Chapter One noted, become identified with the architectural Orders Vitruvius was later to describe. It has been seen that Villalpando provided the earliest literal and pictorial source for this view (see Fig. 73). In so doing he 'Christianised' the classical (and therefore pagan) columns in the context not only of the Temple but also of the Tabernacle, which he also illustrated.[49] Here Vitruvian canons and the ensigns of the twelve tribes combine to order the Temple plan (Fig. 135). The Tabernacle and Temple thus represented the embodiment of both heraldry and the architectural Orders, and this biblical virtue was enhanced by the fact that both forms of decoration could also be traced to the Golden Age of Troy.

Arguments in favour of the biblical antiquity of heraldry were further assisted by its supposed links with the secret wisdom of the Egyptians. Coats of arms,

emblems and devices found a common origin in the picture language of hieroglyphics, which in its Renaissance form was often understood to signify divine mysteries given to Moses by God.[50] An anonymous letter of commendation to Samuel Daniel's 1585 translation of Giovio's *Dialogo* observed:

> concerning the arte of *Impresse*, I neede not draw the petigree of it, sith it is knowne that it descended from the auncient *Aegiptians,* and *Chaldaeans* . . . by the picture of a Stork they signified . . . [family devotion]. By a serpent pollicie . . . drawing these Charecters from the world, as from a volume wherein was written the wonders of nature. Thus was the first foundations layd of *Impresse.* From hence were derived by succession of pregnant wittes *Stemmata* Coates of Armes, Insignia *Ensignes,* and the old Images which the Romaines used as witnesses of their Auncestors, *Emblemes* and *Deuises.*[51]

This ancestry resonated in Bolton's description of heraldry as 'the HIEROGLYPHICKS of Nobility', whilst alongside a discussion of architectural heraldry Guillim's 'pillars' were called 'the *Hieroglyphicks* of *fortitude*'.[52] The common ancestry enjoyed by heraldry, emblems and the Orders cannot have escaped Jones's notice as the friend of some of the leading emblematists and heraldic scholars of his day. His understanding of this interrelationship is demonstrated in his *STONE-HENG . . . RESTORED* (1655), where the Tuscan 'columns' are interpreted with reference to Neoplatonic emblem books including Valeriano's *Hieroglyphica.*[53] Indeed, it will be remembered that it was owing to Jones's over-reliance on emblematic spectacle that his *all'antica* masque designs became mere 'Court hieroglyphics' according to Jonson.

With their shared design rules and antiquity, the heraldry and architectural Orders as used by Jones came jointly to embody not only the Stuart court's image of its own ancestry but also that of two important institutions with close links to his work. One was of significance to the court, namely the Protestant Garter knights, and the other central to civic life, namely the City Livery Companies.

135 Juan Bautista Villalpando, plan of the Temple of Solomon with the tribes of Israel, zodiac and planets from *In Ezechielem Explanationes* (1604)

* * *

'THE DISPLAY OF HERALDRY':
GARTER KNIGHTS, CITY COMPANIES
AND JONES'S CHIVALRIC ORDERS AT
ST PAUL'S CATHEDRAL

Jones was involved with the Order of the Garter early on in his career, having been present at the conferring of the order in 1603 on Christian IV of Denmark, the brother-in-law of James I, as an act of Protestant alliance. Some of Jones's most important patrons were Garter knights, including the earls of Pembroke and Arundel (who became Earl Marshal in 1622). James had set out to revamp the Garter on assuming the English throne, and he increased both its influence and prominence.[54] As a consequence, it became involved in a number of Jones's court building projects. Providing a setting for the ceremonies of the Garter and their processions including the heralds, with their armorial coats, was an important part of the conception of the Banqueting House, as but one example.[55] Van Dyck's sketch of 1638 for proposed tapestries to the Banqueting House depicts Charles I and the knights in just such a procession, set against an *all'antica* backdrop (see Figs 86–7).[56] Jones's early masque scenes for Prince Henry prefigured this relationship with the Garter. Henry was made a Garter knight in 1603, and the antique scene in the *Barriers* centring on St George's Portico can be understood as a Garter celebration. St George was the Garter's patron saint, and the desirability of reviving the antique columns used for his 'portico' was thus proclaimed early on in the Stuart court as bound up with the equivalent revival of the Garter. Much like the columns, the Garter Order's badge of St George became a visible sign for the early Stuarts of the revival of Geoffrey's British antiquity and its Protestant chivalry. James I, for example, was often pictured wearing the badge (see Fig. 138).

The Garter Order was charged with the symbolic duty to protect London as the New Jerusalem, in the spirit of their crusading ancestors. As such, it was thought to embody an unbroken link past the Crusades to Arthur, and, via Roman occupation, once again to Trojan Brute.[57] Elias Ashmole, the Windsor herald, noted: 'Yet may we very well affirm, *Knighthood* to be neer as ancient as *Valour* and *Heroick Vertue*', and therefore 'may we derive the Original of *military Honor*, whence most of our *Europeans* account it their greatest honor to derive their Original, namely, from *Troy*'.[58] In discussing this origin in the first-ever history of the Garter, Ashmole implied the link between chivalry and the architecture of Vitruvius, who was cited in the text.[59] Moreover, as an aspect of the parallel conception

of Stuart London as a second Rome, the Garter became the focus for the idea of a college, or senate of honour, modelled on the Roman Senate. This college was proposed to the king in 1617 by none other than Edmund Bolton, and was to consist of three classes in echoing the Roman 'Senatus', 'Equestrian Order' and 'Plebeians'.[60] Membership of these classes ranged from the Garter knights at the top, down to 'the most able and most famous lay gentlemen of England', amongst which was Jones.[61] Members were to have extraordinary supervisory powers over the arts, examining all English translations of secular learning and authorising all books other than those on theology, as well as contributing to the creation of a new history of England.[62]

Bolton's college came to nothing, but Garter knights nevertheless played a significant role in the arts along the lines he had envisaged, and a number of them were directly involved in Jones's work at St Paul's. The Garter had a vested interest in the cathedral's restoration. A chantry was dedicated to St George, whilst tombs and stained-glass shields of founding members of the Garter survived and were eventually absorbed, both physically and symbolically, within Jones's refacing.[63] His early scheme for the cathedral tower of 1608, with its mix of *all'antica* and medieval details, had been prepared under the direct patronage of the Garter knight Robert Cecil, 1st Earl of Salisbury (see Fig. 26).[64] The Garter went on to play a central role in the procession to St Paul's in 1620, and of the twenty-five members of the order, seven, according to Dugdale, served on the restoration committee formed that year.[65] They represent the largest single group of court officials to advise on, or maybe even supervise, Jones's early work at St Paul's; 'supervise', since the proposed workings of Bolton's college might suggest the way in which the relationship between the committee and Jones operated at the cathedral. An example of such supervisory powers lay in the design of heraldry, of significance given Wotton's understanding of the Orders, for it was the established role of the Garter Principal King of Arms to oversee the design and grant the use of arms to such as the London Companies, for example.[66] Bolton's own books on heraldry were officially approved by the Garter Principal.[67] The influence of the Garter at the cathedral would have been natural enough, since their worship at Windsor Castle became an important model for the High Church ceremonial later introduced under William Laud at the time of the cathedral refacing; the interior of the order's chapel at Windsor was redesigned with Laud's close involvement and affected aspects of the refacing, discussed in Chapter Eight.[68] The Garter's central importance to the court during

this period was demonstrated in Thomas Carew's masque *Coelum Britannicum* (1634). Jones designed a circular cloud with Charles I at its centre, 'and in the lower part was seen afar off the prospect of Windsor Castle, the famous seat of the most honourable Order of the Garter'.[69] In line with Van Dyck's sketch for the Banqueting House, it is perfectly reasonable to imagine that the Garter knights viewed Jones's new cathedral surface as akin to their heraldry in expressing their own ancient traditions of Protestant chivalry. For the task of restoring St Paul's as Solomon's Temple, in the New Jerusalem of London, would readily have been identified by the Garter knights with the mission of their crusading ancestors to restore Jerusalem to the Christian faith.[70]

The Order of the Garter was not the only influential group linked to the Royal Surveyor's work that might have seen the cathedral's embellishment as akin to their heraldry in its celebration of their mythology and Protestant beliefs. For members of the City Companies supplied the building workforce and served alongside the Garter knights on the two restoration committees, and as such obviously held the work in high regard. Most of the twelve main Companies contributed financially to the building work. Laud sent exhortations to the City, writing to the Barber Surgeons on 30 January 1632, for example, that:

> The general body of this City have done very worthily in their bounty already, also the Lord Mayor, Aldermen and Sheriffs severally, for their own persons. These are, therefore, according to their examples, heartily to pray and desire you, the Master Warden and other assistants of the worthy Company of Barber Surgeons to contribute out of your public stock to the work aforesaid.[71]

Obviously, St Paul's was of special significance to the City of London and its Companies in forming, as Laud put it in this letter, 'the mother church of this City and Diocese'.[72] On completion of repair work to the cathedral after a fire in 1561, a procession went by torchlight to St Paul's that included the Lord Mayor, aldermen and 'all the crafts of London in ther leverey'.[73] It was noted in the previous chapter that on these occasions the City Companies were traditionally responsible for the lavish temporary decorations, with heraldry and such like. Many of the Companies were celebrated in more permanent form in the fabric of St Paul's through their heraldry in stained glass and chantries.[74]

It was also noted that the mythology of the City Companies had much in common with that of the court, and especially with the Garter knights. Ashmole

for one implied an ancient link between the craft of masonry and the Garter in his description of 'the elegant and beauteous structure' of St George's Chapel at Windsor (Fig. 136).[75] Orders of chivalry and craft associations, masonry in particular, were both understood in the seventeenth century as secret societies, with shared legends and traditions expressed through their ensigns.[76] Like the Garter, the twelve Companies and their heraldry were linked to Brute's Troy Novant in festivals such as Dekker's *Troia-Nova Triumphans* (1612) and in works of antiquarianism such as Stow's *Survey of London* (1633 edition). The Company ensigns were illustrated alongside Jones's resurfaced cathedral and references to Trojan foundation on William Faithorne's map of London of 1658. With Stuart London cast as the New Jerusalem in sermons, and with it 'protected' as such by the Garter, it follows that the twelve tribes of Israel became an obvious biblical

136 The medieval chapel at Windsor Castle, engraved by Wenceslaus Hollar from Elias Ashmole's *The Institution, Laws & Ceremonies of the Most Noble Order of the Garter* (1672), p. 139

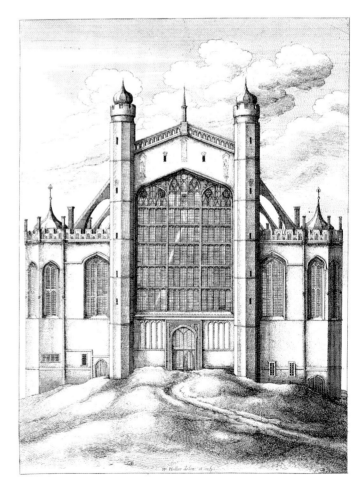

model for the twelve Companies in parallel to the alternative celestial one represented by the signs of the zodiac. In the case of those concerned with building, even closer biblical links existed, since like the Garter these Companies traced their origins back to Solomon's Temple.[77] For example, according to Bolton the building Companies had inherited 'Arch-mysteries' employed on the Temple:

> an hammer Smith, or worker in yron, that being one of those Arch-mysteries . . . Nay, there belonged in Gods owne judgement so great praise to the particular excellency of some artificers, as that, in the building of *Salomons* Temple, they are registered to all posterities in Scripture; and their skill is not onely made immortally famous, but a more curious mention is put downe of their parentage, and birth place, then of many great Princes, as in *Hirams* case, not he the King, but the brasse-founder.

In the same way, the origins of the art of stonemasonry and the carving of the stone Orders had been linked in the Solomonic mythology cultivated by the masons. Bolton further related that St Paul was himself initiated in the mysteries of the building crafts:

> And in the new Testament, *S. Paul* . . . had the manuall Art of *Scoenopoea*, commonly englished, Tent-making: upon Wch place of *St. Pauls* trade . . . [he] was brought up so, by a traditionall precept, binding such as would studie sacred letters, to learne some one or other mysterie in the Mechanicks.[78]

Bearing in mind the cathedral's dedication to St Paul and the task of its restoration as Solomon's Temple, the masters and apprentices working for Jones could easily have also identified the refacing as a celebration of their own antique, biblical origins. The scale of work involved many of the building Companies, given that plumbers, masons, bricklayers and carpenters were all essential.[79] Their understanding of it in this way is suggested by *Portland-Stone in Paules-Church yard. Their Birth, their Mirth, their Thankefulnesse, their Advertisement* (1622), which was addressed by the private citizen Henry Farley to the king and members of the 1620 royal commission. The cathedral was restored on 'Pauls-Sion Hill' and the workmen and commissioners were jointly exhorted:

> So now you Workmen, listen what we say, . . .
> Learne by the Scriptures what you ought to doe,
> Let them direct your hands and conscience to;
> *Ezra, Ne'miah, Chronicles*, and *Kings*,
> And *Haggai* will show you many things:

> How justly men did worke about the Temple,
> Which there is Registred for your example.[80]

The biblical books of Ezra and Nehemiah record the foundation of Solomon's Temple, Chronicles the architect's name, Hiram (Huram), and Kings its architectural details; the prophet Haggai had exhorted the rebuilding of the Temple, in whose footsteps Farley had followed.

Whilst City officials and clerics played an important role in the refacing proposals of 1620, it was in fact Farley who spread most propaganda in favour of the cathedral restoration. He was, according to Dugdale, 'extreamly zealous to promote the work' and issued his series of appeals between 1616 and 1622.[81] It was noted in the previous chapter that one of these appeals consisted of a diptych painted by John Gipkyn, the outside leaf of the first panel of which depicted a royal procession that recorded, or more likely prefigured, the events of 1620 (see Fig. 82). On the second panel Farley had represented a speculative restoration of his own (Fig. 137). This painting illustrated a poem by him entitled *The Complaint of Paule's* (1616), which concluded with 'The Dream', in which the cathedral became 'beautified' with chivalrous emblems.[82] On the west pinnacle:

> was the picture of King James:
> His *Armes* were in the highest plane,
> And then many noble man,
> Had their *Armes* under *His*.[83]

The four pinnacles and their heraldry reflected the divisions in Stuart society, for to the east was a bishop, 'on the toppe his *Scutchion* stood', to the north a Lord Mayor, 'the *Cittie Armes* were highest there', and to the south a farmer, 'A *wheat-sheafe* was his *Armes* I trowe'.[84] All were seen to have an equal stake in the work. Further, Farley included images of Queen Anne, Prince Charles, Princess Elizabeth and, finally, 'Denmarks royall King' (the Garter knight Christian IV). This bore some similarity to Jones's later restoration, given that his portico supported the statues of the two Stuart kings, dressed in armour (see Fig. 247).[85] It has been seen that it was possibly intended for these statues to be flanked by those of the Saxon kings who had founded the cathedral, as the engraving by Flitcroft of 1727 illustrates, but these statues were never put in place (see Fig. 252). If they had been they would have evoked memories of *Prince Henry's Barriers*, with its potent chivalrous imagery of porticoes and statues. Like heraldry, statues were generally understood by Stuart commentators as having served as emblems of chivalry in antiq-

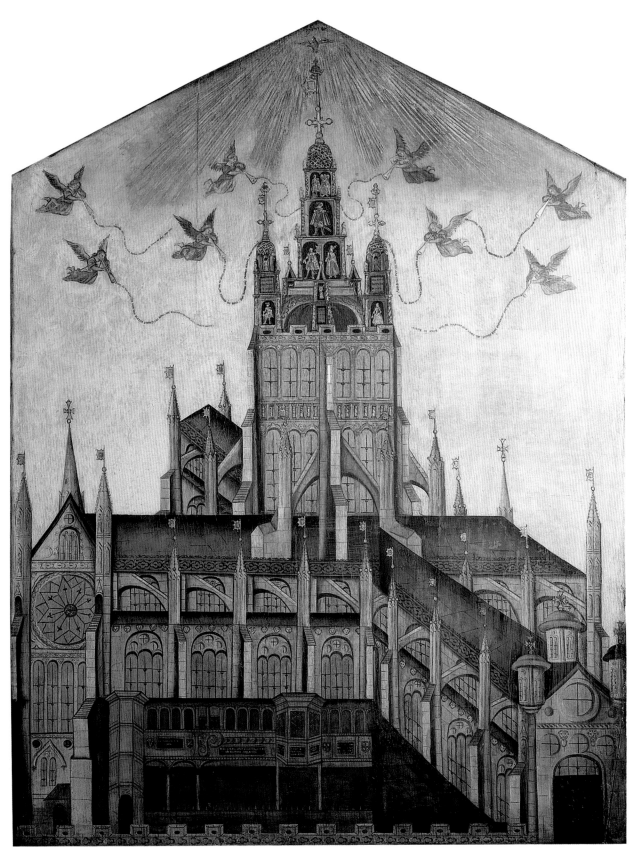

137 John Gipkyn for Henry Farley, 'restored' tower of St Paul's Cathedral (second inner panel of diptych), *c.*1616. The Society of
Antiquaries, London

uity.[86] In this way, Farley's imaginary restoration pre-figured not only the theme of the royal procession cel-ebrated in the eventual work, but also elements signi-fying royal chivalry and heraldry proposed by Jones for the cathedral.

Farley provides a rare clue as to how ordinary citi-zens and workmen understood their activities at St Paul's. Much like the Garter knights advising on restoration, each building Company must surely have seen the proud task of refacing the old cathedral, using the ordered language of classical forms, as a triumph of its own craft and its antiquity. As Jonson remarked in the *Barriers*, antiquity was equally a time 'When every stone was laid by virtuous hands'.[87] Through carving and erecting Jones's columns and pilasters, the masons in particular might reasonably have imagined that the building was being decorated in their heraldry, as it had been, albeit temporarily, during processions.[88] After all, the Trojan and Solomonic antiquity of Jones's style, as understood by the court, was also cultivated by the building Companies and Garter knights through their respective heraldry.

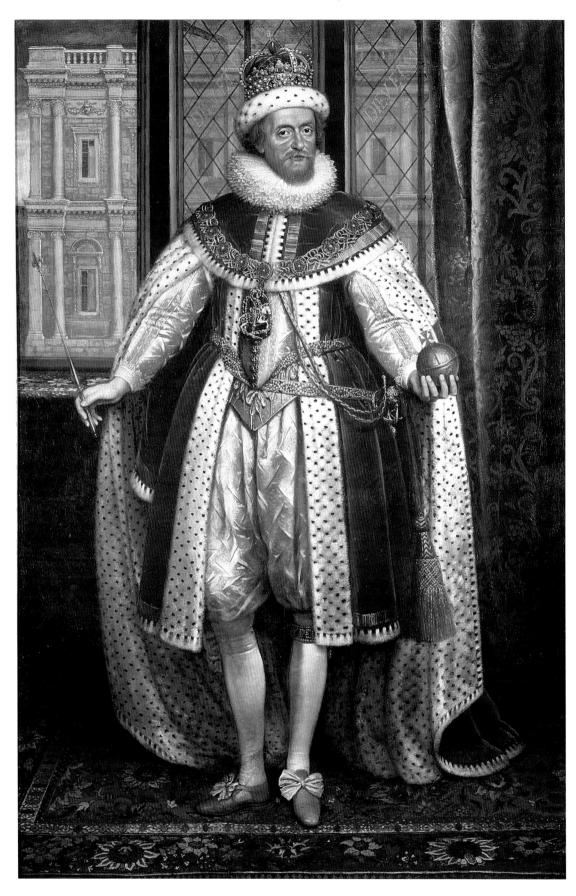

138 Paul van Somer, *James I and the Banqueting House*, c.1620. Royal Collection

HER MAJESTY RESEMBLED
TO THE CROWNED PILLAR:
THE BODY OF JONES'S COLUMNS AND
THE LEGAL BODY OF THE STUART KING

All'antica columns were initially used in England to ornament the doorways and windows of the provincial houses built by members of the Elizabethan and early Stuart courts. It has been seen that these early columns had associations with heraldry and other forms of elite display. This link between English nobility and the columns was subsequently underlined by their use alongside more traditional emblems of monarchy on James I's arches of 1604 (see Figs 78, 80, 81). Here the body of the king and the new architectural style were introduced together, to the crowd's evident delight. Jonson went on to make clear in *Prince Henry's Barriers* of 1610 that the 'obelisks and columns broke, and down' were a perfect reflection of 'the style of majesty'.[1] As the previous chapters have shown, these two early royal events – processions and masques – must have conditioned how Jones saw the Orders when designing for his royal patrons. In line with these festive links between columns and majesty, this chapter will propose that the shaft or 'body' of the columns on Jones's court buildings was understood by him to express the idealised body of the king. Jones was, after all, a committed royalist. Such an understanding is given force by the fact that the king's body was universally celebrated in Stuart art as the very pattern of the fundamental Vitruvian qualities of symmetry and proportion. If the king's body is accepted as the ultimate 'pattern' of Jones's columns, then it follows that they would have been seen by the Royal Surveyor as representing the crucial power that

the monarch embodied. This was the ability to make law by Divine Right.

'JUSTICE, EQUITY AND PROPORTIONS': LEGAL PRACTICES AND VITRUVIAN RULES

Heraldry was not the only medieval practice to provide a means by which the new architectural style could be explained. Although not perhaps immediately apparent, well-established legal concepts and the less-familiar principles of *all'antica* architecture had much in common.[2] The English translations of architectural terms central to the Vitruvian canon had a natural counterpart in legal terminology widely employed in Stuart statutes. Proportion and harmony, order and decorum, symmetry and balance, licentiousness and the rule, as well as scale and measure, all featured in the theory of both disciplines. Moreover, 'ordinance' was defined as the set of rules governing the design of the architectural Orders (particularly their proportions) and, especially in France, as a law of the king.[3] Daniele Barbaro in his commentary to Vitruvius, first published in 1556 and studied by Jones in the 1567 (Italian) edition, had explained the concept of architectural proportion through citing those of equity and justice in his introduction to Book Four on the Orders. Jones translated Barbaro's comment that: 'Euruthmia is the

tempering of the proportion applied to the matter as equity is to justice.'

Medieval legal disputes had frequently centred on issues of scale and measure, as the *Merchant of Venice* (*c.*1600) dramatises, whilst judgements were passed with reference to proportion. As with heraldry, this legal tradition provided a useful native reference-point in the earliest English explanations of the principles of scale and proportion, equally implicit in the Orders, that it is known Jones studied. The polymath John Dee, in his 'Mathematical Preface' to the English Euclid of 1570 that Jones consulted in his work at St Paul's Cathedral, outlined mathematical arts including law and Vitruvian architecture.[4] Addressing his intended readership of artisans and builders he first noted:

> What nede I, (for farder profe to you) of the Schole-masters of Justice, to require testimony: how nedefull, how frutefull, how skillfull a thing *Arith-metike* is? I meane, the Lawyers of all sortes. Undoubtedly, the Civilians, can mervaylously declare: how, neither the Auncient Romaine lawes, without good knowledge of *Numbers art*, can be perceived.

Dee also made a specific analogy between proportion and the law, of relevance to the contemporary understanding of *all'antica* architectural principles based on proportion: 'what proportion, 100 hath to 75 . . . Which is *Sesquitertia*: that is, as 4 to 3 . . . Wonderfull many places, in the Civil law require an expert *Arithmeticien*, to understand the deepe judgment, & just determination of the Auncient Romaine Lawmakers.' He continued by echoing Barbaro that: 'in the lawes of the Realme . . . justice and equity might be greately preferred, and skilfully executed, through due skill of Arithmetike, and proportions appertainyng'.[5]

Dee's justification of the importance of number through reference to how proportion functioned in law served as an introduction to a similar explanation concerning the less well-understood importance of proportion to architecture:

> But marveilous pleasant, and profitable it is, in the exhibiting to our eye . . . the plat of a Citie, Towne, Forte, or Pallace, in true Symmetry . . . &c. Hereby, the *Architect* may furnishe him selfe, with store of what patterns he liketh: to his great instruction: even in those thinges which outwardly are proportioned: either simply in them selves: or respectively, to Hilles, Rivers, Havens, and Woods adioyning.

Dee went on to make it clear that he was talking about *all'antica* architecture via more standard references to Vitruvius and Leon Battista Alberti: 'We thanke you Master *Baptist*, that you have so aptly brought your Arte, and phrase therof, to have some Mathematicall perfection: by certaine order, number, forme, figure, and Symmetrie *mentall*: all naturall & sensible stuffe set a part.'[6] Ancient architectural and legal practices thereby shared a conformity to nature's laws through their particular dependence on numerical proportions and Euclidean geometry.[7] Dee's emphasis on number and proportion as the interrelated key to both ancient practices represented an attempt to underline their compatibility with the values, or rather what would increasingly become the value-free claims, of the natural sciences. This was in the face of native suspicions towards arts such as *all'antica* architecture and sculpture, with their pagan and sometimes Catholic superstitious associations.

As if to echo Dee, Jonson's poetry equated the language of Vitruvian theory with qualities of moral 'solidity' and justice.[8] Wotton too would use a legal metaphor when explaining the rules of proportion through translating the Roman rhetorician Quintilian on painting: 'Parasius did exactly limit all the Proportions so, as they call him the Law giver, because in the Images of the Gods and of Heroicall Personages, others have followed his Paternes like a Decree.'[9] Hence the early modern texts on *all'antica* architecture by English theorists relied on practical and metaphorical legal analogies to explain the principles of proportion. These theoretical analogies can be seen to have paved the way, as it were, for Jones's expression of the traditional legal concept of the king's 'two bodies' through his decoration of court buildings.

'MARKING THE PILLARS AND PINNACLES': THE BODY OF JONES'S COLUMNS AND THE 'TWO BODIES' OF THE KING

The fundamental link between the human body and *all'antica* building practice was spelt out in the only English treatise on architecture to be published during Jones's lifetime. Wotton, in *The Elements of Architecture*, advised his reader 'to passe a running examination over the whole *Edifice*, according to the properties of *a well Shapen Man*'.[10] Vitruvius recorded that the various antique columns had imitated male or female bodies, from masculine Doric to maidenly Corinthian (IV.i.6–8). These Vitruvian archetypes were reflected quite literally in a design by Jones and Webb for the King's Court and the Queen's Court at Whitehall

Palace of around 1638. Here, standing in for columns, male caryatids support a Doric entablature and, above these, female caryatids support a Corinthian one (Fig. 139). The human basis of the columns' proportions was probably well enough understood by Stuart builders, given the powerful characterisation of the Five Orders by Shute in his albeit rare architectural treatise of 1563 (see Figs 153, 159–62).[11] Robert Stickells, working during the Elizabethan period but alive until 1620, displayed a primitive knowledge of Vitruvian theory when commenting on building proportion: 'These thinges consisteth in man hime self, for that man is the proporctinall & Reasonable creature.'[12] Wotton noted with reference to Vitruvius that the height of the Tuscan Order

> shall be six *Diameters*, of the grossest [i.e., thickness] of the Pillar below. Of all proportions, in truth, the most naturall; For our Author tells us, *lib.3.cap.I.* that the foote of a man is the sixt part of his bodie in ordinary measure, and *Man* himselfe . . . [is] as it were the *Prototype* of all exact *Symmetrie*.[13]

Jones studied these ideas at first hand in his copy of Vitruvius, where he observed that: 'the boddi of man well proporsioned is the patern for proportion in buildings', adding: 'the round figure forms the Bodi of man'.[14] He referred here to Vitruvius's description of the perfect body of man encompassed by a circle and a square, as famously illustrated by Leonardo da Vinci and in architectural treatises (Vitr. III.i.3; Fig. 140). His close analysis of human proportion is evident in numerous drawings of figures for masque costumes as well as in studies of the body that fill his 'Roman Sketchbook' and in other sketches (Figs 141–2).[15] An allusion to this obsession can be found in Jonson's *A Tale of the Tub* (1633), where a character who satirises Jones called 'In-and-In Medlay' exclaims with a nod to Vitruvius: 'A Knight is six diameters; and a Squire / Is vive, and somewhat more: I know't by compasse, / And Skale of man'.[16] Here the proportional system of the Orders, measured against the human body, has become appropriated to express native social and chivalrous distinctions, much as Wotton had argued.

Jonson's interconnection between social hierarchy and bodily proportion made in the context of Jones's work for the king is suggestive. For it was surely the idealised body of no lesser figure than the king that the Royal Surveyor, and indeed the Stuart populace as a whole, would have identified as setting the ultimate pattern for his well-proportioned court architecture. In an earlier work, of 1620, Jonson had urged that when viewing James I's body,

139 John Webb and Inigo Jones, design for the elevations of the King's Court and the Queen's Court, Whitehall Palace, London, *c.*1638 (detail of Fig. 16)

> Read him as you would do the book,
> Of all perfection, and but look,
> What his proportions be;
> No measure that is thence contrived,
> Or any motion thence deriv'd,
> But is pure harmony.[17]

Perhaps not surprisingly, the king's body was consistently celebrated in Stuart art and propaganda as the exemplar of earthly harmony. As such, it became seen as the ideal microcosm and pattern of perfect proportion. For the Stuart apologist George Marcelline, the body of Charles I was 'composed of the purest mold

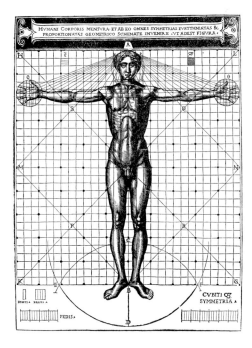

140 Vitruvian man as Christ: a (*left*) from Cesare Cesariano, *De architectura* (1521); b (*below left*) from Fra Giocondo, *M Vitruvius per Iocundum solito castigatior factus* (1511); c (*below right*) from Pietro Cataneo, *I Quattro primi libri di architettura* (1554)

that lodged in the bosome of Nature', so that 'indeed he seemeth the Masterpeece of Nature'.[18] Marcelline went on to extend this praise of the king's body using the body-building metaphor, in proclaiming the 'stateliness of the building' and 'rareness of the edifice'.[19]

Idealisations of the royal body reflected the medieval concept that the king possessed not only a human or physical body, but also a divine or mystical one. This was a legal and religious notion termed the king's 'two bodies'.[20] Whilst one body was subject to decay, the other was an embodiment of the monarch's sovereignty

and prerogatives, and as such was immortal. Ernst Kantorowicz notes that 'the anointed King appeared as a "twinned person" because *per gratiam* this King reflected the two natures of the God-man, "man by nature and, through his consecration, God by grace" '.[21] An important sign of the immortality of the monarch's body in the popular imagination was his supposed power to cure the 'King's Evil' through touch. James took part in ceremonies in the Banqueting House involving this semi-magical belief.[22] He often wrote that the king was two persons – as a man he was

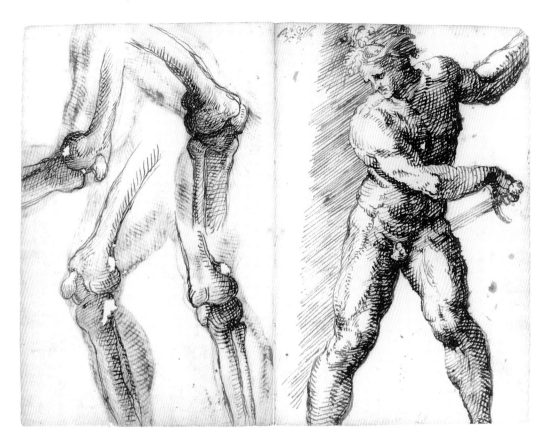

141 Inigo Jones, studies of the body in the 'Roman Sketchbook', fols 24*v*–25*r*. Devonshire Collection, Chatsworth

mortal, whilst as sovereign and head of the Church he ruled with divine power in succession to the Old Testament kings and to Christ. When he spoke before the Lords and Commoners in March 1610 to justify the Protestant doctrine of Divine Right he observed that

> THE state of MONARCHIE is the supremest thing upon earth. For Kings are not only GODS Lieutenants upon earth, and sit upon GODS throne, but even by GOD Himselfe they are called Gods . . . a King is truly *Parens patriae*, the politique father of his people. And lastly Kings are compared to the head of this Microcosme of the body of man.[23]

The Stuart kings saw their sovereignty as sanctified by the God-given right to make law by statute, and this 'Divine Right' represented the most important practical manifestation of their powers. Royalists maintained that the king alone made the law in Parliament, acting with its advice and consent but without actually sharing the right to legislate. The concept was known as the 'order theory of Kingship' and was equated with the king's 'immortal' or 'legislative body'.[24] This is what James was

saying to Parliament in placing himself at the 'head' of the body politic conceived as a microcosm. As Shute had earlier made clear when dedicating his treatise on the Orders to Elizabeth I, a body politic is a commonwealth; its parts form an integrated whole, as in *all'antica* architectural design, with a head to rule and everything in its place and in proportion.[25]

The idealisation of the king's body in court policy and art, and its expression of the king's legal prerogatives, also emphasised the Stuart monarch's role as a Christian prince directly empowered by God. This was because Christ, as the archetypical prince, was traditionally celebrated as the ultimate human embodiment of divine proportion. Hence the so-called Vitruvian man was represented as a crucified figure by Cesare Cesariano in his edition of 'Vitruvius' of 1521 (see Fig. 140a).[26] It would therefore have been perfectly natural for Jones and indeed his royal patron to have identified the harmonious properties of the king's 'ideal' or legal body, as cultivated elsewhere in Stuart art, with the Vitruvian form; and then to have sought to reflect these royal virtues through the symmetry and proportions of

142 Inigo Jones, eleven studies of heads arranged in three rows, general sheet probably from a Sloane volume. British Museum, London

143 (*above*) Albrecht Dürer, *Flagellation of Christ*, woodcut, 1496–7. British Museum, London

144 (*right*) A verse entitled 'Her Majestie resembled to the crowned pillar' in George Puttenham's discussion of proportion in *The Arte of English Poesie* (1589)

his court architecture, the possibility for which had been implied by Barbaro and Dee. This would have been especially pertinent given that the theory of Divine Right, and the 'ideal' body of the king that underpinned it, became the pre-eminent political and legal theory in Stuart England.

More particularly, the form of the column, with its shaft or 'body', obviously lent itself to the expression of this theory, or in other words to the concept of the king's 'two bodies'. Like the king, the antique column as described by Vitruvius was composed of two bodies: one visible, based on the human features of head and torso, and the other invisible, based on ideal human proportions exemplified by Christ. (As if to emphasise their relationship, Christ and the antique column were bound together more literally still at the time of his flagellation, as Piero della Francesca and Albrecht Dürer famously depicted; Fig. 143).[27] Furthermore, the body

of the king and that of the column were considered as both material *and* transcendent. The column's constituent ornament was, like the physical body of the king, subject to decay; while the essentially invisible canonical proportions of the column were by their nature immortal, like the king's 'divine' body. During the period when Jones was active there is no doubt that proportion was understood as a quality that was invisible, and which had certain beneficial magical properties similar to the king's powers. Dee described 'the necessary, wonderfull and Secret doctrine of Proportion', for example, and Wotton pointed to the talismanic capacity of architecture to 'ravish the Beholder . . . by a secret *Harmony* in the *Proportions*'.[28] Whatever the physical state of an antique façade, it was

80 OF PROPORTION. LIB. II.

The Piller, Pillaster or Cillinder.

The Piller is a figure among all the rest of the Geometricall most beawtifull, in respect that he is tall and vpright and of one bignesse from the bottom to the toppe. In Architecture he is considered with two accessarie parts, a pedestall or base, and a chapter or head, the body is the shaft. By this figure is signified stay, support, rest, state and magnificence, your dittie then being reduced into the forme of a Piller, his base will require to beare the breath of a meetre of six or seuen or eight sillables: the shaft of foure: the chapter egall with the base, of this proportion I will giue you one or two examples which may suffise.

Her Maiestie resembled to the crowned pil-ler. Ye must read vpward.

Is blisse with immortalitie.
Her trymest top of all ye see,
Garnish the crowne
Her iust renowne
Chapter and head,
Parts that maintain
And womanhead
Her mayden raigne
In te gri tie:
In ho nour and
with re ri tie:
Her roundnes stand
Strēgthen the state.
By their increase
with out debate
Concord and peace
Of her support,
They be the base
with stedfastnesse
Vertue and grace
Stay and comfort
Of Albions rest,
The fourme Pillar
And seene a farre
Is plainely exprest
Tall stately and straight
By this no ble foure traict

Philo to the Lady Calia, sendeth this Odolet of her prayse in forme of a Piller, which ye must read downward.

Thy Princely port and Maiestie
Is my ter ren: dei tie,
Thy wit and sence
The streame & source
Of e lo quence
And deep: discours,
Thy faire eyes are
My bright loadstarre,
Thy speach: a darte,
Percing my harte,
Thy face a las,
My loo king glasse,
Thy loue ly loo es
My prayer bookes,
Thy pleasant cheare
My sunshine cleare,
Thy ru full sight
My darke midnight,
Thy will the stent
Of my con tent,
Thy glo rye floure
Of myne ho nour,
Thy loue doth giue
The lyfe I lyue,
Thy lyfe it is
Mine earthly blisse:
But grace & fauour in thine eies
My bodies soule & souls paradise.

145 Anthony Van Dyck, the column and the crown: *Charles I, Henrietta Maria and their Eldest Children, Prince Charles and Princess Mary*, 1632. Royal Collection

146 Anthony Van Dyck, the column and the crown: *Charles I*, 1636. Royal Collection

the proportions of the individual elements – and especially of the column as its principal ornament – that lent harmony to the whole design. Some monuments in Rome may have been ruined, but their proportions were nearly always perceived as still intact by Renaissance architects, including Jones. Closer to home, the monoliths of Stonehenge, although much decayed, evidently preserved in his view the 'harmoniacall proportions, of which only the best times could vaunt'.[29] Their preservation allowed Jones to identify the stones with the plain Tuscan Order, in the absence of the actual mouldings (see Fig. 68).

Shute went so far as to elevate the humble Tuscan to regal status in representing the column as proportioned after Atlas, king of Mauritania (see Fig. 159). Elizabethan poets had made direct links between the form of the antique column and the royal body. In George Puttenham's discussion of proportion in *The Arte of English Poesie* (1589), a verse in praise of Elizabeth is column-shaped and entitled 'Her Majestie resembled to the crowned pillar' (Fig. 144).[30] The column's 'pedestal', body and capital stand in, as it were, for the monarch with her crown. Here the reading of the column as a 'Pillar of State' could not be more apropos. The verse even identifies the column as 'The Sounde Pillar Of Albions rest'. It will be recalled that the body of the queen and that of the antique column were linked in royal imagery, such as that by Crispin de Passe (Senior) showing Elizabeth standing between two Corinthian columns (1596; see Fig. 112).[31] Somewhat later, Van Dyck and Daniel Mytens on a number of occasions pictured Charles I directly below a single column shaft (and sometimes next to a crown as, by implication, a parallel sign of sovereignty; Figs 145–6). The bodies of the king and the column were almost fused in these carefully composed images. The link between the king's body and Jones's columns was also alluded to in court propaganda. The sermon preached in 1620 at St Paul's by the Bishop of London, and written with the king's assistance, to announce the restoration of the cathedral through new *all'antica* façades made reference to 'the bodie of the King, a building not made with hands, but shaped of flesh and bloud'. For the king, 'himselfe shall come, *and stretch his body upon the body*, afford his owne bodily presence' and 'marke the pillars and pinnacles, and make it his princely care'.[32]

★ ★ ★

'CROWNING PEACE WITH LAW': JONES'S ARCHITECTURE OF STUART JUSTICE

One reason why this understanding of the column would have found favour with Jones's royal patrons was the fact that the legitimacy of the king's legal powers needed asserting, since it could not be taken for granted. This much concerned James following the act of royal union and his succession in 1603 to the newly created 'British' throne. The question surrounding the extent of the monarch's powers defined in relation to natural law was the central theme of Shakespeare's tragedies, as with *King Lear*, which was performed at court in 1606. An important characteristic of the later Stuart period was the battle between the institutions of court and Parliament concerning their respective statutory powers. The concept of the king's 'legislative body' was countered by Parliament's three estates – the Bishops, Lords and Commoners – some of whom argued the so-called community-centred view that the king shared the law-making powers with them.[33] This conflict led to Charles I's eleven-year period of 'Personal' or prerogative rule, when he made law without the consent of Parliament following its dissolution in 1629, and after 1642 it defined even more dramatically the battle lines of the Civil War.[34]

Not surprisingly, it was the king's view as to his legal powers, necessarily vested in his body, that early court art sought to affirm and Jones's masque architecture to consolidate. The mutual harmony of natural justice and the king's legal prerogative was frequently celebrated in court masques and poetry. Thus, Jonson eulogised the first visit of the newly crowned monarch to Parliament in 1603 by presenting Stuart England as the home of harmonic justice. This was symbolised by the descent from heaven of the Greek goddess of law and personification of justice, Themis, together with her daughter, Eunomia, who were 'but faintly known / On Earth, till now, they came to grace his Throne'.[35] Successive court masques emphasised the king's relationship with the law as the source of earthly harmony expressed through Jones's ordered *all'antica* settings. In the masques for James I, personifications of peace (Irene), as well as her heavenly sisters harmonic justice (Dice) and law (Eunomia), were presented as royal virtues set within Jones's piazzas and column-lined, porticoed temples. Jones and his friend George Chapman created *The Memorable Maske of the two honorable houses, or Innes of Court: the Middle Temple, and Lyncolns Inne* (1613) to celebrate the marriage of Princess Elizabeth to Fredrick V; here Eunomia served as a priestess in a temple to

147 The figures of Minos (on the left) and Numa (on the right), royal law-givers of Greece and Rome, in Jones's proscenium for the masque *The Triumph of Peace* (1634). RIBA Library Drawings Collection, London

Honour, which was formed from 'an octagonal figure, whose pillars were of a composed order, and bore up an architrave, frieze, and cornice'.[36] Again hardly surprisingly, under Charles I the justification of prerogative rule came to influence all court art, especially masques.[37] The figures of Minos and Numa, royal law-givers of Greece and Rome, were used as statues in Jones's ornamental proscenium for *The Triumph of Peace* (1634; Fig. 147). This masque stressed James's Virgil-inspired motto that there can be no peace without law ('to crown Peace with Law'), and that only from their mutual harmony can justice prevail.[38] All three virtues were once more represented to the court through Jones's Roman architecture, as the embodiment of the civil order and decorum that the law upheld. His own interest in ancient civil decorum, and the philosophy of ethics in particular as the basis of Vitruvius's ideas on architectural decorum, is evidenced by his close study of Xenophon, Aristotle, Plutarch and the

Renaissance moral philosophy of Alessandro Piccolomini. And his faith in the power of architecture to lend decorum to society is attested by his Stonehenge thesis in which he argued that it was only upon being taught the '*Romane* manner of *Architecture*' that the ancient Britons acquired Roman civil order.[39]

The celebration of royal justice extended into court sermons where, following Dee, proportion became used as an obvious metaphor. In the course of eulogising James's rule in 1610, Marcelline had compared the royal 'figure' or 'number of *Justice*' with a cube's ideal 'Triple-dimension of length, bredth, and depth'.[40] And the Bishop of Bristol, John Thornborough, in warning against the disunity of Britain apparent in 1641 on the eve of the Civil War, noted that 'a common Weale may fitly be resembled to musicall instruments', and the 'harmony is in the unity of proportion with agreeable consent of distinct sounds'.[41] Here again harmonic proportion represented civil order and justice affirmed by

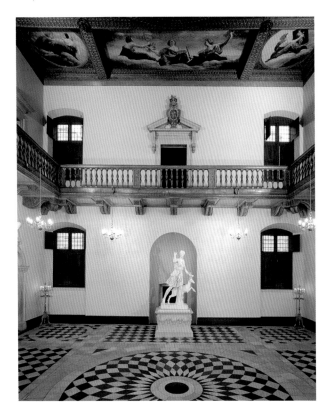

148 Inigo Jones, cubic hall of the Queen's House at Green-
wich, 1632–8

the king. As far as Thornborough was concerned, the
Stuart monarchy justly distributed its virtues 'equally,
and graciously among all, by Geometricall propor-
tion'.[42] In its reliance on geometry and proportion,
Jones's work as Royal Surveyor somewhat inevitably
gave physical expression to these ideals. This is almost
certainly how Marcelline or Thornborough would have
interpreted the proportions of many of Jones's interi-
ors. The Banqueting House was given the proportions
of a double cube (55 feet by 55 feet by 110 feet), for
example, and the cube or its multiple was a common
feature of his work. The interiors of his Catholic
chapels at St James's Palace and Somerset House were
both double cubes, a form later used at Wilton by Webb
(with advice from Jones), whilst the Great Hall in the
Queen's House is a single cube (Fig. 148).

Jones also celebrated the theme of Stuart justice and
legal authority in the iconography of his projects for
the court and Church. At St Paul's Cathedral, for
example, the work on which was carried out during
the years of Charles's 'Personal rule', the statues of James
I and Charles I that surmounted the royally funded
portico only served to emphasise, somewhat controver-
sially as it would turn out, that the king's prerogatives

were invested in his body. Here the royal figures were
upheld, both literally and symbolically, by Jones's
majestic Corinthian columns (see Fig. 1).[43] The Corin-
thian columns on his proposed arch at Temple Bar
frame emblems representing the king's sovereignty and
legal prerogatives (see Fig. 99). And Jones's unbuilt
design of 1617 for a new Star Chamber has giant
columns, again of the regal Corinthian Order, making
the link between the royal prerogative and Stuart *all'
antica* architecture explicit (Figs 149–50).[44] It was in the
high court of Star Chamber that the king met with the
Privy Council to issue royal proclamations (amongst
other duties), and it became a powerful symbol of sov-
ereignty independent of Parliament and the judiciary.[45]
In selecting a suitable model for this column-lined
basilica, with its apse 'celebrating' the bodily presence
of the royal judge, Jones turned to Palladio's descrip-
tion of the ancient basilica 'in which judges presided
under cover to administer justice' and where a great
niche was recommended for 'the tribunal of the praetor
or the judge' (Book III, chapter 19). Palladio's temple to
the Sun and Moon also influenced the design, again
appropriate since the sun was the principal symbol of
divine authority (see Fig. 110).[46] The existing chamber
for the dispensing of Stuart justice at Westminster was
adorned with a huge star on its ceiling and was hailed
in Thomas Carew's masque *Coelum Britannicum* (1634)
as the 'eighth room of our celestial mansion'.[47] Stuart
justice was thereby presented as a direct reflection of
the natural order of the macrocosm, an understanding
that Jones's harmonious designs clearly sought to
embody.

149 John Webb, after Inigo Jones, revised section of the Star
Chamber, c.1660. Worcester College, Oxford

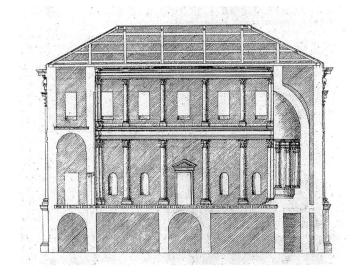

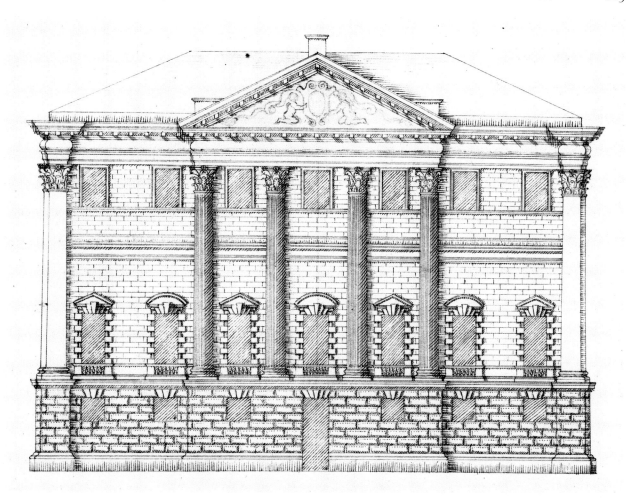

150 John Webb, after Inigo Jones (scheme of 1617), elevation of the Star Chamber, Whitehall, *c.*1660. Worcester College, Oxford

★ ★ ★

In this way Jones's court architecture can be understood as a persuasive attempt to proclaim in stone the Stuart monarch's legal legitimacy and law-making powers. This was equivalent to the more transient and private justifications made in the court masques for which he designed *all'antica* settings. If the 'perfect' numbers and canonical proportions that he used to compose his columns and rooms were seen to reflect the absolute, divine qualities of the royal body, as seems likely, then they would have also reflected the absolute Divine Right of his royal patron to rule by statute law.[48] For this right too was traditionally represented by the king's body. According to this view concerning the purpose of Jones's work, royal decorum was expressed by architectural decorum; the 'order theory of kingship' was represented by the use of the Orders; and the balanced, natural justice of statute law and 'equity' was matched

by the Vitruvian canons of symmetry and proportion, much as first Barbaro and then Dee had suggested. In Jones's designs the individual column stands as a 'pillar' of royal justice.

This is surely the domestic message of Paul van Somer's portrait of James I (Fig. 138).[49] The king is pictured in a traditional pose with crown, Garter necklace, orb and sceptre, standing in front of the Protestant motto 'Dieu et mon droit' (God and my Right, engraved in the glass of the window), and a partial view of Jones's Banqueting House. Given that the building was incomplete at the time of the portrait, around 1620, its detailed presence here is not accidental and Jones must have had an involvement in the painting. What by this date had become a conventional bodily image of the Protestant king, with his badges of sovereignty, is combined with and authenticates Jones's revolutionary new architecture.[50] The symmetry and proportions of Jones's façade are the natural counterpart of those of

the king's body which the picture dramatises and perfects. And the link between the policy of Divine Right and Jones's façade is made equally explicit. James is represented as the very embodiment of absolutism, reflecting his role as the 'new Caesar' in court sermons, and as such he is necessarily identified once more with the architecture of Rome.

'CELESTIAL MANSIONS':
STUART LONDON AND
THE 'IDEAL' COMMONWEALTH

The ideals of natural law and justice are fundamental to the well-governed state, whether princely or republican. Shakespeare's *Merchant of Venice* sought to dramatise to the Stuart citizens the implications of losing sight of this fact. This is why James stressed the antique-biblical roles of the king as the wise judge, lawgiver and indeed builder through his identification with Solomon and Augustus in court mythology. His cultivation of the role of 'peacemaker' in negotiations such as the Spanish Match also emphasised these judicial qualities, as a type of supreme Justice of the Peace. Through a series of new, well-ordered building façades the Stuarts aimed to transform London into the seat of royal justice, and it became a city conceived in succession to Rome as the imperial (Protestant) centre from which law and order emanated. The law was itself used as an instrument to realise this symbolic objective. In building statutes issued by James in 1615 and 1619, almost certainly with advice from Jones, London was again projected as a second Rome restored by its new Augustus (Fig. 151).[51] Here James observed that:

> We doe well perceive in Our Princely wisdom and providence, now, that our Citie of London is become the greatest, or next the greatest Citie of the Christian world . . . as it was said by the first Emperour of Rome that he had found the Citie of Rome of Bricke, and left it of Marble, so that Wee, whom God hath honoured to be the first king of Great Britaine, mought bee able to say in some proportion, that Wee had found our Citie and Suburbs of London of stickes, and left them of Bricke.[52]

The expression of the king's legislative authority through the control of new building work was a central tenet of these statutes, and, not surprisingly, they were denounced by the House of Commons in 1624 as 'a great grievance to the freedom and state of the subjects'.[53] An essayist wrote in 1659 that London's buildings, 'by their diversity of frontings do declare a

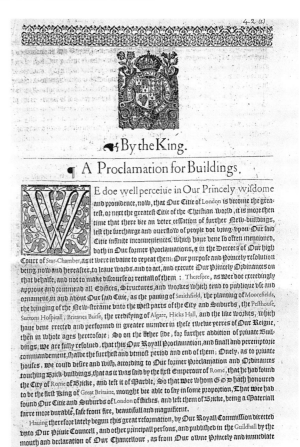

151 Building statute issued by James I in 1615. Cambridge University Library

freedome of our subjects, that what they acquire by industry may be bestowed at pleasure; not obliged to build so for the will of princes: whereas the citizens of Paris are so forced to uniformity'.[54]

The statute of 1615 had stipulated just such an ordered uniformity for all new façades. At least by implication these were to follow the rules of Vitruvius, who had worked for Augustus, and no doubt also follow those of the 'Vitruvius Britannicus', Inigo Jones. The statute of 1619 reinforced this requirement for regularity in stipulating no 'jutting, or Cant windows', 'the windows of every whole storey, to be of more height than breadth', 'a sufficient peer of brick, between the windows for strength', and 'the windows of every half storey [i.e., basement] to be made square every way, or near thereabouts'. James concluded by commanding officials such as Justices of the Peace to enforce these statutes. From 1630 onwards Jones served as a Justice of the Peace, a role perfectly compatible with his celebration of Stuart justice and peace in the masques, and he had been a member of the commission of 1618 charged

with the enforcement of the first statute of 1615.[55] His Banqueting House façade, with its vertical walls, its tall windows, column 'piers' between each window, and its square windows in the basement half-storey, clearly exemplified James's statutes, albeit transformed by Vitruvian principles (see Fig. 7). The building was commenced in 1619, the same year as this second statute. Jones and Arundel had been involved in November of the previous year in a further commission, this time to promote the laying out of Lincoln's Inn Fields, for which the architect was instructed to prepare a plan. Lindsey House, built on the west side in the years 1639–41, is variously associated with Jones and Nicholas Stone and again closely matches the ideals of the proclamations (Fig. 152).[56]

Had the Stuart monarchy survived, the Banqueting House might eventually have formed part of the new Whitehall Palace; this was conceived, in all its *all'antica* splendour, as a modern rival to Solomon's temple and palace (with a new Privy Council chamber; see Fig. 53). It will be recalled that on the ceiling of Jones's masquing chamber Rubens portrayed James I as Solomon, the archetypal wise judge, framed by the twisting columns of Solomonic mythology (strikingly depicted as 'pillars' of royal justice; see Figs 229–32).[57] The palace became the focus of the Platonic harmony of heaven and earth in the masque *Albion's Triumph* (1632), which closed with:

> a prospect of the King's palace of Whitehall and part of the city of London seen afar off, and presently the whole heaven opened, and in a bright cloud were seen sitting five persons representing Innocency, Justice, Religion, Affection to the Country, and Concord, being all companions of Peace.[58]

Within the confines of the court, the god of justice presented the palace as a Stuart temple of harmonic law, just as a series of well-ordered buildings were being planned and built by Jones to proclaim the king's 'legislative body' throughout the capital. It might even have been hoped that the opposing strands of Stuart society,

152 Lindsey House, Lincoln's Inn Fields, London, 1639–41

from Puritan to Catholic, would one day become united by the universal harmony of law and architecture in Charles's ideal commonwealth.

★ ★ ★

In the event Whitehall Palace was destined to form the backdrop not to this Stuart apotheosis but, following the customary fate of palaces in antique and Shakespearian drama, to royal tragedy. The decapitation of the king's physical and, along with it, his 'legislative' body in 1649 was one of the most decisive of Parliament's acts during the period of its administration. It was enacted, appropriately enough according to the argument advanced here, in front of the Banqueting House (see Fig. 259). The 'defacing' of the cathedral's Corinthian portico and the toppling of its statues a year later further testify to the popular identification of Jones's architecture with royal authority and the understanding of his columns as 'Pillars of State'.

Supercilium.
Coronices. G
Zophorus. A.
Epistilium S.
Mutilos. B;
Cimatium. Γ.

CORON

D
B
C
T
P

Y. Fascia. 3.
X. Fascia. 2.
V. Fascia. 1.

P. abacus.
R. Echinus.
Q. Voluta.

O
N
Z

L. Astragalus.
M. Regula.

COMPO-
SITA,
OR
ITALICA

N

Ischnographia

I.
L. Astragalus.
F. plinthus.

E. Torus 7
K. Scotia.
G. Torus.

BASIS. D.

Coronices. B.

STYLO.
BATA
A.

BASIS. C

UNIVERSITY
LIBRARY
CAMBRIDGE

DENTIC

CIMATIVM.

153 Composite Order as Pandora, from John Shute's *The First and Chief Groundes of Architecture* (1563), fol. xiiiir

MORAL ARCHITECTURE:
THE EARLY ENGLISH ARCHITECTURAL
TREATISES AT THE BANQUETING HOUSE
AND ST PAUL'S CATHEDRAL

So far I have shown how the Stuart court and its institutions appropriated the antique columns through the work of Inigo Jones in order to help give themselves historical legitimacy. In acquiring 'British' virtues in masques, processions, heraldry and paintings, the Orders were in turn cleansed of their foreign provenance. Nevertheless, for the vast majority of Stuart citizens, and especially those of a Puritan persuasion who had not witnessed Jones's Arthurian porticoes in 1610, the Orders could still all too easily be viewed, at least by implication, as at best pagan and at worst Roman Catholic.[1] It has been seen that the Jesuit Villalpando had sought to overcome the former vice in 1604, but if anything he had made the latter association, especially concerning the Corinthian, even greater (see Fig. 73). These Catholic associations would have been reinforced in England by some notable early decorative structures built in the antique manner in Puritan Cambridge, for instance, the most prominent example of all'antica architecture, the highly ornamental gates of Humility, Virtue and Honour at Gonville and Caius College, were put there in 1573–4 by a Catholic (see Fig. 2).[2] There is no doubt that ancient and modern Italian artworks were much admired by leading Stuart courtiers, as the artefacts imported by Pembroke, Buckingham and Arundel testify.[3] In common with other Protestant states, however, England in the early 1600s had developed a culture that was wary of the decorative arts. The preference of many ordinary citizens was for the plain

over the embellished. In Jonson's poem 'To Penshurst', written around 1612 and published in 1616, the eponymous house's simple architectural style was seen to reflect native earthly virtues (underlined by its owner Sir Philip Sidney's militant Protestantism; Fig. 154). These were in strong contrast to the more decadent moral values identified with the rich display of the 'prodigy' houses:

> Thou art not Penshurst, built to envious show,
> Of touch, or marble; nor canst boast a row
> Of polished pillars, or a roof of gold, . . .
> Thou joyest in better marks, of soil, of air,
> Of wood, of water; therein thou art fair.[4]

Moreover, the Puritan temperament resisted, and ultimately sought to destroy, objects and iconography that claimed to embody and signify the divine in physical terms.[5] This was especially so if these objects were based on Catholic models. In strongly favouring the plain over the ornamental and luxurious, the Puritans were equally suspicious of court art forms such as the theatre and ornamental architecture designed to appeal to the visual senses. A graphic illustration of this aesthetic conflict was in the dress of the two sides in the Civil War, with the fancy uniform of the royalist 'Cavaliers' strongly contrasting with the plainness of that of the Puritan 'Roundheads' (Fig. 155).

For those of a Puritan disposition, decorative works of art and some ancient artefacts like pictures and busts

154 Penshurst Place, Kent

had inevitable associations with Catholic Rome, given the tradition of iconoclasm in Post-Reformation England.[6] In justifying the use of the Orders, Wotton alluded to Puritan suspicions surrounding arts with an antique pedigree:

> I heare an *Objection* . . . that these delightfull *Craftes*, may be divers wayes ill applied in a *Land*. I must confesse indeede, there may bee a *Lascivious*, and there may be likewise a *Superstitious* use, both of *Picture* and of *Sculpture* . . . Nay, finally let mee aske, what ART can be more pernicious, then even RELI-GION it selfe, if it selfe be converted into an Instrument of ART: Therefore, *Ab abuti ad non uti, negatur consequentia.*[7]

This last line reads: 'The abuse of a thing is no argument against the use of it', and is no doubt an oblique reference to the Counter-Reformation Mannerist practices of the Roman Church. As the Preface pointed out, Jones's own negative reaction to the Mannerist excesses of the Counter-Reformation in Rome as witnessed by him in 1614 was recorded in his 'Roman Sketchbook'. Mannerism epitomised the style that he described with some distaste here as made up of 'Composed ornamentes' that were 'brought in by Michill Angell and his followers'.[8] In Rome he would also have witnessed the early Catholic churches of the Baroque, a movement still in its infancy but which promoted superfluous ornamental flourishes of the type that he evidently regarded as unsuitable for façades, at least in England in 1615.[9]

What made matters worse was that, according to the mythology of the English Reformation as upheld, 'officially' at least, by James and a majority of Stuarts, Rome was viewed as the 'Whore of Babylon'. It was regarded as the seat of the Antichrist with a tradition of Christian persecution and idolatry. The Protestant apologist John Gordon, who had close connections with the court, noted for example that just as during 'the first three hundred yeeres the true Christians who worshipped one onely God' had been 'persecuted by Pagan Rome', so more recently 'the worshippers of this true adoration have beene cruelly persecuted' by 'Rome disguised with a Christian maske'.[10] As the centre of the Catholic Church, the city was supposedly out of bounds to English Protestants – although this had not stopped Jones and his party from visiting in 1614.[11] For some, the city's ancient buildings such as the Colosseum were tainted by pagan brutality no matter how splendid their ornament. The traveller William Lithgow, for example, reported that amongst the ruins in the city there was an 'auncient Amphitheatre beautified with great Columnes, of a wonderfull bignesse and height, and a mile in compasse; the reason why it was first devised, the ghosts of the slaughtered Romes Sabines may testifie'.[12] It was as if the 'great columns' were in some way implicated in the ancient crimes.

The fact that James had suffered the shock of the Gunpowder Plot barely two years after his coronation only served to underline to those of an iconoclastic disposition the threat of tolerating the artefacts of Catholic worship. But by the 1630s the relative success of the

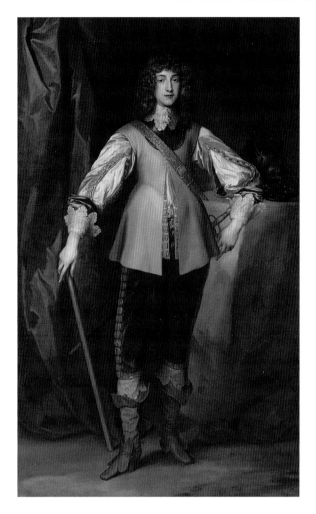
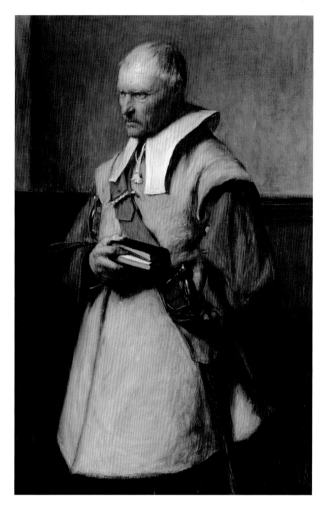

155 Royalist Cavalier compared with a Puritan Roundhead: a. *Prince Rupert, Count Palatine*, studio of Anthony Van Dyck (1637). National Gallery, London; b. *The Puritan*, by John Pettie (first exhibited in 1894). Sheffield Museums and Galleries

Puritan view produced a counter-argument advanced by Arminians for relaxing the Church's suspicion of religious imagery and ancient decorative art forms such as sculpture and painting.[13] This was prompted in part by the anti-Calvinist theology and High Church allegiance of Archbishop William Laud. In the court, too, Charles I and his Catholic queen cultivated a liberal, and supportive, policy towards decorative art forms, examples of which were often directly imported from Rome. It was noted in the Preface that although practising a moderate form of Counter-Reformation Catholicism, Henrietta Maria was far more overt a Catholic than Anne of Denmark had been. At the same time Charles was perceived by some as 'keeping company' at court with idolaters including the Catholic convert Walter Montagu.[14] Throughout this period of increased toleration, Charles's artistic policy was consistently attacked by Puritans both in writing and, eventually, through violence. In the early years of the Civil

War the Parliamentary authorities would paint the royalists as idolaters and papists, since many Catholics sided with the crown.[15]

The underlying tensions concerning the propriety of architectural ornament in the aftermath of the Reformation resurfaced in the Civil War when, as will be seen in the Conclusion, particular examples of Jones's work became the subject of open abuse alongside the violent destruction of various types of religious decorative ornament. Perhaps the most notable Puritan attack was made in May 1643 on the infamous Cross in Cheapside, with its Doric pilasters framing statues of saints and bishops and supporting a golden cross (see Fig. 258). The pilasters also framed a statue of the Virgin and Child, all of which made associations between the column and popery, here at least, unavoidable. In the same year the architectural fabric at Norwich Cathedral was included in an attack that was recorded by Bishop Joseph Hall in a rare eyewitness account:

Lord, what work was here, what clattering of Glasses, what beating down of Walls, what tearing up of manuscripts, what pulling down of Seats, what resting out of Irons and Brass from Windows and Graves, what defacing of Arms, what demolishing of curious Stonework, that had not any representation in the World, but only the Cost of the Founder and Skill of the Mason.[16]

Jones had to respond to these aesthetic tensions when choosing between the range of ornamental forms – from plain to decorative through to capricious – as described by him in his 'Roman Sketchbook'. This was an especially sensitive task when ornamenting his church designs, whether Protestant or Catholic. His apparent preference for 'graviti in Publicke Places', as expressed at the Queen's Chapel at St James's Palace and St Paul's in Covent Garden (see Figs 47, 221–2), would be echoed by Protestant clergymen such as Thomas Warmstry and Peter Smart. In 1641 Warmstry called for churches to be outwardly 'grave and decent', whilst in the same year Smart stressed the importance of prayer and other 'true ornaments of the house of God' rather than 'outward ceremonies, and costly and glorious decking of the said house or Temple of the Lord'.[17] Elsewhere, Jones exhibited suitable puritanical outrage when noting in Alberti's Ninth Book 'An exelent Admonition' against contempt for the ostentation of Caligula's marble stable and Eliogabalus's golden pavements.[18] Nevertheless, although Jones was culturally a Protestant his own religious affiliations were, by contemporary record, ambiguous.[19] And even though he had a theoretical preference for the 'masculine and unaffected' external style, certainly in 1615, in practice he went on to use the full range of the Orders, including the feminine Ionic and Corinthian, as patrons and court circumstance dictated. This dichotomy, and why Jones chose a particular type of ornament here and not there, will form the subject of subsequent chapters.

This chapter will show how native stylistic proprieties were reflected in the *all'antica* architectural theory published in England just before and during the period when Jones was active. The focus here will be on the earliest English treatises by authors already encountered like Shute, Dee and Wotton, as well as translations of Continental treatises by some new names.[20] It was these English books that did most to popularise the more restrained Vitruvian style advocated by Jones in 1615. This task was achieved in no small part through their analogies with the well-established national heraldic, legal and geometric practices studied in the previous chapters. Moreover, as will now be seen, Protestant sen-

sitivities to decorative and Italian-based art forms had a powerful influence on the explanation of the Orders in these books. This is an important aspect of the story of Jones's integration of the columns into English architectural practice. For, as his notes imply, the puritanical approval of the simpler of the column types was contrasted in these books by the moral disapproval of the more decorative and 'licentious' ones. The books provide valuable evidence as to the moralistic terms in which Jones's *all'antica* style was at first perceived by a literate public much less familiar than were members of the court with his justifications in the masques.

'THE MOST LICENTIOUS OF THE BUILDING STYLES': JOHN SHUTE'S NOBLE TUSCAN AND EVIL COMPOSITE

Links between decoration and civic morality had been introduced by Vitruvius when outlining the concept of architectural decorum. Decorum advanced moralistic and ethical notions of a 'proper', and a corresponding 'improper', use of different styles of ornament. The idea that these styles could provide a fitting expression for moral qualities related to human virtues such as strength, and vices such as crudeness, was developed by the evangelical architectural theorist Sebastiano Serlio in his treatise first published in instalments between 1537 and 1575, and translated into English in 1611. Serlio's achievement was to bring *all'antica* architecture into a Christian framework, in which it became as capable as any other visual art of representing virtues and vices. In the course of studying Serlio, Jones would have seen the moralistic term 'licentious' (*licentioso*) used to describe the most decorative and non-canonic architectural forms.[21] Notable in this regard was the Composite Order, which, with its hybrid capital, lacked the purity of the other four columns and the 'licence' of a model in nature (such as the human form). For Serlio it was the 'most licentious of all the building styles', a principle faithfully translated in the English edition of 1611.[22] Serlio's terminology emphasised a link between architectural and moral decorum that Jones himself echoed in his 'Roman Sketchbook' when making reference to imagination 'sumtimes liccenciously flying out' (or what might now be called 'running wild'), and in identifying non-masculine (and by implication feminine) forms of ornament with affectation or pretence.[23] For Serlio, the intention was not so much that these decorative and 'abused' ornamental forms should not be used; rather that they signified negative characteristics such as moral licentiousness and the 'bestial'

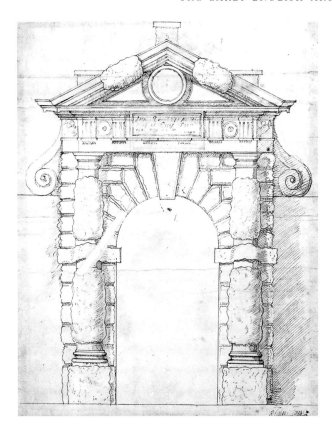

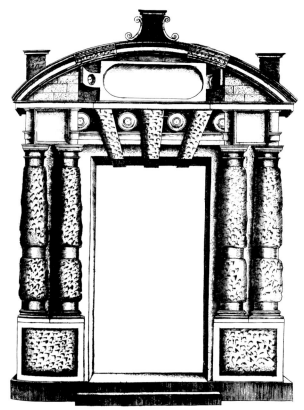

side of nature, and were best suited to 'special situations', including garden gates and loggias. Jones echoed this too in his 'Roman Sketchbook' when recommending 'composed ornamentes' for 'gardens loggis'. Serlio gave full expression to this possibility in his *Extraordinario libro di architettura* of 1551, with its collection of Mannerist gates, from 'delicate' to 'rustic', created in the wilds of the French countryside; some of these models were used by Jones for his own gate designs (Figs 156–8).[24] For less 'extraordinary' design situations Serlio reflected Protestant, or rather evangelical, sensitivities by calling for ornamental restraint when proposing in his seventh book:

> let us take for example a beautiful, well-formed woman who in addition to her beauty is adorned

156 (*above left*) Inigo Jones, design for the front (outer) side of the Vineyard gateway at Oatlands Palace, Surrey. RIBA Library Drawings Collection, London

157 (*above right*) Sebastiano Serlio, Rustic gate VI from the *Extraordinario libro di architettura* (1551), fol. 5v

158 (*right*) Sebastiano Serlio, Rustic gate XXIX with its monsters, from the *Extraordinario libro di architettura* (1551), fol. 17r

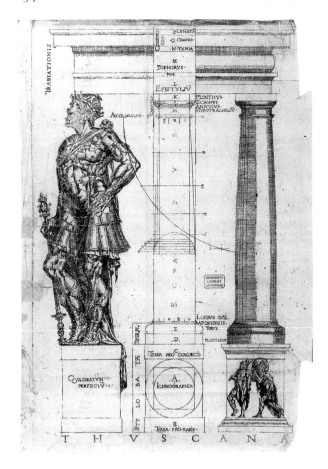

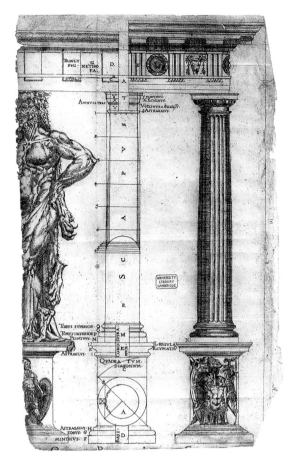

159 Tuscan Order as Atlas, from John Shute's *The First and Chief Groundes of Architecture* (1563), facing fol. iiiir

160 Doric Order as Hercules, from Shute's *The First and Chief Groundes of Architecture* (1563), facing fol. vir

with sumptuous – but august rather than lascivious – clothing, and she has a beautiful jewel on her forehead and two beautiful and expensive pendants hanging from her ears . . . However, if many jewels were placed around her temples, on her cheeks and on other parts superfluously, tell me please, would she not be monstrous? Yes, unquestionably. But if a beautiful and well-proportioned woman is, in addition to her beauty, ornamented in the way first mentioned, she will always be praised by men of 'judgment'.[25]

Jones was well aware of the contents of Book Seven and would have seen this identification of excessive ornament with immorality, which Serlio understood as expressed by a lascivious appearance.[26] Indeed, Serlio's call for decorative restraint favoured by 'men of judgment' foreshadowed Jones's in his 'Roman Sketch-book' for plain decoration reflecting the restrained demeanor favoured by a 'wise man'. The 'moralising' of Roman architecture was emphasised in Jonson's contemporary masques, which equated the language of

Vitruvian theory – harmony, proportion, symmetry – with terms of moral 'solidity' in the form of virtue, valour and justice.[27] And a persistent attempt to link the antique philosophy of ethics and morality to the Vitruvian notion of decorum is evident in Jones's annotations in his Barbaro Vitruvius, as well as in his copies of Xenophon, Aristotle, Piccolomini and Plutarch.[28]

Serlio's moralistic ornamental attributions also prefigured Jones's identification of the Protestant virtue of simplicity, as apparently possessed by the ancient Romano-British, with the so-called Tuscan Order at Stonehenge. As such, Jones's Stonehenge had the added virtue of being 'masculine and unaffected'. An important native precedent for his approach to the Tuscan was to be found in John Shute's *The First and Chief Groundes of Architecture used in all the auncient and famous monymentes*. This appeared in London in 1563, and was the first English treatise published on architecture.[29] It is inconceivable that Jones would not have studied this book, and it is worth outlining its contents in some detail. Shute's opening dedication to Elizabeth I as the

161 Ionic Order as Hera, from Shute's *The First and Chief Groundes of Architecture* (1563), facing fol. viiir

162 Corinthian Order as Aphrodite, from Shute's *The First and Chief Groundes of Architecture* (1563), facing fol. xv

'defendor of the faith' (sig. Aij*r*) gave the work, and the Orders that it so vividly depicted, an especially Protestant imperial context.[30] Here the body–column analogy was freely interpreted with reference to Vitruvius and Serlio through unprecedented illustrations of five human figures that personified the Orders in the tradition of moral emblems (Figs 153, 159–62).[31] In describing the characteristics of the three Greek Orders, that is the Doric, Ionic and Corinthian, Shute closely followed Vitruvian precedent (Vitr. I.ii.5) as codified in Serlio's Fourth Book.[32] Shute described the 'manly' Doric as signifying Hercules and Mars, and the column was pictured as Hercules; the 'matronly' Ionic was seen as appropriate for temples to Diana or Apollo, and was represented as the Greek moon-goddess Hera, the wife of Zeus (and identified with the Roman goddess Juno); and the 'maidenly' Corinthian was linked with temples to Vesta and virgins in general, and was drawn most probably as the beautiful Aphrodite.[33] All these Greek 'types' were named, according to Shute, in reflection 'of their vertues' and possessed varied degrees

of moral fitness and fortitude perfectly compatible with Protestant preferences.

The Tuscan and Composite Orders, however, were not Greek but Roman inventions that first Vitruvius and then Serlio had failed to ascribe to particular gods. Shute's unprecedented characterisation of these, the simplest and the richest Orders, might be understood to say the most about his overall adaptation of the columns to Elizabethan decorative sensitivities. Like Serlio, Shute helped set the moral tone for, and possibly even influenced, Jones's own attitude to capricious ornament outlined in the 'Roman Sketchbook'. Shute's Tuscan was 'likned unto Atlas, kynge of Maurytania' (sig. Biiii*v*; see Fig. 159). Atlas had supported the heavens according to the Greek poet Hesiod, and the Tuscan Order was by tradition the 'strongest' of the five columns. The plural of Atlas, 'Atlantes' (Roman *telamones*), is the term for male statues used to support an entablature, and the Atlas mountains border Mauritania, where the Greek hero was supposed to have dwelt. What is noteworthy is Shute's depiction of the Tuscan

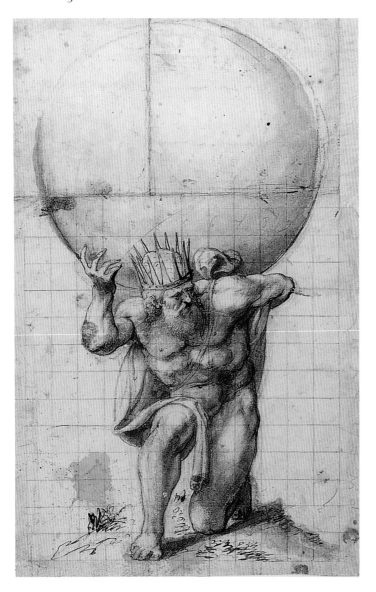

163 Inigo Jones, drawing of Atlas, the back shutter for the masque *Coelum Britannicum* (1634). Devonshire Collection, Chatsworth

Atlas's mythological role, and possibly even the implied links with ancient Britain, is shown by his drawing for the masque *Coelum Britannicum* of 1634 (Atlas here supporting 'heavenly Britain'; Fig. 163). In any event, Shute provided Jones with a perfect precedent for a bodily link between columns and kings and, moreover, for an identification of the Tuscan Order with ancient Romano-British culture at Stonehenge.

As Jones was also no doubt aware, the virtues of the Tuscan were further underlined by Shute in comparison with his interpretation of the other Order for which no immediate model existed, the Composite. Once again, Shute's characterisation can be seen to have conformed to Protestant, or more precisely Puritan, conventions of taste. His treatment of this, the most decorative and 'licentious' Order, strongly contrasted with his ennobling of the least ornate one. For here he chose as his figurative model 'Pandora, of Hesiodus' (sig. Biir; see Fig. 153). As literate readers like Jones would have recalled, Hesiod's poetry compared the blessings that righteousness brings to a nation with the punishment heaven sends down upon immorality.[35] In being the first attempt at systematic theology, Hesiod's *Theogonia* fitted easily within a Christian framework and Protestant moral proprieties. According to the poet's 'Works and Days', the first woman, called Pandora, had been created as 'an evil thing' by Zeus following the theft of fire by Prometheus and his gift of it to mortals.[36] Hesiod reported that whilst Pandora appeared as 'a sweet, lovely maiden-shape, like to the immortal goddesses in face', Aphrodite bestowed on her 'cruel longing and cares that weary the limbs'. Of course, this reinforced a prime Puritan sentiment to which Jones needed to have been sensitive; namely, that outward decorative appearances can be deceptive and represent earthly temptation, or as the clergyman Edmund Gurnay wrote in 1638, a 'mere outward and forged beauty'.[37] It informed Jones's own identification of the virtue of wisdom with external ornamental restraint in his 'Roman Sketchbook'.

Hesiod continued by observing that the 'divine Graces and queenly Persuasion put necklaces of gold upon' Pandora, 'and the rich-haired Hours crowned her head with spring flowers'. These ornaments can be seen in Shute's illustration (see Fig. 153). Furthermore, since the Composite was formed from the Corinthian and the Ionic Orders, Shute's representation of the Corinthian as Aphrodite perfectly reflected Hesiod's story of her role as an element in Pandora's composite character. As a figure of evil in the ancient world whose name meant the 'all-endowed', 'Pandora' was an appropriate symbol of Composite's unnaturalness; she stood

column as a king, whose mace and crown would obviously signify English royalty to a contemporary reader – especially one working for the king, such as Jones. Shute's transformation of the Tuscan is despite its traditional humble status as the simplest in detail of the Orders described by Vitruvius, and is some way from Serlio's marriage of the Tuscan with Rustic work.[34] Perhaps his characterisation of the column as a recognisably English antique king, complete with Roman military uniform and English royal insignia, might hint at Brute, Atlas's fellow fabled Greek hero, who according to Tudor mythology founded the nation as the first king of 'Britain'? That Jones was at least fully aware of

apart from Shute's pantheon composed of the noble Atlas, strong Hercules, matronly Hera and maidenly Aphrodite.[38] Jones's similar reference to the Composite as the 'Bastard order' in his Palladio equally emphasised its unnaturalness (at least according to the Shakespearian dictates of his time).[39] In so doing he reflected the moral reading of ornament in general and of such 'mixed' work in particular. It was noted that through their use of this mixed ornament, Serlio's gates as copied by Jones had also given expression to the evils of the natural world – ranging from human vices to monstrous forms (see Fig. 158). Even if Composite's characterisation via Hesiod was somewhat obscure, Pandora was named in Shute's text and would have been readily identified by those with Neoplatonic sympathies, such as Jones, as an alchemical emblem of evil.[40]

It is possible that Shute went further, and conceived of the Five Orders as in some way reflecting Hesiod's description of the five ages of the world that followed the fable of Pandora in 'Works and Days'.[41] Certainly, this interpretation would have had some striking contemporary parallels. According to Hesiod, the world began with a pure, noble Arcadian age in which men 'lived like gods'. Shute's identification of the Tuscan column with this first age and possibly with Trojan Brute would explain his break with Vitruvian tradition in depicting the Tuscan in noble, indeed godly, form.[42] According to Hesiod, the world then descended through two stages of evil and war (symbolised by Hercules's club?) to a partial renewal of a Golden Age. This might be identified as an epic Corinthian age ruled by Vesta and her virgins. In Shute's illustration of this virginal Order, the floral motifs in the pedestal were standard Golden Age imagery (see Fig. 162). Vitruvius had associated the Order with a virgin from Corinth (IV.i.9), and Serlio went on to identify it with the Virgin Mary; despite his reliance on Serlio, Shute does not mention this and neutralises any Catholic overtones via his illustration of Aphrodite and reference to the Corinthian as resembling 'Vesta or some lyke virgin' (sig. Biir). This would surely have made the Order particularly significant to his Elizabethan readers as signifying their own age, ruled as they were by a 'virgin queen' in the form of Shute's dedicatee, Elizabeth. The queen was popularly cast as the virgin Astraea, herald of a new Golden Age, and she was to be frequently identified with imperial Corinthian columns in engravings such as De Passe's heraldic image of 1596 (see Fig. 112).[43] Appropriately enough, in this image the virgin queen was paired with the Order of the Corinth virgin. Hesiod related that the world finally descended into absolute immorality in the fifth age, the age of Pandora.

As has been seen, Shute directly identified Pandora with the fifth column, the Composite. His characterisation of the five columns, with its British mythological overtones, can thus be interpreted using the moralistic narrative of the world outlined by Hesiod, one of Shute's acknowledged sources. This reading of the Orders when displayed together will inform an understanding of Jones's Banqueting House, examined below.

Shute was not alone amongst early English architectural theorists and translators in warning against, or even censoring, the more ornamental aspects of the new *all'antica* style.[44] For example, contemporary prejudices towards Catholic decorative forms influenced Richard Haydocke's addition of illustrations and textual omissions to his translation of Giovanni Lomazzo's *Trattato dell'arte della pittura scultura et architettura* (1584).[45] Haydocke's Protestantism was attested from the outset by his dedication to Thomas Bodley, in which was noted Bodley's 'vertuous desire, of increasing both the Common-wealth and Church Militant' (sig. ij*v*). In Haydocke's frontispiece Pandora was again to symbolise the Puritan principle that surface decoration was deceptive (Fig. 164). She was pictured on the left-hand side in the middle clasping her box, a vessel here shaped as a Renaissance covered cup or tazza of goldsmith's work. The evils that the box contained were concealed within a refined gift of tempting aspect, much like 'deceitful' Composite work. Jones may well have studied Haydocke's Protestant-inspired additions and omissions at first hand in comparison with the original, 1584 edition of Lomazzo when referring to it in notes on proportion and colour in his 'Roman Sketchbook'.[46] He would also have seen nationalistic and denominational responses to *all'antica* principles, similar to those of Shute and Haydocke, in other works he is known to have studied. Hans Vredeman de Vries illustrated a distinctly northern European-inspired *all'antica* architecture, for example, and the evangelical Philibert de l'Orme formulated a Protestantised architectural theory and a 'French' Doric Order (Figs 165–6).[47]

'THE LABOURER AND THE PROSTITUTE': HENRY WOTTON'S ORDERS AND JONES'S BANQUETING HOUSE FAÇADE

Evidently Jones felt at perfect liberty to use Composite columns in the privacy of the court masques, as, for example, with a Roman Atrium in *Albion's Triumph* (1632; see Fig. 188).[48] But he used the Order only once on a public façade of a court building. This was in no lesser project than the Banqueting House, the most

Within the central cartouche:

A
TRACTE CONTAI
NING THE ARTES
of curious Paintinge Caruinge &
Buildinge

written first in Italian by Jo:
Paul Lomatius painter of Milan

AND ENGLISHED BY
R:H Student in Physik

In the handes of the skilfull shall
the worke be approued
Eccl. 9·19

IO: PAOLO LOMAZZO:

164 Richard Haydocke, emblematic frontispiece to Lomazzo's *Trattato*, translated as *A Tracte Containing the Artes of Curious Paintinge Carvinge & Buildinge* (1598)

prominent new court structure in London, where the Composite appears above a Rustic Tuscan base and Ionic middle storey (1619–23; see Fig. 7).[49] Jones left no explanation for his motives. The possible reasons as to why this turned out to be the first and last time he used Composite 'in public' for a court building will be examined in the next chapters. However, a more immediate question presents itself: given Serlio's description of the column as 'licentious', together with the somewhat extreme way in which Shute introduced its 'deceptive' beauty to his English readers and Jones's own moralistic description of the Order as 'bastard', what might have been his intentions in using this ornamental scheme? The importance of this question is underlined by the fact that his use of the feminine Ionic Order clearly broke his own puritanical strictures, outlined only four years earlier, dictating a building's 'masculine and unaffected' outward appearance.

The answer to this question is not straightforward in the absence of an explanation by Jones for his work. Whatever his intentions, one possible contemporary interpretation of the novel ornament is obviously pro-

165 (left) The 'French column', from Philibert de l'Orme's *Le Premier Tome de l'architecture* (1567)

166 (below) Hans Vredeman de Vries, scene from *Perspective* (1604–5), no. 13

vided by Shute's 'five ages' interpretation of the five columns. Having given equally detailed attention to the 'evil' Composite as to the 'noble' Tuscan, Shute implied that it was possible, indeed desirable, to unite the Composite with some or all of the other four columns as at the Banqueting House.[50] They were first so united in England on the gate of the Old Schools in Oxford, leading to the library of Haydocke's dedicatee Thomas Bodley; this gate was resurfaced from 1613, following Bodley's death that year (see Fig. 132). Something of a

167 Nicholas Stone, monument to Thomas Bodley in Merton College chapel, Oxford, 1613

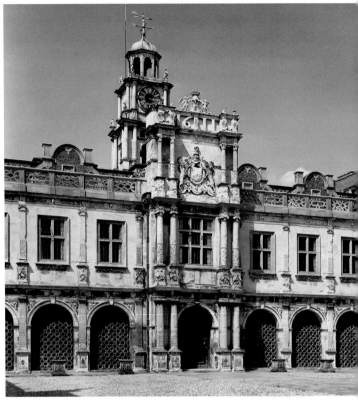

168 The south façade of Hatfield House, Hertfordshire, 1610–11

fashion for 'Towers of the Orders' had developed in late Elizabethan and Jacobean England.[51] The central tower on the south front of Hatfield House in Hertfordshire, designed for Robert Cecil in 1610–11, possibly with Jones's help, has the Doric, Ionic and Corinthian in ascending order (Fig. 168).[52] When seen in the context of Shute's treatise, the use of a similar sequence at the Banqueting House and the near-contemporary Old Schools could have been understood to narrate Hesiod's moral fable or warning against deceptive beauty and licentious excess. Any puritanical objections to licentious ornament would have been easily over-ruled, given that it was turned to such moralistic and poetic purposes. As didactic and moral emblems, the Orders were, of course, perfectly appropriate on a gate to a university library or, for that matter, on a royal masquing house. The pilasters on Bodley's monument in Merton College chapel were turned to just this purpose, celebrating as they do the moral virtue of learning, in comprising books laid flat whilst thinner and thicker volumes combine to form the capital and base; accompanying muses represent the liberal arts (Fig. 167).[53] According to this view, Jones's Whitehall pilasters come to stand in, as it were, for the emblem-

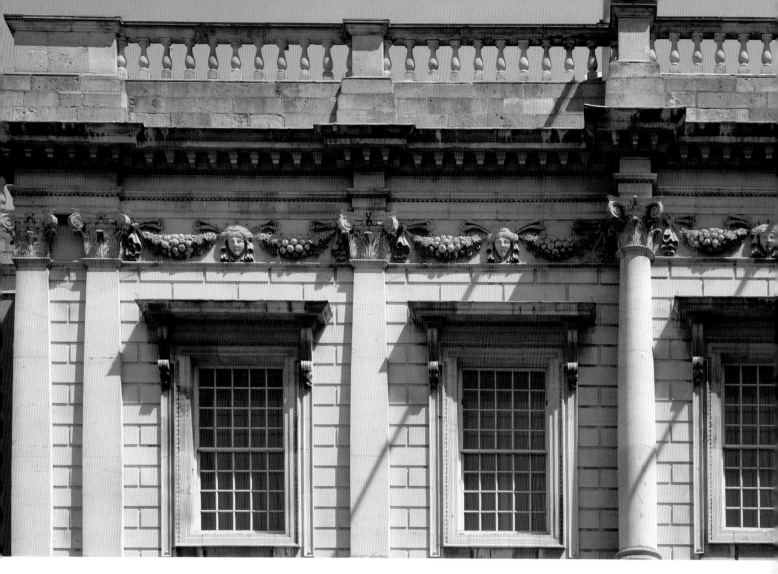

169 The elaborate festoons and female faces or masks in the Composite frieze of the Banqueting House, Whitehall (1619–23)

atic and moralistic characters of his masques enacted within the same building. In her guise as Composite on the front, Pandora might have reminded a courtier familiar with these masques of the evil world of the anti-masque performed in front of the main drama. And these observers would surely have been further reminded of the Composite's deceptive outward beauty by the presence here of capricious female faces or masks in its frieze (Fig. 169; see Fig. 227).

This is simply to interpret the novel decorative arrangement of these façades using Shute's near-contemporary treatise as a guide. That Jones intended his scheme to be understood in this way is, of course, pure speculation. However, given that the Banqueting House façade was designed for none other than the king, it would have been entirely reasonable for it to be seen to reflect moral attitudes of the Church of which he was the head. This is certainly implied in Van Somer's picture of James, with his Protestant motto

trusting in God, standing in front of the Banqueting House (see Fig. 138).

This is also how Jones's sometime masque collaborator George Chapman might well have interpreted the façade. Chapman had already made the connection between his friend's architecture and love of ancient Greek poetry. His fulsome praise of Jones in *The Memorable Maske* of 1613 was followed three years later by his reaffirmation of this friendship in *The Divine Poem of Musaeus*. The work concerned the pupil or son of Orpheus and opened with the dedication

To the Most Generally Ingenious, and Our only Learned Architect, my Exceedingly good Friend, INYGO JONES Esquire; Surveigher of His Majesties Workes.

Ancient Poesie, and ancient Architecture, requiring to their excellence a like creating and proportionable Rapture, and being alike over-topt by the monstrous

Babels of our Moderne Barbarisme; Their unjust obscurity, letting no glance of their trueth and dignity appear, but to passing few; To passing few is their lest appearance to be presented. Your selfe then being a Chiefe of that few, by whom Both are apprehended: & their beames worthily measur'd and valew'd. This little Light of the one, I could not but object, and publish to your choise apprehension; especially for your most ingenuous Love to all Workes, in which the ancient Greeke Soules have appear'd to you . . . supplied with . . . invention and elocution.[54]

Jones was forcefully reminded by his friend that the building of eloquent architecture was a moral imperative and could be achieved only by using a pure *all'antica* language. Such architecture stood in contrast to the confused and explicitly immoral ornamental vocabulary of Jacobean buildings (described as 'the monstrous Babels of our Moderne Barbarisme'). This classical ideal was reinforced elsewhere by Chapman. The emblematic frontispiece to his translation of Homer's works also of 1616 pictured Achilles and Hector set, appropriately enough, against Doric columns as part of the Golden Age that the two heroes of the Trojan conflict personified (Fig. 170). His earlier translation of the *Iliad* (from 1598) had been dedicated to Prince Henry, and so not surprisingly his work too was bound up with the mythology of Jones's erstwhile patron. Two years later Chapman went on to provide the first English translation of Hesiod, to much acclaim by the likes of Jonson and Drayton.[55] The fable's moral purpose was outlined in the title: *The Georgicks of Hesiod . . . Containing Doctrine of Husbandrie, Moralite, and Pietie* (1618). Jones must therefore have been familiar enough with Hesiod, as with the works of other 'ancient Greek souls' such as Homer, and a year later he was to achieve Chapman's poetic ambitions for him as the 'Surveigher of His Majesties Workes' rather spectacularly at the Banqueting House.

Most significantly, a possible moralistic reading by contemporaries of the Banqueting House's façade is suggested also by Wotton. At the end of the *Elements* he promised an additional treatise entitled *A Philosophicall Survey of Education*, which he described as 'a second *Building*, or repairing of Nature' and 'a kinde of *Morall Architecture*'.[56] Here he underlined the didactic, moral purpose assigned to architecture during this period. He observed that in antiquity statues formed a 'continuall representation of vertuous examples', and his Orders reflected this idea in expressing degrees of moral fortitude ranging from wholesomeness to sin.[57] The Tuscan

was described as a 'plain, massie, rurall Pillar, resembling some sturdy well-limmed Labourer, homely clad'.[58] In the early English treatises it was the Tuscan more than any other column that became clothed in national dress, ranging from Shute's Romano-British king to Wotton's rural labourer. As Chapter Three discussed, the next Order, the Doric, was compared to 'good *Heraldry*'. In sharp contrast, however, the decorative Corinthian was described as 'laciviously decked like a Curtezane, and therein much participating (as all Inventions doe) of the place where they were first borne: *Corinthe* having been without controversie one of the wantonest Townes in the world'.[59] Despite his admiration for Vitruvius, Wotton somewhat dramatically reversed the Roman's 'virginal' characterisation of the Corinthian as introduced in the previous era by Shute. He thereby ignored its traditional heraldic association with English monarchy, nominating instead the Italianate figure of the courtesan whose character was the antithesis of the Tuscan labourer. His source on the licentiousness of Corinth was no doubt St Paul's letters to the Corinthians, but the identification of the Corinthian column with the moral licentiousness of a court prostitute had no precedent.[60] Nevertheless, as with Shute's Composite, the moralistic reading of the more ornamental of the Orders can be understood in the context of Puritan rejection of various antique arts as idolatrous, a viewpoint that Wotton himself addressed whilst still urging their use.

Clearly, it was the richness of Corinthian decoration, together with its representation of the licentiousness of its place of origin as confirmed by the Bible, that led Wotton to identify the Order with immorality. Once again, whether a courtesan or a Pandora, outward beauty was seen as deceptive. It follows that the Composite Order was next dismissed by him as 'nothing in effect, but a *Medlie*, or an *Amasse* of all the precedent *Ornaments*, making a new kinde, by stealth, and though the most richly tricked, yet the poorest in this, that he is a borrower of all his Beautie'.[61] With the more decorative 'upper' Orders dismissed, regardless of their lofty position in the hierarchy of the columns, Wotton claimed that: 'few *Palaces* Auncient or Moderne exceede the third of the Civill *Orders*'.[62] Although thus recommending the Ionic Order for attics, Wotton followed Shute in implying that if the Orders were arranged vertically in the order of their decorative progression, as at the Banqueting House, then a moral architecture displaying a range of human behaviour and 'types' would result. This went from virtue to vice, that is from Tuscan labourer through Ionic matron to Composite charlatan.

170 George Chapman, the emblematic frontispiece to the translation of *The whole works of Homer* (1616)

Wotton's moral censure of the Composite was despite, or perhaps even because of, Jones's use of it on the attic storey of the Banqueting House at the 'modern palace' of Whitehall; the building was finished externally in 1623, only a year prior to the publication of the treatise. It is sometimes suggested that the two Stuart courtiers agreed as to the meaning of the Orders.[63] But Wotton's association of the Corinthian with immorality, and his corresponding distaste for the deceptive Composite, could easily have been a reaction to Jones's intentions: the building of the Banqueting House has been interpreted by Per Palme as a celebration of the anticipated marriage of Charles and the Infanta, to which Wotton expressed moral objections,

and the emerging Catholic court culture that it heralded.[64] Chapter Six will discuss the strong Catholic credentials of the Corinthian and Composite, of which Wotton was no doubt fully aware following his time in Venice. As an ardent champion of the Protestant cause, which evidently also informed his decorative tastes, Wotton would naturally have identified any such expressions of Catholic toleration through the use of Composite with a degree of immorality. He advised his readers to use his book to 'censure Fabriques already raised'.[65] In taking up his invitation, the moral terms in which Jones's ornamentation might well have been understood by contemporaries is again emphasised. For on being presented with a copy of Wotton's book so soon after the building's completion, what were the clergymen William Laud, George Abbot and William Juxon most likely to have concluded on reading of Composite's 'stealth' and 'trickery'?

<center>★ ★ ★</center>

The early English treatise writer-translators who were active in, or just before, Jones's lifetime thus aimed to establish a temperate classicism in line with architects in other Protestant countries.[66] This comprised neither an architecture without an Order (that is, astylar) nor a licentious one retaining the Orders but in a mixed or abused form (as with the Composite). In this ambition they clearly had a preference for the male Tuscan and Doric over the female Corinthian and Composite. This sobering aim should be seen as a corrective to the flamboyant and licentious display of *all'antica* ornament on Elizabethan country houses such as Kirby Hall and Longford Castle (see Figs 3–4). Although the decorative Corinthian had been introduced as a virginal Order, highly suitable for use in the Protestant iconography of Elizabeth I, within the space of sixty years it became associated, at least by Wotton, with vice and, it is implied, the decorative excesses of Catholicism. Nevertheless, both conditions are opposite extremes of a consistent moral order, an order that would naturally lead the two main Protestant treatise writers in the Tudor and Stuart eras to condemn the impurity of Composite as 'licentious'.

The same Protestant sentiment lay behind Jones's call in 1615 for a 'masculine and unaffected' public style and his identification of this with the social gravity of a 'wise man'; this was in contrast to a superfluity of imagination and ornament that was appropriate to interiors and (or so he implies) to women. After all, it was pointed out that his observations were most likely made in response to the Mannerist abuses and emerging

Baroque excesses of Catholic Rome, Jones having recorded these now-famous notes on decoration in his 'Roman Sketchbook' just after his return from the city. In France an obvious parallel example of this 'masculine and unaffected' Protestant aesthetic was Salomon de Brosse's Temple at Charenton-le-Pont, which was astylar on the outside and Doric internally (1623, now destroyed; Fig. 171).[67] Jones's chapel at St James's Palace and his church of St Paul at Covent Garden are equally good examples of temperate classicism (see Figs 184, 221–2).

171 Jean Marot, engraving of Salomon de Brosse's temple at Charenton-le-Pont, Val-de-Marne (1623)

'LETTING PASS ALL SUPERSTITION': THE EUCLIDEAN GEOMETRY OF JOHN DEE AND ROBERT PEAKE, AND JONES'S ST PAUL'S CATHEDRAL

In this way leading Stuart courtiers found some forms of decoration easier to accept than others, at least around the time of Jones's Banqueting House. A more neutral basis than ornament for the advocacy by architectural theorists of the new *all'antica* style, and the par-

allel reform of Elizabethan crafts, was provided by emphasising its embodiment of the practical virtues of Euclidean geometry. Most notable in this regard were the books of John Dee and Robert Peake, whose emphasis on useful geometry can be seen to have influenced Jones's composition, and possibly even his philosophical understanding, of the Orders.[68]

It was pointed out in the previous chapter that Dee's 'Mathematical Preface' to the English Euclid of 1570 had explained the principles of proportion with reference to domestic legal practices. Dee's aim in advancing Euclidean geometry and the architecture of Vitruvius was to demystify and make practical, in line with the canons of Protestant humanism.[69] It was also noted in Chapter One that he attempted to cleanse the Orders of pagan associations when observing that Vitruvius 'did write ten bookes' on architecture that were dedicated 'to the Emperour *Augustus* (in whose daies our Heavenly Archemaster, was borne)'. Rather than concentrate on pagan classicism, Dee linked architecture to the apparently more refined and better established, or at least the better thought of, Euclidean and Platonic world of the natural sciences. In this he followed Shute, who had observed on Vitruvian architecture that: 'it hath a natural societie and as it were by a sertaine kinred & affinitie is knit unto all the Mathematicalles which sciences and knowledges are frendes and a maintayner of divers rationall artes'.[70]

Unlike Shute, however, Dee did not choose to describe the various forms of the antique column or even to dwell on ornament in general. Instead, his focus was on geometric regularity as the most important principle and virtue of the 'new' architectural language. This may well have been because geometry, in both its practical applications and Platonic forms, could be presented as a truth of nature and therefore as universal. Geometry was rather like the Latin language or the principles of the wise ancient sages Euclid and Vitruvius, and even their modern counterpart Alberti, whom Dee also cited. It was understood as similar to linear perspective, its Renaissance cousin, in its immateriality and consequent freedom from foreign or religious associations.[71] On the other hand the Orders were a material invention of mankind originating for the most part from specific geographic locations or peoples, after which they were named (the Tuscan in Tuscany, the Doric from the Dorian, the Ionic in Ionia, and the Corinthian in Corinth, a relationship finally broken with the 'bastard' Composite). In other words, ornament was a 'Materiall or corruptible thing', as Dee observed concerning building, and as such was value-ridden and potentially controversial in the context of

Puritan tastes of the time.[72] Jones would have seen Dee's distinctions when studying the author on the subject of mechanics.[73]

Dee was followed in his reliance on geometry as a means to explain *all'antica* architecture by Robert Peake in his translation of Serlio. This was published in London in 1611 and was most probably made from the Dutch edition of Serlio published by Cornelis Claesz in 1606.[74] Jones must have seen this work also since it was dedicated to Prince Henry, to whom he had just been appointed Surveyor.[75] Leaving aside any Protestant affiliations such a dedication inevitably implied, the book formed part of a nationalistic mission by those associated with the prince to improve the level of English artistic production through the education of both patrons and workmen in technical matters.[76] Peake set the tone for his translation by adding opening remarks that single out geometry as the practical purpose of his enterprise. This was over and above the more problematic promotion of ornament, on the virtues of which he too was silent. In his dedication Peake noted that he presented 'this new-Naturalized Worke of a learned Stranger: Not with pretence of Profit to your Highnesse', but

> under the Patronage of your powerfull Name, to benefite the Publicke; and convay unto my Countrymen (especially Architects and Artificers of all sorts) the Necessary, Certaine, and most ready Helps of *Geometrie*: The ignorance and want whereof, in times past (in most parts of this Kingdome) hath left us many lame Workes, with shame of many Workemen; which, for the future, the Knowledge and use of these Instructions shall happily prevent.[77]

In that this dedication was to Jones's current patron, and that his earliest designs for thoroughgoing perspective backdrops based on those by Serlio formed part of Henry's *Barriers* of the previous year, Jones represented a prime example of the educated artificer at which Peake's edition was aimed.[78]

Although the English edition followed Serlio's original by including all the five Orders in neutral succession, without censorship, Peake's opening comments highlighted the fact that the columns were to act as expressions of geometry, as opposed to decorative style, and were therefore value-free. Following the Dutch edition of 1606, the English translation even concluded that 'letting passe all superstition', Serlio 'hath brought the Columnes & Pedestals into a due measure'.[79] In other words, his universal 'common rule' for the proportional ratios of the columns, as illustrated in the opening woodcut of the five, had triumphed over any

regional religious or aesthetic prejudices and superstitions of which the translators were all too aware. This undoubted neutrality would surely account for Serlio's widespread European appeal.[80]

Perhaps the denominational neutrality of geometry also held some appeal for Jones. Given Webb's description of him as 'a great *Geometrician*', this art can certainly be seen as a fundamental, if sometimes invisible, aspect of his work.[81] His annotations to Vignola, Palladio and Lorini, as but three main examples, illustrate his developing understanding of the fundamental importance of geometry to antique practices (Figs

172 (*left*) Annotations by Inigo Jones to his copy of Vignola's *Regola delli cinque ordini* (1607), showing a geometric diagram for the construction of the Attic base. Worcester College, Oxford

173 (*below*) Annotations by Inigo Jones to his copy of Lorini's *Le fortificationi* (1609), showing mathematical instruments. Worcester College, Oxford

174 (*facing page top*) Annotations by Inigo Jones to his copy of Palladio's *I quattro libri dell'architettura* (1601 edition), showing the geometric construction of the plan of the temple of 'Le Galluce'. Worcester College, Oxford

domed and rusticated composition of Oberon's Palace can be compared to a number of Serlio's woodcuts (Figs 176–7). It represents a prime example of the medley of *all'antica* and medieval forms that characterised Jones's early designs (see Figs 25–6).[84] Rather than an instance of stylistic naivety as is sometimes claimed, Jones's palace fused English vernacular traditions with French fashion; as too the virtues surrounding imperial Rome with those of Protestant chivalry and a mythic ancient Britain celebrated a year earlier in *Prince Henry's Barriers*. Parts are taken from De l'Orme (namely the turrets from the Château d'Anet; Fig. 175), parts from Serlio (in particular the windows and ground storey), whilst the dome is based on Bramante's Tempietto in Rome (again via Serlio; see Fig. 35). Bearing in mind Serlio's influence on the design, the geometric constructions on the drawing, to the left of the palace, bear striking similarities to the oval constructions in Serlio's First Book, about to be dedicated to the prince (Fig. 178). The additional virtues of Euclidean rationality might thus be traced in the design, no doubt helping to neutralise any inherent connections with Italian decorative superfluity and Catholic tastes that its sources had the danger of evoking.

In Jones's 'restoration' of Stonehenge not only were the crumbling stones transformed into Tuscan columns, but their arrangement was also moulded to fit within a duo-decagon – four equilateral triangles inscribed within a circle (Fig. 179). This is the scheme that to

172–4). Jones's over-reliance on Euclidean geometry, as Jonson saw it, echoed through the poet's famous attacks on the architect. In the last of these, within the masque *Love's Welcome at Bolsover* performed in 1634, Jones was characterised as 'Cornell Vitruvius', or more pointedly still, 'Iniguo Vitruvius'. Here he entertained the king and queen with the 'Dance of the Mechanickes', and was made to exclaim: 'Well done, my Musicall, Arithmeticall, Geometricall Gamesters! Or rather my true Mathematicall Boyes! It is carried, in number, weight, and measure, as if the Aires were all Haramonie, and the Figure a well-tim'd Proportion!'[82] Obviously, for Jonson at least, Jones's work relied on geometry at the expense of what might be seen as the superstitious and poetical aspects of Neoplatonic harmony. The efforts by Dee and Peake to distance *all'antica* architecture from these were clearly being put into practice by Jones rather too successfully for Jonson's liking, whose poetry and masques celebrated some of the more magical aspects of Neoplatonism.[83]

Jonson's attacks may not have been misplaced, since Jones's preoccupation with Euclidean geometry is perfectly evident in his earliest designs. Take as a case in point the masque *Oberon*, also produced for Prince Henry in the same year as Peake's translation, 1611. The

175 Philibert de l'Orme, Château d'Anet, France, 1547–52

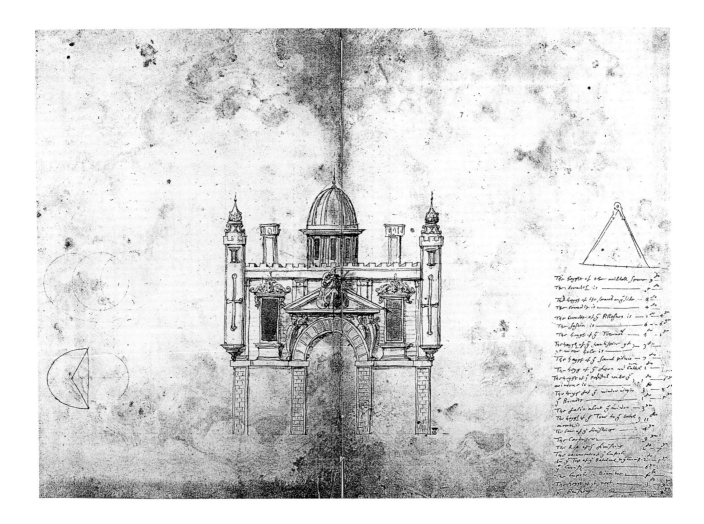

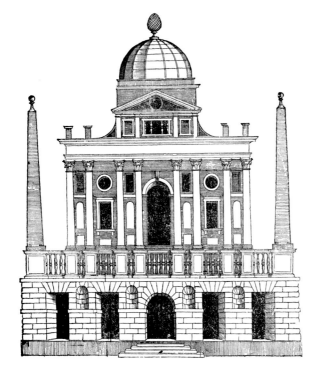

176 (*above*) Inigo Jones, Oberon's Palace from *Oberon, the Fairy Prince* (1611), with geometric constructions. Devonshire Collection, Chatsworth

177 (*left*) Sebastiano Serlio, model temple design, Book Four, *D'Architettura* (1537), fol. LVIIIr

178 (*facing page top*) Sebastiano Serlio, oval constructions, Book One, *D'Architettura* (1545), translated as *The first (-fift) Book of Architecture, made by Sebastian Serly, entreating of Geometrie. Translated out of Italian into Dutch, and out of Dutch into English* (1611)

179 (*facing page bottom*) Inigo Jones, circular and triangular layout of Stonehenge, woodcut from Jones's *STONE-HENG . . . RESTORED* (1655)

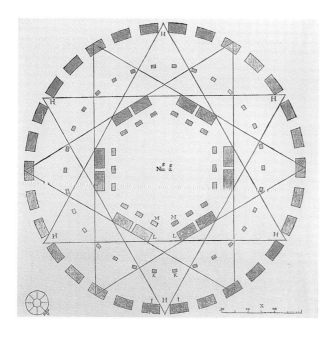

Jones's mind comprised 'those harmoniacall proportions, of which only the best times could vaunt'.[85] The enigmatic stones came to represent an ancient British emblem of Vitruvian order shaped by geometric immutability. This particular geometry and its powerful ancient associations may well have found resonances elsewhere in Jones's work. Roy Strong has shown how a circle and equilateral triangle also define the limits of one of the Webb-Jones plans for Whitehall Palace, where the apex of the triangle coincides with the position of the altar.[86] I have demonstrated the possibility of the same geometry being used in Jones's preliminary design for the façade of St Paul's, where a circle defines the outline whilst the base of an inscribed equilateral triangle defines the cathedral's base (Fig. 181).[87] Above the door between the Solomonic reclining angels and their palms there is a pencil 'x' formed by compass sweeps that mark the centre of the perimeter circle (Fig. 180).[88] The same circular profile circumscribes the elevation engraved by Henry Flitcroft and published by William Kent in 1727, although the

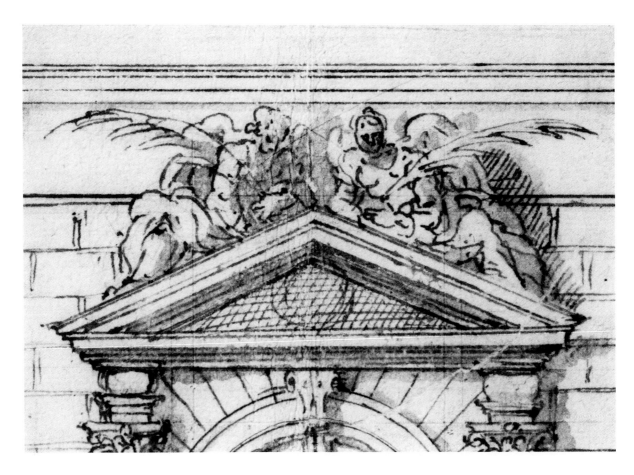

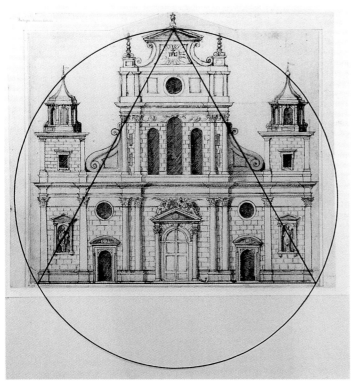

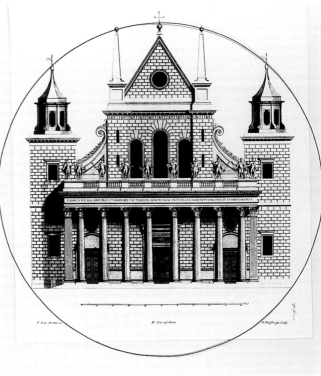

exact basis of this engraving is uncertain (Fig. 182).[89] Curiously enough, in vindicating Jones's Stonehenge theories Webb made passing reference to the use of 'an *equilateral Triangle* in the Conformation of St. *Paul's* Cathedral'.[90] The use of this geometry would not have been unprecedented. The famous Italian edition of 'Vitruvius' of 1521 had proposed something similar to organise medieval Milan Cathedral (Fig. 183). When used at St Paul's these circles and triangles not only reflected the antique virtues of Stonehenge but also had the added ones of alluding to the medieval *ad triangulum* diagram,[91] as well as unimpeachable Platonic and Vitruvian rationalism advanced by the likes of Dee. Furthermore, they resonated with popular Protestant preachers such as George Marcelline, whose *The Triumphs of King James the First* (1610) reads like a description of Jones's cathedral façade:

> That he is the Common *Father* of all his people, ordering all his affections in an equall partage, like unto the *Geometricall* point, which beholdeth all his circumference in one & the same proportion. Answerable to the Sun, which shineth equally upon all . . . Or like unto the Palme-tree, which distributeth his nourishment to his leaves and branches, even as if it were by just weight & measure . . . this Harpe of MY KING is made in a triangle, having ten strings, which being touched above, doe resound beneath, and deliver such an acceptable melody, as it pierceth all the Celestiall Spheares.[92]

Here the universal forms of circles and triangles are now, like the Orders, brought firmly into the service of Protestant propaganda.

In line with heraldry and the law, the traditional art and practice of geometry also assisted in the task of introducing into England the Vitruvian ideals of symmetry and order. The presentation of the antique columns as free of what both Wotton and Peake called 'superstition' helped lay the path for the Palladian rationality of the eighteenth century, in the development of which Jones was seen as a pivotal figure. Through his use of these native geometric practices, however, he can equally be seen as a bridge between the two building traditions, medieval and Renaissance, and the two cultures, British and Italian. In other words, what emerges is a picture of Jones the medieval mason, not just the 'British Vitruvius'.

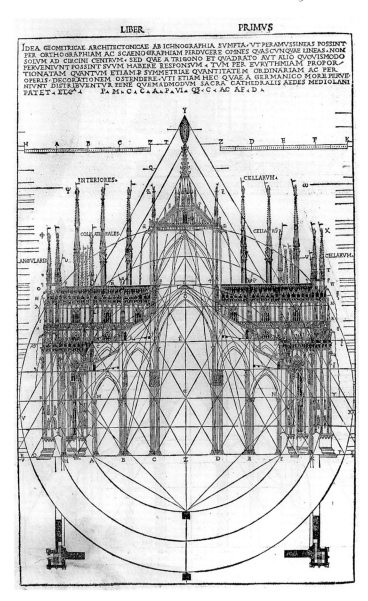

183 Proposed geometric order of Milan Cathedral from Cesariano's 'Vitruvius' (*De architectura*, 1521), Book One, chapter two

180 (*facing page top*) Inigo Jones, detail of preliminary design for the west façade of St Paul's Cathedral, undated (see Fig. 244), showing pencil 'x'. RIBA Library Drawings Collection, London

181 (*facing page bottom left*) Inigo Jones, preliminary design for the west façade of St Paul's Cathedral, undated (see Fig. 244), with a circle and equilateral triangle superimposed. RIBA Library Drawings Collection, London

182 (*facing page bottom right*) Inigo Jones, west front of St Paul's Cathedral according to Henry Flitcroft from William Kent's *The Designs of Inigo Jones* (1727), with a circle superimposed (see Fig. 252)

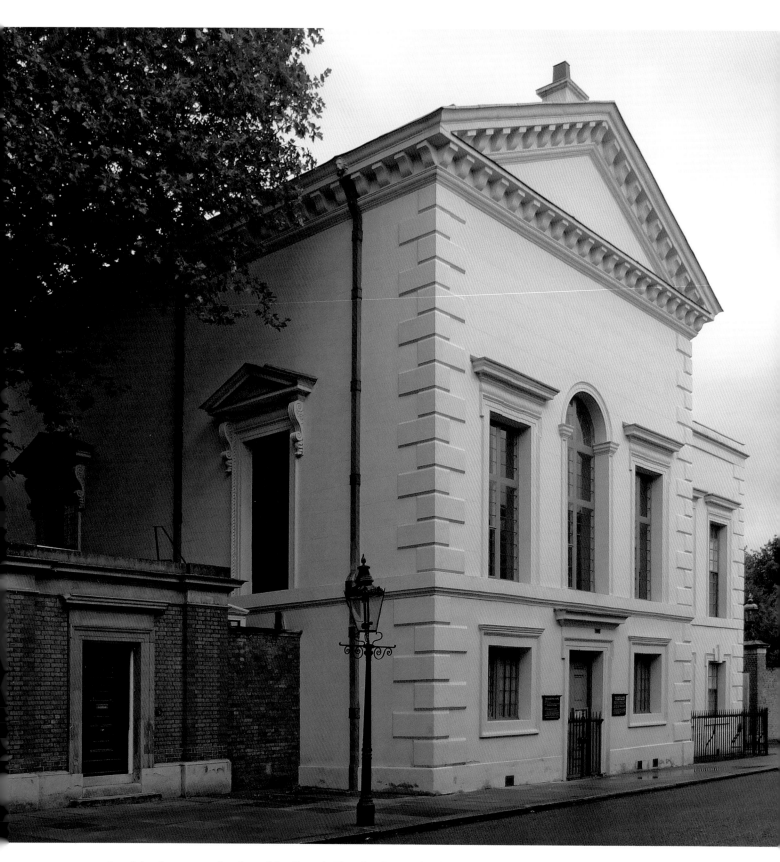

184 Inigo Jones, west elevation of the Queen's Chapel at St James's Palace, London, 1623–6

MASCULINE AND UNAFFECTED: THE 'ROMAN SKETCHBOOK' AT THE QUEEN'S HOUSE, NEWMARKET LODGING AND THE CATHOLIC CHAPELS

Inigo Jones recorded his now-famous notes on decoration, which are quoted in the Preface, in his 'Roman Sketchbook' on Friday, 20 January 1615 after his return to England.[1] Made in response to the Mannerist abuses of *all'antica* architecture attributed by him to Michelangelo 'and his followers', these notes fell in line with the puritanical prejudices of the early English architectural writers and later Protestant theologians examined previously. Here Jones spelt out a gender-based distinction between feminine private or internal decoration ('as nature hirsealf dooth often tymes Stravagantly') and masculine public or external ornamentation that can be seen in most – but significantly not all – of his court buildings. Within interior spaces at least, antique decoration was to be judged according to its visual pleasure or delight, whilst the exterior was to be grave and restrained. In practice, this implied a preference on Jones's part for the use of the more decorative, feminine Orders internally (Ionic, Corinthian and their licentious or what he calls 'bastard' combination, Composite) and the simpler, 'masculine and unaffected' Orders externally (Tuscan and Doric). This was a preference restated by him on other occasions.[2] Perhaps not surprisingly, given Wotton's dislike of the Corinthian and Composite, he too was to draw similar distinctions. For 'on the *Out-walles* of *Buildings*' decoration should be used only, if at all, with 'dignity', but 'now for the *Inside*, here growes another doubt, whether *Grotesca* (as the *Italians*) or *Antique* worke (as wee call it) should be received, aganst the expresse authoritie of

Vitruvius himself'. Although Wotton mostly followed the Roman author's strictures, when it came to the application of grotesque work inside he argued that 'wee must take leave to depart from our *Master*' and instead offer 'scope' to the 'imaginations' of craftsmen and painters.[3]

Possible reasons why Jones's Banqueting House façade represented an anomaly to his rule, or in other words 'Imagination set free', and why at St Paul's Cathedral he used the feminine Corinthian and flirted with Jesuit iconography, will be considered in some detail in the following chapters. This chapter will discuss Jones's other projects for the crown, namely the Queen's House, Newmarket Lodging and the Catholic chapels. Drawing on annotations in important books in his library, it will examine his use of the contrasting, and recommended, 'masculine and unaffected' external style on these projects in his effort with each to, as he put it, 'Compose yt w^th deccorum according to the youse, and y^e order yt is of'.[4]

'VARYING WITH REASON': JONES'S STUDY OF ARCHITECTURAL DECORUM

Jones actively sought to understand, and where possible apply, Vitruvius's principles of decorum as popularised by Serlio (*decor* at Vitr. I.ii.5, 9). According to these rules, the decorative embellishment of façades

could express aspects of the character of buildings and patrons, such as their status and religious denomination, necessarily tempered however by the circumstances of time and place. The decorous use of the Orders had been related to the expression of divine attributes, or more accurately temple dedications, from earliest times. Having specified the gender of the three Greek columns – the masculine Doric, matronly Ionic and the maidenly Corinthian – Vitruvius had matched these human types to the character of temples dedicated to particular gods.[5] Hence the Doric Order was appropriate for the temples of Minerva, Mars and Hercules because 'of their might'; Ionic for those of Juno, Diana and Bacchus, taking account 'of their middle quality'; and Corinthian for temples to Venus, Proserpine and Flora 'on account of their gentleness'. It has already been seen how Shute reinterpreted this to suit native sensitivities in 1563 (see Figs 153, 159–62). In his Fourth Book of 1537 Serlio not only developed Vitruvius's ornamental range to include the two Roman Orders – Tuscan and Composite – but also took account of modern building functions as well as Christian dedications and patrons. Rather like the design of the Renaissance art forms of heraldry, masque costumes and court dress, a particular Order might on occasions be used to give expression to the character of a patron, including his or her religious denomination.[6] Hence Wotton noted that 'Decor is the keeping of a due respect betweene the Inhabitant, and the Habitation'.[7]

Jones was a conscientious student of the principles of decorum and of the representational power of archi-tecture. For example, Vitruvius's observation that decorum 'demands the faultless ensemble of a work composed, in accordance with precedent, of approved detail' was curtailed by Jones to 'Thinges doon with autoriti Decorum'.[8] When discussing antique chariots and ships in his 'Roman Sketchbook' he concluded: 'thear formes ar varied according to the Subjects ether rich or Playne Cap[r]iccious or Sodo [solid] . . . all thes things ar appropriated to the god that is in the[m] or other Pearson'.[9] These ideas on representation formed the grammatical rules of the Orders and facilitated their use as a metaphorical language. As such the application of the principles of decorum fell in line with the apparently more absolute ones of Platonism dictating perfect numbers and harmonic ratios, which Jones also used.[10] These absolutes helped shape the private drama of the masque, and even the composition of public façades, although the emotive use of decoration was obviously subject to more circumstantial factors. Nevertheless, Gordon Higgott has observed Jones's capacity to vary ornament, not arbitrarily but 'with reason'.[11] Some years after the 'Roman Sketchbook' notes, when discussing Tuscan Stonehenge, Jones was to refer to 'the *Decorum* used by' the ancients 'in building their particular *Temples*'. Here he affirms just how absolute he regarded these principles in adding: 'These aforesaid rules also were so firmly observed by the *Ancients*, that even at first sight the *Roman Architects* of old were able to judge, to what *Deity*, this, or that *Temple* sacred.'[12] Jones put this theory into practice in his copy of Palladio in Book Four, chapter thirty-one, when

185 Wenceslaus Hollar, *The Courtyard of Arundel House, London*, showing the stable probably built by Inigo Jones, *c*.1618. British Museum, London

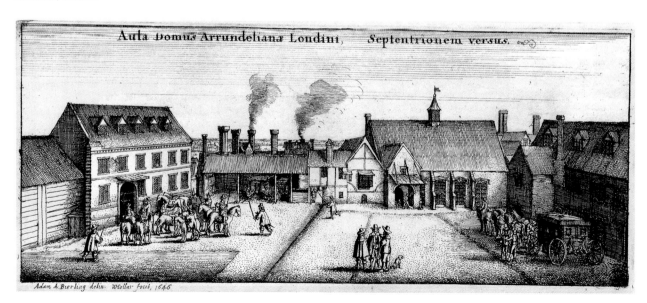

186 Sebastiano Serlio, use of the Serliana, or Venetian window in a. the model palace of a governor or president; and b. the model palace of the king, from the unpublished Book Six, *D'Architettura*, MS, *c*.1547–54, fols 63r and 71r. Staatsbibliothek, Munich

observing on 'Neptune's Temple': 'this is not likely for to Neptune being a robustious god the[y] made dorrik temples and not corrinthian nor so adorned'. As it happens, in this case he was correct since the temple is in fact dedicated to Venus Genetrix!

Jones's application of the principles of decorum in his built work has not gone un-noted. Rather than focus on the use of the Orders, Giles Worsley considered Jones's selective choice of ornamental forms in his architecture. This ranged from his humble astylar stable designs thought to be for Hatfield House (*c*.1610) and Arundel House (*c*.1618) to his use of imperial forms in his more illustrious commissions (Fig. 185; see Fig. 123). Examples of these forms include the circular courtyard in the Whitehall Palace schemes, the Serliana, or Venetian window, in the Queen's Chapel at St James's Palace and the portico at St Paul's Cathedral (see Figs 51, 209, 247).[13] Worsley has shown that these forms were traditionally used as symbols of sovereignty, by Serlio and others (Figs 186–7); and as a result Jones restricted their use to royal buildings or to those for the Church with

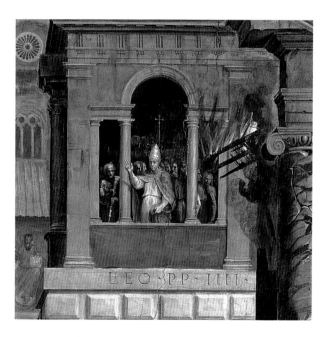

187 Raphael, *Fire in the Borgo*, 1514, Vatican Palace, Rome: detail showing the Benediction window

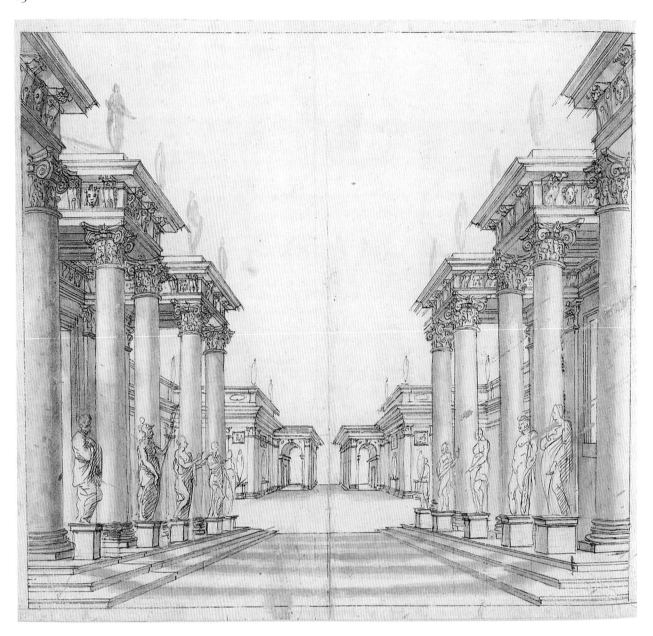

188 Inigo Jones, Roman atrium in the king's masque *Albion's Triumph* (1632). Devonshire Collection, Chatsworth

strong royal affinities such as St Paul's. In so doing he sought a contrast with his more humble projects, in line with the fundamental principles of decorum. The courtyard, Serliana and portico had the advantage of being free from associations with any particular Order, not least the more decorative and licentious ones whose use, as has been seen, was problematic.

When it came to the masques, Jones used the Orders selectively to form part of the emblematic representation of the political policies and religious beliefs of the monarchy. In this internalised, court-based spectacle Jones was at liberty to use all the Orders at any time,

as his 'Roman Sketchbook' notes imply. John Peacock has discussed Jones's application of the principles of decorum to the design of his stage buildings for the Caroline masque to express the king's and queen's characters.[14] For example, these rules help explain the contrast between the opening scenes of the masques of 1632. These comprised the grand palace or 'Roman Atrium' of the king's masque *Albion's Triumph*, with its Composite Order suggesting, as Peacock points out, 'Roman imperium', and the informal garden architecture of the queen's masque *Tempe Restored*, with its more humble and 'feminine' Ionic Order (Figs 188–9).

The principle of matching ornament to setting was equally reflected in *Chloridia* (1631), in which 'the scene is changed into a delicious place, figuring the bowre of Chloris, wherein an arbour fayn'd of Goldsmith's worke, the ornament of which was borne up with Termes of Satyrs, beautifi'd with Festones, Garlands and all sorts of fragrant flowers'. For the proscenium in *The Temple of Love* (1635), Jones adapted the Doric Order

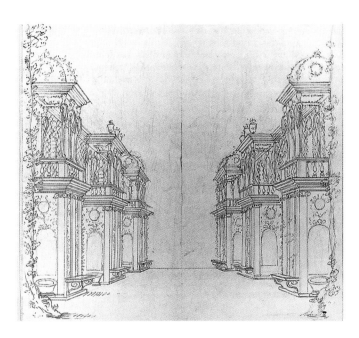

189 Inigo Jones, garden architecture in the queen's masque *Tempe Restored* (1632). Devonshire Collection, Chatsworth

to include exotic ornament and improvised an 'Indian Order' appropriate to Henrietta Maria's stage character as 'Indamora, Queen of Narsinga' (Fig. 190). The settings for the Catholic queen are very different from the chivalrous male ones comprising the proto-Doric porticoes and palaces designed by Jones at the outset of his career for the Protestant prince Henry. The private, courtly world of the masque allowed him the freedom to evolve a full expression of the Orders, including the Composite and grotesque ornamental variants. It became an experimental theatre for him to formulate what Peacock calls 'a personal style of ornament' that developed 'Lomazzo's idea of ornament as a coherent system of language' expressive of the masque's moral order.[15] For Jones's public works, however, the audience was necessarily more conservative and puritanical.

As Surveyor, Jones obviously worked for a consistent patron in the form of the royal household, and so his equally consistent public use of the less humble, more

decorative Orders to express royal status might at first sight be expected. However, given the influence of prevailing puritanical tastes on his 'Roman Sketchbook' notes, and his implied link between opulent decoration and Catholic Rome ('ye aboundance of dessignes . . . brought in by Michill Angell and his followers'), he clearly felt it appropriate to recommend the 'masculine and unaffected', at least in 1615; and to use the more decorative Orders in public only on certain occasions. These notes, and Jones's general interest in the rules of decorum, suggest the influence of circumstantial factors: these include the contrasting denominational persuasions of his various royal patrons, the extent of

190 Inigo Jones, costume designs for the masque *The Temple of Love* (1635), performed by Henrietta Maria and her ladies. Devonshire Collection, Chatsworth

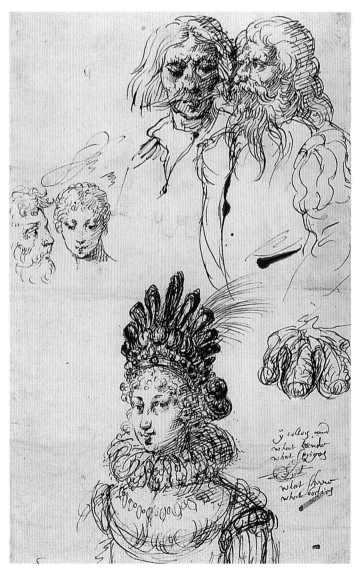

their open toleration towards Catholic worship and the growing importance of the High Church party under William Laud.[16] It will be recalled that the religious aims of Jones's Stuart masters ranged from Henry's Protestant imperialism and decorative temperance on the one hand, to Charles I's Catholic toleration and decorative luxury on the other.

Jones's notes indicate that he was guided in the decorous selection of ornament by its capacity to express opposing qualities such as gravity and imagination, propriety and licentiousness, and by implication at least Protestant and Catholic aesthetic conventions. And the masques, too, suggest that this awareness of the suitability of the Orders with regard to denominational sensitivities played a significant role in his determination of which Order to use when and where. Of the treatises Jones studied, Serlio's Fourth Book was the most explicit about how the various columns could be used to represent particular Christian saints with their inevitable denominational connotations. Jones studied Serlio as early as 1610, but during these formative years only one passage tempted him to annotation.[17] This was Serlio's discussion of the correct modern circumstances in which to use the Doric Order:

> When we have to build a temple consecrated to Jesus Christ our Saviour, or to St Paul, St Peter, St George or other similar Saints, since they not only professed to be soldiers, but were also manly and strong in leading out their lives in the faith of Christ, the Doric type is suitable for Saints of this sort.[18]

Jones translated Serlio's passage as: 'the Ansients dedicated This Dorricke Order T[o] most Roboustious good[s]/Christians to saints of the like nature. Also to Sooldierly an[d] Robustious persones of what Condittion Soever'; this leads to the conclusion: 'and varry ye worke i[n] Dillicacy or strength [acco]rding to ye personn'.[19] In representing St George and Christian chivalry, the Order would have carried explicit associations with the Garter to Serlio's English readers. And given Wotton's explanation of the Doric as akin to heraldry, it might easily have been identified as a form of Garter heraldry and Protestant badge. This was especially the case when used by Jones on 'St George's Portico', for example, or on James I's catafalque (see Figs 71, 129).[20] The sermon for the king's funeral made a marginal reference to Serlio that could have only underlined the relevance of his understanding of the Doric to the catafalque, at least in the eyes of Puritan sympathisers such as Bishop Williams who wrote it.[21]

If the Doric had Protestant compatibilities, then the Corinthian had Catholic ones. Serlio continued by recommending that when a church was dedicated 'to the Mother of our saviour Jesus Christ, the Virgin Mary', it should be ornamented with the Corinthian Order.[22] In Serlio's extensive discussion of the Corinthian, this is the one comment underlined by Jones. Not only did Serlio Christianise *all'antica* ornament, as Villalpando would go on to do, he in effect Catholicised the Corinthian by dedicating it to the Virgin. In so doing he reflected what for many Italian architects had become common practice. For as John Onians has pointed out, during the sixteenth century the Corinthian and Composite were most often found on Catholic churches.[23] It might be assumed that this usage would not have escaped Jones's notice when visiting Rome, or for that matter Wotton's given his time as ambassador in Venice. Wotton's warning against the superstitious use of decorative art forms, and in particular sculpture and pictures, implied hostility to their use by the Counter-Reformation; and it equated with his Puritan rejection of Corinthian and Composite as licentious. The strong inference is that they too were works of Rome. The Catholic credentials of the Composite would have been enhanced by its popular name as the 'Italic' or 'Latin' Order, an identity that may well have aided the early treatise-writer's suspicions of it.[24] Notably, Shute's illustration of the Order clearly identifies it as such (see Fig. 153). Jones confirmed his awareness of this identity when noting in his Palladio: 'Scamotzio in his composite w[ch] he cales Romano'.[25]

Given the Calvinism of James I, together with the dominant Puritanism of Stuart England, Jones might therefore be expected to have stipulated at the outset of his Surveyorship that the public face of court buildings should tend towards the expression of Doric temperance over Corinthian luxury. Hence in 1615, in anticipation of working for his new royal patron, he observed that the external ornaments of a building, whether secular or sacred, ought ('oft') to be solid, 'according to the rules. masculine and unaffected'. 'Ought' to be built in this way, but not always so, for his application of architectural decorum was not rigidly predetermined by moral or social absolutes but rather by the relative principle of 'varying with reason' the use of ornament according to context and court mood. As will now be seen, in practice Jones's selection of the Orders in masques and buildings varied not only with regard to the factors he studied in the Renaissance treatises – the function and dedication of the building, and the status of the patron – but also according to shifts in religious toleration and therefore aesthetic tastes over the forty years or so of his career. During this time his work as Surveyor was inevitably bound up with the

forces of seventeenth-century Protestant politics, ranging from pro-Catholic to Puritan. And the animosity some of the work could generate is indicated by the violence with which the Puritans attacked his cathedral portico and railed against his Caroline masques during the Civil War.

'GRAVITY IN PUBLIC PLACES': CATHOLIC TOLERATION AND JONES'S EARLY USE OF THE ORDERS

Approximately twenty years or so separated Jones's direct contact with Italian classical buildings, most probably in 1601, and his first full homage to them at the Banqueting House in the years 1619–23. The decorative blend of the familiar with the new that characterised his early unbuilt designs for such as the New Exchange and the cathedral tower, both of 1608 (see Figs 25–26), as well as the relative austerity of the small number of subsequent buildings actually constructed up to the time of the Banqueting House, represents an apparent stylistic anomaly between practice and experience. Commentators have described Jones's early buildings – notably the Queen's House (from 1616) and the Prince's Lodging at Newmarket (1618–19) – as rudimentary precursors to the Banqueting House that were produced during a period of learning.[26] It has been seen, however, that his decorum-based principles were fully developed by the time of the 'Roman Sketchbook' notes in 1615 and were being researched by 1610, if not earlier. So these early buildings deserve to be considered more carefully, and particularly in the context of Jones's decorous preference during this period for a 'masculine and unaffected' external style.

Perhaps not surprisingly, Jones's very first designs reflected the eclectic, decorative blend of familiar Gothic forms and all'antica ornament that had been common enough in Elizabethan court buildings. The Elizabethan 'prodigy' houses of Wollaton, Burghley, Kirby Hall and Theobalds were built for the entertainment of the queen and her court, and provided decorative backdrops largely specific to the court (see Fig. 3).[27] It is tempting to see the often flamboyant mix of medieval and all'antica forms that characterised these houses as an aspect of the religious toleration at court, where both Catholics and Protestants vied for the queen's favour. In contrast, many of the smaller late sixteenth-century country houses designed by Robert Smythson, himself a Protestant, for wealthy Protestant gentry unsympathetic to the apparent decadence of

court life were built in a style of temperate classicism later advocated by Jones.[28] Mark Girouard has suggested that this austere form of the 'new all'antica fashion', which began to appear towards the end of the sixteenth century, is evidence of a Protestant-led anti-classical reaction to the decorative architecture of the court and of Italy.[29] The 'prodigy' houses were the object of Chapman's attack in 1616 when calling on Jones in moralistic terms to replace 'the monstrous Babels of our Moderne Barbarisme' with 'proportionable . . . ancient Architecture'.[30] Moreover, it has been seen that these houses were precisely the 'proud, ambitious heaps' that the Protestant panegyrist Jonson described around 1612 as 'built to envious show', when praising the old house at Penshurst as typifying the decorum and modesty of the traditional English estate (see Fig. 154).[31] Penshurst was the birthplace and home of the Protestant courtier of his age, Sir Philip Sidney, and associations are clearly made in Jonson's verse. It was under James that Jonson became a more central figure at court, and his distaste for 'envious show' and 'polished pillars' found a curious echo in his colleague Jones's apparent preference at this time for the 'masculine and unaffected'.

The plain style of all'antica architecture was adopted too in court buildings north of the border, most notably in the Protestant Chapel Royal at Stirling (Fig. 191). This was designed in 1593–4 by William Schaw in preparation for the baptism of Prince Henry. The project created political difficulties for James as Scotland's first Protestant monarch, since he had carefully to balance the pressures from Episcopalian and Presbyterian factions while trying not to antagonise his most powerful Catholic subjects. As Deborah Howard has suggested, this may be why the simple barn-like structure, with stepped gables and plain ashlar masonry, expresses no obvious denominational bias in its form.[32] However, the building's simple exterior in contrast to the decorative interior, and the restriction of columns to openings (here used on the entrance portico alone),[33] are both features that Jones would use in England. The continuity between the style of court architecture in Jacobean Scotland and England could be seen as evidence of James's largely ignored influence on Jones's design principles.[34] Consider, for example, the striking similarity between the 'outer' gravity presented by Jones as a virtue of the 'wise man' and James's recommendation to Prince Henry for 'a King's outward behaviour' to be related to 'the vertuous qualities of his minde'; this was made in the third book of Basilikon Doron (first published in 1599, with further editions in 1603 and 1616).[35] Jones's concept of outer gravity concealing inner liberty of thought is necessarily noble. For

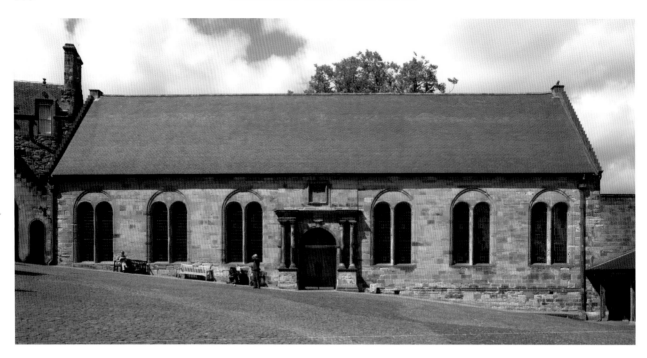

191 William Schaw, the Protestant Chapel Royal at Stirling (1593–4)

if the king's 'behauiour bee light or dissolute', accord-
ing to James the people 'will conceiuve prae-occupied
conceits of the Kings inward intention'.[36] When James
recorded his commendations to Henry concerning the
virtues of temperance in outward appearance, only
about five years had passed since the construction of
the Chapel Royal for the prince.[37]

South of the border, before Jones's influence, the
flamboyant Elizabethan court style continued into
James's reign with the coronation arches, and their dec-
orative Orders, of 1604 (see Figs 78, 80–81). It should
not be forgotten, however, that these arches were gifts
of the City Companies and were temporary. Never-
theless, if the influence of religious sectarianism on
architectural tastes is accepted, it is possible to see their
style too as a reflection of the continuing attitude of
Catholic tolerance at court. For in the early days after
his coronation James had promoted the cause of reli-
gious unity. But the Gunpowder Plot of 1605 changed
this (see Fig. 13). It forced James openly to acknowl-
edge Puritan fears and placate anti-Catholic prejudices
with harsh legislation in 1606 and an oath of alle-
giance.[38] John Foxe's *Actes and Monuments* was reprinted
in 1610 in light of the plot, and the conspiracy encour-
aged Puritan iconoclasm.[39] These events surely also
played their part in influencing James's more cautious
early attitude towards the public endorsement through
architecture of luxury and decorative opulence on the

Catholic model. The stylistic shift from the ornate to
the plain that occurred in court architecture after the
arches suggests that the political repercussions of the
plot had an equally inhibiting effect on artistic expres-
sion. In the patronage of such a public art as architec-
ture, so soon after the plot, the problems associated with
using an ornamental vocabulary perceived to be
imported from the very home of the Catholic faith
must have been significant.

Court architecture under James I became character-
istically 'masculine and unaffected', which dictated the
use of Rustic Tuscan or Doric ornamentation. In this
way one of Jones's most important formative works, his
sculpture gallery at Arundel House in the Strand of
around 1618, commissioned by the 2nd Earl of Arundel
(who had recently been received into the Church of
England), included a colonnade of the Doric Order. As
will be seen in a moment, the only (known) early
buildings where Jones toyed with using the Corinthian
Order 'in public' – the Prince's Lodging at Newmarket
and the early Queen's House – were most likely built
astylar; moreover, the Star Chamber design remained on
paper (1617; see Figs 43, 150, 195).[40] Whatever flirtations
with lavish decoration he entertained at the design
stage, this was consistently eradicated if and when the
building was actually constructed. This design process
has never been satisfactorily explained. But it is cer-
tainly curious, since at first sight it would seem just as

appropriate to display the more decorative Orders on any of these early royal buildings as it would be at the Banqueting House and eventually at St Paul's Cathedral. Jones may well have been compelled to reflect the political and religious circumstances of the time by 'varying with reason' his use of the Orders, for the most part towards more simple and masculine forms – as his own notes on the principles of public decorum required.

The Banqueting House was the building that broke with this pattern and these rules. But the circumstances of its construction from 1619 to 1623 conform to this understanding of the influences that shaped Jones's style. It was designed to celebrate the proposed marriage of Prince Charles to the Spanish Infanta, and what turned out to be short-lived plans to accommodate Catholic worship in James's court.[41] It surely cannot be a coincidence that following the building of its ornate façade, the two Orders most readily identifiable with Catholicism, the Corinthian and Composite, were routinely used in the court masques of Charles and his Catholic queen and then in public again at St Paul's. The cathedral too was designed during a time when there was much more open toleration of Catholicism at court, and when the High Church faction of Laud was dominant. And as will be seen in subsequent chapters, ecumenical themes of peace and unity can be identified in the ornament of both these more decorative designs.

The Spanish Match negotiations ultimately failed (at the end of 1623) and the Banqueting House did not establish a new public style for court architecture. Jones returned to the 'masculine and unaffected' manner in 1625 for James I's catafalque, drawing heavily on that by Domenico Fontana for Sixtus V of 1591, but replaced Fontana's Composite capitals with those of the Doric Order (see Figs 129–30).[42] The column bases follow the Ionic model proposed by Vitruvius, and thereby added a delicacy to the design to reflect, as Higgott has noted, aspects of James's character.[43] Whilst undoubtedly capturing the required solemnity, this heraldic structure also epitomised, above all others, the king's stylistic preferences and self-image.

In this way the Gunpowder Plot of 1605, the public announcement of the Spanish Match negotiations in 1619, their collapse in 1623 and the subsequent establishment of the court of Henrietta Maria all influenced the fluctuating levels of Catholic toleration at court; they also coincided with stylistic change in court art and architecture. Jones's central stylistic principle outlined between these first two events, that a building's exterior should be less ornate than its interior, was

also applied consistently to the architecture of the early masques. For example, whilst the exterior of Oberon's Palace of 1611 had Doric pilasters, the interior had statues and a Corinthian arcade (only the fourth masque on which, as far as is known, Jones worked; see Figs 32, 225).[44] Moreover, the stylistic progression of Jones's masque architecture mirrored that of his built work. Backdrops to *The Masque of Queens* (1609), *Prince Henry's Barriers* (1610) and *Oberon* (1611) had the same stylistic blend that characterised Elizabethan court architecture, but, as might be expected, with less decorative Orders (see Figs 71, 225). Later, *The Vision of Delight* (1617) included 'A Street in Perspective' comprising façades of the Doric Order or a simplified version that were much more strictly *all'antica* and of a similar style to court buildings at this time (Fig. 192).[45] Soon after, Jones was to produce two backdrops that continued the marriage between masque and built architecture. The composition of 'Cupid's Palace' (c.1619–23) can be related to the central portico of one of Jones's schemes for the Prince's Lodging at Newmarket of around this period (Fig. 193; see Fig. 44).[46] To either side of the masque palace are buildings shown in perspective that are designed in the manner of the Banqueting House, which Jones was also working on at this time. Just as the masquing hall's façade would be his first ornamented with the more decorative Orders, so 'Cupid's Palace' was the first of his stage façades to be ornamented in this style. This synchronicity was underlined in 1623 when the opening scene of *Time Vindicated to Himself and to His Honours* was set against a backdrop of the Banqueting House itself (see Fig. 24). Following James's death, under Charles I and Henrietta Maria, Jones's masque architecture was to change in character. Indeed, after the Banqueting House his court audiences became used to seeing ornate façades, and not unusually with Corinthian or Composite Orders as noted above; this is amply demonstrated by scenes from *Time Vindicated* (1623), *Artenice* (1626), *Albion's Triumph* (1632), *Tempe Restored* (1632), *The Shepherd's Paradise* (1633), *Coelum Britannicum* (1634), *Britannia Triumphans* (1638) and *Salmacida Spolia* (1640) (Fig. 194; see Figs 188, 189, 213–15, 282).[47] During this period the style of Jones's masque and built architecture was, for the most part, no longer consistent. In the later years of the Caroline court, when the Puritan threat to the crown was growing, the public face of court architecture remained relatively plain. Only in private, inside the masquing hall, royal chapels and Queen's House, was it ornate – that is until what would turn out to be the ill-judged, royally funded Corinthian portico to St Paul's Cathedral.

192 Inigo Jones, 'A Street in Perspective', from *The Vision of Delight* (1617). Devonshire Collection, Chatsworth

193 Inigo Jones, design for 'Cupid's Palace' for an unknown masque *c.*1619–23. Devonshire Collection, Chatsworth

194 Inigo Jones, design for 'A City in Ruins' for the masque *Coelum Britannicum* (1634). Devonshire Collection, Chatsworth

'LARGE HALLS IN GREAT MEN'S HOUSES': JONES'S SECULAR COURT PROJECTS

The secular court buildings on which Jones worked in the period between his 'Roman Sketchbook' notes and the Banqueting House all appear to have followed closely his call for a 'masculine and unaffected' architecture. Take, for example, the Queen's House. It will be remembered from the Introduction that the building was initially conceived in 1616 as a royal lodge for Anne of Denmark.[48] Jones's preliminary design for the south elevation of the 'H'-plan house of 1616 has two storeys (Fig. 195).[49] The ground one is treated as a rusticated basement whilst the upper has a loggia comprising six Corinthian columns. The east/west elevation – straddling the road – is more or less compatible in proportion and detail (Fig. 196).[50] It has a rusticated basement and an upper storey with a bridging room lit by a central Serliana (here again suggesting the form's royal associations). This façade is undecorated, apart from the window mouldings and two Corinthian columns at the edges representing those of the north and south porticoes in side elevation: statues are also seen in side elevation facing north and south above these porticoes, although they are absent on the drawing of the south façade, and none faces east or west. By restricting the proposed statues and Corinthian

columns to the central porticoes on the more private north and south façades (rather than use them on every face, as was common in villa designs), Jones ensured that only the court could see them. For they would be hidden from close public view by the high walls built in the years 1619–24, flanking the roadway. But in any case this design was largely aborted, for it differs substantially from the Queen's House as built from October 1616.[51]

On 30 April 1618 the work was interrupted, presumably due to the queen's ill health. A year later construction was suspended when Anne died and the house passed to Prince Charles. Additional work was carried out in 1629, which included thatching part of the roof. This was required, it has been suggested, for a structure that was incomplete in 1619 and therefore needed protection from rain and frost.[52] By the beginning of the 1630s, with only the brick carcasses of the ground-floor ranges finished, the south front was evidently quite plain. Something of its appearance is indicated in the

195 (*above*) Inigo Jones, the preliminary design for the south elevation of the Queen's House at Greenwich, 1616, facing the royal park. RIBA Library Drawings Collection, London

196 Inigo Jones, the preliminary design for the east or west elevation of the Queen's House at Greenwich, 1616, facing the public road. Worcester College, Oxford

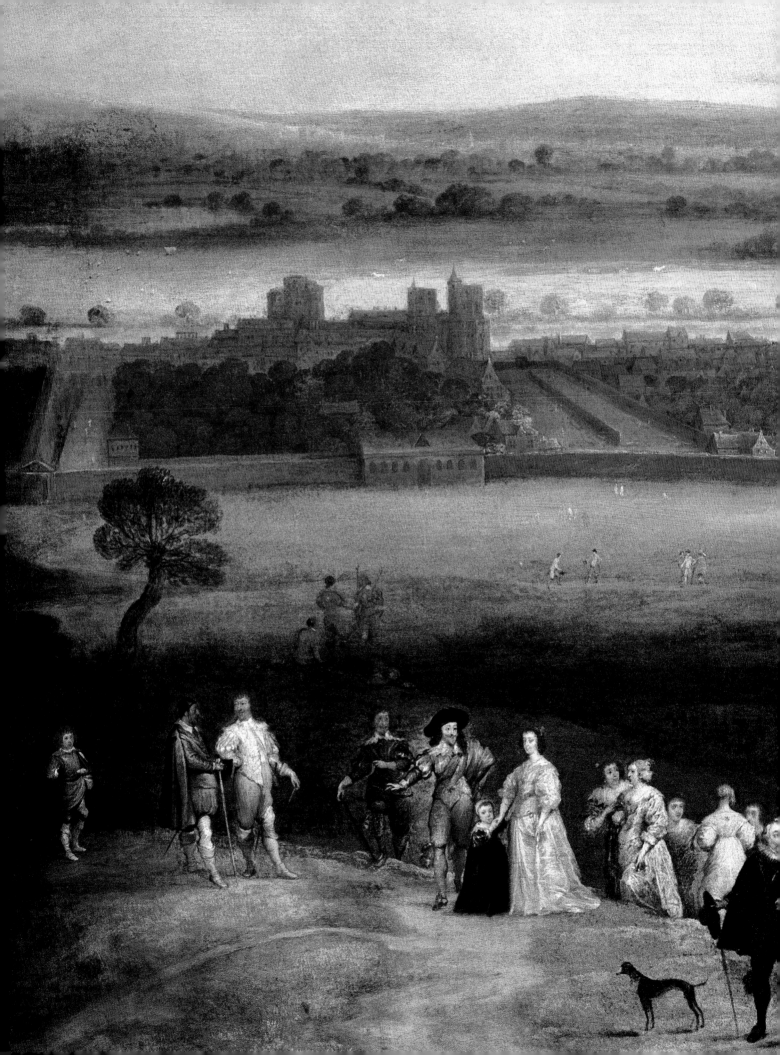

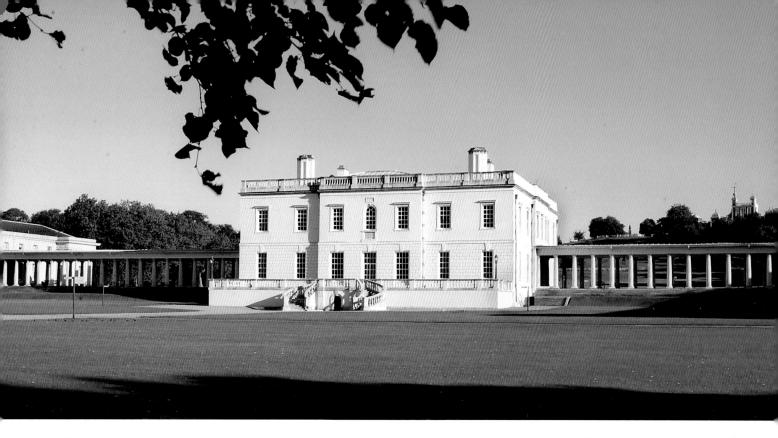

198 Inigo Jones, the north façade of the Queen's House at Greenwich, 1632–8. Compare this plain façade with the flamboyance of Kirby Hall (1570–75; see Fig. 3)

painting by Van Stalbemt and Van Belcamp of around 1632, portraying Charles I and his queen in the royal park with a group of courtiers who include Jones (Fig. 197).[53] A tall archway is depicted, flanked on either side by four arched windows set in a plain, astylar façade capped by a horizontal band or 'cornice'. Whether this early building ever performed a function related to its intended royal purpose, as this painting perhaps implies, is difficult to say. But the façade in the painting certainly complied with Jones's call, made just the year before work started, for an architecture that was 'masculine and unaffected'. The thatched structure might perhaps be compared in its typology to one of Serlio's Rustic buildings in his satiric scene in Book Two of his treatise, a model that Jones would have known from his masque designs (see Fig. 278).

Work resumed at the Queen's House shortly after this picture and went on until 1638, at which point it was occupied by Henrietta Maria. In its completed state the building continued to reflect the public restraint called for in the 'Roman Sketchbook' (Figs 198–9). As Higgott has noted, Jones simplified his ornaments from the design of 1616, reducing the window entablatures to architrave-cornices and eliminating the running mouldings on the walls.[54] The use of columns was now limited to a central loggia on the south front, which

was built between 1632 and 1635 to address the relatively exclusive royal park. The original simplicity of the astylar north front of the building, before later alterations, is recorded in a drawing of around 1635 possibly by Nicholas Stone (Fig. 200).[55] Decorative additions to this façade were flirted with for Henrietta Maria, notably capricious *trompe l'œil* figures of terms and angels that are sketched on this drawing, but which were never executed.[56] In choosing the Order for the south loggia Jones switched from the original Corinthian to Ionic, and in so doing reflected the strictures of Serlio, who considered Ionic columns appropriate 'if you had to make anything for matrons'.[57] Following Vitruvius, Serlio also recommended that the Ionic should be used for buildings dedicated to Diana as the Roman (and ancient British) goddess of the hunt. This was an identification that Jones repeated when discussing Stonehenge, and was patently suited to the origins of his Greenwich building in Tudor hunting lodges.[58] Anne of Denmark's hunting lodge in Surrey, called Byfleet House, also had an Ionic (and Doric) frontispiece added in 1617 that is attributed to Jones (Fig. 201).[59] The Greenwich loggia provided a viewing platform for the queen and her ladies to watch the hunting in the royal park. Henrietta Maria was herself a keen hunter and as has been seen she was often iden-

197 *(facing page)* Adriaen van Stalbemt and Jan van Belcamp, *A View of Greenwich, c.*1632, detail of Fig. 18 showing Charles I and Henrietta Maria with the unfinished Queen's House. Royal Collection

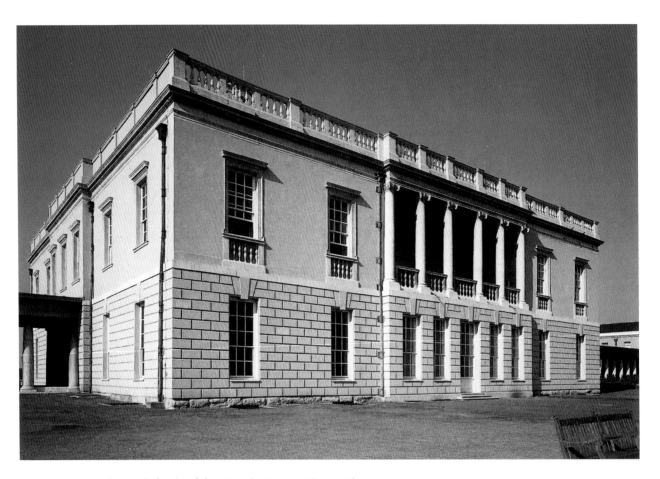

199 Inigo Jones, the south façade of the Queen's House at Greenwich, 1632–8

200 Nicholas Stone (attributed), drawing of *c*.1635 recording the original simplicity of the astylar north front of the Queen's House, before the addition of the terrace and stairs in 1636–7 (drawing lost). The pencil sketches of figures around the central window were added *c*.1640

201 John Aubrey, sketch of Byfleet House, Surrey, with Doric and Ionic frontispiece added in 1617 and attributed to Jones. Bodleian Library, Oxford, Aubrey MS 4

tified with Diana in court art (see Fig. 109).[60] But Jones was also fully aware that, having been recommended by Serlio as appropriate for buildings dedicated to the Virgin, the Corinthian had traditional associations with Catholicism. He would surely have wished to avoid these when designing a house for a queen increasingly unpopular with Puritans for her open Catholic worship at court. If this was indeed the case, his reticence was soon justified, given the Puritan animosity during the Civil War to his Corinthian portico at St Paul's.

What of the relationship between the inside and outside of the Queen's House? Although altered over time, the lavishness of the original Jones interiors is indicated by sketch designs for chimneypieces of around 1637 in the RIBA drawings collection; notable is that based on a design by Jean Barbet drawn alongside studies of *putti* (Fig. 202).[61] As this ornate design demonstrates, Jones felt little need internally to temper the sumptuous ornamentation popular in Catholic Europe and advanced by Barbet. This too followed his earlier recommendations, principally that such orna-

ments 'do not well in sollid Architecture and y[e] facciati of houses but in gardens loggis, stucco or ornamentes of chimnies peeces & in the inner partes of houses'.[62] In this sense the contrast between a flamboyant interior and plain exterior at Henrietta Maria's Queen's House could not have been greater, and represents a perfect expression of the 'Sketchbook' principles.

The Queen's House was matched in its role as a hunting lodge for a queen by Jones's Prince's Lodging at Newmarket, built to accommodate Prince Charles during the hunting and racing seasons. Two alternative elevations by Jones of this Lodging have survived, pasted onto one sheet, both of 1618–19 (see Figs 43–4).[63] They are similar, except that the upper one has what appear to be Corinthian columns whilst the other design is astylar, with quoins at the edges. Both have pediments, a feature that (together with the heraldry) conferred nobility on the design and was no doubt judged appropriate, as with its use in the early Banqueting House and Queen's House designs, to the building's princely function. It is not known for certain

202 Inigo Jones, chimneypiece design for the Queen's House, c.1637. RIBA Library Drawings Collection, London

ings constructed before the Banqueting House should be considered. Here the absence of rich decoration and Corinthian columns is perhaps less remarkable, irrespective of the fluctuations in Catholic toleration at court. Jones's elevation for the entrance bay to an unidentified house of 1616 and a town-house façade ascribed to Sir Fulke Greville's house in Holborn of around 1617, as well as two entrance designs, are all appropriately astylar (Fig. 203; see Fig. 122).[66] In its stylistic simplicity, Greville's house in particular followed not only his Calvinist views on art but also the decorum-based dictate that, in Jones's words, 'Loges and large halles in great me[n]s houses./for meaner Jentleme[n] lesser houses'.[67] Turning to Jones's gate

203 Inigo Jones, a town-house façade design ascribed to Sir Fulke Greville's house in Holborn, London, of c.1617. Devonshire Collection, Chatsworth

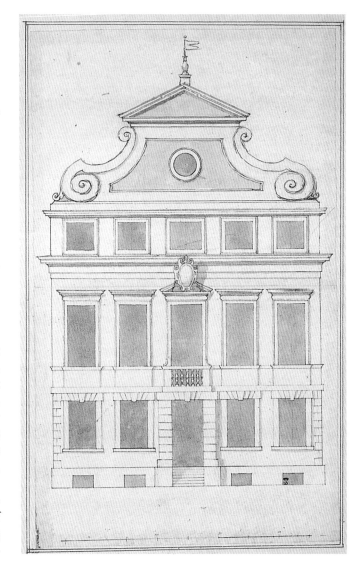

which design was built, but it is most likely to have been a version of the less ornamental and more rustic, astylar design. For not only is this the one inscribed with working dimensions, it also has dormer windows as described in the Declared Accounts.[64] Furthermore, a detail of the Lodging that was drawn *in situ* by Webb shows an entablature that matches more closely that of the astylar elevation.[65] The Lodging's appearance may well have tended therefore towards the rustic rather than the delicate. Given that one of the main differences between these two designs is their decoration, they demonstrate the importance of this issue, and in this case offer a somewhat stark choice in columnar terms between 'all or nothing'. In fact, Jones merely flirts with the use of columns, since the capitals are represented in outline only on the drawing. Designing with decorum in mind involved making these very choices, and in these two schemes Jones might be seen working towards the final solution. The Corinthian was rejected at the Queen's House possibly because it was judged contentious on a lodge designed for the consort of a Protestant king, and one whose open celebration of Catholicism courted controversy. It would seem that at Newmarket this delicate female Order with virginal associations may have been seen on reflection as equally inappropriate for the hunting lodge of a Protestant prince. Jones's Newmarket works were destined to have a short life, for the Parliamentarians demolished much of them, including the Prince's Lodging, in 1650.

Following the Banqueting House, as well as finishing the Queen's House, Jones worked on a series of ecclesiastical projects for the court. Before discussing these projects, the style of his more minor secular build-

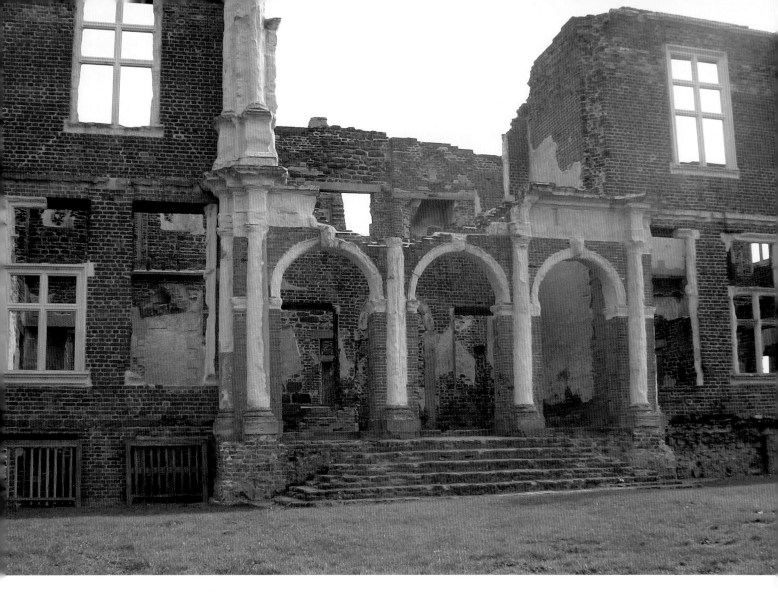

204 Houghton Conquest, Bedfordshire, portico, *c.*1615

designs, these all post-date his trip to Italy in 1614 and conform to the 'masculine and unaffected' style; this is despite the European tradition established by Serlio of highly ornamental – and on occasions licentious – gates.[68] The rusticated Doric gateway Jones designed for Lionel Cranfield in 1621 is the sole survivor, now reassembled in the garden at Chiswick House (see Figs 156–8, 267). Although Jones's ornamentation on his gateways belies standardisation, it nevertheless falls in line with a familiar pattern: like all his royal designs built prior to the Banqueting House, the more decorative, 'feminine' Orders are absent. Subsequent secular designs to the masquing hall have a similar air of ornamental restraint. The gallery Jones built in 1629–30 for Charles I's sculpture collection in the garden at St James's Palace was of the Tuscan Order.[69] In the case of the Goldsmiths' Hall rebuilt in the later 1630s to a design by Nicholas Stone, in which Jones had an

involvement (but was not the main author), the building was astylar.[70] It might be expected that ostentation would be avoided by a group not wishing to draw attention to their wealth. The same austerity was true of the elevation sketched by Webb but marked by him as 'Mr Surveyor's desygne' for a house in Blackfriars for Sir Peter Killigrew of around 1630 (Fig. 207).[71] As also of the notably plain and functional 'Token House' in Lothbury in the City of London, designed by Jones and built at the end of the 1630s for Lord Maltravers (a design for a five-window-wide house at Lothbury of 1638 is also astylar; Figs 205–6).[72] Houghton Conquest in Bedfordshire, built for the Protestant Mary Herbert (Dowager Countess of Pembroke), was, appropriately enough, an astylar house save for intricate yet restrained Doric loggias on the west and north façades (the north with additional Ionic columns). Both were built some time after 1615 and are conventionally associated with

205 Inigo Jones, 'Token House', or warehouse, believed to be for Maltravers House, Lothbury, London, *c.*1638. Worcester College, Oxford

206 Inigo Jones, design for Maltravers House, Lothbury, London, 1638. Worcester College, Oxford

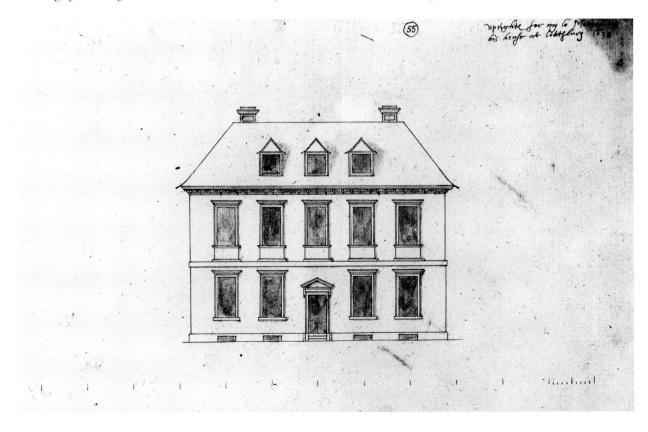

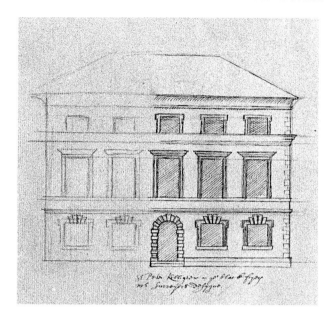

Jones (Fig. 204).[73] Stoke Park, again sometimes attributed to Jones and started around 1629, has giant Ionic pilasters overriding an Ionic colonnade (Fig. 208; see Fig. 15). This is a novel arrangement appropriate, perhaps, to the building's country location (where, according to Serlio, 'a certain license can be taken').[74] The Ionic Order, suitable to men of letters as Serlio once more points out, was also not inappropriate given that the patron, Sir Francis Crane, served as auditor-general from 1617 and member of Charles I's council

207 (*left*) John Webb after Inigo Jones, design for Sir Peter Killigrew's house in Blackfriars, London, *c*.1630. Worcester College, Oxford

208 (*below*) The east pavilion at Stoke Park, Northamptonshire, *c*.1629. Country Life Picture Library

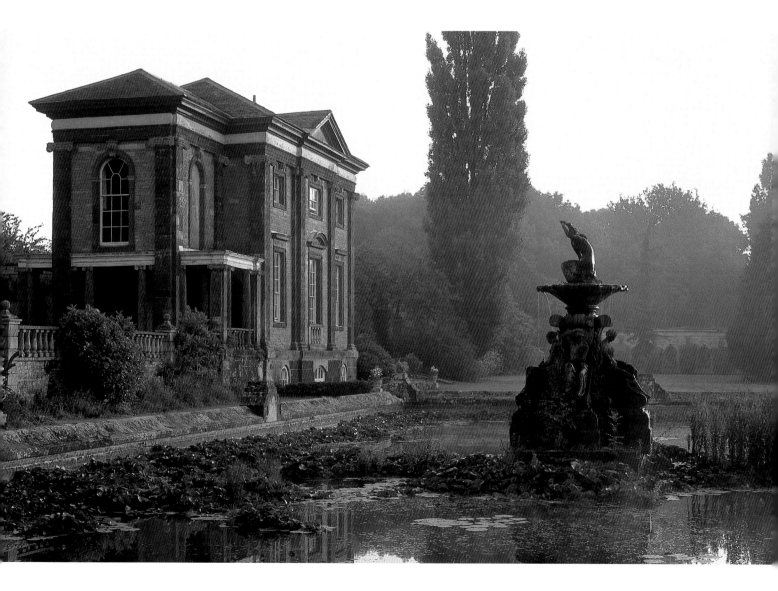

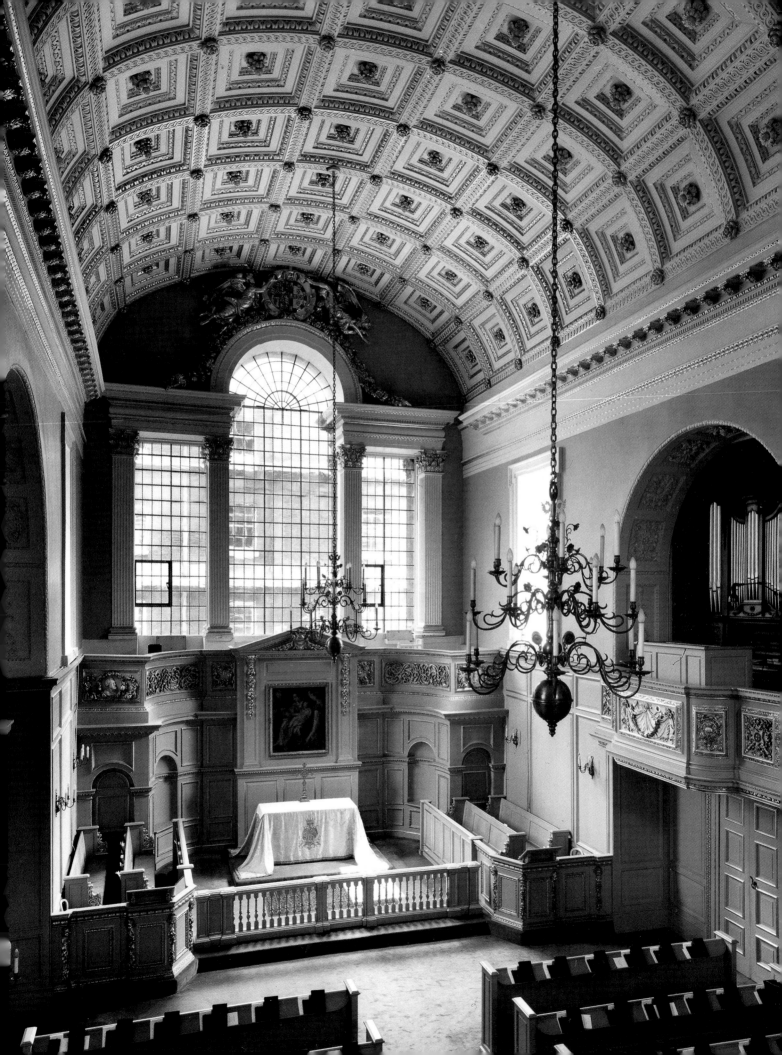

from 1625.[75] These secular works too can be understood to have reflected the principles of architectural decorum, albeit tempered by a sense of social decorum as articulated in Jones's 'masculine and unaffected' dictate.

'DECORUM AT THE TEMPLE': JONES'S ECCLESIASTICAL PROJECTS

It has been seen that Jones followed Serlio in using a human analogy when explaining the moral virtue of plainness, identified with temperance, over the vice of embellishment, identified with affectation and licentiousness. In Jones's case it was the 'wise man', in Serlio's the 'beautiful woman'. Implied in both are the contrasting visual preferences and, from a Protestant point of view at least, moral attitudes of the Churches of England and Rome. These decorative conventions might be expected to have found particular expression in Jones's ecclesiastical projects. This presumption is surely justified given the ancient connection of each Order with specific sacred qualities, as well as the fact that the decoration of temples in antiquity followed rules of decorum that were 'firmly observed' according to Jones. For it was a very small step for him to copy Serlio and apply to his Christian chapels and churches, of either Protestant or Catholic denominations, his observation in his copy of Palladio that 'the Ansientes varied and composed ther o[r]ders according to the nateurres of the gods to whome ye Tempels weare dedicated'.[76] This is especially so given that understanding such a translation from ancient to modern was the very purpose of his annotations. As a wise man himself, Jones nevertheless clearly understood the need to temper free expression in matters religious.

In designing the Queen's Chapel at St James's Palace, for example, Jones stayed true to Protestant notions of public propriety even in the context of a Catholic project (Fig. 184). This austere building with its astylar front façade was begun in 1623 and completed in 1626, with the consecration taking place the following year.[77] The very notion of the court constructing a Catholic chapel in the predominantly Protestant city of London was in itself highly controversial, as the Introduction discussed, without celebrating the fact by highlighting what were all too direct associations in Italy between ornamental façades and Catholic worship.[78] The chapel's external austerity contrasted with the normal arrangement of Catholic church architecture in which the outside was often as decorative as the inside. But this was a building where the use of the Orders – and

any Order, let alone a decorative one – could well have been seen as explicitly popish and even 'idolatrous'.

In the case of both the chapel and the Newmarket schemes, the central section of which the chapel resembles, Jones used quoins to emphasise the edges rather than columns to articulate the wall plane. But the rusticated pillars that framed the doorway to the Lodging are eliminated in the chapel's modest door design. Perhaps to acknowledge its palace location and as a mere hint as to its religious denomination, the Serliana window in the chapel's east end has fluted Corinthian columns both inside and out (Figs 209–10). In discussing this window Worsley has pointed out the connections of the Serlian form with the papacy (see Fig. 187).[79] Although the chapel was originally entirely set within the palace, the east façade was by far the more private of the two end elevations in facing a cloister for the attached friary, whilst the more prominent (west) elevation has the entrance for the congregation.[80] The Corinthian columns of the window were thus visible to the friars alone and are the only external decoration, given the plainness of the west end. They represent Jones's sole acquiescence to the norms of Catholic ornamentation – Composite or Corinthian outside, Corinthian or a less decorative Order inside. The window provides a hint of the chapel's opulent interior, notable for its rich coffered ceiling, cornice and decorative fireplace to the Queen's Closet.[81] The closet also once had a screen with Corinthian pilasters and fes-

210 Inigo Jones, north and east elevation of the Queen's Chapel at St James's Palace, London, 1623–6

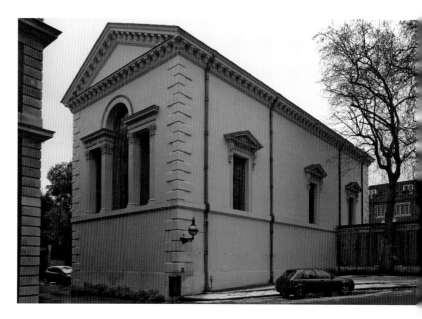

211 Inigo Jones, screen to the Queen's Closet in the chapel at Somerset House, from Isaac Ware's *Designs of Inigo Jones and others* (*c*.1733)

toons.[82] The Catholic courtiers were now free to worship in a setting removed from the Puritan hostility of seventeenth-century London and much closer in character to the interiors of many Italian chapels. By satisfying the Protestant preference for simplicity in outward appearance and the Catholic one for decorative interiors, Jones responded to the sensibilities of both denominations. In a sense this was Catholic architecture 'in disguise'; it will be seen below that Jones himself expressed this perception of his work some fifteen years later when, under Charles I and Henrietta Maria, court attitudes to Catholic representation had altered once more.

In 1632 Jones was again called upon to design a Catholic chapel in the confines of one of the royal palaces, this time at Somerset House (demolished in 1775).[83] An initial design for the chapel was produced during the Spanish Match negotiations, like the Banqueting House and the chapel at St James's, but this has

been lost. The chapel was open to Henrietta Maria's Catholic servants and their families, and it too was designed for the queen's Capuchins, a missionary branch of the Franciscans who occupied a new friary of which the chapel formed a part. The friary buildings were north and south of the chapel and were demolished by 1665. The order was dedicated to the Virgin, who was also the patroness of Henrietta Maria, as her name suggests. As a reflection perhaps of the chapel's significance and the progress of Catholicism at court, the building's consecration in December 1635 was celebrated with a series of Masses over the following days.[84] Divisive from the start, the chapel attracted admiration and hostility in equal measure, depending on the religious perspective of the viewer. An elaborate and temporary Baroque reredos by the French sculptor François Dieussart was constructed for the occasion of the first Mass, complete with optical effects much admired by Charles I according to one of the queen's Capuchins, Cyprian

Gamache.[85] This was related to Jones's masque designs by the Reverend George Gar-rard in a letter to the Earl of Strafford on 8 January 1635:

> such a glorious Scene built over their Altar, the Glory of Heaven, *Inigo Jones* never presented a more curious Piece in any of the Masks at *Whitehall*; with this our *English* ignorant Papists are mightily taken. I went to see it one Evening; much or more flocking of *English* Papists is to this Chapel now, than heretofore, which I am sorry to know.[86]

Garrard's record is of a Catholic spectacle not seen in England for a century.

The few surviving drawings for the chapel by Jones show details only, and there is no way of knowing if they were constructed (see Figs 216, 218–19).[87] Isaac Ware's *Designs of Inigo Jones and others* (c.1733), however, illustrated Jones's screen to the Queen's Closet housing the royal pew at the chapel's north end (the liturgical 'west'; Fig. 211).[88] In addition, the highly decorative cornice, beam and coffering details to the chapel's ceiling were drawn by Henry Flitcroft in the 1720s.[89] Despite the relative poverty of the drawn record, Elizabeth Veevers has suggested that Jones's temple in the masque *The Temple of Love*, as described in some detail in the text, may well have resembled the chapel's interior.[90] It has been seen that Jones frequently used his own buildings in the masques, and this one was performed in 1635 with Henrietta Maria herself appearing on stage just when the chapel was nearing completion. This inter-relationship was reinforced, as Veevers explains, by the title of the masque: 'the word "temple" (often used by contemporaries in connection with Catholic worship) was appropriate for the Queen's Chapel, since the inscription on the foundation stone refers to it as *Templum hoc* . . . and the French description calls it *un temple*'.[91] Jones wrote that the masque temple's interior,

> instead of columns had terms of young satyrs bearing up in the returns of architraves, frieze, and cornice, all enriched with goldsmiths' work; the further part of the temple running far from the eye was designed of another kind of architecture, with pilasters, niches and statues, and in the midst a stately gate adorned with columns and their ornaments, and a frontispiece on the top, all which seemed to be of burnished gold.[92]

This leaves little to the imagination, suggesting perhaps a source in an actual design for the queen fresh in Jones's mind. Given that he was working alongside William Davenant on this masque at the same time as

completing the chapel interior, it is surely likely that the two interiors informed each other. For Jones's screen to the Queen's Closet, as illustrated by Ware, also had terms (comprising winged angels) supporting a decorative architrave (see Fig. 211). Notably, these terms were in turn supported by fluted Doric columns surmounted by an entablature; this had a mask (of a gorgon's head) and garlands in place of triglyphs, somewhat similar to the entablatures on the Banqueting House and based on an antique example in the Arundel collection.[93] Here then, inside the chapel, Jones fully exploited associations between capricious ornament and Catholicism, or at least a Catholic queen. Indeed, he reinforced this link elsewhere at Somerset House in the interiors of the palace (Fig. 212).[94]

212 Inigo Jones, design for an internal painted panel with grotesque ornament and the cipher of Henrietta Maria (early 1630s), unknown location, possibly Somerset House. Ashmolean Museum, Oxford

213 (*left*) Proscenium and standing scene, with enriched Doric, from the masque *The Shepherd's Paradise* (1633). Devonshire Collection, Chatsworth

214 (*below left*) Inigo Jones, 'Love's Cabinet' from the masque *The Shepherd's Paradise* (1633). Devonshire Collection, Chatsworth

215 (*below right*) Inigo Jones, 'Interior of a Temple with Tombs' from the masque *The Shepherd's Paradise* (1633). Devonshire Collection, Chatsworth

In Walter Montagu's *The Shepherd's Paradise* (1633), Jones once again used an enriched Doric. The masque was also written for Henrietta Maria around the time of the construction of the Somerset House chapel and was performed at the palace. On this occasion the Doric Order was for the proscenium arch, whilst terms featured in the opening scene entitled 'Love's Cabinet' (Figs 213–14). A further backdrop entitled 'Interior of a Temple with Tombs' had Corinthian or possibly Composite columns (perhaps also hinting at links with the chapel; Fig. 215). Jones had used the Composite the year before in *Albion's Triumph*, although until then, as far as is known, he had not used it in a scene – or publicly on an actual building – since the Banqueting House

designed some thirteen years earlier (see Fig. 188).[95] But that he considered using this Order on the closeted Catholic chapel at Somerset House is confirmed by his surviving drawings, which represent a niche and a tabernacle of uncertain location (Figs 218–19).[96] Both drawings are of statues flanked by Composite pilasters, with a winged cherub's head in the frieze in one drawing and in the pediment in the other. This image was, as Harris and Higgott point out, popular with the Jesuits and had 'strong Catholic associations'.[97] For this reason winged cherubs were targeted by the iconoclast William Dowsing during the Civil War, despite their Solomonic connections, along with statues in niches.[98] The statues are of Christ as *Salvator Mundi*, again an

216 Inigo Jones, window for the chapel at Somerset House, London, 1632. RIBA Library Drawings Collection, London

217 Domenico Fontana, design for a Doric doorway, from *Della trasportatione dell'obelisco vaticano et della fabriche di nostro signore Papa Sisto V . . . libro primo* (1590), p. 81

undoubted Jesuit detail known to Jones from his time in Rome.[99] Such Catholic iconography reinforces Peacock's assertion that Henrietta Maria's religious devotion had a significant impact on Jones's style. This was particularly so in his interiors and his stage designs for such as *The Shepherd's Paradise* (see Figs 213–15).[100] It cannot be accidental that the chapel screen represents Jones's most ornate built interpretation of the Doric to date.[101] If for Jones the 'solid' Tuscan and 'delicate' Composite represented extremes extending from masculine to feminine and, by implication at least, Protestant to Popish, then the increased ornamentation of an Order made it both less masculine and less Protestant. Jones's enrichment of the masculine Doric – as he puts it in his Serlio, to 'varry ye worke i[n] Dillicacy or strength [acco]rding to ye personn' – can therefore be seen to carry with it visual references appropriate to his Catholic queen.

The cherub reappears in a further surviving drawing by Jones for the Somerset House chapel, this time without doubt depicting an external detail. The drawing is of a window surround that although astylar

has novel triglyphs and is based on a Mannerist design by Domenico Fontana for Sixtus v (Figs 216–17).[102] It is uncertain, however, where this surround went, or even if it were built, since the only view of the chapel externally is a glimpse of the eastern elevation in a painting by Cornelius Bol of the 1640s that shows an astylar façade with plain windows different from this (Fig. 220).[103] The window and possibly the other details are therefore thought likely to have been for the (main) west elevation. This fronted a garden and was less visible from the river, whilst a wall concealed the lower part of the east façade, and the 'Lower House' of the friary abutted the chapel to the south.[104] The window may have lit the Queen's Closet, and the niche was possibly one of three related to the west door.[105] In this way, in the relative confines of Somerset House palace, Jones not only underlined the identification of capricious ornament with Catholicism, but also of the Composite Order with the customary iconography of the Jesuits. Simon Thurley has noted that this west elevation 'presented to Catholics familiar with Jesuit churches in France and Italy a façade that was recog-

218 Inigo Jones, a sketch elevation for a niche at Somerset House, London. RIBA Library Drawings Collection, London

219 Inigo Jones, elevation of a tabernacle at Somerset House, London. RIBA Library Drawings Collection, London

nizably a product of the Counter-Reformation, combining austerity with iconographic emphasis'.[106] In other words, this was 'Catholic architecture' tailored to suit a Protestant context.

Jones was criticised by Catholics for delays in the chapel's construction. He responded in *The Temple of Love* by including anti-masquers of 'various bad influences' that 'delay the appearance of the temple'; they comprise 'a sect of modern devils' who were 'sworn enemy of poesy, music, and all ingenious arts, but a great friend to murmuring, libelling, and seeds of discord'.[107] Jones laid the blame for the temple's delay, as had Catholics in the case of the chapel, squarely at the feet of those hostile to the 'ingenious' arts, namely the Puritans. If his need to condemn Puritan reserve can be viewed as a measure of the hostility he faced, then perhaps it can also be seen as a measure of how much this reserve influenced the outward appearance of his work. Whatever the exterior style of Henrietta Maria's closeted chapel at Somerset House – and the drawings indicate a degree of Catholic symbolism not entertained on the earlier chapel at St James's – it is certain that, true to the 'Roman Sketchbook' requirement for

220 (*above*) Cornelius Bol, *Somerset House from the River Thames* (detail), *c*.1640–50. Dulwich Picture Gallery, London

221 (*facing page top*) Inigo Jones, Tuscan portico of the east front of St Paul's church, Covent Garden, London, 1631–3

222 (*facing page bottom*) Inigo Jones, west front of St Paul's church, Covent Garden, London, 1631–3

internal opulence, both Catholic chapels were ornamented internally in a manner that expressed their denomination.

Although built for a courtier and not the crown, Jones's plain church at Covent Garden stands in striking conformity to his stylistic rules outlined in 1615 (1631; Figs 221–3). This was the first Protestant church built *all'antica* in England, but, as has been seen, Protestantism had found earlier expression in Jones's work. Chapter One discussed how he had introduced the Protestant chivalric credentials of his young patron, Prince Henry, using Rustic backdrops in *Prince Henry's Barriers* (see Figs 70–71). These scenes expressed the

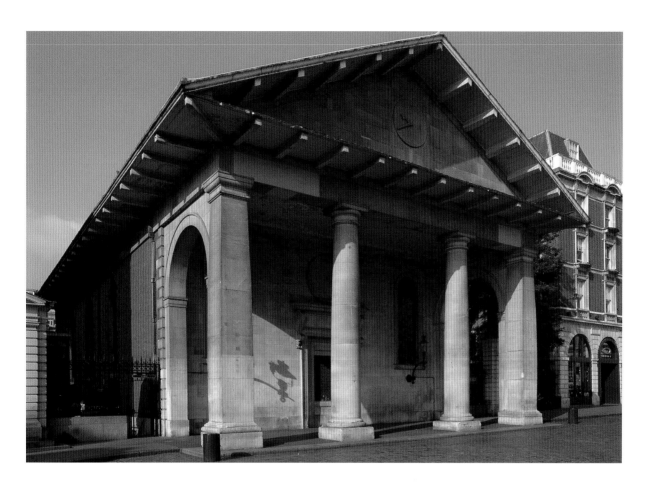

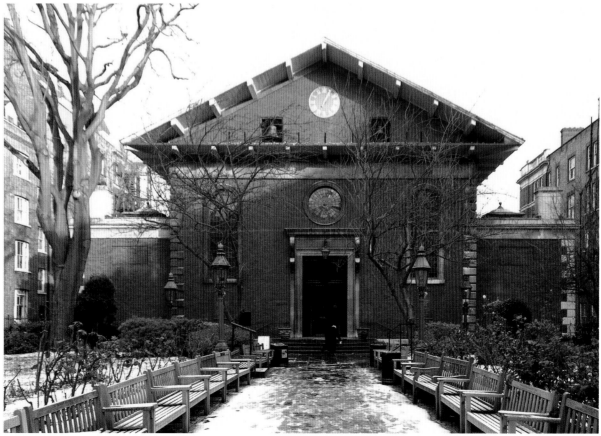

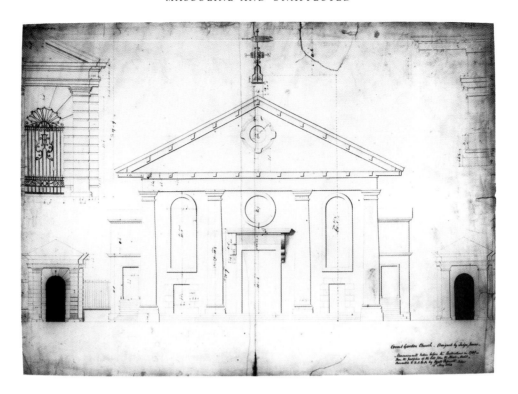

223 John Hiort, elevation of St Paul's church, Covent Garden, London, drawn *c*.1800 and record-
ing the original design with steps and side entrances before alteration in 1788. RIBA Library
Drawings Collection, London

Protestant conception of a restored uncorrupted
theology, once practised by the ancient Britons and
later Arthurian knights; and the 'unaffected' architecture
visualised here prefigured associations that Jones would
later make at 'Tuscan' Stonehenge. Puritan virtues
echoed through his decorum-inspired remark that 'the
Romans . . . made choice of the *Tuscane*, rather than any
other *Order* . . . as best agreeing with the rude, plain,
simple nature of those they intended to instruct, and
use for which erected'.[108] Such an understanding was
in line with the use of the Tuscan column to represent
ancient Britain elsewhere in Stuart frontispieces and
court art (see Figs 76, 230). This validation of Protestant
mythology, together with Jones's 'masculine and unaf-
fected' stylistic preference, provides a compelling
context for his choice of a Tuscan portico at Covent
Garden. For it would seem entirely appropriate that he
should use the Tuscan Order here but not, for example,
on the Catholic chapel at St James's Palace. In refer-
ence to Covent Garden Keith Thomas has noted that:
'it is possible to discern the emergence of a Puritan-
inspired classical church architecture in parallel with the
very differently motivated classicism of Inigo Jones's
Roman Catholic royal chapels at St James's and his
portico at St Paul's'.[109]

It is quite likely that the plain style of the church's
exterior was influenced by the beliefs of Jones's patron
at Covent Garden, the Earl of Bedford.[110] The earl was
a Protestant – or more accurately, a Calvinist – with
Nonconformist sympathies. He described the building
as a simple 'chapel', echoing a common-enough dis-
tinction made by the Reformers over the High Church
party in the Church of England who preferred the term
'church'.[111] According to the famous rumour reported
by Horace Walpole, the earl commanded that: 'I would
not have it much better than a barn'; to which Jones
replied, with a nod to the principles of decorum: 'Well,
then! You shall have the handsomest barn in England.'[112]
The earl was clearly not making reference to economic
concerns, but to symbolic ones, since the building was
relatively expensive.[113] Royal permission for the Covent
Garden scheme stipulated that £2,000 be spent on the
new church.[114] The astylar western elevation with its
overhanging eaves was Jones's answer to the earl's
request (see Fig. 222). Other aspects of the design may
also have reflected, or at least been facilitated by, the
earl's religious preferences. In Jones's original plan the
altar was to be positioned at the unorthodox west of
the church, in line with Puritan indifference to such
worldly matters as fixed altars. The church entrance

was, perfectly appropriately, positioned on the piazza under the eastern portico. It was only after Laud's insistence that the altar was moved to the east in the final design, causing the entrance to be swapped to the west, at what is in effect the 'rear' of the church, and the eastern door to become a blocked panel.

In contrast to the exterior, the original interior of the Covent Garden church contained some ornate elements. No internal view has survived, but Edward Hatton's description of 1708 indicates that the inside was not totally bare.[115] The wooden pulpit was supported by columns and had carved ornamentation. The font was of white marble on a Portland stone pedestal, with a copper cover enriched with 'Imbossments & carveing'.[116] Hatton, however, does not mention any decorative columns or devotional icons associated with Catholic liturgy, and the church's crosses were few in number and plain. The Puritan preacher John Gordon had conceived of an austere place of devotion, with 'no Altars, no Images, nor any materiall crosse of golde, silver, wood or stone'.[117] The interior of St Paul's may have been more ornate compared with the outside, following the 'Sketchbook' notes, but its character was still in keeping with the simple nature of Protestant worship requested by Bedford and agreed to by Jones. Thus, like Jones's 'wise man', the church's exterior presented a dignified aspect to its public whilst inside the ornamentation reflected 'Imagination set free'; although free within the limits defined by Protestant preferences. Jones's church architecture, both Protestant and Catholic, thereby conformed to a very different set of rules from the more opulent strictures that had shaped Italian churches over the previous two hundred years.

'WITHOUT ORNAMENT AND LIVING IN DISGUISE': TOWARDS AN ELOQUENT ARCHITECTURE

In 1606, Edmund Bolton famously recorded in Latin that he had given Giovanni Francesco Bordini's *De Rebus Praeclare Gestis a Sixto V* (1588) to Jones, 'as an earnest and a token of a friendship' with the architect. As the Introduction noted, Bolton hoped that through Jones 'all that is praiseworthy in the elegant arts of the ancients, may some day insinuate themselves across the Alps into our England'. For Bolton, a Catholic, the obvious foreignness of the *all'antica* style, and by implication its association with Catholic Italy (south of the Alps), was seen as an obstacle to its introduction into England. This difficulty was made clear by one word in

particular in the inscription, namely 'insinuate' (*irrepturas*). As Peacock explains, this word is 'related to the modern English "surreptitious", and denotes an incursion which is both intentional and covert'.[118] Cicero's *De oratore*, which it has been noted Jones studied closely in the context of his approval of the analogy between the architect and the orator, used *irrepturas* to describe certain effects of oratory that operate powerfully but surreptitiously.[119] In this way Bolton appears to envisage that the arts will be tacitly introduced into England; they will 'insinuate' themselves under the appropriate auspices of Mercury, the patron of the Muses but also of eloquence and secret learning. It is surely tempting to see the 'disguised' – conspicuously native, less Italianate – version of the *all'antica* style Bolton envisaged as resembling Jones's 'masculine and unaffected' manner.

There are reasons for the covert nature of Bolton's project. He wrote his inscription just a little more than a year after the Gunpowder Plot, an event that indicated that a Catholic threat could come from internal conspiracy rather than from external invasion. It would seem that Bolton was well aware that, so soon after the plot, the problems of introducing a style perceived as imported from the home of Catholicism were significant. The subject of Bordino's *De Rebus* suggests that Bolton's inscription should be interpreted in the context of religious repression. The poem celebrated the revival by Sixtus V of the High Renaissance papacy, one result of which, Bordino hopes, will be an extension of Rome's influence to the heretical hinterlands, including England, and their re-absorption into the Catholic Church.[120] Bolton paraphrases this dangerous topic into his own hope for a benign invasion by the arts, rather than the religion, of Italy.

If this famous inscription can be read as a prologue to Jones's career, then the text of one of the last masques – *Luminalia: The Queen's Festival of Light* (1638) – provides an epilogue. For the covert migration of the arts was also alluded to in the masque. Although the text of *Luminalia* is probably by Davenant, Jones is credited with the 'making' of the 'subject'.[121] He explains this subject in a preamble:

> The muses being long since drawn out of Greece by the fierce Thracians, their groves withered and all their springs dried up, and out of Italy by the barbarous Goths and Vandals, they wandered here and there indecently without their ornaments and instruments, the arch-flamens and flamens, their prophetic priests, being constrained either to live in disguises or hide their heads in caves . . . and in the more civilised parts, where they hoped to have taken some

rest, Envy and Avarice by clipping the wings of Fame
drave [*sic*] them into a perpetual storm, till by the
divine minds of these incomparable pair, the muses
and they were received into protection and estab-
lished in this monarchy, by the encouragement and
security of those well-born wits represented by the
Prophetic Priests of the Britanides.[122]

In the climax of the masque Henrietta Maria appeared
below 'a glory with rays, expressing her to be the queen
of brightness', or in other words to identify her (albeit
covertly) with her namesake, the Virgin Mary.[123] The
religious, even Catholic, allusions in this masque were
unmistakable. Implicit is Jones's eagerness to inform his
Catholic queen that under her enlightened patronage –
free from the shackles of Puritan constraint and with
his 'Imagination set free' – he was at last able to give
full expression to his art. According to the architect, the
reason why the Muses had formerly 'wandered here and
there indecently without their ornaments and instru-
ments' was that they had been constrained either 'to live
in disguises or hide their heads in caves'. Jones's 'mas-
culine and unaffected' designs might similarly be seen
as having appeared as if in disguise 'without their orna-
ments'. He had argued in his 'Roman Sketchbook' that
it was only within the privacy of interior space – or, as
he describes it here twenty or so years later, hidden in
caves – that architecture could be adorned with capri-
cious ornament. In 1610 Jones had produced a decora-
tive design for Oberon's Palace – with *putti*, scrolls and
Corinthian columns – that was indeed hidden within a
cave (Fig. 224). This was in stark contrast to the chosen
design for the palace exterior, now with Doric pilasters
blended with Gothic forms openly set within wooded
crags (Fig. 225). In the sense of Jones's preamble to
Luminalia and his 'wise man' analogy, a 'masculine and
unaffected' façade of a building served as a 'disguise' or
'mask' to the opulence behind it. And in like manner
the wise courtier concealed his true emotions, as James
advised Henry, 'yt inwardly hath his ~~mynd~~ [*sic*] Immag-
inacy set free'. Moreover, Veevers notes that 'there is a
good deal of evidence in the literature of the thirties
that the terms "flamen" and "arch-flamen" were being
used to refer to Catholic priests'.[124] If, for Jones,
Catholic priests in disguise analogise the arts without
ornament, then it follows that ornamental art analogises
Catholicism unveiled. In other words, here in *Lumina-
lia* Jones makes explicit what his use of the Orders con-
sistently suggests, namely the link between religious
affiliation and ornament – or more precisely, between
Catholicism and the freedom to express the ornate. To
use the terms of the masque once more, only under

224 Inigo Jones, Oberon's Palace set within a cavern, from *Oberon,
the Fairy Prince* (1611). Devonshire Collection, Chatsworth

the light of the Catholic queen could the full range of
Jones's ornamental language be 'illuminated' and given
the light of day.

Jones's preamble may imply that his use of *all'antica*
ornament was tempered by anti-Catholic prejudices,
but it cannot be interpreted as an expression of regret.
The words are couched in terms intended to appeal to
his Catholic queen. They are made at a time when the
climate of religious and aesthetic toleration, at least in
court circles, allowed the condemnation of previous
times of suppression. Jones's position at court had always
depended on political and religious flexibility, and this
is reflected in the relative ambiguity of the preamble,
which leaves his personal sympathies largely unclear.
This is true also of his architecture. The principle 'mas-
culine and unaffected' was shaped by the need to create
an *all'antica* architecture distinguishable from the style
of Catholic Europe. His built architecture was orna-
mented according to its Protestant context, which
usually meant, but not always so, a more ornamental
interior than exterior. But his understanding of
decorum allowed the flexibility, when circumstances
allowed, of 'varying with reason' his use of ornament.
Thus at Whitehall even the most capricious Order – the
Composite – could be used on the public face of a
building when its symbolic programme and alterations
in the political climate nudged the prevailing court

225 Inigo Jones, Oberon's Palace from *Oberon, the Fairy Prince* (1611, alternative drawing to Fig. 176). Devonshire Collection, Chatsworth

tastes towards an architecture that was 'feminine and affected'.

★ ★ ★

Jones presented elaborate moral, political and philosophical allegories within the relative privacy of the masque via a sequence of settings judged suitable to the evolving mood of the court. In like manner, through applying his interpretation of ornamental decorum, he aimed at different times in his career to give public expression to what were the conflicting religious and therefore aesthetic ideals of his Stuart masters. These ranged from the fiercely Protestant Prince Henry

through the more moderate James I to the High Churchmanship of Charles I and William Laud. It is surely significant that in the *Barriers* (1610) Jones avoided the temptation to introduce the young prince as the imperial Protestant heir of Corinthian palaces, but rather chose more appropriate rusticated porticoes set in untamed nature. It has been seen that Henry sought to present himself as the reviver of a lost world of Protestant chivalry centred on St George and his 'Doric portico' as reconstructed on stage by Jones (see Fig. 71). The implication was clear: restored *all'antica* architecture of the more masculine variety was the only 'true' architectural expression of the Protestantism attested by the masque's eponymous hero. This affilia-

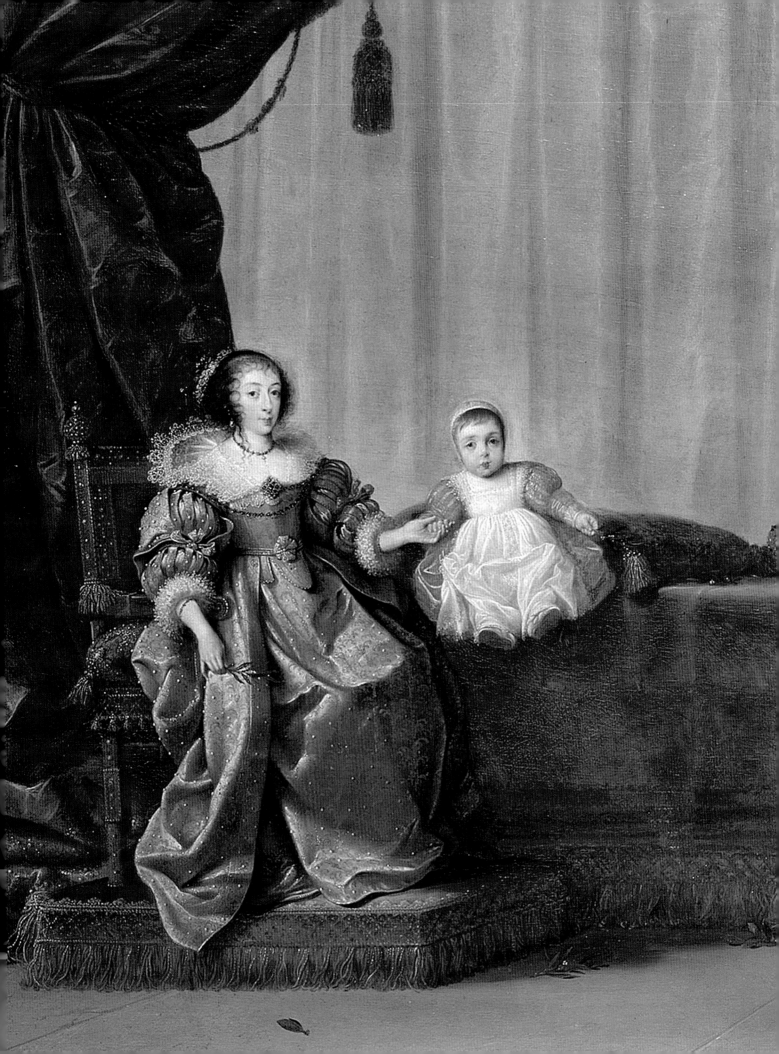

tion between the Protestant cause and the *all'antica* style was the first and, with *Oberon* a year later, the last time it was made quite so overtly in the court masque, given that the attendant Arthurian mythology died with its young advocate. Jones wrote his conservative 'Roman Sketchbook' rules having just served as Surveyor to Henry and on the eve of starting work for another Protestant prince, James I, and so the notes should be understood in this light.

It is hardly surprising that Jones never quite managed to give public expression to the sharply contrasting Catholicism of his last great patron, Henrietta Maria (Fig. 226). But his preliminary scheme for St Paul's Cathedral, complete with its IHS monogram, can be regarded as an architectural fantasy visualising what a native Jesuit-inspired architecture might look like (see Fig. 244). This scheme also combined angels and palms with the Corinthian Order, a mixture to be found in Villalpando's famous illustrations of Solomon's Temple reconstructed along Jesuit lines (see Fig. 73); these illustrations were, it will be remembered, closely studied by Charles I during the Civil War.[125] The fantastical nature of Jones's façade is underlined by the impossibility of actually displaying this Jesuit monogram on the principal cathedral of British Protestantism. Harris and Higgott have pointed out that 'Jones's elevation would have been unthinkable in the predominantly puritan atmosphere before the accession of Charles I in 1625'.[126] In representing the stylistic opposite to that recommended in his early rules and with its Corinthian pilasters suitable, according to Serlio at least, to churches dedicated to the Virgin Mary, this 'feminine and effected' façade would none the less have expressed Henrietta Maria's preferences perfectly.

Jones no doubt closely identified with the 'wise man' of his 'Roman Sketchbook' analogy, and as such sought to work within the shifting artistic constraints and opportunities imposed by the periods of his patrons' political influence.[127] Nevertheless, in following his enlightened friends' expectations for a new architecture blessed by Mercury, which would supplant the 'monstrous Bables' of the past, he aimed throughout to use the language of classical architecture to produce eloquent buildings that spoke of the unity between architectural and social decorum.

226 *(facing page)* Hendricke Pot, Henrietta Maria and the future Charles II, detail from *Charles I, Henrietta Maria and the Prince of Wales*, c.1632. Royal Collection

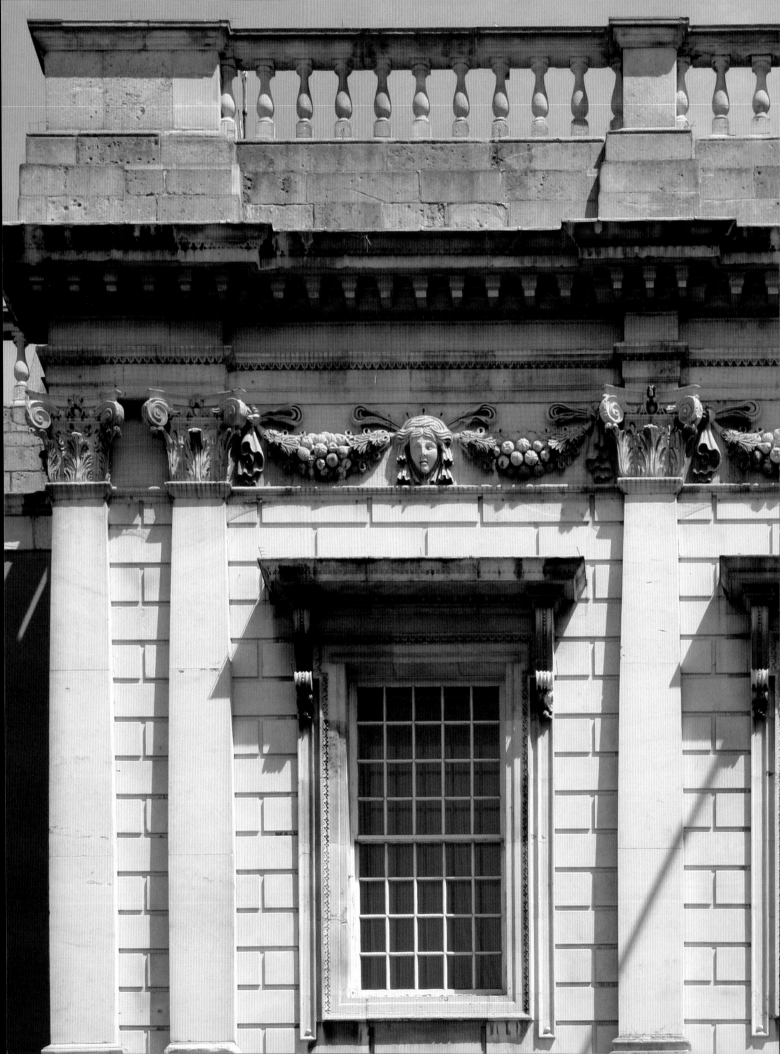

CHAPTER 7

IMAGINATION SET FREE:
ETHICS AND DECORUM AT
THE BANQUETING HOUSE

The Banqueting House, with its feminine façade, stands out in Jones's work as something of an enigma (Fig. 228). Decorative ornament was, of course, perfectly appropriate to the building's royal status and festive function. Nevertheless, it flirts with capricious decoration like none of Jones's buildings before or after. The moralistic way in which contemporary observers such as Wotton could have understood this licentious ornament has been discussed in Chapter Five. Uncertainty remains, however, as to Jones's own intentions in so dramatically breaking his rules with this particular building.

As the previous chapter mentioned in passing, the answer may lie in the Banqueting House's somewhat unique context and programme. Per Palme has pointed out that it was begun in 1619 to celebrate in part at least the anticipated marriage between Prince Charles and the Spanish Infanta.[1] Significantly, the Spanish crown had demanded to see, prior to the arrival of the Infanta, toleration of Roman Catholic worship in England. Jones's chapel at St James's Palace and its planned counterpart at Somerset House were originally intended to satisfy the request. The promotion of this Protestant and Catholic alliance formed a vital aspect of James I's much-cultivated image as the new Solomon and his mission to establish peace in Europe, albeit on Protestant terms (a policy expressed in his motto, 'Beati Pacifici'). As a Catholic convert Anne of Denmark had been a keen supporter of this alliance up to her death in 1619. The early 1620s was a crucial period in the attempt to establish a universal basis for the Church of England under James.[2] Something of a justification for

this Protestant pretension and its connections with the Banqueting House can perhaps be seen in Van Somer's portrait of James pictured in front of the building around this time with the motto 'God and my Right' (see Fig. 138).

Following in Palme's footsteps, this chapter will examine how these royal ambitions for peace and Catholic union found expression through the ornamentation of the Banqueting House, and most notably on its puzzling façade. These aims are at their clearest in the ceiling panels painted by Rubens, whose representation of James I's act of union triumphing over division, and peace over conflict, celebrated themes that had earlier informed the design of the building itself. The resolution of these oppositions and the virtue of the resultant 'mean' condition can be easily traced as themes to Aristotle. For as will now be seen, Jones's much-studied copy of Aristotle's *Nicomachean Ethics* (preserved at Worcester College) was a major philosophical influence not only on his masque designs, as John Peacock has shown, but quite possibly also on his ornamentation of the building in which they were staged.[3] The fundamental importance of the philosopher's ideas to the architect's work was first recognised by Jonson when famously admonishing Jones for setting up architecture as the highest kind of knowledge: for he had 'Drawn Aristotle on us: and thence shown / How much architectonike is your own!'[4]

★ ★ ★

227 (*facing page*) A female face or mask in the Composite frieze of the Banqueting House, Whitehall, 1619–23

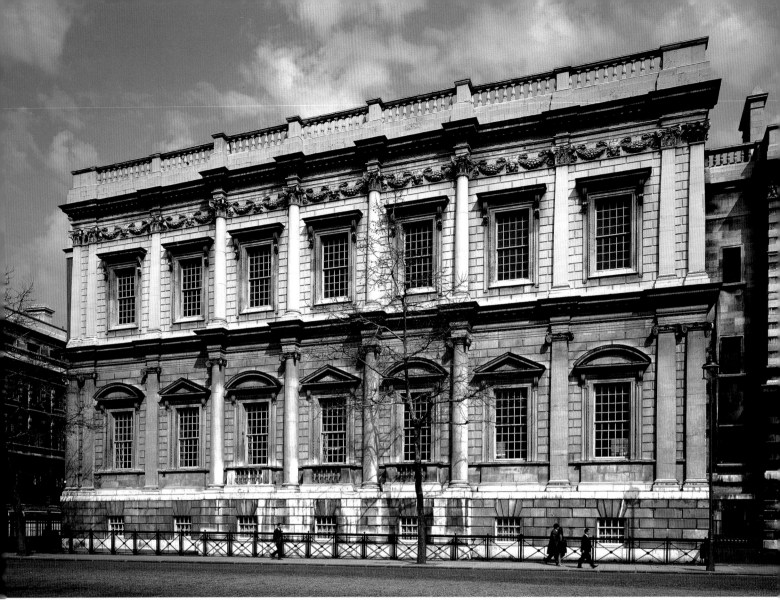

228 Inigo Jones, Banqueting House at Whitehall, 1619–23

'EVOKING ARISTOTLE': JONES'S STUDY OF DECORUM AND THE ARISTOTELIAN 'MEAN'

Before attempting to interpret the ornamentation at the Banqueting House as it might have expressed these Stuart themes of peace and union, it is therefore first necessary to examine Jones's study of Aristotle's ideas on magnificence and the 'mean' in their relationship with the all-important principles of architectural decorum. Vitruvius had not discussed the Greek origins of decorum, and his Renaissance followers were similarly elusive on the matter. Jones was, however, well aware that architectural decorum owed its source to ancient rules of oratory and ethics. Against Scamozzi's citation of 'decorum' in a list of Vitruvian principles, Jones translated: 'in this part archetecture houldes much

of Philosofi morrall & naturall'.[5] In order to address Vitruvius's silence on the ethical and moral background of his concepts, Jones turned to ancient and modern philosophy and studied Italian translations of Xenophon (1521, 1547), Plato (1554), Plutarch (1567, 1607, 1614) and Piccolomini (1575).[6] For example, he carefully worked through Xenophon's account of the conversations of Socrates with the painter Parrhasius and the sculptor Cleiton, concerning the difficulty of depicting the inner life through visual appearances. It was while reading his copy of Bernardo Segni's Italian translation of Aristotle's *Ethics* (1551), however, that Jones came to identify the Aristotelian theory of appropriate expenditure (*megaloprepia*, translated by Cicero as *magnificentia*) with the all-important rules governing the appropriate display of architectural ornament.[7] At the beginning of the second chapter of Book Four of Segni's edition,

accompanying the heading 'Della Magnificenza', there is a single-word annotation by Jones in sepia-coloured ink that has, through time, become faint: the word is 'Decorum'. This was not, as were the vast majority of Jones's annotations, a translation as such, and it clearly demanded analytical interpretation from him. It also represents the only occasion during his approximately thirty-year study of architectural theory when he found it necessary to add a single-word heading encapsulating the passage he was reading. It is as if Jones highlighted the ultimate focus of his years of study.

Aristotle introduced the principle of *magnificentia* by explaining: 'outlay is not the same for the man who maintains a warship as it is for one who leads a delegation to a festival. So the suitability is relative to the agent himself, and to the circumstances and the object of his expenditure.'[8] Jones underlined this and in the margin added a symbol he consistently used to emphasise significant passages, namely a pointing hand (☞). Concerning appropriate expenditure on building, Aristotle observed that it was also characteristic of the magnificent man to build or edify (*edificare* in the Segni translation, although modern translations have to 'furnish') his house 'in a way suitable to his wealth (because even this is a kind of ornament) . . . and in every set of circumstances to spend what is appropriate (because the same expenditure is not equally due to gods and men, nor is the same outlay proper in the case of a temple as in that of a tomb)'.[9] Alongside this passage Jones translated: 'To build a house fytt to our estate / adorned', and 'dicorum in building of Temple or Sepultra'. As far as he was concerned, Aristotle used the term 'magnificence' in reference to the building itself and, more specifically, to how a building was ornamented or 'adorned'. Jones's bridge between Aristotelian magnificence and the principles governing the appropriate use of architectural ornament was rendered complete by his subsequent use of the term 'decorum'. He thereby made explicit what the Renaissance treatises he studied had merely implied, namely the origins of the architectural concept of decorum in Aristotle's theory of magnificence.

In Aristotle's closing remarks on *magnificentia* in Book Four of the *Ethics*, he introduced the fundamental notion of virtue as a 'mean', or rather as the middle way. The 'Golden Mean' was a Stoic ideal, found in Horace and Seneca as well as in Epicurean ethics. Jones was well aware of the concept. It was an important one in the masque *Britannia Triumphans* (1638), for example, where 'Action' opposed 'Imposture' under the motto 'Medio Tutissima' (safest in the middle), and it commanded his attention throughout the *Ethics*.[10] Aristotle

observed: 'the man who goes to excess and is vulgar exceeds (as we have said) by spending more than he ought', a concept that Jones translated as 'Vice is over doing without Dicorum' and underlined, whilst as Aristotle continued: 'the petty man will fall short in all respects'.[11] The effect is to link ideas on appropriateness in architecture, namely the principles of decorum, to the notion of virtue as a 'mean' between the limits of excess and deficiency.

This link is not obvious, perhaps, but it would have been familiar enough to Jones from his study of Alberti and Serlio. When discussing ornamental extremes in his Seventh Book Serlio observed: 'I would conclude that the elements which are "simple" but well conceived will always be more praiseworthy than things which are "confused" and "affected". On the other hand, the mean will never be criticised.'[12] His analogy with the beautiful woman followed. Alberti had made a similar link between decorum and the selection of the mean when defining 'compartition', or the arrangement of ornament, at chapter five of Book Six of his treatise. He explained that each element 'should be made up of members neither too numerous, nor too small, nor too large, nor too dissonant or ungraceful . . . For if the compartition satisfies these conditions completely, the cheerfulness and elegance [*decor*] of the ornament will find the appropriate place.'[13] And in chapter two Alberti famously defined beauty in architecture as a type of mean (*mediocritas*) in the passage that was paraphrased by Jonson around 1604 to describe the coronation arches: 'Beauty is that reasoned harmony of all the parts within a body, so that nothing may be added, taken away, or altered, but for the worst.'[14] Although Alberti gave no source, this definition was highly derivative of Aristotle's explanation of the significance to craftsmen and artists of the doctrine of the mean in the sixth chapter of Book Two of the *Ethics*:

If, then, every art[/craft] performs its function well only when it observes the mean and refers its products to it (which is why it is customary to say of well-executed works that nothing can be added to them or taken away, the implication being that excess and deficiency alike destroy perfection, while the mean preserves it) – if good craftsmen[/artists], as we hold, work with the mean in view; and if virtue, like nature, is more exact and more efficient than any art, it follows that virtue aims to hit the mean. By virtue I mean moral virtue since it is this that is concerned with feelings and actions, and these involve excess, deficiency and a mean.[15]

This is the only time that Aristotle discussed the 'mean'

within the context of artistic theory. Here Jones was prompted to reinforce the link by annotating 'What ye Virtu is in arte' alongside the passage, and drawing a pointing hand in the margin. The significance of the 'mean' to the art of building, which it would appear Jones wished to understand, was confirmed when Aristotle went on to explain that the virtue of magnificence – previously identified by Jones with decorum – can also be considered a 'mean'. Jones heavily underscores this explanation.

The Aristotelian 'mean' influenced John Calvin's arguments in favour of the 'middle way' in decorative matters, made in his *Christianae religionis Institutio* published in Basel in 1536.[16] Calvin's aversion to the display of luxury and preference for the 'mean' may well have restricted the use of the more decorative Orders in the sixteenth century, and restrained, externally at least, 'licentious' showiness and 'superfluity'. This was especially so in territories where his ideas had most influence, such as Scotland. Through the influence of James I they plainly informed Jones's call for decorative restraint externally. Moreover, it was noted in the previous chapter that Jones prescribed an architecture whose overall effect was to unite antipodal characteristics, that is, male with female, public with private, gravity with imagination, and canonic with licentious. These opposites retained their separate identities but in a state of equilibrium, somewhat similar to Serlio's gates in the *Extrordinario libro* (1551), which unite both delicate and rustic forms (see Figs 157–8). Jones would have seen Daniele Barbaro explain in his commentary to Vitruvius of 1567 that 'mixing with reason' the proportion and style of ornament in buildings 'can result in a beautiful form in the middle'.[17] In the Aristotelian sense this equilibrium could be considered as a mean condition – a mean defined, that is, by two ornamental extremes that the architecture as it were 'balances'.

Indeed, Jones's analogy of the 'wise man' who outwardly 'carrieth a gravity' yet 'inwardly hath his Immaginacy set free' was quite clearly Aristotelian. It was an expression of the 'mean' that, in the *Ethics*, every virtuous man strived for in his effort to tread a path between two kinds of vice, 'one of excess and the other of deficiency'.[18] Thus, as Aristotle argued elsewhere, 'it is said that the soul is a harmony of some kind' for 'harmony is a mixture or composition of opposites, and the body is composed of contraries'.[19] This would seem to be the case for Jones's 'wise man'. It might be objected, however, that an architecture that is externally 'masculine and unaffected', and that will therefore essentially appear austere to most observers, cannot in itself represent a mean between extremes. But this represents a misinterpretation of Aristotelian ethics. Aristotle had not defined the mean as necessarily the precise mid-point between extremes, but rather as a point perceived as somewhere closer to the lesser of two evils. Whichever was the greatest vice was dependent on the inclination of the individual, and the influence of circumstance. In this way anyone who aims at the mean should

(1) keep away from that extreme which is more contrary to the mean . . . For one of the extremes is more erroneous than the other: and since it is extremely difficult to hit the mean, we must take the next best course, as they say, and choose the lesser of two evils . . . (2) we must notice the errors into which we ourselves are liable to fall . . . and we must drag ourselves in the contrary direction . . . (3) In every situation one must guard especially against pleasure and pleasant things, because we are not impartial judges of pleasure.[20]

These strictures evidently struck a chord with Jones, for he added not one but two pointing hands. Of course, if Jones as a 'wise man' was to 'drag' himself in the contrary direction to pleasure, or rather licentiousness, his architecture would tend towards the 'masculine and unaffected' that he argued for externally.

Before examining Jones's application of these ideas at the Banqueting House, one further important example of the mean should be considered. After discussing magnificence and the other moral virtues in Book Four of the *Ethics*, Aristotle turned his attention in Book Five to the concept of justice. Jones annotated a passage in chapter one defining justice, which he observed was 'not apart of Virtue but perfect virtue'. He also noted the point at which it was ultimately demonstrated, 'how justice commandos all the virtues & visos'. Justice was described as the mediator between excess and deficiency in terms of behaviour, as the arbiter of virtue and vice, or in Jones's words the moderator of 'ye outward operations'. It therefore played a significant role in social interaction, and was subsequently shown by Aristotle to lie at the root of many of the laws and moral principles that defined appropriate conduct in society. In chapter three of Book Five he demonstrated the significance of the mean in 'Distributive justice': 'Then if what is unjust is unequal, what is just is equal; as is universally accepted even without the support of argument. And since what is equal is a mean, what is just will be a sort of mean.'[21] In this way, much as magnificence (or rather as Jones interpreted it, decorum) was presented as a 'mean', so too was the 'balance' of justice as symbolised, of course, by her scales. Bishop

Thornborough drew on this concept when observing that the Stuart monarchy justly distributed its virtues 'equally, and graciously among all, by Geometricall proportion'.[22] As will be seen shortly, the Aristotelian concept of justice as a mean informed Rubens's Banqueting House ceiling.

The links between 'distributive justice', the 'mean' and 'decorum' were certainly by no means straightforward, but nevertheless Jones acknowledged them. For alongside Aristotle's passage he added the note 'Plato li[bro]: iiii. Civil Decorum' and further highlighted it with one of his pointing hands. The reference was to the fourth book of the *Republic*, and it would seem Jones's intention to establish a link between related theories in the two texts. For in the *Republic* there is a corresponding Jonesian '+' reference marker, together with another pointing hand, against Plato's discussion of how just and civil behaviour in the individual arises from the harmony that exists when appetite and spirit are held in check by reason.[23] Platonic justice, both in the individual and by analogy in the State, was then described in terms similar to Aristotelian justice, that is, as a 'mean' condition achieved by the harmonic union of reciprocal characteristics. Jones's inter-connections between these texts indicate analytical interpretation far beyond mere translation.

Aristotle went on to explain in chapter four of Book Six that reason and variation (what might be called 'invention') were essential to artistic production, or as Jones translated: 'Art is the Habit to do a thing with right reason.' Architecture was the only art that Aristotle listed as an example here. Jones noted in Segni's commentary that artistic production consisted 'of generation invention & contemplation', or in other words to use a more familiar Jonesian concept and one that could well be used to sum up Aristotle's definition of design, it consisted of 'variation with reason'.[24] Quite obviously, Jones's interest in this relationship between antique moral philosophy and designing with decorum extended beyond theoretical deliberations and influenced his practice of architecture and use of ornament. For as will now be seen with the Banqueting House, it was through applying his study of Aristotle's ideas on the 'mean' that he saw himself as producing the well-ordered and decorous architecture – ethically, socially and morally – that his friends Bolton and Chapman expected.[4]

★ ★ ★

'JUSTICE AND VIRTUE COMPREHENDED': RUBENS'S BANQUETING HOUSE CEILING AND THE ARISTOTELIAN 'MEAN'

The Banqueting House was undoubtedly the most important and most expensive building project constructed during the reign of James I. Built in part to celebrate the triumph of the king's policy towards encouraging European peace, the building was conceived by James as a gesture of magnificence in the true Aristotelian sense. For it can be understood as an appropriate (although unprecedented) display of wealth and royal status, which is just what Aristotle's principle of *magnificentia* called for. As has been seen, it was intended as a setting for pageantry and masques chiefly designed to glorify the sovereign and the State. A consistent theme of these performances was the Aristotelian notion of mediation between extremes to create a moral harmony with which Jones was perfectly familiar. In *Salmacida Spolia* (1640), for example, he drew on Aristotle when describing the 'children, with significant signs' that inhabited the proscenium's frieze as 'expressing the several goods, followers of peace and concord, and forerunners of human felicity; so as the work of this front, consisting of picture qualified with moral philosophy, tempered delight with profit'.[25] Aristotelian ethical notions were nowhere more clearly expressed than in Rubens's ceiling panels in the masquing hall, depicting the themes of religious, social and moral harmony achieved during James's reign (Fig. 229). Although the canvases were not dispatched by Rubens until 1635, Palme has shown that their initial programme was worked out in the early 1620s.[26] Its influences were therefore the same as those informing the design of the building itself, and at the time the dominant motifs in court propaganda were peace and the Spanish Match. It must be assumed that Rubens completed their programme working with someone who was familiar with the mythology of the Stuart dynasty, and both Palme and Roy Strong believe that this was Jones.[27] Fiona Donovan has shown that the theme of the ceiling canvases also echoed Rubens's own diplomatic efforts in 1629 to secure a lasting English peace with Spain.[28] The following analysis of the canvases will describe their allegorical subjects, which have been identified by Strong and Donovan as relating to the efforts by the Stuarts to achieve this new Golden Age.[29] The primary aim, however, will be to show that these carefully interwoven motifs are connected by a more basic affinity. This is the celebration of the Aristotelian virtue of the 'mean', a theme that emphasised the mediation between extremes that James I sought in his polit-

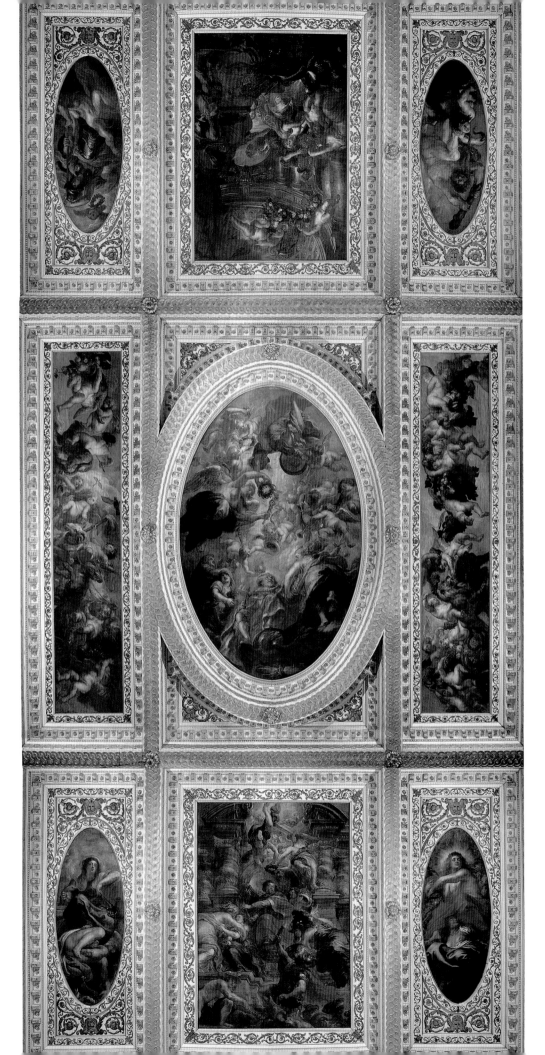

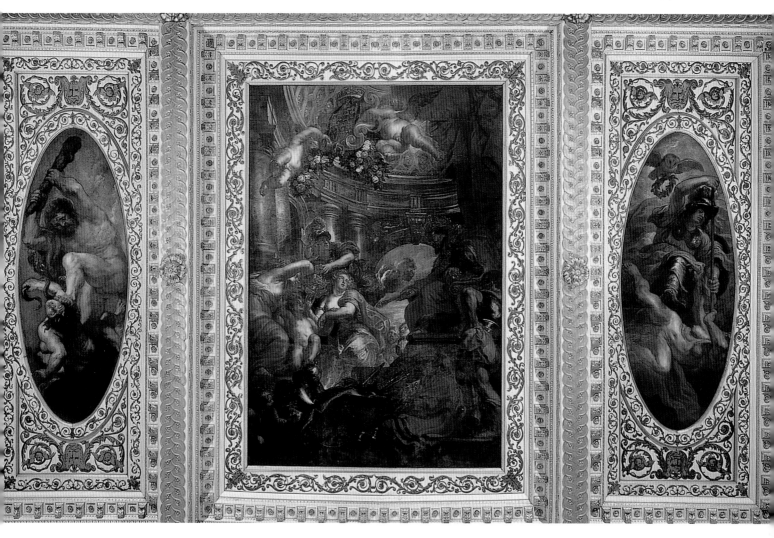

230 Peter Paul Rubens, ceiling panels to the Banqueting House, the northern triptych: *Britannia Perfecting the Union of England and Scotland*. The faces of Lucius and Constantine are below the king's sceptre, and Brute stands to his left

ical endeavours and had wished to celebrate with the construction of the Banqueting House.

The canvases are arranged as three triptychs, each exploring a common theme. In the central panel of the northern triptych, generally known as *Britannia Perfecting the Union of England and Scotland*, James is presented as Solomon re-enacting the story in the biblical book of Kings concerning the disputed baby (Fig. 230).[30] He leans forward on his throne, wearing his robes of state, whilst figures identified as Lucius and Constantine look on. Opposite are two female characters, England and Scotland, between which is pictured the infant Britannia awaiting a crown. The crown is in fact split into two halves (representing the two nations), and a helmeted warrior, identified as Minerva-Pallas (representing the king's secret wisdom), binds them into one (Fig. 231). The restored crown allegorises the main theme of

the entire ceiling, namely the attainment of religious and political unity in order to strengthen the Protestant cause. This theme is reinforced by the setting for this momentous event, a circular temple (the form most associated with unity) composed of a Doric entablature and what appear to be Tuscan columns.[31] Chapter One pointed out the connections between the Tuscan Order and the Protestant legend of a united ancient Britain popularly cultivated by Church and crown. The two oval panels on each side of this northern panel represent the ideal of moral harmony. In the north-western panel Minerva-Pallas, here again representing secret wisdom, is seen thrusting a lance into the neck of a naked woman below, representing Ignorance. In the corresponding panel on the opposite side, Hercules, identified with the heroic virtue of Courage, aims a blow to a woman who represents the moral weakness

229 *(facing page)* Peter Paul Rubens, ceiling panels to the Banqueting House

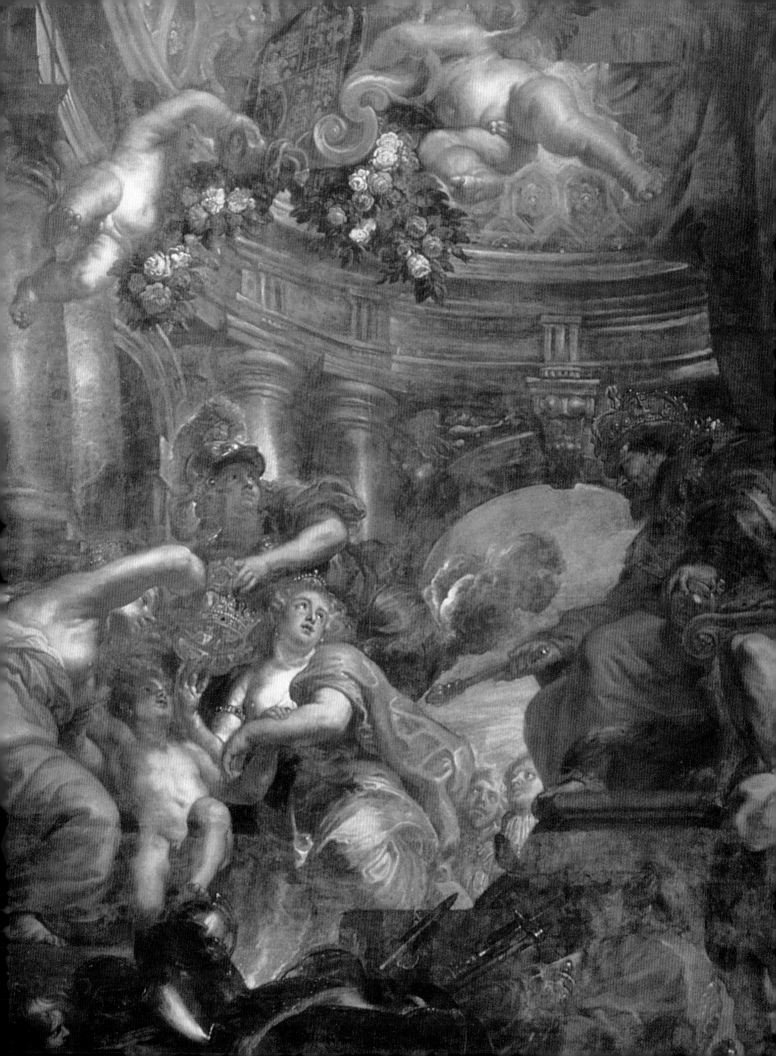

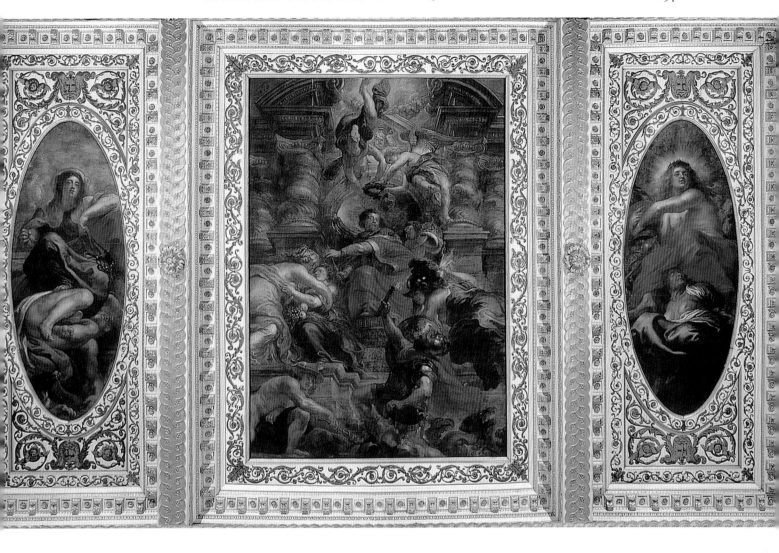

of Envy.[32] Thus to either side of the 'Union' scene there is a straightforward representation of conflict tempered and of virtue reigning supreme over vice.

In the central panel of the southern triptych, entitled *The Benefits of the Government of James I*, James is again cast as Solomon (Fig. 232). The king is enthroned within a niche framed by the twisting columns of Solomonic mythology, and gestures towards a group below. He vanquishes these characters into an abyss while shielding two female figures representing Peace

and Plenty as the benefits of good government. To the left is Mercury, who uses his caduceus to subdue a hydra and a nude with snaky hair, assisted to the right by Minerva-Pallas. Since Protestants conventionally

231 (*facing page*) Detail of Fig. 230, showing Minerva-Pallas binding the crown

232 (*above*) Rubens, ceiling panels to the Banqueting House, the southern triptych: *The Benefits of the Government of James I*

233 (*right*) The pope and the hydra, from Francis Burton's *Fierie Tryall of God's Saints* (1611)

understood the hydra as representing the pope, 'for the average seventeenth-century Protestant English visitor to Whitehall Palace' the evil characters could, according to Strong, 'only ever refer directly to two events, the Gowrie Plot of 1600 and the Gunpowder Plot of 1605' (Fig. 233).[33] As Strong notes, the words in the Prayer Book service for Gowrie Day paraphrase the scene: 'Let them be driven backward, and put to rebuke, that wish any evill to his Royall person, or to our gracious Queene, or to any of their most worthy Progenie.'[34] Evidently, the events of 1605 were still casting their shadow over court art in the 1620s when these panels were devised. One of the most significant benefits of James's rule was, accordingly, the reaffirmation of Protestant supremacy, or, in the parlance of the Stuart court, 'The Golden Age Restored'. The Jones-Rubens ceiling celebrates, therefore, a Protestant monarchy, but it does so in a style of painting and architecture absolutely identified with the Catholic rulers and religion of mainland Europe. What Catholics could perceive as an expression of religious toleration, Protestants, especially Puritans, could identify as popery. The intended Spanish Match and Charles's subsequent marriage to Henrietta Maria had already added to public anxiety over the religious sympathies of the Stuart court. It is likely then that the veiled anti-Catholic references to the Gowrie and Gunpowder plots in this panel were meant to counter such Protestant fears. James had been wary of both Catholics and Puritans in equal measure, a policy that is perhaps reflected by the attempt made in the canvas to appease and appeal to the sensitivities of both. The theme of regal virtues vanquishing vice is continued in the two flanking panels of this southern triptych. To the west a female figure, representing Temperance and holding her attribute, the bridle, sits upon the hunched, naked body of Intemperance or Licentiousness. In the opposite panel another female character, representing Liberality, holds a cornucopia from which a cascade of precious emblems falls into the shadows, where an old hag-like woman representing Avarice crouches in despair. These figures draw heavily on the conventions of moral emblems that it is known Jones studied closely, such as those in Cesare Ripa's *Iconologia* of 1603 (Fig. 234).

The great oval in the middle of the ceiling, entitled *The Apotheosis of James I*, forms the climax of the entire composition (Fig. 235). James is depicted ascending heavenwards on the back of an imperial eagle and globe. His right hand holds the sceptre, while his left grasps a female character carried on a cloud. With a pair of scales in her right hand, she clearly represents Justice. Two figures, one Minerva-Pallas and the other a Victory grasping a caduceus, hold a crown of laurel over the king. This is the triumphant finale: Justice raising James unto the light of heaven. On either side of this central apotheosis are two narrow panels filled by processions of *putti*. One depicts a chariot, into which Liberality's cornucopia is spilling, drawn by a bear and a lion: a *putto* is placing a bridle on the lion, reflecting the virtue of Temperance whose attribute, it will be remembered, was the bridle.[35] The second depicts a further triumphal chariot laden with corn and drawn by a wolf and a ram, now at peace (Fig. 236). The theme is an obvious one, namely the rewards of the restoration of the Golden Age brought about by the virtuous rule of James I. Evidence of Jones's involvement with, or at the very least his full approval of, the ceiling scheme is to be found once again in *Salmacida Spolia* (whose performance in 1640 was five years after

234 (*left*) *Liberalità*, from Cesare Ripa's *Iconologia* (1603)

235 and 236 (*above and below*) Rubens, ceiling panels to the Banqueting House, the central triptych: *The Apotheosis of James I*; and a detail showing the panel on the west side of the central oval

the panels were installed). Here the proscenium also included a *putto* 'extinguishing a flaming torch on an armour' and 'winged children, one riding a furious lion, which he seems to tame with reins and a bit'.[36] In the masque, as on the ceiling, the power that vanquishes the king's opponents is not force but rather his civilising gentleness.

Roy Strong suggests that the 'key source-book' for the Banqueting House iconography is James's exposition of monarchy by Divine Right, the *Basilikon Doron* (1599) written for the edification of Prince Henry. Strong notes,

> the placing of the Virtues on the ceiling follows the book precisely. Justice, James I writes, is the greatest virtue . . . The task of a Prince, according to the *Basilikon Doron*, is principally to 'exercise true Wise-dome' . . . To these James adds the virtues [of Temperance and Liberality] personified in the two [southern] side panels, both of which are conceived by him in the Aristotelian sense as means between extremes.[37]

Strong continues by quoting James's definition of Temperance as the natural quality of a ruler:

> wise moderation, that first commaunding your self, shall as a Queene, commaund all the affections and passions of your minde, and as a Phisician, wisely mix all your actions according thereto therefore, not onely in all the affections and passions, but even in your most virtuous actions, make ever moderation to be the chiefe ruler.

The other virtue on the ceiling mentioned by James is Liberality: 'Use trew Liberalite in rewarding the good, bestowing frankly your honour and weale: but with that proportionall discretion, that every man may be served according to his measure.'[38] However, because the interwoven motifs of all nine canvases transcend James's political achievements to represent these universal virtues, it is likely that both the king and his artists were acknowledging their debt to a more ancient source than the *Basilikon Doron*. James's description of Temperance as 'wise moderation' was, as Strong mentions in passing, a classically Aristotelian interpretation of this virtue as a mean between extremes.[39] Jones studied Aristotle's advice that the just ruler must 'observe the mean', be moderate in all things and avoid both excess and deficiency, around the same time that Rubens was working on the canvases.[40] The *Ethics* is, in the plainest sense, an exposition on the virtues and was evidently a primary source for the *Basilikon Doron* and therefore the ceiling.

The parallels between the ceiling and the *Ethics* are obvious. In Book Three Aristotle discusses the two chief moral virtues, namely Courage and Temperance. In Book Four he names the third virtue as Liberality. This is described as the correct attitude towards wealth, and is defined as the mean between the extremes of Profligacy and Avarice or Meanness. The liberal man, according to Aristotle, will give money or bestow honour 'to the right people, and the right amounts, and at the right time'.[41] This is more or less James's definition of the virtue quoted above. It is here that Aristotle defines 'magnificence' as a special kind of Liberality. It will be recalled that James saw the greatest royal virtue as Justice. This was precisely Aristotle's definition in chapter one of Book Five as he expressed it in the famous proverb 'in Justice is every virtue comprehended'; it was noted that Jones translates this as: 'how justice commandos all the virtues & visos'. Book Six deals with the intellectual virtues, amongst which Wisdom is described as 'the most finished form of knowledge'.[42] In view of Jones's likely contribution to the design of the canvases, it is significant that he assiduously annotated Books Three to Six of the *Ethics*, paying particular attention to the definition of the virtues illustrated in the panels.[43] It has also been seen that Justice, the most complete virtue, holds centre stage in the ceiling. Attending her in the corners are the four regal virtues or 'means', namely Wisdom and Courage, Liberality and Temperance, each overcoming their conflicting vices, Ignorance and Envy, Avarice and Licentiousness. These virtues are reinforced in the central narrow panels by their themes of Temperance and Liberality. It is as if the Jones-Rubens ceiling was intended as a (so far unrecognised) visualisation of the *Ethics*, in constituting an almost literal translation in pictorial terms of Aristotle's exposition on the virtues and their relationship with the 'mean'. The panels would appear to confirm Aristotle as an important source for Jones's decorum-based design philosophy.

It was observed that up to the date of the Banqueting House Jones aimed in his architecture to reflect an analogous equilibrium, that is, between external gravity and internal opulence. Described in the ethical terms characterised in the ceiling canvases, his buildings might represent a form of the 'mean' called Liberality (or *magnificentia*) in uniting, in an extreme form, qualities of (outer) decorative Meanness on the one hand and (inner) Profligacy or Licentiousness on the other. A sense of balance also orders the overall composition of the Banqueting House ceiling, albeit on a single plane. The entire work is thematically symmetrical about both axes. Justice – pictured in the central canvas with her

scales balanced in her right hand – is attended at each corner by the four Aristotelian virtues pictured vanquishing their conflicting vices. The notion of balance or the 'mean', which is fundamental to the philosophy allegorised in the paintings, is therefore consistent in their composition.

Furthermore, this balance is also detectable in the architectural ornament in the panels, where once again the columns are not mere decoration but serve to enhance the meaning of the work. In the central panel of the southern triptych, it will be recalled, James is cast as the 'just mediator' Solomon and he is enthroned within a niche framed by twisting columns, which are here of the Ionic Order. These are the 'pillars of wisdom' that, legend has it, formed the Beautiful Gate to Solomon's Temple. But the ancient twisting columns in St Peter's, and those cast in bronze in Bernini's famous Baldacchino (1624–33), had Composite capitals; Jones would have seen the ancient ones when visiting Rome. It is perhaps significant then that on the ceiling the capitals of the twisting columns take the Ionic form (as also rendered in Raphael's *The Healing of the Lame Man*, a work acquired by Charles I; Fig. 237). For Vitruvius wrote of the Ionic Order: 'if Ionic temples are erected, account will be taken of their middle quality; because the determinate character of their temples will avoid the severe manner of the Doric and the softer manner of the Corinthian'.[44] As such, the Order too reflected an Aristotelian mean between extremes and, at least in terms of biblical iconography, would be the most appropriate for the identification of James as the just mediator, Solomon.

237 Raphael, cartoon of Christ in the Temple entitled *The Healing of the Lame Man*, 1515, distemper on paper. Victoria and Albert Museum, London

In these panels James's policy of peace is raised to the level of 'State philosophy' and the *all'antica* style is offered as its architectural embodiment. Indeed, through the presence of the Orders on the ceiling, their central role in the iconography of statecraft is affirmed. Moreover, they play their part in the expression of the ethical ideal of the 'mean'. The notion advanced in Chapter Five that the ornamentation of the façade was itself viewed in emblematic and moral terms, which this understanding clearly supports, can now be related more specifically to the building's symbolic function.

'A MIDDLE QUALITY': BALANCING TEMPERANCE AND LICENTIOUSNESS ON THE BANQUETING HOUSE FAÇADE

The Banqueting House interior is quite magnificent (Fig. 238). The elaborate carving of the enormous brackets projecting from the Ionic entablature to carry the gallery is certainly, in Jones's parlance, 'capricious'.[45] Between the gilded Corinthian capitals of the pilasters above the gallery is an equally ornate frieze of female heads and swags of fruit and flowers. Anyone familiar with Jones's 'Roman Sketchbook' notes is immediately reminded of the architect's approval of rich internal decoration, and of imagination 'set free'. In its use of the Composite, however, the exterior is completely contrary to these 'Sketchbook' principles. First, it is ornamented with an even more decorative Order than that used in the interior (the original polychrome effect would have emphasised these columns; Fig. 239). And second, although 'proporsionable according to the rules', the façade is not 'masculine and unaffected'. As has been seen, Jones's use of the Composite style was, as far as is known, his first on the external façade of any building project, and this elevation was the first for the court that did not conform to the dignified attitude of a 'wyse man' 'in Publicke Places'. For despite flirting with the feminine and more decorative Orders in earlier works, these schemes appear to have remained on paper. The combination of Composite and Ionic pilasters, above a rusticated basement, was the most extensive ornamental range used by Jones externally on a court building to date (one used only once more externally, on St Paul's Cathedral). It cannot be doubted that as a major court building the Banqueting House 'deserved' an ornate façade, but not necessarily quite such a capricious one. Jones's liberated imagination is now evident here too, where the elaborate festoons and, as if to emphasise the gender change, female faces or masks mirror those inside (see Figs 169, 227). These

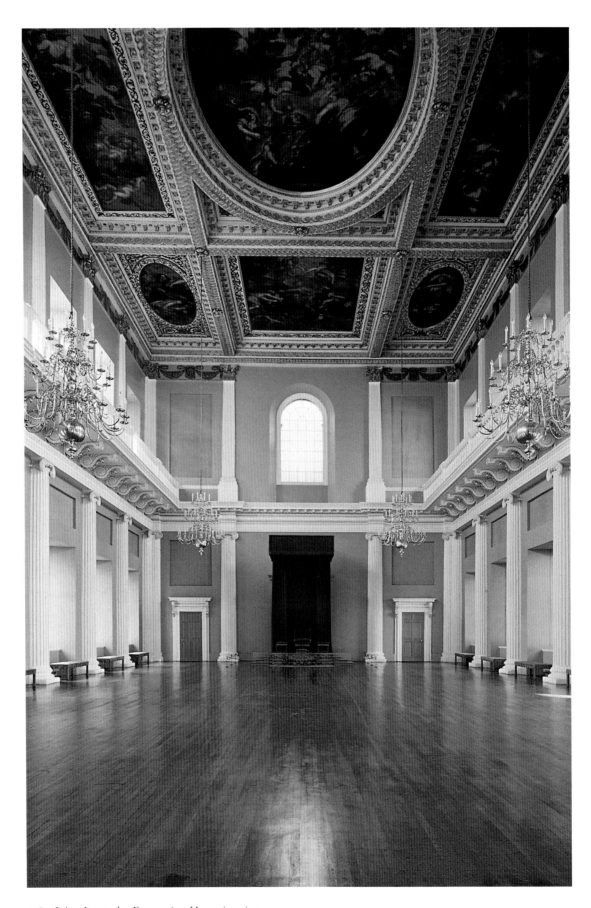

238 Inigo Jones, the Banqueting House interior

239 Computer reconstruction of Inigo Jones's Banqueting House façade as first built, with original basement height, casement windows and poly-chrome effect (Oxfordshire stone basement, Portland stone columns and entablatures, and Northamptonshire stone walls)

female masks obviously take us some way from the 'masculine and unaffected'! So why did Jones redefine the underlying balance of opposites that had previously disciplined his architecture?

It was noted at the start of this chapter that one of the principal intentions behind the Banqueting House was that it should be viewed as a public symbol of the new religious accord in Europe that would result from the Spanish Match. At a general level the harmony and proportion of Jones's Orders would naturally have expressed this theme, echoing the popular musical imagery surrounding the policy of the king's peace.[46] It has already been seen how the double-cubic form of the interior reflected interrelated themes of royal harmony and justice.[47] At a more specific level this theme of accord also found expression through the antique model chosen for the building, given that as a

hall with an apse (later removed) it mirrored the Temple of Peace (now known to be the Basilica of Maxentius; Fig. 240). Jones saw this temple when in Rome and identified it in his Palladio with Augustus and the worship of peace.[48] However, a further way in which Jones could have represented the idea of a Catholic alliance, consistent with the understanding of the Orders offered previously, might well have been through the public use of capricious ornament; for, as Chapter Five discussed, this is suggested by his association of it with Michelangelo's Rome and, by implication, the Counter-Reformation. And it was noted that in Italy by the middle of the sixteenth century it had become increasingly rare to use Corinthian or Composite columns on buildings other than Catholic churches. Given the Banqueting House's conception celebrating peace and the Spanish Match, it was sug-

240a and b Sebastiano Serlio, Temple of Peace (Basilica of Maxentius/Constantine), Rome, section and plan from Book Three, *D'Architettura* (1540), fols XXIII–XXIV

gested in Chapter Five that Jones's decorative façade could have been understood by contemporaries in the context of the shift in court, if not public, toleration towards Catholics and even 'idolatry'. Certainly, James had adopted a marked anti-iconoclastic stance during these marriage negotiations.[49]

But even if greater Catholic toleration did have an influence on the design, it does not account for why Jones inverted his recommended hierarchy of interior and exterior ornament and chose the Composite rather than, say, the more canonical and virginal Corinthian used inside. After all, the moralistic reading of the façade offered in Chapter Five would have been equally clear with the use of Corinthian as far as Wotton's readership was concerned. A straightforward explanation is that Jones may simply have been following precedent. What, then, are the likely sources for the Banqueting House façade? The Vicentine *palazzi* of Palladio and Scamozzi are normally cited as Jones's influences, and in particular Palladio's Porto, Barbarano, Chiericati and Valmarana palaces (illustrated in Book II, chapter 3).[50] But each of the front façades of these four *palazzi* either has a single Order or marshals them in strict progression. The Palazzo Chiericati, for instance, has Ionic

above Doric, whilst the Palazzo Barbarano has Corinthian above Ionic (Fig. 241). All the villas with superimposed Orders illustrated by Palladio share this natural progression. It would seem that Jones's positioning of the 'fifth' Order – the Composite – above the 'third' – the Ionic – owes little to Palladio. Moreover, although the Ionic is common to many of the villas illustrated by Palladio, only one of his private houses with superimposed Orders has Composite columns.[51] On the other hand, the interior ornamentation of the Banqueting House – which quite 'correctly' has Corinthian above Ionic – owes much to particular sources, namely the ancient Basilica and the Egyptian Hall from Vitruvius and the temples of Jupiter and of Peace from Palladio. So none of these precedents helps account for Jones's external use of Composite above an Ionic central storey and Rustic base.

The solution may well lie in Jones's wish to produce a balanced composition of decorative opposites on the Banqueting House façade, in line with Serlio's gates and Aristotle's theory of the 'mean' (see Figs 157–8). Here, as Chapter Five also discussed, the licentiousness of the Composite or 'Italic' on the third storey is perfectly balanced by its apparent opposite, the temperance of the

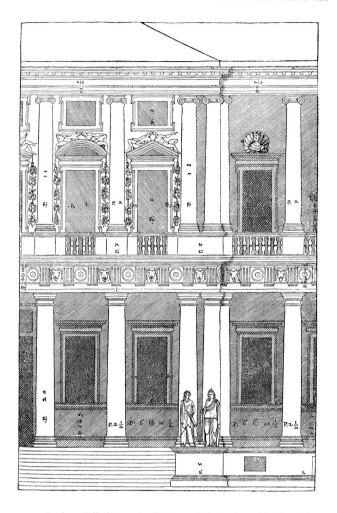 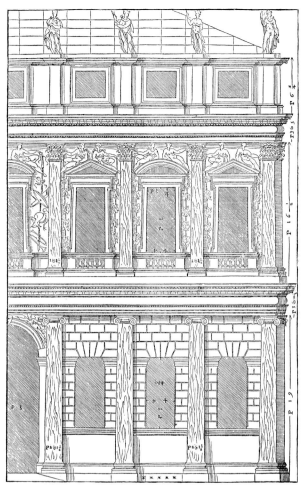

241 Andrea Palladio, a. the Palazzo Chiericati; and b. the Palazzo Barbarano, from *I quattro libri dell'architettura* (1570 edition)

Rustic (a form of Tuscan) on the basement.[52] It will be recalled that this moralistic reading would have been all too evident to an observer with a copy of Serlio, Shute or Wotton as their guide. As if to confirm this understanding, these opposites have now also been identified amongst the characters on the ceiling. When seen within this Aristotelian context, the Ionic Order's location on the central storey of the façade becomes significant. For it neatly reflected its position in the hierarchy of the five canonic Orders, defined by Tuscan and Composite at either end, as well as its Vitruvian interpretation as a stylistic 'mean'. From the viewpoint of courtiers sympathetic with the building's symbolic programme celebrating a Protestant and Catholic marriage, Jones's mixed style would surely have appeared entirely consistent with the desire to construct a symbol of Christian harmony in line with the later ceiling panels. And it is perfectly reasonable to suppose that the royal ambitions that these panels celebrated were the

same as those that had informed the building in which they were installed. Perhaps these ambitions were why the royal heraldry on Jones's earlier schemes was dropped on the façade as built, in being thought to convey too nationalistic a message (Figs 242–3)? It is as if Jones were mimicking the Ciceronian orator, with whom he closely identified, in articulating antithetical ornamental styles of the *all'antica* language in a rhetorical act of persuasion.

<p style="text-align:center">★ ★ ★</p>

The temporary shift in court attitudes towards Catholic toleration in public and the desire to celebrate a Catholic alliance both combine to offer, therefore, a plausible explanation for the use of the female Ionic and Composite Orders for the very first time on the façade of a court building. This was in the face of the apparent moral oppositions to the Composite by

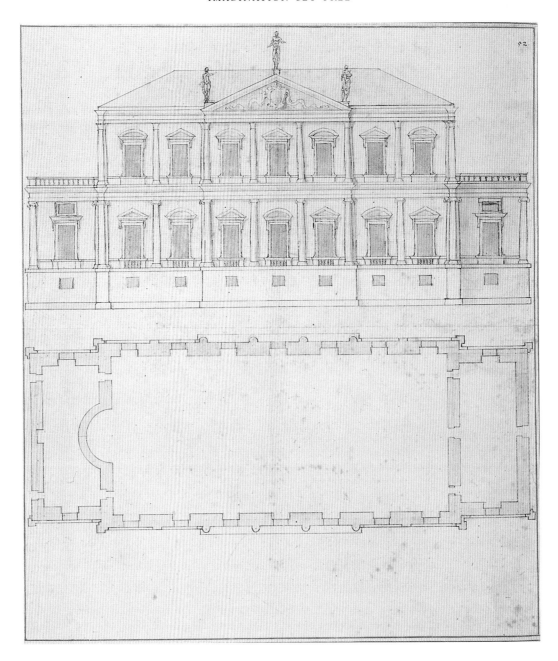

242 Inigo Jones, first design for the Banqueting House at Whitehall, 1619. Devonshire Collection, Chatsworth

English treatise writers, but was in accord with Jones's own understanding of the role of the Aristotelian concept of the 'mean' in matters of architectural decorum. The ornamental oppositions that had previously defined the interior and exterior of Jones's buildings (irrespective of their function and royal patronage) became, in a more tolerant climate, freely balanced on a single external façade. A continuation of the 'masculine and unaffected' style – which Jones was obviously free to adopt – for the Banqueting House façade would

quite clearly not have conveyed the qualities of feminine *magnificentia* and Vitruvian decorum appropriate to such a building and its unique symbolic purpose. Leaving aside the alliance of Protestant and Catholic, this purpose was after all the celebration of a marriage between a prince and a princess. Of course, it is disingenuous to argue that the three styles are completely balanced; in its richness and position, the Composite dominates the façade. As Serlio explains in his Fourth Book, the Romans composed the Composite from a

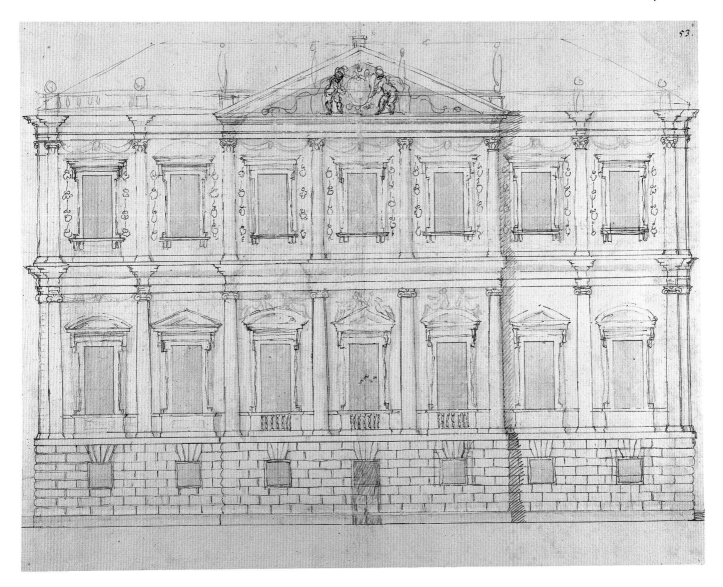

243 Inigo Jones, second design for the Banqueting House at Whitehall, 1619. Devonshire Collection, Chatsworth

combination of the feminine Ionic and Corinthian, 'perhaps because they were unable to outdo the creations of the Greeks,' adding that: 'they used it more for triumphal arches than for any other thing. And they were absolutely right to do this, because since they had triumphed over all those countries from which these works originated, they were quite at liberty as their masters to combine them.'[53] Although Wotton articulated a less favourable view, this understanding of the Composite, as too the decorative progression of the Orders, was common enough in Stuart England. For according to Dekker, the first temporary arch in 1604, at Fenchurch Street (the Londinium Arch; see Fig. 80), had a Tuscan base and drew on Shute in carrying a matching picture of Atlas, 'King of Mauritania'. In justifying the style of the final arch, at Temple Bar (the 'Temple of Janus'; see Fig. 81), Dekker noted,

for as our worke began (for his Majesties entrance) with Rusticke, so did wee thinke it fit, that this our Temple, should end with the most famous Columne, whose beauty and goodlinesse is derived both from the Tuscane, Doricke, Ionicke and Corinthian, and received his full perfection from Titus Vespasian, who advanced it to the highest place of dignitie in his Arch Triumphall, and (by reason that the beauties of it were a mixture taken from the rest) he gave it the name of *Composita* or *Italica*.[54]

In representing a symbol of James I's 'Triumph', now of 'Peace', and his attempt at religious 'mixture', the Banqueting House surely deserved its Composite crown.

In the end there is no way of knowing for certain if this period of greater Catholic tolerance at court moved the accepted ornamental 'mean', as it were, towards the 'feminine and affected' Orders (to paraphrase Jones). Shortly after the construction of the Banqueting House and the failure of the Spanish Match, it will be recalled that Jones returned to a temperate style in public for his major court projects, namely James I's catafalque, the Queen's House and Covent Garden, as too at Wilton (see Fig. 265). His more decorative proposals of the later 1630s for the court such as the Temple Bar arch and Somerset House façades remained on paper. This temperance prevailed until the Corinthian portico added to old St Paul's Cathedral under the similar 'ecumenical' influence of High Church Laudianism. It is worth remembering that prior to this portico Jones had used the Corinthian externally only once, on the private window of the otherwise austere Catholic chapel at St James's Palace (1623–6; see Fig. 209); and like the Banqueting House, this building too was associated with the Infanta. In this way the contradiction between Jones's apparent theoretical disapproval of feminine and capricious ornament externally and his actual use of it can be explained, true to the principles of decorum, by circumstance.

'MASKS, FESTOONS AND SCROLLS': THE LICENTIOUS AND THE GROTESQUE

In the 'Roman Sketchbook' Jones listed some of the ornaments that he would go on to combine to form the Composite frieze at the top of the Banqueting House façade. The list was intended for the inside of halls and stairs, and consisted of ornaments that he might be expected to have considered as amongst the most capricious forms. These included not only swags of fruit but also 'festoni', 'maskquari', 'folliami', 'scroules' and 'balustri'.[55] Added to this were grotesques, or 'the C[h]imeras yoused by the ansients'.[56] The most remarkable ornament on the façade is the row of female faces or masks, with their curious expressions, which belong firmly to the tradition of the grotesque but were not inappropriate for a festive building and masquing hall (Fig. 227). The very essence of the masque as an art form was one of disguise, as its original spelling 'maske' indicates.[57] Jones would, however, use a similar face or mask at the Catholic chapel in Somerset House

(although internally not externally), a reappearance that blurs this meaning whilst enhancing the Catholic one (used on the screen, see Fig. 211). These and the garlands of fruit were absent from his first scheme for the Banqueting House but were pencilled in on the second (see Figs 242–3).[58] Their appearance focuses the attention of the observer upon the presence and indeed decorative character of the Composite capitals. Of the treatises that Jones studied, Giovanni Lomazzo's *Trattato dell'arte della pittura scultura et architettura* (1584) gave the most precise rules for ornamenting the friezes of the Five Orders. He recommended that the figures in the Composite frieze should follow the character of the Order – that is, be 'composite' in character, like sirens, chimeras, harpies or sphinxes.[59] As Jones's studies would have shown him, Lomazzo had recommended such decorative friezes in order to encourage the Catholic Mannerists of Rome. These were the followers of Michelangelo who were to be censured by Jones for their use of such 'composed ornamentes', as he put it, a form of ornament of which the Composite was obviously a type. In so doing he echoed Lomazzo's association between this particular ornament and Catholic architecture, one that Jones's reference to the Composite as the 'Roman' Order further underlined.[60]

One final observation can be made concerning the female faces, with reference to Jones's use of 'capricious' ornament elsewhere about this time. In 1613, not long before he recorded his thoughts on the use of such ornament in the 'Roman Sketchbook', his friend George Chapman produced *The Memorable Maske*. Like the Banqueting House, this masque was also conceived in celebration of a royal wedding, in this case that of Princess Elizabeth to the Elector Palatine, Fredrick V. Jones designed the costumes and settings in the masque, and the detailed description of this scenery can, as Peacock points out, only have been written in close collaboration with its architect.[61] The masquers, according to Chapman, rode in procession to Whitehall Palace. First came

> two cars triumphal, adorned with great mask-heads, festoons, scrolls, and antic leaves, every part enriched with silver and gold . . . The last chariot, which was most of all adorned, had his whole frame filled with moulded work, mixed all with paintings and glittering scarfings of silver, over which was cast a canopy of gold borne up with antic figures, and all composed *à la grotesca*. Before this, in the seat of it as the charioteer, was advanced a strange person, and as strangely habited, half French, half Swiss, his name Capriccio.[62]

The key to Capriccio's character, as Peacock argues, was indicated by one of his lines: 'A man must be a second Proteus, and turn himself into all shapes.'[63] Capriccio personified the idea of change or metamorphosis, an idea symbolised by the grotesque ornament on his chariot and by his 'dual' national dress. Could it be that in using capricious – or even Capriccio's – ornament on the Banqueting House, raised just six years later in the same place as this performance, Jones was also intending to represent change – a new ornament for a new era? The building was, after all, the most public and prominent manifestation of Stuart court art to date. The poets Chapman and Jonson, who collaborated with Jones on the court masques enacted within the building, were themselves students of Hesiod, Aristotle and Vitruvius. They would therefore have been particularly well placed to see in this novel façade a balanced expression of the king's ambition towards religious toleration.

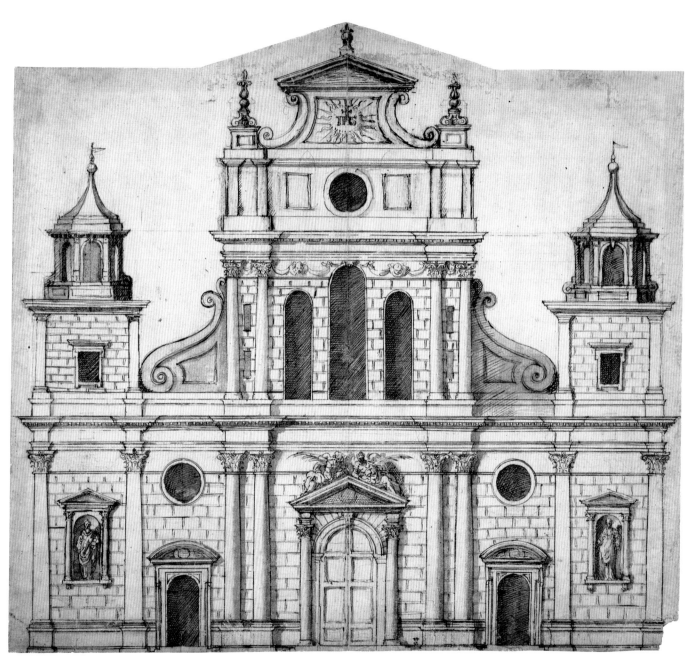

244 Inigo Jones, preliminary design for the west front of St Paul's Cathedral, London, undated. RIBA Library Drawings Collection, London

CHAPTER 8

IMPERIAL SEAT
OR ECUMENICAL CHURCH?
RELIGIOUS AND ORNAMENTAL
HARMONY AT ST PAUL'S CATHEDRAL

Inigo Jones's largest and most important ecclesiastical project was his application of a surface of antique ornament to the Gothic cathedral of St Paul in London.[1] This work was undertaken from 1633 until the outbreak of the Civil War in the early 1640s. Although this project came to be Jones's last involving the court, it was here that he finally used a combination of the four main canonic Orders on a set of public façades, matching the columns to the importance of their location on the building. The contemporary drawings and views indicate that the nave was resurfaced with rusticated masonry and ornamented with a quasi-Tuscan Order, appropriate to the massive ashlar character of this new surface; Jones employed Doric for the lesser doorways and upper frieze, Ionic for the main portal on the west front and Corinthian for the portico (Figs 245–7).[2] In this regard the west front, at least, could not be described as 'masculine and unaffected', but nor is it capricious like the Banqueting House.

Given that the cathedral's restoration had been planned to express and confirm the new Protestant Golden Age under Stuart rule, Jones's iconography might be expected to have conformed to Protestant expectations.[3] After all, St Paul's was seen as a British rival to the glory of St Peter's and, rather like the Church of England itself, the new surface was overlaid onto a fabric whose origins were Catholic. The restoration, however, was announced in 1620 at the same time as the negotiations were under way for a Catholic bride

for Prince Charles and at a moment when, as has been seen, James I entertained the idea of greater Catholic toleration. And although early Stuarts had proposed the cathedral refacing as a triumph of Protestant imperialism and as such a reflection of Calvinist doctrine, the Church's official position later changed. William Laud, in alliance with Charles I, was to adopt a less hostile attitude to Rome. With little actual building work undertaken at St Paul's under James, it was not until Laud became Bishop of London in 1628 that sufficient enthusiasm was aroused to enable the work to proceed.

That Jones's cathedral refacing did not please the Puritan authorities is shown by their treatment of it during the Civil War. These feelings were no doubt enhanced by the fact that Charles had personally associated himself with the work, having agreed to fund the portico and west front in a letter to Laud on St George's Day, 23 April 1634.[4] The influence of Laud's High Church reforms on Jones's cathedral design was also a factor.[5] The interpretation of the Banqueting House's novel ornament suggests the possibility that the similar combination of the Orders at the cathedral, this time from Tuscan to Corinthian, may have lent expression to one of the High Church party's main ambitions; this was the ecumenical one of resolving religious tensions between the Churches of England and Rome. The suggestion is reinforced by Jones's use of iconography from both Protestant and Catholic traditions in his two west front designs. His work at the cathedral

245 Inigo Jones, the north façade of St Paul's Cathedral, 1633–42, recording Jones's resurfacing of the nave and transept, engraved by Wenceslaus Hollar and published in William Dugdale's *The History of St Paul's Cathedral in London* (1658)

246 Inigo Jones, the south façade of St Paul's Cathedral, 1633–42, recording Jones's resurfacing of the nave and transept, engraved by Wenceslaus Hollar and published in William Dugdale's *The History of St Paul's Cathedral in London* (1658)

247 Inigo Jones, the west façade of St Paul's Cathedral, 1633–42, recording Jones's new portico, engraved by Wenceslaus Hollar and published in William Dugdale's *The History of St Paul's Cathedral in London* (1658)

brought together Church and State as never before, and its symbolic programme was informed by preachers and clergymen from diverse ecclesiastical factions. Once again, the marriage of contrasting decorative details and iconography will be seen as designed to signal, albeit paradoxically, a new era of religious harmony.

'ATTEMPTING THE REPAIR GRATIS': DECAYED WALLS AND A TRUNCATED TOWER

Despite the grandeur of old St Paul's, there was according to at least one foreign sightseer in London in 1592 'nothing of importance to be seen'.[6] The spire had been destroyed by a fire after a lightning strike in June 1561 and this diminished the impact of the cathedral on the London skyline (Fig. 248).[7] Continual exposure to London smoke had led to stone corrosion, and some inevitably saw the physical state of St Paul's as representing a sign of God's disfavour. The Catholic apologist James Pilkington, for example, presented the burning of the spire as the end of a series of historical retributions evoked by the English defection from Catholic ranks.[8] Jones's subsequent building work was an attempt to halt not only this decay but also to restore the cathedral's moral decency and symbolic importance after centuries of abuse; the most blatant of these was the infamous Paul's Walk inside the cathedral, down which even prostitutes were to be found.[9] Private

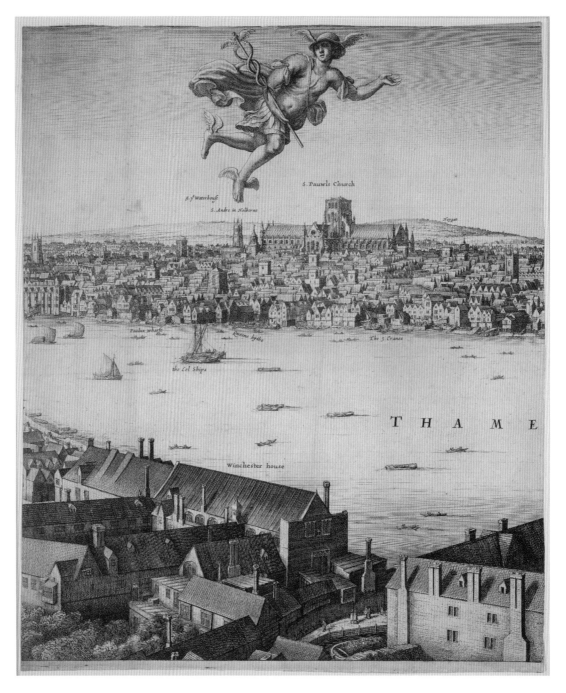

248 Old St Paul's, from Wenceslaus Hollar's *Long View* (detail) of 1647. British Museum, London

dwellings squatted in the cathedral's yard, and their cellars undermined its very foundations. On 24 August 1632 it was 'ordered that Ewin Birch, one of the messengers of his Majs Chamber shall take unto him two experienced Master Masons' and report 'how far the said foundations are endamaged thereby'.[10] The most notable of these encroachments was St Gregory's church, which Jones partially removed from the south-west corner of the cathedral only to have it rebuilt, after the Civil War, using materials left over from the restoration.[11] This clearance of the site was equally intended to create a fitting setting for the re-edified cathedral, the wider urban intentions of which were echoed elsewhere by Jones in his demolition of medieval houses to create London's first public squares at Lincoln's Inn Fields and Covent Garden (see Fig. 89).[12]

There were three Stuart inquiries into the physical state of old St Paul's, and three surveys by Jones, all of which testify to the symbolic importance of the building to the Stuart monarchy and its national Church. The first of these was initiated in July 1608, when, at the insistence of the Earl of Salisbury, James asked the Lord Mayor and the Bishop of London to prepare estimates for a general repair and a new spire.[13] Dugdale reports that James's 'Princely heart was moved with such compassion to this decayed fabrick, that for prevention of its neer approaching ruine . . . considering with himself how vast the charge would be; as also, that without very great and publick helps, it could not be born'.[14] Although Jones was not as yet the Surveyor of Works (and in any case the cathedral was not a royal responsibility), the drawing by him for a new termination to the cathedral tower probably dates from this survey (see Fig. 26). Nothing came of this tower project or indeed of the proposed general repair. Twelve years were to elapse before James set up a royal commission to examine the state of the cathedral, with Jones listed as a commissioner along with, amongst others, George Abbot, Francis Bacon, Lancelot Andrews, the earls of Pembroke and Arundel, and the Duke of Buckingham.[15] Jones probably produced drawings for this commission, for a letter by him to Arundel dated 17 August 1620 notes that 'the plan of all the incroachments about Paules is fully finished'.[16] A complete survey of necessary repairs to decayed stonework and an estimate of the cost were undertaken from April 1620, and included the rebuilding of the tower.[17] Portland stone was also stored, but the collection of money went slowly and no actual building work was started, other than demolition and new glazing.[18]

It was only after Charles I and Laud had assembled a second commission, on 10 April 1631, that the work itself was to begin. This time Jones's name was not on the actual commission list, and he acted in his capacity as surveyor without fee: the State Papers for 4 February 1633 record

By the Lords Comiss[ion]ers for the busines of the Cathederall Church of St Pauls. Upon consideration and debate . . . of the best wayes and meanes for the advancing the works intended for the repairaton of the Cathederall Church of St Pauls and upon conference therof had with Inigo Jones Esq. Surveyor of his Majesties Works . . . the said Mr. Inigo Jones (who for the good of works intendes to attempt the said repair gratis) be app[ointed] Surveyor of the saidworks. And that he from tyme to tyme shall nominate a Substitute to be put in [when] he shall thinke fitt.[19]

The restoration fell only marginally into the concerns of Jones's Office of Works, given that all except the west front was funded mainly by subscriptions from laity.[20] Nevertheless, the fact that he waived his normal payment shows how much he wanted the work.

The second commission held their initial meeting on 16 December 1631, and legal moves to gain possession of the leases of houses encroaching on the cathedral were begun in January 1632.[21] Perhaps on the basis of his report of the preceding month, Ewin Birch was summoned in September to enforce an order requiring demolition of houses from the Great South Gate to the east end of the cathedral.[22] Work was not supposed to begin until at least £8,000 had been raised, but on 26 June 1633, with only £5,416 13s. 6d. actually collected, £2,000 was issued by the paymaster Michael Grigg and work began at the cathedral's south-east end. It then proceeded along the south elevation to the west end, and money was raised as work progressed.[23] The chamberlain of London, Robert Bateman, kept a record of contributions to the restoration drawn up at the end of each year.[24] In 1634 the Lord Mayor and aldermen of London were urged to improve their efforts to raise contributions by a reminder that the king had promised £500 a year for ten years and had taken the west front under his care (although contributions for this were in fact received from other sources).[25] As in the case of modern fundraising, money was donated for the resurfacing of specific parts, which were divided into the west end, nave walls, tower and general repairs.[26] Between September 1631 and the final reckoning in October 1643, approximately £101,330 4s. 8d. was raised, an amount including £10,971 16s. 2d. from the king and £21,237 from the counties.[27] With such a wide cross-section of the populace contributing to this important national project, Jones clearly needed to avoid any accusations of decorative capriciousness, affectation or even licentiousness, to use his own terms. In this context his balanced approach to the ornamentation of the cathedral, from 'masculine' walls to 'feminine' (or at least, decorative) portico, had advantages. For as will now be seen, his work reflected the virtue of appearing 'all things to all people' recommended by none other than St Paul himself.[28]

★ ★ ★

'THE IMPERIAL SEAT':
THE CATHEDRAL UNDER JAMES I

Despite its Catholic origins, the medieval cathedral necessarily represented the metropolitan symbol of the Reformed faith for all except extreme Puritans. St Paul's had become the battleground of the Reformation as related by John Foxe.[29] Many of its Catholic icons had been sold off, whilst shrines, pictures and images were destroyed; even the famous Jesus bells were lost by Henry VIII, on a throw of a dice, to Sir Miles Partridge.[30] Images that had been reintroduced to St Paul's by Mary following the death of Henry were removed again by Elizabeth; for along with royal arms, only the tables of the Decalogue and other texts were now allowed. The Church as an institution had physically stagnated during the brief period of Protestant persecution under Mary.[31] Preachers lamented that: 'our pathewayes to yᵉ churches (beyng overgrowen with nettles, and weedes) cause us to mourne, bycause we do not resort unto our churches as oure forefathers have done before us . . . the temples & churches of Englande . . . stande so naked, and so bare'.[32] Although some churches were repaired under Elizabeth, this stagnation continued and was induced by both bankruptcy and the influence of the Calvinist doctrine of Predestination.[33] The disregard of good works as a contribution to salvation inevitably led to a neglect of architecture.[34] In the wake of this decay and in an effort to escape its Catholic ancestry, the Church of England embarked upon an unprecedented church-building programme under the Stuarts. James was praised at his funeral for his policy of founding new colleges and churches, and the repairing of old ones.[35] This ecclesiastical building programme, of which the repair of St Paul's formed a central part, was planned as a consequence and a celebration of the Church's new confident mood, and its renewed imperial ambition.

It was noted in Chapter One that when advancing the policy of Divine Right at the outset of his rule, James I had cultivated the imperial roles of the British Solomon and Constantine. Both were seen as monarchs of the 'true Church', which Protestantism had restored.[36] This also helped legitimise Jones's *all'antica* style, allowing it to be projected as a renewal of the form of architecture used by these monarchs with their strong British connections. Antique architecture was effectively re-styled as the architecture of the Church of England. The cathedral was itself somewhat fancifully seen as founded on this early pure 'Church invisible', with a contemporary song observing:

Forsooth, all Papists aske us where,
Our churche was many a yeare
Invisible, when theirs was in the height:
But let the poore deceived souls
Look underneath the quire of Pauls,
And they may see her holly fayth.[37]

It has been seen that Protestant rhetoric was reflected unsurprisingly in the sermon announcing James's intention in 1620 to restore the cathedral, most notably when it was described as 'the Chamber of our British Empire'.[38] Jones's future 'restoration' was thus conceived by James's court as a further celebration of the theme of British Protestant imperialism that had characterised early Stuart masques and sermons. This theme was echoed by Charles I when it came to commissioning the refacing in 1631; the cathedral was again described as an 'ornament of the royal city, the imperial seat and chamber of this our kingdom'.[39] And later still, during the Commonwealth, the royalist William Dugdale in lamenting the passing of Charles's reign referred to the refaced cathedral as 'the imperiall seat of this his Realme'.[40] Imperial claims and Jones's 'antique' architecture went hand in hand.

Much as Jones had cultivated a British antiquity for the Orders in masques, and for the Tuscan in particular in his Stonehenge study, Puritans referred the rituals and signs of their worship back to the antique Church for validity. Not unexpectedly, their concept of the ancient Church was of an austere, simple foundation having, according to the Protestant cleric John Gordon, 'no Altars, no Images, nor any materiall crosse of golde, silver, wood or stone'.[41] It has been pointed out that Jones's 'masculine and unaffected' church architecture, which he sought to introduce through his use of the Tuscan at St Paul's in Covent Garden and on the nave walls of the cathedral, was perfectly compatible with this view. In his history of the cathedral of 1658, Dugdale repeated the idea of an ancient Christian Church as the forerunner of the English Church under Stuart rule. This was more opulent than the Church of Gordon's imagination, however, built as it was 'by those our pious Ancestours, who stuck not at that charge for the adoration of his House'.[42] He added: 'Nay so much did the Primitive Christians strive to excell in such fabricks; that, in testimony of their cheerfull affections, thinking nothing too much nor too good for God's service.'[43] Dugdale cited this early Church as justification for the rich Laudian ornamentation at St Paul's, by then under Puritan attack and the preservation of which formed the wider purpose of his *History*. He glossed over the cathedral's Catholic past, and instead

represented medieval St Paul's as a symbol of general Christian virtue. In so doing he reflected the wider beliefs of the Laudian movement whose concept of Church history and attitude to Catholic Rome was at variance with that of the Puritans. Although by no means a new group, the Laudians had assumed control of the Church of England in the period after 1630 during which the actual work on the cathedral was carried out. But what did Laudianism represent, how did its values differ from those of the Church under James I and to what extent were these values also reflected in Jones's design?

'MAGNIFICENCE EXEMPLIFIED':
WILLIAM LAUD AND
THE 'BEAUTY OF HOLINESS'

As a result of rejecting the doctrine of Predestination, the Arminian (or High Church) movement that flourished under William Laud inevitably appreciated the value of good works as a means to salvation, and none was more valuable than building.[44] Laud regarded the re-glorification of St Paul's as one of his most important projects.[45] He observed in a letter to Sir Arthur Ingram in 1638 that: 'I would heartily pray you to open your hand freely to this magnificent work, the re-edifying of St Paul's Church, which God and the King have set me upon.'[46] Laud had become archbishop in 1633, the year work began, and according to Dugdale he 'in all things shewed himself a pious and powerfull furtherer thereof'.[47] He promised an annual donation of £100, but by the time work was brought to a stop in 1642 by the Civil War he had donated £1,200 to the project.[48] St Paul's was at the centre of his national movement for church repair.[49] There was a link between the work at the cathedral and that at St Andrews Cathedral in Scotland, for example, whilst in 1658 Dugdale associated Laud's 'promoting of this famous and necessary work' on St Paul's with 'that noble enlargement' of St John's College in Oxford (Fig. 249).[50] Jones's work on the cathedral had been promoted by the Laudian party from the very beginning of its influence. The 1620 cathedral commission that examined the state of St Paul's included Lancelot Andrewes, the intellectual leader of the Arminians, and

249 The highly ornate gateway of 1635 into William Laud's Canterbury Quad at St John's College in Oxford

the dean, High Churchman Valentine Cary.[51] George Mountaigne, Bishop of London before Laud and one of his most important allies, had encouraged the erection and adoration of images in churches, and after his appointment as bishop in 1621 actively promoted the cathedral work. He preached on the subject at St Paul's Cross and contributed a large sum of money towards the purchase of Portland stone. In contrast, Puritan parishes responded by contributing very little towards the repair. In line with the destruction of the cathedral's Catholic icons, one Puritan even suggested with reference to Jones's proposed restoration that: 'it was more agreeable to the rules of piety to demolish such old monuments of superstition and idolatry than keeping them standing', another that he 'would rather give ten shillings towards the pulling down of that church' than 'five shillings towards the repairing of it'.[52] A popular song of 1620 ran: 'The purelinges of the Citty . . . / Doe hould it for a great offense, / To repayre a church with such expence / That hath beene superstitious all her youth.'[53]

According to Dugdale, it was Laud who gained consent from Charles I for the second cathedral commission of 1631, and two years later the archbishop laid the first of four foundation stones for the new façades. The ceremony reflected the collaboration between the court and Church on the work, since it was performed by officials from both institutions. Again according to Dugdale,

> the said Bishop . . . layd the first stone at the East end thereof: The second stone being then layd by Sir *Francis Windibank* Knight, one of his Majesties principall Secretaries of State; the third by Sir *Henry Martin*, then judge of the Perogative Court; and the fourth by . . . *Inigo Jones*, Surveyor generall of this work.[54]

One stone was no doubt laid at each of the cathedral's corners, thereby explaining the participation of four people, in order to demarcate the re-foundation towards which the work was directed. In line with the official mythology that had surrounded James I, Laud linked these ceremonies to Solomon's foundation of his temple (1 Kings 8) and to the re-consecration of pagan temples under Constantine.[55] Thus through enacting this ceremony at St Paul's, he celebrated the physical and spiritual re-foundation of the British Church in succession to the Church fathers. Needless to say, the arch-Puritan William Prynne, Laud's great opponent, understood such ceremonies as 'Superstitious, Jewish, Popish . . . rather a conjuration then a consecration'; he

added that Laud: 'needs must introduce this Popish Innovation, not onely at *Hammersmith*, but even at the Cathedrall of *Pauls* it self'.[56]

One of the central policies of the Laudians was the promotion of the 'beauty of holiness' (following Psalm 96), in stark contrast to the Puritans, and not surprisingly this animated all aspects of their campaign for the 'restoration' of the cathedral. It was particularly evident in sermons such as Bishop Gyles Fleming's *Magnificence Exemplified: And The Repaire of Saint Paul's exhorted unto* (1634).[57] Fleming evoked the decorus notion of appropriate display, and emphasised a hierarchy of ornament in public buildings – with the cathedral presented as the most magnificent – when rebuking the City authorities for having neglected this principle: 'Are the magazines, Burses, Hals, Guilds, and all your other places of assembly, richly, and statelily adorned; and this place of as solemne, but more holy meeting, onely sordid and unseemely?'[58] Fleming maintained that public and royal buildings had a right to express ideas of Aristotelian 'magnificence', whilst private ostentation was to be avoided: 'Foreigners', said Fleming, will wonder to see 'men clothed, and fed, and lodged, like Kings in their owne houses; yet [have] no regard [to] how unseemely they are in this place [i.e., the cathedral].'[59] Laud's ceremonial and Jones's west front, itself 'richly and stately adorned' with the Corinthian portico, were to give particular expression to these ideas.

Laudian ceremony at St Paul's was based on models of High Church reform such as Peterhouse chapel in Cambridge and Durham Cathedral, in which they sought to outdo the papists in the show of worship.[60] Church music, for example, was encouraged by Laud but hated by the Puritans, as Donald Lupton noted in 1632 with reference to St Paul's:

> *OH Domus Antiqua*, a fit object for pitty, for charity . . . Puritaines are blown out of the church with the loud voice of the organs, their zealous spirits cannot indure the musicke, nor the multitude of the surplices; because they are Relickes (they say,) of *Romes* Superstitions . . . Well, there is some hope of Restoring this church to its former glory.[61]

The Laudian desire to celebrate the 'beauty of holiness' can be found in all aspects of the cathedral's ornamentation. The coloured glass, for example, was repaired by Jones as an essential element in the development of an appropriate symbolism to celebrate the Reformed faith.[62] In George Herbert's vision of the English Church entitled *The Temple* (1633), the windows showed: 'Doctrine and life, colours and light, in one /

When they combine and mingle, bring / A strong regard and awe'.[63] Most of the medieval stained glass in the cathedral had escaped destruction, despite the widespread association of this decorative art with the Church of Rome: in the anonymous *Discourse between a Protestant, a Glasier, and a Separatist* (1641) centred on the windows of the cathedral, a glasier defended his ancestors' work against its being singled out for Puritan attack:

> Me thinkes 'tis pitty ancient monuments
> Because their popish; that's the harme they doe,
> Should from the Churches thus be torne
> and rent,
> Then pull downe Churches they are popish too;
> For surely they were built in popish times,
> And still are guilty of some popish signes.[64]

The inside walls of the cathedral also received Laudian enrichment. Jones's work on the interior was limited to repair, with no new stone faces applied in the manner of the nave exterior.[65] The 1633 edition of Stow's *Survey of London* reported that the choir was however 'painted with rich colours in Oyle'.[66] This indicates something of the opulence of the internal redecoration, and that much had been finished by the time the external refacing began in the same year. Dugdale referred in passing to the embellishment of the medieval choir screen and to new hangings:

> Sir *Paul Pinder* . . . at his own charge, first repaired the decays of that goodly partition, made at the West end of the Quire; adorning the front thereof, outwards, with fair Pillars of black Marble, and Statues of those Saxon Kings, which had been Founders, or Benefactors to the Church; beautified the inner part thereof, with figures of Angells; and all the wainscote work of the Quire, with excellent carving; *viz.* of Cherubins and other Imagery, richly gilded; adding costly suits of Hangings for the upper end thereof.[67]

Jones's screen for Winchester Cathedral, designed in 1637–8, is a notable example of the many that were built during the Laudian period (Fig. 250). As an expression of the growing confidence enjoyed by the High Church party under Laud, the screen had reclining angels identical to those first proposed externally for St Paul's (and to those subsequently attacked by the Puritan iconoclast William Dowsing during the Civil War).[68] It also had Composite pilasters, which obviously were permitted internally by Jones in his 'Roman Sketchbook'. Like the medieval roods, these screens were believed by Laud to sanctify the chancel and to

form a gateway to what served, effectively, as a 'church within a church', whilst the nave became an enormous narthex often used for sermons.[69]

In the Laudian service the altar was to replace the Calvinist pulpit as the focal point of worship, and its location was the subject of much conflict in the seventeenth century.[70] Hollar's plan of the cathedral recorded that the altar was against the east wall of the chancel and raised up by four steps (Fig. 251). It had been somewhat controversially restored to this pre-Reformation position by the Laudians, for in 1550 the old altar that had stood in this location was pulled down and a table set up in its place. This was subsequently removed to the midst of the upper choir, the position favoured by Puritans, and re-orientated with its length set east–west.[71] When moved back to the east end, the Laudian altar enhanced the processional thrust of church plans. During services at the cathedral the clergy progressed through the choir screen, newly ornamented by Jones, to enter a chancel conceived as a permanent setting for the Eucharist symbolised by this fixed, eastern altar.

250 Inigo Jones, choir screen of Winchester Cathedral, 1637–8, engraving by Charles Woodfield (1714)

251 Daniel King, *On St Paul's Cathedral Represented by Mr Dan. King*, 1658, detail showing the plan of St Paul's (after Hollar) recording the steps up to the chancel and the altar against the chancel's east wall, altar-wise and raised up four steps

In arguing for the sanctity of the altar and its position at the east end of the church, Laud appealed to ancient history and tradition. He considered it significant, for example, that the Order of the Garter maintained the Catholic custom of bowing towards the eastern altar in their services at Windsor.[72] Here again, a view of British history underpinned and justified Stuart practices, this time Laud's encouragement of decorative forms of worship ostensibly linked with those of Rome. And the Corinthian columns that Jones used for the cathedral portico, together with his flirtation with Jesuit iconography that will be examined below, were at equal risk of being interpreted as 'relics of Rome's superstitions', as Lupton put it concerning the cathedral's music. These too represented an expression of the 'beauty of holiness' sought by Laud at the cathedral. What were his intentions behind this policy towards the open celebration of iconography and ceremonial that at first sight appeared to be 'popish'?

'RENEWING ANCIENT RITES': LAUD'S ECUMENICAL TEMPLE

Laud wished to rival the splendour of Rome and in so doing restore dignity and beauty to the Church of England. Whilst this aim to promote the 'beauty of holiness' found favour at Charles I's court, it was validated through a reading of the history and practices of British Christianity that was, paradoxically, at variance with that adopted by James I and officially inherited by Charles as an imperial monarch. The Laudians' view of Church history was in essence conciliatory towards the Church of Rome. It stressed a common Christian inheritance beyond the medieval Crusades to the more opulent primitive Christianity that Dugdale later described and which was still visible for Laud in the Greek Church.[73] Furthermore, it was even hoped by some Stuarts that this common history would provide the foundations for future Church reunification, since

Rome maintained its equal status as a 'true Church' for many Laudians.[74] Richard Montagu, for example, saw the Church of England under Laud as the focus for a reunited 'Catholic' Church. This ambition was shared by the 'papist' Francis Windebank, who, perhaps significantly in this light, laid one of the cathedral foundation stones.[75] Central to Montagu's vision was an appeal to British antiquity, and he thus described Charles in 1636 as 'renewing', 'restoring' and 'repairing' ancient rites.[76] Such moves towards Church reunification were obviously at variance with Calvinist doctrine, which stressed the historical opposition to Rome and a future of imperial domination. This had been the massage of countless sermons delivered at the outset of James's reign. The Protestant apologist George Marcelline had even hoped that the Roman Church would be reformed on the English model, with James I at its head. In 1610 he urged that through the king's divinity, 'in assaying to restore the little wandering flocke to the folde of the Church, by a National counsel, or one Oecumenical or Universall, it cannot but bee hoped'.[77] On the conflict between the old Calvinist school of Archbishop James Ussher supported by James and the High Church Arminian movement under Laud, Hugh Trevor-Roper commented,

> Each was defending a distinct concept of the Church. Ussher, the heir of Jewel and Foxe, traced the true Church through the medieval heretics, the Albigensians and the Waldensians. To him the Papacy was Antichrist, absolute evil, and the modern 'Arminians' were papists in disguise. Laud was the heir of Hooker and Andrewes . . . He saw the Christian Church as a continuous institution, vindicated by tradition and reason, of which the Roman Church, though at present corrupted, was a true part. He had no use for Waldensians or Albigensians, and not much for Jewel and Foxe.[78]

Hence although anti-papist, the Laudians did not believe the pope to be the Antichrist, and although roy-

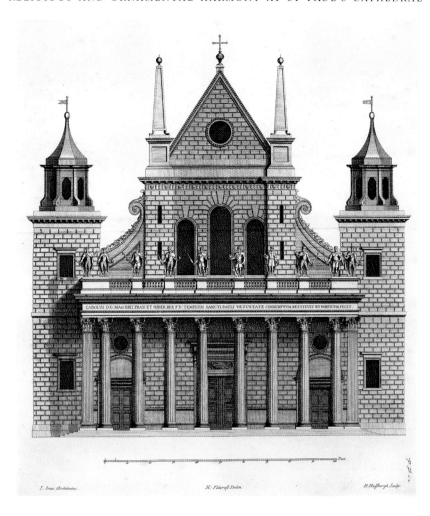

252 Inigo Jones, west
portico of St Paul's
Cathedral, 1633–42, as
engraved by Henry Flitcroft
for William Kent's
The Designs of Inigo Jones
(1727), vol. 2, p. 56

alist in supporting Charles's absolutism, they did not
believe in the priestly authority of the Christian
prince.[79] Whilst anti-popery had worked as a cohesive
force under James, it divided the Church under his son.

Laud's ceremonial and Jones's architectural backdrop,
in uniting outer splendour and inner harmony, were
seen by many in the Church as celebrating the healing
of these divisions, and the continuity of Christian
worship in Britain. For Laudians such as Gyles Fleming
the medieval dignity of the cathedral reinforced this in
reflecting the common past of the Churches of England
and Rome.[80] It follows that they saw the Orders as less
a rediscovered sign of an ancient Protestant purity – as
Jones's early masques, Stonehenge study and Rubens's
ceiling panels all imply, at least for the more simple
column types – than as an architectural progression and
perfection 'superimposed' onto the heroic architecture
of the Middle Ages. This was in line with Laud's view
of Church history.[81] Jones's early design for a cap to the
cathedral tower can be viewed in an analogous way, as
an essentially Gothic structure with superimposed

Orders (1608; see Fig. 26). And clearly the medieval
cathedral represented the 'foundation' onto which the
new order was overlaid, both physically and spiritually;
or as Edmund Waller's poem on Charles I's restored
cathedral put it, 'an earnest of his grand design, / To
frame no new church, but the old refine'.[82] In this light
it was more than just expense that prevented demoli-
tion and the building of a new cathedral, despite the
association of the fabric with superstition by some
Puritans. Like the cathedral's medieval walls, the choir
screen provided an existing surface upon which to
overlay the Laudian view of Church history. For the
common origin of the two Churches was emphasised
through the statues of Catholic Saxon kings that,
according to Dugdale, were added to the screen. These
would have served as internal counterparts of ones
intended to stand either side of the statues of James I
and Charles I on the portico if Flitcroft's engraving is
to be believed, but which were never put in place (Fig.
252).[83] It may also have been the intention to paint the
portico's ceiling or even the western walls with figures

of the Apostles and Old Testament kings, although if started this decoration was almost certainly never completed.[84] The portico's religious purpose, as Protestant propaganda (in obvious rivalry with St Peter's), was indicated by John Webb, following its abuse during the Civil War; for he claimed in somewhat messianic terms that it was intended to evoke nothing less than 'the Envy of all *Christendom* upon our Nation, for a Piece of Architecture, not to be parallel'd in these last Ages of the World'.[85]

'PERFECT UNITY':
FROM REFORM TO REUNIFICATION ON
THE WEST FAÇADE OF THE CATHEDRAL

Something of the Laudian ambition towards religious unity can also be detected in Jones's undated and unexecuted design for the west front (Figs 244, 253).[86] Not only is the ideal of universal harmony implicit in the proportions of its pilasters, following the norms of classical architecture, but its profile also fits within a circle, a form representing unity (see Fig. 181). Moreover, it would be reasonable to interpret a façade with the Jesuitical IHS sunburst at its apex as signalling, at the very least, a degree of Catholic toleration. Laud owned

Bible illustrations incorporating the IHS sunburst, which would prove grounds for Puritan censure.[87] These illustrations have been linked to an architectural style termed 'High Anglican Baroque' used at Peterhouse in Cambridge, but which might equally describe this unexecuted cathedral façade and the work at St John's College in Oxford (see Fig. 249).[88] Together with the IHS and indeed the Corinthian Order (which, it will be remembered, had Catholic overtones), other details of this proposed elevation can be identified as signs of Laudianism and its ambitions. Prominent are the two statues (possibly of St Peter and St Paul) and the two Solomonic angels over the door, as well as the winged cherubim in the upper frieze. Some way from being 'masculine and unaffected' in character, angels and 'cherubins heades w[i]th winges' were listed next to such capricious forms as 'heads of beastes' and 'festoni' in Jones's 'Roman Sketchbook'.[89] A winged cherub was to be carved on each keystone of the nave windows in the actual resurfacing, which were modelled in June 1638 and are shown in Hollar's engravings (Fig. 254). The popularity of this iconography with the Jesuits was pointed out when discussing the winged cherubs on the Catholic chapel at Somerset House. For this reason angels and cherubim were amongst the most loathed 'superstitious' symbols smashed by Dowsing during the Civil War.[90] And bearing in mind that Prynne inter-

253a and b Computer reconstructions of Jones's undated preliminary design for the west façade of St Paul's Cathedral (see Fig. 244)

preted the IHS monogram as 'but an undoubted Badge, and Character of a *Popish*, and *Jesuiticall* Booke; of an *Idolatrous*, and *Romish Devotion*', there can be little doubt that allegations of idolatry would have been the common Puritan reaction had Jones actually built this preliminary scheme.[91] In fact, the whole arrangement of this façade is strongly reminiscent of Jesuit churches, notably those of Sant'Ambrogio in Genoa (1589–1606) and Il Gesù in Rome (1568–80; Fig. 255).[92] As a context for this influence, Jesuit works were much studied by High Churchmen, including significantly John Donne, the cathedral dean from 1621.[93]

There is an all-too-obvious contradiction in decorating a Protestant cathedral with Jesuit symbols. But it will be remembered that a context within the court for the façade can be found in the tastes and influence of Henrietta Maria from 1625, and in the religio-political

254 (*left*) A winged cherub carved on each keystone of the nave windows, shown in Hollar's engravings (detail of Fig. 245)

255 (*below*) Giacomo Barozzi da Vignola and Giacomo della Porta, Il Gesù, Rome, 1568–80

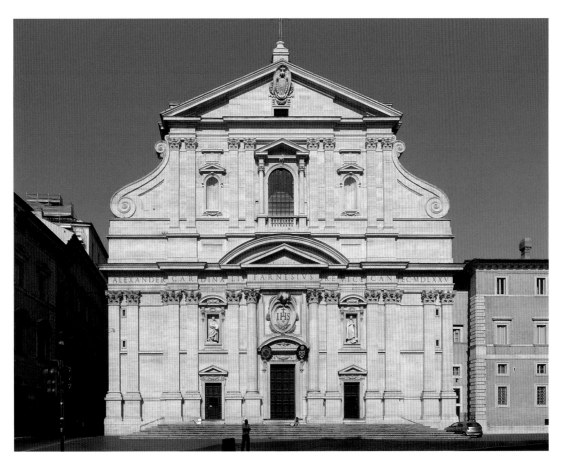

climate of the early 1620s that led to her marriage. For if constructed, this façade would have stood as a natural counterpart in terms of both style and magnificence to the Banqueting House, commissioned to celebrate James I's policy towards an Anglo-Catholic alliance, at first with Spain.[94] It is possible that the timing of the projected Anglo-Spanish union, which also prompted Jones's involvement with the court-patronised Catholic chapels, may have motivated the formation of the 1620 royal commission at St Paul's and this preliminary cathedral scheme. At the very least the Infanta's imminent arrival would have provided a stimulus for the cathedral's basic repair, whilst 'tydings of peace' were delivered in the sermon in which James announced his 'restoration' plans at St Paul's in 1620.[95] Prior to his arrival at the cathedral on this occasion, the king had ordered the royal procession to halt in front of the residence of the Spanish ambassador. After the ambassador's greeting, James bowed very low several times and it was observed that 'great importance is attached to this'.[96] Following the failure of the Spanish treaty, it may not be a coincidence that the collection of building materials at the cathedral came to a standstill, whilst no Jesuit iconography was to appear on the west front built thirteen years later. As with Jones's early proposals for the New Exchange, Queen's House and Prince's Lodging, a relatively ornate design was eventually discarded in favour of a plainer one.

<p style="text-align:center">★ ★ ★</p>

Jones's new cathedral façades were thus intended to glorify the English Church at first for James and then somewhat differently for Charles and Laud, as the main protagonists in the work. It follows that at various stages Jones had to unite and represent their views in his iconography overlaid onto the national Church.[97] For on the one hand, the Calvinist concept of the Christian prince and of the cathedral as an 'imperial seat' can be seen reflected in the imperial statues of James I and Charles I and in the inscription on the royal portico; whilst on the other, the influence of Laudian High Churchmanship and a more 'ecumenical' view might equally be identified in the Jesuit IHS sunburst on the preliminary façade and in the choice of the Corinthian Order for the portico and the Jesuitical winged cherubim for the nave as built. Jones's use of these cherubim was a bold gesture, given their strong Catholic associations, even more bold than was his ornament on the Banqueting House. They can be seen as a clear sign of the greater Catholic toleration under Charles I. It was in expressing this very combination, namely the Stuart

pretension towards their Divine Right and preference for 'Personal Rule' allied with the Laudian celebration of the 'beauty of holiness', that led to the attack on the portico by the Puritan authorities and their toleration of its disfigurement during the 1650s. These events will form the somewhat inevitable conclusion to this study.

The capacity of ornament to represent conflicting values was, of course, fully acknowledged by Jones in his 'Roman Sketchbook'; in the case of the cathedral its ornament was perhaps reminiscent of the 1604 arches where, according to Jonson, the 'Symboles used' were of 'a mixed character, partaking somewhat of all'. In this way Jones's combination on the national cathedral of ornament ranging from 'robust' to 'adorned', that is, from Tuscan to Corinthian and more controversially from Protestant to Jesuit, might find a ready context in the ambition to unify Low and High Church factions. A similar ambition towards religious unity can help explain the comparable decorative combination at the Banqueting House, the only prior occasion of its use by Jones in his work as Surveyor. And the relevance of the Aristotelian principle of balancing oppositions was particularly pertinent at the cathedral, bearing in mind the imminent conflicts. An equivalent decorative and ecclesiastical middle path was urged by Herbert in *The Temple* (1633) when proclaiming a vision of a moderate Church free both of the 'painted Shrines' of Rome and the 'nakedness' of Calvinism.[98] The denominational dichotomy that can be detected in Jones's iconography had a wider contemporary context, for when designing the Protestant cathedral in the early 1630s he was also working on the Catholic chapel at Somerset House for Henrietta Maria, complete with its Jesuit symbols. This more open display of Catholic decoration – if not prominently on the national temple then at least in court circles – reflected the growing confidence of the High Church party under Charles and the ecumenical tendency of certain Laudians.

It was pointed out that Charles's eventual marrige to Henrietta Maria had been one such outcome of this policy towards religious unity and peace. The 'music' of the king's peace was a common metaphor in Stuart sermons and panegyrics, especially in those surrounding the cathedral's restoration. The theme of musical harmony echoed in the sermon delivered by Bishop John King in 1620 on the subject of restoration, with the text supplied by James; here it was hoped that 'the tongue of a *King*, like the harpe of *Amphion*' will 'draw stones to the building'.[99] Later, the poet Edmund Waller, when commenting on a partially restored cathedral, made the Stuart kings 'antique minstrels', with 'Cities their lutes, and subjects' hearts their strings'.

Charles, 'like *Amphion*, makes those quarries leap / Into fair figures, from a confused heap; / For in his art of regiment is found / A pow'r like that of harmony in sound'.[100] Solomon's musical harmony featured in the contemporary 'dream' or vision by Henry Farley for the repair of St Paul's. In *The Complaint of Paule's* of 1616 he allowed the cathedral itself the gift of speech:

> thou send'st a second Salomon . . .
> His song of songs most sure shall be,
> That shall set forth His Kingly love to me,
> His chiefe delight is all in Trinitie,
> Of them to make a perfect Unitie . . .
> For he that in his breast doth weare that Sheild
> (As doth David) need not feare the field.[101]

Farley's appeal appears to pre-empt the notion of Jones's ordered cathedral façades expressing Solomonic harmony and national religious accord, as well as the circular and triangular cathedral profile – with all its universal, non-sectarian and Solomonic associations – illustrated in Chapter Five.

If Jones expected to satisfy and even appease Low and High Church factions by combining the 'low' and 'high' Orders on the national temple, then this certainly reflected a common-enough Stuart policy. For the translators of the 'Authorised' version of the Bible struck a linguistic balance between the plain and the majestic, and left deliberate ambiguities capable of appeasing both Puritans and High Churchmen.[102] Similar ambiguities surrounded chivalry. It has been seen that the Orders were introduced into Britain under the familiar native guise of emblems of chivalry, and were akin to heraldry. A martial reading for the columns as signifiers of imperial Protestantism may

therefore be inferred, but chivalrous display itself was not always seen in this way. On occasions the pageantry of chivalry was used to bridge religious divides; for example, in 1585 English Knights of the Garter combined in the streets of Paris with the Catholic Knights of the Order of the Holy Spirit to celebrate the investiture of Henri III with the Order of the Garter. And Elizabethan chivalry was not only a vehicle for patriotic devotion to the monarch and the Protestant cause, but was also used to emphasise the continuity of Tudor ceremonial with that of pre-Reformation rulers.[103]

The sense in which both Stuart kings aimed to express their attempted healing of religious divides at the cathedral might also account for the support, during the 1630s, of some Puritans for Jones's work. The need to repair St Paul's had, initially at least, served to unite elements of the Church. For John Williams, Archbishop of York and Laud's 'great enemy', approved of the work, and there were a number of notable Puritan benefactors.[104] Perhaps these Puritans were satisfied by the overall Protestant character of the new façades, as strived for by Jones through his ultimate rejection of such overt signs of Catholic culture as the IHS sunburst. Kevin Sharpe has pointed out that there is no actual record of any horrified reactions to the work during Charles I's reign, despite what he calls the 'foreign, popish and alien' aspects of Jones's architecture.[105] Just as James I was pictured as Solomon, framed by twisting columns and uniting factions in his role as the nursing father of the British Church, so the cathedral can be seen ornamented by Jones, ever the 'wise man' himself, with the proverbial Solomonic 'pillars of wisdom'.

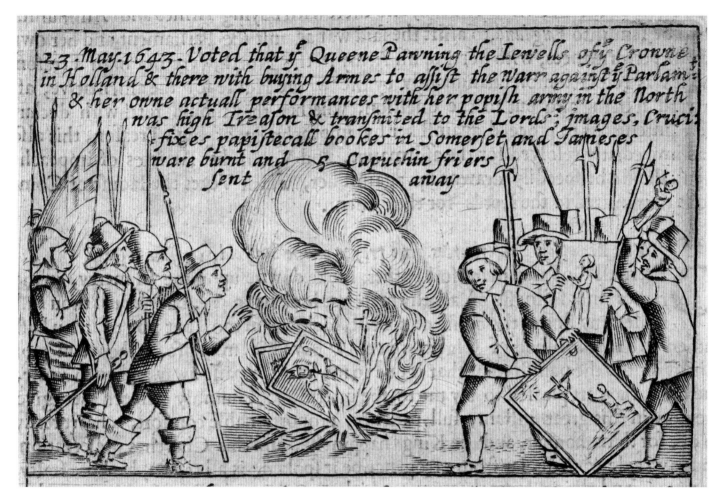

256 The burning of images, crucifixes and books, taken from the royal chapels at Somerset House and St James's Palace in 1643 (an event that took place before the date given here as 23 May), from John Vicars's *True Information of the Beginning and Cause of all our Troubles* (1648), p. 19. British Library, London

BABYLONIAN TRINKETS AND
THE 'VITRUVIUS BRITANNICUS':
THE LEGACY OF INIGO JONES

'STATELY PILLARS HEWED AND DEFACED': THE ARCHITECT OF KINGS

Despite attempts by the Stuart kings to validate their 'new' architectural style in nationalistic terms, Puritans in particular were well aware of the Catholic origin of many aspects of court art and of leading artists in Charles I's employ. This added to their resentment of a ruler who seemed so willing to tolerate Catholicism in the court and city, and to seek favours from the Vatican itself for such 'vanities' as pictures and busts.[1] William Prynne protested, not without justification, that works of art were being used as a 'bribe' to bring Charles closer to the faith of Rome. For the efforts of Cardinal Francesco Barberini (the papal nephew and Cardinal Protector of England and Scotland) to gain Guido Reni's services for Henrietta Maria, and the granting of permission to Bernini to carve a bust of Charles, were all part of a papal plan to bring the king further into sympathy with the Roman faith (Fig. 257). As such, Italianate artworks, especially those of an ornate variety, were used as tokens of ecumenism or even as attempts at outright conversion.

When informed by the queen on 30 January 1636 that pictures sent from Rome by Barberini as a gift from Pope Urban VIII were ready to be viewed, Charles came at once. He was accompanied by the earls of Holland and Pembroke, together with Jones, who is described in the report of the event by the papal agent Gregorio Panzani as 'a great connoisseur of pictures'. Panzani continued:

Immediately Jones saw them, he greatly approved of them [and] in order to study them better threw down his riding coat, put on his spectacles, and took hold of a candle and, together with the King, turned to inspect all of them minutely. They found them entirely satisfactory, as the Abbé Duperron [the queen's almoner], who was present, confirmed to me, and as the Queen reported to Father Philip [her confessor], who was therefore very happy.[2]

A few days later, on 6 February, Panzani reported again on this important event. 'Jones, the King's architect', he wrote,

believes that the picture by da Vinci is the portrait of a certain Venetian, Ginevra Benci, and he concludes this from the G. and B. inscribed on her breast. As he is very vain and boastful, he often repeats this idea in order to show his great experience of painting. He also boasts that as the King had removed the note of the painters, which I had put on each picture, he guessed the names of almost all the artists. He greatly exaggerates their beauty, and says that they are pictures which should be kept in a special room with gilded and jewelled frames, and this he said publicly in the Queen's anti-chamber in spite of being a very stern Puritan.[3]

This vivid report seems to confirm not only the conceited side to Jones's character, but also the essence of the understanding of his work offered here. For Panzani illustrates the links between religious policy and art, and

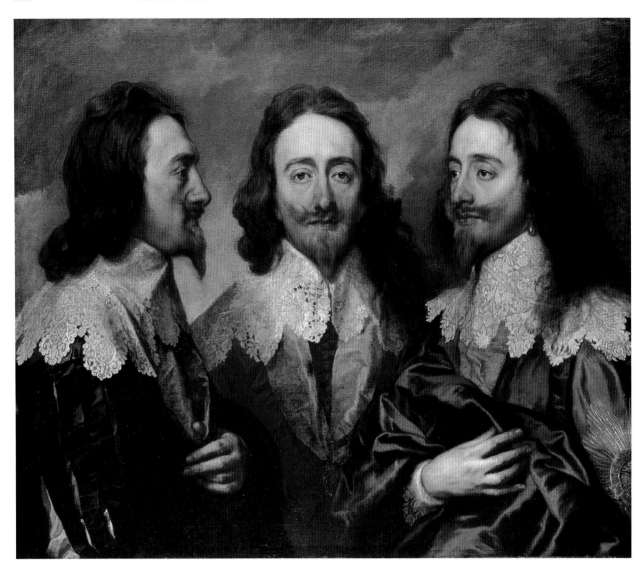

257 Anthony Van Dyck, *Charles I in Three Positions*, 1635, painted to aid the carving of a bust of the king by Giovanni Lorenzo Bernini (bust destroyed in 1698). Royal Collection

especially highlights those between decorative art forms and Catholicism that influenced Jones's practice. These Catholic gifts were, as far as Jones was concerned, of exaggerated beauty and were therefore worthy of being embellished with 'gilded and jewelled frames'. As such, they were to be kept in a 'special' room, far from public gaze. The interior of buildings were, after all, perfectly appropriate for the imagination to be 'set free, and sumtimes liccenciously flying out'. The embellishment and specialness of the pictures would have strongly offended Puritan sentiment, a point underlined by the papal agent's reference to what he at least saw as Jones's own religious preferences. The description 'stern Puritan' (*Puritanissimo fiero*) may in fact be more a term of abuse than a precise description, for tradition also records

Jones a Catholic.[4] Commentators have chosen to believe either story, but this study suggests a sense in which both reports might be true. It would also provide an explanation for the comment by the Superior of the Queen's Capuchins, the Catholic Jean-Marie de Trélon, who noted that Jones appeared to him 'one of those . . . people without religion'.[5] If correct, Jones's own religious ambivalence would help explain his close friendship with both Catholics (Bolton) and Protestants (Arundel), as well as the ease with which he was able to work for, and give expression to, the values of the stridently Protestant prince Henry and, later in life, the unashamedly Catholic Henrietta Maria.

Cardinal Barberini would be involved in a slightly later incident where art and religion now failed to mix.

The centre of the ceiling in Henrietta Maria's bed-chamber in the Queen's House was meant to be adorned with the painting *Bacchus and Ariadne* by Guido Reni. The painting was finished in 1640 but was never sent to London. Barberini, who had commissioned it on the queen's behalf in order to bond further the papacy to the English court, was concerned about the artist's handling of the nude figures, which he characterised as 'lascivious'. He considered that the gift of the painting would backfire in running the risk of scandalising English Protestants and reinforcing their reservations about Catholic morality. This risk was enhanced by the fact that in depicting a marriage, the painting's nude Ariadne would be seen to represent the queen.[6]

Barberini's caution was probably prudent since open hostility to decorative art, and artefacts with a Catholic flavour, was growing. On the eve of the Long Parliament in 1640 a large Puritan crowd broke into St Paul's Cathedral and, by report of the Venetian ambassador in England, 'broke down the altar, and tore to pieces the books containing the new canons. They then tried to kill the very ministers of the archbishop.'[7] In Novem-ber of the same year Jones was the subject of the first bout of Puritan hostility to his work at St Paul's, when the 'Committee for Religion' in the Puritan-dominated House of Commons was petitioned to consider charges that would lead him to be summoned to appear before the House of Lords. He was required to answer accusations brought by the parishioners of St Gregory's, the church adjoining the south-west corner of St Paul's, that he had been high-handed in executing the king's order to demolish the building (only part of the church was in fact demolished and the criminal aspect of the impeachment was eventually dropped).[8] The charge made reference to him as 'sole monarch' of the work at St Paul's, and pitched the virtues of the little church and its parishioners' freedom to worship against the implied vices of the big cathedral and the authoritarianism of its royal and episcopate promoters.

The Puritan animosity to religious iconography of a Catholic nature was given full vent in London in May 1643 with the destruction by the Parliamentary forces of the cross at Cheapside, complete with its Doric pilasters framing statues of saints and bishops and supporting a golden cross (Fig. 258). Jones's cathedral

258 The destruction of the cross at Cheapside from John Vicars's *True Information of the Beginning and Cause of all our Troubles* (1648), p. 17. British Library, London

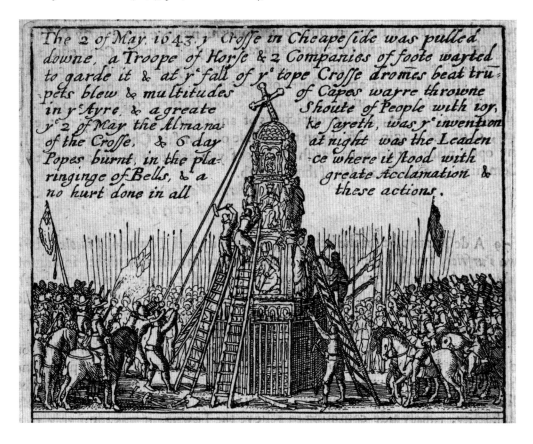

became a less dramatic but none the less inevitable symbolic focus for Puritan attack during the hostilities. This was especially so given its combined expression of royal absolutism and the Laudian 'beauty of holiness' associated in the popular imagination with Catholic toleration by the court. Work on the building had ground to a halt in September 1642 and a year later the preaching cross at St Paul's was destroyed by order of the Long Parliament. The cathedral was again attacked in December 1648, when according to a poem written after the Civil War, 'The carved wood and stone all down did goe, / The crosses, painted glass, and organs too.'[9] The recently enriched nave was now considered suitable only for animals, for Dugdale records that 'the body of the Church hath been frequently converted to a Horse quarter for Souldiers'.[10] This act was no doubt intended as a symbolic gesture, mirroring the use of St Peter's as a stable during the Avignon papacy. However, the cathedral's Gothic choir, merely repaired by Jones, was maintained by the Puritans as a preaching place. Dugdale reported that by 1649 a new partition wall, made of brick, separated the choir from the nave. It thereby marked the boundary and extent of Jones's refacing. St Paul's was superfluous to Puritan worship through the richness of its architectural setting and, in particular, its choir screen, whilst the long aisles were unnecessary for the new services, which were performed without processions or bishops. The programme behind a Laudian cathedral nave had been dictated by the need to provide pathways for Sunday and royal processions as by the need to house a large congregation.[11] The attack on Jones's cathedral brought to the surface religious tensions that he had alluded to in *The Temple of Love* in 1635 and which clearly exerted a powerful influence on him during the preceding twenty-five years.

William Laud was beheaded in January 1645 following his prosecution by Prynne, and Charles I met the same fate in the same month four years later (Fig. 259). In July of the following year, 1650, the Council of State ordered the destruction of the cathedral's royal statues and the removal of the inscription in the frieze, which recorded the late king's beneficence alongside allusions to British imperial mythology (in the event the inscription escaped damage; see Fig. 252).[12] Both examples of Jones's work were evidently viewed, true to their intended purpose, as royalist propaganda. Chronicling the destruction, Dugdale lamented that the 'stately *Portico*, with beautiful Corinthian Pillars' was

> converted to Shops for Seamstresses, and other Trades, with Lofts and Stairs ascending thereto: For

the fitting whereof to that Purpose, those stately Pillars were shamefully hewed and defaced for Support of the Timber-work; and the Statues of King James, and King Charles the Martyr (erected on the Front thereof) despitefully thrown down and broke in Pieces.[13]

Although no doubt some time apart, both actions were linked in intent by Dugdale. At the same time as these statues were toppled, that of Charles I at the Royal Exchange was beheaded, mirroring the fate of the king, its sceptre removed and a new inscription set up: 'Exit tyrannus Regum ultimus, anno primo restitutae libertatis Angliae 1648'.[14] At the Laudian stronghold of Winchester Cathedral in 1643 the brass statues of James I and Charles I (cast by Hubert Le Sueur) set within niches in Jones's choir screen had also been vandalised by Parliamentary troops (see Fig. 250). According to a report in the royalist newspaper *Mercurius Rusticus*, the kings' swords were broken off, a cross from the globe in Charles's hand was severed and his crown slashed.[15] The statues were eventually taken away, only to be rescued and sold back to the cathedral in 1660, where they survive today.

If Jones witnessed in person the state-sponsored attack on his portico at St Paul's – and he was still alive at the time – he might well have been reminded of the vandalised 'columns' at Stonehenge that he had identified; or perhaps of 'those obelisks and columns broke, and down' whose restoration was once hoped would raise 'the British crown to be a constellation'.[16] The toppling of the statues on the cathedral portico provides somewhat dramatic evidence for the Puritan identification of the monarch's body with the autocratic policy of Divine Right. The fact that the Corinthian frieze and columns were bound up in the destruction of the period suggests that they too were part of this identification, given the long-established associations between monarchy and the portico as an architectural form.[17] The central columns at St Paul's quite literally supported the idealised body of the king, rather like the commemorative columns of Rome with their statues of saints; and it has been seen that the Corinthian Order had symbolic meanings that were an anathema to the Puritans. These included royal authority and moral licentiousness (of Corinth), ornamental luxury and visual pleasure, pagan gods and even popery (in representing the Virgin Mary and a Jesuitical Solomon). But worst of all, these columns and statues committed the sin of idolising monarchs both past and present. The portico was seen as emblematic for ancient British nobility and its Catholic religion, as the proposed

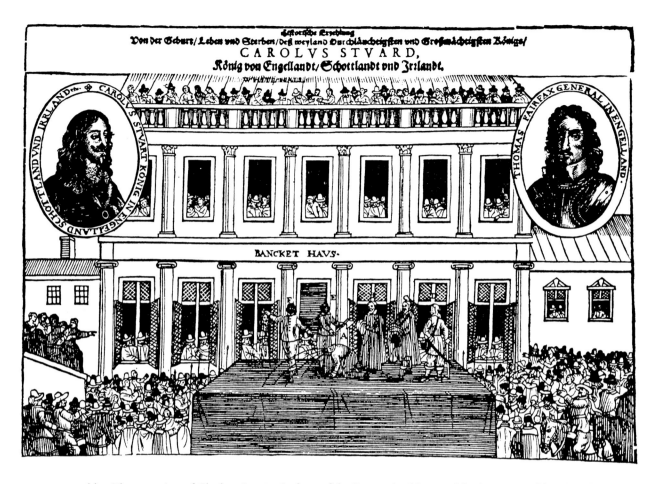

259a and b The execution of Charles I in 1649 in front of the Banqueting House: a (*above*) as engraved by Marx Anton
Hannas. Nuremberg Germanisches Nationalmuseum, HB.24726; b (*below*) unknown artist. The Earl of Rosebery

statues would have celebrated, for according to Dugdale,

> Nor was the King himself without an high sense of the honour done unto Christian Religion; and the same which would redound to this whole English Nation, by thus restoring to life so signall a Monument of his renowned ancestors piety, (I mean King *Ethelbert* and the other Saxon Kings) as may seem by that most magnificent and stately Portico, with Corinthian pillars, which at his own charge he erected at the West end thereof.[18]

Three years after the statues were torn down, Samuel Hering caught the new mood in suggesting to Parliament in 1653 that it should ensure that churches 'have noe out-ward adornments, but the walls' should be 'coullered black, to putt men in minde of that blacknesse and darkenesse that is within them', and also that 'all gay apparell should be forbidden in such places, and noe superiority of place'.[19] Unlike the portico at the cathedral, that at Covent Garden survived relatively undamaged, and in 1645 was even repaired (see Fig. 221).[20] Whilst its simpler, Tuscan decoration may well have helped in its preservation, this church had far fewer links with royalty or episcopacy than its namesake in the City.

The Laudian movement to beautify churches had taken off in the 1630s with the appearance of Gyles Fleming's *Magnificence Exemplified* (1634) and anonymous works including *De Templis, a Treatise of Temples: Wherein Is Discovered the Ancient Manner of Building, Consecrating and Adorning of Churches* (1638). At the same time, Puritans led by Prynne and William Burton complained of an ever-increasing conformity with Rome, with Burton noting: 'how unlike our Cathedrals be to that they were formerly, being newly set out with a Romish dresse'. The bishops were 'master builders', and as such the 're-builders of Babell'.[21] The portico at St Paul's was one prominent architectural expression of this renewed interest by Laud's Church in the 'beauty of holiness' and in architectural ornamentation, or 'Romish dresse'. This was alongside his general celebration of cathedrals as the embodiment of the episcopacy.[22] It is hardly surprising that as a committed Laudian royalist (and Garter King of Arms), Dugdale emphasised that these 'beautiful Corinthian Pillars' were 'shamefully hewed and defaced'; this was in the highly symbolic gesture of converting the 'stately *Portico*' to humble shops 'for Seamstresses, and other Trades' (for which official permission would have been necessary). His choice of words echoed, probably deliberately, the authorities' wish for religious symbols such as crosses

and royalist ones such as arms, statues and inscriptions not only to be removed, or even left 'hewed', but also to be seen in more symbolic terms to be 'defaced'.[23] This approach was a sign of victory in the wake of Charles's execution and grew from one that in earlier years had been limited to attacking religious images held to be superstitious and idolatrous. From 1643 up to around 1646 crosses, tombs, and altars, as well as overtly 'popish' decoration including cherubim and IHS monograms, had been defaced by order of the grandly titled 'Committee for the Demolition of Monuments of Superstition and Idolatry' led by the Presbyterian Sir Robert Harley. [24] Its work represented a far more directed attitude to iconoclasm on the part of the authorities than had earlier been the case, as with the indiscriminate mob at St Paul's Cathedral in 1640.[25] Whilst there is no evidence that columns were singled out for special abuse, Renaissance tombs and altars often incorporated them alongside statues, and as such they were inevitably included in the iconography targeted by the Committee (Fig. 260).[26] This use can only

260 The high altar in the Henry VII chapel at Westminster Abbey, erected by Pietro Torregiano and destroyed around December 1643, from F. Sandford, *A Genealogical History of the Kings of England and Monarchs of Great Britain* (1677)

have added to the popular association of the 'pagan' columns with superstition and idolatry, a fear that Peake and Wotton had sought to address and which the great Puritan poet John Milton would re-emphasise. Writing a decade after Jones's death, Milton decorated Satan's palace (called Pandaemonium) in *Paradise Lost* of 1667 with 'Doric pillars overlaid / With golden architrave', adding: 'nor did there want / Cornice or frieze, with bossy sculptures graven'. Milton's preference was for what he described as 'a homely and yeomanly religion', as opposed to 'the gorgeous solemnities of Paganisme'.[27]

In his role as the king's architect, Jones and his court buildings formed a prime target for Puritan hostility. At Newmarket in 1650 the Parliamentarians led by the regicide and Protestant radical Colonel John Okey demolished almost all the structures, including his Prince's Lodging.[28] The motives seem clear enough, especially given that the site was left with no new buildings until after the Restoration of 1660. Jones's Catholic chapels were particular targets for the iconoclasts. The chapel at St James's Palace was damaged, and the present fittings mostly date from 1682–4. In April 1644 Harley called for the removal of the communion rails and the levelling of the steps to the altar, and some time later the Corinthian screen to the Queen's Closet was destroyed.[29] The Somerset House chapel had been the subject of interference by the Puritans from its inception, prompting Jones's somewhat prophetic allusion to them on stage as 'a sect of modern devils' who were 'sworn enemy of poesy, music, and all ingenious arts, but a great friend to murmuring, libelling, and seeds of discord'.[30] The opulent internal decoration of the chapel, under threat of popular attack since 1640, met with even more violent Puritan hostility than at St James's when in March 1643, with the war only months old, Parliament voted to destroy its artworks in one of the most notorious acts of iconoclasm during this period.[31] The chapel was ransacked soon after not by an indiscriminate mob but by a much better informed group comprising Colonel James Clotworthy and his men. They slashed Rubens's *Crucifixion* hanging over the altar, and threw the fragments into the Thames.[32] They also cut paintings of the Virgin Mary and St Francis, and attacked with hammers sculptures of the Virgin and Child, as well as the sanctuary and altar. Books, ornaments, artworks and what the iconoclast John Vicars described as 'Babylonish trinkets' from both of Jones's Catholic chapels were carried away and burnt in a great fire that he depicted (Figs 256, 261).[33] In January 1647 the last remaining decorative fittings of the Somerset House chapel were sold and it was converted for Protestant worship. The stone and brickwork

261 Iconoclasm on the way to York, from John Vicars's *True Information of the Beginning and Cause of all our Troubles* (1648), p. 7. British Library, London

of Jones's altar was dismantled, and his reredos was taken apart along with all the timberwork; these made way for a plain Protestant preaching house.[34] The religious allegories that had decorated the chapel's ceiling were removed and the substitute panelling painted in sky blue.[35] During the summer of 1649 Parliament drew up a plan for the demolition of the chapel and friary.[36] The chapel survived for the time being, and in the early 1660s its fabric was repaired, if not fully restored to its former glory given the artistic losses, and it resumed Catholic worship when Henrietta Maria returned from France.[37] The damaged palace was presented by keen monarchists as a symbol of royal misfortune; the poet Abraham Cowley, in 'On the Queen's Repairing Somerset House', allowed the building to speak up for itself:

When God (the cause to me and men unknown)
Forsook the royal houses, and his own,
And both abandon'd to the common foe;
How near to ruine did my glories go!
Nothing remain'd t'adorn this princely place
Which covetous hands could take, or rude deface
In all my rooms and galleries I found
The richest figure torn, and all around
Dismember'd statues of great heroes lay;
Such Naseby's field seem'd on that fatal day!'

Cowley added that 'the gasping walls were cleft' and 'The Pillars sunk, the roofs above me wept'.[38]

Not surprisingly, perhaps, the Stuart art form that met with most Puritan hostility was the court masque. Lucy Hutchinson, the widow of a colonel in Crom-

well's army, observed disapprovingly of James I's court that, 'to keep the people in their deplorable security until vengeance overtook them, they were entertained with masques, stage plays and all sorts of ruder sports'.[39] The apparent 'licentiousness' of the Caroline masques had already been the subject of bitter Puritan censure in the form of Prynne's *Histriomastix: The Player's Scourge; or, Actor's Tragedy* (1633). Their lavish spectacle was regarded by Prynne as a surreptitious revival of Catholic ritual. His reference to women actors as 'notorious whores' in his index was widely construed as a direct insult to Henrietta Maria, who had caused a near scandal by speaking in *Artenice* (1626) and dancing in both *Chloridia* (1631) and *Tempe Restored* (performed in 1632, the year before Prynne's outburst). Jones and his architecture were implicated in this moral outrage in that he had designed the stage effects in all three masques, and he would later be dubbed by Puritan pamphleteers as the 'contriver of scenes for the Queen's Dancing Barn'.[40] This was in reference to his timber masquing hall that he had built at Whitehall in 1637 to supersede the Banqueting House (whose ceiling was being damaged by candle smoke), and which was destroyed by Parliamentary supporters in 1645. The masque was the realm in which Jones's architectural ideals were first declared and, whether built of paper, timber or stone, his buildings inevitably became bound up in its disapproval. Even privately sponsored architectural projects in which Jones had played a part, and in which the queen was suspected of involvement, were not free from Prynne's censure. In *Hidden Workes of Darkenes Brought to Publike Light* (1645) he alleged that Covent Garden and Lincoln's Inn Fields were secretly advanced on behalf of nouveau riche Catholics, especially those in the circle of Henrietta Maria.[41]

Not all royalist art, however, suffered at the hands of the Puritans. The Banqueting House ceiling is a spectacular survivor, maybe because it harboured anti-Catholic references and Protestant themes. Equally, from the ashes of the old order a new one was being born that would necessarily appropriate some of the symbols of the past. During the Commonwealth Cromwell was to sell much of Charles I's art collection, but spared Mantegna's *Triumphs of Caesar*, probably because it depicted the victory of another great republican general, and one with whom he was often compared (see Fig. 103).[42] Andrew Marvell in his *An Horatian Ode upon Cromwell's Return from Ireland* (1650) observed, for example, that: 'Then burning through the Air he went, / And Pallaces and Temples rent / And Caesars head at last / Did through his Laurels blast'.[43]

★ ★ ★

'FAMOUS IN REMOTE PARTS': INIGO JONES'S LEGACY

This study has attempted to look beyond Palladio to other, more local influences on Jones and his work. It has been seen that the Orders were introduced into English architectural practice via native royal art forms of masques, processions, heraldry and portraits, as much as they were through his direct experience of Italian Catholic models. His attempt to overcome the Catholic and licentious associations of classical forms involved what amounted to the invention of a nationalistic version of the *all'antica* style. This was validated through a mythic antique Britain visualised in early masques and discovered at Stonehenge. Following in the footsteps of the early treatise writers, Jones's stylistic approach was necessarily cautious, in seeking at first to limit the use of the 'composed ornaments' of modern Italy. His native classicism was based on a 'masculine and unaffected' outward appearance that Jones varied in court architecture only twice, on both occasions in the context of Catholic or High Church influences. Through a close study of the books in his library he sought, as no English architect had before, to understand the underlying philosophy of antique architecture that governed these variations. In particular, he studied the representational concept of decorum, dictating the appropriate use of the Orders, on which Vitruvius had largely been silent. This was not a mere academic study by Jones, but rather one motivated by the practical need to make his buildings and their style reflect a sense of social decorum. For his understanding of architecture was as a social and political art form sensitive to the shifting religious convictions, and views on ornamental appropriateness, not just of his royal patrons but also of the Stuart populace as a whole. Put another way it was not so much a 'temperate classicism' per se that Jones sought to establish but rather a classicism tempered by circumstance.

Later in life Jones was increasingly confronted with the conflicting requirements for decorative temperance on the one hand, advanced by the English treatises as well as the puritanical forces of Parliament and Church, and for magnificence on the other, frequently sought by his Caroline court masters and by Laud. Henrietta Maria's preference for opulence could be tolerated by most Stuarts when displayed in the private courtly realm of Jones's interiors and masques (Fig. 262). But architectural works of a more public nature, and consequentially those even more open to Puritan censure, were obviously a different matter. Jones tried to resolve this dichotomy with reference to Aristotle and the ideal of the 'mean', and his 'masculine and unaffected' exte-

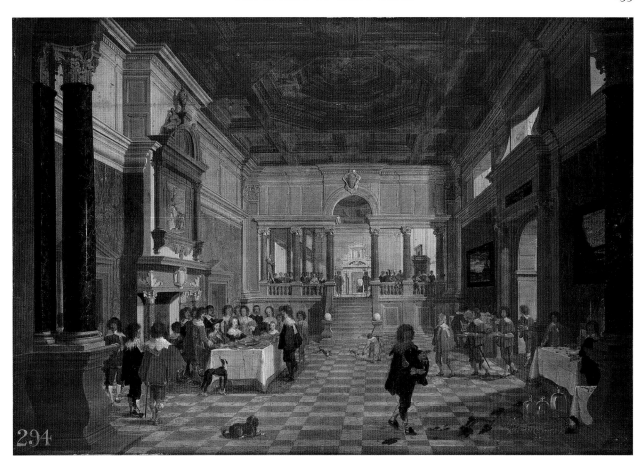

262 Gerrit Houckgeest, *Charles I and Henrietta Maria Dining in Public*, in which the setting is imaginary (1635). Royal Collection

riors and more 'capricious' interiors aimed at just such a balance. This dilemma was, of course, eventually dramatically underlined by the opposing aesthetic preferences and related moral positions held by the two sides in the English Civil War. If Jones thought he could persuade his audience of the possibility of resolving this conflict through either architecture or masques, then the execution of Charles I in front of his Banqueting House in 1649 brought that dream to a dramatic end (see Fig. 259).

Jones died on 21 June 1652 at Somerset House, most likely a few days before his seventy-ninth birthday. He was buried alongside his parents in St Benet's church at Paul's Wharf, where a white marble monument was erected by John Webb bearing reliefs of his two most decorative works, the fronts of the Banqueting House and St Paul's Cathedral (Fig. 263).[44] Webb was Jones's first biographer, motivated in part by a desire to advance his own claims on the Surveyorship. He boasted that Jones was 'not only the Vitruvius of England, but likewise, in his Age, of all Christendom; and it was vox Europae that named him so, being much

more than at Home, famous in remote Parts'.[45] Despite this apparent influence, it was commonly held until relatively recently that Jones's style died with him, only to be resurrected in the first half of the eighteenth century by the Palladians Burlington and Kent. Giles Worsley demonstrated that far from a dormant approach, Jones's predominant preference for simple *all'antica* forms and ornament externally continued to find favour during and after the Commonwealth. This was not just in England through the work of Sir Roger Pratt (in designs such as Kingston Lacy in Dorset of 1663) and Peter Mills (at Thorpe Hall in Northamptonshire of 1654–6), but also in the Dutch Republic through the work of Pieter Post (at the town house at Rapenburg 8 in Leiden of 1668; Fig. 264). When seen in this European context, Jones's work can no longer be viewed as the narrow product of an isolated and somewhat unfashionable genius.[46]

Consistent with the influence of religious preferences on the use of ornament traced in this book, the Commonwealth and the time of maximum Puritan authority under Cromwell coincided with a period when

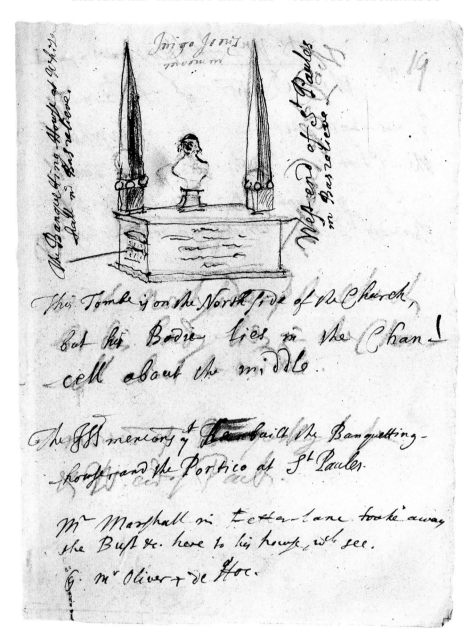

263 John Aubrey, Inigo Jones's monument in St Benet's church, Paul's wharf, London, destroyed in 1666. Bodleian Library, Oxford, Aubrey MS 8, fol. 19r

decorative austerity or so-called Puritan classicism for the most part prevailed.[47] The astylar south façade of Wilton House in Wiltshire, reconstructed by Webb in the years 1648–51 with possible assistance from an elderly Jones for the Parliamentary peer Philip Herbert, Lord Pembroke, fitted the new era perfectly (the Ionic embellishment was limited to the central window; Fig. 265).[48] This is also true of Coleshill House, Oxfordshire, whose attribution to Jones has been much disputed over the years (Fig. 266).[49] Webb followed in his master's footsteps most notably at Greenwich, but his

claims on the Surveyorship were destined to be overlooked: during the Interregnum Edward Carter, who was Jones's 'Substitute' on site at St Paul's and a Presbyterian, became in effect the director of a Parliamentary Office of Works.

The morality of ornament and the propriety of capricious experiments with antique forms are enduring themes in architectural history and they were destined to be played out in the early eighteenth century when Jones again became a pivotal figure. Lord Burlington and Colen Campbell attempted to establish

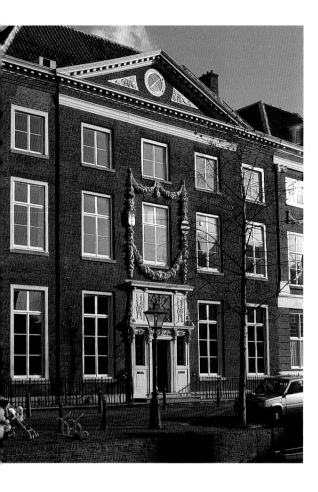

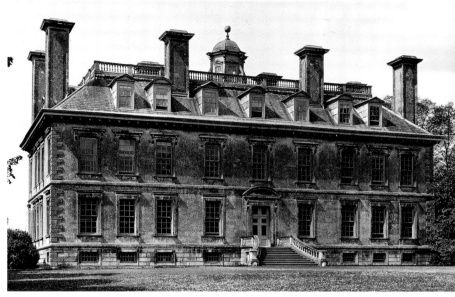

266 Coleshill House, Oxfordshire, *c*.1649–*c*.1662 (destroyed)

264 (*left*) Pieter Post, Rapenburg 8, Leiden, Netherlands, 1668

265 (*below*) Inigo Jones, Isaac de Caus and John Webb, south façade of Wilton House, Wiltshire, 1636–40, 1648–51

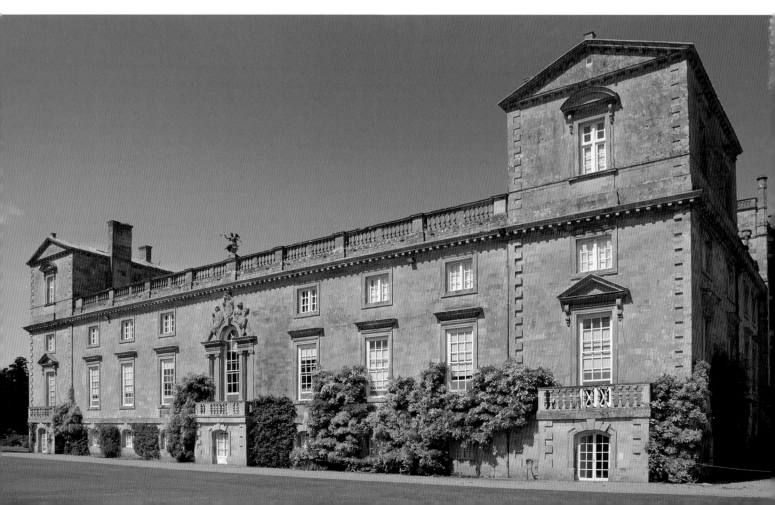

267 Inigo Jones, the Beaufort House gate, 1621, now at Chiswick House, London

a norm in architectural tastes based on the 'true' *all'antica* style, devoid of the Baroque ornamental excesses of the likes of Hawksmoor and Wren; in this campaign Palladio became the prophet, and Jones his disciple. The relocation of Jones's Doric gateway at Beaufort House to Burlington's Chiswick House in 1738 was a tangible expression of the central status of Jones's work in this movement (Fig. 267). Burlington also acquired many of Jones's drawings, now held by the Royal Institute of British Architects in London, although many more were lost. On Jones's death in 1652 these had been inherited by Webb, who subsequently bequeathed them to his son, William, under the provision that none be sold. A large number evidently were, however, and they are next heard of through John Aubrey, writing a series of biographical notes between 1669 and 1696, who reported: 'Mr. Oliver, the city surveyor, hath all his papers and designes, not only of St Paul's Cathedral etc. and the Banquetting-house, but his designe of all Whitehall, suite-able to the Banquetting house.'[50] Some of Jones's drawings formed the basis for the Flitcroft engravings in William Kent's *The Designs of Inigo Jones, Consisting of Plans and Elevations for Publick and Private Buildings* published in 1727, and Isaac Ware's *Designs of Inigo Jones and others* of around 1733 (see Fig. 252). Jones's canon-

isation was made complete in Campbell's *Vitruvius Britannicus; or, The British Architect* (1715–25), in which he became the eponymous hero. His work was interpreted as pointing the way towards a morally wholesome national style (Figs 268–9). Taking his lead from Palladio and echoing Jones's own strictures of 1615, Campbell here condemned the 'affected and licentious' work of Bernini and Carlo Fontana, and the 'widely Extravagant' designs of Borromini, 'who has endeavour'd to debauch Mankind with his odd and chimerical Beauties'. Campbell added that 'the *Italians* can no more now relish the Antique Simplicity, but are entirely employed in capricious Ornaments, which must at last end in the *Gothick*'.[51]

Jones thus became to English Palladianism what Michelangelo had been to the Italian Baroque. But Jones is a somewhat unique figure within architectural history in being cultivated so wholeheartedly half a decade after his death; the career of Philibert de l'Orme, in many ways a parallel to that of Jones, was not the focus of a similar revival in France. There was no eighteenth-century 'Vitruvius Gallicus'. The appropriation of Jones by the Palladians and the subsequent popularity of that movement impaired the ability to understand the complexity of his work in later cen-

Extends 115

aScale of 60 Feet.

The Elevation of the QUEENS House *to the* Park *at* GREENWICH *Invented by* Inigo Iones *1639.*
*is most humbly Inscribed to the Hon.*bⁱᵉ GEORGE CLARKE Esqʳ *One of the* Lords *of the* Admiralty. &c.

Elevation D'une Maison *appartenante a* La REINE. *Du Costé Du Parc a* GREENWICH *tres humblement Dedié a Monsieur* Mʳ. CLERC. &c.

268 Colen Campbell, the south front of the Queen's House, Greenwich, with the addition of statues to enhance the building's 'Palladian' character, from Campbell's *Vitruvius Britannicus*, vol. 1 (1715)

turies. Jones's achievement was seen as the assimilation of Italian tastes into England, through his being a disciple of a foreign style originating with Palladio, and in this process national themes and influences on him tended to get overlooked. Yet the task of assimilation was much more complex than this, in subtly establishing the full potential of classical architecture in its many guises. Without Jones there would have been no Wren, no Hawksmoor or Vanbrugh, no sophisticated English classical tradition which has left such enduring cities as Bath and Edinburgh. As with the Italian master Leon Battista Alberti, Jones introduced new ways of perceiving pictorial as well as civic space. His experiments with the use of linear perspective in his masque scenes bore fruit, to mention just one well-known example, in the layout of Covent Garden. Perhaps of even greater significance, he also followed in Alberti's footsteps in introducing to his native land nothing less than a new language of architecture whose grammar was the Orders. In Jones's case the columns spoke the language of Stuart monarchy. His 'stately pillars' played a leading role in constructing its vision of national identity and sense of Great Britain that lives with us still. The column came to take its place alongside the lion and the unicorn in offering vital support to the crown.

269 William Kent, preliminary design for a statue of Inigo Jones commissioned by Richard Boyle, 3rd Earl of Burlington, for the entrance to Chiswick House, Middlesex. It was executed by J. M. Rysbrack about 1727. Victoria and Albert Museum, London

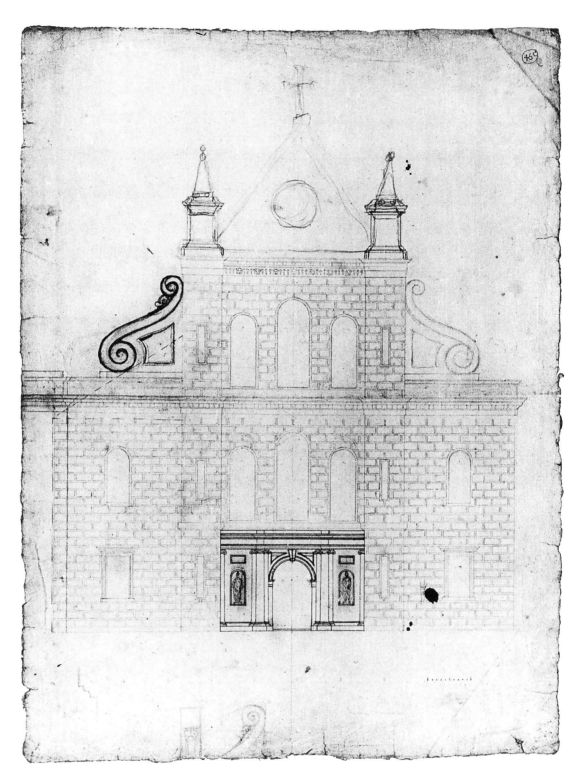

270 Inigo Jones, north transept elevation design for St Paul's Cathedral, undated but post-1633. The sectional outline of the east aisle (dotted) shows how Jones's new face closely masked the old cathedral section. Worcester College, Oxford

PONDEROUS MASSES BEHELD

HANGING IN THE AIR:

JONES'S BUILDING ACCOUNTS AND

THE CATHEDRAL YARD

In light of the confused and incomplete drawn record of the work at St Paul's Cathedral, the most coherent documentation of the extent, cost and progress of the refacing is Webb's monthly building accounts.[1] Through these surviving records, a picture can be built up of Jones's craft organisation, as well as the demolition and construction techniques he used at St Paul's.[2] This throws light on building practices in London in the early seventeenth century.[3] The accounts record the amount spent on building materials and labour per month, and the total for that year; they show that between October 1639 and September 1640, for example, £1,172 10s. 9½d. was spent on the west front alone (Fulham Papers 43). At the end of each year Webb was paid an additional sum for presenting these accounts to the cathedral commissioners, a fact that may explain the detailed nature of the entries. A yearly account of the work was to be rendered at the council chamber at Whitehall on All Souls' Day (2 November) at two o'clock in the afternoon.[4] In addition, other accounts were kept of a purely financial nature, maintained not by Webb but by the chamberlain of London.[5]

Whilst Jones was certainly much involved with the actual construction, as the State Papers and these building accounts record, Webb was Jones's 'Clerk engrosser' from beginning to end and therefore to a large extent controlled the site operation at the cathedral.[6] It was probably in this role that Webb received his training, developing building techniques subsequently used elsewhere.[7] The monthly accounts record Webb's payment for 'double engrossing this book viz one for the paymaster, and one to remain in the office'. In December 1639 Webb's payment entry in the accounts expands on this role, including his annual salary:

To John Webb for his paynes and attendance in assisting to Draft up all the monthly Accompts for the worke, and for draweing faire ingrossing and enteringe into a Ledger Booke the Bargaines made from tyme to tyme with the severall workemen, Quarrymen and undertakers, and for Coppying severall Designes and Mouldings and makinge the tracings of them according to Mr Surveyor's directions for the workemen to followe for all the tyme, being with the worke began at first seaven yeares, viz for the three first yeares after the worke at £13,13s, 4d Ann and for the fower last yeares after the worke at £20 per annum [Works Accounts (henceforth WA) 13].

The building accounts were signed jointly every month by Jones, the paymaster Michael Grigg and an assistant mason, Edward Carter. Throughout the work Carter was paid for being 'Substitute to Inigo Jones Esquire Surveyor of the worke for his Attendance'. In an undated document Webb defines his work at St Paul's against that carried out by Carter:

> Mr Webbe copied all ye designes from ye Surveyors Inven tion, made all ye traceryes in great for ye worke, & all ye mouldings by ye Surveyors direction so yt what the Surveyor invented & Mr Webbe made, ye substitute [Carter] saw putt in worke & nothing else.[8]

This shows the complexity of the chain of command on the large building site, and the apparent infighting between Webb and Carter for design control. Such a strict definition of duties is perhaps also a sign of a reorganisation of site practices resulting from the emergence of the role of the architect as an intermediary between patron and workman.[9] Webb

continues by stipulating that as clerk engrosser he was to 'call the workmen and labourers fower times every daie . . . and to check them in their wages if they be absent or idle'. The document also records Webb's delegation of matters of finance and site security to a 'Clarke of the Store and measurer of materialls' and a 'Purveior'. The former was to 'receive and take chardge of all the materialls, and to deliver them as they are to bee used, of which he must keepe a booke of their trew measure'. He was 'also to take the names of such to whome he delivereth, Ropes, Pulles or any other tooles whatsoever, and if they be not redelivered, they are to be paied for out of their wages who received them'. On the other hand it was the job of the 'Purveior' to order the materials under Jones's direction, and when not engaged in this 'he is to be at the worke to solicett the workmen and labourers to follow their business'.[10]

The cathedral accounts testify to the industry, ambition, scale and particular requirements of Jones's refacing. They are in the tradition of the medieval works' accounts for the building of the royal palaces, the work on which was comparable in scale. The accounts for St Paul's provide a comprehensive record of much of the actual site activity – including the crafts employed, names of individuals, quantities of materials, cost and progress of the work.[11] Listed in order of craft rank, entries for masons, carpenters and labourers give detailed descriptions of their progress, although work by other trades is also listed such as that by masons' apprentices, timber and stone cutters ('sawyers'), smiths, bricklayers, glaziers, painters, plumbers and paving setters. In this way the organisation of the accounts reflected that of the work itself, divided as this work was into trades headed by the masons. According to Dugdale, from the start there was 'a great part of the Church-yard paled in, for Masons to work in; . . . an order was signed . . . to Inigo Jones Esquire . . . to cause the Inclosures and Scaffoldings to be set in hand'.[12] The accounts for April 1633 commence with the payment of carpenters 'for making of a Lodge for the Masons', a structure 92 feet by 10 feet intended as a night store for tools (WA 1). During the night, watchmen were employed to guard the materials and the work (WA 7, May 1637 onwards). Materials listed in the accounts include stone, timber, iron, rope, lime, sand, nails, paint ('colors'), oil, brass, lead, elm and oak board. Against these materials, quantities are frequently legible; in November 1639 payment was made for the carriage of '234 tonnes' of Portland stone from Paul's wharf to the cathedral (WA 13). Details include payment to a joiner at the start of the work for making office furniture for 'Mr Surveyor' (WA 1), and Webb's reimbursement in June 1635 for the purchase of a book (WA 4).

Only the nave was actually re-cased, whilst the fourteenth-century choir was merely repaired (see Figs 245–6). In the choir walls, damaged stonework was replaced, flying buttresses were repaired, and new foliage for the windows was carved by the London mason Edmund Kinsman, who had been actively employed in the service of the crown since 1614.[13] The medieval glass was boarded up and taken down to be repaired (WA 5, January 1636). From August 1634 (WA 2) to June 1635 (WA 4) the 'great East window' was repaired, and in October choir scaffolding was dismantled and re-erected in the north and south yards (WA 5). To the transepts Jones carried the nave encasing around the west walls and north and south façades, but the east transept walls were, like the choir, merely repaired. As Jones's drawing indicates, the whole central part of the north transept façade was taken down and rebuilt (WA 13, February 1640), as was the gable end to the west front, demolished in July 1639 after covers had been built to protect the work in progress (WA 12; Fig. 270).

The inside of the cathedral received attention from Jones's craftsmen, as payment to carpenters for internal scaffolding indicates (WA 7, June 1637), although the interior was repaired, not resurfaced. A certain amount of external work was carried on from inside the cathedral, particularly around the windows, since these formed a unique junction between internal and external surfaces (WA 15, August 1641). Work on the site was dangerous, and the accounts reveal a policy towards the care of injured workmen. From July to October 1635 monthly payments were made to one such casualty, and in November a surgeon was paid for his attendance (WA 4). In November 1637 an allowance was made to a widow whose husband was killed by a fall of scaffolding (WA 9). In July 1639 carpenters roofed over the great west door to protect the work and workmen from 'the fall of the old stone and rubbish from the topp' (WA 11), whilst in November 1640 a workman was paid an allowance after a section of wall fell on him (WA 15). Workmen received payment for the number of days worked on specific jobs – for example, in July 1640 the accounts make reference to painters employed 'by the day' (WA 13). For the purposes of measuring, work was divided up vertically by the form of the building, with an important boundary being referred to as the upper and lower 'battlements' (WA 7, August 1637; WA 13, May 1640). Webb appears to have been responsible for some of the site measurement; in April 1640, for example, he was specifically paid for 'helping to take the measurements of the Mason's Casse Worke' (WA 13). In this task Webb combined the modern roles of architect and quantity surveyor.

The complexity of seventeenth-century site operations in the coordination of craft skills can be understood from these accounts. In October 1635 carpenters were employed in 'making provision for the masons to take up their work on the north side', which included erecting enclosures and putting up scaffolding; then in November of that year masons were paid for 'making of Anchor holes' (WA 5). These anchors were the means by which the new stone was to be tied back to the old surface, and, along with 'cramps', were made by the smiths (WA 13, November 1639). In January 1640 reference is made to masons 'puting in of Irons to holes' (WA 13). Masons underpinned the wall plates and cut holes in the stone for the carpenters' roof trusses, and subsequently plumbers worked on roof leadwork (WA 5, July 1636). Labourers assisted throughout in digging foundations, making mortar, carrying stone and timber into the yards from Tower wharf (or Paul's wharf for the west front stone, WA 10), dis-

mantling scaffolding and carting away rubbish. New timber was stored in a separate 'Timber Yard' (WA 5, September 1636), whilst old timber from the roof was reused as boarding (WA 11, November 1638).

Webb's accounts provide a unique, detailed record of the progress on the portico and can thus be read as a form of diary describing this work. The foundations were begun in July 1635 (WA 3). Then in November of that year labourers were paid 'for bringing upp the Stonework of the foundation of the Portico'; in June 1636 masons levelled these foundations and carpenters planted stakes in the ground to fix guide ropes for setting the bases; in the following month masons brought up the foundations adjoining the old wall for the pilaster bases to stand on (WA 6). In June 1637 carpenters erected scaffolding for the first, second and third stones to each column and railed in the base mouldings to 'save from breaking'; in August scaffolding for the fourth and fifth stones was erected (WA 8), and by March 1638 carpenters had erected scaffolding for the 'last six stones' (WA 10) – making eleven monumental stones to each column shaft, built up, it would appear, simultaneously (probably to keep each course level). Then in September labourers brought stone from Paul's wharf for 'the great Capitalls' and from then on a large number of masons worked on these throughout the next year (WA 12): in December 1638 the seven masons working on these capitals were given a roof to keep the work dry (WA 11, 12). A fragment of one of these columns, with a diameter of 4 feet, has been recently discovered due to the fact that it was reused as rubble in Wren's cathedral, and from this the actual height of the column (including the entablature) can be estimated as 45 feet 6 inches.[14] In May the 'great Marble door' was set, and in August 1639 scaffolding was extended 'for the taking up and setting of the great Capitols' (WA 11). Work then proceeded on the architrave, frieze and cornice, models of which were started in September 1639 (WA 11) and completed the following month, with lettering (in black on gold) tried out by Thomas de Critz (Fulham Papers 43): this model of the entablature was evidently put *in situ*, for in December 1639 carpenters were paid to take it down (WA 13). Finding a piece of stone large enough for the architrave over the central intercolumniation represented a problem, for Webb later recollected that 'search was made in the Royal Quarries of *Portland*, for to find out an Architrave for the middle Intercolum of the *Portico* at the Cathedral of *St. Paul*, which is in Length not fully twelve Foot'.[15] In April 1640 carpenters took down the west front coverings erected for the protection of the marble work, and they were then employed in constructing centrings for the 'great round windowes' over the aisle doors (WA 13). In May 1641 a model was made of 'foliage in the frieze' and for part of the great

271 John Webb, drawing for a pulley for St Paul's Cathedral dated 1637. Sheffield Central Library

272 (*right*) Inigo Jones, diagram of a pulley for lifting masonry, undated and unidentified, inscribed: 'the greate wheeles have 36 coges / the lesser have 6 only'. Devonshire Collection, Chatsworth

west door, and in September a painter was paid for drawing 'letters in great for the front of the west end' (WA 14).[16]

The accounts indicate the importance of cranes in the mechanics of refacing St Paul's and in the construction of the portico in particular.[17] As part of Webb's site work, a surviving drawing in his hand dated 1637 shows a design for a pulley at St Paul's; a further drawing in Jones's hand shows a similar device for an unidentified project (Figs 271–2).[18] In a passage in *STONE-HENG . . . RESTORED* published in 1655, Jones (or possibly Webb writing for him)[19] proudly compared the columns at St Paul's with the monoliths at Stonehenge, with reference to John Dee's mechanics:

> They Wonder also . . . by what Means they (that is, such huge stones) were set up. What may be effected by that Mechanicall Art, which Dee in his Mathematicall Preface to Euclyde, calls Menadry, or Art of ordering Engines for raising weights . . . Had I not been thought worthy (by him who then commanded) to have been sole Architect thereof, I would have made some mention of the great stones used in the work, and Portico at the West end of S. Pauls Church London, but I forebear; though in greatnesse they were equall to most in this Antiquity, and raised to a far greater height than any there.[20]

In Webb's later defence of Jones's book on Stonehenge, published as *A VINDICATION OF Stone-Heng Restored* in 1665, further insight is provided into this use of cranes at St Paul's:

> Furthermore, why might [Stonehenge] . . . not be raised by a Pair of Shears composed of two Masts, focketted or mortaised into a Plank? which resting upon the Ground, was

removed at Pleasure; having Guide-Tackles, Blocks and Shivers proportionable, and Capitals also, firmed in proper and convenient Places: since that in the same manner we have beheld hanging in the Air above thirty, forty, yea, seventy Foot high, those ponderous Masses in the Work at St Paul's, and with a delightful Facility veered by ten or twelve Men only, to the just Places where they were ordered to be set . . . All which, nevertheless, I leave to be farther enquired into by those that are better skilled in the Art of Menadry than I pretend.[21]

Dee's Archimedean art of 'Menadry' had been described in his preface to the English Euclid of 1570.[22] Webb's stones 'beheld hanging in the Air' certainly hint at mechanical magic at St Paul's, in mirroring Jones's mechanical contrivance within court masques.

Jones framed the portico with symmetrical towers, the only elements to remain from his earlier west front design (see Figs 244, 247). With no surviving drawing of the medieval west front, there is no visual record of the old towers that these new structures re-cased or replaced (existing towers are first cited in WA 13, April 1640). It is therefore impossible to say if these old towers were identical, as seems likely, or how far Jones's new towers were based on them.[23] In August 1640 stone was transported for Jones's towers (WA 13), whilst in November payment was made for 'taking downe the upper part of the Two Towers', which implies re-casing (WA 14). These towers contained staircases (WA 13, September 1640), which may have provided access to the lower nave aisle roofs. During September 1641, at the same time as the portico's cornice was being set, a mason, Gabriel Stacey, was working on Jones's towers (WA 14).

273 Marten van Overbeek, *St Paul's from the South-West*, c.1640–53, showing the central tower scaffolded; this was removed in 1653. The Museum of London

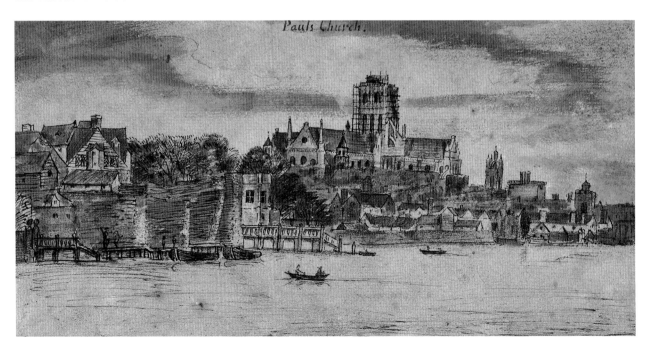

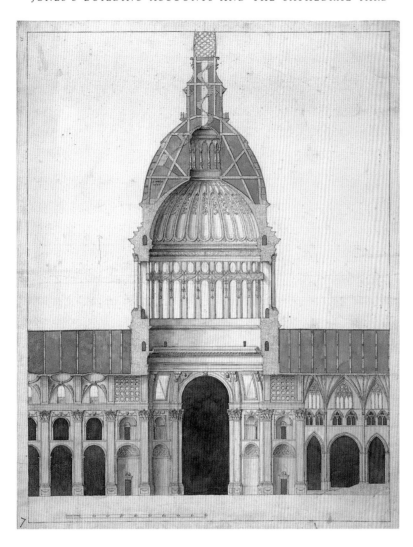

274 Christopher Wren, east–west section showing the Gothic choir of St Paul's Cathedral, repaired but not encased by Jones, May–August 1666. All Souls II.7, Oxford

The accounts record the carving of iconography such as cherubim (WA 9) and lion's heads (WA 5, February 1636; one of these has survived and is in the collection of the dean and chapter of St Paul's). Hollar shows the head of a winged cherub on each keystone of the nave windows, and Sir Roger Pratt reports that lion's heads formed a frieze (which Flitcroft illustrates; see Figs 1, 252, 254).[24] Timber models were also made of these unfamiliar, *all'antica* elements.[25] In Jones's recasing of the nave he removed the crenellations, or 'battlements' as the accounts termed them, and topped the quasi-Tuscan order with what Pratt describes as 'vast pineapples'.[26] Models were also made of these, in November 1639, and in the following month the accounts record payment for the carving of five 'pyne Apples' (WA 13); as with the cherubim, Enoch Wyatt made models of these pine-cones, altering them until 'approved of by the Surveyor'. This illustrates how models were adapted by Jones on site to perfect his designs, and indicates his close control over the ornamental details.

As a final stage in the restoration work, the idea of building a new cathedral spire had not been abandoned, although this project was of a lower priority than the resurfacing or the new portico (the shift in priority from spire to portico reflected the shift in court style). This structure would probably have necessitated the rebuilding of the central tower, and perhaps for this purpose in 1641 the tower was scaffolded both inside and out (this is pictured in a sepia drawing by Marten van Overbeek; Fig. 273). By the time of the cessation of work in September 1642, judging from the last accounts and Hollar's engravings, apart from this new tower and spire nearly all the intended external work would seem to have been completed.[27] It was noted in the Conclusion that during the Civil War the Puritan authorities disfigured the portico and tore down the royal statues.[28] And in the spirit of Hollar's engravings of 1658, the last drawings to record Jones's work were prepared in the cause of its repair. Wren's drawings for the commission considering the repair of the old cathedral in 1666 include parts of its plan and Jones's external work to the west face of the transepts, whilst a section provides a rare glimpse of the Gothic choir internally (Fig. 274; see Fig. 106).[29] In these drawings, however, it is impossible to distinguish with any precision Wren's work from that by Jones. One of Wren's later so-called Warrant

Design drawings would seem to incorporate Jones's portico, although it cannot be trusted since, like the rest of the old cathedral, it is much altered (new statues and columns are added, for example). A letter dated 25 April 1668 from the Reverend Dr William Sancroft to Wren, whilst complaining about Jones's work, indicates the kind of technical difficulties that had faced the Royal Surveyor:

> This Breach has discover'd . . . two great Defects in Inigo Jones's Work; one, that his new Case of Stone in the upper Walls, (massy as it is) was not set upon the upright of the Pillars, but upon the Core of the Groins of the vaulting: the other, that there were no Key-stones at all to tie it to the old Work; and all this being very heavy with the Roman Ornaments on the Top of it, and being already so far gone outward, cannot possibly stand long.[30]

According to the drawings by Hollar and Wren, Jones placed obelisks on the north, south and west nave façades, and these elements or the pine-cones lower down may be Sancroft's 'Roman Ornaments'.[31]

Jones's resurfacing of the Gothic cathedral was perhaps the most important of his commissions, and was celebrated as a central expression of Stuart policy in court masques and sermons. It is only by studying the building accounts alongside the surviving drawings that the scale of this achievement can be fully grasped. The organisation of crafts at St Paul's, although the largest undertaken by Jones, was in many respects traditional: but aspects such as the modelling of unfamiliar *all'antica* details and the use of cranes, which are seen by Webb in terms of Dee's enlightened techniques, were more novel. These accounts spell out the particular problems of relating a new surface of antique ornament to an existing Gothic structure, distinct from the more straightforward procedure of constructing from scratch such free-standing buildings as the Queen's House and the Banqueting House. For nine years Jones and Webb coordinated workmen, ordered materials and overcame unprecedented technical problems on the huge site at St Paul's to create what Dugdale lamented had stood all too briefly as 'one of the principall ornaments of the Realm'.[32]

SALMACIDA SPOLIA:
A COMPUTER MODEL
OF JONES'S PERSPECTIVE STAGE

Jones's masque scenery was either fixed or rotated, and on occasion slid in grooves. The grooved type of scene, called 'Scena ductilis', was composed of up to nine groups of five 'flats' or forward-facing shutters; this sliding arrangement was used in the penultimate Stuart masque entitled *Salmacida Spolia* (performed in January and February 1640 in the new timber masquing house erected at Whitehall in 1637).[1] It was pointed out in the Introduction that Jones's masque stage was based on the temporary theatre designs of Sebastiano Serlio illustrated in the second book of his treatise, published in Paris in 1545 (Figs 275–80). As with Serlio's woodcuts, Webb's plan and section of the stage (which are drawn at a scale of 4 feet to the inch), together with his drawings of the four scenes of this masque, provide a complete record from which a computer model of the stage can be constructed (Figs 281–2).[2] John Orrell has studied the dimensional interrelationships of these drawings, which are amongst the most complete working drawings for a masque to have survived, but no one has built a model to assess how well the perspective scenery actually worked from the point of view of the audience.[3] Here the optimum viewing characteristics of the later Stuart masquing hall can be assessed. Stage painters evidently transferred scenes onto the 'flats' directly from the drawings by Webb and Jones, without making models, using instead the grid that is clearly marked on many of the drawings. For this computer model, the scene was scanned and applied as a template to the modelled shutters, with each template scaled individually to fit the shutter since Webb's drawing is not a true elevation but rather a view drawn in perspective. This stage was then inserted into a representation of the walls of the timber masquing hall.

The computer model shows that, in the absence of side shutters (which were only used on 'fixed' stages), Jones's scenery worked far less well than did Serlio's fixed scenery from the point of view of courtiers positioned at the front edges of the hall (Fig. 283).[4] For the model demonstrates that when viewed from a large area to the front of the hall, the shutter arrangement failed in its task to provide a continuous scene. If lines are extended from the midpoint of the second set of shutters (counting from the front) through the inside edge of the front shutters, they intersect 21 feet from the stage edge (Fig. 284). A courtier who viewed the stage from a position within the triangular area enclosed by these lines would either have seen the gap between the first and second layers of scenery (if positioned very close to the stage) or have seen the inside edge of the retracted scenery on the second set of shutters (it was obviously the purpose of the proscenium arch partially to mask the front shutters in their retracted position). The problem would have been even more acute in the case of the first scene, a group of trees, since they offered less concealment at their trunks whilst, as the computer model shows, they would have overhung the later scenes despite having been retracted.

Perhaps for this reason, seating was not common in this front area; a 'u'-shaped area of raked seating built against the walls of the hall was favoured instead. Some of the front hall area may have been reserved for dancing. A courtier, however, would also have seen part of the offstage (that is, retracted) scene, on the side opposite to where they were seated, from anywhere outside the triangular area enclosed by extending these lines beyond their intersection point. The closer the audience member was to the central axis, then the better (that is, less disjointed) their view: this optimisation matched court hierarchy, since the king was always seated in the best optical position in line with the vanishing point (or points) when not on stage himself, whilst most of the spectators sat sideways on to the stage (which exacerbated the problem of seeing between the shutters).[5] With five grooves recorded on

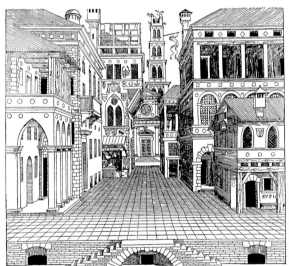

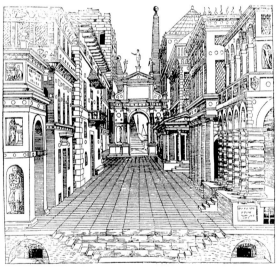

275a and b (*top left and right*) Sebastiano Serlio, theatre plan and section, from Book Two, *D'Architettura* (1545), fols 43*v*, 45*r*

276 (*above left*) Comic scene, from Serlio's Book Two (1545), fol. 46*r*

277 (*above right*) Tragic scene, from Serlio's Book Two (1545), fol. 46*v*

278 (*left*) Satiric scene, from Serlio's Book Two (1545), fol. 47*v*

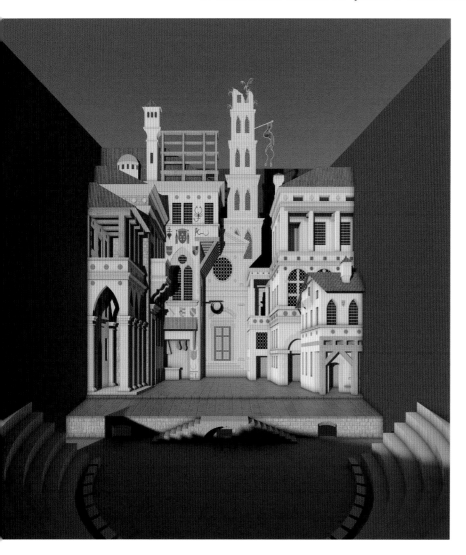

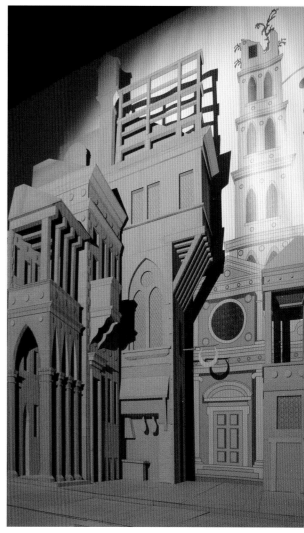

279 Computer reconstruction of Serlio's Comic Scene, Book Two (1545)

280 A model of Serlio's Comic Scene, Book Two (1545)

Webb's plan and only four scenes, the first shutter may well have been a 'blank' to shield the opening shutter in its retracted position, thus lessening the problem.

Further analysis can be made using Webb's (apparently badly constructed) perspective of the last scene, a city and bridge, if it is assumed that the drawing was intended to be used and not just to illustrate stage effect (see Fig. 282). The difference between the angle of the stage floor in the section and that of the ground dictated by the (high) vanishing point in Webb's scene drawing, if taken literally, makes for a mis-alignment between the stage floor and the scenic building's plinths (see Figs 281, 283). The receding walls of the stage buildings on the (forward-facing) shutters inevitably 'rear up' from the stage floor (as modelled following the section) and as such appear to float. This fact was visible only from the rear of the hall, however, since anyone viewing from the front (which, as has been noted, was for the most part left free)

would not have seen this discrepancy because the base of the buildings fell below the lowest sight line allowed by the height of the stage. The computer model indicates that the stage height might have been set at the (high) level of 7 feet for this very purpose. The model also shows that to see the bases of the shutters, a standing viewer (with an eye level of 5 ft 6 in.) would in fact have to be positioned at least 51 feet away from the front of the stage. If seated with their feet on the floor, the viewer would have to be 110 feet from the front of the stage, beyond the back wall of the masquing hall (which, like its predecessor, the Banqueting House, was 110 feet long). From the model one can conclude that the base of the shutters would have presented a visual problem only for a spectator either standing or seated at an elevated position in the back third of the hall, from where it might well have been difficult to distinguish the discrepancy of planes.

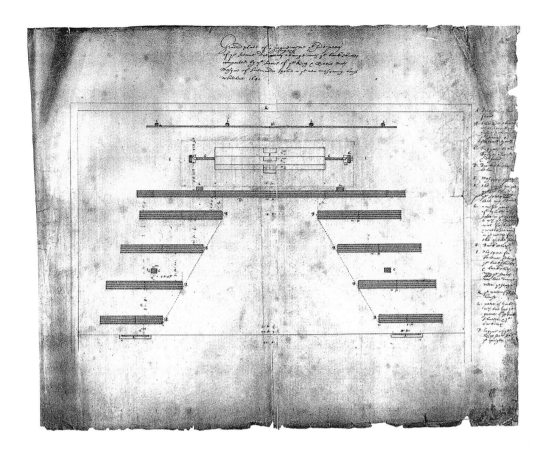

281a and b John Webb, plan and section of the stage for the masque *Salmacida Spolia* of 1640. British Library, London

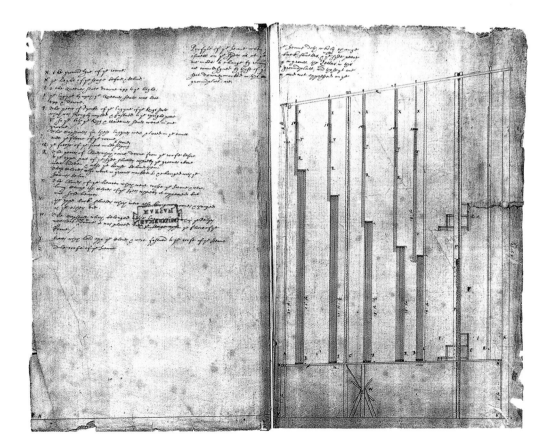

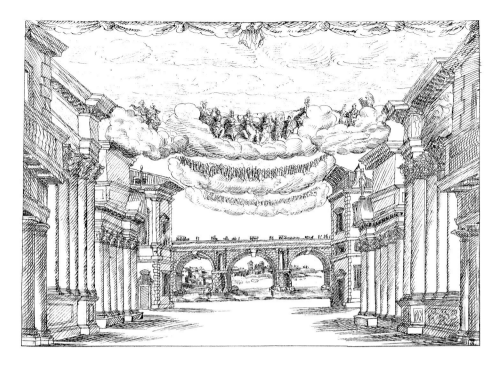

282 John Webb, drawing of 'The suburbs of a great city', scene four from *Salmacida Spolia* of 1640. Devonshire Collection, Chatsworth

283 Computer reconstruction of the masque stage of scene four from *Salmacida Spolia* of 1640 (see Fig. 282), viewed from standing height. This illustrates the visibility of the withdrawn shutters (of trees), through gaps between the shutters, the 'wedge' of ground at the base of the shutters and the relative height of characters at the front and back of the stage

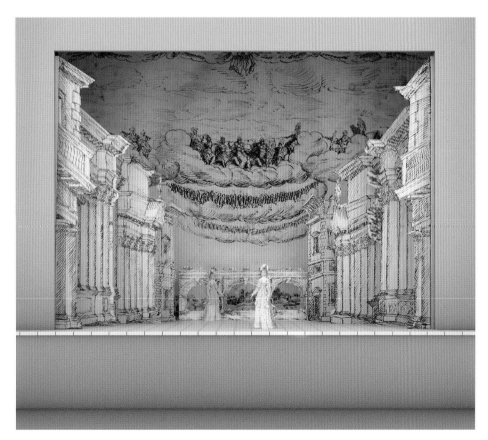

284 Plan and section from the computer model showing the optimum viewing area (within the back triangle) and sight lines for spectators

The detail in the scenes creates a markedly scale-less effect when viewed in the model. The foreground consists either of trees or columns, which are without scale, whilst in the later scene the only humanly scaled elements are the windows and doors on the furthest shutters. When a masquer of average height is placed within the virtual scene in line with the furthest shutter, they appear like a giant, destroying the illusion of the bridge in the distance. A masquer standing in line with the nearest shutter appears at approximately the correct scale for the scene (see Fig. 283). Those masquers who were cast as gods (amongst whom were members of the court) descended from the heavens using machinery situated between the second and third group of shutters, and thus they too would have appeared, appropriately enough, larger than life-sized. The king and queen descended behind the final shutters, and would have appeared huge in comparison with their surroundings, although in scale with their majesty.

Finally, it should be noted that following a practice that Jones had developed, Webb used two main vanishing points for this fourth scene.[6] A number of the upper cornices are drawn to a higher vanishing point than that used for the plinths. This may have been to avoid an uncomfortably steep foreshortening in the upper cornices whilst reducing their height towards the front of the stage. After all, it should not be forgotten that Jones's stage was intended as an illusion, like Serlio's before him, and was viewed as a spectacle of light and motion rather than one of optical correctness.

NOTES

The dates cited are corrected to follow the 'new style'. Before 1752 the convention of the 'historical year' was used, in which the year was deemed to begin on 25 March.

Unless otherwise indicated, quotes from the Stuart masques are taken from Steven Orgel and Roy Strong's two-volume *Inigo Jones: The Theatre of the Stuart Court*, published in London in 1973.

PREFACE

1 W. Dugdale, *The History of St Paul's Cathedral in London* (1716 edn), p. 115; see also p. 148. This material was added in the second edition, no doubt part of the material 'corrected and enlarged by the author's own hand' (as the title reports).

2 H. Wotton, *The Elements of Architecture* (1624), p. 51.

3 Jones was referred to as the 'English *Vitruvius*' in W. Charleton, *CHOREA-GIGANTUM* (1663), p. 7; see also Webb in I. Jones, *The MOST NOTABLE ANTIQUITY OF GREAT BRITAIN, Vulgarly called STONE-HENG, ON SALISBURY PLAIN, RESTORED* (1655), 'preface', p. [viii]. This title was emphasised by Jones's eponymous role in Colen Campbell's *Vitruvius Britannicus; or, The British Architect* of 1715.

4 'Roman Sketchbook', Devonshire Collection, Chatsworth, fol. 76r. See E. Chaney (ed.), *Inigo Jones's 'Roman Sketchbook'* (2006) [transcribed in vol. 2, pp. 167–8].

5 Giulio Romano's column rustication (as used at the Palazzo Tè) is referred to by Jones in his Palladio annotations, Book II, p. 12 (concerning the Palazzo Thiene; see Fig. 8): 'Coll[umn] Caprittio di Julio Romano', pp. 13, 14, 22. He would have witnessed this whilst in Mantua in 1614, making notes on the Palazzo Tè in his copy of Vasari's *Lives*.

6 See S. Thurley, *Somerset House: The Palace of England's Queens, 1551–1692* (2009), p. 45.

7 See J. Peacock, *The Stage Designs of Inigo Jones: The European Context* (1995).

8 See D. Howarth, 'The Politics of Inigo Jones', in Howarth (ed.), *Art and Patronage in the Caroline Courts* (1993), pp. 68–89.

9 See Peacock, *Stage Designs of Inigo Jones*, p. 113. S. Orgel and R. Strong, *Inigo Jones: The Theatre of the Stuart Court* (1973), vol. 1, p. 106, l. 17.

10 For Palladian interpretations, see J. Summerson, *Inigo Jones* (1966 and 2000 edns). J. Newman, 'Inigo Jones's Architectural Education before 1614', *Architectural History*, vol. 35 (1992), pp. 18–50.

11 On the masques, with full texts, see Orgel and Strong, *Inigo Jones*; Peacock, *Stage Designs of Inigo Jones*; M. Butler, *The Stuart Court Masque and Political Culture* (2009). For the masque's relationship to garden designs by Jones, see R. Strong, *The Artist and the Garden* (2000), pp. 103–6, 111–20.

12 G. Worsley, *Inigo Jones and the European Classicist Tradition* (2007), pp. 71, 78–9, also lists Chevening House, Kent (much altered and not accepted by Colvin), and the pavilions at Stoke Park, and a case is made for the stables at Burley-on-the-Hill, Rutland; see also G. Worsley, 'Stoke Park Pavilions, Northamptonshire', *Country Life*, vol. 199 (2005), pp. 90–95. Summerson, *Inigo Jones* (2000 edn), p. 116.

13 Worsley, *Inigo Jones and the European Classicist Tradition*, p. 72.

14 C. Anderson, *Inigo Jones and the Classical Tradition* (2007), p. 165.

15 M. Leapman, *Inigo: The Troubled Life of Inigo Jones, Architect of the English Renaissance* (2003), p. 2.

ACKNOWLEDGEMENTS

1 Earlier versions published as: (with Joe Robson), 'A Computer Model of Inigo Jones's Perspective Stage', *Computers and the History of Art*, vol. 6, no. 1, (1996), pp. 21–7; (with Richard Tucker), '"Immaginacy set free": Aristotelian Ethics and Inigo Jones's Banqueting House at Whitehall', *Res*, vol. 39 (2002), pp. 151–67; and 'Ornament and the Work of Inigo Jones', *Architectura*, vol. 32 (2002), pp. 36–52.

INTRODUCTION

1 Jones's own ambiguous religious affiliations will be discussed in the Conclusion.

2 See note in one of George Vertue's notebooks: 'Dr Harwood from Sr. Christ. Wren, says that Inigo . . . was put apprentice to a joiner in Pauls church yard': *Vertue Note Books*, vol. 1 (1930), p. 105 [see also *Notes and Queries*, vol. 178 (1940), p. 292].

3 Recorded in a list of gifts and rewards in the household accounts of the 5th Earl of Rutland; see *The Manuscripts of His Grace the Duke of Rutland, KG, Preserved at Belvoir Castle: Historic Manuscripts Commission*, vol. 4 (1905), p. 446.

4 J. Webb, *A VINDICATION OF Stone-Heng Restored* (1655 edn), Introduction.

5 See G. Worsley, *Inigo Jones and the European Classicist Tradition* (2007), pp. 5–6.

6 I. Jones, *The MOST NOTABLE ANTIQUITY OF GREAT BRITAIN, Vulgarly called STONE-HENG, ON SALISBURY PLAIN, RESTORED, By Inigo JONES, Esq, Architect General to the King* (1655), preface, p. 1.

7 'Tertio Calendas Januar. MDCVI Styl. Angl. Arrham, tesseramque amicitiae, futurae cum Ignatio Jonesio sempiternae, Edmundus Bolton do libellum hunc. Ignatio Jonesio suo per quem spes est, Statuariam, Plasticen, Architecturam, Picturam, Mimisim, omnemque veterum elegantiarum laudem trans Alpes, in Angliam nostram aliquando irrepturas. MERCURIUS IOVIS FILIUS'. Transcribed in J. Gotch, *Inigo Jones* (1928), p. 251 (the Bordini volume is lost). Transcribed and translated in J. Peacock, *The Stage Designs of Inigo Jones: The European Context* (1995), p. 7.

8 See J. Nichols (ed.), *The Progresses, Processions and Magnificent Festivities of King James I* (1828), vol. 1, p. 558; Gotch, *Inigo Jones*, p. 38.

9 See Appendix Two.

10 See D. J. Gordon, 'Poet and Architect: The Intellectual Setting of the Quarrel between Ben Jonson and Inigo Jones', *Journal of the Warburg and Courtauld Institutes*, vol. 12 (1949), p. 163. See also J. Summerson, *Inigo Jones* (2000 edn), pp. 105–7. See L. E. Semler, 'Inigo Jones, Capricious Ornament and Plutarch's Wise Men', *Journal of the Warburg and Courtauld Institutes*, vol. 66 (2003), p. 134. M. Leapman, *Inigo: The Troubled Life of Inigo Jones, Architect of the English Renaissance* (2003).

11 Gotch, *Inigo Jones*, p. 32; Worsley, *Inigo Jones and the European Classicist Tradition*, p. 6.

12 See L. Stone, 'Inigo Jones and the New Exchange', *Archaeological Journal*, vol. 114 (1957), pp. 106–21. See R. Strong, *Henry Prince of Wales and England's Lost Renaissance* (1986), p. 111; C. Anderson, *Inigo Jones and the Classical Tradition* (2007), p. 30; Leapman, *Inigo*, pp. 96–101. The cathedral tower drawing is held at Worcester College, Oxford; see J. Harris and A. A. Tait (eds), *Catalogue of the Drawings by Inigo Jones, John Webb and Isaac De Caus at Worcester College* (1979), no. 13; J. Harris and G. Higgott, *Inigo Jones: Complete Architectural Drawings* (1989), pp. 36–8, cat. no. 3 (New Exchange) and cat. no. 4 (St Paul's Cathedral).

13 For the argument as to lack of sophistication, see, for example, H. Colvin, 'Inigo Jones', in *A Biographical Dictionary of British Architects, 1600–1840* (1995), p. 555. Summerson, *Inigo Jones* (2000 edn), p. 16, on the New Exchange: 'it is nevertheless obviously the work of somebody who had little to do with architecture and nothing with building'. See, however, Worsley, *Inigo Jones and the European Classicist Tradition*, pp. 6–7.

14 See G. Higgott, 'Inigo Jones in Provence', *Architectural History*, vol. 24 (1983), pp. 24–34. E. Chaney (ed.), *Inigo Jones's 'Roman Sketchbook'* (2006), vol. 2, p. 14.

15 In Jones's Palladio, Book I, p. 64.

16 See Peacock, *Stage Designs of Inigo Jones*, p. 75.

17 See Strong, *Henry Prince of Wales*. See also T. Wilks, 'The Court Culture of Henry Prince of Wales', D.Phil. thesis, Oxford University (1987).

18 See J. Newman, 'An Early Drawing by Inigo Jones and a Monument in Shropshire', *Burlington Magazine*, vol. 115 (1973), pp. 360–67.

19 The Latin verse was possibly by the lawyer and poet John Hoskins, although sometimes catalogued as by Coryate himself, and was translated by John Reynolds. See 'Philosophical Banquet at the Mitre, Fleet Street' [1611], The National Archives, Kew, SP 14/66. See Strong, *Henry Prince of Wales*, p. 113. See also J. Harris, S. Orgel and R. Strong, *The King's Arcadia: Inigo Jones and the Stuart Court* (1973), p. 52 no. 70; and Leapman, *Inigo*, pp. 122–4.

20 G. Chapman, *The Memorable Maske of the two honorable houses or Innes of Court: the Middle Temple, and Lyncolns Inne* [1613], opening credit [S. Orgel and R. Strong, *Inigo Jones: The Theatre of the Stuart Court* (1973), vol. 1, p. 253]. See Strong, *Henry Prince of Wales*, pp. 112–13.

21 See D. Howarth, 'Lord Arundel as an Entrepreneur of the Arts', *Burlington Magazine*, vol. 122 (1980), pp. 690–92; D. Howarth, *Lord Arundel and his Circle* (1985).

22 See J. Gotch, 'Inigo Jones's Principal Visit to Italy in 1614: The Itinerary of his Journeys', *Journal of the Royal Institute of British Architects*, vol. 46 (1938), pp. 85–6. Worsley, *Inigo Jones and the European Classicist Tradition*, pp. 19–30.

23 See E. Chaney, 'Inigo Jones in Naples', in J. Bold and E. Chaney (eds), *English Architecture: Public and Private* (1993), pp. 31–53.

24 'Roman Sketchbook', Devonshire Collection, Chatsworth, fols 14r–19v; Chaney (ed.), *Inigo Jones's 'Roman Sketchbook'*, vol. 2, p. 124. See below, n. 93.

25 In Jones's Palladio, Book IV, p. 13 (Temple of Peace): 'Wils I was in Roome on of thes great Pillors was pulled doune to sett a figure on before St. Marie ma. Jan anno 1614. yt was a erecting'; p. 23 (Temple of Nerva Trajan): 'Whilst I was in Roome Anno 1614, That which remained of this rare temple was pulled doune by the pope Pau. Burgese to have the marble to make a pedistall to sett the collom on wᶜʰ remaind at yᵉ temple of pease and sett beefor St. Maria major' (repeated on p. 24 concerning the demolition of the 'Pillors').

26 In Jones's Palladio, Book IV, p. 41.

27 See Worsley, *Inigo Jones and the European Classicist Tradition*, p. 95.

28 In Jones's Palladio, Book I, p. 50; Book III, p. 34. See also Book II, p. 69: 'Scamozo utterly dislikes this desine of Paladio.'

29 In Jones's Palladio, Book IV, p. 10.

30 See J. Newman, 'Inigo Jones's Architectural Education before 1614', *Architectural History*, vol. 35 (1992), pp. 18–50; Leapman, *Inigo*, pp. 138–57; Worsley, *Inigo Jones and the European Classicist Tradition*, p. 27.

31 Worsley (*Inigo Jones and the European Classicist Tradition*, p. 37) speculates that Jones could have returned to England alone from Venice via Germany.

32 See E. Angelicoussis, 'The Collection of Classical Sculptures of the Earl of Arundel, "Father of Vertu in England"', *Journal of the History of Collections*, vol. 16, no. 2 (2004), pp. 143–59.

33 Harris and Higgott, *Inigo Jones*, p. 66, cat. no. 13. See J. Bold, *Greenwich: An Architectural History of the Royal Hospital for Seamen and the Queen's House* (2000), p. 45. See Worsley, *Inigo Jones and the European Classicist Tradition*, p. 104. This interpretation has been questioned, however, in G. Higgott, 'The Design and Setting of Inigo Jones's Queen's House, 1616–40', *Court Historian*, vol. 11, no. 2 (2006), p. 138.

34 In the RIBA Library Drawings Collection, London. See Harris and Higgott, *Inigo Jones*, p. 70.

35 Harris and Higgott, *Inigo Jones*, p. 70 fig. 19.

36 Harris and Higgott, *Inigo Jones*, pp. 68, 70, cat. nos. 14, 15.

37 The National Archives, Kew, AO1/356/2487; see Harris and Higgott, *Inigo Jones*, p. 66.

38 *Calendar of State Papers: Domestic Series: The Reign of James I, 1611–1618*, ed. M. A. Everett Green, London, 1858: 1617, p. 70.

39 On privileged access to the park, see Bold, *Greenwich*, p. 56. On the Queen's House built in Dunfermline, Scotland, around 1600 for Anne of Denmark, which was also split in two, see A. McKechnie [Mackechnie], 'Sir David Cunningham of Robertland: Murderer and "Magna Britannia's" First Architect', *Architectural History*, vol. 52 (2009), p. 94.

40 For a discussion of the use of the device in Elizabethan architecture, see M. Girouard, *Robert Smythson and the Elizabethan Country House* (1983), pp. 24–8.

41 The bridge was possibly built between 1629 and 1630; see Bold, *Greenwich*, pp. 46, 50 fig. 72.

42 See G. Higgott, 'Inigo Jones's Designs for the Queen's House in 1616', in M. Airs and G. Tyack (eds), *The Renaissance Villa in Britain, 1500–1700* (2007), pp. 161–6.

43 See Bold, *Greenwich*, pp. 44–61; Higgott, 'The Design and Setting of Inigo Jones's Queen's House', pp. 135–48; Higgott, 'Inigo Jones's Designs for the Queen's House', pp. 140–66.

44 Harris and Higgott, *Inigo Jones*, pp. 186–7, cat. no. 53. See J. Peacock, 'Inigo Jones's Catafalque for James I', *Architectural History*, vol. 25 (1982), pp. 1–5. Anderson, *Inigo Jones and the Classical Tradition*, pp. 157–61.

45 In Jones's Palladio, Book I, p. 52.

46 The National Archives, Kew, Declared Accounts, Pipe Office, E.351/3251. The brewhouse was actually begun in 1615.

47 Harris and Higgott, *Inigo Jones*, pp. 49, 181, 265, cat. nos. 9, 50, 90. See Worsley, *Inigo Jones and the European Classicist Tradition*, p. 125. Formerly identified with Newmarket: see J. Harris, 'Inigo Jones and the Prince's Lodging at Newmarket', *Architectural History*, vol. 2 (1959), pp. 26–40.

48 The drawing is at Worcester College, Oxford. See Harris, 'Inigo Jones and the Prince's Lodging at Newmarket', p. 40; Harris and Higgott, *Inigo Jones*, pp. 101, 102 fig. 34.

49 Harris and Higgott, *Inigo Jones*, pp. 103–5, cat. nos. 30, 31. See Anderson, *Inigo Jones and the Classical Tradition*, p. 41.

50 See McKechnie, 'Sir David Cunningham of Robertland'. Robert Stickells has also been suggested; see S. Thurley, *Whitehall Palace: An Architectural History of the Royal Apartments, 1240–1698* (1999), pp. 75–82.

51 See Harris and Higgott, *Inigo Jones*, pp. 108–9.

52 The Banqueting House is included in some (for example, the 'K' scheme), but not all (for example, the 'P' scheme, generally accepted as representing Jones's own proposal for Whitehall Palace), of the seven extant schemes. For this lettering, see M. D. Whinney, 'John Webb's Drawings for Whitehall Palace', *Walpole Society*, vol. 31 (1946), pp. 45–107. The Whitehall project embodied in microcosm the ideal Stuart city, as Summerson (*Inigo Jones* [2000 edn], pp. 123–31) notes: 'one can conceive it as some kind of ideal city, an insulated New Jerusalem, opposing its sublime symmetries to the Boeotian sprawl of London and Westminster; not a walled inward-looking city but one with a fixed and formidable stare to north, south, east and west (the Escorial again) . . . Penetrated, the city would be a model Rome'. See also J. A. Gotch, *The Original Drawings for the Palace at Whitehall Attributed to Inigo Jones* (1912); R. Strong, *Britannia Triumphans: Inigo Jones, Rubens and Whitehall Palace* (1980); J. Bold, *John Webb: Architectural Theory and Practice in the Seventeenth Century* (1989), pp. 107–25; Worsley, *Inigo Jones and the European Classicist Tradition*, pp. 157–74.

53 T. Herbert, *Memoirs Of The Two Last Years Of The Reign Of That Unparallell'd Prince, King Charles I* (1702), p. 43 ('*Villalpandus* upon *Ezekiel*', on which see chapters One and Three).

54 See S. R. Gardiner, *Prince Charles and the Spanish Marriage, 1617–1623: A Chapter of English History* (1869), vol. 1, p. 29. See G. H. Chettle, 'Marlborough House Chapel', *Country Life*, vol. 84 (1938), pp. 450–53.

55 Worsley, *Inigo Jones and the European Classicist Tradition*, pp. 137–55.

56 See Thurley, *Whitehall Palace*.

57 See Harris and Higgott, *Inigo Jones*, p. 193.

58 Isaac de Caus worked for the Bedford family; see Anderson, *Inigo Jones and the Classical Tradition*, p. 204.

59 See Leapman, *Inigo*, p. 21; Worsley, *Inigo Jones and the European Classicist Tradition*, p. 25. See also A. Channing

Downs, 'Inigo Jones's Covent Garden: The First Seventy-Five Years', *Journal of the Society of Architectural Historians*, vol. 26 (1967), pp. 8–33. V. Hart, 'A Computer Reconstruction of Inigo Jones's Original Covent Garden Piazza, *c.*1640', *Computers and the History of Art*, vol. 7, no. 2 (1997), pp. 81–6.

60 See the Conclusion.

61 On Wilton, see A. A. Tait, 'Isaac de Caus and the South Front of Wilton House', *Burlington Magazine*, vol. 106 (1964), p. 74; J. Bold, *Wilton House and English Palladianism* (1988); J. Heward, 'The Restoration of the South Front of Wilton House: The Development of the House Reconsidered', *Architectural History*, vol. 35 (1992), pp. 69–117; H. Colvin, 'The South Front of Wilton House', in Colvin (ed.), *Essays in English Architectural History* (1999), pp. 136–57.

62 J. Aubrey, *The Natural History of Wiltshire*, ed. J. Britton (1847), part II, chapter 2, pp. 83–4.

63 See Colvin, 'The South Front of Wilton House', p. 147.

64 J. Summerson, 'Lectures on a Master Mind: Inigo Jones', *Proceedings of the British Academy*, vol. 50 (1964), p. 185.

65 On the building accounts, see Appendix One.

66 The chief masons employed were Thomas Style and William Mason (in partnership), Thomas Steevens, John Moore, Edmund Kinsman and Gabriel Stacey.

67 On the history of Jones's drawings, see Harris, Orgel and Strong, *The King's Arcadia*, appendix 1, p. 215; Bold, *John Webb*, pp. 8–9; Harris and Higgott, *Inigo Jones*, pp. 22–4. Christopher Wren studied Jones's sketches; see his second tract published in C. Wren, *PARENTALIA; or, MEMOIRS OF THE FAMILY of the WRENS* (1750), p. 354.

68 The elevation for the north and south nave doors is held in the RIBA Library Drawings Collection, London; see J. Harris, *Catalogue of the Drawings Collection of the RIBA: Inigo Jones and John Webb* (1972), drawing 32; Harris and Higgott, *Inigo Jones*, p. 246, cat. no. 80. The north transept elevation drawing is at Worcester College, Oxford; see Harris and Tait (eds), *Catalogue of the Drawings*, no. 14; Harris and Higgott, *Inigo Jones*, p. 244, cat. no. 79. The unexecuted design for the west front is in the RIBA Library Drawings Collection: Harris, *Catalogue: Inigo Jones and John Webb*, drawing 31; Harris and Higgott, *Inigo Jones*, p. 241, cat. no. 78.

69 See Harris, *Catalogue: Inigo Jones and John Webb*, drawing 31. On stylistic grounds Summerson first dated it to 1608, but subsequently revised this to 1630–31; see Summerson, 'Lectures on a Master Mind', p. 184; in Summerson, *Inigo Jones* (1966 edn), p. 100, fig. 43, he cites *c.*1631; and in *The Unromantic Castle* (1990), p. 54 (republished 'Lectures on a Master Mind' article), he corrects 1608 to 1630. John Harris, on the basis of stylistic similarities with the Banqueting House, attributed it to 'about 1620', but has also revised the date to post-1633; see Harris and Higgott, *Inigo Jones*, p. 241: 'The technical and stylistic evidence make it certain that the drawing belongs to William Laud's restoration campaign of 1633–42.' Annarosa Cerutti Fusco dates the scheme to 1621, again on the basis of a similarity of style with the Banqueting House; see *Inigo Jones: Vitruvius Britannicus* (1985), p. 273. Per Palme points out that the fact that the drawing for a door is dated 1634 (it is in fact dated 1637) does not mean the others are of this date. He dates the drawing for the west front to the early 1620s, and links it to the work of the 1620 commission; see *Triumph of Peace: A Study of the Whitehall Banqueting House* (1957), p. 23 n. 1.

70 W. Dugdale, *The History of St Paul's Cathedral in London* (1658 edn), p. 140. See Chapter Eight.

71 Webb, *A VINDICATION OF Stone-Heng Restored* (1725 edn), p. 48.

72 WA 12, April 1640, masons paid for carving the marble for the doorways. Fulham Papers 43, June 1640. Jones's marble specification and step dimension of $5\frac{1}{2}$ inches (Flitcroft's drawing shows five steps, thereby totalling 2 ft 3 in.) is recorded in Howarth, 'Lord Arundel as an Entrepreneur of the Arts'. A rather dramatic, colourfully speculative view of this portico was offered by Roy Strong in 'Britain's Vanished Treasures', *Sunday Times Magazine* (19 November 1989). This was largely reprinted (without the cathedral illustration) in R. Strong, *Lost Treasures of Britain* (1990), pp. 134–5: Strong notes that 'the ceiling above was coffered, carved and gilded', but I can find no evidence of this.

73 Daniel King's drawing was published in A. T. Bolton and H. P. Hendry (eds), *Wren Society Publications* (1937), vol. 14, p. 171 and pl. 53. For Flitcroft's engraving, see W. Kent, *The Designs of Inigo Jones, Consisting of Plans and Elevations for Publick and Private Buildings* (1727), vol. 2, pl. 50. Flitcroft's drawing for this engraving is in the library at Chatsworth.

74 See E. Harris and N. Savage, *British Architectural Books and Writers, 1556–1785* (1990), p. 250.

75 Flitcroft's engraving is frequently erroneously captioned as representing Jones's built design; see J. Rykwert, *The First Moderns* (1980), p. 136; Bold, *John Webb*, p. 27, fig. 13; Summerson, *The Unromantic Castle*, p. 57, fig. 42; R. Tavernor, *Palladio and Palladianism* (1991), p. 137.

76 See Rykwert, *The First Moderns*, p. 137.

77 Webb, *A VINDICATION OF Stone-Heng Restored* (1725 edn), p. 71.

78 Sketch of the south transept of the cathedral after the fire of 1666, by Thomas Wycke, 1666 (Guildhall Library, London); sketch of the west front, anon. (dean and chapter of St Paul's). Both published in Bolton and Hendry (eds), *Wren Society Publications*, vol. 14, p. 170 and pl. 52.

79 A similar arrangement was executed by Nicholas Stone at Kirby Hall, Northamptonshire (see Fig. 3).

80 S. Pepys, *Diary*, ed. R. Latham and W. Matthews (1976), vol. 9, p. 308 (entry for 16 September 1668).

81 Inscribed in the 'Roman Sketchbook', Devonshire Collection, Chatsworth, fol. 1r. See Chaney (ed.), *Inigo Jones's 'Roman Sketchbook'*, vol. 2, pp. 21, 93. This is a line from Petrarch's *Trionfi* (*Triumphus cupidinis, Trionfo d'amore*, no. 1, l. 21). The original here has 'Altro diletto che imparar non *provo*' (my italics: experience, prove in

the old sense, not 'trovo', find). The line was quoted by Daniele Barbaro in his 1567 edition of Vitruvius (a book owned by Jones, in which the motto is also inscribed on the title page). See also Peacock, *Stage Designs of Inigo Jones*, pp. 18–20.

82 On Jones's library and his studies, see Harris, Orgel and Strong, *The King's Arcadia*, pp. 63–7. C. Anderson, 'Learning to Read Architecture in the English Renaissance', in L. Gent (ed.), *Albion's Classicism: The Visual Arts in Britain, 1550–1660* (1995), pp. 239–86. Anderson, *Inigo Jones and the Classical Tradition*, especially pp. 49–87, 98–104, and appendix, pp. 223–6. See also R. Wittkower, 'Inigo Jones, Architect and Man of Letters', *Journal of the Royal Institute of British Architects*, vol. 60 (1953), pp. 83–90 [reprinted in *Palladio and English Palladianism* (1974), pp. 51–66]. See also Peacock, *Stage Designs of Inigo Jones*, pp. 27–8, 270–73; Worsley, *Inigo Jones and the European Classicist Tradition*, pp. 95–6.

83 Attributed by Anderson, 'Learning to Read Architecture', p. 285 n. 90; Anderson, *Inigo Jones and the Classical Tradition*, pp. 67, 224, but this is now doubted in Chaney (ed.), *Inigo Jones's 'Roman Sketchbook'*, vol. 2, p. 16 n. 23.

84 In Jones's Palladio, Book I, p. 27; Book IV, pp. 15, 21, 22, 23, 27 (where he corrects Labacco's identification of the Temple of Mars as the Temple of Nerva) and p. 68 ('Antiquities of Anto: Labacco'); see Newman, 'Inigo Jones's Architectural Education', p. 21.

85 See Anderson, *Inigo Jones and the Classical Tradition*, pp. 28–9, 57.

86 Wren, *PARENTALIA*, pp. 353–8. See Worsley, *Inigo Jones and the European Classicist Tradition*, p. 120.

87 In Jones's Palladio, Book IV, p. 35.

88 See British Library, Harleian MS 6018, fols 179–80.

89 See J. Newman, 'Italian Treatises in Use: The Significance of Inigo Jones's Annotations', in J. Guillaume (ed.), *Les Traités d'architecture de la Renaissance* (1988), pp. 435–41. Newman, 'Inigo Jones's Architectural Education'.

90 The following (here and in the notes below) are held in Worcester College, Oxford, unless otherwise indicated: Marcus Vitruvius Pollio, *I dieci libri dell'architettura*, Venice, 1567 [Barbaro edn, Chatsworth]; Marcus Vitruvius Pollio, *Della Architettura libri dieci*, Venice, 1590 (folio) [Giovanni Antonio Rusconi edn, Jones's annotations]; Sebastiano Serlio, *Libro primo (-quinto) d'architettura*, Venice, 1559–62 [The Queen's College, Oxford]; Sebastiano Serlio, *Tutti L'Opera d'Architettura et Prospettiva*, Venice, 1600 [Jones's annotations, Canadian Centre for Architecture, referred to in his Palladio]; Leon Battista Alberti, *L'architettura*, translated into Italian by Cosimo Bartoli, Monte Regale, 1565 (folio) [Jones's annotations]; Philibert de l'Orme, *Le Premier Tome de l'architecture*, Paris, 1567 (folio) [Jones's annotations, referred to in his Palladio, Book IV, p. 69]; Pietro Cataneo, *L'architettura*, Venice, 1567 (folio); Giorgio Vasari, *Delle vite de'piu eccellenti pittori scultori et architettori*, volume I of part III, Florence, 1568 (4to) [Jones's annotations]; Giorgio Vasari, *Ragionamenti*, Florence,

1588 (4to); Giovanni Lomazzo, *Trattato dell'arte della pittura scultura et srchitettura*, Milan, 1584 [National Art Library, London]; Andrea Palladio, *I Quattro libri dell' architettura*, Venice, 1601 (folio) [Jones's annotations]; Giacomo Barozzi da Vignola, *Regola delli cinque ordini d'architettura*, Rome, 1607 (folio) [Jones's annotations, referred to in his Palladio, Book IV, p. 49]; Vincenzo Scamozzi, *L'idea della architettura universale*, 2 vols, Venice, 1615 (folio) [Jones's annotations, referred to in his Palladio]; Gioseffe Viola Zanini, *Delle architettura*, Padua, 1629 (4to) [Jones's annotations, referred to in his Palladio, Book I, p. 42; Book IV, p. 132].

91 Guido Ubaldo Monte, *Le mechaniche*, translated into Italian by Filippo Pigafetta, Venice, 1581 (4to) [Jones's annotations]; Euclid, *De gli elementi d'Euclide libri quindici*, translated into Italian by Federico Commandino, Urbino, 1575 (folio); Giovanni Scala, *Geometria prattica . . . sopra la tavole dell'Ecc.ᵉ Mathematico Giovanni Pomodoro*, Rome, 1603 (colophon 1599) (folio); Fluvius Vegetius, *Dell'arte della Guerra*, translated into Italian by Francesco Ferrosi, Venice, 1551 (8vo) [Jones's annotations]; Buonaiuto Lorini, *Le fortificationi*, Venice, 1609 (folio) [Jones's annotations]; Gabriello Busca, *L'architettura militare*, Milan, 1619 (4to) [Jones's annotations]. On Jones's military interests, see Anderson, *Inigo Jones and the Classical Tradition*, pp. 77–82.

92 Dio Cassius, *Della Guerre de Romani*, translated into Italian by Nicolo Leoniceno, Venice, 1548 (8vo) [Jones's annotations]; Appian of Alexandria, *Delle guerre civili et esterne de Romani*, translated into Italian by Lodovico Dolce, Venice, 1551 (8vo); Dictys Cretensis and Dares Phrygius, *Della Guerra Troiana*, translated into Italian by Thomaso Porcacchi da Castiglione, Venice, 1570 (4to) [Jones's annotations]; Francesco Patricii, *Le militia romana di Polibio, di Tito Livio, e di Dionigi Alicarnaseo*, Ferrara, 1583 (4to).

93 Herodotus, *Delle guerre de Greci & de Persi*, translated into Italian by Mattheo Maria Boiardo, Venice, 1539 (8vo) [Jones's annotations, referred to in his Palladio, Book III, p. 45]; Torellus Sarayna, *De origine et amplitudine civitatis Veronae*, Verona, 1540, folio; Andrea Fulvio, *Opera di Andrea Fulvio delle antichità della città di Roma*, translated into Italian by Paulo dal Rosso, Venice, 1543 (8vo); Lucius Annaeus Florus, *De fatti de Romani. Dal principio della città per infino ad Augusto Cesare*, translated into Italian by Gioan Domenico Tharsia di Capo d'Istria, Venice, 1546 (8vo); Quintus Curtius Rufus, *De Fatti d'Alessandro Magno*, translated into Italian by Thomaso Porcacchi, Venice, 1559 (4to); Claude Ptolemy, *La geografia di Claudio Tolomeo Alessandrino*, translated into Italian by Girolamo Ruscelli, Venice, 1561 (4to); Polybius, *Les cinq premiers livres des Histoires de Polybe Megalopolitein*, translated into French by Louis Maigret, Lyon, 1558 (folio) [Jones's annotations]; Strabo, *La prima parte della Geografia di Strabone*, translated into Italian by Alfonso Buonaccinoli, Venice, 1562; *La seconda parte della Geografia di Strabone*, Ferrara, 1565 [Italian translation, Jones's annotations]; Bernardo Gamucci da San Gimignano, *Le antichità della città di Roma*, Venice, 1569

(8vo) (referred to in Jones's *Palladio*, Book IV, pp. 11, 13, 23, 42); Francesco Guicciardini, *Dell'epitome dell'historia d'Italia*, Venice, 1580 (8vo); Leandro Alberti, *Descrittione di tutta Italia*, Venice, 1588 (4to); Giovanni Bordini, *De Rebus Praeclare Gestis a Sixto V Pon. Max.*, Rome, 1588 (4to) [lost]; Vincenzo Cartari, *Le imagini delli dei de gli antichi*, Venice, 1592 (4to); Giovanni Antonio Summonte, *Historia della citta e regno di Napoli*, 2 vols, Naples, 1601–2 (4to); Giovanni Battista Cherubini, *Le cose meravigliose dell'alma città di Roma* including *L'antichità di Roma di M. Andrea Palladio*, Venice, 1609 (8vo) [Jones's annotations, Chatsworth]; Julius Caesar [Andrea Palladio], *I commentary di C. Giulio Cesare, con le figure in rame . . . Fatted da Andrea Palladio*, Venice, 1618 (4to) [Jones's annotations].

94 In Jones's *Palladio* in Book II, p. 69 (chapter 41), he notes: 'Scamozo makes y^e kycchen in y^e back part of the house and in no Cortill nether w^ch is most against the text of Vi: Alluding more to an Epistel of Plinny then other'. Pliny the Younger (*c.*61–112), in his Letters (Epistle to Gallus 2.17; Epistle to Apollinaris 5.6), described the beauty of his Laurentine and Tuscan villas.

95 Xenophon, *Della vita di Cyro re de Persi*, translated into Italian by Iacopo di Messer Poggio Fiorentino, Florence, 1521 (8vo); Xenophon, *L'Opere morali di Xenophonte, I sette libri di Xenophonte della impresa di Ciro*, translated into Italian by Lodovico Domenichi, Venice, 1547 (8vo) [Jones's annotations]; Aristotle, *L'ethica d'Aristotile*, translated into Italian by Bernardo Segni, Venice, 1551 (8vo) [Jones's annotations]; Plato, *La Republica di Platone*, translated into Italian by Pamphilo Fiorimbene, Venice, 1554 (8vo) [Jones's annotations]; Plutarch, *Alcuni opusculi de le cose morali del divino Plutarco*, translated into Italian by A. Massa and G. Tarcagnota, Venice, 1567 (8vo) [Jones's annotations]; Plutarch, *Vite di Plutarco Cheroneo de gli Roumini illutstri Greci et Romani*, translated into Italian by Lodovico Domenichi, Venice, 1607 (4to); Plutarch, *Opuscoli morali, di Plutarco Cheronese*, translated into Italian by Marc' Antonio Gandino, Venice, 1614 (4to) [Jones's annotations]; Alessandro Piccolomini, *Della institution morale Libri III*, Venice, 1575 (4to) [Jones's annotations].

96 In Jones's *Palladio*, Book I, p. 42.

97 In Jones's Plutarch, *Opuscoli morali* (1614 edn), Book IX, p. 491. Jones's copy of Cicero is lost.

98 M. Vitruvius Pollio, *I dieci libri dell'architettura*, trans. D. Barbaro (1567 edn), Book III, chapter 1, p. 115. On Alberti's discussion of the relationship between the orator's rhetorical style and architectural style (and Jones's study of this), see Anderson, *Inigo Jones and the Classical Tradition*, p. 133.

99 In Jones's Vitruvius, *I dieci libri*, trans. Barbaro (1567 edn), l. 32. Barbaro's commentary reads: '& altro richiede la piacevolezza, altro la bellezza, & ornamento del parlare. Similmente nelle Idee della fabriche alre proportioni, alter dispositioni, altri ordini, & compartimenti ci vuole, quando nella fabrica si richiede grandezza, & veneratione, che quando si vuole bellezza, o dilicatezza, o simplicitià'.

100 See H. Wotton, *The Life and Letters of Sir Henry Wotton*, ed. L. P. Smith (1907), vol. 1, p. 204. Cicero's *De oratore*, II.xl.36; see Anderson, 'Learning to Read Architecture', p. 255.

101 In Jones's Vitruvius (Barbaro edn), Book I, p. 22.

102 J. Onians, *Bearers of Meaning: The Classical Orders in Antiquity, the Middle Ages and the Renaissance* (1988), p. 38. See now C. Van Eck, *Classical Rhetoric and the Visual Arts in Early Modern Europe* (2007), especially pp. 98–107.

103 Van Eck, *Classical Rhetoric and the Visual Arts*, pp. 5–6.

104 See H. Peacham (Senior), *The Garden of Eloquence* (1593 edn), p. 36, for example, on 'Ironia', or dissimulation through irony (that is, deliberately saying the opposite to the meaning that is intended): 'neither is it a meete forme of speech for every sort of people to use, especially of the inferior toward the superior, to whom by some reason he oweth dutie, for it is against the rule of modestie and good maners, either to deride his better, or to jest with him in this forme and maner'.

105 See Strong, *Henry Prince of Wales*, p. 129.

CHAPTER 1

1 Geoffrey of Monmouth, *The History of the Kings of Britain*, trans. L. Thorpe (1966), pp. 65, 71, 73. Discussed by T. D. Kendrick, *British Antiquity* (1950); R. F. Brinkley, *Arthurian Legend in the 17th Century* (1932); G. J. Gordon, 'The Trojans in Britain', *Essays and Studies by Members of the English Association*, vol. 9 (1924), pp. 9–30.

2 Geoffrey of Monmouth, *History of the Kings of Britain*, p. 107.

3 Geoffrey of Monmouth, *History of the Kings of Britain*, p. 282.

4 This quest for Trojan origins had many European parallels; see M. Corbett and R. Lightbown, *The Comely Frontispiece: The Emblematic Title-Page in England, 1550–1660* (1979), p. 156. Selden remarks on 'that universall desire, bewitching our Europe, to derive their bloud from Trojans', in M. Drayton, *Poly-Olbion; or, A Chorographicall Description of Tracts, Rivers, Mountaines, Forests, and other parts of this renowned Isle of Great Britaine* (1613), The Second Part, Selden's notes, p. 18. Francis Bacon (*The Historie of the Reigne of King Henry the Seventh*, 1622, p. 18) noted that the naming of Henry VII's son as Arthur was 'according to the Name of that ancient worthy King of the Brittaines'. Henry VIII cultivated the legend of Arthur's empire to justify his breach with Rome. See H. MacDougall, *Racial Myth in English History* (1982), p. 16; K. Thomas, *Religion and the Decline of Magic* (1971), pp. 493–6.

5 T. Heywood, *TROIA BRITANICA; or, Great Britaines Troy* (1609), Dedicatory Epistle. See also H. C. Levis, *Notes on the Early British Engraved Royal Portraits Issued in Various Series from 1521 to the End of the Eighteenth Century* (1917). F. Yates, *Astraea: The Imperial Theme in the Sixteenth Century* (1975), p. 59.

6 Reported in F. W. Fairholt, *Lord Mayors' Pageants: being*

Collections towards a History of these Annual Celebrations (1843), part 2, p. 20 [pp. 11–31].

7 See R. Strong, *Britannia Triumphans: Inigo Jones, Rubens and Whitehall Palace* (1980), p. 28. On the themes represented in the ceiling, see also F. Donovan, *Rubens and England* (2004), and here Chapter Seven.

8 S. Orgel and R. Strong, *Inigo Jones: The Theatre of the Stuart Court* (1973), vol. 2, p. 663, ll. 192–3.

9 J. King, *A Sermon at Paules Cross, on behalf of Paules Church* (26 March 1620), p. 4.

10 The portico inscription reads: CAROLUS D:G MAGNAE BRITANNIAE, HIBERNIAE, FRANCIAE: REX F:D: TEMPLUM SANCTI PAULI VETUSTATE CONSUMPTUM RESTITUIT ET PORTICUM FECIT. For the imperial theme of this inscription, see V. Hart, *Art and Magic in the Court of the Stuarts* (1994), p. 44.

11 For the Christian overtones of this masque, see J. Peacock, *The Stage Designs of Inigo Jones: The European Context* (1995), pp. 68–73, 291–2. On Henry as an imperial Protestant prince and this masque, see R. Strong, *Henry Prince of Wales and England's Lost Renaissance* (1986), p. 112.

12 Henry had a month to go until his sixteenth birthday, on 19 February 1610. See Strong, *Henry Prince of Wales*, pp. 142–5.

13 See R. Strong, 'Inigo Jones and the Revival of Chivalry', *Apollo* (August 1967), p. 104. Orgel and Strong have discussed the theme of chivalry within the Stuart masque in the introduction to *Inigo Jones*, vol. 1, pp. 1–75. G. Parry, *Golden Age Restor'd: The Culture of the Stuart Court, 1602–42* (1981), pp. 75–6. F. Yates, *Theatre of the World* (1969), pp. 174–5. However, notions of chivalry were not limited to 'the fairy palace' of masque alone, as Yates has implied, or to a specifically medieval setting.

14 Orgel and Strong, *Inigo Jones*, vol. 1, p. 160, ll. 18–45.

15 See B. Jonson, 'An Execration upon Vulcan', in I. Donaldson (ed.), *Ben Jonson: Works* (1985), p. 365; P. Palme, *Triumph of Peace: A Study of the Whitehall Banqueting House* (1957), p. 39.

16 See Peacock, *Stage Designs of Inigo Jones*, pp. 282–9.

17 Orgel and Strong, *Inigo Jones*, vol. 1, p. 160, ll. 84–6.

18 Orgel and Strong, *Inigo Jones*, vol. 1, p. 160, ll. 46–63.

19 See H. Trevor-Roper, *Catholics, Anglicans and Puritans* (1987).

20 For a further discussion, see G. Williams, 'Some Protestant Views of Early British Church History', in Williams, *Welsh Reformation Essays* (1967), chapter 9, pp. 207–19.

21 J. Gordon, *ENOTIKON; OR, A SERMON OF THE Union of Great Brittannie* (1604), p. 26, 'Preached . . . in presence of the Kings Majesty', part of the title.

22 Gordon, *ENOTIKON*.

23 J. Stow, *Annales; or, A Generall Chronicle of England, Begun by John Stow* (1631–2 edn), p. 1033.

24 Reproduced by W. S. Simpson, *Documents Illustrating the History of S. Paul's Cathedral* (1880), chapter 22, pp. 134–9.

25 Trevor-Roper, *Catholics, Anglicans and Puritans*, p. 50: 'Though [James] . . . detested the Presbyterian dis- cipline of Scotland, and had fallen in love with the hierarchical episcopacy of England, and though he enjoyed the conversation of learned men, regardless of their churchmanship, he remained, intellectually, a Calvinist. He believed, and wrote, that the Pope was Antichrist, and he saw himself as a godly Christian Prince in the style of Queen Elizabeth as seen by John Foxe'. See also V. N. Olsen, *John Foxe and the Elizabethan Church* (1973).

26 James I singled out Gordon 'with a speciall encomion, that he was a man well travailled in the auncients', quoted in 'John Gordon', in *Oxford Dictionary of National Biography* (1937–8 edn). Convinced of the historical justification for the Elizabethan settlement, Gordon's history became centred on James I, a view also to be found in the work of James Ussher, for example. See Trevor-Roper, *Catholics, Anglicans and Puritans*, pp. 135–6.

27 Gordon, *ENOTIKON*, p. 24 and margin p. 28.

28 Gordon, *ENOTIKON*, p. 33.

29 Gordon, *ENOTIKON*, pp. 34–5.

30 For a discussion of this aim in relation to the Banqueting House, see Palme, *Triumph of Peace*, pp. 23–4.

31 W. Laud, *Seven Sermons Preached upon Severall Occasions* (1651), p. 6. The text was Psalm 122.6, 7: 'Pray for the peace of Jerusalem'; 'Peace be within thy Walls, and prosperity within thy Palaces'.

32 See Williams, 'Some Protestant Views of Early British Church History', pp. 214–15. James Howell's *LONDONOPOLIS . . . The Imperial Chamber, and Chief Emporium of Great Britain* (1657), p. 79, reported that the parish church of St Peter upon Cornhill carried a tablet recording that King Lucius had 'founded the same church' and a faith that 'continued the space of four hundred years, unto the coming of *Augustine* the Monk'.

33 See Geoffrey of Monmouth, *History of the Kings of Britain*, Book five, chapter six.

34 Gordon, *ENOTIKON*, p. 46.

35 Gordon, *ENOTIKON*.

36 G. Marcelline, *The Triumphs of King James the First* (1610), pp. 69, 73.

37 Echoed by J. Gordon, *The Union of Great Brittaine* (1604), p. 7.

38 Williams, 'Some Protestant Views of Early British Church History', p. 217: 'Nor could the Protestants abandon the classical Christian conception of human history as part of a mighty cosmic drama, in which the creation of the world and the incarnation of Christ were the most significant episodes, and final redemption the end of which all history was moving . . . The Reformation appeared to be vindicated as the highest fulfilment of the ancient prophecies that the glories of the earlier British Kingdom would, in the fullness of time, be restored.'

39 Strong, *Britannia Triumphans*, pp. 24, 28.

40 Howell, *LONDONOPOLIS*, p. 4.

41 J. Gordon, *England and Scotlands Happinesse* (1604), p. 44.

42 WA 5, February 1636: carving of lion's heads, one of

which survives in the collection of the dean and chapter of St Paul's, see Appendix One. See also J. Harris and G. Higgott, *Inigo Jones: Complete Architectural Drawings* (1989), p. 240, where these lion's heads are identified with those in Hieronymous Cock's engraving of the Baths of Diocletian.

43 I. Jones, *The MOST NOTABLE ANTIQUITY OF GREAT BRITAIN, Vulgarly called STONE-HENG, ON SALISBURY PLAIN, RESTORED* (1655 edn), p. 107.

44 J. B. Villalpando, *In Ezechielem Explanationes et Apparatus Vrbis ac Templi Hierosolymitani*, 3 vols (1596–1604). See J. Rykwert, *The First Moderns* (1980), pp. 9–10; and Rykwert, *On Adam's House in Paradise: The Idea of the Primitive Hut in Architectural History* (1972), pp. 121–35; R. Taylor, 'Hermetic and Mystical Architecture in the Society of Jesus', in Wittkower (ed.), *Baroque Art: The Jesuit Contribution* (1972), pp. 63–97; H. Rosenau, *Vision of the Temple: The Image of the Temple of Jerusalem in Judaism and Christianity* (1979); Hart, *Art and Magic*, p. 71.

45 J. Evelyn, *Parallel of the Ancient Architecture with the Modern . . . upon the Five Orders* (1664), p. 67.

46 J. Williams, *Great Britains SALOMON* (1625), pp. 25, 29.

47 See Strong, *Britannia Triumphans*, p. 61; Hart, *Art and Magic*, p. 111; see also the Introduction, n. 53.

48 Gordon, *ENOTIKON*, p. 43.

49 J. Dee, 'Preface', to *EUCLID* (1570), fol. diij.

50 See Chapter Eight.

51 King, *A Sermon at Paules Cross*, pp. 44–6.

52 Following Michelangelo's projected portico for St Peter's, Jones's columns rivalled those of the Pantheon as the largest free-standing Corinthian portico in the Western world since antiquity. See Rykwert, *The First Moderns*, p. 137.

53 E. Pagitt, *CHRISTIANOGRAPHY; OR, THE Description of the multitude and Sundary sorts of CHRISTIANS in the World* (3rd edn, 1640), p. 3.

54 On Sangallo's scheme, see Harris and Higgott, *Inigo Jones*, p. 38, cat. no. 4; G. Worsley, *Inigo Jones and the European Classicist Tradition* (2007), pp. 10, 12–13. Jones refers to St Peter's in his Palladio, Book IV, p. 40, and the Vatican on the terminal flyleaf.

55 King, *A Sermon at Paules Cross*, pp. 19, 47.

56 W. Dugdale, *The History of St Paul's Cathedral in London* (1658), p. 135.

57 See J. Donne, *The Sermons of John Donne*, ed. G. R. Potter and E. M. Simpson (1953–62), vol. 2, Sermon 10, p. 217.

58 Simpson, *Documents*, pp. 134–9.

59 Williams, *Great Britains SALOMON*, pp. 25, 29.

60 H. King, *A Sermon Preached at St Paul's, March 27. 1640. Being the Anniversary of his Majesties Happy Inauguration to his Crowne* (1640), pp. 50–51.

61 Dugdale, *The History of St Paul's Cathedral*, p. 3.

62 Jones, *STONE-HENG . . . RESTORED*, preface, p. 1. On Jones's study of Stonehenge, see Yates, *Theatre of the World*, p. 176; see also chapter 10, 'Public Theatre and Masque: Inigo Jones on the Theatre as a Temple'; S. Orgel, 'Inigo Jones on Stonehenge', *Prose*, vol. 3

(1971), pp. 107–24; A. A. Tait, 'Inigo Jones's "Stone-Heng"', *Burlington Magazine*, vol. 120 (1978), p. 155; G. Parry, *Hollar's England: A Mid-Seventeenth-century View* (1980), p. 158; A. C. Fusco, *Inigo Jones: Vitruvius Britannicus* (1985), p. 227; J. Bold, *John Webb: Architectural Theory and Practice in the Seventeenth Century* (1989), pp. 48–51; C. Anderson, *Inigo Jones and the Classical Tradition* (2007), pp. 145–7; C. Van Eck, 'Statecraft or Stagecraft? English Paper Architecture in the Seventeenth Century', in S. Bonnemaison and C. Macy (eds), *Festival Architecture* (2008), pp. 120–28.

63 P. Sidney, 'Seven Wonders of England', from 'Sidera II', in *The Complete Poems*, ed. W. Ringler (1962), pp. 169–85: 'Near Wilton, Sweet, huge Heaps of Stone are found, / But so confus'd, that neither any Eye, / Can count them Just, nor Reason Reason try / What Force brought them to so unlikely ground'. Jones, *STONE-HENG . . . RESTORED*, p. 40.

64 Reported in J. Aubrey, *John Aubrey's 'Monumenta Britannica'*, ed. J. Fowles (1980), p. 76. John Webb (*A VINDICATION OF Stone-Heng Restored*, 1725 edn, p. 123) also records Buckingham's explorations: 'the Right Noble *George*, late Duke of *Buckingham*, out of his real Affection to *Antiquity*, was at the Charge in King *James* his Days, of searching and digging there'. Arundel, for example, was involved in digs at Ephesus, Pergamon, Corinth, Samos and Scio; see Parry, *Golden Age Restor'd*, p. 120.

65 Quoted in Aubrey, *John Aubrey's 'Monumenta Britannica'*, p. 236.

66 Webb's dedication to Philip, 4th Earl of Pembroke, the only surviving member of those probably gathered at Wilton in 1620, would seem confirmation of the truth of Jones's story of the king's patronage; see Yates, *Theatre of the World*, p. 178. Walpole makes passing reference to an edition of Jones's book 'which formerly belonged to that Earl': H. Walpole, *Anecdotes of Painting in England* (1782 edn), vol. 2, p. 272. This continuing association with the Pembroke family also indicates the importance of Stonehenge to the Stuart court.

67 E. Spenser, *Poetical Works*, ed. J. Smith and E. De Selincourt (1912), p. 472, ll. 36–9, 85–97.

68 Stow, *Annales*; Stow, *The Survey of London* (1633 edn); W. Camden, *Britannia; or, A Chorographicall Description of the most flourishing kingdomes, England, Scotland, and Ireland* (1610 edn).

69 Jones, *STONE-HENG . . . RESTORED*, p. 15.

70 Pagitt, *CHRISTIANOGRAPHY*, p. 5.

71 Jones, *STONE-HENG . . . RESTORED*, p. 43.

72 Jones, *STONE-HENG . . . RESTORED*, pp. 65, 68.

73 See G. Morolli, *'Vetus Etruria'* (1985).

74 In Jones's Palladio, Book IV, p. 5. Serlio justified the revived use of antique Tuscan work through its relationship to medieval Etruscan rustication; see S. Serlio, *Regole generali di architettura. Sopra le cinque maniere degli edifici* (1537); S. Serlio, *Sebastiano Serlio on Architecture* (1996–2001), vol. 1 [Books I–V of *Tutte l'opere d'architettura et prospetiva*, trans. V. Hart and P. Hicks]. See J. Ackerman, 'The Tuscan/Rustic Order: A Study in the

Metaphorical Language of Architecture', in Ackerman, *Distance Points: Essays in Theory and Renaissance Art and Architecture* (1991), p. 531.

75 See Strong, *Britannia Triumphans*, p. 24. Although the entablature has Doric triglyphs (but with no metopes), the squat columns are without the cymatium (cyma reversa) and ring that form the topmost member of the Doric capital. The columns are also unfluted, as are Tuscan columns. The final celebration of Stuart rule, Davenant's *Salmacida Spolia* (1640), focused on the power of secret wisdom, a 'Tuscan wisdom' (l. 323), unappreciated by the populace but understood by the noble minds of the initiated.

76 This set resembled Serlio's Satiric scene (see Fig. 278); see J. Onians, *Bearers of Meaning: The Classical Orders in Antiquity, the Middle Ages and the Renaissance* (1988), pp. 282–6; and on the Rustic/Tuscan, see Ackerman, 'The Tuscan/Rustic Order', pp. 495–541.

77 Walpole, *Anecdotes of Painting*, vol. 2, p. 264.

78 Yates, *Theatre of the World*, p. 178.

79 Jones, *STONE-HENG . . . RESTORED*, p. 3.

80 Jones, *STONE-HENG . . . RESTORED*, pp. 2, 3.

81 Jones, *STONE-HENG . . . RESTORED*, p. 4.

82 W. Stukeley, *Stonehenge, a Temple restored to the British Druids* (1740), p. 25.

83 Jones, *STONE-HENG . . . RESTORED*, p. 10.

84 Jones, *STONE-HENG . . . RESTORED*, pp. 11, 15.

85 Jones, *STONE-HENG . . . RESTORED*, pp. 14, 40. On this, see Orgel, 'Inigo Jones on Stonehenge', pp. 120–21: 'England becomes heroic through the imposition of Roman order on British nature', adding: 'innocence yields to experience, ignorance to knowledge. So Jones imagined classical palaces for British rulers, and Jonson celebrated British aristocrats in the guise of Greek and Roman heroes.'

86 Jones, *STONE-HENG . . . RESTORED*, p. 16.

87 Jones, *STONE-HENG . . . RESTORED*, p. 38.

88 Jones, *STONE-HENG . . . RESTORED*, p. 25.

89 Jones, *STONE-HENG . . . RESTORED*, p. 39.

90 Oxford, Bodleian Library, MS Top. Gen. C24, fol. 198r. J. Aubrey, *Aubrey's Brief Lives* (1972), p. 139 (where Butleigh is mis-transcribed as 'Butley'). See E. Chaney (ed.), *Inigo Jones's 'Roman Sketchbook'*, vol. 2 (2006), pp. 79–80.

91 Jones, *STONE-HENG . . . RESTORED*, p. 26.

92 Jones, *STONE-HENG . . . RESTORED*, p. 29.

93 For whatever reason, and maybe to avoid a public argument, Jones seems somewhat reluctant to name Bolton; but he must have been aware of this authorship, not least because, as Jones himself reports (*STONE-HENG . . . RESTORED*, p. 44), the title page of *Nero Cæsar* recorded that the translator was also 'known in being Translator of *Lucius Florus*' (in reference to Lucius Florus's *The History of the Roman's*, translated by Bolton in 1619). On Bolton's friendship with Jones, see the Introduction and Chapter Three. Bolton expressed his faith in Geoffrey's version of British History in *HYPERCRITICA; or, A rule of Judgement for writing or reading our History's* (1722) [reprinted in J. Haslewood

(ed.), *Ancient Critical Essays upon English Poets and Poesy*, vol. 2 (1815), pp. 225–54]. In 1600 he became associated with the work of Sidney, Spenser and Raleigh as a contributor to *England's Helicon*.

94 Jones, *STONE-HENG . . . RESTORED*, p. 52.

95 Jones, *STONE-HENG . . . RESTORED*, p. 33.

96 See Orgel, 'Inigo Jones on Stonehenge'.

97 Jones, *STONE-HENG . . . RESTORED*, p. 104.

98 Orgel, 'Inigo Jones on Stonehenge', p. 123.

99 Jones, *STONE-HENG . . . RESTORED*, p. 102.

CHAPTER 2

1 James's entry was delayed by an outbreak of plague following his coronation in 1603. For an eyewitness account, see G. Dugdale, *The Time Triumphant* (1604). For an analysis, see D. M. Bergeron, 'Harrison, Jonson and Dekker: The Magnificent Entertainment for King James', *Journal of the Warburg and Courtauld Institutes*, vol. 31 (1968), pp. 445–8; Bergeron, 'King James's Civic Pageant and Parliamentary Speech in March 1604', *Albion*, vol. 34, no. 2 (2002), pp. 213–31. G. Parry, *Golden Age Restor'd: The Culture of the Stuart Court, 1602–42* (1981), pp. 1–39; R. Strong, *Art and Power* (1984), p. 72; J. S. Mebane, *Renaissance Magic and the Return of the Golden Age* (1989), p. 161. E. Hageman and K. Conway, *Resurrecting Elizabeth I in Seventeenth-century England* (2007), pp. 75–7. See also R. Dutton (ed.), *Jacobean Civic Pageants* (1995); and C. Stevenson, 'Occasional Architecture in Seventeenth-century London', *Architectural History*, vol. 49 (2006), pp. 35–74.

2 For a study of this Renaissance art form, see Strong, *Art and Power*, especially p. 62. See also I. D. McFarlane, *The Entry of Henri II into Paris, 16 June 1549* (1982).

3 The National Archives, Kew, SP 29/5, no. 74 (1), discussed by J. Orrell, *The Theatres of Inigo Jones and John Webb* (1985), p. 15.

4 J. Stow, *Annales; or, A Generall Chronicle of England* (1631–2 edn), p. 1033. See below, p. 82.

5 See L. Manley, *Literature and Culture in Early Modern London* (1997), pp. 219, 223.

6 See in general J. Newman, 'Inigo Jones and the Politics of Architecture', in K. Sharpe and P. Lake (eds), *Culture and Politics in Early Stuart England* (1994), pp. 251–4.

7 Drawing reproduced in F. Yates, *Astraea: The Imperial Theme in the Sixteenth Century* (1975), figs 24–39; see also p. 179, where Yates points out that the bridge at Pont-Neuf was built to facilitate the 'allegorical' traffic of the royal procession. On the entry of Charles IX and his bride in Paris in 1571, see ibid., pp. 222–3.

8 This procession went from Southwark Cathedral (St Mary Overie). See P. Tudor-Craig, *'Old St Paul's': The Society of Antiquaries Diptych, 1616* (2004).

9 The medieval poetry of Langland and Lydgate had celebrated Henry VII's processions leading to St Paul's, and in 1588 Elizabeth proceeded with 'great splendour' to the cathedral to give thanks for the defeat of the

Spanish Armada, seated in a triumphal chariot with pillars bearing the heraldic lion, dragon and arms of England; see J. P. Malcolm, *Londinium Redivivum* (1803), vol. 3, pp. 152–8, 166.

10　See B. Jonson, *Ben Jonson: Works*, ed. C. Herford and P. Simpson (1925–52), vol. 7, 'Part of the King's Entertainment in Passing to His Coronation', pp. 90–91. See also T. Middleton, *Thomas Middleton: The Collected Works and Companion*, ed. G. Taylor (2007).

11　L. B. Alberti, *On the Art of Building in Ten Books*, trans. J. Rykwert, N. Leach and R. Tavernor (1988), Book VI, chapter ii, p. 156.

12　Engravings of the arches by William Kip were published by Stephen Harrison (a joiner, who oversaw the construction and possibly the design of the arches) in *Arches of Triumph* (1604), which is held in the Pepys collection, Magdalene College, Cambridge, *London and Westminster*, vol. 2, pl. 2973/329–33b. Jonson's text for the celebrations at each arch is in Jonson, *Works*, pp. 80–109. See also Middleton, *Collected Works and Companion*.

13　T. Dekker, *The Magnificent Entertainment Given to King James* (1616) [unpaginated].

14　T. Dekker, 'The Song of Troynovant', the arch at Soper Lane End; see Dekker, *The Magnificent Entertainment Given to King James*. Song reproduced in F. W. Fairholt, *The Civic Garland: A Collection of Songs from London Pageants* (1845), p. 12.

15　Dekker, *The Magnificent Entertainment Given to King James*.

16　Stow, *Annales*, p. 1033.

17　W. Dugdale, *The History of St Paul's Cathedral in London* (1658), p. 135. See J. Nichols, *The Progresses, Processions and Magnificent Festivities of King James* (1828), vol. 4, p. 598.

18　Nichols, *Progresses*, vol. 4, p. 597.

19　See W. R. Lethaby, 'Old St Paul's', *The Builder* (10 October and 12 December 1930): 'Stow, speaking of the Churchyard or Cathedral Close, says that the citizens "claimed the west side that they might there assemble themselves together with the Lord of Baynard's Castle, for view of their armour of defence of the city"'.

20　E. Bolton, *The Cities Advocate, In this Case or Question of Honour and Armes* (1628), p. 7.

21　See O. Millar, 'Charles I, Honthorst and Van Dyck', *Burlington Magazine*, vol. 96 (1954), pp. 36–41. The sketch is on view at Belvoir Castle, near Grantham, Lincolnshire.

22　E. Ashmole, *The Institution, Laws & Ceremonies of the Most Noble Order of the Garter* (1672), p. 552.

23　The possibility of a designed royal route through London has been implied by a number of commentators. Whilst discussing a projected triumphal arch at Temple Bar, John Harris observed in 1982 ('Inigo Jones', in *Macmillan Encyclopedia of Architects*, p. 511) that 'with the portico complete, Jones saw the approach road, Fleet Street, as a triumphal way'. Prompted once again by this arch, in 1981 Graham Parry (*Golden Age Restor'd*, p. 249) noted: 'the Christian emperor would be

able to ride from his Roman hall of state at Whitehall to his restored Temple at St Paul's, meeting his citizens at an arch that proclaimed the felicity of Stuart rule by means of emblems of public contentment on the entablature'. Neither Harris nor Parry examined the consequences of this on our understanding of any of Jones's city buildings.

24　Also on the Strand was a new frontispiece comprising door and balcony designed by Jones around 1618 for Edward Cecil's House; this work had the obvious added advantage of facilitating the viewing of royal occasions (it was destroyed by fire in 1628; see J. Harris and G. Higgott, *Inigo Jones: Complete Architectural Drawings*, 1989, p. 90, cat. no. 23; see also design for Fulke Greville's House in Holborn, p. 88, cat. no. 22; see here Fig. 203). In 1624, 2,000 tons of Portland stone were given by James to the Duke of Buckingham for works at York House, the duke's London residence on the Strand; see J. Orrell, *The Quest for Shakespeare's Globe* (1983), p. 43. Some of this stone was evidently taken from St Paul's, for, according to Dugdale, building material collected by the first royal commission was later 'borrowed', on the failure of the planned work at the cathedral to proceed, to build the water gate at York House; see Dugdale, *History of St Paul's Cathedral*, p. 137.

25　Two plans in the Earl of Bedford Papers, Y3, box 3 2/4, at Alnwick Castle.

26　See C. Campbell, *Vitruvius Britannicus*, vol. 2 (1717). See A. Channing Downs, 'Inigo Jones's Covent Garden: The First Seventy-Five Years', *Journal of the Society of Architectural Historians*, vol. 26 (1967), p. 28: 'Many writers have assumed that Inigo Jones intended a row of houses to "complete" the piazza, and . . . Campbell engraved a plan showing this arrangement.'

27　See Strong, *Art and Power*, p. 87.

28　James I, *By the King. A Proclamation for Building* (16 July 1615), and a further proclamation in 1619. See also D. Duggan, '"London the Ring: Covent Garden the Jewel of That Ring": New Light on Covent Garden', *Architectural History*, vol. 43 (2000), pp. 140–61; M. Leapman, *Inigo: The Troubled Life of Inigo Jones, Architect of the English Renaissance* (2003), pp. 279–85. See also Chapter Four, Fig. 151.

29　See N. Smith, *The Royal Image and the English People* (2001), p. 75.

30　For discussion of Jones's designs, see Smith, *The Royal Image and the English People*: Somerset House, pp. 193, 254; New Exchange, pp. 36–7. See also J. Bold, *John Webb: Architectural Theory and Practice in the Seventeenth Century* (1989): Somerset House, pp. 103–7. G. Worsley, *Inigo Jones and the European Classicist Tradition* (2007), pp. 84–6, 159. On the background to the New Exchange, see L. Stone, 'Inigo Jones and the New Exchange', *Archaeological Journal*, vol. 114 (1957), pp. 106–21; Leapman, *Inigo*, pp. 96–101.

31　See S. Thurley, *Somerset House: The Palace of England's Queens, 1551–1692* (2009).

32　See Harris and Higgott, *Inigo Jones*, pp. 251–3. Worsley, *Inigo Jones and the European Classicist Tradition*, p. 159.

33 Book III, chapter 1, fols 101–34. Jones notes against Serlio's Arch of Constantine in his 1560 edition: 'this cornis mar[ked] G is 1/7 part o[f] the base' (fol. 115r); he also notes in his 1601 edition fols 97v–105r and in the index, against the Arch of Titus Augustus (fol. 100r), 'to be Imitated'. In his Palladio, Book IV, p. 61 (chapter 16), Jones notes: 'Paladio thinkes this Templ not Anticke but I do beeleve yt to bee make in Constantines time when Architecture was much fallen and they yoused to build w^th fragmentes of Antike buildinges as in his Arch. se Serlio'. See J. Peacock and C. Anderson, 'Inigo Jones, John Webb and Temple Bar', *Architectural History*, vol. 44 (2001), pp. 29–38.

34 See J. Orgel and R. Strong, *Inigo Jones: The Theatre of the Stuart Court* (1973), vol. 1, p. 71. On ship money, see J. P. Sommerville, *Politics and Ideology in England, 1603–1640* (1986), pp. 136, 159–60.

35 See Parry, *Golden Age Restor'd*, chapter one.

36 J. Stow, *The Survey of London* (1598 edn), p. 407. Stow records the divisions of medieval London.

37 See W. Maitland, *The History of London* (1756), p. 483.

38 For a history of the medieval cathedral, see Dugdale, *History of St Paul's Cathedral*, pp. 1–49. See also Chapter Eight.

39 Nichols, *Progresses*, vol. 4, p. 598.

40 Nichols, *Progresses*, vol. 4, p. 597. See here p. 65.

41 Stow, *Annales*, p. 1033.

42 Orgel and Strong, *Inigo Jones*, vol. 2, p. 662, l. 62.

43 Dugdale, *History of St Paul's Cathedral*, p. 139.

44 It was on the grounds of this unilateral clearance that Jones was to be tried by the Puritans; see J. Newman, 'Inigo Jones', *Oxford Dictionary of National Biography* (2004), vol. 30, pp. 527–38. See also the Conclusion.

45 Stow, *Survey of London* (1633 edn), p. 368.

46 H. H. Milman, *Annals of S. Paul's Cathedral* (1868), p. 335, quotes Clarendon reporting that all shops in Cheapside and Lombard Street, except those of goldsmiths, were directed to be closed; this was probably a reference to booths standing on the public way. In 1598 Stow reported that on the cathedral's south side licences had been granted 'first to builde lowe sheddes, but now higher Houses, which do hide that beautifull side of the Church, save only the toppe and South Gate'; Stow, *Survey of London* (1598 edn), pp. 302–3. See also Chapter Eight.

47 As reported in R. Pratt, *The Architecture of Sir Roger Pratt*, ed. R. T. Gunther (1928), p. 197.

48 Models were made of these in November 1639, and the following month the accounts record payment for the carving of five 'pyne Apples' (WA 13); see Appendix One.

49 'Pineapple' was understood to mean 'pine-cone'; see the *Oxford English Dictionary* (1933 edn): '"Pine-apple", "Pineapple": The fruit of the pine-tree; a pine-cone'.

50 A giant pineapple, or pine-cone, was to be found in the atrium of St Peter's; see E. B. Smith, *Architectural Symbolism of Imperial Rome and the Middle Ages* (1956), pp. 28–9. See also J. A. Gotch, 'Inigo Jones's Principal Visit to Italy in 1614: The Itinerary of his Journeys',

Journal of the Royal Institute of British Architects, vol. 46 (21 November 1938), pp. 85–6.

51 Smith, *Architectural Symbolism of Imperial Rome*.

52 WA 5 February 1636; one of these survives, in the collection of the dean and chapter of St Paul's; see Appendix One.

53 See, for example, the chariot and lion in the representation of the triumphal return of Dionysus from India, silver handle from serving dish, Roman, early third century AD, Metropolitan Museum of Art, New York, 54.11.8; lions pulling a chariot, bronze statuette of Cybele, Roman, second century CE, Metropolitan Museum of Art, 97.22.24.

54 Costume designs in Townshend's *Albion's Triumph* (1632) were taken from *De Ludis Circensibus*; see Orgel and Strong, *Inigo Jones*, vol. 2, p. 453.

55 Rudolf II, for example, appeared as the sun in 1571; see W. Kriegeskorte, *Arcimboldo* (1987), p. 90; Strong, *Art and Power*, p. 71.

56 James I, *Political Works of James I*, ed. C. H. MacIlwain (1918), p. 12.

57 *The Subjects Happinesse, and the Citizens Joy, For the Kings Majesties happy and safe return from Scotland . . . Thursday November 25, 1641* (Cambridge University Library, Pet.K.5.10⁵).

58 Fairholt, *Civic Garland*, vol. 2, pp. 11–12.

59 Bolton, *The Cities Advocate*, p. 56.

60 Pointed out by Nichols, *Progresses*, vol. 4, p. 728 n. 1.

61 Nichols, *Progresses*, vol. 4, p. 728.

62 Nichols, *Progresses*, vol. 4, p. 626.

63 J. King, *A Sermon at Paules Crosse, on behalfe of Paules Church* (1620), p. 50.

64 King, *A Sermon at Paules Crosse*, p. 32.

65 King, *A Sermon at Paules Crosse*, pp. 18, 43.

66 Hollar records an obelisk on each of the corners of Jones's cathedral in the plates published in Dugdale, *History of St Paul's Cathedral*. In this 'Pre-Fire' drawing, however, Wren shows one crowning each upper 'pier', throughout the nave and transepts (Hollar leaves these empty and 'uncelebrated'). Here Wren is probably correct, since these obelisks may well have also been necessary to perform a structural function in preventing the roof from spreading, as Gothic pinnacles would have done in the same location (certainly Wren is accurate in his record of pine-cones at the head of the lower 'piers').

67 Augustus used an obelisk as a sundial in the Campus Martius, Rome; see Pliny, *Natural History*, trans. H. Rackham and D. E. Eichholz (1938), Book 36, chapters 63–73; *Encyclopaedia Britannica* (1910–11 edn): 'Obelisks . . . were sheathed in bright metal, catching and reflecting the sun's rays . . . They were dedicated to solar deities, and were especially numerous at Heliopolis.'

68 On Bordini, see the Introduction. Jones refers to Domenico Fontana in his Palladio, Book IV, pp. 94, 118. On Jones's study of Fontana's *Della trasportatione dell' obelisco vaticano et della fabriche di nostro signore Papa Sisto V . . . libro primo* (1590), see Chapter Six, n. 102.

69 See M. Corbett and R. Lightbown, *The Comely Fron-*

tispiece: The Emblematic Title-Page in England, 1550–1660 (1979), p. 139. In the emblematic frontispiece to Jacques Boissard's *Theatrum vitae humanae* (printed by Theodore De Bry at Metz in 1596), an obelisk rises from an earthly hell to touch the heavenly illumination of the godhead. As part of the sun and moon symbolism employed to celebrate the 'alchemical' wedding of Princess Elizabeth and the Elector Palatine in 1613, an obelisk of silver was flanked by golden statues of the royal couple, in Thomas Campion's *The Lords Maske* (1613); see *Campion's Works*, ed. S. P. Vivian (1909), description of the scene on p. 98. On the Heidelberg obelisk, see R. Patterson, 'The "Hortus Palatinus" at Heidelberg and the Reformation of the World', *Journal of Garden History*, vol. 1 (1981), pp. 94–5.

70 Dekker, *The Magnificent Entertainment Given to King James.*

71 'The House of Chivalry', from *Prince Henry's Barriers* (1610); Orgel and Strong, *Inigo Jones*, vol. 1, p. 160, ll. 38–40, 61.

72 See R. C. Bald, *John Donne: A Life* (1970), pp. 191–8. Both Donne and Jones appear to have been members of a debating 'club'. See here p. 9.

73 See J. Donne, *The Complete English Poems*, ed. C. A. Patrides (1985), pp. 53–4.

74 See C. M. Coffin, *John Donne and the New Philosophy* (1937), pp. 20, 178. See also N. Foxell, *A Sermon in Stone: John Donne and his Monument in St Paul's Cathedral* (1978), pp. 8, 12.

75 The dean traditionally had responsibility for the maintenance of part of the fabric (shared with the chapter responsible for the choir), whilst the Bishop of London had care of the 'whole body' of the church; see Dugdale, *History of St Paul's Cathedral*, p. 136.

76 On this symbol, see Chapter Eight. A link between the created light of the sun and moon and the higher, brighter light of the creation itself, expressed through the sacred name, was illustrated in the emblematic frontispiece to James I's 'Authorised Version' of the Bible (1611).

77 The 'Good Shepherd' chalice plate, *c.*1615, in St John's College, Oxford; the altar at St John's College, Cambridge, above which was a sun 'with great light beams', see N. Tyacke, *Anti-Calvinists: The Rise of English Arminianism, c.1590–1640* (1987), chalice, p. xviii, and fig. 1, altar p. 194. In the citadel of ultra-Laudianism, Peterhouse in Cambridge, for example, the arched ceiling of the new chapel was painted sky-blue, whilst each coffer contained the emblem of a golden burning sun; see H. Trevor-Roper, *Catholics, Anglicans and Puritans* (1987), title in index, p. 302.

78 Jones notes in the left-hand margin of his Palladio, Book IV, p. 37 (chapter 10): 'The Templs of Soll and Luna. I'. [. . .] 'B. The portio is ¼ parte of the tempell from C to D . . . Noat that the statues on yᵉ Acroterri are much bigger then thos over yᵉ collomes being farder from the eye and to agree with the bignes of the collom'. Against the elevation: 'Thes statues are in hight ¼ part of the collom Architrave freese and corrnish'.

79 P. Fraser, *A Catalogue of Drawings by Inigo Jones . . . in the Burlington-Devonshire Collection* (1960), p. 96; and J. Summerson, *Architecture in Britain, 1530 to 1830* (1983 edn), p. 136. However, the portico is also sometimes identified incorrectly with Palladio's temple of Antoninus and Faustina: see J. Harris, S. Orgel and R. Strong, *The King's Arcadia* (1973), p. 143, and again Harris's entry for Jones in the *Macmillan Encyclopedia of Architects*, p. 510, and Parry, *Golden Age Restor'd*, p. 261, n. 32; Harris and Higgott, *Inigo Jones*, p. 240. Summerson in 'Lectures on a Master Mind: Inigo Jones', *Proceedings of the British Academy*, vol. 50 (1964), identifies Jones's portico with both temples, p. 189.

80 For George Marcelline in 1610, following the notion that James was the 'common father' of his people, his rule was 'Answerable to the Sun, which shineth equally upon all'; see *The Triumphs of King James the First* (1610), p. 14 (see also Chapter Five, p. 151). Later, in Jonson's *Love's Triumph through Callipolis* (1631), which depended in particular on Ficino's commentary on the *Symposium* and Bruno's *Degli eroici furori* and with settings by Jones, an idealised Stuart city was discovered in which the queen is told: 'Through all the streets of your Callipolis, / Which by the Splendour of your rays made bright, / The seat and region of all beauty is' (ll. 71–3).

81 See P. Palme, *The Triumph of Peace: A Study of the Whitehall Banqueting House* (1957), p. 263. Millar, 'Charles I, Honthorst and Van Dyck'.

82 Geoffrey of Monmouth recorded that a magical temple to Apollo had once stood in New Troy. The ninth king of Britain, a magician named Bladud, had 'tried to go upon the top of the air, when he fell upon the temple of Apollo in the city of New Troy, and was dashed into many pieces'; see *History of the Kings of Britain*, trans. S. Evans (1963 edn), Book II, chapter 10, p. 35. Bladud featured in James's official genealogy, as part of the attempt to justify the Stuart succession by Heywood in his *TROIA BRITANICA* (1609) and by Thomas Lyte in his royal tree of 1610, in which Apollo's temple is pictured; see H. C. Levis, *The British King Who Tried to Fly: Extracts from Old Chronicles and History Relating to Bladud* (1919), pp. 71–2. Thomas Dekker's *London's Tempe* (1629) presented the capital as the setting for a palace of Apollo, whilst in Jonson's *The Masque of Augurs* (1622) London was pictured by Jones as the setting for a magical porticoed temple to Apollo.

83 M. Drayton, *Poly-Olbion; or, A Chorographicall Description of Tracts, Rivers, Mountaines, Forests, and other parts of this renowned Isle of Great Britaine* (1613), part 8, p. 126. See also Dugdale, *History of St Paul's Cathedral*, p. 3.

84 I. Jones, *The MOST NOTABLE ANTIQUITY OF GREAT BRITAIN, Vulgarly called STONE-HENG, ON SALISBURY PLAIN, RESTORED* (1655), p. 68: 'Yet that there might be a *Roman Temple* in old time standing in that place, I will not deny, the number of Oxeheads digged up and anciently sacrificed there, setting all other reasons aside, so probably manifesting the same.'

85 W. S. Simpson, *Documents Illustrating the History of S. Paul's Cathedral* (1880), pp. 134–9.

86 E. Waller, 'Of the Queen', *The Poetical Works of Edmund Waller*, ed. I. Bell (1784); discussed in Parry, *Golden Age Restor'd*, p. 208.

87 Waller, *Poetical Works*, p. 67.

CHAPTER 3

1 For the consideration of this in Hertfordshire from 1600, see especially P. M. Hunneyball, *Architecture and Image-Building in Seventeenth-century Hertfordshire* (2004).

2 See A. McKechnie [Mackechnie], 'Sir David Cunningham of Robertland: Murderer and "Magna Britannia's" First Architect', *Architectural History*, vol. 52 (2009), p. 81.

3 S. Orgel and R. Strong, *Inigo Jones: The Theatre of the Stuart Court* (1973), vol. 1, p. 160, l. 108.

4 W. Dugdale, *THE ANTIENT USAGE in Bearing of Such Ensigns of Honour As are commonly call'd ARMS* (1682), p. 50, observes that 'younger Brethren do marry, erect, and establish new Houses'. For the 'Fallen House of British Chivalry', see Chapter One.

5 On this topic, see also C. Anderson, *Inigo Jones and the Classical Tradition* (2007), especially pp. 5–6.

6 J. Franklyn and J. Tanner, *An Encyclopaedic Dictionary of Heraldry* (1970). See also C. N. Elvin, *Dictionary of Heraldry* (1889), pl. 43, n. 50, where indicated within a shield is a 'Pillar or Column (Doric) Ducally crowned'.

7 See J. Newman, 'An Early Drawing by Inigo Jones and a Monument in Shropshire', *Burlington Magazine*, vol. 115 (1973), pp. 360–67.

8 On these arches, see Chapter Two. See also G. Parry, *Golden Age Restor'd: The Culture of the Stuart Court, 1602–42* (1981), pp. 1–39.

9 For an interpretation of these two images, see F. Yates, *Astraea: The Imperial Theme in the Sixteenth Century* (1975), pp. 57–8. No link is investigated between the architectural Orders and heraldry.

10 Discussed in Yates, *Astraea*, p. 81. See also G. Addleshaw and F. Etchells, *The Architectural Setting of Anglican Worship* (1948), p. 101.

11 J. Guillim, *A Display of Heraldrie* (1610–11 edn), sig. A2r.

12 See F. S. Eden, *Ancient Stained and Painted Glass* (1933), pp. 179, 182.

13 A. Palladio, *The Four Books of Architecture* (1738), Book II, chapter xvi: 'the fore-part being thus made more eminent than the rest, is very commodious for placing the ensigns or arms of the owners, which are commonly put in the middle of the front'.

14 J. Harris and G. Higgott, *Inigo Jones: Complete Architectural Drawings* (1989), p. 86, cat. no. 21; p. 68, cat. no. 14; pp. 110–13, cat. nos. 33–4.

15 Harris and Higgott, *Inigo Jones*, p. 36, cat. no. 3; p. 98, fig. 31 (Webb drawing); p. 251, cat. no. 82.

16 For the stable drawing, see Harris and Higgott, *Inigo Jones*, pp. 48–9, cat. no. 9.

17 W. Kent, *The Designs of Inigo Jones, Consisting of Plans and Elevations for Publick and Private Buildings* (1727; reprinted 1967).

18 See J. Bold, *John Webb: Architectural Theory and Practice in the Seventeenth Century* (1989), pp. 34, 145, fig. 97, pp. 166–7, fig. 111.

19 Harris and Higgott, *Inigo Jones*, p. 132, cat. no. 42; p. 134, cat. nos. 44–5; p. 186, cat. no. 53. See C. Anderson, 'Learning to Read Architecture in the English Renaissance', in L. Gent (ed.), *Albion's Classicism: The Visual Arts in Britain, 1550–1660* (1995), pp. 257–8. See also J. Peacock, 'Inigo Jones's Catafalque for James I', *Architectural History*, vol. 25 (1982), pp. 1–5.

20 See Anderson, *Inigo Jones and the Classical Tradition*, pp. 157–61.

21 Guillim, *A Display of Heraldrie*, Dedicatory Epistle.

22 For a discussion of the relationship between heraldry and the emblem, see P. M. Daly, *Literature in the Light of the Emblem* (1979), pp. 27–32.

23 See F. Yates, *The Art of Memory* (1966).

24 B. Jonson, 'An Expostulation W[i]th Inigo Jones', in I. Donaldson (ed.), *Ben Jonson: Works* (1985), p. 463, l. 43.

25 E. Bolton, *The Elements of Armories* (1610), Dedicatory Poem, p. 1. Bolton (p. 80) equated architecture with arms at the level of the Platonic Idea when noting that: 'let an Armes painted on a Surcoat, Tabard, or Shield be blotted out, the privation of the Armories, makes no privation of the *Continent . . .* though so I doe no more take it to bee an actuall Armes, then the dreame, or *Idea* of a building is an house'.

26 Bolton, *Elements of Armories*, p. 22.

27 Guillim, *A Display of Heraldrie*, 'To the Courteous Reader'. *Symmetria* ('harmony') is a term frequently used by Vitruvius.

28 B. Jonson, *Ben Jonson: Works*, ed. C. Herford and P. Simpson (1925–52), vol. 7, pp. 90–91.

29 H. Wotton, *The Elements of Architecture* (1624), pp. 35–6.

30 Wotton, *Elements of Architecture*, p. 39.

31 Guillim, *A Display of Heraldrie* (1632 edn), p. 15.

32 Devonshire Collection, Chatsworth, fol. 76r–76v. See E. Chaney (ed.), *Inigo Jones's 'Roman Sketchbook'* (2006). See also Chapter Six.

33 Wotton, *Elements of Architecture*, p. 36.

34 In Jones's hand at the bottom of Palladio's illustration of the Composite Order, Book I, p. 50: 'A drawing of this Sr. He: Wotto. the first that he did for this booke'. See also Book I, pp. 12 (walls), 30, 36 (Ionic Order); Book III, p. 33 (ancient Greek palace); Book IV, p. 29 (the 'Temple of Nerva Trajano'). Jones refers to Wotton as an architectural 'writer', somewhat disparagingly, some years later in his Vitruvius.

35 Quoted by Frederick Hard, Introduction to Wotton's *The Elements of Architecture* (1968 edn), pp. xlv–xlvi.

36 Recorded in H. Wotton, *The Life and Letters of Sir Henry Wotton*, ed. L. P. Smith (1907), vol. 2, p. 285 n. 1. On the commission of 1620, see n. 65 and Chapter Eight.

37 Wotton, *The Life and Letters of Sir Henry Wotton*, vol. 2, p. 363. Abbot came to head the second cathedral restoration committee; see *Calendar of State Papers: Domestic Series: The Reign of Charles I, 1634–1635*, ed. J. Bruce, London, 1864, p. 16.

38 See J. Rykwert, *The First Moderns* (1980), p. 127.

39 Lord Keeper Williams, quoted by Hard, in Wotton, *The Elements of Architecture* (1968 edn), p. 44.

40 Rykwert, *The First Moderns*, p. 128, points out that Wotton's book was aimed at the English country-house builder, and estate management provided much of the focus.

41 B. Jonson, in *Works*, ed. Herford and Simpson, vol. 7, p. 250, ll. 23–41.

42 Orgel and Strong, *Inigo Jones*, vol. 1, p. 160, ll. 40–41, 52–3.

43 See the *Oxford English Dictionary* (1933 edn). Here 'Blazon' and 'Blazonry' are both defined as heraldic in meaning. Guillim, *A Display of Heraldrie*, p. 13: 'This skill of Armory consisteth of – Blazoning and Marshalling'.

44 Bolton, *Elements of Armories*, p. 92.

45 Orgel and Strong, *Inigo Jones*, vol. 1, p. 160, ll. 95–6.

46 T. Heywood, *TROIA BRITANICA; or, Great Britaines Troy* (1609), p. 115.

47 H. Peacham, *Minerva Britanna (or a Garden of Heroical Devices)* (1612), p. 24: 'WHEN Troian youth went out into the field . . .

 With naked Sword they marched, and their Shield
 Devoide of charge, save only painted white:
 Herein the Captaine with his hand did write,
 (The Battaile done,) some Ensigne of his fame,
 Who had by valour, best deserv'd the same'.

48 Dugdale, *THE ANTIENT USAGE*, pp. 34–5.

49 J. B. Villalpando, *In Ezechielem Explanationes et Apparatus Vrbis ac Templi Hierosolymitani*, 3 vols (1596–1604). See Rykwert, *The First Moderns*, pp. 9–10, and Rykwert, *On Adam's House in Paradise; The Idea of the Primitive Hut in Architectural History* (1972), pp. 121–35; R. Taylor, 'Hermetic and Mystical Architecture in the Society of Jesus', in R. Wittkower (ed.), *Baroque Art: The Jesuit Contribution* (1972), pp. 63–97.

50 This notion stemmed from the discovery of Horapollo's manuscript in 1419. See Daly, *Literature in the Light of the Emblem*, pp. 11–16.

51 Quoted by M. Corbett and R. Lightbown, *The Comely Frontispiece: The Emblematic Title-Page in England, 1550–1660* (1979), p. 22.

52 Bolton, *Elements of Armories*, Dedicatory Poem. Guillim, *A Display of Heraldrie* (1632 edn), p. 307.

53 See V. Hart, *Art and Magic in the Court of the Stuarts* (1994), p. 132.

54 On Henri III's revival of the Order of the Holy Spirit in 1578, see Yates, *Astraea*, p. 174.

55 See P. Palme, *The Triumph of Peace: A Study of the Whitehall Banqueting House* (1957), p. 123: 'The ceremonials connected with the cult of sovereignty . . . fused an ecclesiastical tradition of processional liturgy with a secular tradition of martial display.'

56 See O. Millar, 'Charles I, Honthorst and Van Dyck', *Burlington Magazine*, vol. 96 (1954), pp. 36–41.

57 E. Ashmole, *The Institution, Laws & Ceremonies of the Most Noble Order of the Garter* (1672); p. 10 refers to 'Roman Knights'.

58 Ashmole, *Institution, Laws & Ceremonies*, p. 5.

59 Ashmole, *Institution, Laws & Ceremonies*, p. 3: 'C Marins consecrated a little chappel to *Honor* and *Vertue* . . . the Symmetry and Proportion of the Columnes, and what they supported, were perfected by *C. Mucius*, as *Vitruvius* informs us, and that according to the exact Rules of Architecture.'

60 See 'Edmund Bolton', in *Oxford Dictionary of National Biography* (1937–8 edn). Ashmole, *Institution, Laws & Ceremonies*, pp. 7–8: '*The Seminary or Nursery of Senators* . . . may we further parallel it with that of *Knighthood* among us in *England*.' See also Anderson, *Inigo Jones and the Classical Tradition*, p. 67. Bolton was in Italy on the New Year of 1607, possibly with Jones; see J. A. Gotch, *Inigo Jones* (1928), p. 43. On Bolton's gift to Jones in 1607 of Giovanni Francesco Bordini's *De Rebus Praeclare Gestis a Sixto V Pont. Max.*, Rome, 1588, see the Introduction.

61 See 'Edmund Bolton', in *Oxford Dictionary of National Biography*.

62 See 'Edmund Bolton', in *Oxford Dictionary of National Biography*. In this plan Bolton consolidated existing book patronage, since works were frequently dedicated to Garter members: in 1630, for example, James Wadsworth's *Further Observations of the English Spanish Pilgrime, Concerning Spain* was dedicated to Henry, Earl of Holland in his capacity as High Constable of the Castle of Windsor, and 'Knight of the Noble Order of the Garter'.

63 Report in G. H. Cook, *Old St Paul's Cathedral: A Lost Glory of Medieval London* (1955), p. 46. W. Dugdale, *The History of St Paul's Cathedral in London* (1658), p. 36, records the tomb of 'Sir *John de Beauchamp* . . . one of the Founders of the most noble Order of the Garter', within a chantry founded by this knight.

64 See Harris and Higgott, *Inigo Jones*, p. 38.

65 Dugdale, *History of St Paul's Cathedral*, p. 135: James I, Thomas, Earl of Arundel, William, Earl of Pembroke (Lord Chamberlain), Lodovick, Duke of Lenor (Lord Steward), James, Marquess Hamilton, Henry, Earl of Southampton, and John, Earl of Marr. Charles, as Prince of Wales, took part in James I's procession to St Paul's in 1620.

66 Recorded on Company emblems; see J. Stow, *The Survey of London* (1633 edn), pp. 599–620.

67 Bolton, *Elements of Armories*, and Bolton, *The Cities Advocate, In this case or Question of Honor and Armes* (1628), both dedicated to members of the Order of the Garter. The latter was 'approved' by Sir William Segar, the Garter Principal, who found 'nothing therein dissonant to reason, or contrary to the Law of Honor or Arms', p. 61.

68 Laud noted: 'The fulfilling of which Decrees would make a magnificent and worthy supply of all things necessary unto the service of the said *Altar* . . . *These and all that concern the* [Garter] *Order are to be remembered at the next Chapter*'; quoted in W. Prynne, *Canterburies Doome; or, The first part of a Compleat History of the Commitment, Charge, Tryall, Condemnation and Execution of William Laud* (1646), pp. 124–5. On the chapel's influence, see Orgel and Strong, *Inigo Jones*, vol. 1, p. 70.

69 Orgel and Strong, *Inigo Jones*, vol. 2, p. 579, ll. 1078–80.

70 Following such medieval orders of chivalry as the Templars and the Brethren of the Chivalry of the Temple of Solomon; see W. J. Loftie, *The Inns of Court and Chancery* (1895 edn), p. 32.

71 Quoted in W. Benham, *Old St Paul's Cathedral* (1902), p. 66. On the contributions from the Saddler's Company, see W. S. Simpson, *St Paul's Cathedral and Old City Life* (1894), p. 91.

72 In a letter to the Barber Surgeons, dated 30 January 1632, quoted in Benham, *Old St Paul's Cathedral*, p. 66. Obviously, religious rites and ceremonies were interwoven into medieval civic life; see Simpson, *St Paul's Cathedral and Old City Life*, p. 63: 'City Guilds were in their origin, and indeed in their practice, intimately associated with the Church.'

73 Reported by H. Machyn, *The Diary of Henry Machyn . . . 1550 to 1563*, ed. J. Gough Nichols (1848), p. 271.

74 See Cook, *Old St Paul's Cathedral*, p. 52. William Lethaby discusses the Goldsmiths' Company shield: 'Old St. Paul's', *The Builder*, vol. 139 (7 November 1930).

75 See Ashmole, *Institution, Laws & Ceremonies*; Rykwert, *The First Moderns*, p. 134.

76 Rykwert (*The First Moderns*) notes that in the seventeenth century orders of chivalry and masonry 'were still understood as secret societies, with roots in hoary traditions. It is often forgotten that medieval society was made up of a continuous tissue of these, ranging from the pious associations of agricultural labourers to the grandest orders of chivalry . . . the link between chivalry and masonry still seemed easy enough to establish.'

77 Rykwert, *The First Moderns*, p. 135: 'In biblical commentary generally, and in hermetic thinking more particularly, [the Temple] . . . was the image of production as the path to salvation. There can be little doubt that many masons in the seventeenth and eighteenth centuries saw certain tasks as aspects of the masonic "work"'.

78 Bolton, *The Cities Advocate*, pp. 20–21.

79 See Appendix One.

80 Reproduced in Simpson, *St Paul's Cathedral and Old City Life*, p. 198.

81 Dugdale, *History of St Paul's Cathedral*, p. 134.

82 H. Farley, *The Complaint of Paule's, to all Christian Soules, or an humble Supplication, to our good King and Nation, for her reparation* (1616), sec. iii, 'prologue'.

83 Farley, *The Complaint of Paule's*, p. 57.

84 Farley, *The Complaint of Paule's*, pp. 58–9.

85 In following, as at Temple Bar, Jones's costume for ancient British knights in masque, see G. Parry, *Hollar's England: A Mid-Seventeenth-century View* (1980), which notes that these statues were 'decorous in Roman costume', pl. 76.

86 See Bolton, *Elements of Armories*, p. 90; Wotton, *Elements of Architecture*, p. 106.

87 Orgel and Strong, *Inigo Jones*, vol. 1, p. 160, l. 50.

88 This understanding would have reflected the traditional evolution of craftwork and indeed of the Orders themselves as outlined by Vitruvius (IV.ii.1.); that is, from temporary decorations and materials to more permanent ornament, or in this case from ensign to architectural Order.

CHAPTER 4

1 S. Orgel and R. Strong, *Inigo Jones: The Theatre of the Stuart Court* (1973), vol. 1, p. 160, ll. 30, 38.

2 The law (Canon, Common or Roman) and Roman architecture share traditions and concepts. Renaissance legal and architectural treatises shared references to rhetoric, nature and the body as the ultimate 'measure of all things'. See G. C. Herndl, *The High Design: English Renaissance Tragedy and the Natural Law* (1970), especially pp. 77, 303 n. 75; D. R. Kelly, 'Legal Humanism and the Sense of History', *Studies in the Renaissance*, vol. 13, no. 1 (1966), pp. 184–99; Kelly, 'The Rise of Legal History in the Renaissance', *History and Theory*, vol. 9 (1970), pp. 174–94; Kelly, 'Civil Science in the Renaissance: Jurisprudence Italian Style', *Historical Journal*, vol. 22, no. 4 (1979), pp. 777–94; Kelly, *The Human Measure: Social Thought in the Western Legal Tradition* (1990), pp. 31–4. The practices and codes of law and architecture drew from precedents and customs recorded over time as well as universal Platonic ideals. See Kelly, '*Vera Philosophia*: The Philosophical Significance of Renaissance Jurisprudence', *Journal of the History of Philosophy*, vol. 14 (1976), pp. 267–79; Kelly, '*Jurisconsultus Perfectus*: The Lawyer as Renaissance Man', *Journal of the Warburg and Courtauld Institutes*, vol. 51 (1988), pp. 84–102; Kelly, *Human Measure*, pp. 180–83. Vitruvius included law amongst subjects in which the architect should be well versed; see Vitruvius, I.i.3, and I.i.10 (the first passage was quoted by Jones in *The MOST NOTABLE ANTIQUITY OF GREAT BRITAIN, Vulgarly called STONE-HENG, ON SALISBURY PLAIN, RESTORED*, 1655, pp. 3–4). Following Alberti's study of Canon Law at Bologna University, he wrote the legal treatises *De Jure* and *Pontifex* (both 1437), thought to have influenced his urban thinking (see M. Saura, 'Architecture and the Law in Early Renaissance Urban Life: Leon Battista Alberti's "De Re Aedificatoria"', unpublished PH.D thesis, University of California at Berkeley, 1988).

3 The *Oxford English Dictionary* defines 'ordinance' or 'ordonnance' as: 'systematic arrangement, architectural parts or features, an order of architecture' and 'in reference to France and other continental countries: An ordinance, decree, law, or by-law, under the monarchy, a decree of the King or the regent'. The former sense is found in Shute's reference to 'whole ordonnances' (J. Shute, *The First and Chief Groundes of Architecture*, 1563, sig. viiiv), and both readings are contained in Claude Perrault's *Ordonnance des cinq espèces de colonnes selon la méthode des Anciens*, Paris, 1683). A 'norma' is defined in the *OED* as: 'Carpenter's or mason's square: hence pattern, rule, law'.

4 On Jones's study of Dee, see V. Hart, *Art and Magic in the Court of the Stuarts* (1994), pp. 130–31. See also Chapter Five and Appendix One (on Dee's use at St Paul's).

5 J. Dee, 'Mathematical Preface', in *EUCLID. The elements of geometrie of the most auncient philosopher Euclide of Megara. Translated into Englishe, by H. Billingsley with a very fruitfull praeface by M. I. Dee* (1570), sigs ajr–v. See W. H. Sherman, *John Dee: The Politics of Reading and Writing in the English Renaissance* (1995), pp. 135–6. F. Yates, *Theatre of the World* (1969), pp. 109, 146.

6 Dee, 'Mathematical Preface', sig.diiij.

7 See B. J. Shapiro, *Probability and Certainty in Seventeenth-century England: A Study of the Relationships between Natural Science, Religion, History, Law and Literature* (1983), pp. 163–93. Kelly, 'Jurisconsultus Perfectus', pp. 99–101.

8 See A. W. Johnson, 'Angles, Squares or Roundes: Studies in Jonson's Vitruvianism', unpublished D.phil. thesis, Oxford University (1987), p. 170.

9 H. Wotton, *The Elements of Architecture* (1624), p. 92.

10 Wotton, *The Elements of Architecture*, p. 17.

11 On the use of Shute in the London arches of 1604 see Chapter Seven, n. 54. The columns' characteristics were also emphasised in the English 'Lomazzo'; see R. Haydocke, *Trattato dell'arte dell a pittura . . . A Tracte Containing the Artes of Curious Paintinge, Carvinge & Buildinge* (1598), pp. 84–5.

12 Undated document reproduced in J. Summerson, 'Three Elizabethan Architects', *Bulletin of the John Rylands Library*, vol. 40 (1957), p. 228.

13 Wotton, *The Elements of Architecture*, pp. 33–4.

14 Jones's 1567 copy of the 'Barbaro' 'Vitruvius' (III.i), against Vitruvius, p. 109, l. 40, against Vitruvius, p. 111, l. 38.

15 See British Museum, Sloane Volume SL, 5224.23; E. Chaney (ed.), *Inigo Jones's 'Roman Sketchbook'* (2006). J. Peacock, 'Inigo Jones as a Figurative Artist', in L. Gent and N. Llewellyn (eds), *Renaissance Bodies: The Human Figure in English Culture, c.1540–1660* (1990), pp. 154–79.

16 B. Jonson, *A Tale of the Tub* [1633], in *Ben Jonson: Works*, ed. C. Herford and P. Simpson (1925–52), vol. 3: IV, i, ll. 43–5. On this passage, Hart, *Art and Magic*, p. 126. See also C. Anderson, *Inigo Jones and the Classical Tradition* (2007), pp. 156–7.

17 B. Jonson, *Newes from the New World Discover'd in the Moone* [1620], ll. 340–45, in *Works*, ed. Herford and Simpson, vol. 7, pp. 513–25.

18 G. Marcelline, *Epithalamium, Gallo-Britannicum* (1625), pp. 18–19.

19 Marcelline, *Epithalamium*, p. 19.

20 See E. H. Kantorowicz, *The King's Two Bodies: A Study in Mediaeval Political Theology* (1957), especially pp. 87–192. C. C. Weston and J. R. Greenberg, *Subjects and Sovereigns: The Grand Controversy over Legal Sovereignty in Stuart England* (1981), pp. 11, 47.

21 Kantorowicz, *The King's Two Bodies*, p. 141.

22 See Hart, *Art and Magic*, p. 24; K. Thomas, *Religion and the Decline of Magic* (1971), pp. 230–33; M. Bloch, *The Royal Touch: Sacred Monarchy and Scrofula in England and France* (1973).

23 James I, *THE KINGS MAJESTIES SPEACH To the Lords and Commons . . . Wednesday the xxi of March* (1610), sig. 'B' (the date is new style, adjusted from the published date of 1609). James here echoes Jean Bodin on the theory of Divine Right; see Herndl, *High Design*, p. 81. B. P. Levack, 'The Civil Law, Theories of Absolutism and Political Conflict in Late Sixteenth- and Early Seventeenth-century England', in G. J. Schochet (ed.), *Law, Literature and the Settlement of Regimes* (1990), p. 35.

24 See J. Cowell, *The Interpreter, or booke containing the Signification of Words . . . as are mentioned in the Lawe Writers, or Statutes of this victorious and renowned kingdome* (1607), sig. Qq.1. Levack, 'The Civil Law', pp. 29–44.

25 Shute, *The First and Chief Grounds of Architecture*, sig. Aijr.

26 Cesare Cesariano in his edition of 'Vitruvius' of 1521 represented the Vitruvian man (in a square) as a crucified figure, adapting Leonardo's celebrated drawing and thereby 'Christianising' the Roman author's treatise. In the English 'Lomazzo' of 1598 (Haydocke, *Trattato dell' arte*) the perfect human figures were represented as Adam and Eve in the first plate, which is loosely based on Dürer's engraving of 1504 (on the 'Christianisation' of the Vitruvian figure, see C. Sgarbi, 'A Newly Discovered Corpus of Vitruvian Images', *Res*, vol. 23 [1993], pp. 31–51).

27 R. Tavernor, 'Contemporary Perfection through Piero's Eyes', in R. Tavernor and G. Dodds (eds), *Body and Building: Essays on the Changing Relation of Body and Architecture* (2002), pp. 78–93.

28 Dee, 'Mathematical Preface', sig. ijr. Wotton, *The Elements of Architecture*, p. 12.

29 Jones, *STONE-HENG . . . RESTORED*, p. 33.

30 G. Puttenham, *The Arte of English Poesie* (1589), p. 80.

31 The queen's body was itself often presented as heraldic in portraits; see E. Auerbach, 'Portraits of Elizabeth', *Burlington Magazine*, vol. 95 (1953), p. 205: 'Apart from the purely decorative effect, the image itself . . . became the superb expression of an almost heraldic monument of the Queen'. P. Palme, *The Triumph of Peace: A Study of the Whitehall Banqueting House* (1957), p. 33, adds: 'This "heraldic" formalization must have seemed oddly out of date when confronted with the early Baroque trends in European portraiture.' See also E. Chirelstein, 'Lady Elizabeth Pope: The Heraldic Body', in L. Gent and N. Liewellyn (eds), *Renaissance Bodies: The Human Figure in English Culture, c.1540–1660* (1990), pp. 36–59.

32 J. King, *A Sermon at Paules Crosse, on behalfe of Paules Church* (1620), pp. 34, 37.

33 See Herndl, *High Design*, pp. 77–8. Weston and Greenberg, *Subjects and Sovereigns*, pp. 1–7.

34 See K. Sharpe, *The Personal Rule of Charles I* (1992).

35 B. Jonson, *A Panegyre, on the Happie Entrance of James, our Soveraigne, to His first sesion of Parliament* (1603), ll. 25–6: in *Works*, ed. Herford and Simpson, vol. 7, pp. 111–17.

36 Orgel and Strong, *Inigo Jones*, vol. 1, p. 257, ll. 116–18.

This masque was devised in the same month that Jones probably took up rooms in the Middle Temple, having been made a member in 1612; see M. Leapman, *Inigo: The Troubled Life of Inigo Jones, Architect of the English Renaissance* (2003), pp. 125–6. Chapman dedicated his translation of *The Divine Poem of Musaeus* to Jones in 1616; see the Introduction and Chapter Five.

37 See Orgel and Strong, *Inigo Jones*, vol. 1, pp. 51–2, 63–6, 71–2.

38 See J. Peacock, *The Stage Designs of Inigo Jones: The European Context* (1995), p. 295.

39 Jones, *STONE-HENG . . . RESTORED*, p. 54. Jones's copies of these authors' works are preserved at Worcester College in Oxford; see the Introduction.

40 G. Marcelline, *The Triumphs of King James the First* (1610), p. 31.

41 J. Thornborough, *A Discourse, showing the Great Happinesse, that hath, and may still accrue to his Majesties Kingdomes of ENGLAND AND SCOTLAND, BY RE-UNITING them into one Great Britain* (1641), pp. 221–2.

42 Thornborough, *A Discourse*, pp. 222, 234. On Aristotle as a source for this definition of justice, see Chapter Seven.

43 See Hart, *Art and Magic*, pp. 42–4, and Appendix One. See also Palme, *The Triumph of Peace*, pp. 183–91; G. Worsley, *Inigo Jones and the European Classicist Tradition* (2007), p. 171.

44 See J. Harris and G. Higgott, *Inigo Jones: Complete Architectural Drawings* (1989), p. 100, fig. 31 (Webb drawing).

45 See W. Hudson, *A Treatise of the Court of Star Chamber*, undated manuscript, Cambridge University Library, Add. 3106 [in F. Hargrave (ed.), *Collectanea Juridica*, vol. 2 (1792), pp. 1–239]. Sharpe, *Personal Rule of Charles I*, pp. 665–83.

46 See Harris and Higgott, *Inigo Jones*, pp. 98–100.

47 Orgel and Strong, *Inigo Jones*, vol. 2, p. 574, ll. 438–9. See Harris and Higgott, *Inigo Jones*, pp. 98–100, with reference to the 'Verie large starre'.

48 For the use of perfect numbers on the Banqueting House façade, see Hart, *Art and Magic*, p. 147.

49 See O. Millar, *The Tudor, Stuart and Early Georgian Pictures in the Collection of Her Majesty the Queen* (1963), vol. 1, p. 81, no. 104 (see pl. 45).

50 See Peacock, *Stage Designs of Inigo Jones*, p. 44.

51 On the influence of these proclamations, and Jones's role in enforcing them, see J. Summerson, *Inigo Jones* (2000 edn), pp. 78–9, D. Howarth, 'The Politics of Inigo Jones', in D. Howarth (ed.), *Art and Patronage in the Caroline Courts* (1993), pp. 68–89; Leapman, *Inigo*, pp. 183–6; M. Howard, *The Building of Elizabethan and Jacobean England* (2007), pp. 100–05.

52 James I, *By the King. A Proclamation for Building* (16 July 1615); James I, *By the King. A Proclamation declaring His Majesties further pleasure for matters of Buildings* (1619).

53 See W. Cobbett, ed., *The Parliamentary History of England* (1806–20), vol. 1, cols 1496–7.

54 *Gallus Castratus*, appended to *A Character of France* (1659), p. 12.

55 Before the close of 1630 Jones was made a Justice of the Peace for Westminster, enforcing an order from the Privy Council in 1631 to pull down a two-storey house in Long Acre; see J. Newman, 'Inigo Jones', in *Oxford Dictionary of National Biography* (2004), vol. 30, pp. 527–38. In 1621 Jones had become the MP for New Shoreham in Sussex, a seat controlled by the Earl of Arundel, serving just one year. See Leapman, *Inigo*, pp. 200–03 (MP), 221 (JP); Chaney (ed.), *Inigo Jones's 'Roman Sketchbook'*, vol. 2, pp. 24–5 nn. 41–3. On the Commission of 1618, see J. A. Gotch, *Inigo Jones* (1928), p. 118. The new commission appointed by Charles I in 1625 had Arundel's name at its head, and included that of Jones.

56 See Howard, *The Building of Elizabethan and Jacobean England*, p. 105, fig. 62. See also Worsley, *Inigo Jones and the European Classicist Tradition*, pp. 87, 124.

57 See R. Strong, *Britannia Triumphans: Inigo Jones, Rubens and Whitehall Palace* (1980); Hart, *Art and Magic*.

58 In Orgel and Strong, *Inigo Jones*, vol. 2, p. 457, ll. 338–43.

CHAPTER 5

1 See K. Thomas, 'English Protestantism and Classical Art', in L. Gent (ed.), *Albion's Classicism: The Visual Arts in Britain, 1550–1660* (1995), pp. 221–38; M. Howard, *The Building of Elizabethan and Jacobean England* (2007), pp. 98–100.

2 See Thomas, 'English Protestantism and Classical Art', p. 226.

3 See E. Angelicoussis, 'The Collection of Classical Sculptures of the Earl of Arundel, "Father of Vertu in England" ', *Journal of the History of Collections*, vol. 16, no. 2 (2004), pp. 143–59.

4 B. Jonson, 'To Penshurst' [written *c*.1612], ll. 1–3, 7–8, in *Ben Jonson: Works*, ed. C. Herford and P. Simpson (1925–52), vol. 11, p. 33. See W. A. McClung, *The Country House in English Renaissance Poetry* (1977). Jonson was Protestant most of his life, and certainly at the time of writing 'To Penshurst', when he was chief mythographer for the Protestant courts of James and Prince Henry. See also T. Mowl and B. Earnshaw, *Architecture without Kings: The Rise of Puritan Classicism under Cromwell* (1995), especially pp. 59–71 ('Puritan Minimalism and the Restoration Anticipated').

5 See G. Addleshaw and F. Etchells, *The Architectural Setting of Anglican Worship* (1948), p. 118.

6 J. Phillips, *The Reformation of Images: Destruction of Art in England, 1535–1660* (1973); M. Aston, *England's Iconoclasts* (1988); E. Duffy, *The Stripping of the Altars* (1992); J. Peacock, *The Stage Designs of Inigo Jones: The European Context* (1995), pp. 36–7; J. Spraggon, *Puritan Iconoclasm during the English Civil War: The Attack on Religious Imagery by Parliament and its Soldiers* (2003).

7 H. Wotton, *The Elements of Architecture* (1624), pp. 121–2. See Thomas, 'English Protestantism and Classical Art', p. 224. On Wotton, see C. Van Eck, 'Statecraft or Stagecraft? English Paper Architecture in the Seventeenth

Century', in S. Bonnemaison and C. Macy (eds), *Festival Architecture* (2008), pp. 114–17.

8 'Roman Sketchbook', Devonshire Collection, Chatsworth, fol. 76r. See E. Chaney (ed.), *Inigo Jones's 'Roman Sketchbook'* (2006) [transcribed in vol. 2, pp. 167–8]. See also the Preface for this quotation in full.

9 See, for example, Carlo Maderno's façade of Santa Susanna of 1597–1603. On the emerging Baroque, see, however, G. Worsley, *Inigo Jones and the European Classicist Tradition* (2007), p. 24. On the Protestant reading of the Orders in Europe, see M. Carpo, 'The Architectural Principles of Temperate Classicism: Merchant Dwellings in Sebastiano Serlio's Sixth Book', *Res*, vol. 22 (1992), p. 149. C. Randall, *Building Codes: The Aesthetics of Calvinism in Early Modern Europe* (1999). Serlio notes in his letter to the readers in the *Extraordinario libro di architettura*: 'you, O architects grounded in the doctrine of Vitruvius (whom I praise to the highest and from whom I do not intend to stray far), please excuse all these ornaments, all these tablets, all these scrolls, volutes and all these superfluities, and bear in mind the country where I am living, you yourselves filling in where I have been lacking' (fol. 2r). Here again, context – in this case (Catholic) France – played its part in determining the degree of fidelity to Vitruvian forms, linked to prevailing moral norms and acceptable licences.

10 J. Gordon, *The Union of Great Brittaine* (1604), pp. 41–2. Accordingly, it had been James's 'Ilands and Kingdome' that God chose, 'as a refuge for the true Christians which fled from the saide persecutions'; see Gordon, *England and Scotlands Happinesse* (1604), p. 24.

11 See G. Parry, *Golden Age Restor'd: The Culture of the Stuart Court, 1602–42* (1981), p. 112. M. D. Whinney, *Wren* (1971), p. 11; J. Levine, *Humanism and History* (1987), p. 83. M. Leapman, *Inigo: The Troubled Life of Inigo Jones, Architect of the English Renaissance* (2003), pp. 147–8.

12 W. Lithgow, *The totall discourse of the rare adventures, and painefull peregrinations long nineteen yeares travayles from Scotland to the most famous kingdoms in Europe, Asia and Affrica* (1632 edn), p. 14.

13 On Puritan suspicions of ancient arts, see Phillips, *Reformation of Images*, pp. 121–40.

14 On Laud in league with Henrietta Maria, see Spraggon, *Puritan Iconoclasm*, pp. 14–15, 38 (on Richard Montagu's arguments for relaxing the ban on images).

15 Spraggon, *Puritan Iconoclasm*, p. 52.

16 J. Hall, *Bishop Hall's Hard Measure, written by himself upon his Impeachment of high crimes and misdemeanours, for defending the Church of England* (1710), pp. 15–16.

17 T. Warmstry, *A Convocation Speech . . . against images, altars, crosses, the new canons and the oath, &c* (1641), pp. 9–10. P. Smart, *A Short treatise of Altars* (1641?), pp. 3–4.

18 Alberti, Book IX, chapter viii; see L. B. Alberti, *On the Art of Building in Ten Books*, trans. J. Rykwert, N. Leach and R. Tavernor (1988). Jones underlines the names in his edition.

19 See the Conclusion.

20 These translations in order are: Colonna, *Hypnero-*

tomachia. The Strife of Love in a Dreame, trans. 'R. D.' [Roger Dallington?] (1592); G. P. Lomazzo, *A Tracte Containing the Artes of Curious Paintinge, Carvinge & Buildinge*, trans. R. Haydocke (1598); H. Blum, *The Booke of five collumnes of Architecture*, trans. 'I. T.' [John Thorpe] (1601); S. Serlio, *The first (-fift) Book of Architecture, made by Sebastian Serly, entreating of Geometrie. Translated out of Italian into Dutch, and out of Dutch into English*, trans. R. Peake (1611). Thorpe also produced drawn studies of the Orders; see J. Summerson (ed.), *The Book of Architecture of John Thorpe in Sir John Soane's Museum* (1966). See also V. Hart and P. Hicks (eds), *Paper Palaces: The Rise of the Renaissance Architectural Treatise* (1998); E. Harris and N. Savage, *British Architectural Books and Writers, 1556–1785* (1990).

21 S. Serlio, *Sebastiano Serlio on Architecture* (1996–2001), vol. 1 [Books I–V of *Tutte l'opere d'architettura et prospetiva*, trans. V. Hart and P. Hicks], Book IV, fol. 186v [p. 369]. Jones owned and annotated a number of editions, namely the 1600 Venice printing of *Tutte l'Opere d'Architettura et Prospettiva di Sebastiano Serlio*, which is now held in the Canadian Centre for Architecture, Montreal (Webb's 1619 edition is held at the British Architectural Library at the Royal Institute of British Architects, London). Jones also owned a separate copy comprising Books I–IV and part of Book V, published in Venice in the years 1559–62 and now in The Queen's College in Oxford.

22 Book IV, fol. LXIIIIv (Serlio, *Sebastiano Serlio on Architecture*, vol. 1, p. 368); Serlio, *The first (-fift) Book of Architecture*, trans. Peake, fol. 61v.

23 Quoted in full in the Preface. On links between architectural and moral decorum, see Hart and Hicks, *Paper Palaces*, vol. 2, pp. xxxiv–xxxvii. On Serlio as Jones's main source for the concept of ornamental licentiousness, see L. E. Semler, 'Inigo Jones, Capricious Ornament and Plutarch's Wise Men', *Journal of the Warburg and Courtauld Institutes*, vol. 66 (2003), pp. 129–30.

24 See J. Harris and G. Higgott, *Inigo Jones: Complete Architectural Drawings* (1989), p. 76. Jones's design for the Vineyard gateway at Oatlands Palace, Surrey (1617; see Harris and Higgott, *Inigo Jones*, p. 76, cat. no. 17), is based on Serlio's gates, for example Rustic gate VI, from his *Extraordinario libro di architettura* (1551; see Serlio, *Sebastiano Serlio on Architecture*, vol. 2, p. 468).

25 Serlio, Book VII, p. 126 (Serlio, *Sebastiano Serlio on Architecture*, vol. 2, p. 208).

26 Ideas from Serlio's Book VII are reflected by Jones in his 'Roman Sketchbook' (fol. 77v) when contrasting 'rich or Playne Cap[r]iccious or Sodo' (see p. 154); on sodo ('solid') in Serlio, see Serlio *Sebastiano Serlio on Architecture*, vol. 2, p. 597. Jones's screen at Winchester Cathedral of 1637–8 (see Fig. 250; see also Harris and Higgott, *Inigo Jones*, p. 250, cat. no. 81) was based on Serlio's screen models in Book VII, pp. 120–27, which he explained through the use of terms such as 'solid'.

27 A. W. Johnson, 'Angles, Squares or Roundes: Studies in Jonson's Vitruvianism', unpublished D.Phil. thesis, Oxford University (1987), p. 170.

28 See G. Higgott, ' "Varying with reason": Inigo Jones's Theory of Design', *Architectural History*, vol. 35 (1992), p. 63; see also chapters Six and Seven.

29 Harris and Savage, *British Architectural Books and Writers*, pp. 418–22. See also M. Howard, 'The Ideal House and Healthy Life: The Origins of Architectural Theory in England', in J. Guillaume (ed.), *Les Traités d'architecture de la Renaissance* (1988), pp. 425–33.

30 The dedication reflected the Reformist policy and prejudices of Shute's erstwhile patron, John Dudley, 1st Duke of Northumberland; Dudley, as Shute mentions in his dedication, had sent him to Italy to study architecture in 1550. Dudley was a dedicated Protestant up until his late reversion to Catholicism, under the influence of his imminent execution, in 1553 following the death of Edward VI. See D. Loades, *John Dudley, Duke of Northumberland, 1504–1553* (1996); Loades, 'John Dudley', in *Oxford Dictionary of National Biography* (2004), vol. 17, pp. 81–3.

31 The illustrations of the type employed by Shute and the Orders themselves were seen as emblems, as Jonson confirmed concerning the pilasters used on the arches of 1604 (see Chapter Two). Shute's illustrations would have been understood by contemporaries as equivalent to moral emblems, or 'trikes and devises' (sig. Aijr), as he called the architectural drawings that he brought back from Italy. The preface hints at the Orders' 'depe secretes' (sig. Aijv), which were surely signified by these illustrations. Geoffrey Whitney in *A Choice of Emblems, and other devises* (1586) defined an emblem as: 'having some wittie device expressed with cunning woorkemanship, something obscure to be perceived at the first, whereby, when with further consideration it is understood, it maie the greater delighte the behoulder'; see M. Girouard, *Robert Smythson and the Elizabethan Country House* (1983), p. 27. These emblem collections were frequently used by Elizabethan artists in creating frontispieces and other didactic signs capable of moral instruction, in which the Orders often made an appearance.

32 Book IV, fol. IIIr (Serlio, *Sebastiano Serlio on Architecture*, vol. I, p. 254).

33 J. Rykwert, *The Dancing Column: On Order in Architecture* (1996), p. 34.

34 Vitruvius IV.vii. On the Rustic as a form of Tuscan, extensively illustrated by Serlio in Book IV, see J. Ackerman, 'The Tuscan/Rustic Order: A Study in the Metaphorical Language of Architecture', in Ackerman, *Distance Points: Essays in Theory and Renaissance Art and Architecture* (1991), pp. 495–541.

35 On Shute's readership, see Harris and Savage, *British Architectural Books and Writers*, p. 421; J. A. Bennett, 'Architecture and Mathematical Practice in England, 1550–1650', in J. Bold and E. Chaney (eds), *English Architecture: Public and Private. Essays for Kerry Downes* (1993), p. 28. Shute's reference excludes any ambiguity as to Pandora's character, given that later, Roman writers had identified her jar as a bringer of blessings. See, for example, Babrius in the *Fables*, 58.

36 Hesiod, 'Works and Days', in *The Homeric Hymns and Homerica*, trans. G. H. Evelyn-White (1967), ll. 54–105.

37 E. Gurnay, *Gurnay Redivivus; or, An Appendix unto the Homily against Images in Churches* (1660 edn), pp. 8, 20–23, 59.

38 Curiously enough, this distinction is emphasised by the fact that the Composite was illustrated by Shute with a woodcut whilst the other four Orders were engraved.

39 Jones in Palladio, Book II, p. 10: he uses the term 'Opera bastarda' elsewhere to refer to ornament breaking the rules, for example, Book IV, pp. 66, 81 (see Chapter Seven, n. 56). For Serlio's use of the term 'bastard' linked to licentious, see Serlio, *Sebastiano Serlio on Architecture*, vol. 2, p. xxii, and citations listed in the index, p. 633; on Jacopo Strada's translation of 'bastardo' into Latin as 'composito' (Composite), see ibid., p. 260 n. 586. On Serlio as Jones's main source for the concept of ornamental licentiousness, see Semler, 'Inigo Jones, Capricious Ornament and Plutarch's Wise Men', pp. 129–30.

40 On Jones as a Neoplatonist, see V. Hart, *Art and Magic in the Court of the Stuarts* (1994).

41 Hesiod, 'Works and Days', ll. 110–200. Vitruvius hinted that collectively the Orders signified the five ages of man (Rykwert, *Dancing Column*, p. 32), although obviously the actual chronology of the Orders' invention, as described by him (Vitr. IV.i.6–8), and repeated by Shute, is not reflected by the columns' ornamental hierarchy, which places Roman Tuscan before the Greek trio.

42 In any case the rustic Tuscan was an appropriate sign of Arcadia since, following Serlio, Shute determined that it was 'named after the sayde countrey Tuscana' (sig. Biir), and Tuscany/Etruria was commonly considered the origin of the Italian race traced back to the fabled Golden Age of Troy; see G. Morolli, '*Vetus Etruria*' (1985); Hart, *Art and Magic*, p. 53. See also Chapter One.

43 F. Yates, *Astraea: The Imperial Theme in the Sixteenth Century* (1985), especially on engravings of Elizabeth with Corinthian columns, by Vertue after Isaac Oliver (fig. 8b), Remigius Hogenberg (fig. 8d). See Chapter Three.

44 The translation by Robert Dallington of Colonna's *Hypnerotomachia*, published in 1598, modified the Italian to appeal to educated, militant Protestants associated with the court. Most notable in this regard was the book's dedicatee, Sir Philip Sidney, and his followers, such as the Earl of Essex. For example, Dallington inserted local analogies, comparing Colonna's rotating statue of a 'beautifull nymph' crowning a temple with the noise of 'the mynte of the Queene of England' and the 'tower bell of Saint Iohns College in the famous Vniuersitie of Cambridge'. Cambridge was a seat of English Calvinism in the decades leading up to the early 1590s. See L. E. Semler, 'Robert Dallington's *Hypnerotomachia* and the Protestant Antiquity of Elizabethan England', *Studies in Philology*, vol. 103 (2006), pp. 208–41.

45 Haydocke censored the more extreme manifestations of Lomazzo's Mannerist theory, imbued as this was with

Counter-Reformation principles. An opening letter from a canon of Salisbury, Dr John Case, commended these 'corrections', for where Lomazzo, 'trippeth you hold him up, and where he goeth out of the way, you better direct his foote' (sig. ★j*v*). The biblical quotation from Ecclesiastes on Haydocke's frontispiece ran: 'In the handes of the skilfull shall the worke be approved, Eccl. 9.19', and was specifically intended to justify the study and practice of art and architecture against Puritan iconoclasm. Consequently, Haydocke omitted from Lomazzo's preface 'a large discourse of the use of Images' because 'it crosseth the doctrine of the reformed Churches', added to the third book 'A Briefe Censure of The Booke of Colours', and in a marginal note in the fourth book protested against representations of God the Father. Lomazzo, *A Tracte Containing the Artes of Curious Paintinge, Carvinge & Buildinge*, pp. 3–4, 152. See M. Corbett and R. Lightbown, *The Comely Frontispiece: The Emblematic Title-Page in England, 1550–1660* (1979), pp. 67–78. See also Phillips, *Reformation of Images*; Peacock, *Stage Designs of Inigo Jones*, pp. 37, 120; Harris and Savage, *British Architectural Books and Writers*, p. 297.

46 Fols 30*v*–31*r*. See Peacock, *Stage Designs of Inigo Jones*, p. 227; Worsley, *Inigo Jones and the European Classicist Tradition*, pp. 99–100. See also the Introduction.

47 Randall, *Building Codes*, pp. 78–137. On Jones's use of Hans Vredeman de Vries, see Peacock, *Stage Designs of Inigo Jones*, pp. 93–6.

48 See Peacock, *Stage Designs of Inigo Jones*, p. 98.

49 The Banqueting House's basement has a form of Tuscan rustication described by Serlio as 'diagonal cut': Book IV, fol. 138*v*.

50 This followed the arrangement of Serlio's Book IV: later, in 1601, the English 'Blum' had the same arrangement, and concluded with advice on how to build the five Orders, one on top of the other.

51 The Old School's tower followed the four-storey 'frontispiece of the Orders' (Doric, Ionic, Corinthian, Composite) in the Fellow's Quadrangle of Merton College, of 1608–10, commissioned by Henry Savile. On five 'Towers of the Orders' (Burghley House, Lincolnshire; Stoneyhurst, Lancashire; Merton College, Oxford; Hatfield House, Hertfordshire; and Old Beaupre, Glamorganshire), see M. Girouard, *Elizabethan Architecture: Its Rise and Fall, 1540–1640* (2009), pp. 311–16.

52 See L. Stone, 'The Building of Hatfield House', *Archaeological Journal*, vol. 112 (1955), pp. 118–20; Leapman, *Inigo*, pp. 93, 106–7; P. M. Hunneyball, *Architecture and Image-Building in Seventeenth-century Hertfordshire* (2004); Worsley, *Inigo Jones and the European Classicist Tradition*, pp. 10–11.

53 See C. Anderson, 'Learning to Read Architecture in the English Renaissance', in L. Gent (ed.), *Albion's Classicism*, p. 250. In the frontispiece to Walter Raleigh's *The History of the World* (1614), for example, a column emblazoned with books formed a pillar of knowledge (see Fig. 63); see Corbett and Lightbown, *The Comely Frontispiece*, pp. 128–35. The Orders were to play their

part in the instruction of a gentleman, as Jones's friend Henry Peacham's inclusion of architecture in *The Complete Gentleman* (1622) made clear. On the columns as emblems of learning, see also C. Anderson, *Inigo Jones and the Classical Tradition*, p. 139. On 'The Architectural and Mathematical Model' of Clement Edmondes, *c.*1620, with all five Orders decorating a pilaster and similar didactic pretensions, see A. Gerbino and S. Johnston, *Compass and Rule: Architecture as Mathematical Practice in England, 1500–1750* (2009), pp. 72–9.

54 Dedication in G. Chapman, *The Divine Poem of Musaeus* (1616). On this, see Anderson, *Inigo Jones and the Classical Tradition*, pp. 136–7.

55 Hesiod's 'Works and Days' was widely available in Latin or the original Greek.

56 Wotton, *The Elements of Architecture*, p. 122. Wotton, *A Philosophical Survey of Education; or, Moral Architecture, and The Aphorisms of Education*, ed. H. S. Kermode (1938). This work was unfinished when Wotton died in 1639.

57 Wotton, *The Elements of Architecture*, p. 106.

58 Wotton, *The Elements of Architecture*, pp. 33, 35.

59 Wotton, *The Elements of Architecture*, p. 37.

60 1 Corinthians 5.12. See G. L. Hersey, *The Lost Meaning of Classical Architecture* (1988), p. 66.

61 Wotton, *The Elements of Architecture*, p. 8.

62 Wotton, *The Elements of Architecture*, p. 39.

63 On agreement between Jones and Wotton, see R. Wittkower, *Palladio and English Palladianism* (1974), p. 143; Harris and Savage, *British Architectural Books and Writers*, p. 502.

64 See P. Palme, *The Triumph of Peace: A Study of the Whitehall Banqueting House* (1957). Objections to the Spanish Match are recorded in Wotton to Dudley Carleton, 18 December 1621; see H. Wotton, *The Life and Letters of Sir Henry Wotton*, ed. L. P. Smith (1907), vol. 2, p. 222; Wotton to Venetian Cabinet, 18 May 1623, in *Calendar of State Papers Venetian*, vol. 17: *1621–1623*, ed. A. B. Hinds, London, 1911.

65 Wotton, *The Elements of Architecture*, p. 115.

66 See Carpo, 'Architectural Principles of Temperate Classicism', pp. 135–51, 148–9.

67 See Randall, *Building Codes*, pp. 179–86; Worsley, *Inigo Jones and the European Classicist Tradition*, pp. 45–6.

68 See Gerbino and Johnston, *Compass and Rule*, pp. 17–64. On Dee, see P. J. French, *John Dee: The World of an Elizabethan Magus* (1972); A. G. Debus, *John Dee's Preface* (1975); N. Clulee, *John Dee's Natural Philosophy: Between Science and Religion* (1988); W. H. Sherman, *John Dee: The Politics of Reading and Writing in the English Renaissance* (1995); Bennett, 'Architecture and Mathematical Practice', pp. 23–9.

69 As advanced by Roger Ascham and others; see S. Johnston, 'The Identity of the Mathematical Practitioner in 16th-century England', in I. Hantsche (ed.), 'Der "mathematicus": Zur Entwicklung und Bedeutung einer neuen Berufsgruppe in der Zeit Gerhard Mercators', *Duisburger Mercator-Studien*, vol. 4 (1996), p. 107.

70 J. Dee, 'Mathematical Preface', in *EUCLID. The elements of geometrie of the most auncient philosopher Euclide of*

Megara. Translated into Englishe, by H. Billingsley with a very fruitfull praeface by M. I. Dee (1570), sig. Aijv.

71 See C. Anderson, 'The Secrets of Vision in Renaissance England', in L. Massey (ed.), *The Treatise on Perspective: Published and Unpublished* (2003), p. 325.

72 Dee, 'Mathematical Preface', sig. diij.

73 I. Jones, *The MOST NOTABLE ANTIQUITY OF GREAT BRITAIN, Vulgarly called STONE-HENG, ON SALISBURY PLAIN, RESTORED* (1655), pp. 34–5: Jones, or possibly Webb writing in his master's name, went on to link this method to the construction of the new west front of St Paul's Cathedral; see Appendix One. Dee's Euclid may well have been owned by Prince Henry; see T. A. Birrell, *English Monarchs and their Books: From Henry VII to Charles II* (1986), p. 33. See also Anderson, *Inigo Jones and the Classical Tradition*, p. 241 n. 164 (although the handwriting attribution is questionable).

74 Cornelis Claesz's *Den Eersten (-Vijfsten) Boeck van Architecturen Sebastiani Serlii*, Amsterdam (1606).

75 See the Introduction; R. Strong, *Henry Prince of Wales and England's Lost Renaissance* (1986), pp. 134, 150.

76 Serlio's title of Book IV – the '*Regole generali di architettura . . . sopra le cinque maniere de gli edifice*', or 'General Rules of Architecture . . . on the five styles of building' – was rendered as 'Rules for Masonry, or Building *with Stone or Bricke, made after the five maners* or orders of Building'. This emphasised the book's practical value to a native workforce and the new style's reliance on traditional English materials and crafts. See J. Rykwert, 'On the Oral Transmission of Architectural Theory', *AA Files, Annals of the Architectural Association School of Architecture*, no. 6 (May 1984), pp. 1–27; Anderson, 'The Secrets of Vision', p. 328. See also L. Gent, ' "The Rash Gazer": Economies of Vision in Britain, 1550–1660', in Gent (ed.), *Albion's Classicism*, p. 384. On Serlio's early influence, see J. Summerson, *Architecture in Britain, 1530 to 1830* (1993 edn), p. 529 n. 7. D. Yeomans, 'The Serlio Floor and its Derivations', *Architectural Research Quarterly*, vol. 2 (1997), pp. 74–83. On editions of Serlio in English collections, see L. Gent, *Picture and Poetry, 1560–1620: Relations between Literature and the Visual Arts in the English Renaissance* (1981), pp. 66–86.

77 Serlio, *The first (-fift) Book of Architecture*, trans. Peake: 'To the High and Mightie Prince, Henry, Prince of Wales'.

78 See Peacock, *Stage Designs of Inigo Jones*, pp. 58–9, 286–91. See also J. Summerson, 'Three Elizabethan Architects', *Bulletin of the John Rylands Library*, vol. 40 (1957), pp. 202–28 [Robert Adams, Robert Stickells and John Symonds]; J. Summerson, *Inigo Jones* (1966), pp. 15–16; Gerbino and Johnston, *Compass and Rule*, pp. 45–64; Anderson, *Inigo Jones and the Classical Tradition*, pp. 38–9.

79 Serlio, *The first (-fift) Book of Architecture*, trans. Peake: 'The fourth Booke', fol. 71.

80 See Harris and Savage, *British Architectural Books and Writers*, 'Serlio', pp. 414–17; R. Middleton et al. (eds), *The Mark J. Millard Architectural Collection. British Books:*

Seventeenth through Nineteenth Centuries, vol. 2 (1998): 'Sebastiano Serlio', no. 74, pp. 267–71.

81 J. Webb, *A VINDICATION OF Stone-Heng Restored* (1665 edn), p. 11. Jones owned Euclid, *De gli elementi d'Euclide libri quindici*, trans. F. Commandino, Urbino, 1575 (un-annotated); *Geometria prattica . . . sopra le tauole dell'Ecc^de Mathematico Giovanni Pomodoro*, Rome, 1603 (un-annotated); G. Viola Zanini, *Della architettura*, Padua, 1629 (annotated, pp. 7–28). Jones's copy of Palladio, Book I, p. 53 (chapter 23), l. 18, against diagram, 'how to find this heyg[ht] Geometrically, / Euclid the 6 Book Propo: 13'. See Worsley, *Inigo Jones and the European Classicist Tradition*, especially pp. 71–91, 137–55. See Gerbino and Johnston, *Compass and Rule*, pp. 65–82 ('The Vitruvian Model: Inigo Jones and the Culture of the Book').

82 B. Jonson, *Love's Welcome at Bolsover* [1634], in *Works*, ed. Herford and Simpson (1925–52), vol. 7, ll. 67–70. See Hart, *Art and Magic*, pp. 151–2.

83 See A. W. Johnson, *Ben Jonson: Poetry and Architecture* (1994).

84 See Strong, *Henry Prince of Wales and England's Lost Renaissance*, pp. 171–2. Peacock, *Stage Designs of Inigo Jones*, p. 77.

85 Jones, *STONE-HENG . . . RESTORED*, p. 33.

86 Whinney P4, see Fig. 51. R. Strong, *Britannia Triumphans: Inigo Jones, Rubens and Whitehall Palace* (1980), p. 61 and fig. 58.

87 Hart, *Art and Magic*, pp. 115–21; on the use of a compass on this cathedral elevation, see R. Wittkower, 'Inigo Jones, Architect and Man of Letters', *Journal of the Royal Institute of British Architects*, vol. 60 (1953), pp. 83–90 [reprinted in *Palladio and English Palladianism*, 1974, pp. 51–66]; Gerbino and Johnston, *Compass and Rule*, pp. 69–71.

88 These sweeps are, as far as can be gauged, of about the same radius as the perimeter circle, and against Serlio's drawing of a Tuscan gate, Book IV, chapter 5, fol. 9 in his 1559–62 edition of Serlio Jones annotates 'X the centor . . .').

89 See the Introduction, pp. 30–31.

90 Webb, *A VINDICATION OF Stone-Heng Restored* (1725 edn), p. 57.

91 Dictating the use of triangles in the setting out of the building.

92 G. Marcelline, *The Triumphs of King James the First* (1610), pp. 14, 34.

CHAPTER 6

1 Devonshire Collection, Chatsworth, fol. 76r. See the Preface, pp. xiii–xiv, and E. Chaney (ed.), *Inigo Jones's 'Roman Sketchbook'* (2006) [transcribed in vol. 2, pp. 167–8]; the date given by Jones is 1614, but see vol. 2, pp. 37–8, on the (New Style) dating to 1615, and J. A. Gotch, *Inigo Jones* (1928), p. 81. It is possible, of course, that the date is correct and reflected the Italian calendar. On this passage, see especially C. Anderson, *Inigo*

Jones and the Classical Tradition (2007), pp. 104–6, 150–56; L. E. Semler, 'Inigo Jones, Capricious Ornament and Plutarch's Wise Men', *Journal of the Warburg and Courtauld Institutes*, vol. 66 (2003), pp. 123–42.

2 Jones remarked concerning Scamozzi's Palazzo Trissino: 'Thear a great Pallas begon by Scamozio but y^e order w^th in agreith not w^th that without w^ch is an Ionicke Portico that within is Dorricke and lower': last note, fifth (last) flyleaf before title page in his copy of Palladio's *I quattro libri*.

3 H. Wotton, *The Elements of Architecture* (1624), pp. 96–7. See S. Roberts, 'Lying among the Classics: Ritual and Motif in Elite Elizabethan and Jacobean Beds', in L. Gent (ed.), *Albion's Classicism: The Visual Arts in Britain, 1550–1660* (1995), pp. 347–8.

4 See G. Higgott, ' "Varying with reason": Inigo Jones's Theory of Design', *Architectural History*, vol. 35 (1992), pp. 51–77; and more generally J. Onians, 'Style and Decorum in Sixteenth-century Italian Architecture', unpublished PH.D. thesis, Warburg Institute, London University (1968).

5 Vitr. I.ii.5–7: see *On Architecture*, trans. F. Granger (1983 edn), p. 29. Serlio, Book IV (1537), fol. IIIr–v (S. Serlio, *Sebastiano Serlio on Architecture*, 1996–2001, vol. 1, p. 254). See J. Ackerman, 'The Tuscan/Rustic Order: A Study in the Metaphorical Language of Architecture', in Ackerman, *Distance Points: Essays in Theory and Renaissance Art and Architecture* (1991), pp. 495–541. On the Orders as emblems, see V. Hart, *Art and Magic in the Court of the Stuarts* (1994), pp. 73–4; J. Onians, *Bearers of Meaning: The Classical Orders in Antiquity, the Middle Ages and the Renaissance* (1988); and Onians, 'Style and Decorum'.

6 Jonson in *The Masque of Queens* (1609) noted 'that the Nobilyty of the Invention should be answerable to the dignity of theyr persons'; see J. Peacock, *The Stage Designs of Inigo Jones: The European Context* (1995), p. 132. On costume and architectural decorum, see Anderson, *Inigo Jones and the Classical Tradition*, pp. 154–5.

7 Wotton, *The Elements of Architecture*, p. 119.

8 Book I, chapter 2, p. 27, l. 28 (of Daniele Barbaro's commentary in his 1567 edition of Vitruvius).

9 Devonshire Collection, Chatsworth, fols 77v–78r. See Peacock, *Stage Designs of Inigo Jones*, pp. 229–30. See also Chapter Five, n. 26.

10 See Hart, *Art and Magic*. See also G. Worsley, *Inigo Jones and the European Classicist Tradition* (2007), p. 94.

11 See Higgott, ' "Varying with reason" '. See also Anderson, *Inigo Jones and the Classical Tradition*, pp. 108–9, 150–51. Jones notes in his Palladio, Book IV, p. 47: 'how y^e ancients varied w^th reason'.

12 I. Jones, *The MOST NOTABLE ANTIQUITY OF GREAT BRITAIN, Vulgarly called STONE-HENG, ON SALISBURY PLAIN, RESTORED* (1655 edn), pp. 89–90.

13 Worsley, *Inigo Jones and the European Classicist Tradition*; see especially p. 43 and chapter 6, pp. 71–91. Worsley does not mention the influence of shifting attitudes to religious toleration on ornamental display, presenting a case for a pure application (or avoidance) of ornament irrespective of political/religious circumstance. He has demonstrated that Jones's unprecedented use of the Serliana was indebted to its established European use in imperial imagery, and in religious iconography associated with Christ such as Mario Dente's engraving after Raphael of *The Last Supper* (c.1514). Worsley maintains that Jones's use of the Serliana, restricted as it was to his royal projects, reflected Serlio's use of the motif in model palaces illustrated in his unpublished Sixth Book, and as such derived its meaning as a symbol of sovereignty. The inevitable republican overtones of a window form associated for the most part with Venice confuse this reading somewhat, however.

14 Peacock demonstrates that 'The nuances of architectural decorum in the social sense can be seen in the differences between the productions Jones designed for the King and Queen in the 1630s'; Peacock, *Stage Designs of Inigo Jones*, pp. 88–9, 96–104, 238–40.

15 Peacock, *Stage Designs of Inigo Jones*, pp. 240, 265.

16 Semler, 'Inigo Jones, Capricious Ornament and Plutarch's Wise Men', p. 140, observes that Jones's 'ornamentation is linked to personal and political themes'.

17 According to the chronology of Jones's handwriting as determined by John Newman, Jones began annotating his Palladio some time between 1601 and 1610. Towards the end of this period he was also making notes in his copy of Barbaro's *Vitruvius* and his folio edition of Serlio's *Libro primo [-quinto] d'architettura* (Venice, 1559–62; now at The Queen's College Library, Oxford). See J. Newman, 'Italian Treatises in Use: The Significance of Inigo Jones's Annotations', in J. Guillaume (ed.), *Les Traités d'architecture de la Renaissance* (1988), p. 436.

18 Fol. 139r (Serlio, *Sebastiano Serlio on Architecture*, vol. 1, p. 281). Serlio's Fifth Book (on temples) was dedicated to the arch-Protestant Marguerite of Navarre. His dedication of a book containing designs based on Vitruvian principles to a Protestant noble is perfectly balanced, according to my argument here, by his dedication of a subsequent book containing 'licentious' gate designs to the Catholic monarch of France, Henri II.

19 Serlio (1559–62 edn), The Queen's College Library, Oxford, fol. 17r, l. 8 (which he underlines); square brackets denote letters cut off by the trimming of the fore-edge of the volume. See Higgott, ' "Varying with reason" ', pp. 51–77.

20 As well as on an archway probably designed for the entrance of knights during the performance of a barriers; see Peacock, *Stage Designs of Inigo Jones*, pp. 62–4.

21 J. Williams, *Great Britains SALOMON* (1625), p. 8 n.a.

22 Fol. 169r (Serlio, *Sebastiano Serlio on Architecture*, vol. 1, p. 340).

23 The Corinthian Order was dominant on Catholic church façades from Constantine onwards; see Onians, *Bearers of Meaning*, pp. 310–14.

24 Fol. 183r (Serlio, *Sebastiano Serlio on Architecture*, vol. 1, p. 364). Alberti also referred to the Composite as the 'Italian' Order: Book VII, chapter vi; see L. B. Alberti,

On the Art of Building in Ten Books, trans. J. Rykwert, N. Leach and R. Tavernor (1988), p. 201.

25 In Jones's *Palladio*, Book IV, p. 55.

26 See J. Harris and G. Higgott, *Inigo Jones: Complete Architectural Drawings* (1989), p. 84: 'Jones did not return from Italy in 1615 ready to be the full-fledged British Palladio or Vitruvius. There was a need to settle in, and to assess his new role as Surveyor of the King's Works.' R. Tavernor, *Palladio and Palladianism* (1991), pp. 125–6: 'A fully formed classicism did not develop immediately. It took Jones time to assimilate the experience and knowledge gained on his last Italian trip. Also, he had to redirect the energies of the workforce he had taken over from Basil, and train them to meet his own new and more rigorous architectural standards'. See also G. Worsley, *Classical Architecture in Britain: The Heroic Age* (1995).

27 See J. Buxton, *Elizabethan Taste* (1963), p. 70; M. Girouard, *Robert Smythson and the Elizabethan Country House* (1983); J. Summerson, *Architecture in Britain, 1530 to 1830* (1993 edn), pp. 61–80; Girouard, *Elizabethan Architecture: Its Rise and Fall, 1540–1640* (2009).

28 Girouard (*Robert Smythson and the Elizabethan Country House*, p. 166) describes the later development of Robert Smythson's rural Elizabethan architecture as a process of 'simplifying, consolidation, clarifying, leaving out', a tendency that culminated in Hardwick Hall, the epitome of Elizabethan 'temperate classicism'. Although Bess of Hardwick was not known as particularly religious (her own religious beliefs are unclear), she was certainly sympathetic to the Protestant cause, choosing Elizabeth I as the godmother of her first son, Henry, and acting as gaoler of Mary Queen of Scots between 1569 and 1585 (see C. R. N. Routh, *Who's Who in Tudor England*, 1990, p. 276). Most of Smythson's later patrons were Protestant; see M. Girouard, *Robert Smythson and the Architecture of the Elizabethan Era* (1966), p. 212. In contrast, Sir Christopher Hatton, patron of the ostentatious Holdenby and Kirkby, was almost certainly brought up a Catholic (Routh, *Who's Who*, p. 235).

29 See Girouard, *Robert Smythson and the Elizabethan Country House*, pp. 35–6.

30 See Chapter Five, p. 142.

31 See Chapter Five, p. 129.

32 See D. Howard, *Scottish Architecture: Reformation to Restoration, 1560–1660* (1995), p. 31. See also K. Thomas, 'English Protestantism and Classical Art', in L. Gent (ed.), *Albion's Classicism: The Visual Arts in Britain, 1550–1660* (1995), p. 229.

33 The portico has much-simplified Corinthian columns and cornice (almost a 'decorated' Doric capital), possibly in reference to the established Elizabethan iconography of kingship and to Solomon's Temple upon which the chapel was based (see Fig. 73). See Howard, *Scottish Architecture*, p. 33; A. McKechnie [Mackechnie], 'James VI's Architects and their Architecture', in J. Goodare and M. Lynch (eds), *The Reign of James VI* (2000), pp. 154–69.

34 A. McKechnie [Mackechnie], 'Sir David Cunningham of Robertland: Murderer and "Magna Britannia's" First Architect', *Architectural History*, vol. 52 (2009), pp. 79–115.

35 In James I, *The Political Works of James I*, ed. C. H. McIllwain (1918), p. 6.

36 James I, *Political Works*, p. 43.

37 The book was first mentioned in 1598; see S. R. Gardiner, *History of England from the Accession of James I to the Outbreak of the Civil War, 1603–1642* (1896), vol. 1, p. 75.

38 See B. Coward, *The Stuart Age: A History of England, 1603–1714* (1980), p. 111.

39 See Gardiner, *History of England*, pp. 234–64; D. Harris Willson, *King James VI and I* (1956), pp. 217–42; Coward, *The Stuart Age*, pp. 104–31.

40 The elevation of the Star Chamber with its Corinthian pilasters is a revised scheme in John Webb's hand from Jones's design (of which only a plan remains); see Harris and Higgott, *Inigo Jones*, p. 98, cat. no. 29 and fig. 31: 'It would seem that Webb reworked Jones's drawings in a more baroque manner'.

41 P. Palme, *The Triumph of Peace: A Study of the Whitehall Banqueting House* (1957). On the use of ornate decoration on the façade of the Banqueting House, related to contemporary ecumenical events, see here Chapter Seven.

42 In this Doric form the catafalque was true to Fontana's original source, Bramante's Tempietto; see J. Peacock, 'Inigo Jones's Catafalque for James I', *Architectural History*, vol. 25 (1982), pp. 1–5. Peacock, *Stage Designs of Inigo Jones*, p. 31, notes: 'The inwardness of the statement shows how deeply [Jones's] ideals are marked, culturally and aesthetically, by Protestantism'. See also Harris and Higgott, *Inigo Jones*, pp. 186–7, cat. no. 53; Anderson, *Inigo Jones and the Classical Tradition*, pp. 157–61.

43 Higgott, ' "Varying with reason" ', pp. 69–70.

44 See S. Orgel and R. Strong, *Inigo Jones: The Theatre of the Stuart Court* (1973), vol. 1, pls 61, 62 and 63. This 'Doric' façade replaced a design of an ornate arcade with Corinthian columns buried within a cavern: ibid., vol. 1, pl. 61. Harris and Higgott, *Inigo Jones*, pp. 44–6 (see Fig. 224).

45 Orgel and Strong, *Inigo Jones*, vol. 1, pl. 89.

46 Orgel and Strong, *Inigo Jones*, vol. 1, pl. 113. Inscribed 'Cupid's Palace'; as Orgel and Strong note (p. 329): 'No masque that we have records for refers to Cupid's Palace. The drawing could conceivably relate to the lost productions of 1619 or 1621 . . . The setting could even have been for one of the unperformed shows and pageants Jones was instructed to prepare for the arrival of the Infanta in June 1623.' See J. Summerson, *Inigo Jones* (1966 edn), p. 74.

47 See, respectively, 'Proscenium and Standing Scene' (Orgel and Strong, *Inigo Jones*, vol. 2, pls 123 and 135), 'A Roman Atrium' (ibid., vol. 2, pl. 191), 'The Vale of Tempe' (ibid., vol. 2, pl. 216), 'A Palace in Trees' (ibid., vol. 2, pl. 246), 'Side Wings of a City in Ruins' (ibid., vol. 2, pl. 279), 'The Palace of Fame' (ibid., vol. 2,

pl. 339), 'The Suburbs of a Great City in Ruins' (ibid., vol. 2, pl. 409).

48 See G. Higgott, 'The Design and Setting of Inigo Jones's Queen's House, 1616–40', *Court Historian*, vol. 11, no. 2 (2006), pp. 135–48; Higgott, 'Inigo Jones's Designs for the Queen's House in 1616', in M. Airs and G. Tyack (eds), *The Renaissance Villa in Britain, 1500–1700* (2007), pp. 140–66.

49 Harris and Higgott, *Inigo Jones*, p. 68, cat. no. 14.

50 Harris and Higgott, *Inigo Jones*, p. 70, cat. no. 15. The plan of this scheme is reconstructed in Higgott, 'Inigo Jones's Designs for the Queen's House in 1616', p. 153.

51 The 1616 design for the Queen's House was much narrower; see Higgott, 'The Design and Setting of Inigo Jones's Queen's House', pp. 137–9.

52 Henry Wickes, Paymaster of the Works, notes in his accounts for 1 October 1629 to 30 September 1630: '. . . viz.ᵗ in framing and setting up A newe Roofe over the Arch of the newe building . . . Thatchers ymployed in thatching the Roofe of the Arche of the new building' (The National Archives, Kew, E. 351/3263; A.O.I, 60/2426). See G. H. Chettle, *The Queen's House, Greenwich* (1937), pp. 30, 103. J. Bold, *Greenwich: An Architectural History of the Royal Hospital for Seamen and the Queen's House* (2000), pp. 44–61, especially p. 52.

53 Harris and Higgott, *Inigo Jones*, p. 65. Bold, *Greenwich*, p. 46.

54 Higgott, 'The Design and Setting of Inigo Jones's Queen's House', p. 146; Higgott, 'Inigo Jones's Designs for the Queen's House in 1616', pp. 156–7.

55 The drawing is lost; see Harris and Higgott, *Inigo Jones*, p. 226, fig. 67.

56 See Higgott, 'The Design and Setting of Inigo Jones's Queen's House', pp. 136, 147.

57 Serlio, Book IV, fol. 158ᵥ (Serlio, *Sebastiano Serlio on Architecture*, vol. 1, p. 320).

58 Jones observes 'that at *Ephesus* aforesaid being of the *Ionick Order*, the *Order* peculiarly appropriated to *Diana*' and 'Or is Stone-Heng sacred to Diana, because reputed Goddess of Hunting?' (Jones, *STONE-HENG . . . RESTORED*, pp. 60, 61). Diana could be seen as a British goddess: in the legendary British history of Geoffrey of Monmouth she was worshipped by Brute, the founder of Britain; see Peacock, *Stage Designs of Inigo Jones*, p. 75. See also Chapter Two, p. 88.

59 Now demolished, but recorded in a sketch by John Aubrey (Bodleian Library, Oxford, Aubrey MS 4). See Worsley, *Inigo Jones and the European Classicist Tradition*, p. 105.

60 Henrietta Maria is depicted as a huntress in Daniel Mytens's painting entitled *Charles I and Henrietta Maria Departing for the Chase*, and as Diana in Gerard van Honthorst's painting *Apollo and Diana*.

61 Harris and Higgott, *Inigo Jones*, pp. 228–35, cat. nos. 72–6. Jones's design (cat. no. 76) is derived from Barbet's *Livre d'architecture, d'autels, et de cheminées* (1633). The richness of the interior is further emphasised by an entry in the building accounts of 1639 detailing payment to a carver: 'Tenn Pedestals of Timber for marble Statuaes to stand on with Bulls heads festoons fruites leaves & flowers' (The National Archives, Kew, A.O.I, 71/2429). On the sumptuous interior, see Bold, *Greenwich*, pp. 38, 62–76.

62 'Roman Sketchbook', 20 January 1615 (see above, n. 1); see Chaney (ed.), *Inigo Jones's 'Roman Sketchbook'*.

63 Harris and Higgott, *Inigo Jones*, pp. 103–5, cat. nos. 30, 31. See Anderson, *Inigo Jones and the Classical Tradition*, p. 41.

64 The measurements on the elevation indicate that it was for a front façade of 70 feet, exactly the reported measurements of the building in a Parliamentary Survey of the building of 1649; see Harris and Higgott, *Inigo Jones*, p. 103.

65 See J. Harris, 'Inigo Jones and the Prince's Lodging at Newmarket', *Architectural History*, vol. 2 (1959), p. 38. Harris and Higgott, *Inigo Jones*, pp. 101–3.

66 See Harris and Higgott, *Inigo Jones*, pp. 86, 88, 90, 94, cat. nos. 21, 22, 23, 25.

67 Annotation in Jones's Palladio, Book II, chapter 1.

68 See Harris and Higgott, *Inigo Jones*, pp. 76–83, cat. nos. 17–20; pp. 90–91, cat. no. 23; pp. 94–5, cat. no. 25; pp. 126–43, cat. nos. 40–48; pp. 304–9, cat. nos. 114–16; pp. 318–23, cat. nos. 121–3. The Temple Bar arch of 1636 (pp. 251–3, cat. no. 82; see Fig. 99) has Corinthian columns, however (or possibly Composite after its model, the Arch of Constantine), but was unbuilt. See R. Strong, *The Artist and the Garden* (2000), p. 51. P. Henderson, *The Tudor House and Garden: Architecture and Landscape in the Sixteenth and Early Seventeenth Centuries* (2005), pp. 65, 117.

69 See H. Colvin (ed.), *The History of the King's Works* (1963–82), vol. 4, pp. 249–50.

70 The absence of the Orders in a work for a patron other than the king might be seen as natural if, as has been argued, the columns carried regal overtones. See J. Newman, 'Nicholas Stone's Goldsmiths' Hall: Design and Practice in the 1630s', *Architectural History*, vol. 14 (1971), pp. 30–39.

71 See Harris and Higgott, *Inigo Jones*, p. 312, cat. no. 118.

72 See Harris and Higgott, *Inigo Jones*, pp. 256–7, cat. nos. 84–5 (which incorrectly describes the 'Token House' range in Lothbury as unbuilt). See D. Keene, 'The Setting of the Royal Exchange: Continuity and Change in the Financial District of the City of London, 1300–1871', in A. Saunders (ed.), *The Royal Exchange* (1997), p. 262 (where the long range is shown to have been built). See also Worsley, *Inigo Jones and the European Classicist Tradition*, pp. 78, 80.

73 See P. Henderson, 'The Loggia in Tudor and Early Stuart England: The Adaptation and Function of Classical Form', in Gent (ed.), *Albion's Classicism*, p. 127. M. Howard, *The Building of Elizabethan and Jacobean England* (2007), p. 160. See also Worsley, *Inigo Jones and the European Classicist Tradition*, p. 105.

74 Serlio, Book VII, p. 232 (Serlio, *Sebastiano Serlio on Architecture*, vol. 2, p. 376).

75 Serlio, Book IV, fol. 158ᵥ (Serlio, *Sebastiano Serlio on Architecture*, vol. 1, p. 320). See G. Worsley, 'Stoke Park

Pavilions, Northamptonshire', *Country Life*, vol. 199 (2005), p. 94. See also Worsley, *Inigo Jones and the European Classicist Tradition*.

76 Annotation, Book IV, chapter 6 (p. 14). See below, n. 93.

77 See G. H. Chettle, 'Marlborough House Chapel', *Country Life*, vol. 84 (1938), pp. 450–53. As a consequence of its austerity the chapel has been seen as epitomising the Jonesian 'style'; see J. Harris, S. Orgel and R. Strong, *The King's Arcadia: Inigo Jones and the Stuart Court* (1973), p. 123. See also M. Leapman, *Inigo: The Troubled Life of Inigo Jones, Architect of the English Renaissance* (2003), pp. 211–12.

78 Palme, *Triumph of Peace*, p. 20.

79 The window is almost certainly original to Jones's design (see Harris, Orgel and Strong, *The King's Arcadia*, p. 124). See also Worsley, *Inigo Jones and the European Classicist Tradition*, pp. 138–9, 153–4.

80 See the plan in Colvin (ed.), *History of the King's Works*, vol. 5, p. 246 and pl. 25.

81 See Henry Flitcroft's longitudinal section (c.1720s; Harris and Higgott, *Inigo Jones*, pp. 182–3, cat. no. 51), Jones's elevation for the closet chimneypiece and overmantel (1624–5; Harris and Higgott, *Inigo Jones*, pp. 184–5, cat. no. 52), and Johannes Kip's engraving of the chapel interior (c.1686; Harris and Higgott, *Inigo Jones*, p. 184, fig. 51).

82 See Colvin (ed.), *History of the King's Works*, vol. 4, p. 249. See also the Conclusion.

83 See S. Thurley, *Somerset House: The Palace of England's Queens, 1551–1692* (2009), pp. 45–56.

84 See E. Veevers, *Images of Love and Religion: Queen Henrietta Maria and Court Entertainments* (1989), especially pp. 75–109.

85 See R. W. Needham, *Somerset House Past and Present* (1905), pp. 112–14: 'The reredos represented "a paradise of glory", about forty feet in height. There was a great arch, supported by two pillars, about five and a half feet from the two side walls of the chapel. Behind the altar was a dove holding the Blessed Sacrament, and forming the centre of a series of separate oval frames painted with angels seated on clouds, most ingeniously contrived, with the aid of perspective and hidden lights, so to deceive the eye and to produce the illusion of a considerable space occupied by a great number of figures. There were seven of these ovals – the outer and larger ones consisting of angels playing on musical instruments, the central one of angels vested as deacons, and carrying censors, and the inner ones with child angels in various attitudes of devotion. Immediately round the dove were cherubim and seraphim in glory, surrounded by rays of light. When Charles first saw the reredos, according to Gamache he, "admired the composition for a very long time, and said aloud that he had never seen anything more beautiful or more ingeniously arranged".' See also J. H. Harting, *Catholic London Missions from the Reformation to the Year 1850* (1903), pp. 8–9 (which incorrectly describes it as at St James's Palace).

86 In W. Knowler (ed.), *The Earl of Strafforde's Letters and Dispatches* (1739), vol. 1, p. 505.

87 Only four drawings by Jones can be ascribed with certainty to the Somerset House chapel: Harris and Higgott, *Inigo Jones*, pp. 198–203, 322, cat. nos. 59, 60, 61, 123 – a plan and elevation for an external window surround, a sketch elevation for a niche, the elevation of a tabernacle and an outline section of the chapel.

88 The reredos is also illustrated, but is not by Jones; see Colvin (ed.), *History of the King's Works*, vol. 5, p. 257 n. 2, who notes the payment claimed in 1687 for two statues, of St Peter and St Paul.

89 See J. Harris, *Catalogue of the Drawings Collection of the RIBA: Inigo Jones and John Webb* (1972), p. 15, no. 39; Harris and Higgott, *Inigo Jones*, p. 198, fig. 58.

90 Veevers, *Images of Love and Religion*, pp. 137–41. The drawings for the temple do not survive.

91 Veevers, *Images of Love and Religion*, p. 137.

92 Orgel and Strong, *Inigo Jones*, vol. 2, p. 604, ll. 459–65.

93 In his Vitruvius at Book IV, p. 163, Jones referred to his design for an architrave at Somerset House in relation to an Arundel marble (a fragment of temple frieze) with gorgons' heads (this marble was excavated on the site of Arundel House and is the same as that depicted by Van Dyck in the *Continence of Scipio*, painted for the Duke of Buckingham around 1621; see Harris, Orgel and Strong, *The King's Arcadia*, p. 65). Interestingly, Jones paraphrased almost exactly Vitruvius on decorum when noting the origin of the frieze in Book IV, chapter 6 (p. 14) of his Palladio: 'Architrave at Ar: House w^ch I thinke was of the tempell of Minerva at Smirna by reason of y^e gorgons heades in the mettopes of freese beetwene y^e Cartottzzi w^ch are in the stead of Trigliffios a rare invention and to bee imitated sheauing how the Ansientes varied and composed ther o[r]ders according to the nateurres of the gods to whome y^e Tempels weare dedicated.' The gorgons' heads suggested to Jones a dedication to Minerva, which in turn suggested the Doric Order, albeit that here the ancients had been suitably inventive in replacing the triglyphs with consoles and metopes with the gorgons' heads. See Higgott, ' "Varying with reason" ', pp. 59, 69.

94 Harris and Higgott, *Inigo Jones*, pp. 196–7, cat. no. 58.

95 According to the building accounts, Jones was to use the Composite Order on Charles I's 'private' hunting lodge in Hyde Park (still at this time the king's private hunting park), a playful building called 'New Lodge', of 1634–5, now demolished; see Worsley, *Inigo Jones and the European Classicist Tradition*, p. 124. See also accounts in The National Archives, Kew, E. 351/3268. The attic Order of the preferred Jones–Webb scheme for the Somerset House façade may be Composite; see Fig. 97.

96 See above, n. 87.

97 Harris and Higgott, *Inigo Jones*, p. 202.

98 J. Spraggon, *Puritan Iconoclasm during the English Civil War: The Attack On Religious Imagery by Parliament and its Soldiers* (2003), pp. 229, 244. In Cambridge, Dowsing visited Peterhouse on 21 December 1643 and recorded in his Journal: 'We pulled down two mighty great

angells, with wings, and divers other angells, and the 4 Evangelists, and Peter, with his keies on the chappell door (see Ezek. viii. 36, 37 [?*recte* vi. 3–7] and ix. 6; Isa. xxvii. 9 and xxx. 22) and about a hundred chirubims and angells, and divers superstitious letters in gold.' He visited All Saints' on 1 January 1644, and recorded: 'We brake down divers superstitious pictures and 8 cherubims'; see T. Cooper (ed.), *The Journal of William Dowsing: Iconoclasm in East Anglia during the English Civil War* (2001).

99 See Thurley, *Somerset House*, p. 52 (however, there would have been no need for the queen and her priests to have informed Jones of this iconography through prints, given the evidence of his 'Roman Sketchbook' notes).

100 J. Peacock, 'The French Element in Inigo Jones's Masque Designs', in D. Lindley (ed.), *The Court Masque* (1984), pp. 155–7. On the imposition of Henrietta Maria's French tastes on the royal houses, see Thurley, *Somerset House*, p. 45. On the influence of Henrietta Maria's Catholicism on the gardens of the period, and of imagery associated with the cult of the Virgin Mary, see Strong, *The Artist and the Garden*, pp. 103–4.

101 See Higgott, ' "Varying with reason" ', p. 69.

102 See Harris and Higgott, *Inigo Jones*, pp. 198–9, cat. no. 59. D. Fontana, *Della trasportatione dell'obelisco vaticano et della fabriche di nostro signore Papa Sisto V . . . libro primo* (1590), p. 18.

103 Kip's illustration of Somerset House in *Britannia Illustrata* (1708) gives practically no information as to the chapel's external appearance.

104 See the plan in Colvin (ed.), *History of the King's Works*, vol. 5, fig. 22. But see now Simon Thurley's plan, *Somerset House*, p. 48, fig. 11, and (astylar) reconstruction, p. 50, fig. 12.

105 See Thurley, *Somerset House*, pp. 52–3. However, Harris and Higgott note concerning the niche: 'Clearly it was, as inscribed, "without" or outside the chapel proper, and it has been suggested that it might have adorned the exterior of the west transept, but this is unconvincing . . . In fact, "without" the chapel might mean in the Vestry House or vestibule behind the altar at the south end' (Harris and Higgott, *Inigo Jones*, p. 200).

106 Thurley, *Somerset House*, p. 52.

107 Ll. 273, 300–03. See Veevers, *Images of Love and Religion*, p. 141.

108 Jones, *STONE-HENG . . . RESTORED*, pp. 65, 68.

109 Thomas, 'English Protestantism and Classical Art', p. 228.

110 On Bedford's religion and the church, see D. Duggan, ' "London the Ring. Covent Garden the Jewel of That Ring": New Light on Covent Garden', *Architectural History*, vol. 43 (2000), pp. 140–61.

111 Jones's model for the form of the 'chapel', the Tuscan temple as described by Vitruvius (IV.vii), was also anti-Laudian in as much as it was at variance with their understanding of the distinction between temples and churches in ancient, that is, primitive Christian, times. See J. Mede, *Churches, that is, Appropriate Places for Chris-tian Worship both in and ever since the Apostles Times* (1638), pp. 63–6; J. Newman, 'Laudian Literature and the Interpretation of Caroline Churches in London', in D. Howarth (ed.), *Art and Patronage in the Caroline Courts* (1993), pp. 181–2. See also Thomas, 'English Protestantism and Classical Art', p. 225.

112 Reported in H. Walpole, *Anecdotes of Painting in England* (1782 edn), vol. 2, p. 275. On Covent Garden, see Duggan, ' "London the Ring" ', pp. 140–61; A. Channing Downs, 'Inigo Jones's Covent Garden: The First Seventy-Five Years', *Journal of the Society of Architectural Historians*, vol. 26 (1967), pp. 8–33. Newman, 'Laudian Literature', pp. 181–6. See also Anderson, *Inigo Jones and the Classical Tradition*, p. 210; and on the rural associations of the Tuscan 'barn', pp. 204–12.

113 See also Chapter Eight. Jones's use of the Tuscan is sometimes presented as arising from economic constraint, but, as Arthur Channing Downs has observed, Covent Garden was not cheap; he concludes that there is little to support a theory that the Order was chosen primarily for economy (besides, the stone necessary for a Tuscan column would surely be no less – and the carving no less involved – than, say, for a Doric). See Channing Downs, 'Inigo Jones's Covent Garden', pp. 12–13: 'The desire for economy expressed by his "economic challenge" would be understandable, if he actually did make it. The fact remains he approved the plans for a church which was almost as large as the church serving the *entire* parish of which Covent Garden was then a part, and which was to cost £4,886 5s. 8d.'

114 Royal letter (draft) to the Attorney General, in the Earl of Bedford Papers, Alnwick Castle, Y3, box 4 2/8.

115 E. Hatton, *A New View of London* (1708), p. 478.

116 Hatton, *A New View of London*.

117 J. Gordon, *The Union of Great Brittaine* (1604), p. 13.

118 J. Peacock, 'Inigo Jones and Renaissance Art', *Renaissance Studies*, vol. 4, no. 3 (1990), p. 252. See also Peacock, *Stage Designs of Inigo Jones*, pp. 12–13.

119 Cicero, *Orator*, ed. and trans. H. M. Hubbell (1962), vol. 32, p. 97: 'Haec modo perfringit, modo irrepit in sensus' (Now it storms the senses, now it creeps in). See also Cicero, *De oratore*, ed. and trans. E. W. Sutton and H. Rackham (1948), Book III, chapter 53, p. 203: 'tum illa quae maxime quasi irrepit in hominum mentes, alia dicentis ac significantis dissimulatio . . .' (on the effect of irony).

120 See Peacock, 'Inigo Jones and Renaissance Art', pp. 249–59.

121 Orgel and Strong, *Inigo Jones*, vol. 2, p. 706, l. 3.

122 Orgel and Strong, *Inigo Jones*, vol. 2, p. 706, ll. 16–29.

123 Orgel and Strong, *Inigo Jones*, vol. 2, p. 709, ll. 356–7; Veevers, *Images of Love and Religion*, pp. 145–6.

124 Veevers, *Images of Love and Religion*, p. 147.

125 See T. Herbert, *Memoirs Of The Two Last Years Of The Reign Of That Unparallell'd Prince, King Charles I* (1702), p. 43. On Villalpando, see chapters One and Three. See also J. Rykwert, *The First Moderns* (1980), pp. 9–10, and Rykwert, *On Adam's House in Paradise* (1972), pp.

121–35. Hart, *Art and Magic*, p. 111 (on two references to Villalpando in James's funeral sermon of 1625).

126 Harris and Higgott, *Inigo Jones*, p. 241, cat. no. 78.

127 See Semler, 'Inigo Jones, Capricious Ornament and Plutarch's Wise Men', pp. 125–6, 134.

CHAPTER 7

1 P. Palme, *The Triumph of Peace: A Study of the Whitehall Banqueting House* (1957). The Catholic Infanta (Marie-Theresa) was Philip IV's eldest child by his first wife, Isabelle of France, daughter of Marie de' Medici. S. R. Gardiner, *Prince Charles and the Spanish Marriage, 1617–1623: A Chapter of English History* (1869), vol. 1, p. 29.

2 See N. Tyacke, *Anti-Calvinists: The Rise of English Arminianism, c.1590–1640* (1987), p. 104; R. Strong, *Henry Prince of Wales and England's Lost Renaissance* (1986), p. 72.

3 John Peacock (*The Stage Designs of Inigo Jones: The European Context*, 1995, pp. 19–20) has demonstrated that the concept of the masque and Jones's use of imitation in his stage designs were based on Aristotle and the rhetorical notion of imitation. See also C. Van Eck, 'Statecraft or Stagecraft? English Paper Architecture in the Seventeenth Century', in S. Bonnemaison and C. Macy (eds), *Festival Architecture* (2008), p. 127.

4 B. Jonson, 'An Expostulation w[i]the Inigo Jones' [*c*.1631]; see I. Donaldson (ed.), *Ben Jonson* (1985), p. 462. Rather like Jones's use of the Orders, and the Tuscan in particular, this dependence on Aristotle can be traced to Stonehenge, where Jones had described the geometry used by him to 'restore' the British monument as an 'Architectonicall Scheme'. I. Jones, *The MOST NOTABLE ANTIQUITY OF GREAT BRITAIN, Vulgarly called STONE-HENG, ON SALISBURY PLAIN, RESTORED* (1655 edn), p. 68. He drew on Aristotle's term 'Architettonica' used in the *Ethics* to denote the ultimate end to which all knowledge was directed and subordinated, namely virtuous action. Aristotle's 'architettonica', *Ethics*, Book I, chapter 1, and Book VI, chapter 7. In his copy of the *Ethics* Jones underlined this term and in the margin noted: 'Architectonicall or Universall'; *L'ethica d'Aristotile*, trans. and ed. Bernardo Segni (1551), p. 188. See V. Hart, *Art and Magic in the Court of the Stuarts* (1994), p. 131.

5 Against Scamozzi's text: ' l'Architettura in tutte queste parti tenghi della Filosofia morale, e naturale', V. Scamozzi, *L'Idea dell'architettura universale* (1615), vol. 1, pp. 8–9.

6 See the Introduction. Jones's books are listed in J. Harris, S. Orgel and R. Strong, *The King's Arcadia: Inigo Jones and the Stuart Court* (1973), appendix III, pp. 217–18.

7 On 'magnificence', see J. Onians, *Bearers of Meaning: The Classical Orders in Antiquity, the Middle Ages and the Renaissance* (1988), p. 123.

8 From Aristotle, *Nicomachean Ethics*, trans. J. A. K. Thomson (1976), p. 151.

9 Aristotle, *Nicomachean Ethics*, trans. Thomson, p. 151 (which has 'furnish' instead of 'build/edify'); *L'ethica d'Aristotile*, trans. and ed. Bernardo Segni, fol. 114v: 'È anchora da Magnifico l'haversi ed[i]ficara [*sic*] una casa conveniente alla sua ricchezza; chè una tal'cosa mostra in se *ornamento*'.

10 In Book II, chapter 7, Jones notes: 'Nemesi is the midoll between Envi and being glad of another's hurt' (see *Nicomachean Ethics*, trans. Thomson, p. 106: 'Righteous Indignation is a mean between envy and spite'). In Book III, chapter five, Jones drew a ☞ alongside 'Siasi ditto adunche da noi universalimente della Virtù . . . ' (ibid., p. 126: 'We have now given a general account of the virtues, stating in outline what their genus is, viz. that they are mean states and dispositions'). On the social virtue of amiability and the corresponding vices at Book IV, chapter 6, Jones notes 'the midell but not being the extreme is commendable. and is named friendship. How it different from friendship' (ibid., p. 163: 'The person who corresponds to the intermediate state is the sort that we mean when we speak of a good friend; although that implies an element of affection. But this quality differs from friendship in that it is independent of feeling').

11 Aristotle, *Nicomachean Ethics*, trans. Thomson, p. 152. Alongside Aristotle's clarification that both 'these dispositions are vices, but they do not actually bring disrepute', Jones's final note reads: 'Some vicious habits not very hurtfull'. It should be noted that this was one of the few occasions throughout his annotations, and one of only three instances in his copy of the *Ethics*, that Jones saw fit to use underlining.

12 Serlio, Book VII, p. 126 (see S. Serlio, *Sebastiano Serlio on Architecture*, 1996–2001, vol. 2, p. 280).

13 From L. B. Alberti, *On the Art of Building in Ten Books*, trans. J. Rykwert, N. Leach and R. Tavernor (1988), p. 163. On this as an injunction to seek the perfect mean, see A. Payne, *The Architectural Treatise in the Italian Renaissance* (1999), p. 81.

14 See chapters Two and Three.

15 Aristotle, *Nicomachean Ethics*, trans. Thomson, pp. 100–101.

16 See M. Carpo, 'The Architectural Principles of Temperate Classicism: Merchant Dwellings in Sebastiano Serlio's Sixth Book', *Res*, vol. 22 (1992), pp. 135–51. C. Randall, *Building Codes: The Aesthetics of Calvinism in Early Modern Europe* (1999).

17 Vitruvius, *I dieci libri dell'architettura di M. Vitruvio tradotti e commentati da Monsig. Daniele Barbaro* (1567 edn), Book III, chapter 1, p. 115: 'però dico io, che mescolando con ragione nelle fabriche le proportioni d'una maniera, o componendole, o levandole, nè puo risultare una bella forma di mezo'. On the influence of the mean on Serlio's selection of ornament, see Carpo, 'Architectural Principles of Temperate Classicism'.

18 Book II, chapter 9: Aristotle, *Nicomachean Ethics*, trans. Thomson, p. 108.

19 Aristotle, *De Anima*, p. 407 b. 30–31, from *The Basic Works of Aristotle*, ed. R. McKeon (1941), p. 546.

20 Book II, chapter 9: Aristotle, *Nicomachean Ethics*, trans. Thomson, p. 109.

21 Aristotle, *Nicomachean Ethics*, trans. Thomson, p. 177.

22 See Chapter Four, p. 124.

23 *La Republica di Platone*, trans. Pamphilo Fiorimbene (1554), p. 170. See Plato, *The Republic*, trans. H. D. P. Lee (1955), p. 219 (Jones's mark is around 443e, i.e., chapter xvii, undivided in his 1554 edition).

24 See G. Higgott, '"Varying with reason": Inigo Jones's Theory of Design', *Architectural History*, vol. 35 (1992), pp. 51–77.

25 S. Orgel and R. Strong, *Inigo Jones: The Theatre of the Stuart Court* (1973), vol. 2, p. 730, ll. 58–9, 64–8 (the drawing is lost). See Peacock, *Stage Designs of Inigo Jones*, p. 262.

26 See Palme, *Triumph of Peace*, pp. 77–80.

27 Palme, *Triumph of Peace*, p. 287; R. Strong, *Britannia Triumphans: Inigo Jones, Rubens and Whitehall Palace* (1980), p. 14. On Rubens's possible wider influence on Jones, see G. Worsley, *Inigo Jones and the European Classicist Tradition* (2007), pp. 118–20.

28 F. Donovan, *Rubens and England* (2004).

29 The following synopsis is also based in part on Palme, *Triumph of Peace*, pp. 260–61.

30 Following Julius Held's orientation of the canvases according to a reconstruction of Rubens's preliminary sketch for the ceiling at Glynde. See J. Held, 'Rubens's Glynde Sketch and the Installation of the Whitehall Ceiling', *Burlington Magazine*, vol. 112 (1970), pp. 274–81. See also Strong, *Britannia Triumphans*, p. 28.

31 See Chapter One, n. 75.

32 Roy Strong identified Hercules with 'Heroic Virtues' and entitled this *Hercules Vanquishing Envy*; see *Britannia Triumphans*, p. 32.

33 Strong, *Britannia Triumphans*, p. 36.

34 *A fourme of Prayer with Thanksgiving, to be used by all the Kings Maiesties loving Subjects every yeere the fifth of August* (1603).

35 See Strong, *Britannia Triumphans*, pp. 45, 49 (incorrectly citing the lion as an attribute of *Temperanza*).

36 Orgel and Strong, *Inigo Jones*, vol. 2, p. 730, ll. 31–2, 60–61 (the drawing is lost). See Peacock, *Stage Designs of Inigo Jones*, pp. 261–2.

37 Strong, *Britannia Triumphans*, pp. 45–6.

38 The 1616 edition of *Basilikon Doron*, from *The Political Works of James I*, ed. C. H. McIlwain (1918), pp. 37, 42.

39 Each of the virtues illustrated in the side panels is, in the Aristotelian sense, a mean between extremes. Temperance, for instance, is described in the *Ethics* as the mean virtue between licentiousness and insensibility.

40 It is estimated that Jones did not start annotating the *Ethics* until the mid- to late 1620s (see J. Newman, 'The Dating of Inigo Jones's Handwriting' [1980], typescript from 'Essays Presented to Professor Peter Murray', lodged in the Senate House Library, University of London).

41 Aristotle, *Nicomachean Ethics*, trans. Thomson, p. 143.

42 Book VI, chapter 7: Aristotle, *Nicomachean Ethics*, trans. Thomson, p. 211.

43 For example: 'Fortitude a principal virtue or most manifest' (III.vi). 'The temperate desire what as and when he ought, and so reason commands of disposition' (III.xii). 'Intellective Science and wisdom mean not the prudence and they must noble the Art' (VI.ii).

44 Vitr., I.ii, from Vitruvius, *On Architecture*, trans. F. Granger (1983 edn), p. 29.

45 'Roman Sketchbook', Friday, 20 January 1615, Devonshire Collection, Chatsworth, fol. 76r–v. See E. Chaney (ed.), *Inigo Jones's 'Roman Sketchbook'* (2006). The existing gallery is an early nineteenth-century reconstruction.

46 On the 'music' of the king's peace, see Chapter Eight; on the proportions of the Orders on the Banqueting House façade, see Hart, *Art and Magic*, pp. 146–8.

47 See Chapter Four.

48 Jones notes in his Palladio that this temple was rededicated after 'an altar dedicated by Augustus to the goddess of Pease'; Book IV, p. 11.

49 P. D. Yorke, 'Iconoclasm, Ecclesiology and "Beauty in Holiness": Concepts of Sacrilege and "the Peril of Idolatry" in Early Modern England, *c.*1590–1642', unpublished PH.D thesis, University of Kent (1977), pp. 10–11.

50 See G. Toplis, 'Inigo Jones: A Study of Neoplatonic Aspects of his Thought and Work', unpublished MA dissertation, Liverpool University (1967), pp. 3–4. A. C. Fusco, *Inigo Jones: Vitruvius Britannicus* (1985), p. 216. C. Anderson, *Inigo Jones and the Classical Tradition* (2007), p. 171.

51 Palladio's villa designed for Giovanni Battista Garzadori, Book II, p. 77 (chapter 17). The ground-storey columns are Corinthian (one rank 'inferior' to the upper, Composite columns).

52 Internally, the situation is quite different, in that the floor is at *piano nobile* level above the basement expressed as the Rustic storey on the façade. As a result the walls are divided into only two storeys, and true to one of the main precedents for the interior, the Egyptian hall, the Corinthian is superimposed above the Ionic. As such it makes the external use of the Composite, whose capital combined elements from both Orders, all the more remarkable. On the Rustic as a form of Tuscan, see J. Ackerman, 'The Tuscan/Rustic Order: A Study in the Metaphorical Language of Architecture', in Ackerman, *Distance Points: Essays in Theory and Renaissance Art and Architecture* (1991), pp. 495–541.

53 Serlio, Book IV, fol. 183r (see Serlio, *Sebastiano Serlio on Architecture*, vol. 1, p. 364).

54 Text against each arch in S. Harrison, *Arches of Triumph* (1604); see T. Dekker, *The Magnificent Entertainment Given to King James* (1616) [unpaginated].

55 'Roman Sketchbook', 19 January 1615, fol. 76v (see above, n. 45); see Chaney (ed.), *Inigo Jones's 'Roman Sketchbook'*. See Peacock, *Stage Designs of Inigo Jones*, p. 53.

56 'Roman Sketchbook', 20 January 1615, fol. 76r (see above, n. 45); see Chaney (ed.), *Inigo Jones's 'Roman Sketchbook'*. Ben Jonson referred to '*Chimaera's*, by the

vulgar unaptly called *Grottesque*' (*Ben Jonson: Works*, ed. C. Herford and P. Simpson, 1925–52, vol. 8, p. 611), and Thomas Marshall recorded Jones's praise of Giovanni da Udine as 'excell[en]t in grotescs, wch the ancients called Chimaraes' (commonplace book of Thomas Marshall, Bodleian Library, Oxford, Marshall 80, ll. 1568–9; see J. Wood, 'Inigo Jones, Italian Art and the Practice of Drawing', *Art Bulletin*, vol. 74, no. 2, 1992, Appendix III, p. 269). The 'Opera bastarda', that is, corrupted architectural ornament, was also to be allowed at least internally: Jones notes in his Palladio concerning the Pantheon's problematic upper Order of pilasters (Book IV, p. 81): 'The second order had in my opinion better have been an Opera bastarda, for so yt is now in effectte'.

57 See Peacock, *Stage Designs of Inigo Jones*, p. 1.

58 See J. Harris and G. Higgott, *Inigo Jones: Complete Architectural Drawings* (1989), pp. 110–13, cat. nos. 33, 34.

59 From G. P. Lomazzo, *Scritti sulle arti*, ed. R. P. Ciardi (1973–5), vol. 2, p. 363.

60 See Chapter Six, n. 25.

61 Peacock, *Stage Designs of Inigo Jones*, p. 228. See the Introduction and Chapter Four.

62 Orgel and Strong, *Inigo Jones*, vol. 1, p. 256, ll. 9–11, 62–7.

63 Orgel and Strong, *Inigo Jones*, vol. 1, p. 258, ll. 260–61. See also L. E. Semler, 'Inigo Jones, Capricious Ornament and Plutarch's Wise Men', *Journal of the Warburg and Courtauld Institutes*, vol. 66 (2003), p. 140.

CHAPTER 8

1 For a complete history of the cathedral, see D. Keene, A. Burns and A. Saint (eds), *St Paul's: The Cathedral Church of London, 604–2004* (2004). On this symbolic aspect of the cathedral refacing, see V. Hart, *Art and Magic in the Court of the Stuarts* (1994), pp. 42–4. See also M. Jansson, 'The Impeachment of Inigo Jones and the Pulling Down of St Gregory's by St Paul's', *Renaissance Studies*, vol. 17, no. 4 (2003), pp. 716–46.

2 See J. Summerson, *Inigo Jones* (1966 edn), p. 104; and P. Palme, *The Triumph of Peace: A Study of the Whitehall Banqueting House* (1957), p. 24. Roger Pratt observed in 1672 that beneath the huge upper cornice, the ornament 'falls confusedly into a kind of Freeze . . . of Lyons heads, and Bobbins, for so I must call them from the nearest thing I know doth any wise resemble them', adding that the arrangement: 'seems somewhat to allude to the Dorick order, where the Bobbins are set for the Triglifes, and the Lyons heads for the Metopes'; see R. Pratt, *The Architecture of Sir Roger Pratt*, ed. R. T. Gunther (1928), p. 197.

3 See J. Summerson's account in H. Colvin (ed.), *The History of the King's Works* (1963–82), vol. 3, pp. 147–53; and Summerson, 'Lectures on a Master Mind: Inigo Jones', *Proceedings of the British Academy*, vol. 50 (1964), pp. 169–92. See also Hart, *Art and Magic*, and Appendix One.

4 The letter of 23 April 1634 on cathedral repair from Charles I to Laud reveals that this funding arose from early opposition to collecting money for the work: 'yet we are not ignorant what jealousies have been cast amongst our loving people by some ill affected persons, both to ourself and that glorious work; . . . as if contrary to our just and princely disposition the work were but pretended by us to get some great sum of money together, and then to turn it to other uses; . . . we are resolved to enlarge that bounty of ours, and to undertake the whole repair of the west end of that church without having any to share in the honour of that particular with us', quoted in D. Wilkins, *Concilia Magnae Britanniae et Hiberniae* (1737), vol. 4, p. 492. Just as the stripping of the cathedral during the Reformation had enriched the crown, so the re-embellishment of St Paul's aided the court's bankruptcy. Between September 1631 and the final reckoning in October 1643, £101,330 4s. 8d. was raised, an amount including £10,971 16s. 2d. from the king. Of course, such outlay speaks of the cathedral's importance to the court. For a breakdown of financial expenditure, see Appendix One, and Summerson in Colvin (ed.), *History of the King's Works*, vol. 3, pp. 151–2; W. Dugdale, *The History of St Paul's Cathedral in London* (1658), p. 109.

5 S. Orgel and R. Strong, *Inigo Jones: The Theatre of the Stuart Court* (1973), vol. 2, p. 668, describes the cathedral as a 'symbol . . . of High Church Laudian reform'; G. Parry, *Golden Age Restor'd: The Culture of the Stuart Court, 1602–42* (1981), p. 250, notes: 'for Laud, the work was . . . a pledge of the material renewal and beautification of the Church throughout England, done in conjunction with the King's will'. H. Trevor-Roper, *Archbishop Laud, 1573–1645* (1940 edn), in plates between pp. 124 and 125, and on p. 125 even entitled the west front 'according to Laud's design', with Jones merely 'given charge of the repairs'.

6 From the diary of the Duke of Württemberg, 1592. See W. B. Rye, *England as Seen by Foreigners* (1865), p. 8.

7 Dugdale, *History of St Paul's Cathedral*, pp. 133–4. Elizabeth promptly ordered the Lord Mayor and Archbishop of Canterbury to collect money from laity and clergy, and gave timber and 1,000 marks in gold for repairs to the roof. Although according to Dugdale 'divers models were then made of it', the spire was not replaced and the accounts for the work were closed in 1566.

8 See J. Pilkington, *The Burnynge of Paules Church in London in the year of our Lord 1561* (1563).

9 The cathedral's shame in front of visitors to London who observed this decay was used as an inducement to repair by Gyles Fleming in *Magnificence Exemplified: And The Repaire of Saint Paul's exhorted unto* (1634), p. 47. See also W. R. Gair, *The Children of Paul's: The Story of a Theatre Company, 1553–1608* (1982), especially chapter one.

10 Calendar of State Papers (Domestic; hereafter cited as SP), The National Archives, Kew, 16/213, fol. 24: 'not withstanding former directions . . . for the filling upp of the sellers & vaults discovoured upon the taking downe

of the house of Elizabeth Porter widow at the west end of Paules. Yet the said sellers & vaults are not filled and that it does appear that by reason of the said vaults & sellers the foundations of the said church may have received further damage.' See Dugdale, *History of St Paul's Cathedral*, p. 135.

11 Dugdale, *History of St Paul's Cathedral*, p. 173. See also the entry for Jones in *Oxford Dictionary of National Biography* (1937–8 edn), vol. 10, pp. 999–1007. The practice of reusing building materials was common enough; see M. Howard, *The Early Tudor Country House: Architecture and Politics, 1490–1550* (1987), p. 23.

12 See chapters Two and Four; see also A. Channing Downs, 'Inigo Jones's Covent Garden: The First Seventy-Five Years', *Journal of the Society of Architectural Historians*, vol. 26 (1967), pp. 8–33.

13 The cost of repairing the choir, nave and aisles, transepts and chapter house, together with rebuilding the spire, was estimated at £22,537 2s. 3d; SP 14/37, no. 29. See Summerson, 'Lectures on a Master Mind', p. 183.

14 Dugdale, *History of St Paul's Cathedral*, p. 134.

15 Dugdale, *History of St Paul's Cathedral*, p. 135.

16 Reported in M. Tierney, *The History and Antiquities of the Castle and Town of Arundel* (1834), p. 437.

17 Guildhall Library, London, MS 25, 490 (unsigned).

18 James promised £2,000, Prince Charles £500 and Bishop King £100 a year from his revenue; see SP 14/131, no. 53. On the collection of stone, see Dugdale, *History of St Paul's Cathedral*, p. 103. For demolition, see the State Papers for 1620: for example, the entries for 13 and 27 July, and 10 November.

19 SP 16/213, fol. 28.

20 For a discussion of this, see Summerson in Colvin (ed.), *History of the King's Works*, vol. 3, p. 147.

21 SP 16/213, fol. 11a.

22 SP 16/223: 16 September 1632.

23 The initial target for the collection is recorded in SP 16/239, no. 20. For the start of the work, see Dugdale, *History of St Paul's Cathedral*, p. 139. See also SP 16/231, no. 31.

24 See Guildhall MS 25, 474, 6 vols, 1633–40, audited accounts of money received by the chamberlain of London for building work, recording sums received and the names of contributors – individuals, chiefly nobility and church dignitaries, listed in approximate order of importance, followed by contributions from the Livery Companies and wards of the City, and from counties.

25 SP 16/259, no. 22.

26 Guildhall MS 25, 474:5. Along with such noble patronage, much of the work was also funded by fines for profanity, adultery and incest; see SP 16/275, no. 35; 16/283, no. 72.

27 Dugdale, *History of St Paul's Cathedral*, p. 109.

28 St Paul, 1 Corinthians 9.19–22.

29 See H. H. Milman, *Annals of S. Paul's Cathedral* (1868), pp. 194–229. On persecutions, see, for example, 'The storie of John Porter, cruelly martyred for reading the Bible in Pauls', in J. Foxe, *Acts and Monuments* (1641 edn), vol. 2, pp. 536–7.

30 See W. S. Simpson, *S. Paul's Cathedral and Old City Life* (1894), p. 6; and Milman, *Annals of S. Paul's Cathedral*, p. 220; on p. 230: 'much of the rich architectural shrine-work, much of the splendid decorations of the churches . . . to the Reformers were . . . an inseparable part and portion of that vast system of debasing superstition, of religious tyranny . . . the intolerable yoke of which it was their mission to burst'.

31 For the Church under Catholic Mary I, see W. Haller, *Foxe's Book of Martyrs and the Elect Nation* (1963), pp. 19–48, 187–8. The persecutions formed the subject of Foxe's work.

32 H. Glasier, *A notable and very fruitefull sermon made at Paules Crosse* (1555), reproduced in Simpson, *S. Paul's Cathedral and Old City Life*, pp. 178–9.

33 See G. W. Bernard, 'The Church of England, c.1529–c.1642', *History*, vol. 75 (1990), pp. 201, 203: 'Maintenance of parish churches had been a concern long before Laud: Whitgift ordered a thorough survey of churches in 1602.' Elizabeth I had inherited an exchequer burdened with heavy debt. The frugal queen gave only 1, 000 marks in gold and 1,000 marks in timber from her woods towards the cathedral repairs of 1561 (see n. 7 above). See G. Addleshaw and F. Etchells, *The Architectural Setting of Anglican Worship* (1948), p. 34: 'Austerity characterized the policy of the Elizabethan authorities on the adornment of churches.'

34 J. P. Malcolm, *Londinium Redivivum* (1803), vol. 3, p. 74: 'No reversions in Heaven were expected: therefore the multitude turned their money into channels which procured mental peace.' See also Bernard, 'The Church of England', p. 183; N. Tyacke, *Anti-Calvinists: The Rise of English Arminianism, c.1590–1640* (1987), predestination and election, pp. 16, 26, 32, 96; good works, pp. 53, 173.

35 J. Williams, *Great Britaines SOLOMON* (1625), p. 52. Bernard, 'The Church of England', p. 195: 'the inherited church buildings, despite their whitewashed walls and new emptiness, spoke of the catholic past and offered a constant background threat of architectural seduction'.

36 See Hart, *Art and Magic*, pp. 49–51.

37 See F. W. Fairholt, *The Civic Garland: A Collection of Songs from London Pageants* (1845), p. 12.

38 J. King, *A Sermon at Paules Crosse, on behalfe of Paules Church* (26 March 1620), p. 43.

39 On the commission for the restoration, of 10 April 1631, see SP 16/188:37.

40 Dugdale, *History of St Paul's Cathedral*, p. 138. On the imperial theme and cathedral refacing, see Hart, *Art and Magic*, pp. 42–4. When advising on a new cathedral design after the Great Fire of 1666, Sir Roger Pratt, a former colleague of Jones, saw the work as establishing just such a Protestant archetype in a manuscript entitled *St Paul's and the new way of Architecture for Churches* (1672) in Pratt, *The Architecture of Sir Roger Pratt*, pp. 186–214. Pratt advised on the repair of Jones's cathedral work; see Evelyn's diary entry for 27 August 1666, in J. Evelyn, *Diary of John Evelyn*, ed. W. Bray (1906).

41 J. Gordon, *The Union of Great Brittaine* (1604), p. 13.

42 Dugdale, *History of St Paul's Cathedral*, p. 18.

43 Dugdale, *History of St Paul's Cathedral*, p. 3.

44 For Laud as the leader of the Arminians, see H. Trevor-Roper, *Catholics, Anglicans and Puritans* (1987), p. 57; Tyacke, *Anti-Calvinists*, appendix II; and Bernard, 'The Church of England', pp. 183–206. The Laudian bishop Gyles Fleming urged support for the cathedral restoration as an important opportunity for salvation by works; see Fleming, *Magnificence Exemplified*, pp. 24–6.

45 J. Rykwert, *The First Moderns* (1980), p. 138, describes the 'porticoed cathedral' as the 'perfect Laudian microcosm'.

46 Quoted by F. Bickley, *An English Letter Book* (1925), p. 22.

47 Dugdale, *History of St Paul's Cathedral*, p. 139.

48 Dugdale, *History of St Paul's Cathedral*, p. 104. See W. Laud, *THE HISTORY OF THE TROUBLES AND TRYAL OF THE Most Reverend Father in God, and Blessed Martyr, WILLIAM LAUD, Lord Arch-Bishop of Canterbury* (1695), p. 244.

49 See Trevor-Roper, *Archbishop Laud*, p. 347.

50 Dugdale, *History of St Paul's Cathedral*, p. 137. See G. Henderson, 'Bible Illustration in the Age of Laud', *Transactions of the Cambridge Bibliographical Society*, vol. 8, pt 2 (1982), p. 174. On the highly ornate gateway of 1635 into Laud's Canterbury Quad at St John's College in Oxford, see T. Mowl and B. Earnshaw, *Architecture without Kings: The Rise of Puritan Classicism under Cromwell* (1995), pp. 194–6.

51 On Andrewes, see Trevor-Roper, *Catholics, Anglicans and Puritans*, p. 299. On the cathedral commission of 1620, see Dugdale, *History of St Paul's Cathedral*, p. 135.

52 Quoted in Trevor-Roper, *Archbishop Laud*, p. 124. See also K. Thomas, 'English Protestantism and Classical Art', in L. Gent (ed.), *Albion's Classicism: The Visual Arts in Britain, 1550–1660* (1995), pp. 227–8. In the Colchester district contributions were particularly small owing to the influence of Puritan preachers; one large parish gave only 6d., and some nothing at all; see also ibid., p. 347. Lack of money would in fact always hamper progress; see C. Wren, *PARENTALIA; or, MEMOIRS OF THE FAMILY of the WRENS* (1750), p. 281: 'but the voluntary Contributions of pious and charitable People . . . came in so slowly . . . that celebrated Architect was not able to execute a third Part of what was necessary'.

53 Fairholt, *Civic Garland*, p. 11.

54 Dugdale, *History of St Paul's Cathedral*, p. 139. See also Hart, *Art and Magic*, pp. 106–7.

55 Recorded in W. Prynne, *Canterburies Doome; or, The first part of a Compleat History of the Commitment, Charge, Tryall, Condemnation and Execution of William Laud* (1646), pp. 126, 497–9.

56 Prynne, *Canterburies Doome*, pp. 119, 126.

57 See Fleming, *Magnificence Exemplified*, especially pp. 42–4.

58 Fleming, *Magnificence Exemplified*, pp. 48–9.

59 Fleming, *Magnificence Exemplified*, p. 47.

60 See Trevor-Roper, *Catholics, Anglicans and Puritans*, pp. 71, 89–90.

61 D. Lupton, 'Of S. Paul's Church', in *London and the Countrey Carbonadoed* (1632), p. 14.

62 William Parker left £500 for 'the repairing of the Windowes of *Pauls Church*'; see J. Stow, *The Survey of London* (1633 edn), p. 371. In 1620 James had inspected three windows 'with the story of Saint *Paul*', and Chapter One pointed out that these possibly celebrated his role in founding the English Church; see J. Stow, *Annales; or, A Generall Chronicle of England, Begun by John Stow: Continued and Augmented* (1631–2 edn), p. 1033. Webb's building accounts in the Guildhall Library, London (see Appendix One): Guildhall MS 25, 471, WA 5 notes the payment of glass painters in October 1635, and January and March 1636. The glass was to be taken down and repaired, or boarded in (for which carpenters were paid). In February 1636 the great east window was repaired. A letter from Thomas Langton to the Warden of Wadham College, Oxford, in July 1621 reported his intention of installing new stained glass at St Paul's. Langton, a 'Merchant Adventurer' who imported coloured glass, commented on employing the glass painter Bernard van Linge: 'I have set your Colledge before St Paule's Church for if you doe not entertayne him presently then will I set him In worke in Paules'; see T. G. Jackson, *Wadham College, Oxford* (1893), p. 164. The Van Linge brothers, Bernard and Abraham, belonged to a family of glass painters from the Dutch town of Emden and were important artists in Laud's movement towards encouraging the 'beauty of holiness'. Laud encouraged both to settle in England. See Tyacke, *Anti-Calvinists*, p. 219 and fig. 4. See also C. Woodforde, *The Stained Glass of New College, Oxford* (1951), p. 13.

63 G. Herbert, *George Herbert and Henry Vaughan*, ed. F. Kermode (1986), 'The Windows', p. 58.

64 Reproduced by W. S. Simpson, *Gleanings from Old St Paul's* (1889), pp. 70–75. See in general chapter 4: 'Stained glass windows in the Cathedral'. Dugdale, *History of St Paul's Cathedral*, pp. 39–113. See also J. Spraggon, *Puritan Iconoclasm during the English Civil War: The Attack on Religious Imagery by Parliament and its Soldiers* (2003), pp. 46–7.

65 See Appendix One.

66 Stow, *Survey of London*, p. 767. This work evidently continued, for Guildhall MS 25, 471, WA 5 notes payment, in October 1635, of painters in oil.

67 Dugdale, *History of St Paul's Cathedral*, p. 140.

68 See Chapter Six, n. 98.

69 See Addleshaw and Etchells, *Architectural Setting of Anglican Worship*, p. 42.

70 See Tyacke, *Anti-Calvinists*, p. 246.

71 See Tyacke, *Anti-Calvinists*, pp. 197–216; see also Addleshaw and Etchells, *Architectural Setting of Anglican Worship*, pp. 26, 28.

72 Addleshaw and Etchells, *Architectural Setting of Anglican Worship*, p. 140.

73 See A. Milton, 'The Laudians and the Church of Rome, *c.*1625–1640', unpublished Ph.D. thesis, Cambridge University (1989), pp. 194–240.

74 For a study of the attitude of Laudians to Rome as a 'true Church', see Milton, 'The Laudians and the Church of Rome', pp. 265–99.

75 For Windebank and Montagu, see Milton, 'The Laudians and the Church of Rome', pp. 265–99. See also Rykwert, *The First Moderns*, p. 133; J. P. Sommerville, *Politics and Ideology in England, 1603–1640* (1986), pp. 218–19; Tyacke, *Anti-Calvinists*, pp. 47, 75, 125–63.

76 See Tyacke, *Anti-Calvinists*, p. 239.

77 G. Marcelline, *The Triumphs of James the First* (1610), p. 58.

78 Trevor-Roper, *Catholics, Anglicans and Puritans*, p. 143.

79 On Laud's defence of absolutism, see Sommerville, *Politics and Ideology in England*, pp. 45, 193. See also Trevor-Roper, *Catholics, Anglicans and Puritans*, p. 96; and Milton, 'The Laudians and the Church of Rome', especially chapters 1 and 2; Tyacke, *Anti-Calvinists*, pp. 106, 245–7.

80 Fleming, *Magnificence Exemplified*, p. 37. Fleming also appeals to the model of primitive Christianity, p. 45. See also Milton, 'The Laudians and the Church of Rome', p. 233.

81 See Milman, *Annals of S. Paul's Cathedral*, p. 341.

82 E. Waller, 'Upon His Majesty's Repairing of St Paul's', in *The Poetical Works of Edmund Waller*, ed. I. Bell (1784), p. 67.

83 These statues of Saxon kings are not recorded by Hollar or mentioned in the building accounts. They were, however, illustrated by Henry Flitcroft in his west front elevation published in William Kent's *The Designs of Inigo Jones* (1727). See also Hart, *Art and Magic*, p. 42.

84 See Keene, Burns and Saint (eds), *St Paul's*, pp. 181–2.

85 J. Webb, *A VINDICATION OF Stone-Heng Restored* (1725 edn), p. 27. For the apocalyptic view of history implicit in Webb's comment, see Hart, *Art and Magic*, p. 198.

86 On this cathedral drawing, see Hart, *Art and Magic*, p. 134; see also the Introduction (n. 69 above) and Chapter Six. J. Harris and G. Higgott, *Inigo Jones: Complete Architectural Drawings* (1989), p. 241, cat. no. 78, dating the drawing on religious grounds, arguing that it was part of Laud's work of 1633–42. If, however, the scheme was drawn around 1620, in forming part of Jones's work for the first cathedral commission, then this is probably the first instance of the proposed use of the monogram on the face of a church in Britain. The IHS monogram had, however, been used by the Elizabethan Catholic Thomas Tresham, on the Triangular Lodge he built at Rushton, Northamptonshire, in 1593.

87 Henderson, 'Bible Illustration in the Age of Laud', p. 179. The Arminian settlement of Little Gidding prominently displayed an IHS monogram in their parlour and their correspondence was headed by it. Charles I visited Little Gidding, saw their illustrated books and was given three, which he deposited in the Royal Library; see T. A. Birrell, *English Monarchs and their Books: From Henry VII to Charles II* (1986), p. 52.

88 See Henderson, 'Bible Illustration in the Age of Laud', p. 179.

89 'Roman Sketchbook' note, 19 January 1615; see E. Chaney (ed.), *Inigo Jones's 'Roman Sketchbook'* (2006). See J. Peacock, *The Stage Designs of Inigo Jones: The European Context* (1995), p. 53.

90 See Chapter Six, n. 98.

91 W. Prynne, *A Briefe Survay and Censure of Mr Cozens His Couzening Devotions* (1628), p. 4. St Bernardine of Siena had had a great love of the IHS monogram and urged his people to inscribe it on churches and public buildings in place of arms and other military emblems; see A. L. Maycock, *Nicholas Ferrar of Little Gidding* (1938), p. 150. On Prynne's anti-Arminianism, see Tyacke, *Anti-Calvinists*, pp. 225–6. On the use by the Jesuits of statues in tabernacles, see Harris and Higgott, *Inigo Jones*, p. 202.

92 See Harris and Higgott, *Inigo Jones*, p. 241: on Laudian reform and Jesuit façades.

93 See T. S. Eliot, 'Lancelot Andrewes', in *For Lancelot Andrewes* (1970), p. 26.

94 Palme, *Triumph of Peace*. See Chapter Seven.

95 King, *A Sermon at Paules Crosse*, p. 39. For Lionel Cranfield's involvement in the marriage negotiations and finances for St Paul's restoration, see Palme, *Triumph of Peace*, p. 22.

96 D. Gondomar, *Correspondencia oficial de don Diego Sarmiento de Acuña, conde de Gondomar* (1936–45), vol. 2, p. 306. See also Palme, *Triumph of Peace*, p. 25.

97 In presenting the restoration as an 'imposition' of 'Catholic culture' by Charles I and Laud, Trevor-Roper (*Archbishop Laud*, pp. 125–6) further notes: 'The motives which inspired them were not identical, – for Laud looked upon the arts in a more utilitarian spirit, as the external forms by which men were drawn to the support of a given system, – but they operated in the same direction.'

98 Herbert, *George Herbert and Henry Vaughan*, p. 97. For an interpretation, see Parry, *Golden Age Restor'd*, p. 244.

99 King, *A Sermon at Paules Crosse*, p. 53.

100 Waller, 'Upon His Majesty's Repairing of St Paul's', p. 67, ll. 11–14.

101 H. Farley, *The Complaint of Paule's, to all Christian Soules, or an humble Supplication, to our good King and Nation, for her reparation* (1616), pp. 27, 41.

102 See Bernard, 'The Church of England', p. 189: 'the translators left the Authorized Version open to a range of meanings . . . capable of embracing differing, even apparently incompatible, interpretations – partly one assumes because there were many puritan and catholic critics only too ready to accuse it of partiality. A translation which could admit ambiguity was nearly always to be preferred to a narrowly interpretative one.'

103 See F. Yates, *Astraea: The Imperial Theme in the Sixteenth Century* (1975), pp. 109–10.

104 Williams is described as Laud's 'great enemy' in Trevor-Roper, *Catholics, Anglicans and Puritans*, p. 149, title in index, p. 316. See also Trevor-Roper, *Archbishop Laud*, p. 124. On Williams, see here p. 48. The Puritan Sir James Cambell/Campbell (1570– 1642), for example, contributed £1,000. Puritans also contributed through the

City Companies or, after 1631, sat on the restoration committee. See V. Pearl, *London and the Outbreak of the Puritan Revolution* (1961), pp. 79, 91, 94, 295.

105 K. Sharpe, *Criticism and Compliment: The Politics of Literature in the England of Charles I* (1987), p. 21. See also J. C. Robertson, 'Caroline Culture: Bridging Court and Country?', *History*, vol. 75 (1990), pp. 392, 413.

CONCLUSION

1 See G. Parry, *Golden Age Restor'd: The Culture of the Stuart Court, 1602–42* (1981), pp. 223–4.

2 'Subito venuto il Rè avvisato dalla Regina, che haveva havuti li Quadri corsa á vederli, e chiamò il Gions Architetto molto intendente di Pitture, il Conte di Olanda, et il Conte Pembroch ivi presenti. Il Gions subito che li vidde approvandoli molto, per meglio considerarli buttò giù il suo Feraiuolo, si accomodò li Occhiali, e prese una Candela in mano e voles considerarli tutti minutamente insieme col Rè e li approvarono straordinariamente come m'ha attestato il S.re Abbate di Perona, che v'era presente, et come hà riferito la Regina al P. Filippo, la quale però n'è contentissima'. These letters are held in the Barberini Library of the Vatican, but the correspondence is also available in the copies in The National Archives, Kew, Roman Transcripts 9/17: Panzani's letters to Barberini, and 10/10: Barberini's replies. See R. Wittkower, 'Puritanissimo Fiero', *Burlington Magazine*, vol. 90 (1948), pp. 50–51 [reprinted in *Palladio and English Palladianism*, 1974, pp. 67–70]. See also E. Chaney (ed.), *Inigo Jones's 'Roman Sketchbook'* (2006), vol. 2, pp. 59–60.

3 'Il Gions Architetto del Rè crede, che il Quadro del Vinci sia il ritratto d'una tal Ginevra Benzi Venetiana, e lo raccoglie da G. e B. che hà nel petto, e questo suo concetto, come che è huomo vanissimo, e molto Vantatore, lo replica spesso per monstrare la sua gran'pratica di Pitture. Si vanta ancora, che havendo il Rè levato la nota delli Autori, che io havevo messo à ciaschedun Quadro indovino quasi il nome di tutto gli Autori. Essagera mirabilmente la loro bellezza, e dice, che sono Quadri da tener in una Camera con le Cornici d'oro, e di gemme, e questo hà ditto publi-camente nell'Anticamera della Regina nonostante ch' egli sia Puritanissimo fiero'.

4 See Wittkower, 'Puritanissimo Fiero'. See also M. Leapman, *Inigo. The Troubled Life of Inigo Jones, Architect of the English Renaissance* (2003), pp. 18–19. Horace Walpole and most of the later biographers of Jones have stated that he was a Roman Catholic. Walpole's authority was probably a note in one of George Vertue's notebooks: 'Dr Harwood from Sr. Christ. Wren, says that Inigo Dy'd at Somerset House in the Strand, a Roman Catholick, that he was put apprentice to a joiner in Pauls church yard.' See *Vertue Note Books*, vol. 1 (1930), p. 105 [see also *Notes and Queries*, vol. 178 (1940), p. 292]. It has been argued more recently that the plain style of architecture that Jones adopted for most of his projects was a reflection of his Puritan religious and political beliefs; see T. Mowl and B. Earnshaw, *Architecture without Kings: The Rise of Puritan Classicism under Cromwell* (1995). This argument is refuted in E. Chaney, *The Grand Tour and the Great Rebellion* (1985), pp. 342–4, and in the review by Chaney entitled 'A New Model Jones', *Spectator* (13 January 1996), pp. 34–6. The fact that Jones was an MP (in 1621) and a JP (from 1630) means that, outwardly at least, he must have been a conforming Anglican during his active life, despite having Catholic friends in his youth such as Edmund Bolton and Tobie Matthew (see Leapman, *Inigo*, pp. 95–6).

5 Quoted by Wittkower, 'Puritanissimo Fiero'.

6 Barberini informed the queen's agent in a letter dated September 1640 that he considered the painting 'lascivious', 'both for the story and for the way in which the painter has chosen to depict it'. He added: 'I hesitate to send it for fear of further scandalising these Heretics, especially since the subject of the work was chosen here in Rome . . . The truth is I do not think that Guido has done a better painting and, considering his age, he will not be painting many more. But, as I say, its faults are serious ones in so much as they offend decorum.' See S. Madocks, '"Trop de beautez decouveries": New Light on Guido Reni's Late *Bacchus and Ariadne*', *Burlington Magazine*, vol. 125 (1984), pp. 545–6; A. B. Banta, 'A "Lascivious" Painting for the Queen of England', *Apollo* (June 2004), pp. 66–71. The painting was destroyed in France in the seventeenth century by the widow of Michel Particelli d'Hémery, who was scandalised by the female nudes it contained.

7 G. Giustinian, in *Calendar of State Papers Venetian*, vol. 25: *1640–42*, ed. A. B. Hinds (1924), p. 93: 9 November 1640.

8 See M. Jansson, 'The Impeachment of Inigo Jones and the Pulling Down of St Gregory's by St Paul's', *Renaissance Studies*, vol. 17, no. 4 (2003), pp. 716–46; on this demolition, see also Leapman, *Inigo*, pp. 272–4.

9 W. Boghurst, untitled poem [1666], in W. Lethaby, 'Old St Paul's', *The Builder*, vol. 139 (26 December 1930), pp. 1988–90. See G. Higgott, 'The Fabric to 1670', in D. Keene, A. Burns and A. Saint (eds), *St Paul's: The Cathedral Church of London, 604–2004* (2004), p. 182.

10 W. Dugdale, *The History of St Paul's Cathedral in London* (1658 edn), p. 173.

11 See G. Addleshaw and F. Etchells, *The Architectural Setting of Anglican Worship* (1948), p. 18.

12 For the inscription, see Chapter One, n. 10 above; see Higgott, 'The Fabric to 1670', p. 186.

13 Dugdale, *History of St Paul's Cathedral* (1716 edn), p. 115, see also p. 148. It is not clear when the shops were erected, although here they are linked to the destruction of the statues.

14 *Calendar of State Papers: Domestic Series, 1650*, ed. M. A. Everett Green (London, 1876), p. 261. See M. Aston, 'Gods, Saints and Reformers: Portraiture and Protestant England', in L. Gent (ed.), *Albion's Classicism: The Visual Arts in Britain, 1550–1660* (1995), pp. 203–5.

15 *Mercurius Rusticus* was re-published as B. Ryves, *Angliae Ruina; or, England's Ruine represented in the barbarous and sacrilegious outrages of the sectaries of this kingdome* (1647 [1648] edn), see p. 233. See J. Spraggon, *Puritan Iconoclasm during the English Civil War: The Attack on Religious Imagery by Parliament and its Soldiers* (2003), pp. 54, 210.

16 See Chapter Two, p. 87.

17 G. Worsley, *Inigo Jones and the European Classicist Tradition* (2007), pp. 129–32 (where a particular example is the portico at St Paul's).

18 Dugdale, *History of St Paul's Cathedral* (1658 edn), p. 140.

19 S. Hering, *Original Letters and Papers of State addressed to Oliver Cromwell*, ed. J. Nickolls (1743), p. 99.

20 See A. Channing Downs, 'Inigo Jones's Covent Garden: The First Seventy-Five Years', *Journal of the Society of Architectural Historians*, vol. 26 (1967), p. 14. On the internal alterations to the Laudian layout under Puritan control, see J. Newman, 'Laudian Literature and the Interpretation of Caroline Churches in London', in D. Howarth (ed.), *Art and Patronage in the Caroline Courts* (1993), pp. 185–6.

21 H. Burton, *For God and the King* (1636), pp. 160, 161–2. During the 1650s there was even a movement in Parliament to demolish cathedrals, see Spraggon, *Puritan Iconoclasm*, p. 198.

22 See Spraggon, *Puritan Iconoclasm*, pp. 26–7, 58, 134, 177–80.

23 Spraggon, *Puritan Iconoclasm*, pp. 76, 81.

24 Spraggon, *Puritan Iconoclasm*, pp. 42–6, 73, 83–98.

25 Spraggon, *Puritan Iconoclasm*, pp. 72–3, 81–98.

26 The ornate high altar in the Henry VII chapel at Westminster Abbey, erected by Pietro Torregiano in 1522 with Corinthian columns and pilasters, was destroyed by the Harley Committee around December 1643: see F. Sandford, *A Genealogical History of the Kings of England and Monarchs of Great Britain* (1677), p. 471; Spraggon, *Puritan Iconoclasm*, pp. 91–2, pl. 3, p. 229 (statues).

27 J. Milton, *Complete Prose Works of John Milton*, ed. D. M. Wolfe (1953–82), vol. 1, p. 556; *Paradise Lost*, 1, ll. 713–16.

28 In 1676 Wren described the site of the old palace as a 'vacant yard'; see H. Colvin, *The History of the King's Works* (1963–82), vol. 5, p. 214.

29 See Colvin, *History of the King's Works*, vol. 4, p. 249. This screen does not appear in Henry Flitcroft's section of the early 1720s. See also Spraggon, *Puritan Iconoclasm*, p. 95.

30 *The Temple of Love* (1635), ll. 273, 300–03. See Chapter Six.

31 See Spraggon, *Puritan Iconoclasm*, pp. 61, 71–3, 95; M. White, *Henrietta Maria and the English Civil Wars* (2006). In 1640 apprentices threatened to pull down both of Jones's Catholic chapels because they were houses of popery; see S. Thurley, *Somerset House: The Palace of England's Queens, 1551–1692* (2009), p. 55. See also Thurley, 'The Stuart Kings, Oliver Cromwell and the Chapel Royal, 1618–1685', *Architectural History*, vol. 45 (2002), pp. 238–74.

32 A. J. Loomie, 'The Destruction of Rubens's "Crucifixion" in the Queen's Chapel, Somerset House', *Burlington Magazine*, vol. 140 (1998), pp. 680–82.

33 J. Vicars, *Magnalia Die Anglicana; or, England's Parliamentary-Chronicle* (1646), part two, p. 294; illustrated in Vicars, *True Information of the Beginning and Cause of all our Troubles* (1648), p. 19. See also Spraggon, *Puritan Iconoclasm*, pp. 72–3.

34 See Thurley, *Somerset House*, pp. 57–8. Jones's screen to the Queen's Closet, with its structural columns, survived to be engraved by Isaac Ware; see here Fig. 211.

35 See L. Huygens, *The English Journal, 1651–1652*, ed. A. G. H. Bachrach and R. G. Collmer (1982), p. 60. Henry Flitcroft made a measured drawing of the ceiling for Lord Burlington in the 1720s; see J. Harris and G. Higgott, *Inigo Jones: Complete Architectural Drawings* (1989), p. 198, fig. 58.

36 See Thurley, *Somerset House*, pp. 57–8.

37 J. Harris, S. Orgel and R. Strong, *The King's Arcadia: Inigo Jones and the Stuart Court* (1973), p. 153.

38 A. Cowley, *Poems*, ed. A. R. Waller (1905), pp. 433–4.

39 L. Hutchinson, *Memoirs of the Life of Colonel Hutchinson*, ed. N. H. Keeble (2000 edn), p. 42.

40 *Mercurius Britannicus*, 20 October 1645. See Colvin, *History of the King's Works*, vol. 4, pp. 156–8.

41 W. Prynne, *Hidden Workes of Darkenes Brought to Publike Light* (1645), p. 196. See F. H. W. Sheppard (ed.), *Survey of London*, vol. 36 (1970), p. 28. See also Leapman, *Inigo*, pp. 287–8.

42 One of the first acts of the Commonwealth (1649–60) was to make a priced inventory of the household goods and artworks 'belonging to the late king', and have them sold 'by order of the Council of State, from ye severall Places and Palaces'; see British Library, Bibl. Harley no. 4898. On Cromwell's preference for a 'plain style' of portraiture, see K. Sharpe, *Image Wars* (2010), pp. 493–4.

43 A. Marvell, *The Poems and Letters of Andrew Marvell*, ed. H. M. Margoliouth (1971 edn).

44 The drawing of the monument by John Aubrey is held in the Bodleian Library, Oxford, MS Aubrey 8, fol. 19r.

45 I. Webb in Jones, *The MOST NOTABLE ANTIQUITY OF GREAT BRITAIN, Vulgarly called STONE-HENG, ON SALISBURY PLAIN, RESTORED* (1655), p. 8.

46 On Jones's reception, see J. Bold, 'The Critical Reception of Inigo Jones', *Transactions of the Ancient Monuments Society*, vol. 37 (1993), pp. 147–56.

47 Worsley, *Inigo Jones and the European Classicist Tradition*, p. 186; see also Mowl and Earnshaw, *Architecture without Kings*.

48 On Wilton, see A. A. Tait, 'Isaac de Caus and the South Front of Wilton House', *Burlington Magazine*, vol. 106 (1964), p. 74; J. Bold, *Wilton House and English Palladianism* (1988); J. Heward, 'The Restoration of the South Front of Wilton House: The Development of the House Reconsidered', *Architectural History*, vol. 35 (1992), pp. 69–117; H. Colvin, 'The South Front of Wilton House', in Colvin (ed.), *Essays in English Architectural History* (1999), pp. 136–57.

49 In 1650 Sir Roger Pratt discussed with Jones the new design for Coleshill House, in the ruins of the old. See R. Pratt, *The Architecture of Sir Roger Pratt*, ed. R. T.

Gunther (1928), p. 5; Worsley, *Inigo Jones and the Euro-
pean Classicist Tradition*, pp. 43, 86–7, 175, 186.

50 J. Aubrey, *'Brief Lives', chiefly of Contemporaries, set down
by John Aubrey, between the Years 1669 and 1696*, ed. A.
Clark (1898), vol. 2, p. 10.

51 C. Campbell, *Vitruvius Britannicus; or, The British Archi-
tect* (1715–25), vol. 1: 'Introduction'.

APPENDIX 1

1 On the surviving drawings, see the Introduction. The
Guildhall Library keeps the records formerly in the
Cathedral Library, MS 25, 490 (1620 survey), MS 25, 471
(building accounts), WA 1–15, April 1633–September
1641. At Lambeth Palace, Fulham Papers 43 (October
1639–September 1640, west end). WA 1, April–October
1633, south-east end; WA 2, November 1633–September
1634, east end, south and north sides; WA 3, November
1634–September 1635, west end; WA 4, October
1634–September 1635, east end, south and north sides;
WA 5, October 1635–September 1636, south-east end;
WA 6, October 1635–September 1636, west end; WA 7,
October 1636–September 1637, south and north sides;
WA 8, October 1636–September 1637, west end; WA 9,
October 1637–September 1638, south and north sides;
WA 10, October 1637–September 1638, west end; WA 11,
October 1638–September 1639, south and north sides;
WA 12, October 1638–September 1639, west end; WA 13,
October 1639–September 1640, south and north sides;
Fulham Papers 43, October 1639–September 1640, west
end; WA 14, October 1640–September 1641, west end;
WA 15, October 1640–September 1641, whole building.

2 See V. Hart, *Art and Magic in the Court of the Stuarts*
(1994). See also J. Summerson, 'Lectures on a Master
Mind: Inigo Jones', *Proceedings of the British Academy*, vol.
50 (1964), pp. 169–92.

3 On the organisation of site work at this time, see J.
Newman, 'Nicholas Stone's Goldsmiths' Hall: Design
and Practice in the 1630s', *Architectural History*, vol. 14
(1971), pp. 30–39. For a detailed description of the fif-
teenth-century building site at the Escorial, Spain, see
G. Kubler, *Building the Escorial* (1982), pp. 77–97.

4 Calendar of State Papers: Domestic Series, between
1620 and 1643, The National Archives, Kew, 16/213,
fol. 28.

5 Guildhall, MS 25, 475, MS 25, 476, MS 25, 478, MS 25,
479, MS 25, 486 and MS 25, 488. Day books, monthly
summaries and rough cash books recording money
received by the chamberlain of London and payment
to officers of the cathedral, from 1631 to 1644.

6 For Webb's role at St Paul's, see J. Bold, *John Webb: Archi-
tectural Theory and Practice in the Seventeenth Century*
(1989), pp. 2, 168–70, (although Bold inaccurately states
that the 'work achieved at St Paul's was the remodel-
ling of the whole of the exterior, apart from the central
tower'). See also J. Summerson, in H. Colvin (ed.), *The
History of the King's Works* (1963–82), vol. 3, pp. 150–51.

7 Relieving arches such as those used at St Paul's were

employed by Webb at Lamport Hall, for example; see
Bold, *John Webb*, p. 87.

8 Transcribed in F. Godfrey (ed.), 'Inigo Jones and St
Paul's Cathedral', *London Topographical Society Record*, vol.
18 (1942), p. 42, which also lists the involvement of
'Articens of the worke, Mason Carpinter Plomber
Smithe Glasier'. Webb's role is discussed by J. Orrell,
The Theatres of Inigo Jones and John Webb (1985), p. 15.

9 See Newman, 'Nicholas Stone's Goldsmiths' Hall',
pp. 32–3.

10 See Godfrey (ed.), 'Inigo Jones and St Paul's Cathedral',
p. 43.

11 For the medieval building accounts, for example, on
Westminster Palace, see Summerson, in Colvin (ed.),
History of the King's Works, vol. 4, p. 290.

12 W. Dugdale, *The History of St Paul's Cathedral in London*
(1658), p. 139.

13 WA 1, September 1633 (windows), WA 4, November
1634 (choir buttresses repaired), WA 5, January 1636
(repair of stone 'flowers on the topp of the pinacles').
On Kinsman, see Summerson, in Colvin (ed.), *History
of the King's Works*, vol. 4, p. 329.

14 See Howard Colvin's footnote in J. Summerson, *Inigo
Jones* (2000 edn), p. 99. It would appear that Flitcroft's
columns are incorrectly drawn (see here Fig. 252).

15 J. Webb, *A VINDICATION OF Stone-Heng Restored*
(1725 edn), p. 44.

16 Unnamed in the accounts, but possibly De Critz, cited
above (Fulham Papers 43).

17 Guildhall MS 25, 471; WA 5, November 1635, notes: 'John
Snoett, Carpenter payed for framming and setting upp
of two great cranes, one at the Tower wharf the other
at St Paul's wharf.' The crane at Paul's wharf later col-
lapsed in raising a cornice stone for the west face, WA
15, May 1641. WA 13, October 1639 and July 1641 notes:
'in laying over above great peece of Tymber from the
head of the great shivers to the church, for the taking
up and setting of the Capitalls and Architrave on the
northend of the portico at the westend of the church'.

18 Webb's drawing from Strafford Letters, 24–5 (133), 14
July 1637: Wentworth Woodhouse Muniments, Central
Library, Sheffield. Jones's explanation of its mechanism
reads: 'This Engine is the best and easiest for the lading
of great stones and is the most in use of any other. It
is made of a mast in bignesse according to the great-
nesse of the stones which have to bee raised marked A.
It hath two pullies the one at the topp the other at the
bottome with a double Cable marked B. The Rope
marked C: which takes upp the stones is wound about
on a Removing Capstall which Capstall marked D:
must be fastened to yᵉ ground with stakes marked E.
The Mast hath some Ropes on the topp to gird it
marked F. And it stands in a stepp marked G: so as it
may move more easily every way. H: the stone to bee
raised. I the Rope that guides yᵉ stone to bee raysed.'
See Bold, *John Webb*, pp. 168–70. D. Howarth, 'Lord
Arundel as an Entrepreneur of the Arts', *Burlington Mag-
azine*, vol. 122, no. 931 (1980), pp. 690–92. For Jones's
pulley drawing, see S. Orgel and R. Strong, *Inigo Jones:*

The Theatre of the Stuart Court (1973), vol. 2, p. 801, no. 456 verso.

19 On the problem of authorship of this document, see Hart, *Art and Magic*, appendix, pp. 201–5.

20 I. Jones, *The MOST NOTABLE ANTIQUITY OF GREAT BRITAIN, Vulgarly called STONE-HENG, ON SALISBURY PLAIN, RESTORED* (1655), pp. 34, 35. On the possible date of this passage, see Hart, *Art and Magic*, appendix, pp. 201–5.

21 Webb, *A VINDICATION OF Stone-Heng Restored*, pp. 214–15.

22 J. Dee, 'Mathematical Preface', in *EUCLID. The elements of geometrie of the most auncient philosopher Euclide of Megara. Translated into Englishe, by H. Billingsley with a very fruitfull praeface by M. I. Dee* (1570), fol. dj. On Dee's preface, see N. Clulee, *John Dee's Natural Philosophy: Between Science and Religion* (1988), pp. 146–76. See also J. A. Bennett, 'Architecture and Mathematical Practice in England, 1550–1650', in J. Bold and E. Chaney (eds), *English Architecture: Public and Private. Essays for Kerry Downes* (1993), pp. 23–9.

23 These towers have been discussed by W. Longman, *A History of the Three Cathedrals Dedicated to St Paul in London* (1873), pp. 34–6: 'The first question is, whether there were any western towers? Dugdale does not mention any, nor are there any in Hollar's plates . . . The turrets represented on each side of Inigo Jones' portico do not deserve [Stowe's] description of "a strong tower of stone," . . . and are hardly large enough to be used as a prison. They may, however, have been rebuilt by Inigo Jones on the foundations of larger towers, but, it must be stated, there is no evidence of this. No drawings or plates are known to exist which would settle this question.' J. Summerson, *Architecture in Britain, 1530 to 1830* (1983 edn), p. 136, assumes that Jones's southern tower was 'a recasing of the old tower of St Gregory-by-St-Paul's, the other a duplicate for symmetry', but earlier ('Lectures on a Master Mind', p. 184) he had noted 'the two ancient but remodelled towers'.

24 See R. Pratt, *The Architecture of Roger Pratt*, ed. R. T. Gunther (1928), p. 197.

25 In January 1636 Andreas Came, listed as carver and mason, modelled a lion's head in clay (WA 5), and in

June 1638 Enoch Wyatt was making models of cherubim (WA 9).

26 Pratt, *Architecture of Roger Pratt*, p. 197. See Chapter Two.

27 Dugdale, *History of St Paul's Cathedral*, p. 104; WA 13, September 1640; WA 14 and WA 15, October 1640. See Summerson, in Colvin (ed.), *History of the King's Works*, vol. 3, p. 151.

28 Dugdale, *History of St Paul's Cathedral* (1716 edn), p. 115.

29 These drawings are in the collection at All Souls, Oxford. Published in A. T. Bolton and H. P. Hendry (eds), *Wren Society Publications* (1937 edn), vols 1, 2 and 3.

30 Quoted in C. Wren, *PARENTALIA; or, MEMOIRS OF THE FAMILY of the WRENS; viz . . . chiefly of Sir Christopher Wren* (1750), p. 279.

31 See Chapter Two.

32 Dugdale, *History of St Paul's Cathedral* (1658 edn), p. 135.

APPENDIX 2

1 See J. Peacock, *The Stage Designs of Inigo Jones: The European Context* (1995), pp. 104–111. See also the Conclusion.

2 British Library, Lansdowne MS 1171, fols 1b–2 (elevation of stage), 31–4 (ground plan of the stage and scenery). See J. Orgel and R. Strong, *Inigo Jones: The Theatre of the Stuart Court* (1973), vol. 2, pp. 740–52. See also the hall plan, and stage plan and section for *Florimène* (1635), in ibid., pp. 638–45.

3 J. Orrell, *The Theatres of Inigo Jones and John Webb* (1985), pp. 149–59; Orrell, *The Human Stage: English Theatre Design, 1567–1640* (1988), pp. 225–52.

4 See V. Hart and A. Day, 'A Computer Model of the Theatre of Sebastiano Serlio, 1545', *Computers and the History of Art*, vol. 5, no. 1 (1995), pp. 41–52.

5 See Peacock, *Stage Designs of Inigo Jones*, p. 51. C. Anderson, 'The Secrets of Vision in Renaissance England', in L. Massey (ed.), *The Treatise on Perspective: Published and Unpublished* (2003), pp. 323–47; C. Van Eck, 'Statecraft or Stagecraft? English Paper Architecture in the Seventeenth Century', in S. Bonnemaison and C. Macy (eds), *Festival Architecture* (2008), p. 119.

6 Orrell, *The Theatres of Inigo Jones and John Webb*.

BIBLIOGRAPHY

PRIMARY SOURCES

Alberti, L. B., *On the Art of Building in Ten Books*, trans. J. Rykwert, N. Leach and R. Tavernor, Cambridge, MA, 1988

Albertini, F., *Opusculum de mirabilibus novae & veteris urbis Romae*, Rome, 1510

Anon., *Sir Gawain and the Green Knight* [*c*.1400], Harmondsworth, 1972

——, *A fourme of Prayer with Thankesgiving, to be used by all the Kings Maiesties loving Subjects every yeere the fifth of August*, London, 1603

——, [J. Hoskins?], 'Philosophical Banquet at the Mitre, Fleet Street' [1611], The National Archives (formerly the Public Record Office), Kew, SP 14/66

——, *De Templis, a Treatise of Temples: Wherein Is Discovered the Ancient Manner of Building, Consecrating and Adorning of Churches*, London, 1638

——, *Majesties happy and safe returne from Scotland . . . Thursday November 25, 1641* [four pages, Cambridge University Library, Pet.K.10⁵]

——, *Mercurius Britannicus*, 20 October 1645

——, *Gallus Castratus*, appended to *A Character of France*, London, 1659

——, 'Henry Farley', *Gentleman's Magazine*, vol. 50 (1780), p. 179

——, *The Manuscripts of His Grace the Duke of Rutland, KG, Preserved at Belvoir Castle: Historic Manuscripts Commission*, vol. 4, London, 1905

Ariosto, L., *Orlando Furioso*, 2 vols, Harmondsworth, 1977

Aristotle, *L'ethica d'Aristotile*, trans. and ed. B. Segni, Venice, 1551

——, *The Basic Works of Aristotle*, ed. R. McKeon, New York, 1941

——, *Nicomachean Ethics*, trans. J. A. K. Thomson, Harmondsworth, 1976

Ashmole, E., *Theatrum Chemicum Britannicum*, London, 1652

——, *The Institution, Laws & Ceremonies of the Most Noble Order of the Garter*, London, 1672

——, *Elias Ashmole, 1617–92: His Autobiographical and Historical Notes*, ed. C. H. Josten, 5 vols, Oxford, 1966

Aubrey, J., *The Remaines of Gentilisme and Judaisme*, London, 1686–7

——, *The Natural History of Wiltshire*, ed. J. Britton, London, 1847

——, *'Brief Lives', chiefly of Contemporaries, set down by John Aubrey, between the Years 1669 and 1696*, ed. A. Clark, 2 vols, Oxford, 1898

——, *Aubrey's Brief Lives*, Harmondsworth, 1972

——, *John Aubrey's 'Monumenta Britannica'*, ed. J. Fowles, Sherborne, Dorset, 1980

Bacon, F., *The Historie of the Reigne of King Henry the Seventh*, London, 1622

——, *Literary and Professional Works*, ed. J. Spedding, R. L. Ellis and D. D. Heath, 14 vols, London, 1857–74

——, *Advancement of Learning, The New Atlantis, and Other Pieces*, Oxford, 1906

Barbet, J., *Livre d'architecture, d'autels, et de cheminées*, Paris, 1633

Barrow, H., *The Writings of Henry Barrow, 1587–90*, ed. L. H. Carlson, London, 1962

Bede, *A History of the English Church and People*, Harmondsworth, 1955

Birch, T., *Life of Henry, Prince of Wales*, Dublin, 1760

Birkenhead, J., *Two Centuries of Pauls Church-yard*, London, 1653

Blum, H., *The Booke of five collumnes of Architecture*, trans. 'I. T.' [John Thorpe], London, 1601

Boghurst, W., Untitled poem [1666], in W. Lethaby, 'Old St Paul's', *The Builder*, vol. 139 (26 December 1930), pp. 1988–90

Boissard, J., *Theatrum vitae humanae*, Metz, 1596

Bolton, E., *The Elements of Armories*, London, 1610

——, *Nero Cæsar; or, Monarchie Depraved*, London, 1624

——, *The Cities Advocate, In this Case or Question of Honour and Armes*, London, 1628

——, *HYPERCRITICA; or, A rule of Judgement for writing or reading our History's*, Oxford, 1722 [reprinted in J. Haslewood (ed.), *Ancient Critical Essays upon English Poets and Poesy*, vol. 2, London, 1815]

Bordini, G. F., *De Rebus Praeclare Gestis a Sixto V*, Rome, 1588

Burton, H., *For God and the King: The summe of two sermons preached on the fifth of November last in St Matthewes Friday-Streete*, London, 1636

Busca, G., *L'architettura militare*, Milan, 1619

Camden, W., *Britannia; or, A Chorographicall Description of the*

most flourishing kingdomes, England, Scotland, and Ireland, trans. P. Holland, London, 1610 edn

Campbell, C., *Vitruvius Britannicus; or, The British Architect,* 3 vols, London, 1715–25

Campion, T., *Campion's Works,* ed. S. P. Vivian, Oxford, 1909

Carew, T., *The Poems of Thomas Carew,* ed. R. Dunlop, Oxford, 1949

Cataneo, P., *L'architettura,* Venice, 1567

Cesariano, C., *Vitruvius,* Como, 1521

Chapman, G., *The Memorable Maske of the two honorable houses, or Innes of Court: the Middle Temple, and Lyncolns Inne,* London, 1613

——, *The Divine Poem of Musaeus,* London, 1616

——, *The Georgicks of Hesiod . . . Containing Doctrine of Husbandrie, Moralite, and Pietie,* London, 1618

Charleton, W., *CHOREA GIGANTUM; or, The most FAMOUS ANTIQUITY . . . STONE-HENG,* London, 1663

Cicero, *De oratore,* ed. and trans. E. W. Sutton and H. Rackham, Cambridge, MA, and London, 1948

——, *Orator,* ed. and trans. H. M. Hubbell, Cambridge, MA, and London, 1962

Cobbett, W. (ed.), *The Parliamentary History of England,* 36 vols, London, 1806–20

Colonna, *Hypnerotomachia. The Strife of Love in a Dreame,* trans. 'R. D.' [Roger Dallington?], London, 1592

Coryate, T., *Coryate's Crudities,* London, 1611

Cowell, J., *The Interpreter, or booke containing the Signification of Words . . . as are mentioned in the Lawe Writers, or Statutes of this victorious and renowned kingdome,* Cambridge, 1607

Cowley, A., *Poems,* ed. A. R. Waller, Cambridge, 1905

Dawes, L., *Sermons,* London, 1653

De Caus, I., *Le Jardin de Wilton,* London, c.1645

De l'Orme, P., *Le Premier Tome de l'architecture,* Paris, 1567

Dee, J., 'Mathematical Preface', in *EUCLID. The elements of geometrie of the most auncient philosopher Euclide of Megara. Translated into Englishe, by H. Billingsley with a very fruitfull praeface by M. I. Dee,* London, 1570

Dekker, T., *The Magnificent Entertainment Given to King James,* London, 1616

Donne, J., *The Sermons of John Donne,* ed. G. R. Potter and E. M. Simpson, 10 vols, Berkeley, CA, 1953–62

——, *The Complete English Poems of John Donne,* ed. C. A. Patrides, London, 1985

Drayton, M., *England's Heroicall Epistles,* London, 1597

——, *A pæan triumphal; composed for the Societie of the Goldsmiths of London, congratulating his Highnes' magnificent entring the Citie. To the Majestie of the King,* London, 1604 [in J. Nichols, *The Progresses, Processions and Magnificent Festivities of King James I,* vol. 1 (1828), pp. 402–7]

——, *Poly-Olbion; or, A Chorographicall Description of Tracts, Rivers, Mountaines, Forests, and other parts of this renowned Isle of Great Britaine,* London, 1613

——, *Nymphidia: the Court of Fayrie,* ed. E. Brydges, Lee Priory, 1814 edn

Du Cerceau, J. A., *Les plus excellents bastiments de France,* 2 vols, Paris, 1576–9

Dugdale, G., *The Time Triumphant,* London, 1604

Dugdale, W., *The History of St Paul's Cathedral in London,* London, 1658; enlarged edn, 1716

——, *THE ANTIENT USAGE in Bearing of Such Ensigns of Honour As are commonly call'd ARMS. WITH A Catalogue of the present NOBILITY and BARONETS of ENGLAND,* Oxford, 1682

Euclid, *De gli elementi d'Euclide libri quindici,* trans. F. Commandino, Urbino, 1575

Evelyn, J., *Parallel of the Ancient Architecture with the Modern, in a collection of ten principal authors who have written upon the Five Orders,* London, 1664

——, *Diary of John Evelyn,* ed. W. Bray, 4 vols, London, 1906

Fairholt, F. W., *Lord Mayors' Pageants: being Collections towards a History of these Annual Celebrations* [Percy Society Publication, vol. 10], London, 1843

——, *The Civic Garland: A Collection of Songs from London Pageants,* London, 1845

——, *Poems and Songs relating to George Villiers, Duke of Buckingham,* London, 1850

——, *Notes from the Ecclesiastical Court Records at Somerset House* [Transactions of the Royal Historical Society, 4th series, vol. 1], 1921

Farley, H., *The Complaint of Paule's, to all Christian Soules, or an humble Supplication, to our good King and Nation, for her reparation,* Cambridge, 1616

——, *Portland-Stone in Paules-Church yard. Their Birth, their Mirth, their Thankefulnesse, their Advertisement,* London, 1622

Favyn, A., *The Theatre of Honour and Knighthood,* London, 1619

Fleming, G., *Magnificence Exemplified: And The Repaire of Saint Paul's exhorted unto,* London, 1634

Fontana, D., *Della trasportatione dell'obelisco vaticano et della fabriche di nostro signore Papa Sisto V . . . libro primo,* Rome, 1590; 1604 edn

Foxe, J., *Actes and Monuments,* London, 1563; 1641 edn

Geoffrey of Monmouth, *The History of the Kings of Britain,* trans. S. Evans, London, 1963 edn

——, *The History of the Kings of Britain,* trans. L. Thorpe, Harmondsworth, 1966

Gerbier, B., *The Interpreter of the Academie for Forrain Languages, and all Noble Sciences, and Exercises,* London, 1648

——, *A Brief Discourse Concerning the Three Chief Principles of Magnificent Building,* London, 1664

Giustinian, G., in *Calendar of State Papers Venetian,* vol. 25: *1640–42,* ed. A. B. Hinds, London, 1924, p. 93: 9 November 1640

Glasier, H., *A notable and very fruitefull sermon made at Paules Crosse,* London, 1555

Glover, R., *The Catalogue of Honour,* London, 1610

Gondomar, D., *Correspondencia oficial de don Diego Sarmiento de Acuna, conde de Gondomar,* 4 vols, Madrid, 1936–45

Gordon, J., *England and Scotlands Happinesse,* London, 1604

——, *ENOTIKON; OR, A SERMON OF THE Union of Great Brittannie in antiquite of language, name, religion and Kingdome,* London, 1604

——, *The Union of Great Brittaine,* London, 1604

——, *EIPHNOKOINONIA. THE PEACE OF THE COMMUNION OF THE CHURCH OF ENGLAND,* London, 1612

Guillim, J., *A Display of Heraldrie*, London, 1610–11 edn; republished 1632

Gurnay, E., *Gurnay Redivivus; or, An Appendix unto the Homily against Images in Churches*, London, 1660 edn

Hall, J., *Bishop Hall's Hard Measure, written by himself upon his Impeachment of high crimes and misdemeanours, for defending the Church of England*, London, 1710

Harrison, S., *Arches of Triumph*, London, 1604 [Magdalene College, Cambridge, *London and Westminster*, vol. 2, pl. 2973/329–33b]

Hatton, E., *A New View of London*, London, 1708

Haydocke, R., *Trattato dell'arte della pittura . . . A Tracte Containing the Artes of Curious Paintinge, Carvinge & Buildinge*, Oxford, 1598 [English trans. of Lomazzo 1584]

Herbert, G., *George Herbert and Henry Vaughan*, ed. F. Kermode, Oxford, 1986

Herbert, T., *Memoirs Of The Two Last Years Of The Reign Of That Unparallell'd Prince, King Charles I*, London, 1702

Hering, S., *Original Letters and Papers of State addressed to Oliver Cromwell*, ed. J. Nickolls, London, 1743

Hesiod, 'Works and Days', in *The Homeric Hymns and Homerica*, trans. G. H. Evelyn-White, London and Cambridge, MA, 1967, pp. 2–65

Heywood, T., *TROIA BRITANICA; or, Great Britaines Troy*, London, 1609

——, *The Life of MERLIN . . . His Prophesies, and Predictions Interpreted . . . Being a Chronographicall History of all the Kings . . . from BRUTE to the Reign of our Royall Soveraigne King CHARLES*, London, 1641

Holland, H., *Ecclesia Sancti Pauli Illustrata*, London, 1633

Howell, J., *LONDONOPOLIS . . . The Imperial Chamber, and Chief Emporium of Great Britain*, London, 1657

Hudson, W., *A Treatise of the Court of Star Chamber*, undated manuscript, Cambridge University Library, Add. 3106 [in F. Hargrave (ed.), *Collectanea Juridica*, vol. 2, London, 1792, pp. 1–239]

Hutchinson, L., *Memoirs of the Life of Colonel Hutchinson*, ed. N. H. Keeble, London, 2000 edn

Huygens, L., *The English Journal, 1651–1652*, ed. A. G. H. Bachrach and R. G. Collmer, Leiden, 1982

James I, *THE KINGS MAJESTIES SPEACH To the Lords and Commons . . . Wednesday the xxi of March*, London, 1610

——, *By the King. A Proclamation for Building*, London, 16 July 1615

——, *The Workes of the Most High and Mightie Prince James*, London, 1616

——, *By the King. A Proclamation declaring His Majesties further pleasure for matters of Buildings*, London, 1619

——, *Psalmes of King David*, Oxford, 1631

——, *The Political Works of James I*, ed. C. H. McIlwain, Cambridge, MA, 1918 [inc. *Basilikon Doron*, Edinburgh, 1599]

Jones, I., *The MOST NOTABLE ANTIQUITY OF GREAT BRITAIN, Vulgarly called STONE-HENG, ON SALISBURY PLAIN, RESTORED, By Inigo JONES, Esq, Architect General to the King*, London, 1655; reprinted 1972, 2003

——, [Forgery of Masonic document, 'Inigo Jones MS'], *Quatuor Coronatorum Antigrapha*, vols 4–7, July 1881

——, *Inigo Jones on Palladio: being notes by Inigo Jones in his copy of I Quattro Libri dell Architettura di Andrea Palladio 1601*, 2 vols, Newcastle upon Tyne, 1970

——, *Three volumes annotated by Inigo Jones: Vasari's* Lives *(1568)*, Plutarch's Moralia, Plato's Republic, ed. A. W. Johnson, Abo, Vaasa, 1997

Jones, J., *Londons Looking Backe to Jerusalem; or, God's Judgement Preached at Paul's Cross*, London, 1633

Jonson, B., *A Panegyre, on the Happie Entrance of James, our Soveraigne, to His first sesion of Parliament*, London, 1603. In *Works*, ed. Herford and Simpson, vol. 7, pp. 111–17

——, *To Penshurst* [c.1612]. In *Works*, ed. Herford and Simpson, vol. 11, p. 33

——, *Newes from the New World Discover'd in the Moone* [1620]. In *Works*, ed. Herford and Simpson, vol. 7, pp. 513–25

——, *A Tale of the Tub* [1633]. In *Works*, ed. Herford and Simpson, vol. 3, pp. 3–92

——, *Love's Welcome at Bolsover* [1634]. In *Works*, ed. Herford and Simpson, vol. 7, pp. 787–814

——, *Works*, ed. C. Herford and P. Simpson, 11 vols, Oxford, 1925–52

——, *The Alchemist*, ed. D. Brown, London, 1966 edn

——, 'An Execration upon Vulcan', in I. Donaldson (ed.), *Ben Jonson*, Oxford, 1985, p. 365

——, 'An Expostulation W[i]th Inigo Jones', in Donaldson (ed.), *Ben Jonson*, p. 462

Juxon, W., *The Subjects Sorrow; or, Lamentations upon the Death of Britaines Josiah, King Charles*, London, 1649

Kent, W., *The Designs of Inigo Jones, Consisting of Plans and Elevations for Publick and Private Buildings*, 2 vols, London, 1727; reprinted 1967

——, and Vardy, J., *Some Designs of Mister Inigo Jones and Mister William Kent*, London, 1744; reprinted 1967

King, H., *A Sermon Preached at St Paul's, March 27. 1640. Being the Anniversary of his Majesties Happy Inauguration to his Crowne*, London, 1640

King, J., *A Sermon at Paules Crosse, on behalfe of Paules Church*, London, 26 March 1620

Knowler, W. (ed.), *The Earl of Strafforde's Letters and Dispatches*, 2 vols, London, 1739

Laud, W., *Seven Sermons Preached upon Severall Occasions*, London, 1651

——, *THE HISTORY OF THE TROUBLES AND TRYAL OF THE Most Reverend Father in God, and Blessed Martyr, WILLIAM LAUD, Lord Arch-Bishop of Canterbury*, London, 1695

——, *The Works of . . . William Laud*, ed. W. Scott and J. Bliss, 7 vols, Oxford, 1847–60

Legh, G., *The Accedens of Armory*, London, 1562

Lightfoot, J., *The Temple Especially as it stood in the dayes of our Saviour*, London, 1650

Lithgow, W., *The totall discourse of the rare adventures, and painefull peregrinations long nineteen yeares travayles from Scotland to the most famous kingdoms in Europe, Asia and Affrica*, London, 1632 edn

Lomazzo, G. P., *Trattato dell'arte della pittura scultura et architettura*, Milan, 1584 [English trans., Haydocke 1598]

——, *Scritti sulle arti*, ed. R. P. Ciardi, 2 vols, Florence, 1973–5

Lorini, B., *Le fortificationi*, Venice, 1609

Lupton, D., *London and the Countrey Carbonadoed*, London, 1632

Machyn, H., *The Diary of Henry Machyn . . . 1550 to 1563*, ed. J. Gough Nichols, London, 1848

Maitland, W., *The History of London*, 2 vols, London, 1756

Marcelline, G., *The Triumphs of King James the First*, London, 1610

——, *Epithalamium, Gallo-Britannicum*, London, 1625

Marvell, A., *The Poems and Letters of Andrew Marvell*, ed. H. M. Margoliouth, 2 vols, Oxford, 1971 edn

Mede, J., *Churches, that is, Appropriate Places for Christian Worship both in and ever since the Apostles Times*, London, 1638

Middleton, T., *Thomas Middleton: The Collected Works and Companion*, ed. G. Taylor, Oxford, 2007

Milton, J., *Complete Prose Works of John Milton*, ed. D. M. Wolfe, 8 vols, New Haven, 1953–82

Newcourt, R., *Repertorium ecclesiasticum parochiate Londinense*, 2 vols, London, 1708–10

Nichols, J., *The Progresses, Processions and Magnificent Festivities of King James I*, 4 vols, London, 1828

Pagitt, E., *CHRISTIANOGRAPHY; OR, THE Description of the multitude and Sundary sorts of CHRISTIANS in the World*, 3rd edn, London, 1640

Palladio, A., *The Four Books of Architecture*, trans. I. Ware, London, 1738

——, *The Four Books on Architecture*, trans. R. Tavernor and R. Schofield, Cambridge, MA, 1997

Parr, R., *The Life of James Usher*, London, 1686

Peacham, H. (Senior), *The Garden of Eloquence, Conteining the Most Excellent Ornaments, Exornations, Lightes, flowers, and formes of speech, commonly called the Figures of Rhetorike. By which the Singular Partes of mans mind, are most aptly expressed, and the sundrie affections of his heart most effectuallie uttered*, London, 1577 and 1593 edns

Peacham, H. (Junior), *Minerva Britanna (or a Garden of Heroical Devices)*, London, 1612

——, *The Complete Gentleman*, London, 1622

Pepys, S., *Diary*, ed. R. Latham and W. Matthews, 11 vols, London, 1976

Perrault, C., *Ordonnance des cinq espèces de colonnes selon la méthode des Anciens*, Paris, 1683

Pilkington, J., *The Burnynge of Paules Church in London in the year of our Lord 1561*, London, 1563

Plato, *La Republica di Platone*, trans. P. Fiorimbene, Venice, 1554

——, *The Republic*, trans. H. D. P. Lee, Harmondsworth, 1955

Pliny, *Natural History*, trans. H. Rackham and D. E. Eichholz, London, 1938

Plot, R., *The Natural History of Oxford-shire*, Oxford, 1677

Pratt, R., *The Architecture of Sir Roger Pratt*, ed. R. T. Gunther, Oxford, 1928

Prynne, W., *A Briefe Survay and Censure of Mr Cozens His Couzening Devotions*, London, 1628

——, *Histriomastix: The Player's Scourge; or, Actor's Tragedy*, London, 1633

——, *Hidden Workes of Darkenes Brought to Publike Light; or, A necessary introduction to the history of the archbishop of Canterburie's triall*, London, 1645

——, *Canterburies Doome; or, The first part of a Compleat History of the Commitment, Charge, Tryall, Condemnation and Execution of William Laud*, London, 1646

Puttenham, G., *The Arte of English Poesie*, London, 1589

Recorde, R., *First Principles of Geometrie*, London, 1551

——, *The Castle of Knowledge*, London, 1556

Ripa, C., *Iconologia, overo Descrittione d'Imagini delle Virtu, Vitij, Affetti, Passioni humane*, Rome, 1603

Ryves, B., *Angliae Ruina; or, England's Ruine represented in the barbarous and sacrilegious outrages of the sectaries of this kingdome*, London, 1647 [1648] edn

Sandford, F., *A Genealogical History of the Kings of England and Monarchs of Great Britain*, London, 1677

Scala, G., *Geometria prattica . . . sopra le tauole dell'Ec^{ce} Mathematico Giovanni Pomodoro*, Rome, 1603

Scamozzi, V., *L'Idea dell'architettura universale, divisa in 10 Libri*, Venice, 1615

Segar, W., *Honour and Armes*, London, 1590

Serlio, S., *Regole generali di architettura. Sopra le cinque maniere degli edifici*, Venice, 1537

——, *Den Eersten (-Vijfsten) Boeck van Architecturen Sebastiani Serlii*, Amsterdam, 1606

——, *The first (-fift) Book of Architecture, made by Sebastian Serly, entreating of Geometrie. Translated out of Italian into Dutch, and out of Dutch into English*, trans. R. Peake, London, 1611

——, *Sebastiano Serlio on Architecture*, 2 vols, New Haven and London, 1996–2001 [trans. V. Hart and P. Hicks of Serlio's *Tutte l'opere d'architettura et prospetiva*, vol. 1: Books I–V; vol. 2: Books VI–'VIII', and the 'Extraordinary Book of Doors' (*Extraordinario libro di Architettura*)]

Shakespeare, W., *The Tempest*, Harmondsworth, 1968

Shute, J., *The First and Chief Groundes of Architecture used in all the auncient and famous monymentes*, London, 1563; facsimile reprint, 1912

Sidney, P., *The Complete Poems*, ed. W. Ringler, Oxford, 1962

——, *The Countess of Pembroke's Arcadia*, ed. M. Evans, Harmondsworth, 1977

Simpson, W. S., *Documents Illustrating the History of S. Paul's Cathedral* [Camden Society], Westminster, 1880

——, *Chapters in the History of Old St Paul's*, London, 1881

——, *Gleanings from Old St Paul's*, London, 1889

——, *S. Paul's Cathedral and Old City Life*, London, 1894

Smart, P., *A Short treatise of Altars*, London, 1641?

Spenser, E., *Poetical Works*, ed. J. Smith and E. De Selincourt, Oxford, 1912

Steward, R., *THE ENGLISH CASE, Exactly set down by HEZEKIAH'S Reformation, In A Court Sermon At PARIS*, London, 1659

Stow, J., *The Survey of London*, London, 1598 and 1633 edns

——, *Annales; or, A Generall Chronicle of England, Begun by John Stow: Continued and Augmented*, London, 1631–2 edn

Stukeley, W., *Stonehenge, a Temple restored to the British Druids*, London, 1740

Thornborough, J., *The Joiefull and Blessed Reuniting of the two mighty and famous kingdomes, England and Scotland into their ancient name of great Brittaine*, Oxford, 1604

——, *A Discourse, showing the Great Happinesse, that hath, and may still accrue to his Majesties Kingdomes of ENGLAND AND SCOTLAND, BY RE-UNITING them into one Great Britain*, London, 1641

Tierney, M., *The History and Antiquities of the Castle and Town of Arundel*, 2 vols, London, 1834

Valeriano, G. P., *Les Hieroglyphiques*, [Lyon, 1615], French trans. by I. de Montlyard, New York, 1976

Vertue, G., *Vertue Note Books*, vol. 1 [Walpole Society Publications, vol. 18], Oxford, 1930

Vicars, J., *Magnalia Die Anglicana; or, England's Parliamentary-Chronicle*, London, 1646

——, *A Sight of ye Trans-actions of these Latter Yeares Emblemized with Ingraven Plats, which men may read without Spectacles*, London, 1646

——, *True Information of the Beginning and Cause of all our Troubles*, London, 1648

Vignola, G. B., *Regola delle cinque ordini d'architettura*, Rome, 1607

——, *VIGNOLA; or, The Compleat Architect, Shewing . . . The rules of the Five Orders in Architecture . . . by J. Barazzio*, trans. J. Moxon, London, 1655

Villalpando, J. B., *In Ezechielem Explanationes et Apparatus Vrbis ac Templi Hierosolymitani*, 3 vols, Rome, 1596–1604

Vincent, T., *Gods Terrible Voice in the City*, London, 1667

Viola Zanini, G., *Della architettura*, Padua, 1629

Vitruvius, *I dieci libri dell'architettura di M. Vitruvio tradotti e commentati da Monsig. Daniele Barbaro*, Venice, 1556 and 1567 edns

——, *On Architecture*, Books I–X, trans. F. Granger, 2 vols, London, 1931 edn; republished 1983

Wadsworth, J., *Further Observations of the English Spanish Pilgrime, Concerning Spain*, London, 1630

Walker, W., *A Sermon Preached in St Paul's Church*, London, 1628

Waller, E., *The Poetical Works of Edmund Waller*, ed. I. Bell, Edinburgh, 1784

Walpole, H., *Anecdotes of Painting in England*, 5 vols, London, 1782 edn

Walton, B., *Biblia Sacra Polyglotta*, 6 vols, London, 1655–7

Ware, I., *Designs of Inigo Jones and others, published by I. Ware*, London, c.1733

——, *A Complete Body of Architecture, Adorned with plans and elevations, from original designs. By Isaac Ware, Esq. . . . In which are interspersed some designs of Inigo Jones, never before published*, London, 1756

Warmstry, T., *A Convocation Speech . . . against images, altars, crosses, the new canons and the oath, &c*, London, 1641

Webb, J., *A VINDICATION OF Stone-Heng Restored: In which the ORDERS and RULES OF ARCHITECTURE Observed by the ANCIENT ROMANS, ARE DISCUSSED*, London, 1665 and 1725 edns

——, *AN HISTORICAL ESSAY Endeavoring a Probability that the LANGUAGE of the Empire of CHINA is the Primitive LANGUAGE*, London, 1669

Whitelocke, B., *MEMORIALS OF THE ENGLISH Affairs, from the suppos'd EXPEDITION OF BRUTE to this Island, To The End of the REIGN of King JAMES the First*, London, 1709

Whitney, G., *A Choice of Emblems, and other devises*, Leyden, 1586

Wilkins, D., *Concilia Magnae Britanniae et Hiberniae*, 4 vols, London, 1737

Wilkins, J., *Mathematicall MAGIC, OR, THE WONDERS That may be performed by Mechanicall Geometry*, London, 1648

Williams, J., *Great Britains SALOMON. A Sermon Preached at*

THE MAGNIFICENT Funerall, of the most high and mighty King, JAMES, the late King of Great Britaine, London, 1625

Wilson, A., *The History of Great Britain, being the life and reign of king James the First*, London, 1653

Wotton, H., *The Elements of Architecture . . . collected from the Best Authors and Examples*, London, 1624 [facsimile reprint, ed. F. Hard, Charlottesville, VA, 1968].

——, *The Life and Letters of Sir Henry Wotton*, ed. L. P. Smith, 2 vols, Oxford, 1907

——, *A Philosophical Survey of Education; or, Moral Architecture, and The Aphorisms of Education*, ed. H. S. Kermode, Liverpool, 1938

Wren, C., *PARENTALIA; or, MEMOIRS OF THE FAMILY of the WRENS; viz . . . chiefly of Sir Christopher Wren*, London, 1750

——, *St Paul's Cathedral: Original Wren Drawings from the Collection at All Souls College, Oxford*; see Bolton and Hendry 1924–43, vols 1–2

Wright, R., *A Receyt to Stay the Plague*, London, 1625

Wyrley, W., *The True use of Armorie*, London, 1592

SECONDARY SOURCES

Ackerman, J., 'The Tuscan/Rustic Order: A Study in the Metaphorical Language of Architecture', in Ackerman, *Distance Points: Essays in Theory and Renaissance Art and Architecture*, Cambridge, MA, 1991, pp. 495–541

Addleshaw, G., and Etchells, F., *The Architectural Setting of Anglican Worship*, London, 1948

Anderson, C., 'Learning to Read Architecture in the English Renaissance', in L. Gent (ed.), *Albion's Classicism: The Visual Arts in Britain, 1550–1660*, New Haven and London, 1995, pp. 239–86

——, 'La lettura dei testi come strategia di progettazione: Inigo Jones e la facciata occidentale della chiesa di Saint Paul', *Annali di architettura*, vol. 9 (1997), pp. 245–64

——, 'Masculine and Unaffected: Inigo Jones and the Classical Ideal', *Art Journal*, vol. 56, no. 2 (1997), pp. 48–54

——, 'Masculinity and English Architectural Classicism', in *Gender and Art*, vol. 5 of G. Perry (ed.), *Art and its Histories*, New Haven and London, 1999, pp. 130–53

——, 'Palladio in England: The Dominance of the Classical in a Foreign Land', in *Palladio nel Nord Europa: libri, viaggiatori e architetti*, Centro Internazionale di Studi di Architettura Andrea Palladio, Vicenza and Milan, 1999, pp. 59–61, 122–49

——, 'A Gravity in Public Places: Inigo Jones and Classical Architecture', in L. Durning and R. Wrigley (eds), *Gender and Architecture: History, Interpretation and Practice*, Chichester, 2000, pp. 7–28

——, 'Monstrous Babels: Language and Architectural Style in the English Renaissance', in G. Clarke and P. Crossley (eds), *Architecture and Language*, Cambridge and New York, 2000, pp. 148–61

——, 'Wild Waters: Hydraulics and the Forces of Nature', in P. Hulme and W. H. Sherman (eds), *'The Tempest' and its Travels*, London, 2000, pp. 41–7

——, 'Gorgeous Palaces and Solemn Temples: Inigo Jones and New Ideas of Architecture', in *Théorie des arts et création artistique dans l'Europe du Nord du XVIe au début du XVIIIe siècle. Actes du colloque international organisé les 14 et 16 décembre 2000 à l'Université Charles-de-Gaulle, Lille 3*, ed. M. Heck, F. Lemerle and Y. Pauwels, Lille, 2002, pp. 155–69

——, 'The Secrets of Vision in Renaissance England', in L. Massey (ed.), *The Treatise on Perspective: Published and Unpublished*, Washington, DC, 2003, pp. 323–47

——, *Inigo Jones and the Classical Tradition*, Cambridge, 2007

Angelicoussis, E., 'The Collection of Classical Sculptures of the Earl of Arundel, "Father of Vertu in England"', *Journal of the History of Collections*, vol. 16, no. 2 (2004), pp. 143–59

Anon., *Notes and Queries*, vol. 178 (1940), p. 292

——, *London Topographical Record*, vol. 18 (1942)

——, *Inigo Jones and Seventeenth Century British Architecture: A Selected Bibliography* [Bibliographic Research Library], Monticello, 1984

——, *A Selection of the festival designs by Inigo Jones: Scenery and Costumes from the court masques of James I and Charles I from the Chatsworth Collection . . . Eastbourne, February 23rd–April 4th 1972*, Towner Art Gallery, Eastbourne, 1984

Aston, M., *England's Iconoclasts*, Oxford, 1988

——, 'Gods, Saints and Reformers: Portraiture and Protestant England', in L. Gent (ed.), *Albion's Classicism: The Visual Arts in Britain, 1550–1660*, New Haven and London, 1995, pp. 181–220

Auerbach, E., 'Portraits of Elizabeth', *Burlington Magazine*, vol. 95 (1953), pp. 197–205

Bald, R. C., *John Donne: A Life*, Oxford, 1970

Banta, A. B., 'A "Lascivious" Painting for the Queen of England', *Apollo* (June 2004), pp. 66–71

Benham, W., *Old St Paul's Cathedral*, London, 1902

Bennett, J. A., 'Architecture and Mathematical Practice in England, 1550–1650', in J. Bold and E. Chaney (eds), *English Architecture: Public and Private. Essays for Kerry Downes*, London, 1993, pp. 23–9

Bergeron, D. M., 'Harrison, Jonson and Dekker: The Magnificent Entertainment for King James', *Journal of the Warburg and Courtauld Institutes*, vol. 31 (1968), pp. 445–8

——, 'King James's Civic Pageant and Parliamentary Speech in March 1604', *Albion*, vol. 34, no. 2 (2002), pp. 213–31

Bernard, G. W., 'The Church of England, *c.*1529–*c.*1642', *History*, vol. 75 (1990), pp. 183–206

Bickley, F., *An English Letter Book*, London, 1925

Birch, T., *Court and Times of James I*, 2 vols, London, 1848

Birrell, T. A., *English Monarchs and their Books: From Henry VII to Charles II*, London, 1986

Bloch, M., *The Royal Touch: Sacred Monarchy and Scrofula in England and France*, trans. J. E. Anderson, London, 1973

Bold, J., *Wilton House and English Palladianism* [Royal Commission on the Historical Monuments of England], London, 1988

——, *John Webb: Architectural Theory and Practice in the Seventeenth Century*, Oxford, 1989

——, 'The Critical Reception of Inigo Jones', *Transactions of the Ancient Monuments Society*, vol. 37 (1993), pp. 147–56

——, *Greenwich: An Architectural History of the Royal Hospital for Seamen and the Queen's House*, New Haven and London, 2000

——, 'John Webb', in *Oxford Dictionary of National Biography*, Oxford, 2004, vol. 57, pp. 837–41

Bolton, A. T., and Hendry, H. P. (eds), *Wren Society Volumes*, 20 vols, Oxford, 1924–43

Brinkley, R. F., *Arthurian Legend in the 17th Century*, Baltimore, 1932

Brooke-Little, J. P., *An Heraldic Alphabet*, London, 1973

Butler, M., *The Stuart Court Masque and Political Culture*, Cambridge, 2009

Buxton, J., *Elizabethan Taste*, London, 1963

Carpo, M., 'The Architectural Principles of Temperate Classicism: Merchant Dwellings in Sebastiano Serlio's Sixth Book', *Res*, vol. 22 (1992), pp. 135–51

Cassirer, E., *The Platonic Renaissance in England*, trans. J. Pettegrove, London, 1953

Chaney, E., *The Grand Tour and the Great Rebellion: Richard Lassels and 'The Voyage of Italy' in the Seventeenth Century*, Geneva, 1985

——, 'Inigo Jones in Naples', in J. Bold and E. Chaney (eds), *English Architecture: Public and Private. Essays for Kerry Downes*, London, 1993, pp. 31–53

—— (ed.), *Inigo Jones's 'Roman Sketchbook'*, 2 vols [Roxburghe Club], London, 2006

Channing Downs, A., 'Inigo Jones's Covent Garden: The First Seventy-Five Years', *Journal of the Society of Architectural Historians*, vol. 26 (1967), pp. 8–33

Chettle, G. H., *The Queen's House, Greenwich*, London, 1937

——, 'Marlborough House Chapel', *Country Life*, vol. 84 (1938), pp. 450–53

Chippindale, C., *Stonehenge Complete*, London, 1983

Chirelstein, E., 'Lady Elizabeth Pope: The Heraldic Body', in L. Gent and N. Llewellyn (eds), *Renaissance Bodies: The Human Figure in English Culture, c.1540–1660*, London, 1990, pp. 36–59

Clulee, N., *John Dee's Natural Philosophy: Between Science and Religion*, London, 1988

Coffin, C. M., *John Donne and the New Philosophy*, New York, 1937

Coffin, R., *Laud: Storm Center of Stuart England*, New York, 1930

Collier, J., *An Ecclesiastical History of Great Britain*, 9 vols, London, 1841

Colvin, H., 'Inigo Jones and the Church of St Michael Le Querne', *London Journal*, vol. 12 (1986), pp. 36–40

——, 'The South Front of Wilton House', in H. Colvin (ed.), *Essays in English Architectural History*, New Haven and London, 1999, pp. 136–57

——, 'Inigo Jones', in *A Biographical Dictionary of British Architects, 1600–1840*, 4th edn, New Haven and London, 2008, pp. 584–93 [3rd edn, 1995, p. 555]

——, 'John Webb', in *A Biographical Dictionary of British Architects, 1600–1840*, 4th edn, New Haven and London, 2008, pp. 1094–8

—— (ed.), *The History of the King's Works*, 5 vols, London, 1963–82

Cook, G. H., *Old St Paul's Cathedral: A Lost Glory of Medieval London*, London, 1955

Cooper, T. (ed.), *The Journal of William Dowsing: Iconoclasm in East Anglia during the English Civil War*, Woodbridge, 2001

Corbett, M., *Engravings in England in the Sixteenth and Seventeenth Centuries*, Cambridge, 1952

——, and Lightbown, R., *The Comely Frontispiece: The Emblematic Title-Page in England, 1550–1660*, London, 1979

Coward, B., *The Stuart Age: A History of England, 1603–1714*, London, 1980

Croft-Murray, E., *Decorative Painting in England, 1537–1837*, 2 vols, London, 1962

Cunningham, A., *The Lives of the Most Eminent British Painters, Sculptors and Architects*, 5 vols, London, 1831

Cunningham, P., *Inigo Jones: A Life of the Architect*, London, 1848; republished 2004

Daly, P. M., *Literature in the Light of the Emblem*, Toronto, 1979

De Beer, E. S., 'Notes on Inigo Jones', *Notes and Queries*, vol. 178 (1940), pp. 290–92

Debus, A. G., *John Dee's Preface* [Science History Publication], New York, 1975

Dinsmoor, W. B., 'The Literary Remains of Sebastiano Serlio', *Art Bulletin*, vol. 24 (1942), pp. 55–91 (pt 1), pp. 115–54 (pt 2)

Donaldson, I. (ed.), *Ben Jonson*, New York, 1985

Donovan, F., *Rubens and England*, New Haven and London, 2004

Downes, K., *Sir Christopher Wren*, London, 1982

Duffy, E., *The Stripping of the Altars*, New Haven and London, 1992

Duggan, D., '"London the Ring: Covent Garden the Jewel of That Ring": New Light on Covent Garden', *Architectural History*, vol. 43 (2000), pp. 140–61

Dutton, E. (ed.), *Jacobean Civic Pageants*, Keele, 1995

Eden, F. S., *Ancient Stained and Painted Glass*, Cambridge, 1933

Eliot, T. S., 'Lancelot Andrewes', in *For Lancelot Andrewes*, London, 1970

Elvin, C. N., *Dictionary of Heraldry*, London, 1889

Finch, R. H., 'Old St Paul's: A Reconstruction', *The Builder*, vol. 148 (19 and 26 April 1935), pp. 728–30, 772–3 and 778–9

Fisch, H., *Jerusalem and Albion*, London, 1964

Fowles, J., *The Enigma of Stonehenge*, London, 1980

Foxell, N., *A Sermon in Stone: John Donne and his Monument in St Paul's Cathedral*, London, 1978

Frankl, P., 'The Secret of the Mediaeval Masons', *Art Bulletin*, vol. 27 (1945), pp. 46–60

Franklyn, J., and Tanner, J., *An Encyclopaedic Dictionary of Heraldry*, London, 1970

Fraser, P., *A Catalogue of the Drawings by Inigo Jones . . . John Webb . . . Richard Boyle . . . in the Burlington-Devonshire Collection*, London, 1960

French, P. J., *John Dee: The World of an Elizabethan Magus*, London, 1972

Fusco, A. C., *Inigo Jones: Vitruvius Britannicus*, Rimini, 1985

Gair, W. R., *The Children of Paul's: The Story of a Theatre Company, 1553–1608*, Cambridge, 1982

Gardiner, S. R., *Prince Charles and the Spanish Marriage, 1617–1623: A Chapter of English History*, 2 vols, London, 1869

——, *History of England from the Accession of James I to the Outbreak of the Civil War, 1603–1642*, 10 vols, London, 1896

Gent, L., *Picture and Poetry, 1560–1620: Relations between Literature and the Visual Arts in the English Renaissance*, Leamington Spa, 1981

——, '"The Rash Gazer": Economies of Vision in Britain, 1550–1660', in Gent (ed.), *Albion's Classicism: The Visual Arts in Britain, 1550–1660*, New Haven and London, 1995, pp. 377–93

Gerbino, A., and Johnston, S., *Compass and Rule: Architecture as Mathematical Practice in England, 1500–1750*, New Haven and London, 2009

Gilbert, A. H., *The Symbolic Persons in the Masques of Ben Jonson*, Durham, NC, 1948

Girouard, M., *Robert Smythson and the Architecture of the Elizabethan Era*, London, 1966

——, *Robert Smythson and the Elizabethan Country House*, London, 1983

——, *Elizabethan Architecture: Its Rise and Fall, 1540–1640*, New Haven and London, 2009

Godfrey, F. (ed.), 'Inigo Jones and St Paul's Cathedral', *London Topographical Society Record*, vol. 18 (1942), p. 42

Gordon, D. J., 'Hymenaei: Ben Jonson's Masque of Union', *Journal of the Warburg and Courtauld Institutes*, vol. 8 (1945), pp. 107–45

——, 'Poet and Architect: The Intellectual Setting of the Quarrel between Ben Jonson and Inigo Jones', *Journal of the Warburg and Courtauld Institutes*, vol. 12 (1949), pp. 152–78

——, *The Renaissance Imagination: Essays and Lectures by D. J. Gordon*, ed. S. Orgel, Berkeley, CA 1975

Gordon, G. J., 'The Trojans in Britain', *Essays and Studies by Members of the English Association*, vol. 9 (1924), pp. 9–30

Gotch, J. A., *The Original Drawings for the Palace at Whitehall Attributed to Inigo Jones*, London, 1912

——, *Catalogue of the Drawings Attributed to Inigo Jones, Preserved at Worcester College, Oxford, and at Chatsworth*, London, 1913

——, *Inigo Jones*, London, 1928

——, 'Inigo Jones's Principal Visit to Italy in 1614: The Itinerary of his Journeys', *Journal of the Royal Institute of British Architects*, vol. 46 (1938), pp. 85–6

Gould, R. F., *The History of Freemasonry*, 6 vols, London, 1884

Hageman, E., and Conway, K., *Resurrecting Elizabeth I in Seventeenth-century England*, Madison, NJ, 2007

Haller, W., *Foxe's Book of Martyrs and the Elect Nation*, London, 1963

Harris, E., and Savage, N., *British Architectural Books and Writers, 1556–1785*, Cambridge, 1990

Harris, J., 'Inigo Jones and the Prince's Lodging at Newmarket', *Architectural History*, vol. 2 (1959), pp. 26–40

——, *Catalogue of the Drawings Collection of the RIBA: Inigo Jones and John Webb*, Farnborough, 1972

——, 'Inigo Jones', in *Macmillan Encyclopedia of Architects*, London, 1982, pp. 504–13

——, and Higgott, G., *Inigo Jones: Complete Architectural Drawings*, New York, 1989

——, Orgel, S., and Strong, R., *The King's Arcadia: Inigo Jones and the Stuart Court*, London, 1973

——, and Tait, A. A. (eds), *Catalogue of the Drawings by Inigo Jones, John Webb and Isaac De Caus at Worcester College*, Oxford, 1979

Harris Willson, D., *King James VI and I*, London, 1956

Hart, V., 'Conservation and Computers: A Reconstruction of Inigo Jones's Original Whitehall Banqueting House, *c*.1620', *Computers and the History of Art*, vol. 4, no. 1 (1993), pp. 65–9

——, 'Heraldry and the Architectural Orders as Joint Emblems of British Chivalry', *Res*, vol. 23 (1993), pp. 52–66

——, *Art and Magic in the Court of the Stuarts*, New York, 1994

——, 'Inigo Jones's Site Organisation at St Paul's Cathedral: Ponderous Masses beheld hanging in the Air', *Journal of the Society of Architectural Historians*, vol. 53 (1994), pp. 414–27

——, 'Imperial Seat or Ecumenical Temple? On Inigo Jones's Use of "Decorum" at St Paul's Cathedral', *Architectura*, vol. 25 (1995), pp. 194–213

——, *St Paul's Cathedral: Christopher Wren*, London, 1995

——, 'Lost Cities and Standing Stones: Stuart London and Palladian Bath', *Architectural Heritage: The Journal of the Architectural Heritage Society of Scotland*, vol. 6 (1996), pp. 14–32

——, '"Justice and equity . . . and proportions appertainyng": On Inigo Jones and the Stuart Legal Body', in R. Tavernor and G. Dodds (eds), *Body and Building: Essays on the Changing Relation of Body and Architecture*, Cambridge, MA, 2002, pp. 138–49

——, and Day, A., 'A Computer Model of the Theatre of Sebastiano Serlio, 1545', *Computers and the History of Art*, vol. 5, no. 1 (1995), pp. 41–52

——, and Robson, J., 'A Computer Model of Inigo Jones's Perspective Stage', *Computers and the History of Art*, vol. 6, no. 1 (1996), pp. 21–7

——, and ——, 'A Computer Reconstruction of Inigo Jones's Original Covent Garden Piazza, *c*.1640', *Computers and the History of Art*, vol. 7, no. 2 (1997), pp. 81–6

——, and Tucker, R., '"Immaginacy set free": Aristotelian Ethics and Inigo Jones's Banqueting House at Whitehall', *Res*, vol. 39 (2002), pp. 151–67

——, and ——, 'Ornament and the Work of Inigo Jones', *Architectura*, vol. 32 (2002), pp. 36–52

——, and Hicks, P. (eds), *Paper Palaces: The Rise of the Renaissance Architectural Treatise*, New Haven and London, 1998

Harting, J. H., *Catholic London Missions from the Reformation to the Year 1850*, London, 1903

Held, J., 'Rubens's Glynde Sketch and the Installation of the Whitehall Ceiling', *Burlington Magazine*, vol. 112 (1970), pp. 274–81

Henderson, G., 'Bible Illustration in the Age of Laud', *Transactions of the Cambridge Bibliographical Society*, vol. 8, pt 2 (1982), pp. 173–216

Henderson, P., 'The Loggia in Tudor and Early Stuart England: The Adaptation and Function of Classical Form', in L. Gent (ed.), *Albion's Classicism: The Visual Arts in Britain, 1550–1660*, New Haven and London, 1995, pp. 109–45

——, *The Tudor House and Garden: Architecture and Landscape in the Sixteenth and Early Seventeenth Centuries*, New Haven and London, 2005

Herndl, G. C., *The High Design: English Renaissance Tragedy and the Natural Law*, Lexington, 1970

Hersey, G. L., *The Lost Meaning of Classical Architecture*, Cambridge, 1988

Heward, J., 'The Restoration of the South Front of Wilton House: The Development of the House Reconsidered', *Architectural History*, vol. 35 (1992), pp. 69–117

Higgott, G., 'Inigo Jones in Provence', *Architectural History*, vol. 24 (1983), pp. 24–34

——, '"Varying with reason": Inigo Jones's Theory of Design', *Architectural History*, vol. 35 (1992), pp. 51–77

——, 'The Fabric to 1670', in D. Keene, A. Burns and A. Saint (eds), *St Paul's: The Cathedral Church of London, 604–2004*, New Haven and London, 2004, pp. 171–90

——, 'The Design and Setting of Inigo Jones's Queen's House, 1616–40', *Court Historian*, vol. 11, no. 2 (2006), pp. 135–48

——, 'Inigo Jones's Designs for the Queen's House in 1616', in M. Airs and G. Tyack (eds), *The Renaissance Villa in Britain, 1500–1700*, Reading, 2007, pp. 140–66

Holmes, G., *The Order of the Garter*, Windsor, 1984

Höltgen, K. J., *Aspects of the Emblem: Studies in the English Emblem Tradition and the European Context*, Kassel, 1986

——, 'An Unknown Manuscript Translation by John Thorpe of du Cerceau's *Perspective*', in E. Chaney and P. Mack (eds), *England and the Continental Renaissance*, Woodbridge, 1994 edn, pp. 215–28

Horne, H. P., 'An Essay in the Life of Inigo Jones, Architect', in *The Hobby Horse*, London, 1893, pp. 20–40, 60–80

Howard, D., *Scottish Architecture: Reformation to Restoration, 1560–1660*, Edinburgh, 1995

Howard, M., *The Early Tudor Country House: Architecture and Politics, 1490–1550*, London, 1987

——, 'The Ideal House and Healthy Life: The Origins of Architectural Theory in England', in J. Guillaume (ed.), *Les Traités d'architecture de la Renaissance*, Paris, 1988, pp. 425–33

——, *The Building of Elizabethan and Jacobean England*, New Haven and London, 2007

Howarth, D., 'Lord Arundel as an Entrepreneur of the Arts', *Burlington Magazine*, vol. 122 (1980), pp. 690–92

——, *Lord Arundel and his Circle*, New Haven and London, 1985

——, 'The Politics of Inigo Jones', in D. Howarth (ed.), *Art and Patronage in the Caroline Courts*, Cambridge, 1993, pp. 68–89

Hunneyball, P. M., *Architecture and Image-Building in Seventeenth-century Hertfordshire*, Oxford, 2004

Jackson, T. G., *Wadham College, Oxford*, Oxford, 1893

Jansson, M., 'The Impeachment of Inigo Jones and the Pulling Down of St Gregory's by St Paul's', *Renaissance Studies*, vol. 17, no. 4 (2003), pp. 716–46

Johnson, A. W., 'Angles, Squares or Roundes: Studies in Jonson's Vitruvianism', 2 vols, unpublished D.Phil. thesis, Oxford University, 1987

——, *Ben Jonson: Poetry and Architecture*, Oxford, 1994

Johnston, S., 'The Identity of the Mathematical Practitioner

in 16th-century England', in I. Hantsche (ed.), 'Der "mathematicus": Zur Entwicklung und Bedeutung einer neuen Berufsgruppe in der Zeit Gerhard Mercators', *Duisburger Mercator-Studien*, vol. 4 (1996), pp. 93–120

Jones, E. van B., *Geoffrey of Monmouth, 1640–1800*, Berkeley, CA, 1944

Kantorowicz, E. H., *The King's Two Bodies: A Study in Mediaeval Political Theology*, Princeton, 1957

Keene, D., 'The Setting of the Royal Exchange: Continuity and Change in the Financial District of the City of London, 1300–1871', in A. Saunders (ed.), *The Royal Exchange*, London, 1997, pp. 253–71

——, Burns, A., and Saint, A. (eds), *St Paul's: The Cathedral Church of London, 604–2004*, New Haven and London, 2004

Kelly, D. R., 'Legal Humanism and the Sense of History', *Studies in the Renaissance*, vol. 13, no. 1 (1966), pp. 184–99

——, 'The Rise of Legal History in the Renaissance', *History and Theory*, vol. 9 (1970), pp. 174–94

——, '*Vera Philosophia*: The Philosophical Significance of Renaissance Jurisprudence', *Journal of the History of Philosophy*, vol. 14 (1976), pp. 267–79

——, 'Civil Science in the Renaissance: Jurisprudence Italian Style', *Historical Journal*, vol. 22, no. 4 (1979), pp. 777–94

——, '*Jurisconsultus Perfectus*: The Lawyer as Renaissance Man', *Journal of the Warburg and Courtauld Institutes*, vol. 51 (1988), pp. 84–102

——, *The Human Measure: Social Thought in the Western Legal Tradition*, Cambridge, MA, 1990

Kendrick, T. D., *British Antiquity*, London, 1950

Knoop, D., *The Medieval Mason*, Manchester, 1933

——, *The London Mason in the 17th Century*, Manchester, 1935

Kriegeskorte, W., *Arcimboldo*, Berlin, 1987

Kubler, G., *Building the Escorial*, Princeton, 1982

Lang, J., *Rebuilding St Paul's after the Great Fire of London*, London, 1956

Leapman, M., *Inigo: The Troubled Life of Inigo Jones, Architect of the English Renaissance*, London, 2003

Lees-Milne, J., *The Age of Inigo Jones*, London, 1953

Lesser, G., *Gothic Cathedrals and Sacred Geometry*, 3 vols, London, 1957

Lethaby, W. H., 'Old St Paul's', *The Builder*, vol. 138 (1930): 4 April (pp. 671–3), 2 May (pp. 862–4), 6 June (pp. 1091–3); vol. 139 (1930), 4 July (pp. 24–6), 1 August (pp. 193–4), 8 August (pp. 234–6), 5 September (pp. 393–5), 10 October (pp. 613–15), 7 November (pp. 791–3), 12 December (pp. 1005–7), 26 December (pp. 1988–90)

Levack, B. P., 'The Civil Law, Theories of Absolutism and Political Conflict in Late Sixteenth- and Early Seventeenth-century England', in G. J. Schochet (ed.), *Law, Literature and the Settlement of Regimes*, Washington, DC, 1990, pp. 29–44

Levine, J., *Humanism and History: Origins of Modern English Historiography*, Ithaca, NY, 1987

Levis, H. C., *Notes on the Early British Engraved Royal Portraits Issued in Various Series from 1521 to the End of the Eighteenth Century*, London, 1917

——, *The British King Who Tried to Fly: Extracts from Old Chronicles and History Relating to Bladud*, London, 1919

Loades, D., *John Dudley, Duke of Northumberland, 1504–1553*, Oxford, 1996

——, 'John Dudley', in *Oxford Dictionary of National Biography*, Oxford, 2004, vol. 17, pp. 81–3

Loftie, W. J., *The Inns of Court and Chancery*, Southampton, 1895 edn

Longman, W., *A History of the Three Cathedrals Dedicated to St Paul in London*, London, 1873

Loomie, A. J., 'The Destruction of Rubens's "Crucifixion" in the Queen's Chapel, Somerset House', *Burlington Magazine*, vol. 140 (1998), pp. 680–82

McClung, W. A., *The Country House in English Renaissance Poetry*, Berkeley, CA, and London, 1977

MacDougall, H., *Racial Myth in English History*, Montreal, 1982

McFarlane, I. D., *The Entry of Henri II into Paris, 16 June 1549*, New York, 1982

McKechnie [Mackechnie], A., 'James VI's Architects and their Architecture', in J. Goodare and M. Lynch (eds), *The Reign of James VI*, East Linton, 2000, pp. 154–69

——, 'Sir David Cunningham of Robertland: Murderer and "Magna Britannia's" First Architect', *Architectural History*, vol. 52 (2009), pp. 79–115

Maclure, M., *The Paul's Cross Sermons, 1534–1642*, Toronto, 1958

Madocks, S., '"Trop de beautez decouveries": New Light on Guido Reni's Late *Bacchus and Ariadne*', *Burlington Magazine*, vol. 125 (1984), pp. 544–7

Malcolm, J. P., *Londinium Redivivum*, 4 vols, London, 1803

Manley, L., *Literature and Culture in Early Modern London*, Cambridge, 1997

Martines, L., *Society and History in English Renaissance Verse*, Oxford, 1985

Matthews, W. R., and Atkins, W. M. (eds), *A History of St Paul's Cathedral, and the Men Associated with It*, London, 1957

Maycock, A. L., *Nicholas Ferrar of Little Gidding*, London, 1938

Mebane, J. S., *Renaissance Magic and the Return of the Golden Age*, Lincoln, NE, 1989

Mercer, E., *English Art, 1553–1625* [Oxford History of English Art, vol. 7], Oxford, 1962

Middleton, R., et al. (eds), *The Mark J. Millard Architectural Collection. British Books: Seventeenth through Nineteenth Centuries*, vol. 2, Washington, DC, and New York, 1998

Millar, O., 'Charles I, Honthorst and Van Dyck', *Burlington Magazine*, vol. 96 (1954), pp. 36–41

——, *The Tudor, Stuart and Early Georgian Pictures in the Collection of Her Majesty the Queen*, 2 vols, London, 1963

Milman, H. H., *Annals of S. Paul's Cathedral*, London, 1868

Milton, A., 'The Laudians and the Church of Rome, c.1625–1640', unpublished PH.D. thesis, Cambridge University, 1989

Morolli, G., '*Vetus Etruria*', Florence, 1985

Mowl, T., and Earnshaw, B., *Architecture without Kings: The Rise of Puritan Classicism under Cromwell*, Manchester, 1995

Needham, R. W., *Somerset House Past and Present*, London, 1905

Newman, J., 'Nicholas Stone's Goldsmiths' Hall: Design and Practice in the 1630s', *Architectural History*, vol. 14 (1971), pp. 30–39

——, 'An Early Drawing by Inigo Jones and a Monument in Shropshire', *Burlington Magazine*, vol. 115 (1973), pp. 360–67

——, 'The Dating of Inigo Jones's Handwriting' [1980], typescript from 'Essays Presented to Professor Peter Murray', lodged in the Senate House Library, University of London

——, 'Italian Treatises in Use: The Significance of Inigo Jones's Annotations', in J. Guillaume (ed.), *Les Traités d'architecture de la Renaissance*, Paris, 1988, pp. 435–41

——, 'Inigo Jones's Architectural Education before 1614', *Architectural History*, vol. 35 (1992), pp. 18–50

——, 'Laudian Literature and the Interpretation of Caroline Churches in London', in D. Howarth (ed.), *Art and Patronage in the Caroline Courts*, Cambridge, 1993, pp. 181–6

——, 'Inigo Jones and the Politics of Architecture', in K. Sharpe and P. Lake (eds), *Culture and Politics in Early Stuart England*, Basingstoke, 1994, pp. 251–4

——, 'Inigo Jones', in *Oxford Dictionary of National Biography*, Oxford, 2004, vol. 30, pp. 527–38

Olsen, V. N., *John Foxe and the Elizabethan Church*, Berkeley, CA, 1973

Onians, J., 'Style and Decorum in Sixteenth-century Italian Architecture', unpublished PH.D. thesis, Warburg Institute, London University, 1968

——, *Bearers of Meaning: The Classical Orders in Antiquity, the Middle Ages and the Renaissance*, Cambridge, 1988

Orgel, S., 'Inigo Jones on Stonehenge', *Prose*, vol. 3 (1971), pp. 107–24

——, *The Illusion of Power: Political Theatre in the English Renaissance*, Berkeley, CA, 1975

——, and Strong, R., *Inigo Jones: The Theatre of the Stuart Court*, 2 vols, London, 1973

Orrell, J., *The Quest for Shakespeare's Globe*, Cambridge, 1983

——, *The Theatres of Inigo Jones and John Webb*, Cambridge, 1985

——, *The Human Stage: English Theatre Design, 1567–1640*, Cambridge, 1988

Osborne, J., *Hampton Court Palace*, Kingswood, 1984

Palme, P., *The Triumph of Peace: A Study of the Whitehall Banqueting House*, London, 1957

Parry, G., *Hollar's England: A Mid-Seventeenth-century View*, Salisbury, 1980

——, *Golden Age Restor'd: The Culture of the Stuart Court, 1602–42*, Manchester, 1981

Parsons, A. E., 'The Trojan Legend in England', *Modern Language Review*, vol. 24 (1929), pp. 253–64, 394–408

Patterson, R., 'The "Hortus Palatinus" at Heidelberg and the Reformation of the World', *Journal of Garden History*, vol. 1 (1981), pp. 67–104, 179–202

Payne, A., *The Architectural Treatise in the Italian Renaissance*, Cambridge, 1999

Peacock, J., 'Inigo Jones's Catafalque for James I', *Architectural History*, vol. 25 (1982), pp. 1–5

——, 'Inigo Jones's Stage Architecture and its Sources', *Art Bulletin*, vol. 64 (1982), pp. 195–216

——, 'The French Element in Inigo Jones's Masque Designs', in D. Lindley (ed.), *The Court Masque*, Manchester, 1984, pp. 155–7

——, 'Inigo Jones as a Figurative Artist', in L. Gent and N. Llewellyn (eds), *Renaissance Bodies: The Human Figure in English Culture, c.1540–1660*, London, 1990, pp. 154–79

——, 'Inigo Jones and Renaissance Art', *Renaissance Studies*, vol. 4, no. 3 (1990), pp. 245–72

——, *The Stage Designs of Inigo Jones: The European Context*, Cambridge, 1995

——, and Anderson, C., 'Inigo Jones, John Webb and Temple Bar', *Architectural History*, vol. 44 (2001), pp. 29–38

Pearl, V., *London and the Outbreak of the Puritan Revolution: City Government and National Politics, 1625–43*, Oxford, 1961

Peck, L. Levy (ed.), *The Mental World of the Jacobean Court*, Cambridge, 1991

Phillips, J., *The Reformation of Images: Destruction of Art in England, 1535–1660*, Berkeley, CA, 1973

Pocock, N., *The Life of Richard Steward, Dean Designate of St Paul's*, London, 1908

Pritchard, A., 'A Source for the Lives of Inigo Jones and John Webb', *Architectural History*, vol. 23 (1980), pp. 138–40

Ramsey, S., *Inigo Jones*, London, 1924

Randall, C., *Building Codes: The Aesthetics of Calvinism in Early Modern Europe*, Philadelphia, 1999

Roberts, S., 'Lying among the Classics: Ritual and Motif in Elite Elizabethan and Jacobean Beds', in L. Gent (ed.), *Albion's Classicism: The Visual Arts in Britain, 1550–1660*, New Haven and London, 1995, pp. 325–58

Robertson, J. C., 'Caroline Culture: Bridging Court and Country?', *History*, vol. 75 (1990), pp. 388–416

Rosenau, H., *Vision of the Temple: The Image of the Temple of Jerusalem in Judaism and Christianity*, London, 1979

Routh, C. R. N., *Who's Who in Tudor England*, London, 1990

Rowe, C., 'Theoretical Drawings of Inigo Jones', unpublished MA dissertation, London University, 1947

Rye, W. B., *England as Seen by Foreigners*, London, 1865

Rykwert, J., *On Adam's House in Paradise: The Idea of the Primitive Hut in Architectural History*, New York, 1972

——, *The First Moderns*, London and Cambridge, MA, 1980

——, 'On the Oral Transmission of Architectural Theory', *AA Files: Annals of the Architectural Association School of Architecture*, no. 6 (May 1984), pp. 1–27

——, *The Dancing Column: On Order in Architecture*, Cambridge, MA, 1996

Saura, M., 'Architecture and the Law in Early Renaissance Urban Life: Leon Battista Alberti's "De Re Aedificatoria"', unpublished PH.D. thesis, University of California at Berkeley, 1988

Scharf, G., *Catalogue of Pictures Belonging to the Society of Antiquaries*, Bungay, 1865

Schuchard, M. K., *Restoring the Temple of Vision: Cabalistic Freemasonry and Stuart Culture*, Leiden and Boston, MA, 2002

Semler, L. E., 'Inigo Jones, Capricious Ornament and Plutarch's Wise Men', *Journal of the Warburg and Courtauld Institutes*, vol. 66 (2003), pp. 123–42

——, 'Robert Dallington's *Hypnerotomachia* and the Protestant Antiquity of Elizabethan England', *Studies in Philology*, vol. 103 (2006), pp. 208–41

Sgarbi, C., 'A Newly Discovered Corpus of Vitruvian Images', *Res*, vol. 23 (1993), pp. 31–51.

Shapiro, B. J., *Probability and Certainty in Seventeenth-century*

England: A Study of the Relationships between Natural Science, Religion, History, Law and Literature, Princeton, 1983

Sharpe, K., *Criticism and Compliment: The Politics of Literature in the England of Charles I*, Cambridge, 1987

——, *The Personal Rule of Charles I*, New Haven and London, 1992

——, *Image Wars: Promoting Kings and Commonwealths in England 1603–1660*, New Haven and London, 2010

Sheppard, F. H. W. (ed.), *Survey of London*, vol. 36, London, 1970

Sherman, W. H., *John Dee: The Politics of Reading and Writing in the English Renaissance*, Amherst, 1995

Simpson, P., and Bell, C. F., *Designs by Inigo Jones for Masques and Plays* [Walpole Society], vol. 12, Oxford, 1923–4

Sinclair, W., *Memorials of St Paul's Cathedral*, London, 1909

Smith, E. B., *Architectural Symbolism of Imperial Rome and the Middle Ages*, Princeton, 1956

Smith, N., *The Royal Image and the English People*, Aldershot, 2001

Somerville, R., 'Henry Farley', *London Topographical Record*, vol. 25 (1985), pp. 163–75

Sommerville, J. P., *Politics and Ideology in England, 1603–1640*, London, 1986

Spraggon, J., *Puritan Iconoclasm during the English Civil War: The Attack on Religious Imagery by Parliament and its Soldiers*, Woodbridge, 2003

Stevenson, C., 'Occasional Architecture in Seventeenth-century London', *Architectural History*, vol. 49 (2006), pp. 35–74

Stone, L., 'The Building of Hatfield House', *Archaeological Journal*, vol. 112 (1955), pp. 118–20

——, 'Inigo Jones and the New Exchange', *Archaeological Journal*, vol. 114 (1957), pp. 106–21

Strong, R., 'Inigo Jones and the Revival of Chivalry', *Apollo* (August 1967), pp. 102–7

——, *Splendour at Court: Renaissance Spectacle and Illusion*, London, 1973

——, *The Renaissance Garden in England*, London, 1979

——, *Britannia Triumphans: Inigo Jones, Rubens and Whitehall Palace*, London, 1980

——, *Art and Power*, Woodbridge, 1984

——, *Henry Prince of Wales and England's Lost Renaissance*, London, 1986

——, *The Cult of Elizabeth*, London, 1987

——, 'Britain's Vanished Treasures', *Sunday Times Magazine* (19 November 1989)

——, *Lost Treasures of Britain*, London, 1990

——, *The Artist and the Garden*, London, 2000

Summerson, J., *Georgian London*, London, 1945

——, 'Three Elizabethan Architects', *Bulletin of the John Rylands Library*, vol. 40 (1957), pp. 202–28

——, 'Lectures on a Master Mind: Inigo Jones', *Proceedings of the British Academy*, vol. 50 (1964), pp. 169–92

——, *Inigo Jones*, Harmondsworth, 1966 [republished with intro. by H. Colvin, New Haven and London, 2000]

——, *Architecture in Britain, 1530 to 1830*, Harmondsworth, 1983 and 1993 edns

——, *The Unromantic Castle*, London, 1990

—— (ed.), *The Book of Architecture of John Thorpe in Sir John Soane's Museum*, Glasgow, 1966

Tait, A. A., 'Isaac de Caus and the South Front of Wilton House', *Burlington Magazine*, vol. 106 (1964), p. 74

——, 'Inigo Jones: Architectural Historian', *Burlington Magazine*, vol. 112 (1970), p. 235

——, 'Inigo Jones's "Stone-Heng"', *Burlington Magazine*, vol. 120 (1978), pp. 155–9

Tavernor, R., *Palladio and Palladianism*, London, 1991

——, 'Contemporary Perfection through Piero's Eyes', in R. Tavernor and G. Dodds (eds), *Body and Building: Essays on the Changing Relation of Body and Architecture*, Cambridge, MA, 2002, pp. 78–93

Taylor, R., 'Architecture and Magic: Considerations on the Idea of the Escorial', in H. Hibbard (ed.), *Essays in the History of Art Presented to Rudolf Wittkower*, London, 1967, pp. 81–109

——, 'Hermetic and Mystical Architecture in the Society of Jesus', in R. Wittkower (ed.), *Baroque Art: The Jesuit Contribution*, New York, 1972, pp. 63–97

Thomas, K., *Religion and the Decline of Magic*, London, 1971

——, 'English Protestantism and Classical Art', in L. Gent (ed.), *Albion's Classicism: The Visual Arts in Britain, 1550–1660*, New Haven and London, 1995, pp. 221–38

Thurley, S., *Whitehall Palace: An Architectural History of the Royal Apartments, 1240–1698*, New Haven and London, 1999

——, 'The Stuart Kings, Oliver Cromwell and the Chapel Royal, 1618–1685', *Architectural History*, vol. 45 (2002), pp. 238–74

——, *Somerset House: The Palace of England's Queens, 1551–1692* [London Topographical Society, Publication no. 168], London, 2009

Toplis, G., 'Inigo Jones: A Study of Neoplatonic Aspects of his Thought and Work', unpublished MA dissertation, Liverpool University, 1967

Trevor-Roper, H., *Archbishop Laud, 1573–1645*, London, 1940 edn

——, *Catholics, Anglicans and Puritans*, London, 1987

Tudor-Craig, P., *'Old St Paul's': The Society of Antiquaries Diptych, 1616* [London Topographical Society, Publication no. 163], London, 2004

Tyacke, N., *Anti-Calvinists: The Rise of English Arminianism, c.1590–1640*, Oxford, 1987

Ullmann, W., *On the Influence of Geoffrey of Monmouth in English History*, Freiburg, 1965

Van Eck, C., *Classical Rhetoric and the Visual Arts in Early Modern Europe*, Cambridge, 2007

——, 'Statecraft or Stagecraft? English Paper Architecture in the Seventeenth Century', in S. Bonnemaison and C. Macy (eds), *Festival Architecture*, Oxford and New York, 2008, pp. 113–28

Veevers, E., *Images of Love and Religion: Queen Henrietta Maria and Court Entertainments*, Cambridge and New York, 1989

Westfall, C. W., *In This Most Perfect Paradise: Alberti, Nicholas V and the Invention of Conscious Urban Planning in Rome, 1447–55*, University Park, PA, 1974

Weston, C. C., and Greenberg, J. R., *Subjects and Sovereigns: The Grand Controversy over Legal Sovereignty in Stuart England*, Cambridge, 1981

Wheatley, H. B., *London Past and Present*, 3 vols, London, 1891

Whinney, M. D., 'John Webb's Drawings for Whitehall Palace', *Walpole Society*, vol. 31 (1946), pp. 45–107

——, *Wren*, London, 1971

White, M., *Henrietta Maria and the English Civil Wars*, London, 2006

Wilkinson, R., *London Illustrata*, London, 1819

Wilks, M., *The Problem of Sovereignty in the Later Middle Ages*, Cambridge, 1963

Wilks, T., 'The Court Culture of Henry Prince of Wales', unpublished D.Phil. thesis, Oxford University, 1987

Williams, G., 'Some Protestant Views of Early British Church History', in Williams, *Welsh Reformation Essays*, Cardiff, 1967, pp. 207–19

Willson, D. H., *King James VI and I*, London, 1956

Wittkower, R., 'Pseudo-Palladian Elements in English Neo-Classical Architecture', *Journal of the Warburg and Courtauld Institutes*, vol. 6 (1943), pp. 154–64

——, 'Puritanissimo Fiero', *Burlington Magazine*, vol. 90 (1948), pp. 50–51 [reprinted in his *Palladio and English Palladianism*, 1974, pp. 67–70]

——, *Architectural Principles in the Age of Humanism*, London, 1949

——, 'Inigo Jones, Architect and Man of Letters', *Journal of the Royal Institute of British Architects*, vol. 60 (1953), pp. 83–90 [reprinted in his *Palladio and English Palladianism*, 1974, pp. 51–66]

——, 'English Literature on Architecture', in Wittkower, *Palladio and English Palladianism*, 1974, pp. 95–112

——, *Gothic versus Classic*, London, 1974

——, *Palladio and English Palladianism*, London, 1974

Wood, J., 'Inigo Jones, Italian Art and the Practice of Drawing', *Art Bulletin*, vol. 74, no. 2 (1992), pp. 247–70

Woodforde, C., *The Stained Glass of New College, Oxford*, London, 1951

Worsley, G., *Classical Architecture in Britain: The Heroic Age*, New Haven and London, 1995

——, 'Stoke Park Pavilions, Northamptonshire', *Country Life*, vol. 199 (2005), pp. 90–95

——, *Inigo Jones and the European Classicist Tradition*, New Haven and London, 2007

Yates, F., *The Art of Memory*, London, 1966

——, *Theatre of the World*, London, 1969

——, *The Rosicrucian Enlightenment*, London, 1972

——, *Astraea: The Imperial Theme in the Sixteenth Century*, London, 1975; republished 1985

——, *The Occult Philosophy in the Elizabethan Age*, London, 1979

Yeomans, D., 'The Serlio Floor and its Derivations', *Architectural Research Quarterly*, vol. 2 (1997), pp. 74–83

Yorke, P. D., 'Iconoclasm, Ecclesiology and "Beauty in Holiness": Concepts of Sacrilege and "the Peril of Idolatry" in Early Modern England, *c*.1590–1642', unpublished Ph.D. thesis, University of Kent, 1977

PHOTOGRAPH CREDITS

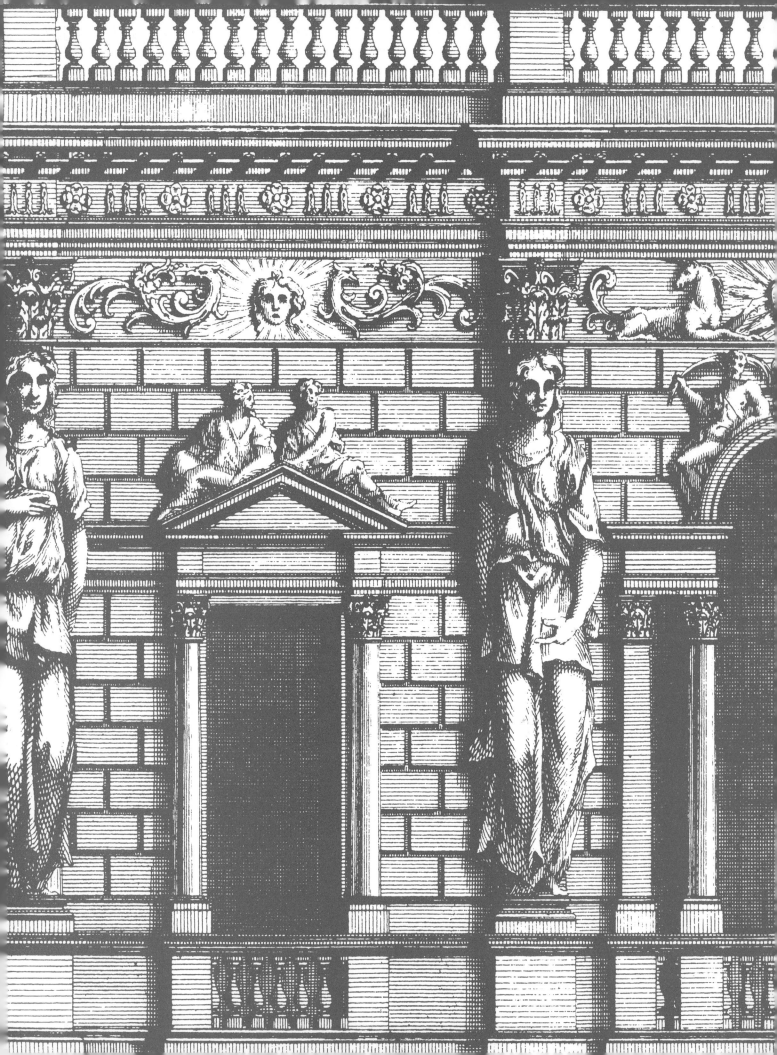